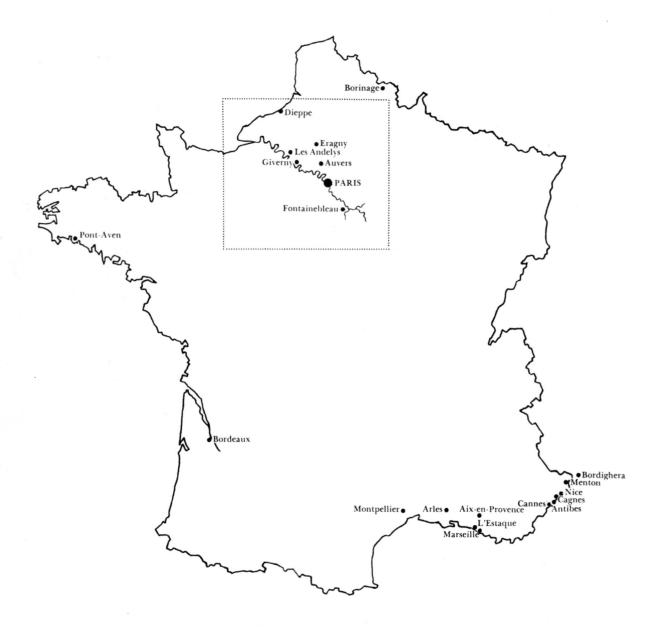

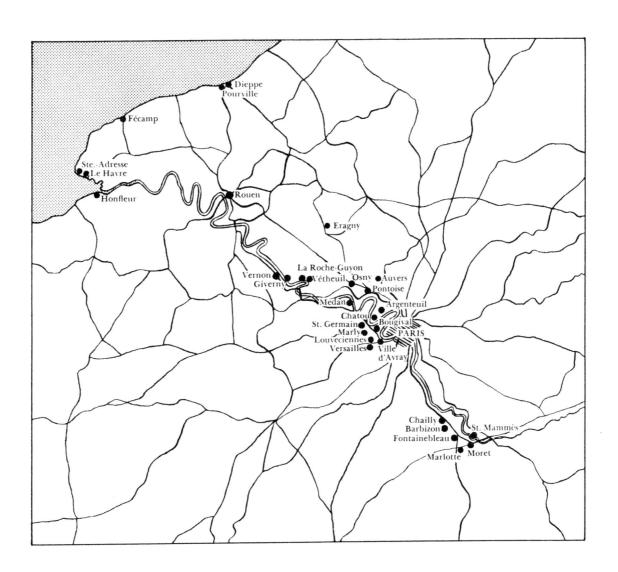

THE HISTORY OF IMPRESSIONISM

BOOKS BY JOHN REWALD

GAUGUIN, New York, 1938

Maillol, New York, 1939

Georges Seurat, New York, 1943, 1946

Paul Cézanne, New York, 1948

PIERRE BONNARD, New York, 1948

Les Fauves, New York, 1952

Post-Impressionism - From van Gogh to Gauguin, New York, 1956, 1962, 1978

SEURAT - L'ŒUVRE PEINT, BIOGRAPHIE ET CATALOGUE CRITIQUE (in collaboration with Henri Dorra), Paris, 1959

CÉZANNE, GEFFROY, GASQUET, Paris, 1959

REDON - MOREAU - BRESDIN (in collaboration with D. Ashton and H. Joachim), New York, 1961

Camille Pissarro, New York, 1963

GIACOMO MANZÙ, New York, 1967

Edited by the same author

PAUL CÉZANNE, LETTERS, London, 1941, New York, 1976

Paul Gauguin, Letters to A. Vollard and A. Fontainas, San Francisco, 1943

CAMILLE PISSARRO, LETTERS TO HIS SON LUCIEN, New York, 1943, 1972

The Woodcuts of Aristide Maillol (a catalogue), New York, 1943

The Sculptures of Edgar Degas (a complete catalogue), New York, 1944, 1956

Renoir Drawings, New York, 1946, 1958

Paul Cézanne, Carnets de Dessins, Paris, 1951

Gauguin Drawings, New York, 1958

In preparation

Paul Cézanne (catalogue raisonné of his paintings and watercolors)

Post-Impressionism - From Gauguin to Matisse

Paul Gauguin, Letters (complete edition; in collaboration with M. Bodelsen and B. Danielsson)

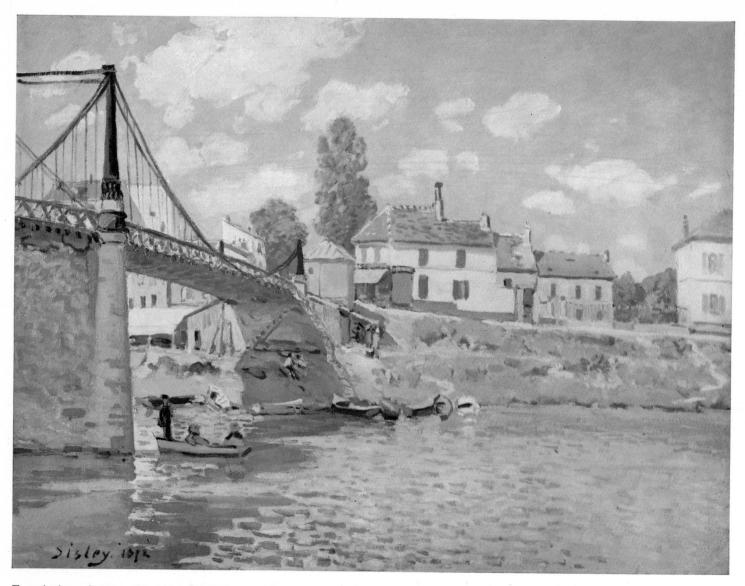

Frontispiece, Sisley: The Bridge of Villeneuve-la-Garenne, d. 1872. $19\frac{3}{4} \times 25\frac{5}{8}$ ". Ittleson Collection, New York.

THE HISTORY OF IMPRESSIONISM

Fourth, Revised Edition JOHN REWALD

Secker & Warburg • London

TRUSTEES OF THE MUSEUM OF MODERN ART

WILLIAM S. PALEY, CHAIRMAN OF THE BOARD; GARDNER COWLES, MRS. BLISS PARKINSON, DAVID ROCKEFELLER, VICE CHAIRMEN; MRS. JOHN D. ROCKEFELLER 3RD, PRESIDENT; MRS. FRANK Y. LARKIN, DONALD B. MARRON, JOHN PARKINSON III, VICE PRESIDENTS; JOHN PARKINSON III, TREASURER; MRS. L. VA. AUCHINCLOSS, EDWARD LARRABEE BARNES, ALFRED H. BARR, JR.*, MRS. ARMAND P. BARTOS, GORDON BUNSHAFT, SHIRLEY C. BURDEN, WILLIAM A. M. BURDEN, THOMAS S. CARROLL, FRANK T. CARY, IVAN CHERMAYEFF, MRS. C. DOUGLAS DILLON, GIANLUIGI GABETTI, PAUL GOTTLIEB, GEORGE HEARD HAMILTON, WALLACE K. HARRISON*, WILLIAM A. HEWITT, MRS. WALTER HOCHSCHILD*, MRS. JOHN R. JAKOBSON, PHILIP JOHNSON, RONALD S. LAUDER, JOHN L. LOEB, RANALD H. MACDONALD*, MRS. G. MACCULLOCH MILLER*, J. IRWIN MILLER*, S. I. NEWHOUSE, JR., RICHARD E. OLDENBURG, PETER G. PETERSON, GIFFORD PHILLIPS, MRS. ALBRECHT SAALFIELD, MRS. WOLFGANG SCHOENBORN*, MARTIN E. SEGAL, MRS. BERTRAM SMITH, MRS. ALFRED R. STERN, MRS. DONALD B. STRAUS, WALTER N. THAYER, R. L. B. TOBIN, EDWARD M. M. WARBURG*, MRS. CLIFTON R. WHARTON, JR., MONROE WHEELER*, JOHN HAY WHITNEY*

*HONORARY TRUSTEE

EX OFFICIO: EDWARD I. KOCH, MAYOR OF THE CITY OF NEW YORK; HARRISON J. GOLDIN, COMPTROLLER OF THE CITY OF NEW YORK

All Rights Reserved

First published in England in clothbound edition 1973, reprinted 1980, first published in England in paperbound edition 1980 by

Martin Secker & Warburg Limited, 54 Poland Street, London W1V 3DF

First published in the United States of America 1946 by

The Museum of Modern Art, New York

4th revised edition, 1973

1st edition, 1946; 2nd revised edition, 1955; 3rd revised edition, 1961

Clothbound SBN 436 41150 4

Paperbound SBN 436 41149 0

Printed in Japan by Toppan Printing Company Ltd.

CONTENTS

Introduction			7
Chapter I	1855–1859	The Paris World's Fair, 1855 A Panorama of French Art	13
Chapter II	1859–1861	Monet and Boudin Manet and Degas L'Académie Suisse The Atelier of Courbet	37
Chapter III	1862–1863	Gleyre's Studio The Salon des Refusés and the Reorganization of the Ecole des Beaux-Arts	69
Chapter IV	1864–1866	Barbizon and Its Painters New Salons Successes and Disappointments	93
Chapter V	1866–1868	Zola as an Art Critic Another World's Fair Plans for a Group Exhibition More Difficulties for Monet	139
Chapter VI	1869–1870	The Café Guerbois Japanese Prints "La Grenouillère"	197
Chapter VII	1870–1871	The Salon of 1870 The Franco-Prussian War and the "Commune" Monet and Pissarro in London	239
Chapter VIII	1872–1873	The Years after the War Auvers-sur-Oise Another Salon des Refusés (1873)	271
Chapter IX	1873-1874	The First Group Exhibition (1874) and the Origin of the Word "Impressionism"	309

Chapter X	1874–1877	Argenteuil Caillebotte and Chocquet Auction Sales and Further Exhibitions First Echoes Abroad Duranty's Pamphlet "La Nouvelle Peinture"	341	
Chapter XI	1877–1879	The Café de la Nouvelle-Athènes Renoir, Sisley, and Monet at the Salon A New Art Critic: Huysmans Serious Disagreements	399	
Chapter XII	1880–1883	More Exhibitions and Divisions of Opinion The Death of Manet	439	
Chapter XIII	1883–1885	Dissatisfaction and Doubts Gauguin in Copenhagen Redon Seurat and Signac The Société des Indépendants (1884)	481	
Chapter XIV	1886	The Eighth and Last Impressionist Exhibition Durand-Ruel's First Success in America Gauguin and van Gogh	521	
Chapter XV		The Years after 1886	547	
Sources of Illustrations			590	
List of Participants in the Various Group Shows			591	
Biographical Chart				
Bibliography				
Index				
Map of Places Where the Impressionists Worked				

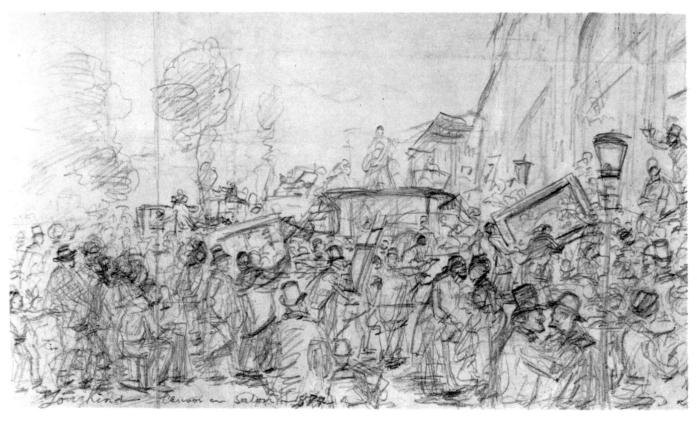

Jongkind: Delivery of Paintings at the Salon, d. 1874. Pencil, $9\frac{3}{8} \times 16\frac{3}{4}$ ". Private collection, New York.

INTRODUCTION

In the spring of 1874 a group of young painters defied the official Salon in Paris and organized an exhibition of its own. While this was in itself a break with established customs, the works which these men showed seemed at first glance even more revolutionary. The reaction of visitors and critics was by no means friendly; they accused the artists of painting differently from the accepted methods simply to gain attention or pull the legs of honest folk. It took years of bitter struggle before the members of the little group were able to convince the public of their sincerity, not to mention their talent.

This group included Monet, Renoir, Pissarro, Sisley, Degas, Cézanne, and Berthe Morisot. They were not only of diverse characters and gifts, but also, to a certain extent, of differing conceptions and tendencies. Yet born almost within the same decade, they all went through similar experiences and fought against the same opposition. Thrown together more or less by chance, they accepted their common fate and eventually adopted the designation of "impressionists," a word coined in derision by a satirical journalist.

When the impressionists organized their first group exhibition, they were no longer awkward beginners; all of them were over thirty and had been working ardently for fifteen years and more. They had studied—or tried to study—at the *Ecole des Beaux-Arts*, gone to the older generation for advice, discussed and absorbed the various currents in the arts of their time. Some even had obtained a certain success at different Salons before the Franco-Prussian War. But they had declined to follow blindly the methods of the acclaimed masters and pseudo-masters of the day. Instead, they had derived new concepts from the lessons of the past and the present, developing an art entirely their own. This independence had brought them into repeated conflicts with the reactionary jury of the Salon, to the extent that to show their works outside of the official exhibitions seemed to be the only means left them to approach the general public.

Although their canvases shocked their contemporaries as being brazen, they represented in fact the true continuation of the endeavors and theories of their predecessors. Thus the new phase in the history of art inaugurated by the impressionist exhibition of 1874 was not a sudden outbreak of iconoclastic tendencies; it was the culmination of a slow and consistent evolution.

The impressionist movement, therefore, did not begin with the year 1874. While all the great artists of the past contributed their share to the development of impressionist principles, the immediate roots of the movement can be most clearly discovered in the twenty years preceding the historic exhibition of 1874. Those were the years of formation, during which the impressionists met and brought forth their views and talent toward a new approach to nature. Any attempt to retrace the history of impressionism will thus have to begin with the period in which the essential ideas took shape. That period, dominated by such older men as Ingres, Delacroix, Corot, and Courbet, as well as by ill-understood traditions, was the background against which the young generation promoted its heretical concepts. This explains the importance of those early years when Manet (who chose not to participate in the group exhibition), Monet, Renoir, and Pissarro refused to follow their teachers and set out on a road of their own, the road which led to impressionism.

The present survey follows the evolution of the impressionist painters from their beginnings to the culmination of their efforts in 1874 and throughout the eight exhibitions organized by them. It ends virtually with the year 1886 in which the last group show marked the definite disbandment of the companions and their more or less complete abandonment of impressionism. As to the story of the twenty succeeding years—until the death of Cézanne—it will be treated in an equally detailed history of post-impressionism, of which the first volume, From van Gogh to Gauguin, appeared in 1956. After the publication of the second part, From Gauguin to Matisse (now in preparation), the three volumes together will cover fifty years of French art, from 1855 to 1906.

"It would be impossible now, I'm afraid," stated E. A. Jewell in 1944, "for anyone to piece together a full and in the minutest degree accurate report of developments that led up to the first impressionist exhibition.... An inclusive record such as that would cover the germinating decade, and to it we should want added, of course, as full and minute and accurate a report covering the decade that followed,

with its triumphs and its setbacks, its slow and often painful success in breaking down barriers of critical and popular disesteem." Nothing could describe better the program of the present book, for it is exactly its ambition to offer such an "accurate report of developments."

There exist already a score of publications on impressionism, but most of them are divided into chapters devoted to the individual painters, and do not tell the story of the movement itself. The first attempt to consider simultaneously the evolution of the various artists was made by R. H. Wilenski, whose brilliantly conceived *Modern French Painters* (1940) unfortunately suffers from numerous inaccuracies as well as from an abundance of not always related details. As to the many books concerning individual members of the impressionist group, they naturally have a tendency to isolate their specific subject. Yet, to appreciate fully the stature of each impressionist, it seems essential first to study his position in the movement, his contribution to it, and also the contribution of the others to his own progress.

"Perfection is a collective work," Boudin once wrote. "Without that person, this one would never have achieved the perfection he did." If this is true of any artist, it is even more so in the case of a group of painters who learned, fought, suffered, and exhibited together. But not all who participated in these exhibitions were real impressionists, while others, who did not openly join the group, can be considered as such. For this reason the scope of the present study has been extended to the men who, from near or far, were connected with the movement and collaborated in giving it shape. Even if they sometimes acted contrary to each other's interests and were, as a group, occasionally divided by internal struggles, their works tell, almost better than their actions, how they pursued—both individually and together—the conquest of a new vision.

The story of this conquest may be told in many ways, but most effectively by presenting it through the works themselves. By placing these in their historical context, by reproducing together paintings conceived and executed during the same period by the various members of the group, by following the progress of each artist simultaneously with that of his colleagues, it seems possible to obtain a true image of the impressionist movement. Such a procedure may not always do justice to individual works—since it considers them merely as part of a whole—but once they have been given their place in that whole, it will become easier for others to explore them more completely.

The evidence on which this study is based can be divided roughly into the following elements: the artists' works (and here, in many instances, little-known ones have been reproduced in preference to more famous examples); next to these, the writings and comments of the artists themselves; furthermore, the numerous accounts of witnesses, who offer substantial information about these artists, their work, their surroundings, etc.; finally, contemporary criticisms, which are essential insofar as they are not only of anecdotal interest but are facts in every artist's life, implying a wide range of psychological and financial consequences. By quoting contemporary sources extensively in preference to rewriting the information derived from them, I endeavored to reconstitute to a certain extent the atmosphere of the period, placing the reader in direct contact with the original texts. In this way students are provided with actual documents that could otherwise be obtained only through

long research. Most of these documents, moreover, have not previously been available in English.

Although I was able to gather some material for this book in France (the descendants of Pissarro, Zola, Cézanne, and Berthe Morisot were most helpful in this connection), I naturally had to depend chiefly on previous publications. A list of them, together with a discussion of their respective value for the student, will be found in the bibliography, but it should be stated here that even the most authoritative sources have not been used without checking.

It is obvious that the historian who explores a period through which he himself has not lived must rely exclusively upon sources and upon deductions derived from them. The extreme of scholarly procedure would be therefore to accompany every single sentence by a footnote explaining its origin. Although this can be done, such a method is hardly advisable in a book destined for a wide public. With notes reduced in most cases to simple references at the end of each chapter, it appears not unimportant to acquaint the reader with the manner in which the material has been handled, so as to convince him that every fact has been investigated and every word carefully weighed. Wherever I have not resorted to actual quotations, the reader is given (a) information derived directly from documents, though these remain unquoted; (b) deductions arrived at by consideration of facts often in themselves not worth mentioning; (c) guesses, indicated as such by the use of qualifying adverbs—"probably," "apparently," etc. Deductions are more difficult to obtain when various sources contradict each other. Since the most scrupulous investigation does not always yield definite results, I have occasionally resorted to guessing unless I felt authorized to draw conclusions.

In doing so, I have been inspired by the principles of the great French historian Fustel de Coulanges, who wrote: "History is not an art, it is a pure science. It does not consist in telling a pleasant story or in profound philosophizing. Like all science, it consists in stating the facts, in analyzing them, in drawing them together and in bringing out their connections. The historian's only skill should consist in deducing from the documents all that is in them and in adding nothing they do not contain. The best historian is he who remains closest to his texts, who interprets them most fairly, who writes and even thinks only at their direction."

The first edition of this book, published in 1946, was followed by a second printing in 1955, featuring only minor alterations and corrections, except for the bibliography, which was brought up to date. The third edition, however, which appeared in 1961, was extensively revised, a great number of illustrations, both in color and in black and white, were added, and the format was changed to match that of the first volume on post-impressionism. For the present edition, further revisions have been made, if not always in the text, at least in the footnotes in order to take into account all the findings and data included in recent publications.

Because the material is chronologically arranged, it was possible, for the third printing as well as for the present one, to make additions and revisions without interrupting the narrative or interfering with the general plan of the book. Indeed, all new documents and facts almost automatically found their logical place in the general context. Errors have been corrected (but only in very few instances are such corrections discussed in notes) and a few passages have been shifted. A major change

in the third edition concerned the division of chapters, which had to be modified so that the accumulation of new material would not unduly lengthen some sections of the book. As a result, there were fifteen chapters in the third edition as compared to eleven in the previous ones, but these additional chapters were not really altogether "new." It should be added that an effort has been made—particularly in the last chapters—to deal more extensively with various figures such as J. K. Huysmans, Gauguin, Seurat, Signac, and van Gogh, in order to introduce more fully some of the personalities who are prominently featured in the first volume on post-impressionism and thus to establish a closer link between the present book and its sequel. If the final chapter on the impressionists after 1886 has been maintained, the reason is that the impressionists were mostly kept "in the background" in the succeeding volume. On the other hand the section devoted to the years 1884–86 unavoidably overlaps with the opening pages of *Post-Impressionism—From van Gogh to Gauguin*.

Any effort to encompass a period and its numerous protagonists must forcibly neglect to a certain extent the individual figures. Fortunately, since this book first appeared some twenty-seven years ago, many valuable works have been published, on which I have drawn for this revised edition. Among these are the Degas œuvre catalogue by P. A. Lemoisne; the catalogues of Bazille's and Sisley's paintings by F. Daulte; A. Tabarant's exhaustive volume on Manet, N. G. Sandblad's study of the same master's artistic conception, G. H. Hamilton's treatise on Manet and his critics; D. Rouart's excellent publication of Berthe Morisot's correspondence; and a complete edition of Zola's art criticism by F. W. J. Hemmings and R. J. Niess. Among general surveys, special mention should be made of J. C. Sloane's book on French art from 1848 to 1870, O. Reuterswärd's study of impressionism, and J. Lethève's compilation of press comments on the impressionists and their exhibitions. Articles in periodicals with important contributions are too numerous to be listed here. Of publications which had previously escaped my attention, I wish to mention A. Silvestre's volume of souvenirs which provided much additional information for the chapter on the Café Guerbois. Quotations from these and other sources are acknowledged in the notes; it goes without saying that these sources as well as many other publications are also listed in the newly extended bibliography.

Documents which appeared for the first time in the previous editions of this book are still listed in the notes as "unpublished." In addition there are now others that have not been made public before and that are given here with the same indication.

I should like to record my deep appreciation of the generous assistance I have received—in the United States as well as abroad—from many scholars and collectors who permitted me to examine and reproduce their paintings, from scholars and staffs of museums and libraries who helped with my research, and from art dealers. Special thanks are due to the Durand-Ruel Galleries, whose important role in the history of impressionism cannot be over-emphasized, for facilitating the use of their invaluable files of photographs, catalogues, and other records, as well as for assisting me in any conceivable way; also to Mr. Herbert Elfers, formerly of the New York branch of that firm, for his gracious personal support.

Because of war-time conditions, the original edition of this book had to be prepared exclusively in the United States, but the revisions were made with access to European sources. The late Mlle Guillaumin in Paris kindly corrected some errors about her father, Armand Guillaumin, and the late Mme Julie Manet-Rouart, also of Paris, did likewise concerning her mother, Berthe Morisot, Maître Jean Ribault-Menetière, Paris, and especially Dr. Oscar Reuterswärd, Stockholm, drew my attention to a number of inaccuracies which I have thus been able to amend; Miss Hanne Finsen, Copenhagen, gave assistance with translations of Scandinavian texts; Dr. Ernest L. Tross, Denver, kindly communicated personal recollections of Renoir. M. Jean Adhémar of the Bibliothèque Nationale, Paris; M. Albert Châtelet, Strasbourg; the late V. Loewinson-Lessing, formerly Counsellor to the Director, Hermitage, Leningrad; Mr. Helmut Ripperger, New York; Dr. Haavard Rostrup, Director of Ordrupgaardsamlingen, Copenhagen; Mr. William Seitz, University of Virginia; MM. Daniel and the late Georges Wildenstein of Paris and New York were particularly helpful in providing photographs and information. Without the untiring courtesy of M. François Daulte, Geneva, it would have been impossible to discuss Bazille as extensively and to reproduce as many of his works as I was able to do. I am also conscious of having taxed with innumerable queries the patience of Mlle Martine Charpentier of the Durand-Ruel Galleries in Paris; to her and to M. Charles Durand-Ruel I wish to express my special gratitude.

Last but not least, I am greatly indebted to Mr. Alfred H. Barr, Jr., Miss Agnes Rindge, and Professor Meyer Schapiro for their constructive criticism of the original manuscript; also to Mr. Monroe Wheeler for his sympathetic encouragement and to Miss Isabella Athey for perfecting the translations. For the third edition, Mr. Allan Porter and Miss Frances Pernas gave me invaluable and always friendly help; this fourth printing owes much to the untiring care of Ms. Christie Kaiser, Ms. Jane Fluegel, and Mr. Richard Oldenburg.

J. R.

NOTE CONCERNING THE ILLUSTRATIONS

There are usually no references in the text to illustrations if reproductions of works mentioned appear in the same chapter. Generally such references are given only when reproductions occur in other chapters.

As far as possible, the illustrations are arranged chronologically and in close connection with the narrative. For dated works, the date is given in the caption preceded by the letter d. (for dated); for undated works which can be dated within a definite year, this date is given; for works which can be dated only by deduction, the date is either preceded by c. (for circa), or two different years are indicated, connected by a hyphen. In cases of doubt, the date is followed by a question mark in parentheses.

Unless otherwise mentioned, the medium is oil on canvas. In all dimensions height precedes width.

A list of sources of illustrations may be found on p. 590. The illustrations themselves are incorporated, under the artists' names and in alphabetical order according to titles, into the general index; they are given in italics and are invariably listed after all other entries concerning the artist.

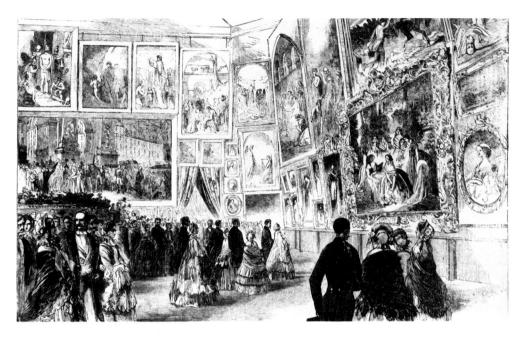

The Central Hall of the *Palais des Beaux-Arts* at the Paris World's Fair. Wood engraving. *The Illustrated London News*, Sept. 1, 1855.

I 1855-1859

THE PARIS WORLD'S FAIR, 1855

A PANORAMA OF FRENCH ART

When Camille Pissarro came to France in 1855 he arrived in time to see the great *Exposition Universelle* in Paris, the first of its kind to include a large international section devoted to the arts. Eager to show its liberalism toward industry, commerce, and art, the newly established Second Empire had spared no efforts to make this a truly representative manifestation of its strength as well as of its progressive ideas. Queen Victoria and the French Emperor together visited the imposing exhibition while their soldiers fought side by side in the Crimean peninsula where Constantin Guys, then still completely unknown, watched the war with Russia as a pictorial reporter for *The Illustrated London News*. Meanwhile Prince Napoléon proclaimed that the international fair was helping to produce "serious links for making Europe one

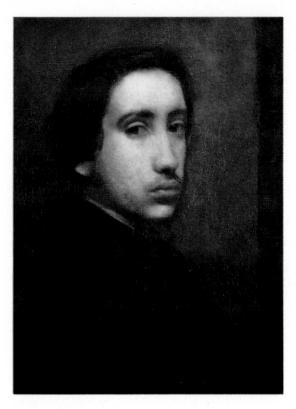

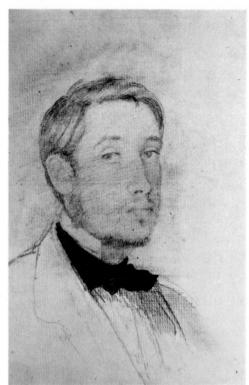

Far left, Degas: Self Portrait, c. 1854. $16\frac{1}{4} \times 13''$. Albright-Knox Art Gallery, Buffalo (George B. and Jenny R. Mathews Fund).

Left, Degas: Self Portrait, c. 1856-57, from a sketchbook. Pencil, $9\frac{5}{8} \times 7''$. Cabinet des Dessins, Louvre, Paris.

large family." Proud of her achievements and confident of her destiny, France seemed to inaugurate a new era in a spirit of enterprise on a scale unknown in the defunct kingdom of Louis-Philippe, the man against whom Daumier had published his wittiest cartoons.

The young Pissarro certainly did not fail to note this difference, for he had spent several school years in Paris before he was called back in 1847 to his native St. Thomas in the Danish West Indies, a small and rocky island near Puerto Rico. There he worked as a clerk in his father's general store, devoting all his spare time to drawing. Whenever he was sent to the port to supervise the arrival of shipments, he took a sketchbook with him and, while entering the merchandise that was being unloaded, made drawings of the animated life of the harbor surrounded by verdurecovered rocks and hills capped by citadels. For five years he struggled between his daily chores and his vocation. Since he could not obtain permission to devote himself to painting, one day he ran away, leaving a note for his parents. He went to Caracas in Venezuela in the company of a painter from Copenhagen, Fritz Melbye, whom he had met while sketching in the port.² Pissarro's parents then reconciled themselves. However his father argued that if he really wanted to be an artist, he would do better to go to France and work in the studio of one of the well-known masters. And so, at the age of twenty-five, Camille Pissarro returned to Paris at the very moment when the most significant works of all living painters were assembled in a

Right, Degas: Sketch after Ingres' *Bather*, 1855, from a sketchbook. Pencil, 6 × 4\frac{1}{8}". Bibliothèque Nationale, Paris.

Far right, Ingres: Bather (so-called Baigneuse Valpinçon), 1808. 56\(^3\) × 38\(^4\)". Mus\(^6\) du Louvre, Paris.

huge exhibition, among them typical examples of the new British Pré-Raphaelite movement, shown for the first time on the Continent. Artists from twenty-eight nations were represented in this exhibition which constituted "the most remarkable collection of paintings and sculpture ever brought within the walls of one building." In this collection France's share was incomparably the most brilliant one.

The artists invited to participate in the exhibition had selected their works with the greatest care, since, for the first time in history, they were being given a chance to measure themselves not only with their countrymen, but with artists from all parts of the world.⁴ Delacroix had chosen a series of paintings representing the various phases of his development, an arrangement such as had never been seen before, one-man shows being still unknown at that period. Ingres, who for twenty years had not deigned to send pictures to the Salon because the public and the critics had not given him the praise which he expected, had agreed to break this rule. Perhaps he was encouraged to do so by the government's promise of special honors.

Ingres had almost failed to obtain one of his most important works, a Turkish *Bather*, belonging to a M. Edouard Valpinçon, who refused to part with his treasure. But the son of M. Valpinçon's banker friend Auguste De Gas was so aroused by the idea that anybody should ignore a request of the master that he managed to prevail upon the collector. Thereupon M. Valpinçon took twenty-year-old Edgar De Gas—then about to abandon his law studies in order to become a painter—directly to

Ingres' studio and informed the artist that, owing to the insistence of this young admirer, he was willing to lend the painting to the World's Fair. Ingres was very pleased; when he learned that his visitor intended to devote himself to art, he advised him: "Draw lines, young man, many lines; from memory or from nature, it is in this way that you will become a good artist." Edgar De Gas was never to forget these words.

It seems doubtful whether, among all the pictures that solicited his admiration, Camille Pissarro gave special notice to Ingres' Turkish *Bather*, particularly since he was mainly interested in landscapes. There were more than five thousand paintings crowding the walls, without any space between them, frame touching frame from the floor in three or more rows up to the ceiling—not to speak of all the other attractions, most of which were assembled in the new *Palais de l'Industrie*. For Pissarro, who had spent so many years far from the art world, the grandiose display at the *Palais des Beaux-Arts* must have been both exciting and confusing: exciting on account of the large number of works shown, and confusing because of the amazing dissimilarity in style and conception of these works.⁶

Ingres exhibited over forty canvases and many drawings in a special gallery, while his opponent, Delacroix, dominated a central hall with thirty-five paintings; yet Corot, for whom Pissarro immediately felt a strong inclination, was represented by only six works, Daubigny and Jongkind by even fewer, and Millet had but one painting in the entire show. Though Charles Baudelaire proclaimed in a vibrant article the triumph of Delacroix and accused Ingres of being "stripped of that energetic temperament which forms the destiny of genius,"7 Pissarro must have observed with some surprise that all the medals and prizes of the exhibition went to men who followed more or less closely Ingres' lead. Among them were Gérôme and Cabanel, both of whom received the red ribbon of the Legion of Honor; Meissonier, whose precious little genre scenes were rewarded with a Grande Médaille d'Honneur; Lehmann, a pupil of Ingres, and Couture, both teachers at the Ecole des Beaux-Arts, to whom went first-class medals (Couture refused his, having anticipated a higher reward); and Bouguereau, who for the time being had to content himself with a second-class medal. Daubigny's medal was third-class; Jongkind and Millet did not receive any, nor did Courbet, who, because the jury had refused two of his most important canvases, had defiantly constructed at his own expense his Pavillon du Réalisme close to the official building. There he exhibited fifty of his paintings, among them the rejected ones. This courageous gesture met with little success, however. When Delacroix went to see the two controversial pictures, which he discovered to be masterpieces, he remained for almost an hour in Courbet's Pavillon and was absolutely alone, although the entrance fee had been greatly reduced.8

One of the two rejected canvases was Courbet's huge composition representing his studio and bearing the paradoxical title: L'Atelier du peintre, allégorie réelle, déterminant une phase de sept années de ma vie artistique (The painter's studio, a true allegory, defining a seven-year phase of my artistic life). The artist's intention had been to recapitulate and to group the various principles and personalities which had influenced his life, assembling—within one large frame—all the social types and all the ideas that had been part of his existence since 1848, introducing portraits of some of his friends, such as Baudelaire, Champfleury, and the collector Bruyas from Montpellier. A woman

Degas: Sketch after Ingres' Angélique, 1855, from a sketchbook. Pencil, $6 \times 4\frac{1}{8}$ ". Bibliothèque Nationale, Paris.

PISSARRO: Sketch after Ingres' La belle Zélie, c. 1895, from a sketchbook. Pencil, $6 \times 4\frac{1}{8}$ ". Private collection, New York.

posing in the nude occupies the center of the canvas, while, amidst the crowd of people in his studio, the artist himself, strangely enough, works on a landscape affixed to his easel. This contradiction in the composition may have startled Pissarro, but even more striking, no doubt, were the vigorous brushstrokes and the bold treatment with which the artist had rendered his subject. In rejecting this picture, the members of the jury had declared, as Courbet put it, that "at all costs a stop has to be put to my painting tendencies, which are disastrous for French art." And the general public tacitly approved of the jury's decision by shunning Courbet's exhibition. The public favored the classicism of Ingres and his numerous followers, it admired the eclectic taste of Couture, who cleverly blended the Venetians with elements of classicism, romanticism, and even realism; it was no longer completely hostile to pure landscapes and bought works of Rousseau and Troyon, but it seemed only reluctantly aware of Delacroix's greatness. Bewildered by the diversity of currents in the arts, the public was neither ready nor willing to face a new issue and to approve of Courbet's revolutionary program to "interpret the manners, the ideas, the aspect of my time, in terms of my own evaluation, in a word, to produce living art."10

Confronted with these different problems, Pissarro avoided taking a position for or against Ingres, Delacroix, or Courbet. He apparently did not even try to approach Chassériau, for a time one of Ingres' most promising pupils, who had left his master and "gone over" to Delacroix (Pissarro could very well have introduced himself, for Chassériau's father had been French consul at St. Thomas and had done some business with his father). Instead, Pissarro turned to Corot, whose soft harmonies and poetic sentiment seemed closest to his own aspirations. After having met Antoine Melbye, the brother of his friend Fritz and a well established painter of seascapes, who promised help and counsel, Pissarro paid a short visit to Corot himself, who, as was his habit, received the beginner with great friendliness. Corot had never accepted regular pupils but was always ready to give advice and to propagate his belief that "the first two things to study are form and values. These two things are for me the serious bases of art. Color and execution give charm to the work."11 However, if Pissarro wanted to profit from Corot's experience, he would have had to show some of his own work for criticism. Since he had not yet produced anything of importance and must have felt that the tropical landscapes which he continued to paint during his first year in Paris were still rather conventional, he heeded his father's wishes and entered one of the many studios where artists found models and occasional instruction.

Although it may seem to have been natural for Pissarro to address himself to Corot for guidance, it required a certain courage to do so, for Corot's works were far from being accepted; many still saw in them mere sketches of an amateur who did not even know how to paint a tree and whose figures were "the most miserable in the world." As one critic stated: "Among his followers are those with neither talent for drawing nor gift for coloring, but who hope to find glory with the least effort under his banner." 12

The path of "least effort" was considered to be the simple study of nature as the painters of the Barbizon group had already practiced it for twenty-five years in the small village on the borders of Fontainebleau forest. Their devotion to nature and their disregard for historical or anecdotal subjects had deprived the public of what it most liked in a painting, the story told by the artist; for the public was by no means

PISSARRO: Tropical Landscape (souvenir of St. Thomas, painted in Paris), c. 1856. $10\frac{5}{8} \times 13\frac{3}{4}$ Formerly owned by Antoine Melbye. Collection Mr. and Mrs. Paul Mellon, Upperville, Va.

inclined to content itself with beauty of color, freshness of execution, the natural poetry of trees and rocks, huts and lanes, which made rustic Barbizon so attractive to the eyes of its painters. Had Pissarro bought a book on Fontainebleau which appeared that very year of 1855, he would have found in it, from the pen of Paul de Saint-Victor, one of the best known and most influential art writers of the day, the unequivocal declaration: "We prefer the sacred grove where fauns make their way, to the forest in which woodcutters are working; the Greek spring in which nymphs are bathing, to the Flemish pond in which ducks are paddling; and the half-naked shepherd who, with his Virgilian crook, drives his rams and she-goats along the Georgic paths of Poussin, to the peasant, pipe in mouth, who climbs Ruysdael's back road."13 Such comment might have helped Pissarro understand why Millet was represented only by a single painting in the World's Fair exhibition, for romantic as his subjects would seem compared to those of Courbet, they showed a sentimental interest in rural life that was intolerable to people of so-called taste and refinement. "This," declared Count Nieuwerkerke, the Imperial Superintendent of Fine Arts, "is the painting of democrats, of those who don't change their linen, who want to put themselves over on men of the world; this art displeases and disgusts me."14

Since Pissarro was not disgusted by the works of Millet or Corot, it seems obvious that he could not have been much attracted by the *Ecole des Beaux-Arts*, supervised by the same Nieuwerkerke.¹⁵ He apparently worked in different studios, including that of Ingres' pupil Lehmann, but did not stay long in any of them. Because he was in touch with various masters and their students, he probably soon became acquainted with all the written and unwritten laws of French art life, compliance with which was a decisive factor in the career he had chosen. For art was a career like any other, comparable especially to a military one, so strictly was it governed

by rules which provided a step-by-step advancement, offering as ultimate rewards fame and wealth, social standing and influence. Murger's touching tales of Bohemian life describe only one aspect of the artist's existence in Paris, and although young Whistler, who had arrived in the city at about the same time as Pissarro, devoted himself with ardor to a manner of living worthy of his favorite author, the so-called serious students knew that the path to glory led not so much through romantic garrets as through the bare studios of the *Ecole des Beaux-Arts*. There, pupils were prepared in somewhat dry lectures and uninspiring courses to climb the ladder of perfection which leads from honorable mentions to medals, from the *Prix de Rome* to purchases by the state and finally from government commissions to election to the Academy.

It was this Academy of Fine Arts, one of the sections of the *Institut de France*, which despotically governed the arts in France. From its members were chosen the teachers at the *Ecole des Beaux-Arts* and the directors of the French Academy in Rome, that is, those entrusted with the education of new generations. At the same time the Academy controlled the jury of admission and of rewards at the biennial Salons and was thus given the power to exclude from these exhibitions any artist who did not comply with its requirements. Through its influence with the Director of Fine Arts, the Academy also took part in decisions upon the purchases of pictures for museums or for the Emperor's personal collection, as well as upon the award of commissions for mural decorations. In all these questions the Academy naturally favored its most docile pupils, who in turn were favored by that public which sees in medals and prizes the proof of an artist's talent.

The artistic concepts which guided the Academy in its policy were those put forward in David's teaching half a century before and transformed though not relaxed by his most famous pupil, Ingres. In the year 1855, when Pissarro arrived in Paris, Ingres had been for thirty years a member of the Academy, and this strange and haughty man, who himself had suffered at the outset of his career from the rigidity of his master's principles, had now adopted an attitude in no way more tolerant. Unwilling to give a thought to the natural laws of development, unwilling to see in the past anything but the artists he admired, despising Rubens and hence Delacroix, Ingres had clung to his classic ideals without any consideration for, or interest in, the efforts of those who had chosen other roads, never asking himself whether his conceptions were still in accordance with the times. In a final discussion with his former master, Chassériau had been surprised to find that Ingres "has no comprehension of the ideas and the changes which have taken place in the arts in our day. He is completely ignorant of all the poets of recent times." 16

Although his convictions in art matters were so strong as to give him the power of tyrannical authority, Ingres had been a very inadequate teacher himself. His genius was able to find expression only in affirmations that excluded any reply, and his impatience and narrow-mindedness never admitted discussion.¹⁷ His pupils, therefore, had been more anxious to imitate than to understand him. Even his followers admitted the shortcomings of his instruction; those who were not blinded by admiration openly accused him of utter failure. "It may be said," wrote Baudelaire, "that his teaching was despotic and that he has left an unfortunate mark upon French painting. A man full of stubbornness, endowed with highly special capacities, but

determined to deny the utility of those capacities which he does not possess, has attached to himself the extraordinary, exceptional glory of extinguishing the sun." ¹⁸

Rearing his pupils in what he thought to be the tradition of Raphael, Ingres had advised them to copy their models stupidly and not to forget that an object well drawn is always well enough painted. He never tired of proclaiming the superiority of line over color, a statement which led his followers to regard paintings merely as colored drawings, and to consider as "badly drawn" the landscapes of Corot or the compositions of Delacroix because in these every object was not carefully delineated by a minute contour. To Ingres' pupils correct drawing finally became an end in itself, and a "noble contour" was a sufficient excuse for lack of inspiration, dry execution, and dull coloring. In the absence of any personal link with the classical ideals admired by their master, they simply blended the classical tradition with a cheap genre style. It was this mixture of empty craftsmanship with anecdotal platitude that, at the Salons, caused the delight of the picture-reading public. No response to nature, no observations of life guided these artists in their work. Only after the choice of subject had been made would they have models pose for the figures and indulge in scholarly research so as to be meticulously "true" in every detail. Yet, as Delacroix put it, their works did not contain that "dash of truth, the truth which comes from the soul."19

Ingres himself deplored this state of affairs and frankly admitted that "the Salon stifles and corrupts the feeling for the great, the beautiful; artists are driven to exhibit there by the attractions of profit, the desire to get themselves noticed at any price, by the supposed good fortune of an eccentric subject that is capable of producing an effect and leading to an advantageous sale. Thus the Salon is literally no more than a picture shop, a bazaar in which the tremendous number of objects is overwhelming, and business rules instead of art."20 In protest, Ingres had not only abstained from exhibiting at the Salon but had also refused to participate in the duties of the jury. Yet he had failed to recognize that it was the exclusiveness of his own convictions and the rigid suppression of any individual tendencies that had equipped the new generation of painters with conceptions and means of such a uniformity that through their subjects alone could they hope to find a personal note. Since all the paintings at the Salons were conceived and executed according to the same rules, it was in fact the subject that distinguished a work from its neighbors; hence it was upon their subjects that the artists concentrated most. Nevertheless Courbet's friend Champfleury could speak of "the mediocre art of our exhibitions in which a universal cleverness of hand makes two thousand pictures look as if they have come from the same mould."21

Ingres' statement that the Salon was a "picture shop" was absolutely correct, so much so that many well-known artists did not bother to exhibit, because they no longer had to look for customers. But this fact in itself did not offend the dignity of art, because artists have to live from their works and because, as a natural consequence of the political and economic situation, the Salon had become the normal place for their trade. Since the beginning of the century France had known at least five different forms of government and as many monarchs. The inevitable rise and fall of favorites, which accompanied every change, had brought fortune and misfortune not only to artists; it had particularly affected the nobility, among whom art

DEGAS: Ingres in the Attire of an Academician, 1856–57, from a sketchbook. Pencil, $3\frac{1}{8} \times 2\frac{1}{2}$ ". Formerly collection Marcel Guérin, Paris.

LEHMANN: Portrait of Ingres, d. 1863. Pen and ink, $7\frac{1}{2} \times 5\frac{1}{2}$ ". Art Institute of Chicago (Walter S. Brewster Bequest).

patrons were normally recruited. To make up for this loss, the artists had turned toward the rising bourgeoisie and had found it perfectly willing to take an interest in art and to buy paintings, all the more as the short existence of the various regimes and the uncertainties of the times were favorable to investments in small objects of assured value. It was precisely at the Salons that the artists could present themselves, achieve a reputation through the help of the press and reach this large public of new buyers. These buyers, however, lacked any art education and were satisfied with whatever flattered their eyes and hearts: pretty nudes, sentimental stories, religious subjects, heroic deeds, flowers which one could almost "smell," patriotic scenes, and touching tales. It was natural that pure landscape was considered an inferior category, and that painters of historic events concentrated on their figures, leaving the landscape background to some professional master of hill and cloud. The critics themselves, in their reviews, put particular emphasis on the subject, describing pictures rather than judging them. Had not Théophile Gautier, one of the most influential critics, once reproached an artist for having painted a swineherd with his pigs, whereas he could have given "much more importance to his composition" by portraying instead the Prodigal Son Driving Swine?22

It might have been perfectly within Ingres' power to fight against such misconceptions with regard to subject matter. But Ingres had not merely been sterile as a teacher, he was not a leader. Instead of allying himself with the healthy and progressive forces of romanticism against the rising pettiness, he had seen no other danger than that of romanticism itself. He could not forgive Delacroix for abandoning the "perfect type of the human figure," for rejecting the systematic use of the nude, for denying the superiority of antique draperies, for distrusting academic recipes and for favoring individualism and liberty, not only of concept, but also of execution. He was horrified to see sentiment take the lead over reason and to witness Delacroix's participation in the political struggle, glorifying the barricade and the Greeks' fight for independence, while he, Ingres, kept his art "pure" by painting scenes from the past, portraits of the various monarchs and meticulous likenesses of his wealthy patrons. No wonder then, that he failed to realize that his rival could have supplied at the Ecole des Beaux-Arts all the elements he himself lacked: imagination and vitality, passion for action and color, and a keen interest in all manifestations of life. Quite the contrary, Ingres and his followers concentrated their forces in an effort to eliminate Delacroix from any position in which he could exert some influence. There had even been a time when Delacroix was summoned by the Minister of Fine Arts, who gave him to understand that he would have to change his style or renounce the prospect of seeing his works acquired by the State.

Six times already Delacroix had presented his candidacy at the Academy, only to see the vacancies filled by some nonentities. If Ingres cannot be held responsible for the ostracism Delacroix had to suffer, he nevertheless had something to do with the policy of intolerance increasingly manifested by the Academy. Only once had he threatened to resign from this body, upon the occasion when a work by his favorite pupil, Jules Flandrin, had been rejected by the Salon jury; but never had he voiced any disapproval when Delacroix was barred. Relentlessly Ingres pursued the fight of classicism against romanticism, of line against color, which was to be for many years the chief topic wherever artists met. When Paul de Saint-Victor introduced his

newly arrived cousin, John La Farge, at Chassériau's, the American student was startled at being questioned immediately, as if it were of first importance, about the position he held with regard to Ingres and Delacroix.²³ And those away from Paris were informed through newspaper caricatures and articles of "how hot the disputes of the Ingrists and Delacroix fanatics are."²⁴ Artists, collectors, and critics were openly divided into two hostile camps, between which the followers of both painters did their best to widen the breach. "Ingres" and "Delacroix," wrote the Goncourt brothers, were the two battle-cries of art.²⁵

Delacroix meanwhile confined himself to his work and left the propaganda for his ideals entirely to his friends and admirers among the writers and artists of the new generation, with whom he had indeed little personal contact. John La Farge remarked with some surprise that the solitary master "was known to the younger men at a great distance. His studio was open to anyone who wished to call, if they were students... Notwithstanding, we all felt a veil of something between us and him, and few of us had the courage to do more than occasionally present our respects." Pissarro apparently did not have even this courage, although he was certainly not indifferent to Delacroix's art and must have felt, like so many others, its fertile forces as compared to the cold skill of his own teachers at the *Ecole des Beaux-Arts*, Lehmann, Picot, and Dagnan. In the different studios in which Pissarro worked, Ingres' spirit governed uncontested, in spite of the fact that his system began to be attacked more and more violently.

"How does one proceed when teaching drawing according to the classical method?" asked one of the antagonists of the *Ecole*. "One begins by showing the pupils silhouettes that are called outline drawings, and having them copy these mechanically. The eye... first of all begins by acquiring a bad habit, which is that of not taking account of planes, and of seeing in the object to be interpreted nothing but a flat surface surrounded by a contour.... Then of what does the teaching at the *Ecole des Beaux-Arts* consist? It confines itself to having the young people copy what are properly called *academies*, that is, a male nude, always illuminated by the same light, in the same spot, and subject to a pose which may generally be considered torture at hourly rates." Only after several years of such studies were students permitted to paint, and the historical subjects which they then had to deal with had nothing whatsoever to do with their own visual experiences, with real life. "They are taught the beautiful as one teaches algebra," said Delacroix with disdain.

Without any consideration for the natural inclinations of the individual pupil, the academic system was applied in an atmosphere of pressure that has been best analyzed by the architect Viollet-Le-Duc in an acid criticism of the instruction in the fine arts. Studying the problems of the artist-to-be, he thus described such a student's situation:

"A young man shows inclination for painting or sculpture.... This young man has usually to overcome first the distaste of his parents, who would rather see him enter the school for engineers or make a merchant's clerk of him. His powers are doubted, proofs of his abilities are desired. If his first efforts are not crowned by some sort of success, he is considered mistaken or lazy; no more allowance. Hence it is necessary to pursue that kind of success. The young artist enters the *Ecole*, he gets medals... but at what price? Upon condition of keeping precisely and without any

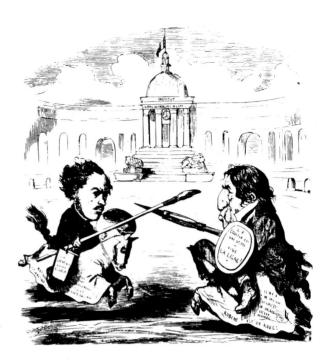

Caricature of Delacroix and Ingres dueling in front of the *Institut de France*. Delacroix: "Line is Color!" Ingres: "Color is Utopia. Long live Line!"

deviation within the limits imposed by the corporation of professors, of following the beaten track submissively, of having only exactly the ideas permitted by the corporation and above all of not indicating the presumption of having any of his own. . . . We observe besides that the student body naturally includes more mediocrities than talented people, that the majority always aligns itself on the side of routine; there is no ridicule sufficient for the person who shows some inclination toward originality. How is it possible for a poor fellow, despised by his teachers, chaffed by his companions, threatened by his parents, if he does not follow the middle of the marked-out highway, to have enough strength, enough confidence in himself, enough courage to withstand this yoke—commonly adorned with the title 'classical teaching'—and to walk freely?''28

There were actually very few who had this courage. Some of them toiled for many years at the *Ecole* before they could free themselves, some avoided entering it, some stayed only a short while, as Pissarro himself did; but each of them was confronted, at one moment or the other, with the alternative of heeding his parents' wishes or of going his own way without their help. It is true that there was, outside the *Ecole des Beaux-Arts*, a teacher who tried new methods. Lecoq de Boisbaudran's system was based on the development of pictorial memory, and his pupils were trained to permeate themselves so with what they saw that they would be able to reproduce it entirely from memory.²⁹ Their master even went so far as to have them observe dressed or undressed models moving freely in a forest or a field, in order to study natural attitudes. But not more than a dozen students followed his classes, among them Henri Fantin-Latour. The bulk of those who wanted an art career preferred for obvious reasons the *Ecole des Beaux-Arts*, where the studio of Thomas

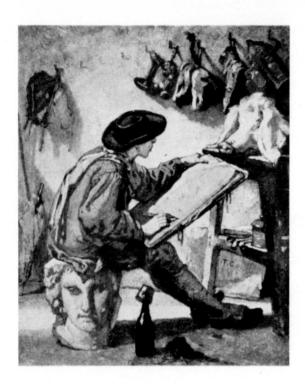

COUTURE: The Realist, d. 1865. $18 \times 14\frac{3}{4}$ ". Formerly in the Vanderbilt Collection, New York. Present whereabouts unknown.

Couture was particularly popular, among Americans too, of whom there were quite a number.³⁰

Couture, a rather self-satisfied and arrogant man, was jealous of his independence and allied himself neither with Delacroix nor with Ingres, being "very sure that he was the greatest painter living and that all others were mere daubers..." Yet his teachings were not far from Ingres' principles since they were based on a careful and, if possible, stylish or elegant outline drawing of the subject to which colors were added, each one in its exact place. His motto was *Ideal and Impersonality*. "He used to say," as one of his pupils remembered, "that he preferred a thin to a stout model, because you could study the structure, and could *add* as much as you liked; whereas, in the other case, the flesh hid everything from view, and you did not know how much to *take off*." To paint the models as they were would have been, in his eyes, to copy nature servilely. Couture's constant preoccupation with idealization did not prevent his admirers from admitting, in the words of the American painter Ernest W. Longfellow, that "his faults were a certain dryness of execution... and a want of unity in his larger compositions, arising in part from his habit of studying each figure separately, and in part from a lack of feeling for the just relation of values." 31

John La Farge, who was for a short while among Couture's pupils, was annoyed not only by his theories but even more by his "constant running-down of other artists greater than himself. Delacroix and Rousseau were special objects of insult or depreciation." Of Millet, too, Couture made all possible sport, ridiculing his pictures and drawing caricatures of his subjects, until one of his favorite students, the American William Morris Hunt, left him for the peasant painter. Subsequently

Couture became even more satirical and bitter but ceased to refer to Millet. Soon, however, he found another object for attack in Courbet's realism and drew for the benefit of his pupils caricatures of a *realist* in whose studio Laocoön is replaced by a cabbage, and who copies a pig's head while sitting on the head of Olympian Jupiter. But, for Couture's students, romanticism and realism were far too serious to be dismissed in this way.

In spite of Couture's mockeries, one of his pupils, Edouard Manet, went, accompanied by his friend Antonin Proust, to ask Delacroix for permission to copy his Dante and Virgil in the Luxembourg Museum, a permission which Delacroix granted, although he received the young man with such a polite coldness that Manet resolved not to repeat his visit. Fantin-Latour, who had abandoned Lecoq de Boisbaudran for the Ecole des Beaux-Arts, decided to leave his classes after only a year, preferring to work in the Louvre. He had been deeply impressed with Courbet's exhibition and shared his enthusiasm with another student of the Ecole, James McNeill Whistler, a pupil of Gleyre, the least aggressive and most lenient among the teachers. In the Pavillon du Réalisme Fantin had also met, it seems, Edgar De Gas who—in spite of his admiration for Ingres—had been greatly excited by the works of Courbet as well as Delacroix. After obtaining his father's permission to abandon law and devote himself

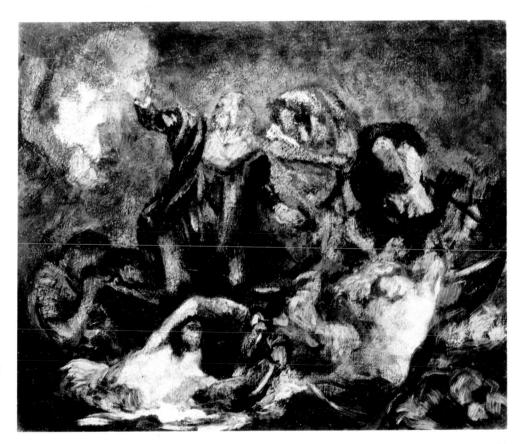

Manet: Copy after Delacroix's Dante and Virgil, c. 1854. $13 \times 16\frac{1}{8}$ ". Metropolitan Museum of Art, New York (H. O. Havemeyer Collection).

to art (signing his pictures "De Gas" until about 1870 when he changed to "Degas"), he had made fast friends with one of Delacroix's pupils, Evariste de Valernes, fourteen years older than himself. Although he entered the *Ecole des Beaux-Arts*—he did so in the very year of the World's Fair—Degas actually worked there hardly at all, preferring the private studio of Louis Lamothe, one of Ingres' ablest pupils.

The fact that Degas was open-minded enough to combine his fervor for Ingres with sincere appreciation for Courbet and especially Delacroix caused his father serious misgivings. The latter had followed his son's evolution with benevolence but was eager to see the somewhat turbulent young man—continually oscillating between juvenile ardors and discouragements—embrace his destiny in a more level-headed fashion. Echoing the prejudices of the day, the elder De Gas therefore advised the novice:

"You know that you have no or almost no money, that you must make painting your career, your existence... All thoughtless actions, all resolutions made giddy-brained and without wise consideration are as many stones which roll into the abyss and destroy the edifice [of hope]; whatever one undertakes, one arrives at the end of one's days without having secured one's livelihood, without having created or done anything. If the artist should be enthusiastic about art, he should [nevertheless] wisely regulate his conduct for fear of remaining a nonentity. You know that I am far from sharing your opinion of Delacroix; this painter has abandoned himself to the passion of his ideas and—unfortunately for his own good—has neglected the art of draftsmanship, the sacred pillar on which everything depends; he has completely lost himself. As to Ingres, he has elevated himself through drawing... One must recognize... that if painting is destined to be reborn in this century, Ingres will

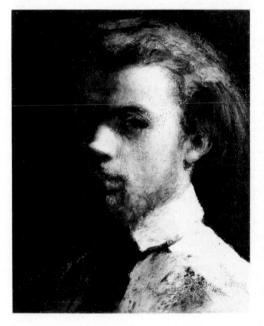

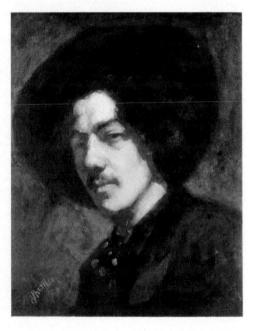

Far left, Fantin-Latour: Self Portrait, c. 1858. $16 \times 12\frac{1}{2}$ ". National Gallery of Art, Washington, D. C. (Chester Dale Collection).

Left, Whistler: Self Portrait, c. 1858. $18\frac{1}{2} \times 15\frac{1}{4}$ ". Freer Gallery of Art, Washington, D. C.

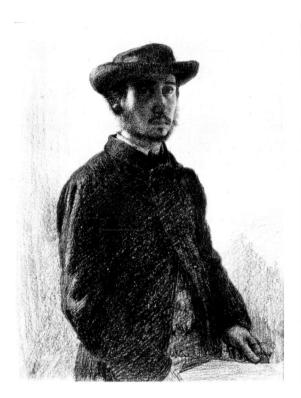

Degas: Self Portrait, 1857. Black crayon heightened with white, $11\frac{3}{4} \times 9''$. Collection the late Walter C. Baker, New York.

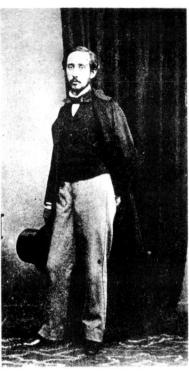

Photograph of Edgar Degas, c. 1857. From Edouard Manet's album of photographs.

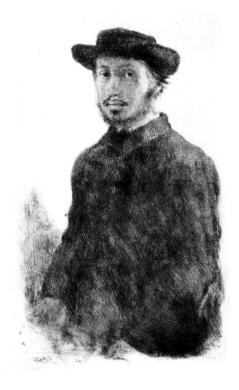

Degas: Self Portrait, 1857–58. Etching, $9 \times 5\frac{8}{8}$ ". National Gallery of Art, Washington, D. C. (L. Rosenwald Collection).

have strongly contributed to its renaissance, by showing those who understand him which is the path to follow towards perfection, or rather by stimulating those who are capable of attaining it."34

It is not known how Degas replied to this admonition, but it is true that his early works followed more closely the example of Ingres than that of Delacroix. While he was four years younger than Pissarro, the Parisian Degas showed from the beginning the refined touch of a delicate and highly cultivated artist, raised in a home where questions of art—especially music—were intelligently discussed; Pissarro's first paintings, on the other hand, still betrayed a somewhat "provincial approach" of which only Paris could rid him. Yet Degas himself had grown tired of his cosmopolitan surroundings and decided to go to Italy, the only place where he could really get acquainted with classic art as well as with the primitives who attracted him particularly. But before he left he had many long discussions with a friend of his parents, Prince Grégoire Soutzo, who not only taught him the technique of etching but also helped him to understand nature in a fashion not unlike Corot's.

Although Degas had participated very little in Parisian art life, he was so disgusted with it that he put down in one of his Italian notebooks: "It seems to me that today, if one wants to engage seriously in art and make an original little niche for oneself,

or at least to preserve the most unblemished of personalities, it is necessary to steep oneself again in solitude. There is too much going on; one might say that pictures are produced like stock exchange prices by the friction of people eager to gain; there is as much need, so to speak, of the mind and ideas of one's neighbor, in order to produce whatever it may be, as business men have need of other people's capital in order to profit in speculation. All this trading puts the spirit on edge and falsifies the judgment."35

After three years in Paris, Pissarro, too, was to feel the desire to steep himself again in solitude, but not before he had exhausted all that Paris could offer him. Indeed, there were, besides the Ecole des Beaux-Arts, many places where a student could teach himself. While there did not then exist any art galleries with regularly changing exhibitions, there were a few shops in which pictures could be seen, among others that of Durand-Ruel, who handled the works of many of the Barbizon painters and who had established himself shortly after the World's Fair in new quarters in the rue de la Paix. There were the Louvre, of course, and the Luxembourg Museum, where contemporary art was sheltered, or at least what the Academy considered contemporary art. But almost more interesting to a young student, eager to become acquainted with the burning art questions of the day, were the cafés in which the different groups of artists met. The Café Taranne, for instance, where Fantin and his friends came together and where Flaubert occasionally appeared; the Café Fleurus, with panels decorated by Corot and others, which was favored by the pupils of Gleyre; the Café Tortoni on the boulevards, where the more fashionable painters held forth, and, more popular among the Bohemians, the Brasserie des Martyrs and the Andler Keller, where Courbet appeared frequently. The two smoke-filled rooms of the Andler Keller were always crowded with writers, poets, journalists as well as painters from all the different schools, the "realists" and the "fantasists," the "Ingrists" and the "colorists" as they were called, and it was not at all unusual to see the followers of rivals, the pupils of Delacroix, Couture, and Ingres, fraternize at their tables laden with beer. The discussions here centered not so much around the perennial struggle between classicism and romanticism as around the more recent issue of realism, so forcefully proclaimed by Courbet in 1855. Fernand Desnoyers, a thin and loud poet, never missed an occasion to affirm his belief in the new style. In a challenging article, published at the end of 1855, he had hailed the breach which realism had made in the "brushwood, the battle of the Cimbri, the Pandemonium of Greek temples, of lyres and Jew's harps, of Alhambras and tubercular oak-trees, of sonnets, odes, daggers, and hamadryads in the moonlight."36

"Let's be a little ourselves, even though we might be ugly!" Desnoyers proclaimed enthusiastically. "Let's not write, not paint anything except what is, or at least what we see, what we know, what we have lived. Don't let us have any masters or pupils! A curious school it is, don't you think, where there is neither master nor student, and whose only principles are independence, sincerity, individualism." And quoting Courbet's friend Proudhon he added: "'Any figure, whether beautiful or ugly, can fulfill the ends of art.' Realism, without being a defense of the ugly or the evil, has the right to show what exists and what one sees." 36

Another young author and habitué of the Brasserie des Martyrs, Edmond Duranty, had founded in 1856 a short-lived review, Réalisme, to excoriate vehemently the

literary romanticists. In an article devoted to painting he complained about the abundance of "Greek visions, Roman visions, medieval visions, visions of the 16th, 17th, and 18th centuries, with the 19th century absolutely forbidden!" "The man of antiquity created what he saw," he told the painters: "Create what you see!" 37

Courbet himself apparently did not contribute much to the general discussions, for he was seldom inclined to speeches and doctrines, but was perfectly happy amidst the heated verbal fights, making drawings with the beer spilled on his table. When he spoke, he did so mainly about himself and had a tendency to repeat the same things over and over. If actually engaged in an argument, as once for instance with Couture, he was likely to raise his voice in the fire of the debate until the passers-by would stop in the street. At the Brasserie Courbet was surrounded by friends such as Baudelaire, Champfleury, and de Banville, the critic Castagnary, the painters Amand Gautier and Bonvin. The smaller fry seldom actually approached him, all those "runners after imagery and chiselers of sentences, knights-errant of the pen and brush, seekers after the infinite, merchandisers of chimeras, contractors for towers of Babel," who were generally more productive in discussions than in works.

Among those who frequented these cafés was a young medical student, Paul Gachet, who later finished his studies in Montpellier, where he met Courbet's friend, Bruyas, and who was never to give up the vivid interest in art with which the sessions at the brasseries had inspired him.

The noisy atmosphere of these cafés, where idols were created or demolished within a few minutes, where no title to glory was well enough earned to prevent insults, where logic was often replaced by vehemence and comprehension by enthusiasm — this atmosphere was in violent contrast to that of the official art circles. Here were life and a tremendous will to conquer, and even if many erred or exaggerated, there was in their fight against prejudice and tradition a positive element, the desire to

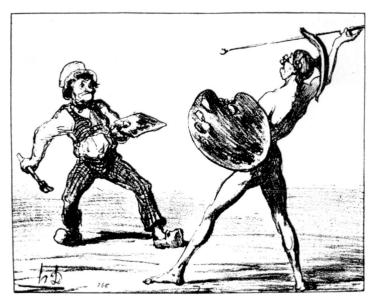

DAUMIER: Battle of the Schools—Realism versus Classic Idealism. Caricature published in Le Charivari, 1855.

prove the value of new beliefs through the quality of new works. Pissarro's often proclaimed opinion that the Louvre ought to be burned may well have had its root in these discussions where the heritage of the past was considered harmful for those who wanted to build a world of their own. (In one of his articles Duranty had almost openly advocated that fire be set to the palace.) The more the Academy claimed to embody sacred traditions, the more these traditions became suspect at the Brasserie. But those able to grasp the new ideas and to apply them found more than the negation of the past and glorious dreams of the future; they found directions for their efforts as well as stimulating comradeship. And comradeship is invaluable, since courage and will-power are not always enough in the tracing of new roads. To feel oneself in harmony with others, to be convinced of participating in a "movement" gives added strength. Around the tables of the cafés were born numerous friendships of which

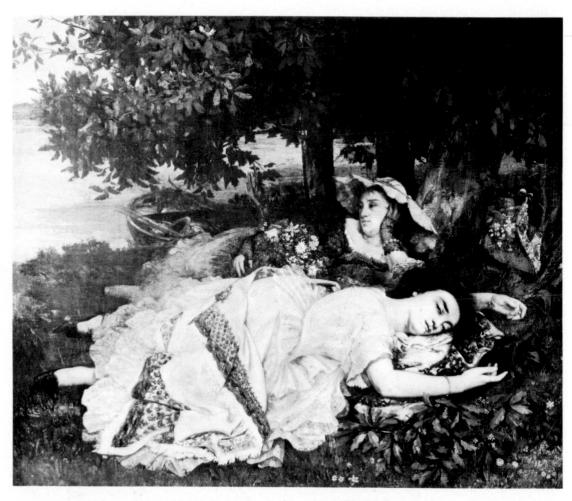

Courbet: Les Demoiselles au bord de la Seine, 1856. $68\frac{1}{8} \times 81\frac{1}{8}$ ". Exhibited at the Salon of 1857. Palais des Beaux-Arts de la Ville de Paris.

later Salon reviews bear ample proof. Many an artist's struggle for recognition may have been shortened by the praise which some critic, met at the Brasserie, subsequently printed in more or less obscure papers.

Zacharie Astruc, a poet and sculptor, one of those whose pen was to serve the new cause, summed up the situation when he wrote: "The new school is detaching itself little by little. It has to build upon ruins . . . but it builds with the consciousness of a duty. Feeling has become greatly simplified and rarefied. It becomes studious, honest, and wise. . . . Tradition is but a pale principle of teaching; romanticism, a soul without body. . . . The future therefore belongs entirely to the young generation. The latter loves truth and to it devotes all its fire." Yet this truth met with many obstacles; when Courbet, after his self-imposed exile of 1855, sent no fewer than six paintings to the Salon of 1857, his *Demoiselles au bord de la Seine* was considered shocking, vulgar, and immoral, partly because the two women represented obviously did not belong to "Society." The critics found it safer to praise his landscapes, devoid of any social implications, but Castagnary, destined to become an intimate friend of the artist, whose republican and anti-clerical views he shared, flatly stated that, as a landscape painter, Courbet had "viewed nature only through a tavern window." 40

The administration evidently sensed the threat which aggressive realism, superseding subversive romanticism, presented for the world of official art. When M. Fould, Minister of State, opened the Salon of 1857, he exorted all new talents to remain within the folds of academic codes. "Faithful to the traditions of their illustrious masters, they will know how to bind themselves perseveringly to those serious studies without which the happiest genius remains sterile or wanders astray. . . . Art is very near to losing itself when—abandoning the high and pure regions of the beautiful and the traditional paths of the great masters to follow the teachings of the new school of realism—it seeks for nothing more than a servile imitation of the least poetic and elevated offerings of nature. . . . " He warned his listeners against "that deplorable tendency to put art at the service of fashion or the caprices of the day," while exclaiming: "At no time has France furnished more ample material for the chisel and the brush of her artists. How many great things just since the beginning of the reign!" To glorify Napoléon III evidently was considered a powerful antidote against succumbing to the fashions of the day.

In the face of rising realism the Academy apparently convinced itself that it had nothing to fear any more from the old and ailing Delacroix. In 1857 he was finally elected membre de l'Institut. But to the embittered painter this honor, accorded after much hesitation and with no real conviction, had no longer the meaning it could have had. If this election had occurred earlier, he wrote to a friend, he might have become a professor at the *Ecole* and there could have exerted some influence. However, as a member of the Academy, Delacroix also became a member of the Salon jury, and here at least he saw some possibility for fruitful action. "I flatter myself that I can be of use there, because I shall be nearly alone in my opinion," he stated with satisfaction albeit with few illusions.⁴²

Two years later Delacroix lived up to his intentions. When Edouard Manet, who in the meantime had left Couture's studio, first presented a painting to the Salon jury, Delacroix declared himself in favor of the work. But just as he had anticipated, his voice was not strong enough to prevent rejection; Couture, also a member of the

WHISTLER: At the Piano, 1859. 26 × 36". Rejected by the Salon jury in 1859; exhibited in Bonvin's studio. Taft Museum, Cincinnati, Ohio (Gift of Louise Taft Semple).

jury, voted against his former pupil's work. Manet's friend, Fantin—they had met in 1857 while copying in the Louvre—did not fare better, nor did Whistler. The paintings of all three aroused the jury's anger because, although rather somber, they were conceived as harmonies of masses modeled in color without the aid of lines; yet there was nothing really "revolutionary" in them. But the jury this time was particularly harsh, even rejecting a canvas by Millet. The refusals actually reached such proportions that the artists organized a protest in the vicinity of the *Institut de France*; the police finally had to route those who whistled in dissent beneath the windows of Count Nieuwerkerke.⁴³

Fantin and Whistler were fortunate enough to interest the good-hearted painter Bonvin in their fate, who decided to show some of the refused works in his own studio, where all his friends would be able to judge the injustice of the jury. Courbet went there and, according to Fantin, "was struck with Whistler's canvas."⁴⁴ The whole affair made a scandal; the exhibition at Bonvin's became famous, and the pictures impressed many artists besides Courbet. Thereafter both Whistler and Fantin could call on Courbet and ask for his advice. As for Manet, his first rejection was soon followed by another one: a portrait he had painted of a lady was refused by the family of the sitter, because he had shown himself more interested in the opposition of lights and shadows, and in fluid brushstrokes, than in flattering his model (p. 34).

Only Pissarro was successful with the jury. Having spent the summer of the previous

Fantin-Latour: The Artist's Sisters Embroidering, d. 1859. $39\frac{1}{4} \times 52''$. Rejected by the Salon jury in 1859; exhibited in Bonvin's studio. City Art Museum, St. Louis.

year near Paris at Montmorency, where he could work in the open, he had sent a landscape of that locality to the Salon of 1859. It was accepted. Since beginners customarily indicated the name of their teacher, the Salon catalogue lists Pissarro as *pupil of Antoine Melbye*. The picture must have hung quite inconspicuously; at least it did not attract the attention of any critic, and if Zacharie Astruc mentioned it in his review, he did so to please a comrade rather than because he was convinced of its qualities. He said merely that it was well painted and almost omitted Pissarro's name.⁴⁵ Nevertheless Pissarro could proudly inform his parents that within four years after his arrival in France one of his paintings was being shown at the Salon. At the same time this "success" probably gave the timid artist the courage to return to Corot and ask for an opinion concerning the road he should follow.

In his lengthy review of the Salon of 1859 (a series of nine articles) Baudelaire summed up the inextricable relationship between the visiting crowds and the exhibitors. "Our public... wants to be astonished by means alien to art, and the obeying artists conform themselves to its taste; they endeavor to astonish, to surprise, to stupefy it through unworthy tricks since they know the public to be incapable of being carried away by the natural tactics of true art."46

On the same occasion Baudelaire concerned himself with the relationship between art and the comparatively recent invention of photography "of which the poorly applied progress has contributed a good deal...to the impoverishment of French

Manet: Portrait of Mme Brunet, 1860. $39\frac{1}{4} \times 15$ ". Refused by the family of the sitter. Private collection, New York.

artistic genius, already so scarce." In his conclusion which almost sounded like a hidden reproach directed at Courbet's *Réalisme*—reproach uttered not only by an admirer of Delacroix but also, after all, by a poet of essentially romantic inclination—Baudelaire complained: "From day to day art diminishes its self-respect, prostrates itself before exterior reality, and the artist becomes more and more inclined to paint not what he dreams but what he sees."46

While the vigor of his talent certainly preserved Courbet from a photographic approach to nature, this approach could be found precisely in the carefully conceived, minutely painted insipidities, stupidly "copied" from the model, which surrounded Pissarro's unnoticed landscape at the Salon. Among the visitors to this Salon was an enthusiastic young man who eagerly examined the works of all the famous painters whose names he had so often heard pronounced by his friend Boudin. He presumably paid little attention to Pissarro's modest canvas nor did he know of Bonvin's small "exhibition of the rejected." His name was Monet and he had just arrived from Le Havre to study art in Paris.

NOTES

- 1 Rapport de S. A. I. le Prince Napoléon, président de la Commission impériale; see Salon de 1857, official catalogue, p. xxx-xxxvi. Speeches made at the distribution of awards, etc., are always reproduced in the catalogue of the next Salon.
- 2 On Pissarro's youth see J. Rewald: Oeuvres de jeunesse inédites de Camille Pissarro, L'Amour de l'Art, April 1936; Camille Pissarro in the West Indies, Gazette des Beaux-Arts, Oct. 1942; J. Joëts: Camille Pissarro et la période inconnue de Saint-Thomas et de Caracas, L'Amour de l'Art, 1947, No. 2; also the catalogue of the exhibition "Pissarro en Venezuela," Caracas, May 1959; J. Rewald: Pissarro in Venezuela, New York, 1964; and especially A. Boulton: Camille Pissarro en Venezuela, Caracas, 1966.
- 3 Illustrated London News, June 9, 1855; see also E. and J. de Goncourt: Etudes d'art, Paris, 1893, and T. Gautier: Les Beaux-Arts en Europe—1855, Paris, 1856, 2 v. For plans of the Fair and the Palais des Beaux-Arts, see Magazine Pittoresque, 1855, p. 210 and 215.
- 4 One of the French craftsmen who first revealed himself at this exhibition was the ceramist-potter Chaplet with whom Gauguin was to work some thirty years later.
- 5 There are several versions concerning the way in which Degas met Ingres. The artist himself gave two different accounts to Paul Valéry; see Valéry: Degas, Danse, Dessin, Paris, 1938, p. 59-62. (See also E. Moreau-Nélaton: Deux heures avec Degas, L'Amour de l'Art, July 1931; P. A. Lemoisne: Degas, Paris, n.d. [1912], p. 7; P. Lafond: Degas, Paris, 1919, v. I, p. 31-32; P. Jamot: Degas, Paris, 1924, p. 23.) The version here given is based on information provided by Valéry and Moreau-Nélaton. The advice given by Ingres is quoted after Valéry, op. cit., p. 61 and M. Denis: Théories, Paris, 1912, p. 94, where Degas is identified simply by his initial.
- 6 For an excellent survey of the period see J. C. Sloane: French Painting Between the Past and the Present—Artists, Critics, & Traditions from 1848 to 1870, Princeton, 1951; also "The Salon in the Nineteenth Century" in G. H. Hamilton: Manet and his Critics, New Haven, 1954; and A. Boime: The Academy and French Painting in the 19th Century, London, 1971.
- 7 C. Baudelaire: Exposition universelle de 1855, ch. II; reprinted in: L'art romantique. Baudelaire's writings on art were assembled by him in two volumes: L'art romantique and Curiosités esthétiques. For an English translation see: The Mirror of Art, Critical Studies by Baudelaire, New York, 1956 (Anchor Books).
- 8 Delacroix, Journal, Aug. 3, 1855; see The Journal of Eugène Delacroix, New York, 1937, p. 479-480.

- 9 Courbet to Bruyas, spring 1855; see P. Borel: Le roman de Gustave Courbet, Paris, 1922, p. 74.
- 10 Courbet: Le Réalisme; see G. Riat: Gustave Courbet, Paris, 1906, p. 132-133.
- 11 Corot, notes from a sketchbook; see E. Moreau-Nélaton: Corot raconté par lui-même, Paris, 1924, v. I, p. 126.
- 12 F. de Lasteyrie: Review of the Salon of 1864, Fine Arts Quarterly Review, Jan. 1865.
- 13 P. de Saint-Victor *in* Hommage à C. F. Dennecourt—Fontainebleau, paysages, légendes, souvenirs, fantaisie, edited by F. Desnoyers, Paris, 1855.
- 14 See M. de Fels: La vie de Claude Monet, Paris, 1929, p. 59.
- 15 On Nieuwerkerke see Sloane, op. cit., p. 49, note 13.
- 16 Chassériau to his brother, Sept. 9, 1840; see L. Bénédite: Théodore Chassériau, sa vie et son oeuvre, Paris, 1931, v. I, p. 138.
- 17 See Amaury-Duval: L'atelier d'Ingres, edited by E. Faure, Paris, 1924, especially p. 88-90; also M. Denis: Les élèves d'Ingres *in* Théories, Paris, 1912.
- 18 C. Baudelaire: Salon de 1859, ch. VII; reprinted in L'art romantique.
- 19 Delacroix, Journal, June 17, 1855; op. cit., p. 468.
- 20 Ingres, quoted by Amaury-Duval, op. cit., p. 211.
- 21 J. Champfleury: Histoire de l'imagerie populaire, Paris, 1869, p. xii.
- 22 T. Gautier: Salon de 1837, La Presse, March 8, 1837.
- 23 See R. Cortissoz: John La Farge, New York, 1911, p. 85.
- 24 J. Breton: Nos peintres du siècle, Paris, 189[?], p. 48.
- 25 E. and J. de Goncourt: Manette Salomon, Paris, 1866, ch. III.
- 26 J. La Farge: The Higher Life in Art, New York, 1908, p. 14.
- 27 E. Viollet-le-Duc: Réponse à M. Vitet à propos de l'enseignement des arts et du dessin, Paris, 1864; see P. Burty: Maîtres et petits maîtres, Paris, 1877, p. 7-8.
- 28 E. Viollet-le-Duc: L'enseignement des arts, Gazette des Beaux-Arts, June, 1862 (series of four articles).
- 29 On Lecoq de Boisbaudran see Viollet-le-Duc, op. cit., Burty, op. cit., also A. Jullien: Fantin-Latour, sa vie et ses amitiés, Paris, 1909, and the book by Lecoq de Boisbaudran: Education de la mémoire pittoresque, 2nd ed., Paris, 1862 (Engl. transl.: The Training of the Memory in Art, London, 1911).

- 30 On Couture see his: Méthodes et entretiens d'atelier, Paris, 1867; Paysage, causeries de l'atelier, Paris, 1869; as well as: Thomas Couture, sa vie, son oeuvre, son caractère, ses idées, sa méthode, par lui-même et par son petit-fils, Paris, 1932. Also E. W. Longfellow: Reminiscences of Thomas Couture, Atlantic Monthly, August, 1883; H. T. Tuckerman: Book of the Artists, American Artist Life, New York, 1867, v. II, p. 447–448 [the name is misspelled: Coiture]; Cortissoz, op. cit.; and especially A. Boime, op. cit. On Manet at Couture's studio see A. Proust: Edouard Manet, Souvenirs, Paris, 1913, p. 17-23 and p. 27-35.
- 31 Longfellow, op. cit.
- 32 Cortissoz, op. cit., p. 96.
- 33 See H. M. Knowlton: Art-Life of William Morris Hunt, Boston, 1899, p. 8 and 11.
- 34 Auguste De Gas to his son, Jan. 4, 1859; see P. A. Lemoisne: Degas et son oeuvre, Paris, 1946, v. I. p. 229, note 35.
- 35 Degas, notes; see P. A. Lemoisne: Les carnets de Degas au Cabinet des Estampes, *Gazette des Beaux-Arts*, April 1921; and especially T. Reff: The Chronology of Degas' Notebooks, *Burlington Magazine*, Dec. 1965; on Degas' early trips to Italy see Lemoisne: Degas et son oeuvre, Paris, 1946, v. I, p. 16-32.
- 36 F. Desnoyers: Du Réalisme, L'Artiste, Dec. 9, 1855.
- 37 E. Duranty: Notes sur l'art, Réalisme, July 10, 1856.
- 38 F. Maillard: Les derniers bohèmes, Paris, 1874, quoted by G. Geffroy: Claude Monet, sa vie, son oeuvre, Paris, 1924, ch. III. On the brasseries see also A. Schanne:

- Souvenirs de Chaunard, Paris, 1887, ch. XLI; P. Audebrand: Derniers jours de la bohème, Paris, n. d., p. 77-233; J. Champfleury: Souvenirs et portraits de jeunesse, Paris, 1872, ch. XXVII; A. Delvau: Histoire anecdotique des Cafés et Cabarets de Paris, Paris, 1862; J. Grand-Carteret: Raphaël et Gambrinus ou l'art dans la Brasserie, Paris, 1886; T. Silvestre: Histoire des artistes vivants, Paris, 1856, p. 244; as well as the monographs on Courbet by G. Riat, T. Duret, H. d'Ideville et al. See also: Courbet and the Naturalist Movement, edited by G. Boas, Baltimore, 1938.
- 39 Z. Astruc: Le Salon intime, Paris, 1860, p. 108.
- 40 See G. Mack: Gustave Courbet, New York, 1951, p. 143-146.
- 41 Address reprinted in the catalogue of the Salon of 1859; here quoted after Sloane, op. cit., p. 45.
- 42 Delacroix to Pérignon, Jan. 21, 1857; see Correspondance générale de Eugène Delacroix, Paris, 1937, v. III, p. 369.
- 43 See A. Tabarant: Manet et ses oeuvres, Paris, 1947, p. 30.
- 44 See E. R. and J. Pennell: The Life of James McNeill Whistler, London, 1908, v. I, p. 75.
- 45 See Z. Astruc: Les 14 stations au Salon, Paris, 1859; Pissarro's name is given in the index but not with the description of his painting, p. 370.
- 46 C. Baudelaire: Salon de 1859, chapter: Le public moderne et la photographie, in Variétés critiques, Paris, 1924, v. II, p. 121-124.

Left, Courbet: The Andler Keller, 1862. Etching, $3\frac{5}{8} \times 5\frac{3}{4}$ ". Illustration for Delvau: Histoire anecdotique des Cafés et Cabarets de Paris. Right, Courbet: Beer Drinkers at the Andler Keller, 1848. Charcoal. Formerly collection Juliette Courbet.

MONET AND BOUDIN

MANET AND DEGAS

L'ACADÉMIE SUISSE

THE ATELIER OF COURBET

Though born in Paris, Claude Oscar Monet—his parents called him Oscar—had passed his youth in Le Havre, where his father owned a grocery store together with a brother-in-law, Lecadre. His boyhood had been essentially that of a vagabond, as he himself later remarked; it had been spent more on the cliffs and in the water than in the classroom.¹ He was undisciplined by nature, and school always seemed to him a prison. He diverted himself by decorating the blue paper of his copybook and using it for sketches of his teachers, done in a very irreverent manner. He soon acquired a great deal of skill at this game. At fifteen he was known all over Le Havre as a caricaturist.² His reputation was so well established that he was sought after to make caricature-portraits. The abundance of these orders, and the insufficiency of subsidies derived from maternal generosity, inspired him with a bold resolve that scandalized his family: he took money for the portraits . . . 20 francs.

Having gained a certain reputation by these means, Monet was soon "an important personage in the town." In the shop window of the sole frame maker his caricatures were arrogantly displayed, five or six in a row, and when he saw the loungers crowding in admiration and heard them exclaiming: "That is so and so!" he "nearly choked with vanity and self-satisfaction." Still, there was a shadow in all this glory. Often in the same shop window, hung above his own productions, he beheld marines, which he, like most of his fellow citizens, thought "disgusting." The author of these seascapes that inspired Monet "with an intense aversion" was Eugène Boudin; without knowing the man Monet hated him. He refused to make his acquaintance by way of the frame maker, until one day he entered the shop without having noticed Boudin's presence at the rear. The frame maker grasped the opportunity and presented Monet as the young man who had so much talent for caricature.

"Boudin, without hesitation, came up to me," Monet remembered, "complimented me in his gentle voice and said: 'I always look at your sketches with pleasure; they are amusing, clever, bright. You are gifted; one can see that at a glance. But I hope you are not going to stop there. It is all very well for a beginning, yet soon you will

have had enough of caricaturing. Study, learn to see and to paint, draw, make landscapes. The sea and the sky, the animals, the people, and the trees are so beautiful, just as nature has made them, with their character, their genuineness, in the light, in the air, just as they are."

But, according to Monet himself, "the exhortations of Boudin had no effect. The man, after all, was pleasing to me. He was earnest, sincere, I felt it; yet I could not digest his paintings, and when he offered to take me with him to sketch in the fields, I always found a pretext to decline politely. Summer came — my time was my own — I could make no valid excuse; weary of resisting, I gave in at last, and Boudin, with untiring kindness, undertook my education. My eyes were finally opened and I really understood nature; I learned at the same time to love it."

Young Oscar Monet, then seventeen years old, could not have found a better teacher, for Boudin was neither doctrinaire nor theorist; all that he knew he had learned with his eyes and his heart, trusting them with genuine naiveté. A simple man with a humble devotion to nature and to art, he was well aware of his own limitations, having no other aspiration than to express himself with the conscientiousness of an artisan. It was Boudin who, fourteen years earlier (in 1844, when he was twenty years old) had opened the stationery and framing shop where he later met Monet. There he had framed and even sold the works of the numerous artists who used to spend their summers at the coast. Among his clients were Couture and Troyon, author of innumerable pleasant landscapes crowded with sheep and cows; Boudin himself began to paint in Troyon's manner. When, around 1845, Millet arrived in Le Havre, still unknown and obliged to earn his living by doing portraits of wealthy citizens for 30 francs apiece, he too bought his supplies at Boudin's. One day the painter-shopowner brought out his own studies, which Millet corrected. From that moment Boudin lost interest in his business and resolved to become an artist, although Millet did not fail to stress all the difficulties and the poverty that might be expected from such a decision. Boudin left the shop to his associate and went to Paris, where he made copies in the Louvre. In 1850 two pictures of his were bought by the "Society of Art Friends of Le Havre," and the next year, sponsored by his former clients Troyon and Couture, he obtained from the city a three-year fellowship to enable him to live in Paris and study seriously. But at the end of those years, which he had mostly spent far from the classes of the Ecole des Beaux-Arts, Boudin had not made the progress his benefactors had expected. Instead of doing pleasant genre pictures he had turned to studies painted directly in the open, and all he brought back from Paris was the conviction that "the romantics have had their day. Henceforth we must seek the simple beauties of nature ... nature truly seen in all its variety, its freshness."3

This conviction Boudin now wished to communicate to his young pupil, and under his influence Monet was not long in sharing it, for he not only watched Boudin at work but also profited by the other man's conversation. Boudin had both a sensitive eye and a clear mind, knowing how to put his observations and experience into simple words. "Everything that is painted directly on the spot," he stated, for instance, "has always a strength, a power, a vividness of touch that one doesn't find again in the studio." He was in favor of "showing extreme stubbornness in retaining one's first impression, which is the good one," while insisting that "it is not a single part which should strike one in a picture but indeed the whole."

Left, Monet: L'homme au petit chapeau, 1856–58. Drawing, $7\frac{3}{4} \times 5\frac{7}{8}$ ". Center, Monet: Caricature of His Teacher, Ochard, 1856–58. Drawing, $12\frac{5}{8} \times 9\frac{3}{4}$ ". Right, Monet: Caricature of a Lawyer, 1856–58. Drawing, $24\frac{1}{8} \times 17\frac{5}{8}$ ". All Art Institute of Chicago (Gift of Mr. and Mrs. Carter H. Harrison).

Boudin was too modest a man, however, to think that his lessons would be enough to put Monet on the right track. He used to say that "one never arrives alone, unless with very powerful propensities, and yet, and yet... one does not invent an art all by oneself, in an out-of-the-way spot, without criticism, without means of comparison...." After six months of such admonition, and in spite of his mother who had begun to worry seriously on account of the company her son was keeping, believing him lost in the society of a man in such bad repute as Boudin, Monet announced to his father that he wished to become a painter and that he was going to settle down in Paris to learn. Monet's father was not exactly opposed to the idea, especially since Oscar's aunt in Le Havre, Madame Lecadre, did some painting in her leisure time and was willing to let her nephew work in her attic studio (where he discovered a small painting by Daubigny, which he admired so much that she gave it to him). Although understanding and possibly even proud of his talents, Monet's family was partly unwilling, partly unable to help him financially; in March 1859 his father wrote to the Municipal Council, hoping that it would do for his son what it had done once for Boudin:

"I have the honor to state to you that my son Oscar Monet, aged eighteen years, having worked with MM. Ochard [Monet's art teacher at school], Vasseur, and Boudin, wishes to become a candidate for the title of Pensioner of Fine Arts of the city of Le Havre. His natural inclinations and his taste, which he definitely fixed upon painting, oblige me not to turn him away from his vocation, but since I have not the necessary means to send him to Paris to attend the courses of the important

masters, I hereby beg you to be so kind as to accept favorably my son's candidacy...'6 Two months later the Municipal Council examined this request, as well as the still life that had been submitted at the same time, and rejected it, fearing that Monet's "natural inclinations" for caricature might "keep the young artist away from the more serious, but less rewarding studies which alone deserve municipal generosity."

Without even waiting for this answer, Monet's father gave permission for a short trip to Paris so that his son might ask advice of some artists and see the Salon, which was to close in June. Fortunately Monet was in a position to get along without aid, at least for a while, since he had made it a practice to entrust the earnings from his caricature-portraits to his aunt Lecadre, keeping only small sums for pocket money. Before leaving he obtained from several art patrons who looked out for Boudin, and also from Boudin himself, some letters of introduction to different more or less well-known painters. He departed from Le Havre in high spirits.

Shortly after his arrival in Paris in May 1859, Monet sent his first report to Boudin: "I haven't yet been able to go more than once to the Salon. The Troyons are superb, the Daubignys are for me something truly beautiful. There are some nice Corots. . . . I have paid visits to several painters. I began with Amand Gautier who is counting on seeing you in Paris in the near future. That is everyone's opinion. Don't stay, letting yourself become discouraged in that cotton town — I have been to see Troyon. This is what he advised me to do: I showed him two of my still lifes: on that score he told me: 'Well, my good fellow, you'll have color, all right; it's correct in the general effect; but you must do some serious studying, for this is very nice, but you do it too easily; you'll never lose that. If you want to heed my advice and be serious about art, begin by entering a studio where they do nothing but the figure, learn to draw; that's what you'll find almost everyone lacks today. Listen to me and you will see that I'm not wrong; but draw with all your might; one never knows too much about it. Don't neglect painting, however; from time to time go to the country to make sketches, carry them through. Make some copies in the Louvre. Come to see me often; show me what you do, and, with courage, you'll get there."

And Monet added: "My parents have decided to let me stay a month or two, in accordance with Troyon's advice, who urges me to draw hard. In this way, he told me, 'you'll acquire proficiency, you'll go to Le Havre and you'll be able to do good sketches in the country, and in the winter you'll come back to settle here definitely.' This has been approved by my parents."

Monet's second letter to Boudin was not written until two weeks later; he excuses himself because "work, and this overwhelming Paris, make me forget a little the duties of a friend." But now he does give a detailed account of the Salon, which he has revisited several times. He admires Troyon's huge canvases of animals, yet thinks they are a little bit too black in the shadows; he likes Rousseau's landscapes but is severe toward a painting by Monginot (a pupil of Couture and comrade of Manet) whom Boudin had advised him to see; Hamon, a favorite of the general public, displeases him because he has no "idea of nature"; Delacroix, in his opinion, has done better things than those exhibited, but he finds in them "animation, movement"; he is still enthusiastic about Daubigny's paintings and now considers Corot's canvases "out-and-out marvels." He is happy to state that "marine paintings are

Monet: Still Life, c. 1859. $16 \times 23\frac{1}{2}$ ". Possibly the painting submitted to the Municipal Council of Le Havre; presented by the artist to Boudin. Collection Mr. and Mrs. Leigh B. Block, Chicago.

completely missing" and thinks that this is for Boudin "a road that should take you far." He has also been to see Monginot, who has received him with great kindness— "he's a charming fellow. He is young. He showed me a little seascape of yours. He does very beautiful things. He has put his studio at my disposal and I shall take advantage of it from time to time."

Monet questioned Troyon and Monginot about the classes they would recommend; both pronounced themselves for Couture, but Monet decided not to heed their advice, because he disliked Couture's work and apparently also because he felt apprehensive about losing freedom of action. Paris was too new and too exciting an adventure for him to be given up in favor of regular courses at the *Ecole des Beaux-Arts*. Instead, Monet attended the "sessions" at the Brasserie des Martyrs, where he found what he had missed in Le Havre, stimulating company and vivid discussions. But he did not see Courbet, who had left for Le Havre.

While Courbet was strolling in Le Havre with his friend Schanne, he saw in the lone frame-shop some small seascapes which immediately interested him; he asked for the name and address of the painter. Boudin was of course enchanted by the visit Courbet paid him and volunteered to guide the two friends through Le Havre and its outskirts, especially leading them to the modest inn of mère Toutain at the Ferme

Saint-Siméon, whence they could admire the vast panorama of the Seine estuary. One morning while the three painters were walking along the harbor, they met Baudelaire and spent the day with him. ¹⁰ Courbet did not fail to mention his admiration for Boudin's paintings, particularly for the skies, and Baudelaire not only went to see them in Boudin's humble abode, but instantly made a last-minute insertion in his review of the Salon of 1859, devoting a page full of praise and poetic interpretation to Boudin's pastel sketches. ¹¹ Even more important for Boudin than these eulogistic lines were his talks with Courbet. Boudin jotted down in his notebook: "Courbet has already freed me somewhat of timidity; I shall try some broad paintings, things on a big scale and more particular in tone. . . . He has a broad principle that one may appropriate, but it nevertheless seems to me rather coarse, rather careless as to detail."¹²

Monet was doubtless informed of these significant events. He in turn kept his friend apprised of all the news of the Paris art world, and of his own work in particular, the more since he was eager to have Boudin join him and to ask for advice about his work. After the first two months, Monet had decided to remain indefinitely in Paris. This might have been all right, as far as his parents were concerned, had he not refused to enter the *Ecole des Beaux-Arts*. His father cut his allowance, and Monet had to live on his savings, which were forwarded by his aunt. At the Brasserie he now sometimes saw Courbet but never had an opportunity to speak to him.

Courbet's friend Champfleury had just published a short novel, Les amis de la nature, which doubtless was the center of many discussions in the midst of which Monet found himself. In this novel Champfleury gently ridiculed all those poets and painters, "lovers of nature," who spent their days and their nights in the smoke-filled Brasserie, debating the problems of their art. He had even gone further and more or less attacked Courbet and his philosopher friend Proudhon by a malicious assault upon their theories about subject matter in art and its social meaning. Shortly afterward Champfleury was to break with Courbet.¹³

In the book Champfleury describes a session of the Salon jury in which a painting of a Cheddar cheese by an English artist has just been accepted; next is submitted a canvas by a Flemish painter portraying a Dutch cheese. This has hardly been admitted when there arrives a third painting, this time of a French Brie by a Parisian artist, represented with such fidelity that the jury members automatically hold their noses. They now have had enough of cheese and reject the final painting. The grief of the French artist is described as particularly intense because he considers the works of his rivals to be executed without any *realism* (Champfleury must have used this word intentionally). But a philosopher acquaintance of the Frenchman then explains the deeper reasons for the rejection:

"In France, painting with ideas is not liked....There is an idea in your picture; that is what got you excluded. The members of the jury accepted the Cheddar and the Dutch cheese because they don't contain anything subversive; but they judged your Brie to be a demagogic picture....The *idea* must have shocked them. It is a poor man's cheese; the knife with its horn handle and worn blade is a proletarian's knife. It was noted that you have a fierce liking for the utensils of poor people: you are judged demagogic, and you are. You are an anarchist without knowing it." 14

This mockery reflects well enough the subjects of discussion at the Brasserie, for

Boudin: Cloud Study, c. 1859 (?). Pastel, $7\frac{3}{8} \times 11\frac{1}{4}$ ". Present whereabouts unknown.

Courbet had antagonized his opponents not only through the conception and execution of his works, but also through his new approach to the question of subject matter. As a reaction against classicism and romanticism Courbet had found in the representation of everyday life new pictorial and political possibilities. Ingres, with his willful ignorance of the trivial aspects of life that led his followers toward pettiness, and Delacroix, with his tendency to emphasize emotional values that opened a dangerous trend toward melodrama, had both neglected to see the plain people around them. Even when Delacroix had derived inspiration from the revolution of 1830, he had represented, in his painting of the Barricade, less the actual fighters than the spirit of the event and the symbol of liberty, an allegorical woman carrying the Tricolor into the street battle. And the title was actually not Barricade but Liberty Leading the People. Courbet, except for his Studio canvas, which was intended as the first of a series but was never followed by other compositions of its kind, had avoided any allegories and devoted himself to the observation of his contemporaries, preferably of the lower classes. In doing so he had by no means rejected subject as such but had striven to give it a new meaning. Abetted, if not really urged on, by his socialist friend Proudhon, Courbet saw in the peasants he painted not simply a medium for pictorial realization — as did Millet — but considered his canvases social commentaries. So insistent were his arguments that he apparently even succeeded for a while in making his unpolitical and gentle friend Boudin look upon his own paintings from the same point of view. Questioned about his subject preferences,

Boudin defended his exclusive interest in people observed on the beaches with words that might have come directly from Courbet's mouth:

"The peasants have their painters, . . ." Boudin wrote to a friend, "that is fine, but, between ourselves, those middle-class people who are strolling on the jetty at the hour of the sunset, have they no right to be fixed upon canvas, to be brought to our attention? Between us, they are often resting from strenuous work, these people who leave their offices and cubbyholes. If there are a few parasites among them, are there not also people who have fulfilled their task? Here is a serious, irrefutable argument." 15

Monet, however, seems not to have cared at all whether anybody had the *right* to be depicted on canvas. He thoroughly despised the citizens of his home town Le Havre, parasites or not, and was interested only in what captivated his eye, an approach in which Boudin himself had encouraged him. Monet never gave a thought to the moral considerations with which Courbet adorned his works. It therefore seems doubtful whether he took an active part in the discussions at the Brasserie in which the value and interest of subjects were weighed according to their social implications. Nor is it known whether he was concerned with political problems, although it is more than likely that these were hotly debated at Brasserie sessions.

Three years after his election to the presidency of the Republic, in 1848, Napoléon III had broken his solemn oath to the constitution, eventually proclaiming himself Emperor. Only through the use of absolute power could he maintain himself against a republican opposition on the one hand and various royalist factions on the other.

Boudin: Beach at Trouville, c. 1863. $14\frac{1}{8} \times 22\frac{7}{8}$ ". Collection Mr. and Mrs. Paul Mellon, Upperville, Va.

Boudin: Fishing Boats at Trouville, d. 1874. $9\frac{1}{4} \times 12\frac{7}{8}$ ". Collection Mr. and Mrs. Morris Hadley, New York.

Guys: Emperor Napoléon III Riding in the Bois de Boulogne. Pencil, pen, and grey ink with watercolor, $7\frac{1}{4} \times 10\frac{1}{4}$ ". Collection J. Spreiregen, London

Ruthless political oppression and a rigid censorship, muzzling the liberal press and prosecuting authors such as Flaubert and Baudelaire, represented the shadow side of a regime that favored industrial progress and endeavored to make France once more one of Europe's leading powers. In the summer of 1859, after the victorious end of the Crimean war and a successful intervention against the Austrian yoke over northern Italy, the French ruler felt secure enough to proclaim an amnesty for all political exiles. But some of these, such as Victor Hugo, proudly declined. "When liberty returns, I shall return!" the poet declared, subsequently explaining: "After eight years the criminal considered it convenient to absolve the innocents; the assassin offered his pardon to the assassinated, and the executioner felt the need to forgive his victims." 16

Later that same year, when Hugo published his epic and romantic volume of poems, La légende des siècles, the French press remained silent or else attacked it bitterly. The Catholic Church, siding with the Throne, particularly deplored the author's free-thinking attitude and — strangely — coupled his name with that of Delacroix because they were both "devoted to the cult of imagination and color" and both "sacrificed everything to the effect" they wished to produce. "With advancing age their faults have become systematical. Drawing, proportion, the true and even the merely possible are equally repugnant to them..." 17

There can be little doubt that in questions of liberty versus tyranny Monet's sympathies were with those who opposed the Third Empire. His lifelong liberalism, of which he was to give repeated proof in later years, may well have been nourished

if not implanted by his early contacts in Paris — a hotbed of advanced ideas as compared to Le Havre — although for the time being he seemed occupied mainly with his work. Shunning the question of subject matter in art, he had surrounded himself with friends who were all exclusively landscapists. If there was anything of interest for him in Champfleury's book, *Les amis de la nature*, it might have been this statement, contributed by Duranty in his introduction: "Minds imbued with correctness are resigned to sacrificing the new and the original to their beloved correctness; they buy it thus, and it is somewhat expensive. In the same way, others pay the price of certain lapses from correctness for the invaluable discoveries which they make in the fields of newness, delicacy, sensibility, and originality, and this is assuredly cheaper." Wasn't this exactly Monet's case, for he had discarded the "correctness" of Couture's teaching so as to be ready for some "invaluable discoveries."

As a matter of fact, Monet had made some progress since arriving in Paris. At the studio where he worked occasionally he had made friends with other young artists. As a result of their exchange of ideas and of his own new experiences, his taste had become firmer and his appreciation more discriminating. He had an opportunity to exercise these faculties when, at the beginning of 1860, a large exhibition of modern paintings, lent by private collectors and organized without the Academy's interference, was opened on the boulevard des Italiens. This exhibition offered a startling contrast to the Salon of the preceding year, in which a "stale harmony, obtained by

Right, Photograph of Monet at age of eighteen (1858).

Far right, De Séverac: Claude Monet, d. 1865. $15\frac{3}{4} \times 12\frac{5}{8}$ ". Musée Marmottan, Paris (Bequest of Michel Monet).

COROT: Le Martinet near Montpellier, d. 1836. Pencil, $13\frac{1}{4} \times 19\frac{3}{4}$ ". This drawing was given by the artist to Pissarro. Metropolitan Museum of Art, New York.

the sacrifice of all virgin colors and of all vigour" had reigned. As Théophile Gautier put it: "What is striking, upon observing these walls, is the strength, the brilliance, the intensity of color. . . ." Monet had exactly the same impression — he had never seen anything but the 1859 Salon — and exclaimed with joy that this new show proved "that we are not so far gone in decadence as it is said." In a long letter to Boudin he shows himself enthralled by Delacroix's eighteen canvases, by the land-scapes of the Barbizon painters, by Courbet's and Corot's works, by Millet's La mort et le bûcheron, which had been refused by the Salon jury the year before. Monet does not even mention Ingres or Meissonier and relaxes in his admiration for Troyon, since the latter's works could not be compared with those of the others. As for Couture, he considers his paintings outright bad, as well as those of Rosa Bonheur, then at the height of her vogue. Monet also informs his friend that "the only seascape painter we have, Jongkind, is dead to art; he is completely mad. The artists are taking a subscription to cover his needs." And he adds naively: "There is a nice seat for you to take." 20

In his letter to Boudin, Monet gives some details concerning his own work: "I am surrounded by a small group of young landscape painters who will be very happy to get to know you. Besides, they are real painters. . . . I find myself very well fixed here: I am drawing figures hard; that's a fine thing. And at the Academy, there are only landscapists. They begin to perceive that it's a good thing."20

PISSARRO: Rue St. Vincent at Montmartre, d. 1860. Charcoal heightened with white, $5\frac{7}{8} \times 8\frac{3}{4}$ ". Private collection, New York.

The "Academy" that Monet mentions in his letter was not a real Academy but an establishment opened by a former model, where artists could for a small fee work from the living model without any examinations or tuition, and where numerous landscape painters came to study anatomy. From the name of its owner, it was called the Académie Suisse.21 It was located on the quai des Orfèvres, near the Pont Saint-Michel, in an old and sordid building where a well-known dentist pulled teeth at one franc apiece. Courbet once had worked there, Manet had come there to draw freely while still a pupil of Couture, and Pissarro occasionally dropped in when he was in town, in order to work from the nude or simply to meet some friends. There Monet soon became acquainted with him, and it is possible that Pissarro was one of the two companions with whom he went to paint some landscapes at Champignysur-Marne, near Paris, in April 1860. According to Monet's recollections Pissarro was then "tranquilly working in Corot's style. The model was excellent; I followed his example."22 In a drawing of a street in Montmartre which Pissarro did that very year he was already combining Corot's poetic charm with a forceful opposition of light and dark masses that reflects his connection with Courbet. Corot had given him one of his own drawings, not one of his later sketches with trees and planes summarily indicated, but an earlier study, full of patient detail, possibly to attract Pissarro to a less bold approach to nature. (While Pissarro seemed only slowly to "succumb" to Courbet's influence, Whistler, in one of his first important paintings,

representing Wapping on Thames, all but openly proclaimed his indebtedness to the Master of Ornans.)

Monet's work in the company of Pissarro cannot have lasted long, because his conscription term had arrived. He looked forward to it without fear, and so did his parents, who had not forgiven him his flight and had allowed him to live as he chose only because they thought they would catch him at this moment. Military service was then decided by a lottery, and those who drew unlucky numbers had seven years in the army before them. Since it was possible, however, to "buy" a substitute, Monet's father intended to do so if his son would bend to his will, but the latter was firm. "The seven years of service that appalled so many," he explained later, "were full of attraction to me. A friend, who was in a regiment of the Chasseurs d'Afrique and who adored military life, had communicated to me his enthusiasm and inspired me with his love for adventure. Nothing attracted me so much as the endless cavalcades under the burning sun, the razzias, the crackling of gunpowder, the sabre thrusts, the nights in the desert under a tent, and I replied to my father's ultimatum with a superb gesture of indifference. I drew an unlucky number. I succeeded, by personal insistence, in being drafted into an African regiment. In Algeria I spent two really charming years. I incessantly saw something new; in my moments of leisure I attempted to render what I saw. You cannot imagine to what extent I increased my knowledge, and how much my vision gained thereby. I did not quite realize it at first. The impressions of light and color that I received there were not to classify themselves until later; they contained the germ of my future researches."22

While Monet was combining his military life with new visual experiences, Pissarro continued to work in the country around Paris, where he met the landscape painters Chintreuil, who like him had profited by the advice of Corot, and Piette, a former pupil of Couture. Piette soon became one of Pissarro's most intimate friends and sat for a portrait, done in 1861. Doubtless it was again a landscape which Pissarro sent to the Salon of that year, but this time the jury, in whose decisions neither Ingres nor Delacroix participated, rejected his canvas.

Fate having reversed its favors, two paintings submitted by Manet were accepted, although very badly hung. For obvious reasons Manet omitted calling himself in the catalogue a pupil of Couture. He exhibited a portrait of his parents and the Spanish Guitar Player (p. 53), which in spite of its bad place immediately attracted attention. Its broad execution, its vivid colors, its pleasing subject and lively attitude inspired critics, especially Théophile Gautier, who had been in Spain, to warm praise, for here was a work that combined the observation of real life with the "glamor" of an exotic and picturesque costume. And the extraordinary happened: owing to the favorable comments the canvas was rehung, assigned a place in the center of a panel and finally awarded an "honorable mention." It is said that Delacroix had something to do with this distinction. Through the success of his first works at the Salon, Manet, then twenty-nine years old, found himself overnight with a reputation that assigned him an enviable place among the "promising young men" of new tendencies.

Manet's Spanish Guitar Player drew the attention of many young painters, who were interested particularly in Manet's achievement of translating a visible influence of Goya and especially Velázquez into modern accents. Only the previous year Champfleury had stated in an article on Courbet that "the master, with his rehabilitation of

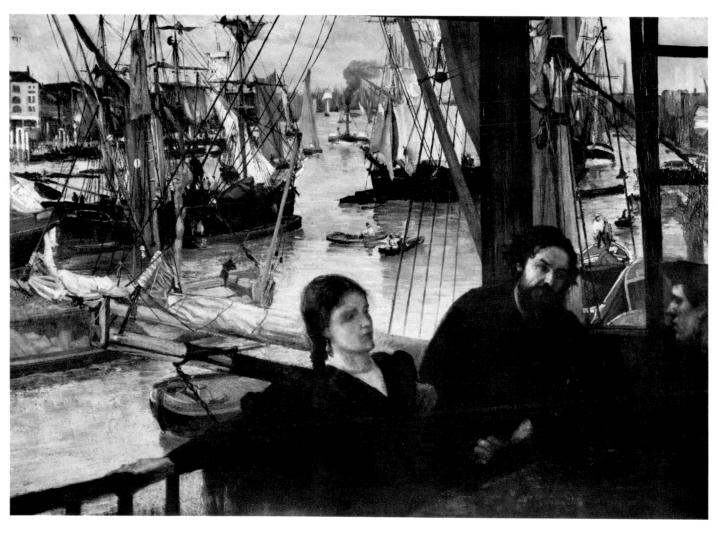

Whistler: Wapping on Thames (Joanna Heffernan, the French artist Alphonse Legros, and a sailor), d. 1861. 28 × 40". Exhibited at the Salon of 1867. Collection Mr. and Mrs. John Hay Whitney, New York.

the modern and the excellent manner in which he recaptures the presentation of the modern, will perhaps facilitate the arrival of a noble and great Velázquez, of a scoffing and satirical Goya."²³

Champfleury, without knowing it, had been a prophet, for Manet, with the conscious or unconscious help of Courbet, had succeeded in establishing a link with the past which was not merely a slavish dependence on his predecessors; quite to the contrary, he had added new life to an admirable tradition. In the midst of the repetitions and imitations at the Salon his canvas struck a new and brilliant note. According to Fernand Desnoyers, mouthpiece of the Brasserie des Martyrs, who told the story a few years later half seriously, half jokingly, "a group of painters: Legros

[a former pupil of Lecoq de Boisbaudran who himself obtained that very year a considerable success with a painting inspired by Courbet], Fantin [who had already met Manet], Carolus-Duran, Bracquemond [an etcher and friend of Degas], Amand Gautier, stopped short before a Spanish Guitar Player. This canvas, which made so many painters' eyes and mouths open wide, was signed by a new name, Manet. This Spanish musician was painted in a certain strange, new fashion, of which the young, astonished painters believed themselves alone to possess the secret, a kind of painting that stands between that called realistic and that called romantic. . . . It was decided then and there, by this group of young artists, to go in a body to M. Manet's. This striking manifestation of the new school took place. M. Manet received the deputation very graciously and replied to the spokesmen that he was no less touched than flattered by this proof of sympathy. He gave, about himself and about the Spanish musician, all the information desired. He informed the speakers, to their great astonishment, that he was a pupil of M. Thomas Couture. They did not limit themselves to this first visit. The painters even brought a poet and several art critics to M. Manet."24 These critics were doubtless the very men who defended Courbet and had thus shown their receptiveness to new forms of art: Castagnary, a staunch supporter of realism, Astruc, Desnoyers himself, Champfleury, whose books Bracquemond had adorned with frontispieces, Duranty, for whose first novel, published the previous year, Legros had contributed four etchings, and possibly also Théophile Gautier.

In spite of the fact that Courbet himself expressed some criticism concerning Manet's relation to Velàzquez, his followers greeted Manet as a welcome addition to their camp. But Manet abstained from joining the artists and writers around Courbet at the Brasserie. A Parisian dandy of wealthy parents, he was jealous of his independence and also of his career, not wanting to compromise himself in their company. Despite his disputes with Couture, he had spent six years in the latter's studio because he believed that he could realize his ambitions within the framework of official institutions, and now that a sudden success had crowned his efforts, it was certainly not the moment to join those whose very names were identical with revolution. Manet had just rented a studio in the Batignolles quarter, far from the spots where Courbet met his friends; more attracted by the Parisian "high life" than by Bohemia, he preferred the fashionable terrace of the Café Tortoni on the boulevards to the Brasserie.

The poet who was introduced to Manet by his new painter friends can have been no other than Baudelaire. For a short time a comrade of Courbet, Baudelaire had long since detached himself from this painter, and, as he said, "the mob of vulgar artists and literary men whose short-sighted intelligence takes shelter behind the vague and obscure word realism." He had not, however, relinquished a constant interest in all manifestations of art. Ardent admirer of Delacroix, friend of the lonely Constantin Guys, severe but just critic of Ingres (whose foibles had not distracted him from his qualities), one of the few who recognized in Daumier more than a mere caricaturist, Baudelaire had a sensibility more receptive to visual impressions than almost any other man in literature. This faculty made him respond unfailingly to the pictorial qualities which it took the majority of his contemporaries decades to discover. As a poet he valued words not only for their meaning but as conveyors of images as well and, further, knew how to exploit their rhythm and their sound. It

Manet: Portrait of Baudelaire, 1862. Etching, $4\frac{1}{4} \times 3\frac{1}{2}$ ".

Manet: Spanish Guitar Player, 1860. $57 \times 44\frac{5}{8}$ ". Awarded honorable mention at the Salon of 1861. Metropolitan Museum of Art, New York (Gift of William Church Osborn).

Courbet: Portrait of Baudelaire, 1848–50. $21\frac{1}{4} \times 24\frac{1}{2}$ ". Musée Fabre, Montpellier (Bruyas Bequest).

may have been this that enabled him to recognize in painting the qualities which lie beyond the subject: the vigor of execution, the harmony of color, and the creative power which through inanimate means achieves what Hugo had called in Baudelaire's own case "un frisson nouveau."

Eleven years older than Manet, Baudelaire approached the painter with both the curiosity of an eternal seeker after new sensations and the empathy of the isolated genius who sees a younger man headed for the same fate of a lifelong battle for recognition. He immediately perceived Manet's "brilliant faculties" but also his "feeble character," ill adapted to the struggle ahead. "Never will he completely overcome the gaps in his temperament," he wrote later to a friend, "but he has temperament, that is the important thing." Attracted by Manet's work, Baudelaire did not take long to express his appreciation publicly. About one year after they had met, in the fall of 1862, he published an article in which he lauded Manet for knowing how to unite with "a decided taste for modern truth . . . a vivid and ample, sensitive, daring imagination without which all the better faculties are but servants without a master." In the same year, 1862, Manet etched Baudelaire's profile and

included it in his painting *Concert in the Tuileries Gardens* (p. 77), one of his first canvases concerned with contemporary life. This painting also contains portraits of several others among Manet's new friends: Champfleury, Astruc, Théophile Gautier, and a military man, Commandant Lejosne, who was a mutual friend of Manet and Baudelaire. The latter also introduced the artist to the influential literary critic Sainte-Beuve.

At about the same period during which Manet met Baudelaire, he also made the acquaintance of Edgar Degas. He might have met Degas through Bracquemond, but it seems that Manet first spoke to him when he watched Degas copy in the Louvre and was amazed by his audacity. Only two years younger than Manet, as removed from Bohemian milieu as he himself, well dressed, of elegant manners, highly intelligent and witty, Degas was the perfect companion for the worldly Manet, and they soon became fast friends.

From several trips to Italy, where his father had many relatives and where his married sister lived, Degas had brought home a large number of drawings after models as well as after Italian masters, and a series of family portraits, to which he added others done in Paris of his younger brothers and of himself. These portraits were executed in Ingres' tradition, with a reverent respect for linear precision, but Degas had not refrained from livening their austere color scheme with certain vivid accents, nor from adding some lively strokes to his smooth brush work. While his

Right, Degas: Madonna and Child, sketch after a Milanese work of about 1500, c. 1857. Pencil, 13 × 10". Formerly Durand-Ruel Galleries, New York.

Far right, Degas: Copy after a drawing in the Uffizi, Florence, attrib. to Pontormo, c. 1857. Pencil, $14\frac{1}{2} \times 11^{\circ}$. Collection Robert L. Rosenwald, Jenkintown, Pa.

earlier portraits, such as those of his brothers, still show a dependence upon more or less rigid and classical poses, he was soon to introduce into his pictures attitudes that were far from what Ingres would have approved. Painting in 1858–59 the family of his father's sister, Baroness Bellelli in Florence,²⁸ he depicted his uncle almost from the back and showed the central figure of his little cousin on a chair with one leg folded and entirely hidden under her ample skirt. Whereas Ingres, preoccupied with his style, told his sitters how he wanted them to pose, Degas was more interested in doing, as he later said, "portraits of people in familiar and typical attitudes, above all in giving to their faces the same choice of expression as one gives to their bodies."²⁹ In spite of a certain inclination toward the unorthodox and a gift for observation unhampered by any conventions, Degas had not yet turned to subjects derived from the life around him. When he met Manet, Degas was painting historical scenes which

Degas: Portrait of the Artist's Brother Achille in the Uniform of a Cadet, c. 1857. $25\frac{1}{4} \times 20''$. National Gallery of Art, Washington, D. C. (Chester Dale Collection).

Degas: Portrait of the Artist's Brother René, 1855. $36\frac{1}{4} \times 29\frac{1}{2}$ ". Smith College Museum of Art, Northampton, Mass.

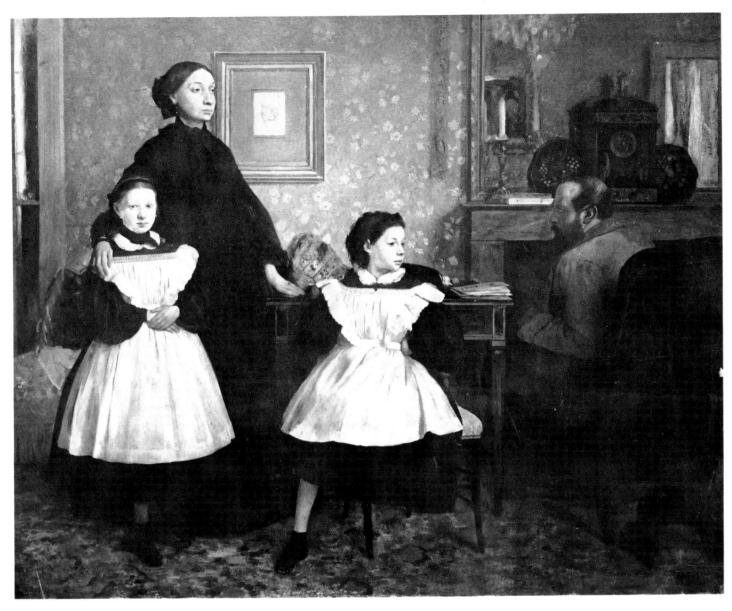

Degas: Portrait of the Bellelli Family in Florence, 1858–59. $78\frac{3}{4} \times 99\frac{1}{2}"$. Musée du Louvre, Paris.

DEGAS: Study for *The Daughter* of *Jephthah* in the Smith College Museum of Art, c. 1859. Pencil, $7 \times 10_4^{1}$ ". Wildenstein Galleries, New York.

in their themes, though not in their conception, were closely linked to those of the Ecole des Beaux-Arts. Around 1860 he began work on a composition representing Spartan girls provoking young men to a contest, in which he willfully neglected to imitate the conventional type of Greeks, choosing instead for models what have been called children from Montmartre and thus combining in a strange way a historical subject and a classical execution with types and observation drawn from his own period. This also holds true for another painting, Semiramis Founding a Town, executed in 1860-61. In a third picture, issuing from the same inspiration, The Daughter of Jephthah, he abandoned a certain stiffness, as well as his fashion of grouping the figures on horizontal levels parallel to the surface of the canvas, in favor of a more intricate composition into which there also entered some of the agitation and liveliness that distinguished Delacroix's treatment of similar topics. Degas even mentioned the name of Delacroix in some notes referring to this painting, the largest he ever did.30 None of these works shows in any way the hand of a beginner: there is neither exuberance nor hesitancy, neither awkwardness nor narrow clinging to given models. From the very start Degas reveals himself as a clever and disciplined craftsman, avoiding facileness, disregarding cheap effects, solving ambitious problems in a style that shows his kinship with Ingres, and in a spirit that sometimes approaches Delacroix's.

In spite of their friendship Manet did not at all approve of Degas' choice of sub-

Degas: Young Spartans Exercising, 1863–64? $43\frac{1}{4} \times 60\frac{3}{4}$ ". Exhibited at the fifth Impressionist show, 1880. National Gallery, London.

Degas: Semiramis Founding a Town, 1860-61. $59\frac{3}{8} \times 102\frac{1}{4}$ ". Musée du Louvre, Paris.

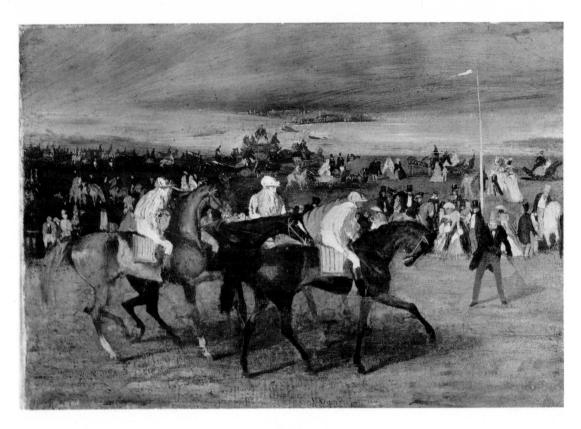

DEGAS: At the Races: "They're Off" (probably a souvenir of Epsom), 1860-62. $12\frac{5}{8} \times 18\frac{1}{8}$ ". Fogg Art Museum, Cambridge, Mass.

jects. The *Ecole des Beaux-Arts* had inspired Manet with a horror for historical scenes — peintre d'histoire was the worst insult he could think of. It therefore seems very possible that at the beginning of their relationship Manet was more attracted by the man Degas than by the artist, happy to find a companion of culture and distinction, openminded but not too anarchistic in his beliefs. In the autumn of 1861 Degas spent a few weeks in Normandy on the estate of his friend Valpinçon and became interested in horses since there were several studs near his property of Ménil-Hubert. It may well be that Degas combined recollections of an earlier trip to Epsom with the observations he now made when he began painting his first canvases of racing scenes. These constitute his initial venture away from historical subjects and from the family circle in which he had found all his models. Since he had not yet exhibited at the Salon, Degas was a mere beginner compared to Manet who, in the fall of 1861, appeared for the second time before the public eye with an important group of recent paintings exhibited in the gallery of Louis Martinet on the boulevard des Italiens; from then on this dealer almost always had on hand some of Manet's works.

During this same year of 1861 Delacroix at last finished his murals in the church of Saint-Sulpice in Paris; Manet's friend Fantin was among those who immediately went to study and admire them. To those who used every available argument against Delacroix and now accused him of decadence, Baudelaire replied that never

had the artist "displayed more splendidly and cleverly supernatural colors, never more consciously epic drawing." But more than the color and the drawing, Delacroix's admirers among the artists were interested in a purely technical problem that had here been brilliantly solved. Since the murals were destined to be seen at a certain distance, Delacroix had adopted large and separate brushstrokes, which blended naturally at that distance and gave to the color more energy and freshness.

Boudin, who spent part of the year 1861 in Paris, was probably among those who saw Delacroix's new decorations. In order to help Boudin financially, Troyon had asked him to brush in the skies and backgrounds for his landscapes, eternally crowded with cattle, for which the demand was so heavy that Troyon could hardly supply the quantities wanted. During his stay in Paris, Boudin saw Courbet again and possibly Baudelaire; he also met Champfleury and Corot, but he apparently did not make the acquaintance of the friends Monet had wanted him to meet, Pissarro for instance.

Pissarro continued to work in the outskirts of Paris and to drop in at the Académie Suisse. There he was soon attracted by a young man from southern France whose heavy provincial accent and strange behavior were no less mocked by all the other artists than were his sketches, full of strong feeling. He was the son of a well-to-do banker of Aix-en-Provence, Louis-Auguste Cézanne. For three years Paul Cézanne had struggled with his father in order to obtain permission to devote himself to art but had been obliged instead to study law in Aix. In dire need of guidance, since the local art school provided only dusty plaster casts, occasional male models and uninspired instruction, he had so far mainly copied works in the museum at Aix—frequently choosing rather sentimental and insipid canvases—or had used poor black

Right, PRUD'HON: Children with Rabbit, $9\frac{1}{2} \times 8\frac{1}{4}$ ". Hermitage Museum, Leningrad.

Far right, Cézanne: copy after Prud'hon's *Children with Rabbit*, 1858–60. $21\frac{5}{8} \times 18\frac{1}{8}$ ". (From an engraving after Prud'hon's painting and hence reversed.) Zimet Bros., New York.

Left, Cézanne: Standing Nude, 1861–65. Charcoal, $19\frac{1}{2} \times 11\frac{1}{2}$ ". Private collection, New York. Center, Cézanne: Study of a Negro Model, c. 1865. Charcoal, $19\frac{3}{4} \times 13\frac{3}{8}$ ". Present whereabouts unknown. Right, Cézanne: Study of a Nude, 1861–65. Charcoal, $19\frac{1}{4} \times 12\frac{1}{4}$ ". Private collection, Paris.

and white engravings after paintings (photographic illustrations did not yet exist) as sources of inspiration.

Having finally overcome his father's opposition, Cézanne, at the age of twenty-two, had hurried to Paris to join his college friend, Emile Zola. He worked regularly at the Académie Suisse from 6 a.m. to 11 a.m., no doubt so as to prepare himself for the entrance examinations at the Ecole des Beaux-Arts. 31 According to Monet, Cézanne was in the habit of putting a black hat and a white handkerchief next to the model in order to fix the two poles between which to establish his values.32 His uncouth manners and violent absorption in his work made him the laughing stock of his class. Pissarro later remembered how he went to see the bizarre young provençal at the Académie Suisse "where his drawings of nudes were ridiculed by all those impotent fellows from the Ecole des Beaux-Arts."33 But besides Pissarro, who instantly discerned some personal elements in his work, and Armand Guillaumin, a somewhat younger man whom he met also at Suisse's, Cézanne seemed completely isolated and even saw his old friend Zola less frequently than he had hoped. He was soon disgusted with the large city, and since his juvenile dreams of success failed to become true at once, he decided, in spite of Zola's most fervent exhortations, to return to Aix. He left Paris in the fall of 1861 with the intention of entering his father's bank as a clerk and of giving up art once and for all.

CÉZANNE: Study for *The Autopsy*, c. 1865. Charcoal, 12½ × 18¾". Art Institute of Chicago (Gift of Tiffany and Margaret Blake).

Cézanne: Nude Studies, 1861–65. Charcoal, $7\frac{7}{8} \times 10\frac{1}{8}$ ". Collection Carl E. Pickhardt, Jr., Cambridge, Mass.

All these drawings were probably made at the *Académie Suisse* during Cézanne's different sojourns in Paris.

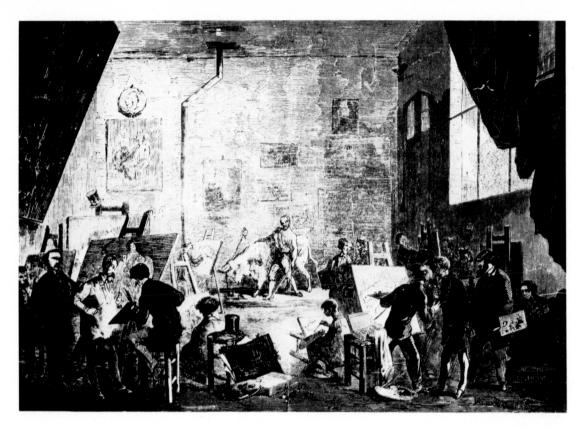

Courbet's Studio, rue Notre-Dame-des-Champs. (Courbet stands at right in profile holding a palette.) Wood engraving by A. Prévost, published in Le Monde Illustré, March 15, 1862.

The Ecole des Beaux-Arts, which had seemed the logical goal to Cézanne and even more so to his father, continued to be far from a heaven to those who did manage to matriculate. The end of 1861 was to see a serious uprising by a group of students pupils of both Picot and Couture — who were dissatisfied with their master's methods and were eagerly looking for a new teacher. Their first thought was of Courbet because that artist, in the midst of sterile struggles and of uncertainties, was telling his followers to break with the past, to go forward and be venturesome. Nothing appealed more to their own inner impulses than this call to set free their youthful forces and to assert themselves in large, even brutal works of bold conception and vigorous treatment. They therefore asked Courbet whether he would accept them as pupils and initiate them. Courbet, in a long letter written with the help of Castagnary, told them that he could not be their teacher because every artist ought to be his own, but that he was willing to open an atelier, not unlike a Renaissance studio, where, considering them not as pupils but as collaborators, he would explain to them how he himself had become a painter; each of them would remain entirely free to search for the expression of his individual conceptions.34

During the first weeks of January 1862, the students began to flock to the studio which had been rented in the rue Notre-Dame-des-Champs, and there were soon over forty of them; each contributed 20 francs for the rent and the model. This model was in turn a horse or a bull, chained to the wall and guarded by a peasant. The unusual

sight of a bull in a Paris studio became the talk of the town, and it was not long until gangs of gamins besieged the studio while Courbet passed from one easel to the other — Fantin was among his "pupils" — talking about art in general and his methods in particular. It is not known whether it occurred to anyone that instead of bringing a bull into a studio it would have been more natural to go out into the suburbs and study the animal in its proper surroundings; at any rate the experiment did not last very long. Courbet got tired of "teaching," and the students were probably weary, after a while, of his repetitions. In April 1862, the studio was disbanded, yet even its short-lived existence had been enough to show once more that the Ecole des Beaux-Arts was slowly losing its hold upon the students. Whether in consequence of this event or not, it remains a fact that, in March 1862, a special commission was officially appointed to study means of introducing some improvements into the Ecole, the Academy in Rome, and the rules governing the Salon.

"I regret very much not being able to induce you to come to Paris at this time," Troyon had written in January 1862 to Boudin, then returned to Le Havre. "The situation is trying: the artists are in general little satisfied.... The poor young folk have some right to complain." And Fantin said at about the same time in a letter to some friends in England: "Paris — that's free art. No one sells, but there one has freedom of expression and people who strive, who struggle, who approve; there one has partisans, sets up a school; the most ridiculous as well as the most exalted idea has its ardent supporters.... At bottom, an atrocious place to live." Yet this atrocious place continued to attract young talents from all over the country, if not from all over the world. Only in Paris, it seemed, could they get stimulation, meet companions, lose or find themselves, and plant the seeds of glory. Pissarro had come from the West Indies, Boudin and Monet from Le Havre, Cézanne and Zola from Aix; others like them were to take the road for Paris full of hope and expectations.

Fantin-Latour: Self Portrait, d. 1859. Charcoal, $14\frac{1}{2} \times 10\frac{1}{4}$ ". Denver Museum of Art (T. Edward Hanley Collection).

- 1 The first five paragraphs of this chapter are based more or less literally on an account of his youth given by Monet himself; see Thiébault-Sisson: Claude Monet, an Interview. Originally published in *Le Temps*, Nov. 27, 1900, translated and reprinted in English for Durand-Ruel Galleries, New York.
- See H. Edwards: The caricatures of Claude Monet, Bulletin of the Art Institute of Chicago, Sept.-Oct. 1943; also
 P. Georgel: Monet, Bruyas, Vacquerie et le Panthéon Nadar, Gazette des Beaux-Arts, Dec. 1968.
- 3 Boudin, note, Feb. 27, 1856; see G. Jean-Aubry: Eugène Boudin, Paris, 1922, p. 31. The author of this work had access to hundreds of letters by Boudin as well as to the painter's notebooks, registers, et al. His book offers much valuable information concerning Monet's youth. On Boudin see also G. Cahen: Eugène Boudin, sa vie et son oeuvre, Paris, 1900 and R. L. Benjamin: Eugène Boudin, New York, 1937 (which makes available in English the documents collected by Jean-Aubry and Cahen).
- 4 Boudin, notes from sketchbooks, quoted by Cahen, op. cit., p. 181, 184, 194.
- 5 Boudin to his brother, April 20, 1868; see Jean-Aubry, op. cit., p. 66.
- 6 A. Monet to the municipal council of Le Havre, March 21, 1859: see Jean-Aubry, op. cit., p. 171.
- 7 Séance du conseil municipal, Le Havre, May 18, 1859; see M. de Fels: La vie de Claude Monet, Paris, 1929, p. 32-33.
- 8 Monet to Boudin, May 19, 1859; see G. Geffroy: Claude Monet, sa vie, son oeuvre, Paris, 1924, v. I, ch. IV.
- 9 Monet to Boudin, June 3, 1859; ibid.
- 10 See G. Riat: Gustave Courbet, Paris, 1906, p. 179-180; also A. Schanne: Souvenirs de Chaunard, Paris, 1867, p. 229-230.
- 11 See C. Baudelaire: Salon de 1859, ch. VIII; reprinted in L'art romantique.
- 12 Boudin, note, June 18, 1859; see Jean-Aubry, op. cit., p. 39.
- 13 On Champfleury see E. Bouvier: La Bataille Réaliste, Paris, n.d. [1913].
- 14 J. Champfleury: Les amis de la nature, Paris, 1860, ch. II.
- 15 Boudin to Martin, Sept. 3, 1868; see Jean-Aubry, op. cit., p. 70.
- 16 See P. Angrand: Le Centenaire de "La Légende des Siècles," La Pensée, Nov.-Dec. 1959.
- 17 A. Nettement: Poètes et artistes contemporains, Paris, 1862, p. 245, quoted by Angrand, *ibid*.

- 18 E. Duranty: Caractéristique des oeuvres de M. Champfleury; introduction to Champfleury: Les amis de la nature, op. cit., p. xxi. On Duranty see notably M. Crouzet: Un méconnu du Réalisme—Duranty—l'Homme, le Critique, le Romancier, Paris, 1964.
 - Degas, who later became one of the closest friends of Duranty, was also in those years an ardent admirer of Champfleury.
- 19 T. Gautier: Exposition de tableaux modernes, Gazette des Beaux-Arts, Feb. 1860. On the same exhibition see Z. Astruc: Le Salon intime, Paris, 1860.
- 20 Monet to Boudin, Feb. 20, 1860 (and not 1856, as often indicated); see Geffroy, op. cit., v. I, ch. IV. Occasionally, however, Monet continued to draw caricatures. Geffroy relates that he did one of Bénassit at the Brasserie des Martyrs where the young artist met Cajart, in whose short-lived weekly, Diogène, there appeared in 1860 a portrait-charge of the actor Laferrière by Monet (see E. Bouvy: Une lithographie inconnue de Manet, l'Amateur d'Estampes, Jan. 1928). But, according to Geffroy (ch. III), Monet seems to have refused to contribute regularly to La Presse de la Jeunesse, published by Andrieu, another habitué of the Brasserie.
- 21 On the *Académie Suisse* see the article by Dubuisson in *Paris-Midi*, Jan. 2, 1925, quoted *in G. Mack: Paul Cézanne*, New York, 1935, p. 104-105.
- 22 Monet to Thiébault-Sisson; see Interview, op. cit.
- 23 J. Champfleury: Courbet en 1860; reprinted in Grandes figures d'hier et d'aujourd'hui, Paris, 1861, p. 252.
- 24 F. Desnoyers: Le Salon des Refusés, Paris, 1863, p. 40-41.
- 25 C. Baudelaire: L'oeuvre et la vie d'Eugène Delacroix, ch. III; reprinted *in* L'art romantique.
- 26 Baudelaire to Mme Paul Meurice, May 24, 1865. Baudelaire's letters to Manet or concerning the painter are assembled by E. Faure in his edition: C. Baudelaire: Variétés critiques, Paris, 1924, v. II, appendix p. 223-225. See also J. This: Manet et Baudelaire, *Etudes d'Art*, published by the Musée National d'Alger, I, 1945.
- 27 C. Baudelaire: Peintres et aqua-fortistes, Le Boulevard, Sept. 1862; reprinted in Curiosités esthétiques.
- 28 See M. Guérin: Remarques sur des portraits de famille peints par Degas, Gazette des Beaux-Arts, June 1928; also R. Raimondi: Degas e la Sua Famiglia in Napoli, Naples, 1958.
- 29 Degas, notes; Bibliothèque Nationale, carnet 21, p. 46-47, datable 1868-72 (see T. Reff; The Chronology of Degas' Notebooks, Burlington Magazine, Dec. 1965).
- 30 See E. Mitchell: "La fille de Jephté" par Degas, genèse et

- évolution, Gazette des Beaux-Arts, Oct. 1937. The painting is in the Smith College Museum of Art, Northampton, Mass. Degas may also have been influenced by Chassériau's decorations for the Paris Cour des Comptes (destroyed during the Commune), the drawings for some of which are reproduced in l'Art Vivant, Jan. 1938. see also P. Pool: The History Pictures of Edgar Degas and Their Background, Apollo, Oct. 1964 and D. Burnell: Degas and His "Young Spartans Exercising," Museum Studies 4, The Art Institute of Chicago, 1969.
- 31 Cézanne had been thrilled by the Salon and wrote a long letter to a friend about it; see Paul Cézanne, Letters, London, 1941, p. 57-59.
- 32 This story was told the author by Henri Matisse who had heard it from Claude Monet.
- 33 See Pissarro's letter to his son, Dec. 4, 1895, in Camille

- Pissarro: Letters to His Son Lucien, New York, 1943, p. 277 [here newly translated].
- 34 Courbet's letter to his pupils, dated Dec. 25, 1861, was published in *Le Courrier du Dimanche*, Dec. 29, 1861; see C. Léger: Courbet, Paris, 1929, p. 86-88. On Courbet's studio see G. Riat: Gustave Courbet, Paris, 1906, p. 193-195. Riat reports that the studio was opened in the first days of Dec. 1861, but it must have been rather early in Jan. 1862, after the publication of Courbet's letter. This letter is partly translated *in*: Artists on Art, edited by R. Goldwater and M. Treves, New York, 1945, p. 295-296.
- 35 Troyon to Boudin, Jan. 29, 1862; see Jean-Aubry, op. cit., p. 53.
- 36 Fantin to Edwards, Nov. 23, 1861; see A. Jullien: Fantin-Latour, sa vie et ses amitiés, Paris, 1909, p. 23.

Boudin: Beach Scene, d. 1865. Pencil and watercolor, $4\frac{1}{4} \times 9\frac{1}{4}$ ". City Art Museum, St. Louis.

Jongkind: Chapel of Notre Dame de Grâce near Honfleur, d. 1864. Watercolor, $14\frac{1}{4}\times19\frac{7}{8}''$. Collection Mr. and Mrs. E. V. Thaw, New York.

 $\begin{array}{lll} \mbox{Monet: Chapel of Notre Dame de Grâce} \\ \mbox{near Honfleur, c. 1864. } 20\frac{1}{2}\times26\frac{3}{4}". \\ \mbox{Present whereabouts unknown.} \end{array}$

Ш

GLEYRE'S STUDIO

THE SALON DES REFUSÉS AND THE REORGANIZATION OF THE ÉCOLE DES BEAUX-ARTS

At the beginning of the year 1862 Claude Monet fell seriously ill in Algiers and was sent home to recuperate. He spent six months of convalescence drawing and painting with redoubled energy. Seeing him thus persistent, his father became at last convinced that nothing was going to curb the young artist. As the doctor had warned that his son's return to Africa might have fatal consequences, the father decided, toward the end of Monet's furlough, to "buy him out." Again Monet was free to work on the beaches, alone or in company with Boudin. It so happened that at precisely the same time Jongkind was also painting at Le Havre, he whom Monet had thought "dead to art," but who through the help of some painter friends, among them Bracquemond, Bonvin, Diaz, Corot, and Cals, had recovered his self-confidence and his will to work. An Englishman who had watched Monet sketching a cow near a farmhouse introduced him to Jongkind; Monet, in turn, introduced Boudin to his new acquaintance.

Monet was deeply impressed by Jongkind, then in his forties, at the same time gay and melancholy, cordial and shy, speaking French not only with a strong Dutch accent but also with a complete disregard for grammar and syntax. A tall, husky, and bony man with the awkwardness of a sailor on solid ground, haunted by a strange persecution mania, Jongkind was at ease only when he could work, or talk about art. His agitated and unhappy life had not deprived him of his freshness of vision, his sureness of instinct. Like Boudin he had preserved a certain innocence of the eye that had saved him from dry learning and routine. There were for him no other subjects than the ever varying aspects of nature which his agile hand, in quick annotations, transformed into nervous lines and luminous spots of color without ever being repetitious. Less placid than Boudin, he infused into his work something of his own agitation, a curious element of excitement, admirably blended with the naiveté of his eye, the lyricism of his heart, and the tranquil audacity of his mind. It is therefore not surprising that Baudelaire was attracted by his etchings, which he admired together with prints by Manet, Whistler, and Meryon in a group exhibition at Cadart's in the fall of 1862.

A warm friendship soon united Jongkind with Monet and Boudin. Monet later recalled that Jongkind "asked to see my sketches, invited me to come and work with

Jongkind: Self Portrait, 1865. Charcoal, $8\frac{1}{2} \times 5\frac{1}{2}$ ". Formerly collection Robert von Hirsch, Basel.

him, explained to me the why and the wherefore of his manner and thereby completed the teaching that I had already received from Boudin. From that time he was my real master; it was to him that I owe the final education of my eye." Yet Monet's aunt, Mme Lecadre, watched her nephew's progress with apprehension and distrust, complaining in a letter to the painter Amand Gautier: "His sketches are always rough drafts, like those you have seen; but when he wants to complete something, to produce a picture, they turn into appalling daubs before which he preens himself and finds idiots to congratulate him. He pays no attention to my remarks. I am not up to his level, so I now keep the most profound silence."

The "idiots" who complimented Monet on his efforts can have been no others than Boudin and Jongkind. Possibly to detach him from this bad company, Monet's father now agreed to send him back to Paris. But, according to the painter's recollections, the older Monet said to him: "It is well understood that this time you are going to work in dead earnest. I wish to see you in a studio under the discipline of a well-known master. If you resume your independence, I will stop your allowance without more ado...." This arrangement no more than half suited Monet, but he felt it was necessary not to oppose his father. He accepted. It was agreed that he should have at Paris an art tutor, the painter Toulmouche, who had just married one of his cousins. Toulmouche, a pupil of Gleyre, was then highly successful, a specialist in gracious ladies, lovely children, and all kinds of sweetness. Astruc once said of his work: "It's pretty, charming, highly-colored, refined—and it's nauseating."

In November 1862, Claude Monet reached Paris and immediately went to Toulmouche. To give a sample of his ability, Monet painted for him a still life with a kidney and a small dish of butter. "It's good," was Toulmouche's comment, "but it's tricky! You must go to Gleyre. Gleyre is the master of all of us. He'll teach you to do a picture." Thus it was decided that Monet should enter the studio of Gleyre.

At the very same moment another young man was arriving in the French capital. Like Cézanne he came from southern France, like Cézanne he was of a wealthy family, and like Cézanne he had been obliged to study in a field that did not attract him. But Frédéric Bazille from Montpellier—where he lived not far from Courbet's friend, the collector Bruyas—had been able to reach a compromise with his parents, who permitted him to go to Paris and there equally divide his time between the study of medicine and of art. He, too, entered Gleyre's studio and very shortly afterward remarked in a letter to his family that his two best friends were a Viscount Lepic and Monet.

Monet was not very happy at Gleyre's. "Grumbling," he later said, "I set up my easel in the studio full of pupils over whom this celebrated artist presided. The first week I worked there most conscientiously and made, with as much application as spirit, a study of the nude from the living model, which Gleyre corrected on Mondays. The following week, when he came to me, he sat down and, solidly planted in my chair, looked attentively at my production. Then he turned round and, leaning his grave head to one side with a satisfied air, said to me: 'Not bad! not bad at all, that thing there, but it is too much in the character of the model—you have before you a short thickset man, you paint him short and thickset—he has enormous feet, you render them as they are. All that is very ugly. I want you to remember, young man,

TOULMOUCHE: Girl and Rose, 1879. $24\frac{3}{4} \times 17\frac{1}{2}$ ". Sterling and Francine Clark Art Institute, Williamstown, Mass.

Monet: Still Life with Kidney, 1862. $13 \times 18\frac{1}{8}$ ". Painted for his cousin Toulmouche. Private Collection, Hamburg.

that when one draws a figure, one should always think of the antique. Nature, my friend, is all right as an element of study, but it offers no interest. Style, you see, is everything.' "5

To Monet, who had learned from Boudin and Jongkind to record faithfully his observations, this advice came as a shock and immediately erected a barrier between him and his teacher. But Monet was not the only student with whose work Gleyre was dissatisfied. There was also a young Parisian, Auguste Renoir, who did not seem able to work properly in the academic spirit. He, too, had entered the studio in 1862 and, like Monet, had tried in his very first week to copy the model as carefully as he could. Gleyre, however, had only glanced at his work and said dryly:

"No doubt it's to amuse yourself that you are dabbling in paint?"

"Why, of course," Renoir replied, "and if it didn't amuse me, I beg you to believe that I wouldn't do it!"

This unexpected answer came from the bottom of the pupil's heart. For several years, Renoir, one of five children of a poor tailor from Limoges, had tried his hand at different jobs and had carefully put aside every penny to be able to pay his tuition. Originally apprenticed as a painter of porcelain, he had begun to paint under the guidance of an older colleague at the china shop. This colleague had succeeded in convincing Renoir's parents that their son was destined for something

better than decorating cups and dishes with flowers or copies after Boucher. Thereupon Renoir had set out to earn money and had soon been successful, owing to his tremendous facility and the speed with which he painted blinds, mural decorations, etc.⁷ At the age of twenty-one he had saved enough to enter the *Ecole des Beaux-Arts*. Full of good will and eager to learn, he could not understand why his studies should not "amuse" him.

The dissatisfaction Gleyre had voiced over the studies of Monet and Renoir must have contributed to create a sympathy between these two. They were joined by Alfred Sisley who, though Parisian by birth, was the son of a British subject born in Dunkirk; his Kentish forebears had been active mostly as smugglers in the Channel area. Having gained considerable wealth in a legitimate silk business, dealing principally with South America, Sisley's father had sent the eighteen-year-old for a commercial apprenticeship to London.⁸ There the young man had devoted more time to the museums, and especially to the study of Turner and Constable, than to acquainting himself with the world of trade. Upon his return to Paris he had been lucky enough not to meet any opposition from his parents when he decided to become an artist. In October 1862, he had enrolled at Gleyre's, a few weeks before the appearance of Monet. With the latter and his friends Bazille and Renoir, Sisley soon formed a group of "chums," who kept themselves apart from the other students.

The studio of Gleyre, like those of most of the other teachers at the *Ecole des Beaux-Arts*—that of Couture, for instance—was only indirectly connected with the *Ecole*. Whereas the latter offered free tuition to all those who passed the various examinations, it presented the great inconvenience that the teaching was done in rotation by the different masters without any real consistency of method. Most of the teachers, therefore, had opened private classes where the pupils could work under their exclusive guidance. Those who were also enrolled at the *Ecole* participated at the same time in the obligatory courses and sat for the periodic examinations. This was the case with Renoir, who had been admitted to the *Ecole* in April 1862, and continued to pass examinations in August 1862, March, August, and October 1863, as well as in April 1864.9

In Gleyre's studio, according to a friend of Whistler, who had worked there for a while, "some thirty or forty art students drew and painted from the nude model every day but Sunday from 8 till 12, and for two hours in the afternoon, except on Saturdays... One week the model was male, the next female.... The bare walls were adorned with endless caricatures in charcoal and white chalk; and also the scrapings of many palettes, a polychrome decoration not unpleasing. A stove, a model-throne, stools, boxes, some fifty strongly-built low chairs with backs, a couple of score of easels and many drawing-boards, completed the *mobilier*." 10

As for the students, they were composed of "graybeards who had been drawing and painting there for thirty years and more, and remembered other masters... younger men, who in a year or two, or three or five, or ten or twenty, were bound to make their mark...others as conspicuously singled out for failure and future mischance—for the hospital, the garret, the river, the morgue, or worse, the traveler's bag, the road, or even the paternal counter. Irresponsible boys, mere rapins, all laugh and chaff and mischief...little lords of misrule—wits, butts, bullies; the idle and the industrious apprentice, the good and the bad, the clean and the dirty (especially

GLEYRE: The Charmer. $32\frac{1}{2} \times 19\frac{7}{8}$ ". Oeffentliche Kunstsammlung, Basel.

the latter)—all more or less animated by a certain *esprit de corps*, and working very happily and genially together, on the whole."¹⁰

But this esprit de corps was more evident in the fun than in the devotion to art. Raffaëlli, a young painter who at about that time studied under Gérôme (himself a former pupil of Gleyre's), discovered with surprise that "the wretched young fellows, most of them coarse and vulgar, indulge in disgusting jokes. They sing stupid obscene songs. They make up shameful masquerades. . . . And never, never, in this assemblage of men called to be artists, is there a discussion about art, never a noble word, never a lofty idea. Over and over again, this dirty and senseless humbug, always filth." The pupils of Gleyre certainly did not differ much from those of Gérôme; they, too, staged shows and even gave a presentation of Macbeth, which Whistler and Gérôme attended, and which Fantin, Champfleury, Duranty, Manet, and Baudelaire are also said to have seen.

Monet participated little in the life of Gleyre's class, but in order not to exasperate his family he continued to appear regularly at the studio, remaining just long enough to execute a rough sketch from the model and to be present at inspection. Bazille, Renoir, and Sisley, however, really applied themselves, and Sisley seems even to have intended to compete for the *Prix de Rome*, a five-year scholarship at the French Academy in Rome and the highest award bestowed by the *Ecole*. Although in disagreement with their teacher, the three friends felt that they might profit from serious work at his classes. Their situation was very much like that of Odilon Redon, a student of Gérôme's, who in later years thus summed up his experiences:

"At the Ecole des Beaux-Arts, I paid a lot of attention to the rendering of form.... I was prompted, in going to the Academy, by the sincere desire to place myself behind other painters, a pupil as they had been, and I expected from the others approval and justice. I was counting without that art formula which was to guide me, and I was also forgetting my own disposition. I was tortured by the professor. Whether he recognized the sincerity of my serious inclination for study, or whether he saw in me a timid person of good will, he tried visibly to inculcate in me his own manner of seeing and to make me a disciple—or make me disgusted with art itself.... He extolled me to confine within a contour a form which I myself saw as palpitating. Under pretext of simplification (and why?) he made me close my eyes to light and neglect the viewing of substances.... The teaching I was given did not suit my nature. The professor had for my natural gifts the most obscure, most complete lack of appreciation. He didn't understand anything about me. I saw that his obstinate eyes were closed before what mine saw. . . . Young, sensitive, and irrevocably of my time, I was there hearing I-don't-know-what rhetoric, derived, one doesn't know how, from the works of a fixed past.... No possible link between the two, no possible union; submission would have required the pupil's being a saint, which was impossible."12

Whereas Redon felt himself tortured by his teacher, Renoir, Bazille, and Sisley were fortunate enough to work under a professor with much less instinct for domination, even though Gleyre's views may not have differed from those of Gérôme. Gleyre was a modest man, disliking to lecture, and all in all rather indulgent; he seldom took up a brush and corrected a student's work.¹³ Renoir afterwards stated that Gleyre had been "of no help to his pupils," but added that he had at least had the merit "of leaving them pretty much to their own devices." ¹⁴ Gleyre did not even

Far left: Photograph of Auguste Renoir, 1861.

Left: Photograph of Paul Cézanne, 1861.

have any preferences in subject matter and let his students paint what they wanted. On his visits to the studio, twice a week, he went the rounds slowly, spending a few minutes at each drawing board or easel. He was content to advise his pupils to draw a great deal and to prepare the tone *in advance* on their palette so that, even while painting, they could devote themselves undisturbed to the linear aspect of the subject. Gleyre always feared that "devilish color" might go to their head. If ever he was irritated, it was by the sketches of pupils whose preoccupation was too much with color, to the exclusion of drawing.¹³

Since Renoir seems to have succumbed from the beginning to the "vice" of color, he made himself something of an outsider in the studio in spite of his genuine application. "While the others shouted, broke the window panes, martyrized the model, disturbed the professor," he once told a friend, "I was always quiet in my corner, very attentive, very docile, studying the model, listening to the teacher . . . and it was I whom they called the revolutionary." ¹¹⁵

Notwithstanding differences of conception between Gleyre and his students, nobody apparently was really unhappy in his studio, and most of his pupils, Bazille and Renoir included, showed a true respect for their teacher. This respect Gleyre seems to have particularly deserved by his unpretentiousness, as well as by his refusal to accept any payment for advice. From the moment when he had agreed, in 1843, to take charge of a studio, he had, remembering his own difficult youth, charged his students for rent and model fees only, exactly ten francs a month, while all the other teachers demanded substantial contributions. As to Gleyre's works, they distinguished themselves by a lifeless but "correct" drawing and a dull coloring; their anemic grace and cold mannerism could hardly inspire admiration.

While Renoir's conflicts with Gleyre never became really acute, he was less at ease at the *Ecole des Beaux-Arts*, where he attended evening courses in drawing and anatomy.

According to his reminiscences, an oil study he had brought to the class aroused the antagonism of his teacher, Signol, famous for peremptoriness. "He was fairly beside himself on account of a certain red that I had used in my picture. 'Be careful not to become another Delacroix!' he warned me."¹⁴

Whereas Renoir, Sisley, and Bazille had entered the studio of Gleyre without any idea of revolt, on the contrary, with an eagerness to learn and to do as the others, Monet's case was entirely different. Obliged to study under Gleyre against his own will, he had been from the very first day a more or less open rebel, especially since he lacked both the desire and the capacity to submit. It was therefore natural that Monet should take the lead over his new friends, all the more so because he could not be considered a mere beginner like them. While they only instinctively felt some disagreement with their teacher, he had the necessary experience and knew the arguments that could free them from the academic formula. He could tell them of his work with Boudin and Jongkind, of the discussions at the Brasserie, of what he had heard about Courbet from Boudin and about Corot from Pissarro. Through Monet they came in touch with the art life outside the *Ecole*, with the new movements and ideas. As their confidence in Gleyre's methods gradually waned, they turned to the masters in the Louvre for instruction. For many painters of their generation the Louvre became a healthy counterbalance to the instruction at the *Ecole*, in spite of Duranty's incendiary intentions. In the Louvre they were free to choose their own masters, could erase the traces of their one-sided education and find in the works of the past a guidance congenial to their own longings. The huge gallery of the museum was always crowded

HOMER: Art Students and Copyists in the Louvre Gallery, 1867. Wood engraving, published in Harper's Weekly, Jan. 11, 1868.

with copyists, and the sight of the numerous artists working there so impressed Winslow Homer on a short visit to France in 1867 that he did a woodcut of it, one of the very few related to his trip abroad.

Manet had copied not only Delacroix but also, among others, Titian, Velázquez, Rembrandt, and Tintoretto; Degas had chosen Holbein, Delacroix, Poussin, and the Italian Primitives; Whistler had done a copy after Boucher and, together with his friend Tissot, another one after Ingres' Angélique; he admired Velázquez and Rembrandt. Cézanne, like Manet, copied Delacroix's Dante and Virgil. But by far the greatest number of copies was done by Fantin, who very often made them to earn a living. His admiration went particularly to Delacroix, Veronese, Titian, Giorgione, Tintoretto, to Rubens, Rembrandt, Hals, de Hooch, and Vermeer, as well as to Chardin and Watteau.

Soon after he had entered Gleyre's, Renoir had fallen in with Fantin, whose studio was nearby. Fantin would take him off to work after Renoir had come from the *Ecole*, lavishing advice and repeating without end: "The Louvre! the Louvre! there is only the Louvre! You can never copy the masters enough!" And Fantin carried him away to the museum, where the lesson was continued by insistence as to the choice among the masterpieces. Though Renoir studied with pleasure the French painters of the eighteenth century, he almost had to force Monet to accompany him to the Louvre. Monet looked only at landscapes, felt annoyed by most of the pictures, and detested Ingres. Bazille, in the meantime, copied Rubens and Tintoretto.

While working in the Louvre, Fantin and his friend Bracquemond had been introduced by Bracquemond's former teacher, Guichard, to two ladies in their early twenties who copied there under his supervision. Edma and Berthe Morisot, daughters of a rich magistrate, had taken up painting with more seriousness and assiduity than did most women of their standing, who looked upon it merely as a pleasant pastime. Berthe especially surprised many visitors to the Louvre by the intrepidity with which she worked on copies of Veronese and other masters. Not satisfied with their copying, the two sisters had told Guichard they wished to abandon his method of working from memory and wanted instead to paint out-of-doors. A pupil of both Delacroix and Ingres, Guichard felt unable to take this venture in hand and introduced them, in 1861, to Corot, who permitted the young ladies to watch him while he painted a landscape at Ville d'Avray, near Paris. He also lent some of his paintings to them, so that they might copy them. Like Pissarro, the Morisot sisters now became "pupils" of Corot.

Corot attracted the more timid of the new generation; the bolder natures turned to Courbet and Manet. Just as Monet had established some kind of intellectual contact between his young comrades and his tutors Boudin and Jongkind, Fantin-Latour could speak to them about Manet, his friend, and Courbet, his erstwhile teacher. At the same time Bazille discovered that the Commandant Lejosne, a distant relative of his, was a friend of Baudelaire and Manet, who had depicted the military man in the crowd of his *Concert in the Tuileries Gardens*. ¹⁷ This very painting, together with thirteen other canvases by Manet, was shown at Martinet's in an exhibition that opened March 1, 1863. Several of these works represented members of a troop of Spanish dancers who had arrived in Paris the previous year, quickening Manet's enthusiasm for Spain by their colorful costumes and picturesque dances. ¹⁸

Manet: Concert in the Tuileries Gardens, 1862. 30 × 463". Exhibited at Martinet's in 1863. National Gallery, London.

But even critics not particularly hostile to new tendencies saw in these paintings a "medley of red, blue, yellow, and black which is the caricature of color and not color itself." "This art," one of them wrote, "may be very straightforward but it isn't healthy and we certainly are not taking it upon ourselves to plead M. Manet's cause before the Salon jury." ¹⁹

Indeed the time for the opening of the Salon of 1863 was drawing closer. Neither Monet (who had been deeply impressed by Manet's exhibition) nor Bazille, Renoir, or Sisley could yet think of submitting anything, but among their comrades at Gleyre's there were certainly many advanced pupils who did so. The four friends thus had ample occasion to learn about all the intrigues, tricks, and undercover work which usually preceded the decisions of the jury. In the years before, it had happened that the jury, without paying attention to signatures, had rejected the works of some of its own members; the recurrence of such unpleasant incidents had fortunately been eliminated by establishing a rule which made all members of the Academy and all artists awarded medals hors concours; their works were accepted without being sub-

Manet: Spanish Dancers, d. 1862. $24\frac{1}{2} \times 36\frac{1}{2}$ ". Shown at Martinet's in 1863. The Phillips Collection, Washington, D. C.

mitted to the jury. The danger of being rejected therefore threatened only those who had not yet obtained recognition. As was natural, the teachers in the different studios—members of the jury—protected their own students as much as they could by trading votes with their colleagues: "If you vote for my pupils, I shall vote for yours." But even without actual bartering the members of the jury showed the greatest indulgence to the followers of their colleagues. Couture tells in his memoirs how he was once assigned to examine a number of paintings, together with Ingres, and how he betrayed his own convictions by "admiring" whatever work he thought executed by a pupil of the master or at least an imitator. Yet to be accepted by the jury was not always enough for the satisfaction of the artists; there still remained the important problem of obtaining an auspicious place, a goal that could be achieved to some extent, by those who could afford it, by distributing money among the janitors who did the hanging. Another vital problem to be solved was that of obtaining favorable comments in the press. Upon all these factors depended to a high degree the artist's chance to sell his works and to achieve social position.

"They have rejected my picture on whose sale I was legitimately counting," complained a former pupil of Couture in a letter to a friend. "The picture had already been recommended to likely buyers who had promised to acquire it at the exhibition, if it appeared to them to merit the high praise it had received. . . . A series of articles by influential critics was ready to brew for me a success at the Salon, and

here these ruffians, these daubers with pontifical positions, of which the jury has been composed, make me lose the fruits of that campaign!"20

To be admitted or rejected was more than a question of pride, it was a vital issue, and few were those who, like Fantin, attached little importance to it. Fantin was unable to understand why his friend Whistler was so preoccupied with the "received or not received" problem, because he should have known that rejections did not necessarily strike the bad paintings. To the general public, however, the decisions of the jury were final. People not only refused to buy pictures rejected by the jury (which at one time was cruel enough to stamp an R on the stretchers), they even returned those previously bought, as happened to Jongkind, who, having sold a landscape a few days before he sent it to the Salon, had to make a refund when the jury rejected the canvas. On the other hand, an accepted painting was likely to sell, to create a favorable impression among the author's patrons, to bring offers from dealers and even commissions. But the jury had little consideration for the fate of the artists it held in its hands, unless they had some "pull." It was a common practice to choose among the different works submitted by an artist the least important and the smallest, if all were not to be rejected. Courbet had experienced this in 1855.

Besides, a new ruling had just been issued according to which the artists would be limited to three works each at the Salon, then held only every other year. This restriction caused great dissatisfaction and, on March 1, the *Courrier Artistique*, published by the dealer Martinet, announced that a "petition has been addressed by a great number of artists to the Minister of State [Count Walewski]...MM. Gustave Doré and Manet, delegated by their colleagues to present this petition to the Minister, have been received by his Excellency with the greatest affability."²¹ Affability was the only satisfaction they got.

In 1863 the jury was even more severe than it had been in previous years, owing, it appears, to the uncompromising attitude of M. Signol, Renoir's teacher at the *Ecole des Beaux-Arts*; neither Ingres nor Delacroix participated in the deliberations. This time many artists who had been more or less regularly admitted heretofore, like Jongkind, or who had received honorable mentions, like Manet, were turned down. According to one of his friends, Manet had called on Delacroix to ask for his support before the jury, but the old master was too ill to attend the sessions. He managed, however, to visit the exhibition at Martinet's where Manet showed fourteen canvases, among them *Lola de Valence*, *Spanish Dancers*, and *Concert in the Tuileries Gardens*. Aroused by visitors laughing in front of these works or threatening to tear them up, Delacroix, upon leaving, said loudly: "I regret not to have been able to defend this man."22

The deliberations of the jury started on April 2, and three days later rumors already began to circulate that its members were committing a veritable "massacre." When, on April 12, the official results were announced, it turned out that of some five thousand paintings submitted by about three thousand artists (many sending in only a single work), the jury had rejected three fifths. Nobody could remember a similar proportion of refusals. There were again clamors for a protest to be submitted to Count Walewski, but Manet's and Doré's recent experience hardly promised any results.

Martinet who, in the past, had exhibited the works of many new painters such as Manet, was besieged with appeals. On April 15 he declared in his *Courrier Artistique*: "Numerous artists, having learned that the jury had refused their works,

have come to ask whether they might exhibit them in our galleries. Here is our reply: We shall try to receive well all those proscribed; the only excess which must be fought and against which one has to be severe is that of mediocrity. Every work of art submitted to us which is free of that blemish shall be welcome."²³ But didn't that mean that Martinet now adopted the role of a one-man jury, as well he might, since his was after all a commercial gallery? Moreover, his premises on the centrally located boulevard des Italiens could under no circumstances accommodate the three thousand rejected canvases (and one thousand pieces of sculpture). With no solution in sight, the agitation in artist circles grew to such an extent that it finally came to the ears of the Emperor.

On the afternoon of April 22, Napoléon III went to the *Palais de l'Industrie*, built for the 1855 World's Fair, where the Salons had since been held. There he inspected part of the rejected works before summoning Count Nieuwerkerke, not only Director General of Museums and Superintendent of Fine Arts, but also president of the jury. As a reversal of the judgments seemed inadvisable, the Emperor made a sensational decision which was announced two days later in the official *Moniteur*:

"Numerous complaints have reached the Emperor on the subject of works of art that have been refused by the jury of the exhibition. His Majesty, wishing to leave the public as judge of the legitimacy of these complaints, has decided that the rejected works of art be exhibited in another part of the *Palais de l'Industrie*. This Exhibition will be elective, and the artists who may not want to take part will need only to inform the administration, which will hasten to return their works to them. This Exhibition will open on May 15 [the Salon proper was to open on May 1]. Artists have until May 7 to withdraw their works. Beyond this limit, their pictures will be considered not withdrawn and will be placed in the galleries."²⁴

"When the notice announcing this decision appeared in the *Moniteur*," wrote the prominent critic Ernest Chesneau a few days later, "there was great excitement among the artists directly concerned, and this excitement is not yet calmed. The public which is interested in art questions received this ruling with real joy. And although it was regarded as being a very liberal point of view, the public at the same time saw in it a lesson to the excessive and boastful pride of people without talent who are all the more prompt to complain as their merit is less. But will this lesson have any effects? We cannot yet answer that question. In fact, uncertainty is great among the so-called victims of the jury. Since this exhibition is elective, the most disturbing perplexity moves all minds: 'Shall we exhibit or shall we not?...' "25

Whereas Chesneau seemed to presume that all the rejected artists were people without talent, Castagnary, who championed Courbet and his friends, described the dilemma of the rejected more justly: "To exhibit means to decide, to one's detriment perhaps, the issue that has been raised; it means to deliver oneself to the mocking public if the work is judged definitely bad; it means testing the impartiality of the commission, siding with the Institute not only for the present but for the future. Not to exhibit means to condemn oneself, to admit one's lack of ability or weakness; it means also, from another approach, to accomplish a glorification of the jury."²⁶

In reality the whole problem can have existed only for a few undecided individuals (with the possible exception of those rabid opponents of the regime to whom any liberal measure promulgated by the Emperor was a priori suspicious). Those among

Artist to porter: "Pay you for your errand? It might encourage you to bring back every year the paintings I submit to the jury." Contemporary caricature.

DAUMIER: View of a Studio a Few Days before the Opening of the Salon. Caricature, published in Le Charivari in 1855.

the rejected artists who sincerely believed in the principles of the *Ecole des Beaux-Arts* had to accept the jury's verdict and, considering their works inferior to academic standards, had to withdraw them. Those, on the contrary, who had little or no sympathy with the concepts of the Institute and believed in their right to follow new directions, could but welcome the chance to measure their strength with the "official art." Whoever hesitated proved that he did not believe in his own efforts; whoever feared to arouse the anger and vengeance of the jury by participating in the counter-exhibition proved that he did not believe in art at all but only in his career.

Courbet's followers and all other uncompromising artists were delighted with the new decree. Whistler, who had sent but one large canvas from England—the rejection of which he expected, for it had been refused at the London Academy the previous year—had already made arrangements with Martinet to exhibit the painting together with other rejected works in his gallery. But when his friend Fantin informed him of the Emperor's decision and asked for instructions, Whistler immediately replied: "It's marvelous for us, this business of the Exhibition of Rejected Painters! Certainly my picture must be left there and yours too. It would be folly to withdraw them in order to place them with Martinet." And he inquired what impression his canvas had made at the Café de Bade.

The Café de Bade had become the headquarters of Manet. It is not known how Whistler's new work was considered there, but one thing is certain: Manet and his circle did not hesitate any more than did Whistler; they welcomed the Salon des Refusés and would have felt disgraced had they withdrawn their paintings. Manet hardly considered himself a revolutionary and probably did not even want to be one. There was none of the provocative element in him which had always made Courbet the center of discussions; his independence was not an attitude chosen to force attention, it was the natural condition in which he lived and worked. Little did he expect that this independence might be considered a challenge by others and that he would have

to fight in order to maintain his right to be himself. But he was ready to fight. He had been and still was of the opinion that the Salon was the natural place for an artist to introduce himself, yet this did not mean that he accepted the jury's decision. Somehow he hoped, as doubtless most of the others did, that the public would be on his side and prove the jury wrong. There even seemed to be a vague possibility that a success of the *Salon des Refusés* might lead to the complete suppression of the jury, for which the realists and their friends had already fought for years.

The commission appointed to study the introduction of improvements into the Ecole des Beaux-Arts and the blow which the Imperial decree had dealt to the jury, threatening to undermine its authority, put the academic painters on the defensive. For them it was of vital importance that the Salon des Refusés should be a "flop." The way in which they went about it has been best described by the English critic Hamerton, who could hardly be accused of sympathizing with the extremists. "It is dangerous," he wrote from Paris to a London periodical, "to allow the jury, or any members of the jury, to have any influence over the hanging of pictures rejected by the jury. Their first object is, of course, to set themselves right with the public, and, to achieve this, they have in this instance reversed the usual order of things by carefully putting the worst pictures in the most conspicuous places."28 The fear of this very thing might have been an additional reason for many painters to withdraw their works, thus indirectly helping the jury to justify itself. Then, too, many artists withdrew in the more or less justified expectation of future reprisals from the jury; others, although they exhibited, did not want their names to appear in the catalogue for the very same reason. Commented Hamerton: "The Emperor's intention of allowing the rejected painters to appeal to the public has been in a great measure neutralized by the pride of the painters themselves. With a susceptibility much to be regretted, and even strongly condemned, the best of these have withdrawn their works, to the number of more than six hundred. We are consequently quite unable to determine, in any satisfactory manner, how far the jury has acted justly towards the refused artists as a body."28

The catalogue of the Salon des Refusés was very incomplete since, as a preliminary note by a committee of rejected artists explains, it was established without any help from the administration and because many artists could not be reached in time.²⁹ Among those listed are Manet with three paintings and three etchings, Jongkind with three canvases, Pissarro with three landscapes, Whistler with his single work, Bracquemond with etchings, and Fantin,³⁰ Amand Gautier, and Legros, who had works both in the Salon and in the counter-exhibition. Not listed, though exhibiting, were Guillaumin and his friend Cézanne, who had given up his work as a clerk in his father's bank and returned to painting, although he had failed the entrance examination for the Ecole des Beaux-Arts.

From the very day of its opening the Salon des Refusés attracted an enormous crowd; on Sundays there were record numbers of three to four thousand visitors. People were, of course, more attracted by the unusual feature of the rejected works, which the press described as hilarious, than by the more or less annoying achievements in the Salon proper. "On entering the present exhibition of refused pictures," Hamerton reported "every spectator is immediately compelled, whether he will or no, to abandon all hope of getting into that serious state of mind which is necessary to a fair

Manet: Mlle V. [Victorine Meurent] in the Costume of an Espada, d. 1862. $65\frac{1}{2} \times 50\frac{3}{4}$ ". Exhibited at the Salon des Refusés, 1863. Metropolitan Museum of Art, New York (H. O. Havemeyer Collection).

comparison of works of art. That threshold once past, the gravest visitors burst into peals of laughter. This is exactly what the jurymen desire, but it is most injurious to many meritorious artists.... As for the public generally," the author added, "it is perfectly delighted. Everybody goes to see the refused pictures." One has to be doubly strong," commented Astruc, "to keep erect beneath the tempest of fools, who rain down here by the million and scoff at everything outrageously." 31

According to Hamerton, although this can hardly be proved, the critics were rather kinder to the refused than to the accepted; it is at least true that the refused were given lengthy comments. The press even published jokes about Salon exhibitors who hoped to be rejected the next year in order to attract more attention, and Jong-kind wrote to his friend Boudin, who had been accepted: "My pictures are among those refused and I have some success." But in spite of such comments, the majority of articles in the important newspapers and periodicals were hostile. Even Martinet's Courrier Artistique predicted on the day of the opening that the Salon des Refusés would most certainly be a "triumph for the jury," and later called the exhibition an "exposition of comics," while Chesneau referred to it as the "Salon of the vanquished." 33

The critic friends of the *Refusés* naturally took advantage of the occasion to proclaim their heretical views. Fernand Desnoyers, formerly of the Brasserie, wrote a brochure devoted solely to insulting both the cowardly artists who had withdrawn

Opposite, Manet: Le déjeuner sur l'herbe, d. 1863. $84\frac{1}{4} \times 106\frac{1}{4}$ ". Exhibited at the Salon des Refusés, 1863. Musée du Louvre, Paris. their works and the stupid bourgeois who indulged in ridicule. In Courbet he saw the hero of the *Salon des Refusés*, the "most rejected of the rejected," for notwithstanding the fact that he was now *hors concours*, one of his paintings had been refused for "moral reasons" and was not even permitted in the *Salon des Refusés*. Zacharie Astruc expressed himself more specifically about the rejected artists. For the duration of the exhibition he founded a daily paper, *Le Salon de 1863*, in which he had the courage to write: "Manet! One of the greatest artistic characters of the time! I would not say that he carries off the laurels in this Salon . . . but he is its brilliance, inspiration, powerful flavor, surprise. Manet's talent has a decisive side that startles; something trenchant, sober, and energetic, that reflects his nature, which is both reserved and exalted, and above all sensitive to intense impressions."³¹

Of the three paintings exhibited by Manet, two derived their color accents from picturesque Spanish costumes; one was a portrait of his brother, Young Man in the Costume of a Majo; the other, Mlle V. in the Costume of an Espada, had been posed for by his favorite model, Victorine Meurent. The third canvas, listed under the title Le Bain, was later to be called Le déjeuner sur l'herbe. It was this last picture that immediately attracted all visitors, the more so because the Emperor had pronounced it "immodest." Mr. Hamerton agreed with the monarch when he wrote: "I ought not to omit a remarkable picture of the realist school, a translation of a thought of Giorgione into modern French. Giorgione had conceived the happy idea of a fête champêtre in which, although the gentlemen were dressed, the ladies were not, but the doubtful morality of the picture is pardoned for the sake of its fine color. . . . Now some wretched Frenchman has translated this into modern French realism, on a much larger scale, and with the horrible modern French costume instead of the graceful Venetian one. Yes, there they are, under the trees, the principal lady, entirely undressed, ... another female in a chemise coming out of a little stream that runs hard by, and two Frenchmen in wide-awakes sitting on the very green grass with a stupid look of bliss. There are other pictures of the same class, which lead to the inference that the nude, when painted by vulgar men, is inevitably indecent."28

As a matter of fact, the central group of Manet's Déjeuner sur l'herbe, though superficially related to Giorgione, had been adapted from an engraving after Raphael. In-

MARCANTONIO after RAPHAEL: Judgment of Paris (detail). Metropolitan Museum of Art, New York (Rogers Fund).

deed, a curious lack of imagination repeatedly led Manet to "borrow" subjects from other artists. Many of his works, if not based directly on old masters, were at least inspired by remembrance (Manet had travelled extensively), by reproductions, prints, etc.³⁴ Although Manet himself rarely made any allusions to his sources, he often used them with so little disguise that it would have been easy to identify them had anybody cared to do so. But in Manet's case the whole question seemed of little importance, since what mattered was not the subject but the way in which he treated it. He found in works of the past only compositional elements; he never copied, because only his inspiration, not his talent, needed an occasional guide. As Degas later explained it: "Manet drew inspiration from everywhere, from Monet, Pissarro, even from me. But with what marvelous handling of the brush did he not make something new of it! He had no initiative...and did not do anything without thinking of Velázquez and Hals. When he painted a fingernail, he would remember that Hals never let the nails extend beyond the fingers themselves, and proceeded likewise. He felt only one ambition, to become famous and to earn money. I told him to be satisfied with being appreciated by an elite; one who works with so much refinement cannot expect to be understood by the masses."35 Yet the irony of fate caused Manet to be attacked for the "vulgarity" of his inspiration, even in cases where he had derived his themes from the classic masters.

It may be doubted whether Manet's painting would have provoked such criticism had it not been painted in broad contrasts and frank oppositions, with a tendency to simplification. His "vulgarity," in the eyes of the public, lay probably even more in his execution than in his subject matter. It was his renunciation of the customary slick brushwork, his fashion of summarily indicating background details and of obtaining forms without the help of lines, by opposing colors or by sketching his contours, if necessary, with decisive brushstrokes in color (which helped to model volumes instead of limiting them), that were responsible for the almost universal disapproval he met. This seems proven by the similar reception accorded Whistler's White Girl, whose subject hardly lent itself to moral or other such objections. Considered particularly ugly, Whistler's painting had been given a "place of honor" before an opening which every visitor had to pass, so that none could miss it. Emile Zola, who visited the exhibition together with his friend Cézanne, later reported that "folk nudged each other and went almost into hysterics; there was always a grinning group in front of it."36 According to a description by an American critic, the canvas represented "a powerful female with red hair, and a vacant stare in her soulless eyes. She is standing on a wolf-skin hearth rug-for what reason is unrecorded."37 That unrecorded and apparently insufficient reason was a purely pictorial one, a tour de force to obtain a harmony of different shades of white enlivened by the model's red hair and by some color touches in the rug, painted-in with short brushstrokes. All this was achieved by a more or less lively technique not very different from Manet's, except that Whistler had chosen to be subtle where Manet had been forceful.

Compared with the prestige of ridicule obtained by Manet and Whistler, most of the other exhibitors at the Salon des Refusés fared rather well with the public and the reviewers. Pissarro even drew a few favorable lines from a renowned critic, who advised him, nevertheless, to be careful not to imitate Corot. Among the young painters outside the Academy, Manet's stature grew immensely through this exhibition

Whistler: The White Girl [Jo], d. 1862. $85\frac{1}{2} \times 43''$. Exhibited at the Salon des Refusés, 1863. National Gallery of Art, Washington, D. C. (Harris Whittemore Collection).

CABANEL: The Birth of Venus. Engraving after the painting exhibited at the Salon of 1863 and purchased by the French Emperor.

so as to make him appear the leader of the new generation (Cézanne, Bazille, Zola were among those deeply impressed), and when Whistler and Fantin took a recent British acquaintance, the nineteen-year-old Swinburne, to the painter's studio, this visit became a highlight of the latter's trip to Paris. "He [Manet] doubtless does not remember it," the poet wrote many years later to Mallarmé, "but for me, then very young and completely unknown . . . you may well believe it is a memory which will not easily be forgotten." 38

Manet's reputation, however, was confined to a small group, whereas the favor of the public at large and of the critics as well went to a *Venus* by Cabanel, shown in the official Salon. Though "wanton and lascivious," she was considered "not in the least indecent" and charmed all the onlookers because, as one reviewer put it, she was "cleverly rhythmical in pose, offers curves that are agreeable and in good taste, the bosom is young and alive, the hips have a perfect roundness, the general line is revealed as harmonious and pure." It is true that there was at least one person who found fault with Cabanel's naked charmer, though not on account of her insipidity but because he did not consider her sufficiently attractive. Indeed, an American commentator relieved himself of a somewhat unexpected observation:

"While the English flesh is painted after models taken from the coarsest class, and so can only be artificially refined, it is plain that the tradition of French society still enables eminent artists to find models in the highest ranks. . . . The fact is, the nudity of the French school is the only nudity that is not coarse. . . . This may be said of nearly every French artist except Cabanel, whose . . . Birth of Venus seems to me unredeemed by delicacy of expression." The French themselves did not share this puritan view; Cabanel's thoroughly insignificant but highly pleasant achievement

not only was purchased by the Emperor but brought its author a promotion in the Legion of Honor and election to the Institute.

A few weeks before Cabanel was elected to the Academy of Fine Arts, its only liberal member, Eugène Delacroix, had died. The old and lonely painter closed his eyes at the very moment when many of those who—though under Ingres' tutelage—had benefited from his liberating influence, were beginning to rally around Manet, a man of their own time. Delacroix's isolation had increased during the last years of his life, and he himself may have been ignorant of how great was the respect in which he was held by the new generation. Indeed, he had lost all contact with it. Little did he know that one night at an official ball he had been ardently watched by young Odilon Redon, who had then followed him through the dark streets of Paris all the way to his house, 6 rue de Furstemberg. Nor did Delacroix suspect that in this same house Monet and Bazille, from the window of a friend's apartment, used to observe him at work in his garden studio. Usually they were able to discern only Delacroix's arm and hand, seldom more. They were astonished to see that the model did not actually pose but moved freely about while Delacroix drew it in action, and that sometimes he began to work only after the model had left.⁴¹

Among Delacroix's latest admirers there was a young customs official, Victor Chocquet, who spent his meager earnings on building up a collection of Delacroix's works. He even wrote to the painter, expressing veneration and asking whether he would be willing to accept a commission for a portrait of Mme Chocquet. Delacroix declined, excusing himself because "for several years I have entirely given up doing portraits on account of a certain sensitiveness in my eyes." Many years later, when Chocquet first met Cézanne, it was their mutual admiration for Delacroix that established the foundation for a long friendship. "Delacroix acted as intermediary between you and me," Cézanne was to say, and it is reported that both men had tears in their eyes when, together, they looked at the Delacroix watercolors owned by Chocquet.

Delacroix's death, on August 13, 1863, immediately inspired Fantin with the idea of painting a picture in the master's honor. Around a portrait of the artist he assembled those of his own friends and acquaintances who were, like himself, true admirers of Delacroix's genius. The group was almost identical with that which had approached Manet after his first exhibition at the Salon: Baudelaire (who was then preparing a long article on Constantin Guys) and Champfleury (who actually disliked each other), Legros, Bracquemond, Duranty, Manet, and Fantin, as well as Whistler. The latter had requested that a friend he had recently met in London, Dante Gabriel Rossetti, be included in the picture, but Rossetti was unable to come to Paris and sit for his likeness. According to Fantin his large canvas turned out to be too somber, too much black being used in the shadows; yet he was satisfied enough with the ambitious composition to send it to the Salon of 1864.

The excitement caused by the Salon des Refusés and by the death of Delacroix had hardly quieted down when the art world was again stirred up by an imperial decree published on November 13, 1863.44 Although the Salon des Refusés had proved to be a "flop," inasmuch as the general public had sided openly with the jury and shown by its laughter and witticisms that it considered the rejections justified, the commission appointed to study means of improving certain obsolete rules had won the Emperor's

approval of several drastic measures. (One of the most active members of this commission was the author and academician Mérimée, a personal friend of the monarch and supposedly the natural father of Duranty.) The new regulations abolished the Institute's supervision of the *Ecole des Beaux-Arts*, especially its right to appoint professors, a measure which deeply hurt Ingres.⁴⁵ These rulings also established a yearly instead of a biennial Salon, and in addition provided that only one fourth of the jury was to be nominated by the administration, while three fourths were to be elected by exhibiting artists. To this clause, however, there was attached an important restriction: only those artists might vote who had already received a medal. Since all such artists were *hors concours*, the consequence was that the jury members were elected exclusively by artists who did not themselves have to submit their works to the jury. And there was no provision whatsoever for a renewal of the counter-exhibition.

A minor point which created great dissatisfaction at the *Ecole des Beaux-Arts* was the reduction of the age limit (from thirty to twenty-five) for those who wanted to compete for the Prix de Rome. Among the artists who signed a protest note—mostly candidates for the Rome prize—was Alfred Sisley.⁴⁶ But in general the new decree met with approval. An address to the Emperor, with praise for his liberal measures, was sponsored by Daubigny, Troyon, Chintreuil (one of the organizers of the Salon des Refusés), and about one hundred others. Neither Manet nor his friends, however, seem to have signed this address. Though delighted to see "the Institute chased from the Ecole des Beaux-Arts,"47 as Cézanne put it, they were quick to realize that the new decree, beneath its apparent liberalism, was made up of opportunist half-measures, which left the main problem untouched. After its generosity to the rejected artists in the organization of the Salon des Refusés, the government had now been careful not to extend to them any participation in the election of the jury; yet, by establishing an elected jury, the administration had rid itself of its responsibility. Furthermore, having broken the Institute's jurisdiction over the Ecole des Beaux-Arts, the government had immediately appeased the angry body of academicians by appointing as new teachers men chosen from among the Institute's members. Thus, very little was changed with regard to the situation as a whole, except perhaps that the newly nominated professors were less intransigent and more willing to compromise with public taste: that is to say, they were mediocre without even the excuse of being idealistic. Among these new professors were Gérôme and the creator of Venus, Alexandre Cabanel.

While these men were entering the *Ecole des Beaux-Arts*, others abandoned their own classes. Owing to the violent attacks of which he had been the subject, Couture finally decided, in this same year, to close his studio and to teach no more. A few months later, at the beginning of 1864, Gleyre did the same, although for different reasons. Threatened with loss of sight and having great difficulty in meeting expenses out of his students' modest contributions, Gleyre, to Renoir's chagrin, gave up his classes, but not without advising both Monet and Renoir to continue to work and to make serious progress apart from his supervision.⁴⁸ The year 1864 thus found Sisley, Bazille, Renoir, and Monet entirely on their own.

- 1 Monet to Thiébault-Sisson; see Claude Monet, an Interview, *Le Temps*, Nov. 27, 1900.
- 2 Mme Lecadre to Gautier, 1862; see R. Régamey: La formation de Claude Monet, Gazette des Beaux-Arts Feb. 1927.
- 3 Z. Astruc, quoted by M. de Fels: La vie de Claude Monet, Paris, 1929, p. 54.
- 4 See M. Elder: A Giverny chez Claude Monet, Paris, 1924, p. 19-20.
- 5 See Monet interview, op. cit.
- 6 A. André: Renoir, Paris, 1928, p. 8.
- 7 See the recollections of Edmond Renoir in J. Rewald: Renoir and His Brother, Gazette des Beaux-Arts, March, 1945.
- 8 See C. Sisley: The Ancestry of Alfred Sisley, *Burlington Magazine*, Sept. 1949. On Sisley's apprenticeship in London see also F. Daulte: Alfred Sisley, Lausanne, 1959, p. 27.
- 9 For a complete record of Renoir's career at the *Ecole des Beaux-Arts* see R. Rey: La renaissance du sentiment classique, Paris, 1931, p. 45-46.
- 10 G. du Maurier: Trilby, London, 1895, ch. "Chez Carrel" (alias for Gleyre). Another description of an official studio is given by J. and E. de Goncourt: Manette Salomon, Paris, 1866, ch. V.
- 11 Raffaëlli in L'Art dans une démocratie, quoted by A. Alexandre: J. F. Raffaëlli, Paris, 1909, p. 31-32.
- 12 O. Redon: A soi-même, Paris, 1922, p. 22-24.
- 13 See C. Clément: Gleyre, étude biographique et critique, Paris 1878, p. 174-176; on Gleyre see also J. Claretie: L'Art et les Artistes Français contemporains, Paris, 1876, p. 420-422, and A. Boime: The Academy and French Painting in the Nineteenth Century, London, 1971.
- 14 See A. Vollard: Renoir, An Intimate Record, New York, 1925, p. 31.
- 15 See E. Faure: Renoir, Revue Hebdomadaire, April 17, 1920; also C. L. de Moncade: Le peintre Renoir et le Salon d'Automne, La Liberté, Oct. 15, 1904.
- 16 See A. Segard: Mary Cassatt, Paris, 1913, note p. 47. On Louvre copies see the excellent article by T. Reff: Copyists in the Louvre, 1850-1870, Art Bulletin, Dec. 1964.
- 17 On this painting see N. G. Sandblad: Manet—Three Studies in Artistic Conception, Lund, 1954, ch. I.
- 18 One of the paintings, representing Lola de Valence, was accompanied by the following quatrain by Baudelaire: Entre tant de beautés que partout on peut voir/je com-

DAUMIER: The Influential Critic Walks Through. Caricature published in Le Charivari, June 24, 1865.

- prends bien, amis, que le désir balance/ mais on voit scintiller en Lola de Valence/ le charme inattendu d'un bijou rose et noir.
- 19 P. Mantz: Exposition du Boulevard des Italiens, Gazette des Beaux-Arts, April 1, 1863.
- 20 Desboutin to Simonnet, April 17, 1874; see Clément-Janin: La curieuse vie de Marcellin Desboutin, Paris, 1922, p. 84-85.
- 21 Courrier Artistique, March 1, 1863, quoted in Tabarant: Manet et ses oeuvres, Paris, 1947, p. 63.
- 22 See P. Alexis: Manet, Revue Moderne et Naturaliste, 1880, p. 292.
- 23 Courrier Artistique, April 15, 1863, quoted in Tabarant, op. cit., p. 63.
- 24 Moniteur, April 24, 1863. On the Emperor's visit to the Palais de l'Industrie see E. Chesneau: Salon de 1863, L'Artiste, May 1, 1863; on his visit to the Salon des Refusés, see A. Proust: Edouard Manet, Paris, 1913, p. 46. However, Tabarant, op. cit., p. 72, says that the Emperor never visited the Salon des Refusés.

- 25 Chesneau, op. cit.
- 26 Castagnary: Le Salon des Refusés, L'Artiste, August 1, 1863; reprinted in Salons (1857-1870), Paris, 1892, v. I, p. 155. See also the same author's: Salon de 1873, ibid., vol. II (1872-1879), p. 62-63, part of which is quoted in chapter VIII, p. 306 of the present book.
- 27 Whistler to Fantin, spring 1863; see L. Bénédite: Whistler, Gazette des Beaux-Arts, June 1905 (series of articles, May, June, August, Sept. 1905).
- 28 P. G. Hamerton: The Salon of 1863, Fine Arts Quarterly Review, Oct. 1863.
- 29 The catalogue had to be printed at the publisher's expense and, unlike that for the official Salon, its sale inside the *Palais de l'Industrie* was forbidden (see Tabarant, *op. cit.*, p. 66). For a reprint see: Le Salon des Refusés de 1863—Catalogue et Documents, *Gazette des Beaux-Arts*, Sept. 1965 (with selected bibliography).
- 30 When Fantin inquired why one of his paintings had been rejected, he learned that the reason was "because he had treated life size a subject appropriate only for representation one half or one third its natural format." See J. Dolent: Amoureux d'Art, Paris, 1888, p. 216.
- 31 Z. Astruc: article in Le Salon de 1863, May 20, 1863; quoted by E. Moreau-Nélaton: Manet raconté par luimême, Paris, 1926. v. I, p. 51-52.
- 32 Jongkind to Boudin, June 6, 1863; see G. Cahen: Eugène Boudin, Paris, 1900, p. 51.
- 33 See E. Chesneau: Salon annexe des ouvrages d'art refusés par le jury, 1863; reprinted in Chesneau: L'Art et les Artistes modernes en France et en Angleterre, Paris, 1864, p. 182-197. Many articles and pamphlets appeared in Paris in 1863 on the Salon des Refusés and the question of the jury; notably: L. Leroy: Conseils aux artistes refusés, Charivari, April 28; E. Lockroy: L'Exposition des Refusés, Courrier Artistique, May 16; L. Leroy: Salon de 1863, IX. Les refusés, Charivari, May 20; Courcy-Mennith: Le Salon des Refusés et le Jury; F. Desnoyers: Salon des Refusés -La Peinture en 1863; L. Etienne: Le Jury et les Exposants—Salon des Refusés; H. Le Secq: Les Artistes et les Expositions—Le Jury; V. Luciennes (pseud. for P. Laffite): Le Jury et le Salon; J. Graham: Un étranger au Salon, Le Figaro, reprinted under the author's real name as A. Stevens: Le Salon de 1863, Paris 1866.
- 34 The relationship between the *Déjeuner sur l'herbe* and Raphael was first mentioned by Chesneau and later rediscovered by G. Pauli: Raffael und Manet, *Monatshefte für Kunstwissenschaft*, 1908, p. 53. On Manet's sources of inspiration see G. Bazin: Manet et la tradition, *L'Amour de l'Art*, May 1932 and C. Zervos: A propos de Manet, *Cahiers d'Art*, No. 8-10, 1932; also C. Sterling: Manet et

- Rubens, L'Amour de l'Art, Sept.-Oct. 1932; M. Florisoone: Manet inspiré par Venise, L'Amour de l'Art, Jan. 1937 and P. Colin: Manet, Paris, 1932, p. 1-20. For an excellent analysis of Manet's "borrowings" see J. Richardson: Edouard Manet, London, 1958, p. 25-27; see also A. C. Hanson: Manet's Subject Matter and a Source of Popular Imagery, Museum Studies, no. 3, 1968, and M. Fried; Manet's Sources, Aspects of His Art, 1859-1865, Artforum, March 1969 (special issue).
- 35 Degas in an interview with H. v. Tschudi, 1899; see Tschudi: Gesammelte Schriften zur neueren Kunst, Munich, 1912, p. 21.
- 36 E. Zola: L'Oeuvre, Paris, 1886, ch. V.
- 37 Quoted by H. T. Tuckerman: Book of the Artists, American Artist Life, New York, 1867, v. II, p. 486.
- 38 Swinburne to Mallarmé, July 7, 1875 [letter written in French]; see The Letters of A. C. Swinburne, New York-London, 1919, p. 204; also H. Mondor: Vie de Mallarmé, Paris, 1941, p. 371.
- 39 P. Mantz: Le Salon de 1863, Gazette des Beaux-Arts, June 1863.
- 40 M. D. Conway: The Great Show of Paris, *Harper's*, July 1867 (this article was written on the occasion of the Paris World's Fair of 1867 where Cabanel's painting was once more exhibited).
- 41 See G. Poulain: Bazille et ses amis, Paris, 1932, p. 47.
- 42 Delacroix to Chocquet, March 14, 1862; see J. Joëts: Les Impressionnistes et Chocquet, L'Amour de l'Art, April 1935.
- 43 Cézanne to Chocquet, May 11, 1886; see Paul Cézanne, Letters, London, 1941, p. 184.
- 44 On this decree see Nieuwerkerke: Rapport à son Excellence le Maréchal de France, *Gazette des Beaux-Arts*, Dec. 1, 1863.
- 45 Ingres protested in: Réponse au rapport sur l'Ecole Impériale des Beaux-Arts, Paris, 1863. See also E. Chesneau: Le Décret du 13 Novembre et l'Académie des Beaux-Arts, Paris, 1864, and C. Clément: L'Académie des Beaux-Arts et le décret du 13 novembre in Etudes sur les Beaux-Arts en France, Paris, 1865.
- 46 See H. Lapauze: Histoire de l'Académie de France à Rome (1853-1866), La Nouvelle Revue, June 1, 1909. For a diatribe against the Ecole de Rome and the distribution of the Prix de Rome see E. and J. de Goncourt, op. cit., ch. XVI-XVII.
- 47 Cézanne to Coste, Feb. 27, 1864; see Paul Cézanne, Letters, op. cit., p. 66.
- 48 See Poulain, op. cit., p. 35.

IV 1864-1866

BARBIZON AND ITS PAINTERS

NEW SALONS

SUCCESSES AND DISAPPOINTMENTS

In 1863 Monet and Bazille had spent their Easter holidays in Chailly, a village on the edge of Fontainebleau forest, not far from Barbizon. They had gone there for a week to do some studies of trees out-of-doors, in the woods that were famous for their enormous oaks and picturesque rocks. Their work in the open air was actually a violation of their teacher's credo since Gleyre considered landscape painting "an art of decadence." As soon as Bazille was back in Paris—he returned in order to continue his medical studies, which still took up half of his time—he informed his parents that he had been away with his friend, "who is pretty good at landscape; he gave me some advice that has helped me a great deal.... The forest is truly wonderful in certain sections." It was indeed so wonderful that Monet stayed on alone, detained by the beautiful weather and by the work he had begun. His cousin and tutor, Toulmouche, did not fail to remind him that, in his opinion, it was "a serious mistake to have deserted the studio so soon," but Monet replied immediately: "I haven't at all deserted it. I found here a thousand charming things which I couldn't resist." 2

Exactly one year later, after the closing of Gleyre's studio, Monet took his whole group of friends to Chailly and, together with Renoir, Sisley, and Bazille, devoted himself to studies of forest interiors. Whereas for Renoir and Sisley this seems to have been their first real contact with nature, for which the work at Gleyre's had hardly prepared them, Monet, owing to his friendship with Boudin and Jongkind, was simply continuing to develop the knowledge derived from their experience. His comrades naturally turned to him for guidance. Soon, however, they also were to receive the advice of older men, the actual "masters of Barbizon," with whom they were brought in touch through chance encounters in the woods.

Barbizon had been popular among artists for almost twenty years. Théodore Rousseau had settled there first, in 1836, in order to get away from Paris, where he had become discouraged by lack of success at the Salons. Diaz, Millet, Jacque, and scores of others had later joined him in the tiny village close to the forest, surrounded on three sides by a plain stretching as far as the eye could reach. Near Barbizon and its whitewashed cottages roofed with thatch covered by patches of green moss, they found a rustic landscape that appealed to their longing for solitude and afforded

Manet: Portrait of Courbet, 1878. Pen and ink (?). $9\frac{1}{2} \times 7''$. Present whereabouts unknown.

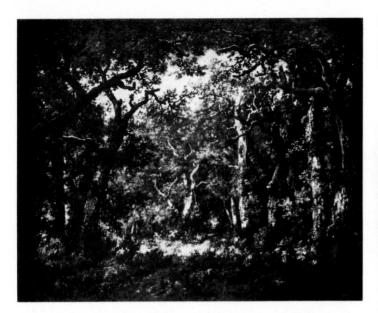

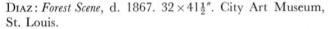

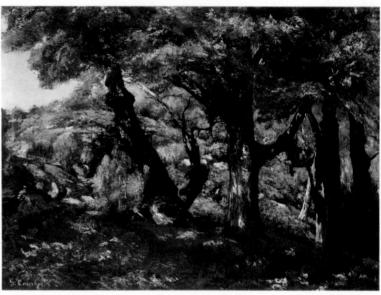

COURBET: The Fringe of the Forest, c. 1856. $35 \times 45\frac{1}{2}$ ". Philadelphia Museum of Art (Louis E. Stern Collection).

them an intimate communion with nature. Yet Paris was close enough to permit occasional visits which enabled these painters to remain in touch with the art movements there. As to Chailly, lying only a mile and a half away, it was equally frequented by numerous artists.

There were two inns in Barbizon, monopolized, at least in summer, by painters who used to scatter throughout the forest, dotting it with their white umbrellas. At the Auberge Ganne, where the board was two francs and seventy centimes a day, the Goncourt brothers noticed with some dismay the "monotony of omelettes, the spots on the tablecloth, the pewter forks that stained the fingers." The artists, however, cared less, since they did not go there for gastronomic reasons but because Barbizon had become synonymous with landscape painting in general.

At Barbizon, Rousseau, Diaz, and their friends had rediscovered nature together with Corot and Daubigny, whose association with the group had been a more or less close one but who, at one time or another, had also worked in Fontainebleau forest. They tried to forget all the official precepts concerning historical or heroic landscapes and endeavored instead to let themselves become steeped in the actual spectacle offered by rural surroundings. After long years of struggle they were slowly achieving fame, owing in part to the relentless efforts of their dealer, Durand-Ruel. Although the individual methods and concepts of the Barbizon painters showed considerable differences, they had in common a complete devotion to nature and a desire to be faithful to their observations. Yet each of them saw in nature only those elements that corresponded to his own temperament and satisfied himself with the pursuit of one peculiar *note*, his own.

Rousseau, a meticulous draftsman, was striving to ally a minute consideration for

detail with the achievement of a general harmony in which no single feature would distract the eye from the whole. His colors were low-keyed and equally subject to the general effect. Diaz, quite to the contrary, excelled in somber woodland interiors in which spots of light or strips of sky shining through the branches would create almost dramatic contrasts. A fanatic adversary of line as well as of the slick academic technique, he loved color and the rough texture of heavily applied paint. Corot preferred the hours of dawn or dusk, when light is tempered, when nature wraps itself in a transparent veil that softens contrasts, hides details and simplifies lines, planes, the essential forms, and colors. For Millet, too, harmony of color consisted more in a just balance of light and dark than in a juxtaposition of specific colors. However, none of these painters actually worked in the open; they were mostly content to make sketches for pictures which they executed in their studios or, like Corot, used to begin a canvas out-of-doors and finish it in the atelier. But in doing so they sought, as Rousseau said, to "keep in mind the virgin impression of nature." Millet usually did not even take notes from nature. He could, he explained to the American painter Wheelwright, "fix any scene he desired to remember so perfectly in his memory as to be able to reproduce it with all the accuracy desirable."5 The work in the studio, far from the distractions and temptations offered by nature, of course helped them to obtain the desired effects, but it also exposed the artists to the danger of succumbing to

Monet: Le Pavé de Chailly, c. 1866. $38\frac{1}{4} \times 51\frac{1}{8}$ ". Metropolitan Museum of Art, New York (Bequest of Julia W. Emmons and gift of Sam Salz).

a favored style while they transcribed their impressions without being able to control them on the spot. Baudelaire had already remarked that style had unfortunate consequences for Millet. "Instead of simply extracting the inherent poetry of his subject," he wrote, "M. Millet wants at all costs to add something to it." The new generation could not overlook the fact that the closer these painters remained to their impressions, the more they preserved their spontaneity, the better they escaped the dangers of style and mannerism.

When Monet and his friends came to Chailly, they consciously or unconsciously approached the forest with eyes that had been trained by interpretations received from the Barbizon painters. Sisley especially was deeply impressed with Corot's work; Renoir oscillated between Diaz, Corot, and Courbet; Monet admired Millet. In one of Monet's earliest landscapes appear two women carrying bundles of wood, reminiscent of Millet. But this seems to be the only instance where such a connection can be established, whereas Pissarro, in later years, frequently was to draw and paint peasants in the fields, his subject matter — although not its treatment — being related to Millet's. Yet unlike the Barbizon masters, Monet endeavored, as Boudin had taught him, to work entirely in the open. His friends did likewise. While Renoir was thus painting in his old porcelain-decorator's blouse, some loafers made fun of his costume until they were driven away by the heavy cane of a man with a wooden leg, who then looked at Renoir's canvas and said: "It's not badly drawn, but why the devil do you paint so black?" The stranger was Diaz, who might have been attracted by Renoir's unusual attire because he himself had begun his career as a painter on porcelain.

According to all who met him, there seems to have been nothing in Diaz' mind which was not kindly and generous. Always cheerful in spite of his lameness, he was "obliging, good-natured, and gentle as a lamb with those whom he liked. He was not

Left, Millet: Women Carrying Fagots. Charcoal, $11\frac{3}{8} \times 18\frac{3}{8}$ ". Museum of Fine Arts, Boston (Gift of Martin Brimmer). Right, Millet: Woodgatherer. Charcoal. Present whereabouts unknown.

Monet: Road in the Forest with Woodgatherers, c. 1864. Oil on wood, 24×36 ". Museum of Fine Arts, Boston (Herman H. and Zoe Oliver Sherman Fund).

Renoir: Clearing in the Woods, c. 1865. $22\frac{1}{2} \times 32\frac{1}{2}$ ". Collection Mrs. Henry Nugent Head, New York.

Bazille: Landscape at Chailly, d. 1865. $32\frac{1}{4} \times 41\frac{3}{8}$ ". The Art Institute of Chicago (Charles H. and Mary F. S. Worcester Collection).

 $\begin{array}{l} {\rm Sisley:} \ {\it Country} \ {\it Lane near Marlotte}, \\ {\rm c.} \ 1865. \ 9\frac{1}{2}\times12\frac{5}{8}". \ {\it Presented} \\ {\rm by the artist to Lise Tr\'ehaut.} \\ {\it Galerie Jacques Dubourg, Paris.} \end{array}$

Below, Sisley: L'allée des châtaigniers à la Celle St. Cloud, d. 1865. 49¼ × 80¾". Palais des Beaux-Arts de la Ville de Paris.

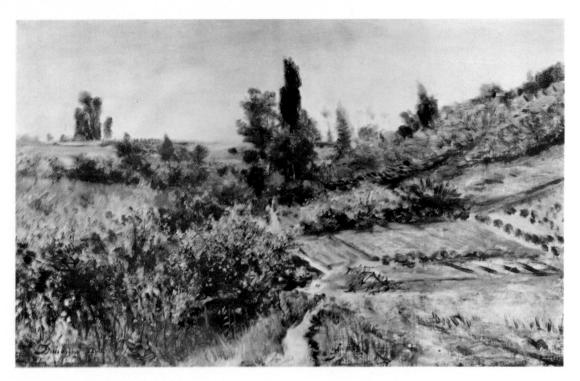

Daubigny: Spring Landscape, d. 1862. 11½ × 18½ ". Private collection, New York.

jealous of his contemporaries and sometimes bought their pictures, which he showed and praised to everyone." Diaz immediately took a great liking to Renoir, whose admiration for the older man grew as he came to know him better. Aware of Renoir's precarious financial situation (at Gleyre's studio he had often picked up the tubes thrown away by others and squeezed them to the very last drop), Diaz put his own paint-dealer's charge account at the disposal of his young friend and thus discreetly provided him with colors and canvas. As to the advice he gave Renoir, it seems that Diaz told him "no self-respecting painter ever should touch a brush if he has no model under his eyes," although this was hardly the way in which he proceeded himself. And Renoir soon changed to brighter colors, much to the amazement of the more conservative Sisley.

Renoir introduced his new acquaintance to his companions, who apparently also met Millet, possibly through Diaz. Unlike the latter, Millet never unbent to the first comer and always retained a sort of heavy dignity which checked any familiarity. His relations with Gleyre's former pupils cannot have been very close; Monet seems never to have met him, for once when he saw Millet in a crowd and wanted to speak to him, he was held back by a friend who told him: "Don't go, Millet is a terrible man, very proud and haughty. He will insult you." Nor did the young friends see much of Corot. "He was always surrounded by a circle of idiots," Renoir remembered later, "and I didn't want to find myself a part of them. I liked him

Photograph of Corot, c. 1865.

Photograph of Jongkind, 1862.

Photograph of Daubigny, c. 1862.

from a distance."¹² But when he did speak to him, several years later, Corot told Renoir that "one can never be sure about what one has done; one must always go over it in the studio."¹³ And to Gérôme's unhappy pupil Redon, Corot said: "Go to the same place every year, copy the same tree."¹⁴

While Monet and his friends had little contact with Corot, Pissarro seems to have seen him frequently, for he received permission to attach to the two landscapes which he sent to the Salon of 1864 the notation, "pupil of A. Melbye and Corot." "Since you are an artist," Corot had told him, "you don't need advice. Except for this: above all one must study values. We don't see in the same way; you see green and I see grey and 'blond.' But this is no reason for you not to work at values, for that is the basis of everything, and in whatever way one may feel and express oneself, one cannot do good painting without it." According to his friend Théophile Silvestre, Corot always "advised his pupils to choose only subjects that harmonize with their own particular impressions, considering that each person's soul is a mirror in which nature is reflected in a particular fashion. He often told them: 'Don't imitate, don't follow others; you'd stay behind them.' "16 He also used to say, "I recommend to you the greatest naiveté in study. And do precisely what you see. Confidence in yourself, and the motto: Integrity and confidence." 17

Of all those to whom he gave advice, Corot seems to have felt himself in special sympathy with Berthe Morisot and her sister, to the extent of agreeing, contrary to his solitary habits, to dine every Tuesday at their parents' house. The two young artists had spent the summer of 1863 between Pontoise and Auvers on the Oise River, painting landscapes. With the ardor of neophytes they started off extremely early each morning, faithfully observing the advice of Corot: "Let's work hard and steadfastly and not follow too closely papa Corot; it is better to consult nature itself." Their teacher, Corot's pupil Oudinot, introduced them to Daubigny, who lived at Auvers, and to Daumier, whose house was in a neighboring village. Berthe Morisot sent two landscapes done that summer to the Salon of 1864, where she exhibited for the first time, but unlike Pissarro she did not designate herself as a pupil of Corot, giving instead as references her former teacher Guichard as well as Oudinot.

Although Daubigny did not at that time work in Barbizon, his example was always present in the mind of Monet, who, from the very first, had felt a vivid admiration for him. Of all the landscapists of the period, except Boudin, Daubigny seems to have been the only one to work directly from nature. Through the freshness of his execution he retained in his canvases a certain character of improvisation which had put a serious obstacle to his being recognized. His paintings at the Salons had been regularly subject to violent attacks; even Théophile Gautier, usually sympathetic to new efforts, could not help writing: "It is really too bad that this landscape painter, who possesses such a true, such a just, and such a natural feeling, is satisfied by an impression and neglects details to this extent. His pictures are but rough drafts, and very slightly developed. . . . Each object is indicated by an apparent or real contour, but the landscapes of M. Daubigny offer merely spots of color juxtaposed." 19

Yet to summarize his impressions was precisely Daubigny's intention (in 1865, one critic even called him "chief of the school of the impression" and he was ready to sacrifice some of the literal truth so as to come closer to the expression of the ever changing aspects of nature. In order to carry out his purpose with greater ease he

DAUBIGNY: The Artist in His Floating Studio, 1861. Etching, $4 \times 5\frac{1}{8}$ ". Baltimore Museum of Art.

had, as early as 1857, constructed on a boat a small cabin painted with large stripes of various colors, and on this craft had made yearly excursions on the Oise. From his little boat he could paint in comfort the river traffic as well as the banks of the Oise, with their reflections in the water and with gentle hills in the background meeting the white clouds. Amused by the floating studio, christened "Le Botin," which was rowed by Daubigny's son, Corot had made an oil sketch of his friend working in the middle of the river. On some of their excursions Daubigny and his son were accompanied by a young painter, Antoine Guillemet, born in 1842, a great admirer of Corot, Daumier, Barye, and Courbet, who was acquainted with Duranty and Zola as well as Pissarro and Cézanne. He had met the latter at the *Académie Suisse* although he remained a "pupil" of Corot and Daubigny.

In spite of the fact that Hamerton heartily disliked Daubigny's work because of its lack of drawing, that critic, in his review of the 1863 Salon, had designated the artist as "the chief of French landscape painters, so far as fame goes." This statement, however, seems grossly exaggerated, for Daubigny's reputation was not even secure among his fellow artists, to say nothing of the general public and critics. When, in 1864, three fourths of the jury members were elected for the first time by all the artists who had previously received medals, Corot alone of the great landscapists obtained enough votes to become a jury member, and even he lagged far behind Cabanel and Gérôme. Gleyre was elected only as a substitute, while Ingres did not gather sufficient votes to achieve even this modest success.

It soon became clear that the new jury, as even the opposition admitted, was more intelligent and generous in its admissions, more equitable and comprehensive in its distribution of awards. Not only did it reserve rooms for the *refusés*²² and give a

COROT: Daubigny Working on His "Botin" near Auvers-sur-Oise, d. 1860. 9\\$\times \times 13\\$\".\" Formerly Knoedler Galleries, New York.

Daubigny: The Ferry, c. 1860 (?). $8 \times 17\frac{1}{2}$ ". The prow in the foreground is probably that of Daubigny's Botin towed by the ferry. The Art Institute of Chicago (John J. Ireland Bequest).

Daubigny: Barge on a River, c. 1860 (?). $8 \times 15\frac{1}{2}$ ". Museum of Fine Arts, Boston.

Daubigny: *Evening*, c. 1857. $22\frac{3}{4} \times 36\frac{1}{2}$ ". Metropolitan Museum of Art, New York (Bequest of Robert Graham Dun).

Monet: Farm in Normandy, c. 1863. $25\frac{5}{8} \times 31\frac{1}{2}$ ". Musée du Louvre, Paris.

CÉZANNE: Forest Scene, 1862-64. $9\frac{1}{8} \times 11\frac{7}{8}$ ". Formerly Collection Paul Cézanne fils, Paris.

Courbet: Forest Scene. $21\frac{1}{4} \times 28\frac{3}{4}$ ". Collection Carl Mathiesen, Stockholm.

medal to Millet, but it accepted the works of several artists rejected the previous year. Manet exhibited two canvases, a Christ with Angels and a Spanish bullfight scene painted from imagination; Fantin also showed two works, one of which was his Hommage à Delacroix. Without consulting either Manet or Fantin, Baudelaire recommended their paintings to a friend of his on the jury so that they would be favorably hung.²³ And when a critic of the poet's acquaintance, W. Bürger, blended his praise to Manet with reproaches for imitating and copying Velázquez as well as Goya and Greco, Baudelaire immediately protested by letter, pretending that the painter had never seen works by Greco and Goya and that such "astonishing parallels may turn up in nature."24 Yet it seems certain that the artist did see at the Louvre Louis Philippe's rich "Spanish Museum" (he was sixteen years old when it was dismantled after the revolution of 1848). Bürger, notwithstanding his doubts, loyally reproduced Baudelaire's letter and declared Manet "more of a painter in himself than the whole band of Grand-Prix-de-Rome recipients."25 This, however, did not keep a jocose commentator from referring to the artist as "Don Manet y Courbetos y Zurbarán de las Batignolas."26

Berthe Morisot and Pissarro had two landscapes each at the Salon, and Renoir, figuring in the catalogue as "pupil of Gleyre," was represented by a painting entitled La Esmeralda, which he destroyed when it was returned to him after the closing, because his studies in Barbizon had in the meantime completely changed his point of view and stiffened his self-criticism. Manet, too, discouraged by the violent attacks which he again suffered, subsequently cut his bullfight scene to pieces, pre-

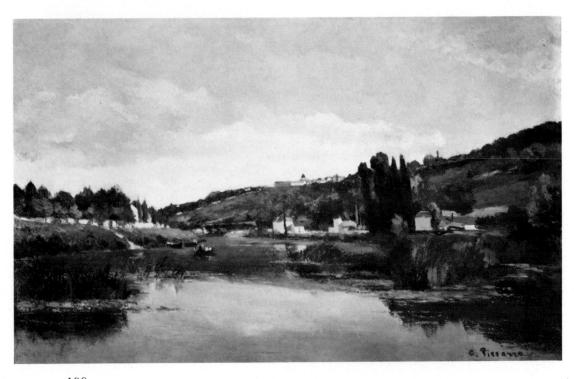

PISSARRO: The Marne at Chenne-vières, 1864-65. $36 \times 57\frac{1}{4}$ ". Probably exhibited at the Salon of 1865. National Gallery of Scotland, Edinburgh.

Manet: Combat of the Kearsarge and the Alabama, 1864. $54\frac{5}{8} \times 51\frac{1}{8}$ ". Philadelphia Museum, of Art (John G. Johnson Collection).

serving only two fragments.²⁷ There is no record of Monet, Bazille, or Sisley's having sent anything to the Salon. As for Cézanne, he had been rejected.

During the summer of 1864 one of the dramas of the American Civil War took place off the French Channel coast when a Confederate ship, having taken refuge at Cherbourg, had to face a much superior Union ship on the open sea. Manet represented the event in a painting of the Kearsarge sinking the Alabama.²⁸ He exhibited the canvas a little later at Cadart's. At about the same period he made studies of horse races at Longchamps (where Degas had worked in 1862) while Degas sketched several portraits of him. Degas also painted a likeness of Manet listening to his wife, a Dutch pianist whom he had married in the fall of 1863. This painting Degas offered to Manet, who because he disliked the portrait of his wife, cut off that part of the canvas.

Degas: Manet Listening to His Wife Playing the Piano, c. 1865. 25§ × 28″. Formerly owned by Manet who cut off the portrait of his wife. Collection K. Wada, Osaka, Japan.

Manet: The Artist's Wife at the Piano in Their Apartment on rue St. Pétersbourg, c. 1867. $15 \times 18\frac{1}{8}$ ". Musée du Louvre, Paris.

Meanwhile Pissarro worked on the banks of the Marne, went to La Roche-Guyon near the Seine and visited his friend Piette on his farm in Montfoucault (Brittany), working there in his company. At the same time Bazille in Paris presented himself for the dreaded medical examinations. While he awaited, not too confidently, the outcome, Monet persuaded him to accompany him to Honfleur, whence Bazille wrote his parents: "As soon as we arrived in Honfleur, we looked for landscape motifs. They were easy to find, because the country is heaven. One could not see richer meadows and more beautiful trees; everywhere there are cows and horses at pasture. The sea, or rather the Seine broadening out, gives a delightful horizon to the masses of green. We are staying in Honfleur itself, at a baker's, who has rented us two small rooms; we eat at the Saint-Siméon farm, situated on the cliff a little above Honfleur; it's there that we work and spend our days. The port of Honfleur and the costumes of the Normans with their cotton caps interest me greatly. I've been to Le Havre.... I had lunch with Monet's family; they are charming people. They have at Sainte-Adresse, near Le Havre, a delightful place. . . . I had to refuse the hospitable invitation they made me to spend the month of August there. I get up every morning at five o'clock and paint the whole day, until eight in the evening. However, you mustn't expect me to bring back good landscapes; I'm making progress and that's all — it's all that I want. I hope to be satisfied with myself after three or four years of painting. I'll have to go back to Paris soon and apply myself to that horrible medicine, which I more and more detest...."29

The Saint-Siméon farm, where Boudin had once lodged Courbet and Schanne,

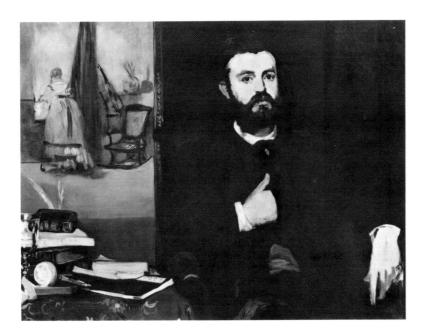

Left, Manet: Portrait of Zacharie Astruc, 1866. $35\frac{1}{2} \times 45\frac{3}{4}$ ". Kunsthalle, Bremen. Right, Degas: Manet at the Races, c. 1864. Pencil, $12\frac{3}{4} \times 9\frac{3}{4}$ ". Metropolitan Museum of Art, New York.

BAZILLE: Beach at Sainte-Adresse, d. 1865. $23\frac{5}{8} \times 55\frac{1}{8}$ ". Collection Pierre Fabre, Saint-Comes (Gard).

Monet: Beach at Sainte-Adresse, 1864-65. $15 \times 28''$. Minneapolis Institute of Arts.

was famous among artists on the coast. In fact, so many painters had worked there—Diaz, Troyon, Cals, Daubigny, and Corot—that the rural inn above the Seine estuary had been called the "Barbizon of Normandy." During his sojourn there Bazille met Monet's friend Boudin, but he could not work beside them very long, since he had to return to Paris, where he learned that he had failed his examinations. He subsequently left for Montpellier, where his parents finally allowed him to give up medicine and devote himself solely to painting.

Not long after Bazille's departure, on July 15, Monet wrote him a long letter: "... Everyday I discover more and more beautiful things; it's enough to drive one

mad; I have such a desire to do everything, my head is bursting with it!... I am fairly well satisfied with my stay here, although my sketches are far from what I should like; it is indeed frightfully difficult to make a thing complete in all aspects. ... Well, my good friend, I intend to struggle, scrape off, begin again, because one can produce what one sees and what one understands. . . . It is on the strength of observation and reflection that one finds it. . . . What I'm certain of is that you don't work enough, and not in the right way. It's not with playboys, like your [friend] Villa and others that you can work. It would be better to be alone, and yet, all alone, there are some things that one cannot fathom; well, all that is terrific and it's a stiff job. I have in mind splendid projects for the time I shall be at Sainte-Adresse and in Paris in the winter. Things are fine at Saint-Siméon — they often talk to me about M. Bazille." ³⁰

Some weeks later, in the fall, Monet again wrote from Honfleur to Bazille: "There are a lot of us at the moment in Honfleur.... Boudin and Jongkind are here; we are getting on marvelously. I regret very much that you aren't here, because in such company there's a lot to be learned and nature begins to grow beautiful; things are turning yellow, grow more varied; altogether, it's wonderful.... I'm sending a flower

Bazille: Farmyard, 1864. $14\frac{1}{8} \times 10\frac{1}{4}$ ". Collection Frédéric Bazille, Montpellier.

Monet: Spring Flowers, d. 1864. $46 \times 35\frac{7}{8}$ ". Cleveland Museum of Art (Gift of Hanna Fund).

Renoir: Potted Plants, d. 1864. $51\frac{1}{4} \times 37\frac{3}{4}$ ". Oskar Reinhart Foundation, Winterthur.

picture to the exhibition at Rouen; there are very beautiful flowers at present.... Now do such a picture, because I believe it's an excellent thing to paint."31

Whereas Monet's flower painting was executed in rich but dark colors not unlike those of Courbet, its vigorous rendering showed the influence of Jongkind and Boudin. It is not unlikely that the latter also painted at this time some of the few flower still lifes he ever did. In that same year Renoir, too, undertook views of a green-house with white blossoms, done in a very similar vein, while Bazille followed only somewhat later Monet's advice to paint flowers.

Monet was so possessed by his work that he repeatedly put off his departure. "I'm still at Honfleur," he wrote to Boudin, who had left; "it is definitely very hard for me to leave. Besides, it's so beautiful now that one must make use of it. And then I've worked myself up in order to make tremendous progress before going back to Paris. I am quite alone at present and, frankly, I work all the better for it. That good fellow Jongkind has gone. . . . "32"

During this same summer Monet also spent some time in nearby Sainte-Adresse with his family, but new disputes had arisen, and the artist was finally entreated to leave and not return any too soon. Fearing that his parents might even cut off his allowance, Monet decided to send three paintings to Bazille in Montpellier; he asked

BAZILLE: Flower Pots, d. 1866. $38\frac{1}{4} \times 34\frac{5}{8}''$. Presented by the artist to his cousin Lejosne. Collection Mr. and Mrs. John Hay Whitney, New York.

BOUDIN: Hollyhocks, c. 1864 (?). $32\frac{1}{2} \times 18\frac{1}{4}$ ". Collection Mr. and Mrs. John Hay Whitney, New York.

him to see whether they might interest his neighbor, the collector and special patron of Courbet, M. Bruyas. "One of these three canvases," he explained, "is a simple sketch which you saw me begin; it is based entirely on nature, you will perhaps find in it a certain relationship to Corot, but that this is so has absolutely nothing to do with imitation; the motif and especially the calm and misty effect are the only reasons for it. I have done it as conscientiously as possible, without having any painter in mind." Bruyas declined to buy any of the three canvases.

There can be no doubt that Monet was sincere in saying that he had no other artist in mind while he worked. From the very beginning he had shown an immense eagerness to learn, yet had always endeavored not to imitate his self-chosen masters. He was aware of the difficulties which confronted him and the need to develop his gifts. But he never doubted his abilities and was devoured by a steadily growing passion to create. It had been his particular luck to be formed by men like Boudin and Jongkind, who, far from trying to make proselytes, had striven to help him find his own personality. They had educated his eyes and given him technical advice, they had taught him the fundamental laws of their craft, but their own respect for nature had prevented them from imposing their vision on the younger man. And Monet had been happy in their company because they treated him as a companion

Jongkind: View of Notre Dame, Paris, d. 1863. Collection C. Roger-Marx, Paris.

JONGKIND: View of Notre Dame at Sunset, d. 1864. Collection Mme Ginette Signac, Paris.

rather than a pupil, having esteem for his great susceptibility and need of freedom. Thus he had gained experience at their side and was working ever more strenuously to attain a perfect command of his perceptions as well as of his means of expression.

Since Jongkind was the stronger personality of the two friends, his ascendancy over Monet probably was the more decisive one. Unlike Boudin he did not paint landscapes in the open, yet his sketches and watercolors done on the spot, his vivid brushstrokes and his intimate feeling for color helped him remain true to his observations and reproduce them in all their freshness. "I love this fellow, Jongkind," Courbet's friend Castagnary had written, "he is an artist to the tip of his fingers; I find him a genuine and rare sensibility. With him everything lies in the impression."34 In order to be faithful to his impressions, Jongkind tried to represent in his works not what he knew of his subject but how it appeared to him under specific atmospheric conditions. Before he had come to Honfleur in the summer of 1864, he had painted two views of the apse of Notre Dame in Paris, one in the silvery light of a winter morning, the other under the flaming sky of a sunset. Several weeks or even months lay between the execution of these two paintings, but the artist had chosen in both cases to stand at the very same place and to reproduce what he saw. While under a bright light every architectonic detail had clearly appeared to him, these details had vanished into a shadowy mass under the setting sun, and Jongkind had refrained from tracing the flying buttresses when he could no longer perceive them distinctly. Thus replacing the form of reality by the form of appearance, Jongkind — as before him Constable and Boudin — had made atmospheric conditions the real subject of his studies. Monet was soon to follow him in the same direction, painting a road in Normandy once beneath a clouded sky and once covered by snow. In observing how

Monet: Road near Honfleur in Winter, 1865. $32 \times 39\frac{3}{8}$ ". Present whereabouts unknown.

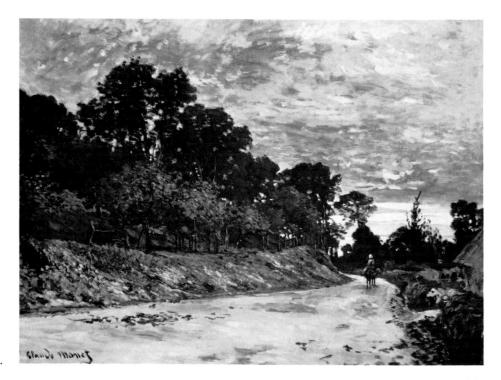

Monet: Road near Honfleur, 1866. $23\frac{1}{4} \times 31\frac{1}{2}$ ". Present whereabouts unknown.

BAZILLE: Zacharie Astruc, c. 1869. 22½ × 18½″. Collection Frédéric Bazille, Montpellier.

BAZILLE: Edmond Maître (fragment), 1867. 14¼ × 11″. Collection Mme E. de Cardenal, Bordeaux.

BAZILLE: Self Portrait, 1867-68. $21\frac{1}{4} \times 18\frac{1}{8}$ ". Minneapolis Institute of Arts (John R. Van Derlip Fund)

the so-called "local colors" and known forms varied according to their surroundings, he made a decisive step toward the full understanding of nature.

Monet returned to Paris late in 1864 with a series of paintings, among them two marines which he intended to send to the Salon. In January 1865, Bazille rented the studio at 6 rue de Furstemberg from which they previously had watched Delacroix at his easel, and Monet joined him. It was there that Pissarro went to see his old acquaintance from the *Académie Suisse*, accompanied by Cézanne. Courbet came too, for in spite of his tireless self-admiration, he was interested in the efforts of the new generation and did not think it beneath his dignity to visit their studios.

During this winter Monet and Bazille frequently visited Bazille's relative, the Commandant Lejosne, at whose home they met Fantin, Baudelaire, Barbey d'Aurevilly, Nadar, Gambetta, Victor Massé, and Edmond Maître, who became a special friend of Bazille and Renoir. They apparently did not find Manet there, although he was a member of Lejosne's circle. Discussions at that period centered very often around musical questions and particularly around the much-debated art of Wagner, for whom Bazille had conceived a veritable passion which was shared by Baudelaire, Fantin, and Maître, among others. They also greatly admired Berlioz. Together with Renoir and the judge Lascaux, Bazille frequented the Concerts Pasdeloup and manifested his admiration loudly, if need be, against the protesting clamors. Cézanne, too, valued the "noble tones of Richard Wagner" and meditated upon painting a picture, Ouverture du Tannhäuser, 35 whereas Fantin had already shown a Scène du Tannhäuser at the Salon of 1864.

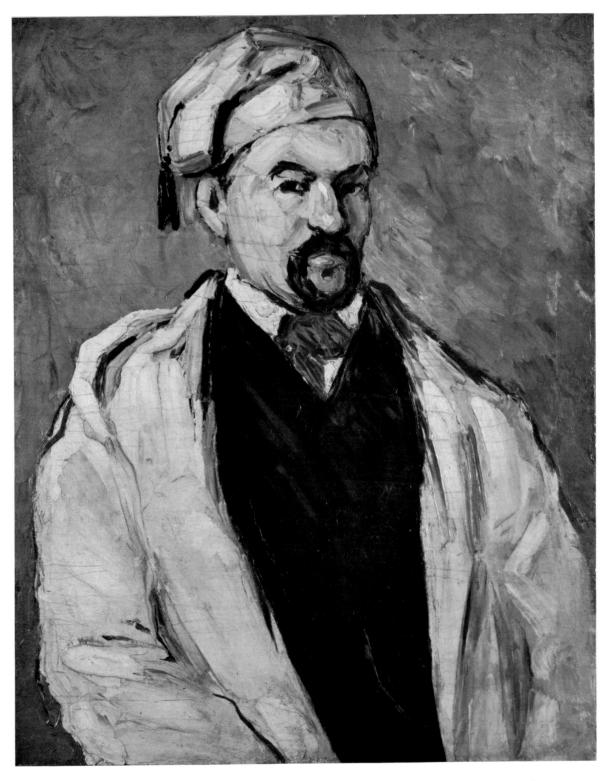

CÉZANNE: Man in a Blue Cap (Uncle Dominique), 1865-66. $31\frac{3}{8} \times 25\frac{1}{4}$ ". Metropolitan Museum of Art, New York (Wolfe Fund; from The Museum of Modern Art, Lillie P. Bliss Collection).

Fantin was then working at a new composition, Hommage à la vérité, in which he again introduced likenesses of the same friends who had been represented in his Hommage à Delacroix: Bracquemond, Duranty, Manet, Whistler, and himself, as well as Astruc (a patient, always welcome model for his colleagues; Manet had painted his portrait in 1864) and some others. Whistler appeared dressed in a colorful kimono. This time Fantin might well have added Whistler's friend Rossetti, for the latter had been in Paris late in the fall of 1864, and Fantin had taken him in the master's absence to Courbet's studio and also to Manet's. But Rossetti's reactions had been such that they hardly warranted his appearance in a painting dedicated to realism. "There is a man named Manet," Rossetti had written his mother, "to whose studio I was taken by Fantin, whose pictures are for the most part mere scrawls, and who seems to be one of the lights of the school. Courbet, the head of it, is not much better." Whereupon Rossetti had returned to London with the conviction that "it is well worth while for English painters to try and do something now, as the new French school is simple putrescence and decomposition." 36

What Rossetti had considered a proof of putrescence — the eagerness for new expression in all fields of artistic activity, the effervescence that reigned among young artists, the animated discussions that treated theoretical issues with a vehemence as if life or death depended upon them, the battles that raged around paintings, symphonies, or books — all these signs of a feverish intellectual activity, which formerly

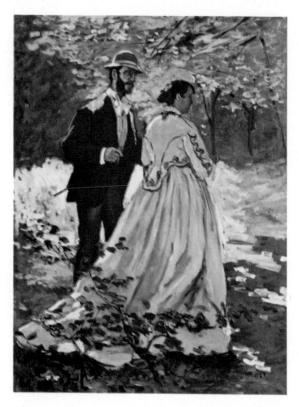

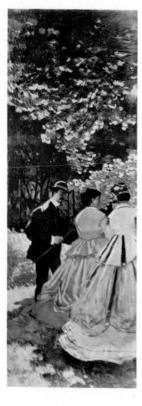

Far left, Monet: Bazille and Camille; study for the Déjeuner sur l'herbe, 1865-66. $36\frac{5}{8} \times 27\frac{1}{8}$ ". National Gallery of Art, Washington, D.C. (Ailsa Mellon Bruce Collection).

Left, Monet: Fragment of the final version of the *Déjeuner sur l'herbe*, 1865-66. 165 × 59" Musée du Louvre, Paris (Gift of Georges Wildenstein).

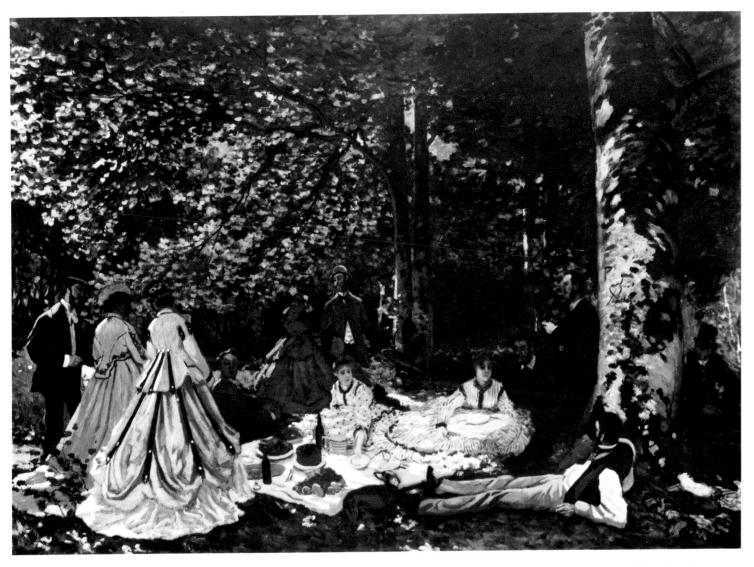

Monet: Study for the Déjeuner sur l'herbe, d. 1866. $51\frac{1}{4} \times 73''$. (Bazille posed for the man at the extreme left as well as for the one stretched out on the grass.) Museum of Western Art, Moscow.

had delighted Monet, now seemed to interest him to a much lesser degree. He was anxious to return to Fontainebleau forest, for he had in mind an ambitious composition of figures in the open, a subject not unlike Manet's *Déjeuner sur l'herbe* but, in contrast to that, painted as far as possible out-of-doors, showing a group of loungers not only in natural light against a real background, but also in the casual attitudes and poses of an everyday picnic. Too large to be actually executed in the forest, the painting was to be done after numerous studies sketched on the spot. In April 1865, Monet was back in Chailly, looking for a suitable site. He soon wrote Bazille, asking him

BAZILLE: Monet after His Accident at the Inn in Chailly, d. 1866. $18\frac{1}{2} \times 24\frac{3}{8}$ ". Musée du Louvre, Paris.

to come in order to approve the choice and to pose for one or even several of the figures. "I think of nothing but my picture," he added, "and if I knew I wouldn't bring it off, I believe I'd go mad." Bazille joined him, but shortly afterwards Monet was injured in the leg and in spite of his fury had to stay in bed. Bazille, who took care of him, knew of no other way to keep him quiet than to paint him immobilized on the large bed of their country inn, after having drawn on his medical knowledge to contrive a complicated installation whereby water, slowly dropping from a suspended jar on the patient's leg, eventually was drained into some pots at the foot of his bed. As soon as he was up again, Monet returned to work with renewed passion, whereas Bazille, in his spare time, painted several landscapes at Chailly. Courbet came to watch Monet work while Bazille posed and introduced the two friends to Corot.

After his return to Paris, Bazille received a letter from Renoir (who was then living at Sisley's near the Porte Maillot), inviting him to join them "for a long sea voyage in a sailing boat. We are going to watch the regattas at Le Havre. We plan to stay about ten days and the entire expense will be around fifty francs. If you wish to come along, this will give me great pleasure. . . . I am taking my paintbox with

me in order to make sketches of any sites I happen to like. I think it will be charming. Nothing to prevent one from leaving a place one dislikes, and nothing either to stop one from lingering on in any amusing spot. The meals will be frugal...We'll have a tugboat tow us to Rouen and, from there on, we'll do whatever we like... As you have already been thereabouts, I thought that you might be happy to revisit the places which you found beautiful."38 But Bazille was too much taken up with his work to join his friends who, during this excursion, probably painted some land-scapes from their boat just as Daubigny used to do from his *Botin*.

Renoir and Sisley also had returned to Fontainebleau but apparently had chosen quarters at the inn of Mother Anthony in the tiny village of Marlotte, where Monet and Pissarro seem to have joined them occasionally. Renoir had come with his younger brother Edmond, who accompanied the painters everywhere, carrying his share of equipment, drinking in their words, dumbfounded by their amazing remarks. Renoir now met his idol, Courbet, possibly through Claude Monet.

Meanwhile the time for the Salon had again come around. The jury, composed almost exactly as the previous year (although Corot had obtained even fewer votes), once more showed a certain clemency toward new talents. Fantin exhibited his homage to truth, now called *Le Toast*; Manet showed two paintings, *Christ Insulted by the Soldiers* and *Olympia* (painted in 1863), which he had sent at Baudelaire's insistence.³⁹ Berthe Morisot and Pissarro (pupil of A. Melbye and Corot) also had two canvases each accepted; so had Renoir, who was represented by a portrait of Sisley's father and a *Summer Evening*. But whereas Renoir again designated himself in the

Left, Renoir: Barges on the Seine, c. 1869. $18\frac{1}{8} \times 25\frac{1}{4}$ ". Musée du Louvre, Paris. Right, Renoir: William Sisley (the painter's father), d. 1864. 32×26 ". Exhibited at the Salon of 1865. Musée du Louvre, Paris.

Monet: The Seine Estuary at Honfleur, d. 1865. $35\frac{1}{2} \times 59''$. Exhibited at the Salon of 1865. Private collection, Switzerland.

catalogue as a pupil of Gleyre, Monet, exhibiting for the first time, indicated no teacher. Edgar Degas, who was also showing for the first time, had sent a War Scene from the Middle Ages, a carefully composed but rather conventional work which he had probably executed several years earlier and for which he was complimented by Puvis de Chavannes. (The catalogue for 1865 and for several years after lists his name as his father spelled it: De Gas.)40

The two canvases shown by Monet were views of the Seine estuary, done near the lighthouse of Honfleur. Since the works at the Salon were now hung in alphabetical order to prevent favoritism, Monet's works found themselves in the same room with Manet's. When the latter entered this room on the opening day, he had the disagreeable surprise of being congratulated by several persons upon his seascapes. Having studied the signatures on the two pictures attributed to him, Manet at first thought it to be some cheap joke; his anger was conceivably not lessened by the fact that the seascapes continued to have more success than his own works. He left in a rage and openly complained to some friends: "I am being complimented only on a painting that is not by me. One would think this to be a mystification."⁴¹

As a matter of fact Monet's paintings immediately met with real success, and since they showed the same directness of approach, the same freedom of execution that characterized the works of Courbet and his followers (not to mention the similarity of his name and signature with Manet's), it was little surprising that they should have been ascribed, at first glance, to the author of the Déjeuner sur l'herbe. But the critics did not make this mistake: while some of them sharply objected to Manet's paintings, they reserved applause for Monet. In a large album, L'autographe au Salon, there even appeared a sketch by Monet after one of his canvases, together with this comment: "Monet. The author of a seascape the most original and supple, the most strongly and harmoniously painted, to be exhibited in a long time. It has a somewhat dull tone, as in Courbet's; but what richness and what simplicity of view! M. Monet, unknown yesterday, has at the very start made a reputation by this picture alone."42 This comment was signed Pigalle, and behind the pseudonym was doubtless hidden one of Monet's acquaintances, possibly Astruc, for the same album also reveals an unusual sympathy for Jongkind, Boudin, et al. But not only friends sang Monet's praises; for instance, the reviewer for the Gazette des Beaux-Arts, Paul Mantz, wrote: "... The taste for harmonious schemes of color in the play of analogous tones, the feeling for values, the striking point of view of the whole, a bold manner of seeing things and of forcing the attention of the spectator, these are qualities which M. Monet already possesses in high degree. His Mouth of the Seine abruptly stopped us in passing and we shall not forget it. From now on we shall certainly be interested in following the future efforts of this sincere marine-painter."43

This sudden and unexpected success was not only a great stimulant for Monet, it could not fail to impress favorably his family in Le Havre. But the artist did not stay long in Paris to savor his triumph; his large composition called him back to Chailly, and Bazille informed his parents: "Monet has had a much greater success than he expected. Several talented painters with whom he is not acquainted have written him complimentary letters. He is at the moment at Fontainebleau and I wish I were too." It seems that before Monet left Paris, Astruc offered to introduce the newcomer to Manet, but, with a sweeping gesture, Manet is said to have refused.

Manet was profoundly depressed by the disastrous reception his canvases had met. "The crowd, as at the morgue, throngs in front of the gamy *Olympia* and the horrible *Ecce Homo* of M. Manet," wrote Paul de Saint-Victor. And Jules Claretie spoke of those "two awful canvases, shams thrown to the crowd, jokes or parodies, what shall I say? Yes, jokes. What is this odalisque with yellow belly, a degraded model picked up I don't know where, and representing Olympia?" Courbet, whose friend Castagnary had already accused Manet of "lack of conviction and sincerity," came out against the artist, too, comparing *Olympia* to a playing card.

Olympia did not fare better with Théophile Gautier, once, with Victor Hugo, a leader of the romantic poets in their fight against tradition. Gautier had since lost all taste for revolutionary ideas, while still posing as a sympathizer with audacity. "With some repugnance I come to the peculiar paintings by Manet." he wrote. "It is awkward to discuss them but one cannot pass them by in silence.... In many persons' opinion it would be enough to dismiss them with a laugh; that is a mistake. Manet is by no means negligible; he has a school, he has admirers and even enthusiasts; his influence extends further than you think. Manet has the distinction of being a danger. But the danger is now passed. Olympia can be understood from no point of view, even if you take it for what it is, a puny model stretched out on a sheet. The

Manet: Olympia, d. 1863. $51\frac{1}{4} \times 74\frac{3}{4}$ ". Exhibited at the Salon of 1865. Musée du Louvre, Paris.

color of the flesh is dirty, the modeling non-existent. The shadows are indicated by more or less large smears of blacking. What's to be said for the Negress who brings a bunch of flowers wrapped in a paper, or for the black cat which leaves its dirty footprints on the bed? We would still forgive the ugliness, were it only truthful, carefully studied, heightened by some splendid effect of color. The least beautiful woman has bones, muscles, skin, and some sort of color. Here is nothing, we are sorry to say, but the desire to attract attention at any price."

Louis Leroy, the critic of *Le Charivari*, who later was to give abundant proof of a malevolent and biting spirit, contented himself with a rather "tame" comment when he said: "If ever I write a single line in praise of *Olympia* I authorize you to exhibit me some place with that bit of my article tied around my neck, and I would have amply deserved it."⁴⁸

The discussions aroused by Manet's paintings did put his name forward to such a degree that Degas could pretend that his friend was now as famous as Garibaldi. It must have seemed to Manet as if whatever he did appeared an offense to others. The delicacy of his color accords, the virtuosity with which he created harmonies of blacks, greys, and whites enlivened by some strong or subtle notes, unexpected and delightful, the mastery with which he combined in his technique a clear and almost cold sense of lines and values with an execution full of temperament, all these rare gifts of the true painter seemed nowhere to find the slightest recognition. Touched by Manet's despair, Baudelaire wrote from Brussels a letter of encouragement and also asked a mutual friend to tell the artist "that ridicule, insult, injustice, are excellent things and that he would be ungrateful if he were not to thank injustice . . . really, Manet has such brilliant and such delicate faculties that it would be a misfortune if he has become discouraged." 49

It could be of little comfort to Manet that Courbet's picture at the Salon, a portrait of his friend Proudhon, who had just died, was also very poorly received and that even Courbet's admirers said they "had never seen such a bad painting" by the master.50 Indeed, there was matter enough for concern, since Courbet's apparent weakness and Manet's so-called jokes set the adversaries of realism raving. The moment seemed particularly grave and it looked as if the whole battle might have to be fought over again. "Today evolution is accomplished," wrote one critic. "There are no more Neo-Greeks, and the realists, too, are inclined to make themselves more scarce, as if, once the disease had vanished, the remedy had become useless. M. Courbet . . . retires. Of the younger people who, from near or far, followed in his path, some have been converted, others have left us. M. Alphonse Legros has gone to settle in London; M. Amand Gautier . . . has become exceedingly prudent. M. Carolus-Duran is in Rome and, one may anticipate..., will return from there transformed. Clearly, enthusiasm is dying down, the group is confused and breaks up. The Salon offers us proof. One portrait painter who is, in a certain measure, connected with the school of whose decadence we are talking . . . M. Fantin, having conceived of uniting in Hommage à la vérité51 the last friends of nature, took all the trouble in the world to assemble a few realists and, since his picture could not remain empty, was obliged to give a place . . . to M. Whistler, who lives in close communion with fantasy, to M. Manet, who is the prince of visionaries. It will be acknowledged that, the moment the creator of Olympia can pass as a realist, the confusion of Babel starts anew, intoxicated words speak nonsense, or rather, there are no more realists."52 (Fantin, incidentally, destroyed his painting after it returned from the Salon — as Manet had done with his Spanish bullfight scene the previous year — preserving only Whistler's portrait.)

Realist or not, Manet suddenly felt the urge to leave Paris; he decided to go to Spain, probably hoping to gain new inspiration from acquaintance with the country whose painters and whose life played such a large part in his conceptions and imagination. However, Manet did not follow the itinerary Astruc had arranged for him and spent only two weeks in Spain, writing to Fantin that decidedly Velázquez was "the painter of painters. He didn't surprise me, but he enchanted me. . . . "53 Yet his short stay left a deep impression on the artist. Equally attracted by exoticism and the observation of reality, Manet now saw his dreams of Spain replaced by actual

Photograph of Manet, 1863.

Guys: On the Balcony (Spain). Pen and brown ink with watercolor, $5\frac{1}{8} \times 7\frac{5}{8}$ ". Private collection, Paris.

knowledge of the country, a country that was less romantic than he had thought. He seems to have realized that what the Spanish masters he so admired had done in depicting their own people, he could do as well for contemporary Paris. He left Spain poorer in colorful illusions but engrossed with a new approach to his surroundings. Thus the "Spanish period" of his evolution came to a nearly abrupt end after his visit to Spain, except for several bullfight scenes which he painted shortly after his return, from sketches done in Madrid.

The fact that Manet abandoned painting models in Spanish costumes or selecting religious subjects may in some way also be related to a series of articles which Baudelaire, toward the end of 1863, had devoted to Constantin Guys (whom Manet admired and many of whose wash drawings he owned). Shying away from any kind of publicity and usually showing little concern for his own work, Guys requested that the poet not name him in his study which, as a matter of fact, appeared under the title: Le peintre de la vie moderne and in which the artist was designated only by his initials C.G. But what Baudelaire had had to say on this strange, independent, and urbane man whom he greatly esteemed, transcended the lively images which Guys had drawn by the thousands of military events, of court life in France and England, of dandies and carriages, of scenes from the Orient, and above all of women, from Turkish beauties to Spanish prostitutes, from Parisian ladies to midinettes and demi-mondaines all the way to impudent dancers, inmates of disreputable houses, and servant girls entertaining sailors in low dives. Indeed, Baudelaire had stated at the outset:

"The past is interesting not only for the beauty which artists, whose present it was, have extracted from it, but also as past, for its historic value. The same applies to the

present. The pleasure which we gain from the representation of the present derives from the beauty with which it may be possessed as well as from its essential quality as present." From this Baudelaire had concluded that it was the artist's role — as Guys was doing — "to retain from fashion whatever it may contain in poetic elements of historic nature, to disengage the eternal factors from the transitory ones."

Studying this aspect of *modernité* — a word coined by him — Baudelaire proclaimed: "It is much easier to declare that everything in the garments of a period is absolutely ugly than to apply oneself to the extraction of the mysterious beauty which they contain, be it ever so trifling or slight. Modernity is the transitory, the fugitive, the contingent, one half of art of which the other half is the eternal and the immutable. Every painter through the ages was in his time modern; most of the beautiful portraits preserved from previous days are dressed in the vestments of their period. They are perfectly harmonious because the costume, the head-dress, and even the

Manet: Bullfight in Spain, 1866. $19\frac{1}{4} \times 24''$. Art Institute of Chicago (Gift of Mr. and Mrs. M. A. Ryerson).

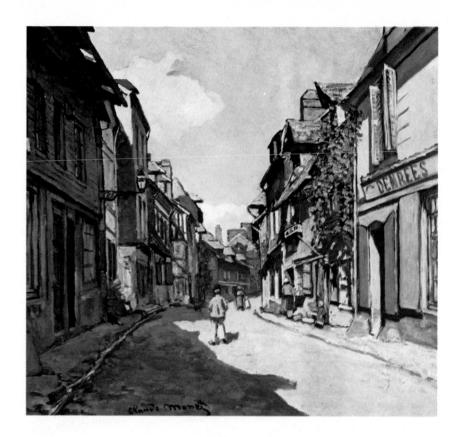

MONET: Rue de la Bavolle, Honfleur, c. 1865. 22³/₄ × 24". Museum of Fine Arts, Boston (Bequest of John T. Spaulding).

Photograph of the same subject, courtesy William C. Seitz.

gesture, the glance, and the smile (each period has its bearing, its glance, and its smile) constitute a whole of complete vitality. This transitory, fugitive element, the metamorphoses of which are so frequent, you have no right to despise or do without. By suppressing it you forcibly tumble into the emptiness of an abstract and undefinable beauty."54

These concepts, at which Degas, too, was soon to arrive after studying the world round him⁵⁵ (he had completely given up painting historical scenes at about the time when Baudelaire's articles appeared), Manet may well have contemplated carefully. Had he not, about 1860, in his composition *La Pêche*, derived the general arrangement and various details from Rubens, but also represented himself and his betrothed in costumes of the Flemish master's time?⁵⁶ Now his short trip to Spain seemed to have taught him that there was no real escape from "modernity" into picturesqueness, a fact of which Courbet and Boudin, to name but these two, had long been aware.

Much less concerned with these problems, Monet, in the meantime, was working again on the coast, this time in the company of Boudin and Courbet, whom Whistler joined. It was the first time that Monet actually painted beside Courbet and he was to draw new and decisive benefits from this experience. The same "broad pinciple" of Courbet that had once fascinated the hesitant Boudin now found a much prompter

Jongkind: Coast near Le Havre, d. 1862. Watercolor, $6\frac{1}{4} \times 12\frac{1}{4}$ ". Collection Dr. and Mrs. Arthur J. Barsky, New York.

Monet: Les Roches Noires near Trouville, c. 1865. Charcoal, $6^7_8 \times 12^4_4$ ". De Young Museum, San Francisco (T. Edward Hanley Collection).

Courbet: Normandy Coast, c. 1865. $8\frac{1}{2} \times 16''$. Smith College Museum of Art, Northampton, Mass.

Courbet: The Artist Saluting the Mediterranean at Palavas, d. 1854. $10\frac{5}{8} \times 18\frac{1}{8}$ ". Musée Fabre, Montpellier (Bruyas Bequest).

Whistler: Courbet at Trouville
—Harmony in Blue and Silver,
1865. 19½ × 29¾".
Isabella Stewart Gardner
Museum, Boston.

COURBET: Jo, the Beautiful Irish Girl (Whistler's Mistress), 1865. 20\(^3_4 \times 25''\). Nelson Gallery-Atkins Museum, Kansas City.

response in Monet, because he felt a need for a broad technique and an almost coarse style. In contact with nature Courbet was superb in his certitude, amazing in his dexterous handling of brushes and palette-knife, instructive in his mastery of blending the delicate with the rough, and exciting in his animation, which made everyone happy and — by his example — communicated to others a real fever for working.

"Courbet," as Monet later remembered, "always painted upon a somber base, on canvases prepared with brown, a convenient procedure, which he endeavored to have me adopt. 'Upon it,' he used to say, 'you can dispose your lights, your colored masses; you immediately see your effect.' "57 But Monet did not follow suit, though his flower still life was painted on a red ground; he generally preferred white canvas, as Manet had been the first to do. By rejecting this century-old tradition (which Degas still respected), Monet renounced conceiving his paintings primarily in terms of light and dark masses, around which intermediary values were filled in. Working directly on the white canvas, he was able to establish his scale of values without concern for predetermined effects, and although this system put a greater strain on his visual imagination — as long as the canvas was not completely covered he could not obtain an equilibrium of harmonies — he was rewarded by the generally lighter aspect of his work, obtained in spite of using mostly opaque colors.

Though Monet did not accept Courbet's old-master procedure, he acquired through him a preference for large canvases, a tendency shared by all his comrades. To find an outlet for their overflowing energies they thought nothing of covering thirty square feet of canvas, occasionally using the palette-knife dear to Courbet. But

whereas the huge stretchers invited the artists to paint broadly and vigorously, they also obliged them to proceed piece by piece, thus sometimes menacing the unity of the projected whole, and equally preventing them from working directly in the open. "I've seen Courbet and others who venture at large canvases, the lucky ones," Boudin wrote his brother; "Monet has one to cover that's twenty feet in length."58

While painting in Trouville, where Daubigny also had arrived and where Monet apparently met him for the first time, Courbet enjoyed an immense popularity among the distinguished summer guests. His studio was invaded, as he said, by two thousand ladies, but among the abundance he was attracted only by "the beauty of a superb red-haired girl whose portrait I have started." She was Jo, Whistler's Irish mistress, who had also posed for his famous White Girl of the Salon des Refusés. Her portrait by Courbet shows, in contrast to his seascapes, a certain lack of vigor, which seems to explain why he was now favored by a public that heretofore had cared little for his "brutalities."

Near Fontainebleau forest, meanwhile, Sisley and Renoir were continuing to paint at Marlotte where they may have been the guests of Renoir's friend Jules Le Coeur, whom the painter apparently had met early in 1865.60 Nine years older than Renoir, originally trained as an architect — like his father and older brother — Jules Le Coeur,

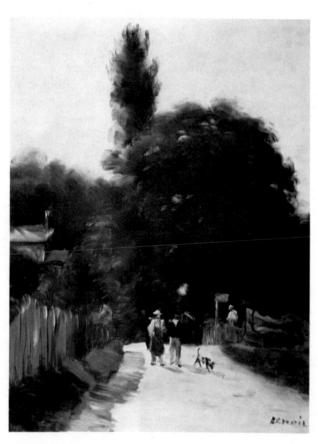

Renoir: Road near Marlotte, c. 1865. $13 \times 9\frac{1}{2}$ ". Presented by the artist to Lise Tréhot. Collection Mrs. Norman B. Woolworth, New York.

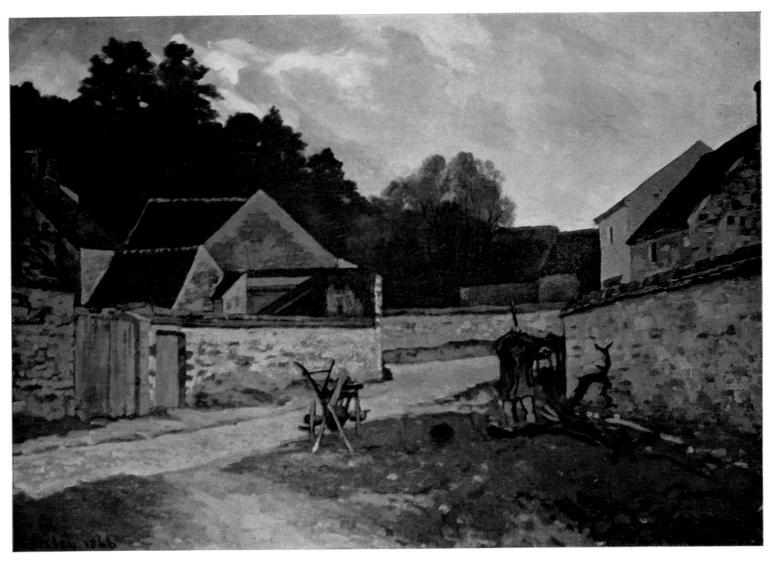

 $S_{\text{ISLEY}}: \textit{Village Street in Marlotte} \text{ d. } 1866. \text{ } 25\frac{5}{8} \times 36\frac{1}{4} \text{''}. \text{ Exhibited at the Salon of } 1866. \text{ Albright-Knox Art Gallery, Buffalo.}$

in 1863, suddenly had decided to devote himself solely to painting and, in the spring of 1865, had acquired a house at Marlotte. A widower, Renoir's new friend at about the same time took as mistress a girl in her early twenties, Clémence Tréhot, with whose seventeen-year-old sister, Lise, Renoir was soon to fall in love. Jules Le Coeur was quite familiar with Corot, worked at his side, received his visit and also was invited by him. In spite of this, however, Renoir did not become acquainted with the old master.

Renoir and Sisley seem to have spent part of the winter at Marlotte where Sisley was doing a view of a village corner intended for the next Salon. Monet returned there, too, in order to finish the large canvas of his *Déjeuner sur l'herbe*. During the

first weeks of 1866, doubtless because he was unable to work out-of-doors, Renoir painted his friends seated around a table at the inn of mère Anthony, a large composition that shows him, too, akin to Courbet. It represents among others Jules Le Coeur, Sisley holding before him the newspaper L'Evénement (to which Cézanne's friend Zola had just been appointed editor), Le Coeur's white poodle, and Nana, the daughter of mère Anthony, said to have been rather generous in her favors to the guests of her mother, who herself appears in the background. On the wall one can make out a caricature of Murger, author of La vie de Bohème.

In Paris, Bazille had now decided to move to new quarters. On this occasion Monet did not follow him. "I'm not put out at living somewhat alone," Bazille wrote his parents. "There are a good many disadvantages in living two together, even when there is mutual understanding." He also mentioned two canvases in preparation for the Salon, one of which represented a young girl at a piano. "Not being able to launch out into a large composition," Bazille explained, "I tried to paint to the best of my ability a subject as simple as possible. Besides, in my opinion, the subject has little importance as long as what I do is interesting from the point of view of painting. I chose the modern period, because that is what I understand best, what I find to be most alive for people who are alive, and that is what will get me rejected." — "I have an appalling fear of being rejected," he added (this was the first time he was submitting anything to the jury), "so I shall send at the same time a still life of fish, which will probably be accepted.... If I am rejected, I shall sign with both hands a petition requesting an exhibition for the refusés." 62

Cézanne had even fewer illusions concerning his chances to be admitted. He actually enjoyed the idea of his works making "the Institute blush with rage and despair." Since he saw in every refusal a confirmation of his originality, he did not suffer from the setback. Quite the opposite, according to one of his companions, he hoped "not to be accepted at the exhibition, and the painters he is acquainted with are getting ready an ovation for him." As for his friend Pissarro, he had had a serious discussion with Corot before submitting recent works to the Salon. Corot was very severe and did not approve of the new tendency which his disciple was displaying, more or less under the influence of Courbet and Manet. Consequently Pissarro no longer designated himself as "pupil of Corot." 65

While Monet in Chailly was putting the final touches to his huge composition, Courbet, who had grown fond of him to the extent of helping him financially, paid him a visit and suggested a few last-minute changes. Monet heeded the advice, to his regret, for the canvas which he had intended for the Salon no longer satisfied him in its new form. He took it from the stretcher, rolled it and, unable to pay his landlord, left it behind in Chailly, where it started to rot. (Monet later retrieved it and salvaged some large sections of the canvas; see page 118.) For the Salon he now painted, in a few days, a full-length, life-size portrait of a young girl, Camille Doncieux, whom he had apparently met shortly before and who was soon to share his misery, his hopes, and his disappointments.

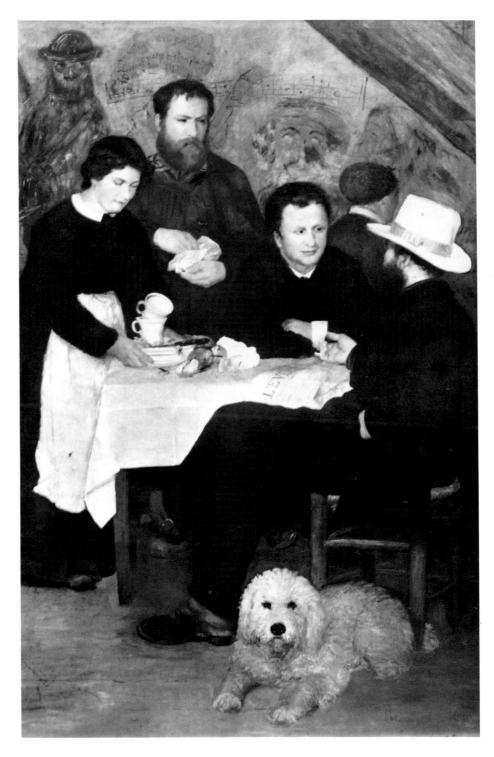

Renoir: At the Inn of Mother Anthony, Marlotte, d. 1866. $76 \times 51''$. (From left to right: Nana, Jules Le Coeur, an unknown man, Mother Anthony, Sisley. On the wall a caricature of Murger.) Nationalmuseum, Stockholm.

- 1 Bazille to his parents, Easter 1863; see G. Poulain: Bazille et ses amis, Paris, 1932, p. 34.
- 2 Monet to Toulmouche, May 23, 1863; see R. Régamey: La formation de Claude Monet, Gazette des Beaux-Arts, Feb. 1927. This letter, as well as information supplied by Poulain, op. cit., contradicts Monet's contention that he spent only two weeks at Gleyre's and induced Bazille, Renoir, and Sisley to leave the studio with him. Monet has frequently tried to emphasize his early independence, but his versions do not withstand investigation. He also very often made errors in dates, etc.
- 3 Goncourt brothers quoted by M. Donel: Barbizon, L'Art Vivant, Sept. 15, 1926; see also E. and J. de Goncourt: Manette Salomon, Paris, 1866, ch. LXXI.
- 4 Rousseau to a friend; see A. Stevens: Le Salon de 1863, Paris, 1866, p. 73.
- 5 E. Wheelwright: Recollections of Jean François Millet, Atlantic Monthly, Sept. 1876.
- 6 C. Baudelaire: Salon de 1859, ch. VIII.
- 7 See A. Vollard: Renoir, An Intimate Record, New York, 1925, p. 33-34.
- 8 T. Silvestre: Histoire des artistes vivants, Paris, 1856, p. 226. On Diaz see also J. Claretie: Peintres et sculpteurs contemporains, Paris, 1873, p. 33-34, and J. La Farge: The Higher Life in Art, New York, 1908, p. 122.
- 9 See A. André: Renoir, Paris, 1928, p. 34.
- 10 See J. Rewald: Renoir and His Brother, Gazette des Beaux-Arts, March 1945.
- 11 See R. Gimpel: At Giverny with Claude Monet, Art in America, June 1927.
- 12 See André, op. cit., p. 57.
- 13 Quoted by M. de Fels: La vie de Claude Monet, Paris, 1929, p. 92.
- 14 O. Redon: A soi-même, Paris, 1922, p. 36.
- 15 Quoted by A. Alexandre: Claude Monet, Paris, 1921, p. 38.
- 16 See Silvestre, op. cit., p. 92-93.
- 17 Corot to Auguin, Aug. 20, 1859; see E. Moreau-Nélaton: Corot raconté par lui-même, Paris, 1924, v. I, p. 125.
- 18 Corot in a letter to Berthe Morisot's mother, summer 1864, quoted in D. Rouart: Correspondence de Berthe Morisot, Paris, 1950, p. 11.
- 19 T. Gautier quoted by E. Moreau-Nélaton: Daubigny raconté par lui-même, Paris, 1925, p. 81.
- 20 See J. Laran: Daubigny, Paris, n.d. [1912], p. 14.

- 21 P. G. Hamerton: The Salon of 1863, Fine Arts Quarterly Review, Oct. 1863.
- 22 The proportion of rejections fell from 70 to 30%; the optional exhibition of rejected works was now called: Annex of entries "judged too weak to participate in the contest for awards." See Tabarant: Manet et ses oeuvres, Paris, 1947, p. 82. The catalogue of the Salon of 1864 lists among others: Fantin-Latour, rue St. Lazare, Hommage à Eugène Delacroix, Scène du Tannhäuser; Manet, 34, boulevard des Batignolles, Les Anges au tombeau du Christ, Episode d'une course de taureaux; Morisot (élève de Guichard et Oudinot), 12, rue Franklin, Souvenir des bords de l'Oise, Vieux chemin à Auvers; Pissarro (élève de A. Melbye et Corot), 57, rue de Vanves, Bords de la Marne, Route de Cachalas à la Roche-Guyon; Renoir (élève de Glayre), 23, rue d'Argenteuil, La Esmeralda.
- 23 See Baudelaire's letter to de Chennevières in Chennevières: Souvenirs d'un directeur des Beaux-Arts, I, Paris, 1883, p. 40.
- 24 Baudelaire to Bürger, 1864; see C. Baudelaire: Oeuvres complètes, Paris, 1918-1937, v. VIII.
- 25 W. Bürger: Salon de 1864; reprinted in Salons, 1861-1868, Paris, 1870, v. II, p. 137-138. On Bürger see P. Rebeyrol: Théophile Thoré, Burlington Magazine, July 1952.
- 26 Bertall in Le Journal amusant, May 21, 1864.
- 27 These fragments are: Toreros in Action, Frick Collection, New York, and The Dead Torero, National Gallery of Art, Washington, D. C. (Widener collection).
- 28 The final argument in the discussion as to whether Manet actually saw the naval battle seems to have been provided through technical observations made by J. C. Sloane: French Painting—Between the Past and the Present, Princeton, 1951, p. 193, note 6, according to which the artist did not witness the scene.
- 29 Bazille to his parents, spring 1864; see Poulain, op. cit., p. 40-41.
- 30 Monet to Bazille, July 15, 1864; see Poulain, op. cit., p. 38-39.
- 31 Monet to Bazille, fall 1864; see Poulain, op. cit., p. 44.
- 32 Monet to Boudin, fall 1864; see G. Cahen: Eugène Boudin, sa vie et son oeuvre, Paris, 1900, p. 61.
- 33 Monet to Bazille, Oct. 14, 1864; see Poulain, op. cit., p. 45.
- 34 Castagnary: article in L'Artiste, Aug. 15, 1863.
- 35 See M. Scolari and A. Barr, Jr: Cézanne in the Letters of Marion to Morstatt, 1865–1868, Magazine of Art, May 1938 (a series of three articles, Feb., April, May 1938).

- 36 Rossetti to his mother, Nov. 12, 1864; also letter to his brother, Nov. 8, 1864; see D. G. Rossetti: His Family Letters, London, 1895, v. II, p. 179-180.
- 37 Monet to Bazille, spring 1865; see Poulain, op. cit., p. 50.
- 38 Renoir to Bazille, July 3, 1865; see F. Daulte: Frédéric Bazille et son temps, Geneva, 1952, p. 47.
- 39 See J. de Biez: Edouard Manet, Paris, 1884, p. 21.
- 40 The catalogue of the Salon of 1865 lists among others De Gas, 13, rue de Laval, Scène de guerre au Moyen-Age, pastel [this was actually an oil painting]; Fantin-Latour, 1, rue Childebert, Le Toast; Manet, 34, boulevard des Batignolles, Jésus insulté par les soldats, Olympia (with some verses by Astruc); Monet, 6, rue Furstemberg, Embouchure de la Seine à Honfleur, La pointe de la Hève à marée basse; Morisot (élève de Guichard et Oudinot), Etude, Nature morte; Pissarro (élève de A. Melbye et Corot), à la Varenne & à Paris chez Guillemet, 20, Grande rue, Batignolles, Chennevières, au bord de la Marne, Le bord de l'eau; Renoir (élève de Gleyre), 43, Avenue d'Eylau, Portrait de M. W. S. [William Sisley], Soirée d'été; Whistler, La Princesse du pays de la porcelaine [Jo].
- 41 See Thiébault-Sisson: Claude Monet, an Interview, Le Temps, Nov. 27, 1900. Monet places this incident in 1866, but in that year Manet had no painting accepted by the jury; this must therefore have happened in 1865. See also E. Moreau-Nélaton: Manet raconté par luimême, Paris, 1926, v. I, p. 90.
- 42 Pigalle: L'autographe au Salon, Paris, 1865.
- 43 P. Mantz: Salon de 1865, Gazette des Beaux-Arts, July 1865.
- 44 Bazille to his family, spring 1865; see Poulain, op. cit., p. 49.
- 45 P. de Saint-Victor, article in *La Presse*, May 28, 1865, quoted by Moreau-Nélaton: Manet, *op. cit.*, v. I, p. 69.
- 46 J. Claretie: Deux heures au Salon de 1865; in Peintres et sculpteurs contemporains, Paris, 1873, p. 109.
- 47 T. Gautier in Le Moniteur Universel, June 24, 1865, quoted by J. Lethève: Impressionists & Symbolists & Journalists, Portfolio & Art News Annual, No. 2, 1960.
- 48 L. Leroy in *Le Charivari*, May 5, 1865, quoted by J. Lethève: Impressionnistes et Symbolistes devant la presse, Paris, 1959, p. 53; on Manet at the Salon of 1865 see also G. H. Hamilton: Manet and His Critics, New Haven, 1954, p. 65-80.
- 49 Baudelaire to Mme Paul Meurice, May 24, 1865; quoted by Moreau-Nélaton: Manet, op. cit., p. 71. See also J. J. Jarves: Art Thoughts, Boston, 1869, p. 269.

- 50 W. Bürger: Salon de 1865; op. cit., v. II, p. 269.
- 51 A Fantin sketchbook at the Louvre contains a series of studies for *Le Toast*, drawn over a period of two to three years. On Jan. 16, 1865, the artist lists those represented: in the center a nude, at left Manet, at right Whistler, and—less prominently shown—Bracquemond, Cordier, Scholderer, Cazin, the writers Duranty and Astruc, the British art patron Edwards. The title of the composition is still given as *A la vérité*, notre idéal.
- 52 P. Mantz: Salon de 1865, Gazette des Beaux-Arts, July 1865. On Fantin's Toast see L. Bénédite: Le "Toast" par Fantin-Latour, Revue de l'art ancien et moderne, Jan., Feb. 1905.
- 53 Manet to Fantin, summer 1865; see Moreau-Nélaton: Manet, op. cit., v. I, p. 72. On Manet's trip to Spain see L. Rosenthal: Manet et l'Espagne, Gazette des Beaux-Arts, Sept., Oct. 1925.
- 54 Baudelaire: Le peintre de la vie moderne, originally published in *Le Figaro*, Nov. 26, 28, Dec. 3, 1863.
- 55 See Degas' notes from the late '60's, quoted p. 174-175.
- 56 See N. G. Sandblad: Manet, Three Studies in Artistic Conception, Lund, 1954, plates 2-4. The painting belongs to The Bernhard Foundation, New York.
- 57 See M. Elder: A Giverny chez Claude Monet, Paris, 1924, p. 52.
- 58 Boudin to his brother, Dec. 20, 1865; see G. Jean-Aubry: Eugène Boudin, Paris, 1922, p. 62.
- 59 Courbet, 1865, quoted by P. Borel: Le roman de Courbet, Paris, 1922, p. 99.
- 60 On Renoir's friendship with Jules Le Coeur see D. Cooper: Renoir, Lise and the Le Coeur Family, Burlington Magazine, May and Sept.-Oct. 1959.
- 61 Bazille to his parents, Feb. 1866; see Poulain, op. cit., p. 62. Monet lived with Bazille from Jan. 15, 1865 to Feb. 4, 1866.
- 62 Bazille to his parents, beginning 1866; ibid. p. 63.
- 63 Cézanne to Pissarro, March 15, 1865; see Cézanne, Letters, London, 1941, p. 68-69.
- 64 See Scolari and Barr, op. cit.
- 65 See E. Moreau-Nélaton: Corot raconté par lui-même, Paris, 1924, v. II, p. 22.
- 66 See Poulain, op. cit. p. 57, also G. Geffroy: Claude Monet, sa vie et son oeuvre, Paris, 1924, v. I, ch. VI, and de Trévise: Le pèlerinage de Giverny, Revue de l'art ancien et moderne, Jan.-Feb. 1927.

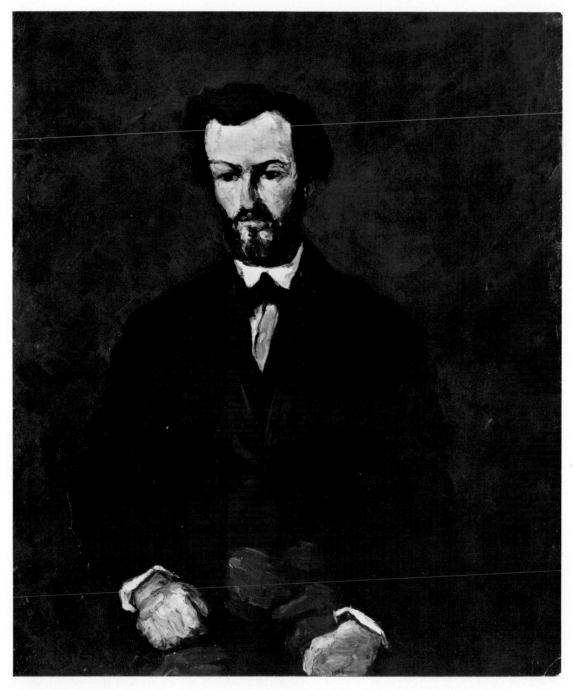

Cézanne: Portrait of Anthony Valabrègue, c. 1866. $45\frac{5}{8} \times 38\frac{5}{8}''$. Probably the painting rejected by the Salon jury in 1866. National Gallery of Art, Washington, D.C. (Paul Mellon Collection).

V 1866-1868

ZOLA AS AN ART CRITIC

ANOTHER WORLD'S FAIR

PLANS FOR A GROUP EXHIBITION

MORE DIFFICULTIES FOR MONET

Among the jury members of 1886 was not only Corot but also Daubigny who, just as Delacroix before him, tried to induce his colleagues to show a more open mind. When Cézanne's portrait of his friend Anthony Valabrègue, a large and rather coarsely painted canvas, came up for decision, Daubigny did his best, to no avail, and Valabrègue informed a comrade: "Paul will without doubt be refused at the exhibition. A Philistine in the jury exclaimed on seeing my portrait that it was not only painted with a knife but even with a pistol. Many discussions already have arisen. Daubigny said some words in defense [of the portrait]. He declared that he preferred pictures brimming over with daring to the nullities which appear at every Salon. He didn't succeed in convincing them."

This new rejection did not come unexpectedly to Cézanne. It may have disturbed him even less than in former years, since Daubigny's "pupil," Guillemet, whom he met at the *Académie Suisse*, had just shown some of his still lifes to Manet, who considered them "powerfully handled." Thereupon Cézanne had paid a visit to Manet, and the latter had promised to call on him in his own studio. "Cézanne is very happy about this," Valabrègue recorded, "though he does not expatiate about his happiness and does not insist on it as is his wont."

Manet himself had not been more successful this year than Cézanne. Apparently considering that its previous tolerance toward him had not been sanctioned either by the critics or the public, the jury rejected the two canvases Manet had submitted. Guillemet and several other young artists of the "realist school" had similar experiences. Monet, however, had both his Camille and a Road in Fontainebleau Forest accepted, while his friend Bazille saw his apprehensions justified: his Girl at the Piano was rejected and only the Still Life of Fish, for which he cared less, was admitted to the Salon. As Renoir had done before, Bazille designated himself in the catalogue as "pupil of Gleyre," and so did Sisley, who exhibited two paintings. Of the group of four from Gleyre's studio, only Monet never publicly indicated his former teacher.

Pissarro (now once more simply "pupil of Melbye") this time had but one landscape

accepted; Berthe Morisot again had two in the exhibition. Degas showed a steeplechase scene, a large canvas with galloping horses and a fallen jockey for whom his brother had posed. Whereas the head of this jockey is very delicately painted and shows similarities with the artist's previous work, the rest of the composition startles by an extreme freedom of execution—the horses are contoured by sweeping outlines —as well as of color, particularly in the two jockeys astride. The many drawings Degas made for this picture reveal him concerned either with a meticulous approach or nervous and summary hatchings, as if torn between the styles of Ingres and Delacroix. The fact is that, at a much later date, the artist reworked parts of the painting, and this explains the more freely brushed sections. In any case, Degas here had followed the general rules of which Bazille apprised his parents: "In order to be noticed at the exhibition, one has to paint rather large pictures that demand very conscientious preparatory studies and thus occasion a good deal of expense; otherwise one has to spend ten years until people notice you, which is rather discouraging."3 In spite of its large size, however, and of its unusual and masterly treatment, Degas' entry does not seem to have been mentioned in any Salon reviews.

According to a letter by the sister of Jules Le Coeur (who saw his own two paintings accepted), Renoir submitted—besides a landscape with two figures—a canvas which he himself considered a sketch and which he had done rapidly at Marlotte. He was so anxious to learn the outcome of their deliberations that he went to the *Palais de l'Industrie* and waited there for the jury members' departure. But when he caught sight of Corot and Daubigny, he felt too timid to ask them about his landscape; instead, he introduced himself as a friend of Renoir, inquiring whether his work had been accepted. Daubigny immediately remembered the painting, de-

Degas: Studies for Steeplechase—The Fallen Jockey, 1866: Jockey, pastel, $10\frac{3}{8} \times 13\frac{5}{8}"$; Running Horses, charcoal, $10\frac{7}{8} \times 17"$, both collection Mr. and Mrs. Paul Mellon, Upperville, Va.; Horse, pencil, $9 \times 14"$, Sterling and Francine Clark Art Institute, Williamstown, Mass.

Opposite, Degas: Steeplechase—The Fallen Jockey, $70\frac{7}{8} \times 59\frac{7}{8}$ ". Exhibited at the Salon of 1866; retouched by the artist at a later date. Collection Mr. and Mrs. Paul Mellon, Upperville, Va.

scribed it to Renoir and added: "We are very disappointed on your friend's account, but his picture is rejected. We did everything we could to prevent it, we asked for that picture again ten times, without succeeding in getting it accepted; but, what do you expect, there were six of us on his side against all the others. Tell your friend not to become discouraged, that there are great qualities in his picture. He should make a petition and request an exhibition of *Refusés*."

It is not known whether Renoir heeded this advice, or whether Bazille, Guillemet, or Manet protested against their rejections. Cézanne, however, did so. When his first letter to the Superintendent of Fine Arts, Count Nieuwerkerke, remained unanswered, he unhesitatingly mailed a second, dated April 19, 1866.

"Sir," wrote Cézanne, "Recently I had the honor of writing to you concerning the two pictures that the jury has just turned down. Since I have had no reply, I feel compelled to insist on the motives which caused me to apply to you. As you have no doubt received my letter, I need not repeat here the arguments that I thought necessary to submit to you. I shall content myself with saying once more that I cannot accept the unfair judgment of colleagues whom I myself have not commissioned to appraise me. I am, therefore, writing to you to emphasize my demand. I wish to appeal to the public and show my pictures in spite of their being rejected. My desire does not seem to me extravagant, and if you were to ask all the painters in my position, they would reply without exception that they disown the jury and that they wish to take part in one way or another in an exhibition which should be open as a matter of course to every serious worker. Therefore, let the Salon des Refuses be re-established. Even were I to be there alone, I ardently desire the public to know at least that I do not wish to be confused with those gentlemen of the jury any more than they seem to wish to be confused with me. I hope, Monsieur, that you will not choose to remain silent. It seems to me that any decent letter deserves a reply."5

This letter, which appears to reflect the attitude of the entire group, was no more favorably received than its forerunner. If Cézanne was honored by an answer, its tenor can be deduced from the marginal note made by an official on his letter: "What he asks is impossible. We have come to realize how inconsistent with the dignity of art the exhibition of the *Refusés* was, and it will not be repeated."

There can be no doubt that Cézanne, in writing his letter, was aided by his old comrade Zola, whose skillful journalistic mixture of impertinence, pride, and mockery can be detected without difficulty. Even before Cézanne had joined him in Paris, Zola had shown a great interest in art, but ever since he had visited the Salon des Refusés in the company of Cézanne (who also took him to the studios of some friends), the problems of the new movements in art had preoccupied him intensely. Through Cézanne he had made the acquaintance of Pissarro, Guillemet, and others in whose company Manet's paintings were often discussed and, while employed at the Hachette publishing house, had met Duranty, who also had spoken to him of Manet. In December 1865, having published a rather sentimental novel dedicated to Cézanne, La Confession de Claude, which did not attract great attention, Zola had had his first brush with the Imperial censors, his work being denounced as immoral. But the report by the ministry of Justice, while pointing out that the young writer had contributed to a newspaper suppressed by court judgment, nevertheless concluded that he had "no trenchant political opinions and his ambition seems to be primarily

Ingres: Count Nieuwerkerke, d. 1856. Pencil heightened with white, $13\frac{1}{8} \times 9\frac{1}{2}$ ". Fogg Art Museum, Cambridge, Mass. (G. L. Winthrop Bequest).

Solari: Bust of Emile Zola, c. 1866. Plaster. Collection Dr. J. E. Zola, Paris.

a literary one." Zola, however, thereupon had left Hachette early in 1866 to become a book reviewer for the daily L'Evénement, newly founded by Henri de Villemessant, who was also director of Le Figaro.

Already in 1865, Zola had discussed Proudhon's posthumously published Du principe de l'art et de sa destination sociale and had visited Courbet's studio before attacking in the name of independence the theories of that master's friend. To Proudhon's definition of art, "an idealistic representation of nature and of ourselves, with a view to the physical and moral perfecting of our species," he had opposed his own concept of a work of art as a "bit of creation seen through the medium of a powerful temperament." Zola had stressed the importance of "temperament" just as Baudelaire had stressed it in admiring Manet, and he had stated that his own admiration for Courbet was not conditioned by the painter's social views but by the "energetic manner in which he has grasped-and conveyed nature."

From long discussions with Cézanne and his friends, Zola had drawn the conclusion that an artist "exists by virtue of himself and not of the subjects he has chosen." "The object or person to be painted are pretexts," he had written. "Genius consists in conveying this object or person in a new, more real or greater sense. As for me, it is not the tree, the countenance, the scene which touches me: it is the man I find in the work, the powerful individual who has known how to create, alongside God's world, a personal world which my eyes will no more be able to forget and which they will recognize everywhere."

These convictions Zola decided to emphasize in a long series of articles after he had learned of the numerous rejections by the jury and had witnessed the failure of Cézanne's appeal for a new Salon des Refusés. He obtained upon request a special assignment to review the Salon of 1866 for L'Evénement and set to work even before the Salon had been opened. In a short notice announcing his articles he proclaimed, concerning the jury: "I have a violent suit to bring against it. I shall no doubt annoy many people, as I am quite resolved to speak awkward and terrible truths, but I shall experience an inner satisfaction in getting off my chest all accumulated rage." "8

Zola's first two articles dealt with the jury, with its election by those who did not have to submit works themselves, the manner in which it passed judgment, mostly guided by indifference, jealousy, rancor, or design, and the principles (or lack of principles) according to which it "hacks at art and offers the crowd only the mutilated corpse." His exposé culminated in a request for a new Salon des Refusés: "I entreat all my colleagues to join with me, I should like to magnify my voice, to have supreme power to obtain the reopening of those exhibition rooms where the public would judge the judges and the condemned in turn." (Zola was not the only one to advance this claim; there was even a Senator, the Marquis de Boissy, who publicly demanded that the Salon des Refusés be re-established.)

No sooner had he begun his series of articles than Zola paid a visit to Manet, to whom he had been introduced previously—it seems—by Guillemet and Duranty. In the painter's studio he examined the rejected canvases together with earlier works and discussed with Manet his views and his attitude in the face of the laughing public. This visit left Zola with a deep impression of the man and his talent. He now wrote a special article devoted to the rejected artist, an unheard-of procedure for a Salon review. Analyzing Manet's personality, Zola went so far as to predict: "M.

Manet's place in the Louvre is marked out, like that of Courbet, like that of any artist of original and strong temperament."9

In order to prove that he was not in favor of any special school or group, Zola, in the next article, made a study of the realists at the Salon. "The word 'realist' means nothing to me who asserts that the real should be subordinated to temperament," he said, explaining that he cared little for a "realistic subject" if it was not treated in an individual manner. He gave high praise to Monet, whom he did not yet know personally but of whom Cézanne and Pissarro must have spoken. "Here is a temperament, here is a man in the midst of that crowd of eunuchs!" he exclaimed, "... a delicate and strong interpreter, who knows how to convey each detail without falling into dryness."

Meanwhile, however, the editorial office of L'Evénement had been flooded with letters of protest, indignation, and threat, demanding it "improve the criticism a little by placing it in hands that have been washed." Obliged to satisfy his readers, the editor made a compromise with Zola whereby the latter was to publish only three more articles (instead of the dozen still planned), while a critic of less heretical convictions was allotted the same number so that he might cover with glory the official artists whose talent Zola denied. But Zola, disgusted, did not even take advantage of this arrangement and contented himself with two more articles. In one he discussed the decline of some of the masters he admired—Courbet, Millet, and Rousseau—accusing them of having lost much of their vigor and explaining the success they now had on the grounds that "the admiration of the crowd is always in indirect ratio to individual genius. You are the more admired and understood as you are the more ordinary."

Courbet, indeed, achieved an unexpected prosperity at the Salon. "I saw Courbet yesterday," Bazille wrote to his parents in April 1866; "he swims in gold. This is what fashion can do! In all his life he has not sold more than 40,000 francs worth of paintings. It's true that this year he exhibits some very beautiful things, yet they are certainly inferior to his *Bathers*, his *Demoiselles de la Seine* [p. 30], etc. The public, however, has made up its mind to prepare a success for him, and since the opening of the Salon he has sold more than 150,000 francs worth of pictures. His drawers are bulging with bank notes; he doesn't know anymore what to do with them. All the collectors besiege him, rummage through a lot of dust-covered old stuff and frantically compete for it." This sudden infatuation obviously rendered the painter suspicious in Zola's eyes.

Zola devoted his last article to a few comments on the artists at the Salon whom he esteemed, Corot, Daubigny, and especially Pissarro (the last admitted only after great difficulties, overcome apparently by Daubigny's insistence). "M. Pissarro is an unknown, about whom no one will probably talk," wrote Zola. "I consider it my duty to shake his hand warmly, before I leave. Thank you, Monsieur; your winter landscape refreshed me for a good half hour, during my trip through the great desert of the Salon... You should realize that you will please no one, and that your picture will be found too bare, too black. Then why the devil do you have the arrogant clumsiness to paint solidly and to study nature frankly.... An austere and serious kind of painting, an extreme concern for truth and accuracy, a rugged and strong will. You are a great blunderer, sir—you are an artist that I like."

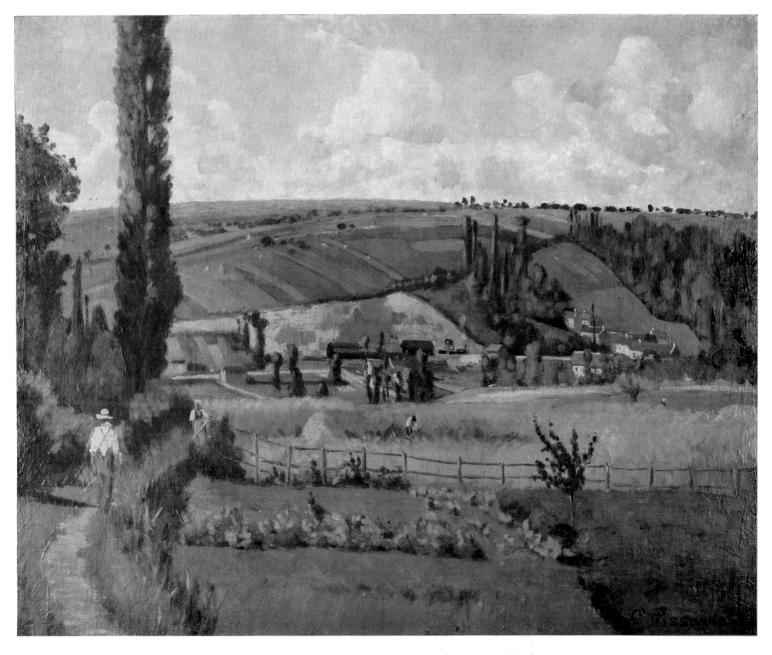

Pissarro: Landscape near Pontoise, d. 1868. $31_8^7 \times 39_8^3$ ". Collection David Rockefeller, New York.

CÉZANNE: Self Portrait, 1865-66. $17\frac{3}{4} \times 16\frac{1}{8}''$. Formerly in the collection of Emile Zola. Collection René Lecomte, Paris.

It may seem surprising that Zola nowhere mentioned Cézanne, not even among those painters toward whom the jury had been too harsh. But in those days he considered Cézanne still far from having given the full measure of his genius, especially since the artist himself very seldom showed satisfaction with his paintings. Therefore Zola apparently preferred to await some major works. However, when he reprinted his articles in a small brochure, published in May 1866, under the title Mon Salon and with the motto: "What I seek above all in a picture is a man and not a picture," Zola wrote a special preface in letter form, To My Friend Paul Cézanne. In it he exalted their ten-year-old friendship. "You are my whole youth," he said. "I always find you mingled in each of my joys, in each of my sufferings. Our minds, in their kinship, developed side by side.... We turned over a mass of shocking ideas, we examined and rejected all systems, and after such strenuous labor, we told ourselves that outside of powerful and individual life there was nothing but deceit and stupidity."¹² And Cézanne, in reply to this tribute which established his spiritual collaboration upon Mon Salon, painted with the palette knife a huge portrait of his father reading a newspaper that bears in large letters the masthead L'Evénement.

Of all the friends who exhibited at the Salon, it was again Monet who obtained the greatest success, although his works were badly hung. Zola had not been the only one to recognize his powerful talent; Bürger praised both *Camille* and the *Road in*

Cézanne: Portrait of the Artist's Father Reading "L'Evénement," 1866. $78\frac{3}{4} \times 47\frac{1}{4}$ ". National Gallery of Art, Washington, D.C. (Gift of Paul Mellon).

MONET: Camille with a Small Dog, d. 1866. 28\frac{3}{4} \times 21\frac{1}{4}". Collection Bührle Family, Zurich.

Fontainebleau Forest, stating that "when one is truly a painter, one does all that one wishes." Castagnary also wrote a few well-meaning lines, commending Monet as a new recruit to the camp of the "naturalists," under which term he united "the whole idealistic and realistic younger generation." Even those reviewers who disliked Camille devoted considerable space to it, and Astruc finally managed to introduce the young artist to Manet, who received him with the same friendliness he had shown Cézanne shortly before. Monet's success was complete when E. d'Hervilly wrote a poem on Camille, published in the periodical L'Artiste, and when he was commissioned to paint a small version of the picture which a dealer intended for the United States. The papers again carried Monet's name to Le Havre and won him once more the esteem of his family. With their esteem came—temporarily at least—a resumption of his allowance.

The designation "naturalist," coined by Castagnary as early as 1863, is an eloquent proof of the fact that the efforts of the new generation could no longer be covered by the word "realism." Courbet, and especially Proudhon, had narrowed its sense to such an extent that it applied less to a concept and a technique than to subject matter. Manet's romantic interest in Spain, the other painters' almost exclusive devotion to landscape, their complete disregard for the social implications of their subjects, made it necessary to create a new word for them.

"The naturalist school," Castagnary explained, "declares that art is the expression

Monet: Camille (The Green Dress), d. 1866. $91\frac{1}{2} \times 60''$. Exhibited at the Salon of 1866. Kunsthalle, Bremen.

of life under all phases and on all levels, and that its sole aim is to reproduce nature by carrying it to its maximum power and intensity: it is truth balanced with science.

—The naturalist school re-establishes the broken relationship between man and nature. By its twofold attempt, in the life of the fields, which it is interpreting with so much uncouth force, and in town life, which reserves for it the most beautiful triumphs, the naturalist school tends to embrace all the forms of the visible world. It has brought back to their true role line and color, which in these works are no longer separable. By placing the artist again in the center of his time, with the mission of reflecting it, it determines the genuine utility, in consequence, the morality of art."

"Whence does it come?" Castagnary asked. "It is the outcome of the very depths of modern rationalism. It springs from our philosophy which, by putting man back into society from which the psychologists have withdrawn him, has made society the principal object of our scrutiny from now on. It springs from our ethics which, by putting the commanding idea of justice in place of the vague law of love, has established the relationship between men and illuminated with a new gleam the problem of destiny. It springs from our politics which, by positing as a principle the equality of individuals and as a *desideratum* the equalizing of conditions, has caused false hierarchies and deceptive differentiations to disappear from the mind. It springs from all that is ourselves, from all that makes us think, move, act." 16

And Castagnary added: "Naturalism, which accepts all the realities of the visible world and, at the same time, all ways of understanding these realities, is... the opposite of a school. Far from laying down a boundary, it suppresses all barriers. It does not do violence to the temperament of painters, it liberates it. It does not bind the painter's personality, but gives it wings. It says to the artist: 'Be free!' "17

Manet and his circle, however, seem to have cared little for this designation, though Zola was to take it up with fervor and use it both in connection with his artist friends and with his own literary tendencies. Yet, whether they considered themselves "naturalists" or not, it remains true that Castagnary's definition applied extremely well to the efforts of the young painters.

Monet, meanwhile, continued to devote himself undisturbed to what he called "experimenting with effects of light and color." In Ville d'Avray near St. Cloud, where he spent the summer of 1866 (and where Corot usually lived), he decided to execute a large painting with figures entirely in the open. For this purpose he had a trench dug in his garden, into which he could lower a huge canvas so as to work at the upper part. In this way he painted Women in the Garden (p. 169), for which Camille posed, while Courbet came from time to time and watched with amusement. When Courbet found him idle one day and asked the reason, Monet explained that he was waiting for the sun. "Never mind," the other answered, "you could always do the landscape background." Monet, however, did not accept this advice, for he knew he could obtain complete unity only if the whole painting was executed under identical conditions of light; otherwise, there seemed no reason to go to the trouble of doing it out-of-doors.

In 1867, Monet decided to do some cityscapes—Renoir soon did the same—and was working on a balcony of the Louvre palace, from which he painted a view of the church of St. Germain l'Auxerrois, as well as of the Garden of the Princess with the Pantheon in the background. This canvas he sold to Latouche, who had a small

Carolus-Duran: Portrait of Claude Monet, d. 1867. 18 1/8 × 15". Musée Marmottan, Paris (Bequest of Michel Monet).

Monet: Garden of the Princess, Paris, 1867. $36\frac{1}{8} \times 24\frac{3}{8}$ ". Allen Memorial Art Gallery, Oberlin, Ohio.

151

paintshop on the corner of rue Laffitte and rue La Fayette where his artist customers used to meet in the evening. Latouche also occasionally bought their works and exhibited them in his window. When he thus displayed Monet's *Garden of the Princess* to passers-by, Daumier impatiently summoned him to take this "horror" out of the window, while Diaz manifested great enthusiasm and predicted that Monet would go far. Manet also stopped in the street, it seems, and said disdainfully to some friends: "Just look at this young man who attempts to do 'plein air'! As if the ancients had ever thought of such a thing!" ²⁰

At that time Monet's work was being done with large brushes in rapid strokes; he applied colors thickly and enjoyed the rough texture of the pigment. He vigorously insisted on forms, yet treated them mostly as flat surfaces offset by deep shadows. Although these shadows were no longer bituminous, as in official Salon pictures—they were, in fact, sometimes surprisingly light in tone—their heavy masses divided the canvas brutally into lighted and unlighted areas. His opaque colors depicted light without being themselves penetrated by it. In combination with these opaque colors Monet occasionally resorted to the use of bright, pure blues, reds, or yellows, the vivid accents of which enliven the entire composition. Around 1867 the artist painted Terrace at the Seaside near Le Havre, in which he not only made extensive use of such unmixed colors but also adopted in various places short, small strokes which dot the canvas in an attempt to reproduce textures as well as vibrations of light. He had used the same technique for the blooming chestnut trees in front of St. Germain l'Auxerrois, opposing the dotted foliage to the more or less uniform masses of architec-

Monet: St. Germain l'Auxerrois, Paris, d. 1866 but painted 1867. $32 \times 39_8^3$ ". Nationalgalerie, Berlin-Dahlem.

Photograph of the same subject (1938).

Monet: Terrace at the Seaside near Le Havre, c. 1867. $37_8^7 \times 50_8^{3''}$. (Painted on the property of the artist's family; his father is in the right foreground.) Metropolitan Museum of Art, New York.

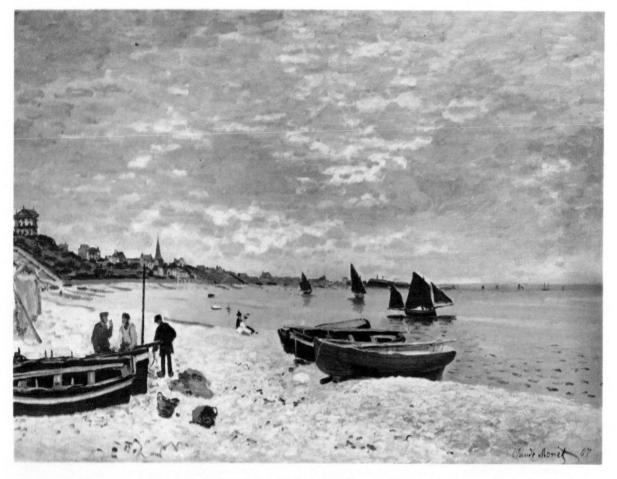

Monet: Beach at Sainte-Adresse, d. 1867. $22\frac{1}{4} \times 32\frac{1}{4}$ ". Art Institute of Chicago (Mr. and Mrs. L. L. Coburn Collection).

ture and sky. Through his colors and his execution, as well as through his somewhat unsentimental approach to nature, Monet overcame Courbet's influence and began to adapt the latter's "broad principles" to a vision and technique all his own.

Curiously enough, at the very moment when Monet was leaving Courbet's path and when the master himself, to his admirers' regret, was beginning to show a tendency toward the pretty which earned him compliments even from Cabanel, Courbet's impact on Monet's friends appeared stronger than ever. Sisley alone seemed to escape it, his faithfulness to Corot being not only a question of conviction but also of disposition. But Renoir, Pissarro, and Cézanne were now all trying in one way or another to appropriate those "broad principles" of Courbet's earlier works, not hesitating even to imitate his palette-knife technique. Cézanne, whose vision was scarcely affected by direct studies of nature, marveled at Courbet's "unlimited talent, for which no difficulty exists," and tried to combine the master's vigor with his own admiration for the Spanish. Unlike the author of Olympia, however, Cézanne's inspiration was derived not from virtuosos like Velázquez and Goya; his preference

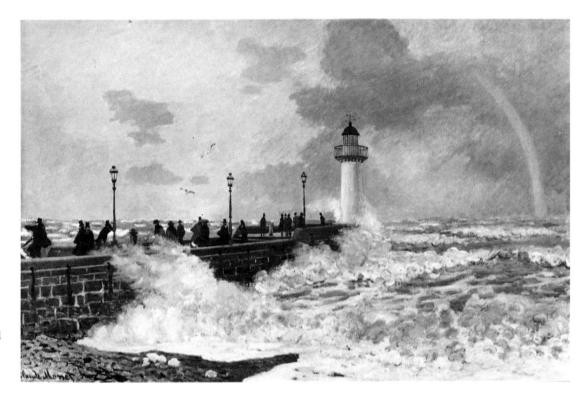

Monet: Jetty at Le Havre, c. 1868. $57\frac{7}{8} \times 89$ ". Probably the painting rejected by the Salon jury in 1868. Private collection, Japan.

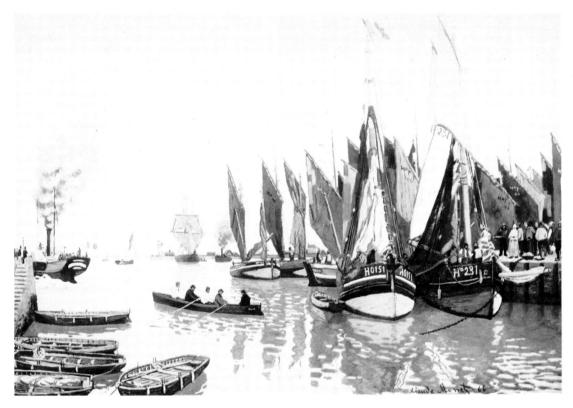

Monet: Steamer and Fishing Boats in the Harbor of Honfleur, d. 1866. $59\frac{1}{2} \times 91$ ". Probably the painting exhibited at the Salon of 1868. Present whereabouts unknown.

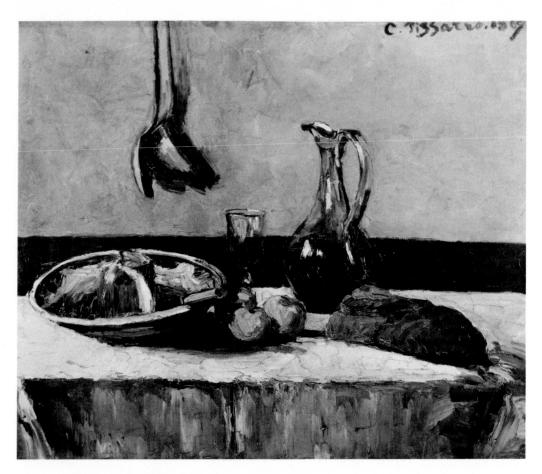

Pissarro: Still Life, d. 1867. 32 \times 39½". Toledo Museum of Art, Ohio.

was for the more dramatic effects of Zurbarán and Ribera, whose chiaroscuro contrasts Cézanne attempted to impregnate with Courbet's monumental simplifications and with colors that show occasional indebtedness to Manet.

In a letter written to Zola in the fall of 1866 Cézanne explained that "pictures painted indoors, in the studio, will never be as good as things done outside. When out-of-door scenes are represented, the contrast between the figures and the ground is astounding and the landscape is magnificent. I see some superb things and I shall have to make up my mind to do only things out-of-doors."²³ But Cézanne did not make up his mind, and among his works of this period there are few that appear to have been done in the open.

Oscillating between observation and the strange and violent dreams with which his imagination seemed to overflow, Cézanne sometimes succeeded, sometimes failed to dominate his visions. Yet when he was able to unite the baroque tendencies of his fantasy with the study of reality—and here Courbet's influence seems to have been most salutary—he created works of unsuspected power. His chromatic sensibility

Cézanne: Still Life, c. 1870. $24\frac{7}{8} \times 31\frac{1}{2}$ ". Musée du Louvre, Paris.

indulged in vibrant contrasts; his still lifes and portraits, as compared with those of Manet and Monet, show an even greater simplification of forms, a bolder technique and stronger oppositions of color. Cézanne "is growing greater and greater," a friend of his wrote in 1866. "I truly believe that of us all it is he who will turn out to have the most violent and powerful temperament. Nevertheless he is continually discouraged."²⁴ But whenever his doubts were mastered, Cézanne's works reflected a superb self-confidence and audacity, though his style varied between diametrically opposed modes of expression, revealing him in search of an appropriate technique. Portraits done with a palette-knife alternated with imaginary scenes such as *Abduction*, which he gave to Zola and in which he used small, comma-like brushstrokes, whereas his still lifes were painted with large brushes in big strokes. "Cézanne keeps on working violently and with all his might to regulate his temperament and to impose upon it the control of cold science,"²⁴ commented one of his friends.

Pissarro was likewise attracted by Courbet's palette-knife methods and executed a few canvases in this technique, among them a still life that bears a strong resemblance

to Cézanne's treatment of analogous themes. It is likely, however, that Pissarro's painting was done before Cézanne adopted a similar style of expression. But Pissarro abandoned it soon, since his sensitivity and perception called for a more subtle representation of nature. He had settled down in 1866 at Pontoise, not far from Paris, where the hills around the town, the orchards and the Oise River offered a great variety of tranquil subjects. He depicted these sometimes in large canvases reminiscent of Courbet, although he preferred broad brushes to the palette-knife and chose a scale of subdued colors, browns and greys and various low greens, never using the colors pure as they came from the tube. Though large in size and execution, his canvases still retain some of the intimate quality of Corot as opposed to the more robust character of Courbet.

Some of the others, too, succumbed for a moment to this robust character, a fact of which Bazille's portrait of Sisley and early works by Pissarro's friend Guillaumin bear proof; even Degas, in *Mlle Fiocre in the Ballet "La Source"* (see p. 175), is revealed to have carefully studied Courbet's colors. As to Renoir, his work possibly owed more to the Master of Ornans than that of any of the others. While Monet and his friends thus absorbed to various degrees the influence of Courbet and while they endeavored to find in the master's art those elements that might help them to develop

Left, Cézanne: The Negro Scipion, 1866-68. 42 × 33½". Formerly collection Claude Monet. Museu de Arte Moderna, São Paulo, Brazil. Right, Cézanne: Abduction, d. 1867. 35¼ × 46". Formerly collection Emile Zola. Collection J. M. Keynes, London.

 $P_{ISSARRO}: \textit{The Hermitage at Pontoise}, c.~1867.~59\frac{1}{8}\times78\frac{3}{4}\text{ ". Solomon R. Guggenheim Museum, New York (Gift of Justin K. Thannhauser)}.$

and define their own personalities, Whistler, in England, tried to turn away from his past. He, too, had profited from Courbet and since 1859 had gone through similar experiences; he had last worked beside Courbet at Trouville in 1865, but two years later, after long self-examination, he began to deny his indebtedness to Courbet and to curse "Realism."

"The period when I came [to Paris] was very bad for me!" he exclaimed in a letter to Fantin. "Courbet and his influence were disgusting. The regret I feel and the rage and even hatred that I have for that now would perhaps astonish you, but here is the explanation. It isn't poor Courbet who revolts me, nor is it his works. I admit, as always, their qualities. Nor am I complaining of the influence of his painting on mine. There wasn't any, and none will be found in my canvases. It couldn't be otherwise, for I am very personal and I was rich in qualities which he had not and which were adequate for me. But here is why all that was extremely harmful for me. It is because that damned Realism made an immediate appeal to my painter's vanity and, sneering at all traditions, cried aloud to me with the assurance of ignorance: 'Long live Nature!' Nature, my dear boy, that cry was a great misfortune for me. Where could one find an apostle readier to accept this thesis so convenient for him, this sedative for all restlessness? Why, the fellow had only to open his eyes and paint what happened to be before him, beautiful nature and the whole mess. It was just that! Well, one would see! And we saw the Piano, The White Girl, the Thames [pp. 32, 87, 51], the view of the sea..., that is, canvases produced by a spoiled

Fantin-Latour: Still Life, d. 1866. $23\frac{1}{4} \times 28\frac{3}{4}$ ". Exhibited at the Salon of 1866. National Gallery of Art, Washington, D.C. (Chester Dale Collection).

Renoir: Bouquet of Spring Flowers, d. 1866. $41\frac{1}{2} \times 31\frac{1}{2}$ ". Formerly in the Le Coeur collection. Fogg Art Museum, Cambridge, Mass. (Grenville L. Winthrop Bequest).

child swollen with the vanity of being able to show other painters his splendid gifts, qualities requiring only strict training to make their possessor a master, at this moment, and not a debauched schoolboy. Oh, my friend, if only I had been a pupil of Ingres! I don't say this out of enthusiasm for his pictures. I like them only moderately.... But, I repeat, if only I had been his pupil! What a teacher he would have been! How he would have guided us sanely!"²⁵ And Whistler went on, loathing color, "the vice," which had made him neglect drawing.

In his distress Whistler evidently forgot that the strict training he desired was not the work of a teacher but of the pupil's own discipline. Manet's long apprenticeship at the *Ecole des Beaux-Arts* had failed to impregnate him with those Ingresque prin-

ciples of drawing which now appeared to Whistler as ultimate salvation; and Degas' work outside the *Ecole* had not prevented him from remaining closer to Ingres than any of the master's direct pupils. Their education had been entirely their own, as was that of Monet and his friends, who had chosen to heed Courbet's call to nature. The development of their personalities was not due to their strict adherence to any teacher's doctrines but to the choice they had made from what their elders offered, to their adopting only what suited their own temperaments and remaining free to go their own ways. What Whistler did not grasp was that nature, too, imposed "strict training" on those who knew how to approach it. By turning his back to nature, by ignoring Courbet's message, Whistler henceforth condemned himself never to penetrate beneath the surface of appearances, to be satisfied with decorative arrangements. Instead of acquiring a discipline, he succumbed on the contrary to a dexterity which checked any progress. It was precisely the absence of contact with nature that favored the development of his virtuosity and induced him to put taste above creative power.

Whistler's friend Fantin was also to take a course that led him away from nature and imprisoned him in a formula which lacked both imagination and strength. Abandoning positive colors and vivid brushwork, he endeavored in portraits and still lifes to renounce his own personality in order to obtain an almost photographic precision. Whether this was the result of too many copies done in the Louvre is hard to judge, but the fact remains that his works began more and more to acquire a lusterless quality of meticulous and uninspired reproduction. Thus these two artists who at the start had found themselves on the path of realism and had given great promise, little by little abandoned the group of their former companions and detached themselves from a movement of which they might have become eminent representatives. The others meanwhile pursued the study of nature, often under very difficult conditions, but with the unalterable conviction of progressing in the right direction, which gave them the courage to endure adversity and proceed without hesitating.

Renoir continued to follow Courbet's example or to disregard it, according to his fancy. Apparently unable yet to grasp the exact nature of his manifold gifts, he seems to have tried his hand at various modes of expression. Less ready than Monet to disregard the heritage of the past, desirous rather to remain within the framework of tradition instead of breaking away from it, he at this time went through a phase of experimentation. Averse to everything even slightly methodical, Renoir was far from Monet's single-mindedness of purpose and thought nothing of essaying a wide range of styles, from Courbet's palette-knife to almost academic conceptions. It is probable, however, that he did so not out of hesitancy but because he wanted to acquaint himself with different methods and because his amazing facility permitted him to oscillate between extremes without much effort. His casual attitude could have disconcerted his companions had they not known that Renoir was somehow never too "serious" about what he did. There was no "system" in his evolution; he always felt perfectly free to follow his whim wherever it might lead him, ready to look for new solutions should he not find satisfaction in any given direction. He knew nothing of Manet's ambition and hurt pride because he had neither ambition nor pride. He was spared Cézanne's burning doubt and Monet's bitter struggles, the selfconsciousness of Degas and the solemn eagerness of Bazille, because he was neither

Photograph of Whistler.

Courbet: Cliffs at Etretat after the Storm, 1869-70, d. 1870. $51\frac{1}{4}\times62''$. Musée du Louvre, Paris.

Renoir: Jules Le Coeur in Fontainebleau Forest, d. 1866. $41\frac{3}{4} \times 31\frac{3}{4}$ ". Museu de Arte Moderna, São Paulo, Brazil.

DIAZ: View of the Forest. Hermitage Museum, Leningrad.

introspective nor an introvert; in spite of his utter poverty he was carefree and gay because he found complete happiness in his work. As he had already told Gleyre, he painted for his own enjoyment, and his pleasure amply justified the various styles which he took up as enthusiastically as he dropped them. Even if a work did not fulfill his expectations, no minute ever seemed lost to him if spent with brushes and paints.

In Fontainebleau forest, Renoir had painted with the palette-knife some land-scapes which were closer to Courbet than almost anything done by the rest of the group, but this technique did not satisfy him because it prevented him from retouching any part of his canvas without first scraping it. These landscapes were therefore succeeded by a large flower still life in delicate shades, executed with a smooth brushwork that shows a certain relationship to the still lifes Fantin was then beginning to paint; except that Fantin's were not devoid of a certain dryness, whereas Renoir handled the subject with tenderness and a subtle feeling for textures. Yet he thought once again of Courbet's more fluent and sweeping brush strokes, the forceful manner in which he enlivened large surfaces and modeled forms, when he painted a first portrait of his young mistress, *Lise Sewing*. She was the sister of Jules Le Coeur's

companion, Clémence Tréhot, daughter of a former country postmaster now living in Paris, and had turned eighteen in the spring of 1866.²⁶ A little later she sat for a large nude, *Diana*, which—though showing her outdoors, at the edge of Fontaine-bleau forest—must have been painted in the studio. The composition features a dead deer, almost a trademark of Courbet (introduced here to transform a simple nude into a goddess with recognizable attributes); but more important, Renoir suddenly returned in this painting to Courbet's palette-knife technique while strangely combining realism and academicism without taking full advantage of the former or escaping the dangers of the latter. He might have hoped that such a compromise would once more open the doors of the Salon to him but was already too fond of nature to engage further in a direction that prevented his spontaneity from expressing itself.

Renoir's liaison with Lise may have tightened his friendship for Jules Le Coeur, with whose family he and Sisley spent the month of August 1866 at Berck on the Channel coast, though they obviously did not take their mistresses along for fear of shocking Le Coeur's relatives. As for Sisley (who presented Lise with a small Corotlike landscape, reproduced p. 99), he too had fallen in love and, that same year, married a twenty-six-year-old girl from Toul, Marie Lescouezec, possibly for the sake of their first child, to be born in 1867.

Back in Paris, Renoir moved in with Bazille, who had rented a studio in the rue Visconti, near the Seine, whereas Sisley settled with his wife in the rue Moncey, not far from the Place Clichy and the Batignolles quarter.

COURBET: Portrait of P.-J. Proudhon and His Family, 1865-67. (Detail.) Musée des Beaux-Arts de la Ville de Paris.

Renoir: Lise Sewing, c. 1866. 22 × 18½". Collection Mr. and Mrs. Emery Reves.

After having finished or almost completed his Women in a Garden at Ville d'Avray, Monet left that spot for Le Havre in the fall of 1866, apparently to escape his many creditors. With a knife he slit the canvases he could not take with him, about two hundred according to his own estimate,²⁷ but even this did not prevent them from being seized and sold in lots of fifty at 30 francs a lot. In Le Havre, Monet could not manage to solve his financial embarrassments any better than in Ville d'Avray. In order to continue work he begged Bazille in December to send him a series of pictures left in Paris so that he might scrape them and use the canvases for new paintings.²⁸

A few weeks later Boudin, then in Paris, received a letter dated from Honfleur in which a friend told him: "Monet is still here at work on enormous canvases, which have remarkable qualities, but which I nevertheless find inferior, or less convincing, than the famous Robe [Camille], which merited him a success that I understand and that is deserved. There is a canvas nearly three meters high with width in proportion: the figures are a little less than life-size; these are women in elegant costume picking flowers in a garden, a canvas begun from nature and out-of-doors. There are qualities in it, but the effect seems to me a little dimmed, no doubt because of a lack of opposition, for the color is vigorous. He is also undertaking a large marine, but it is not yet sufficiently advanced to be able to judge. He has done some rather effective

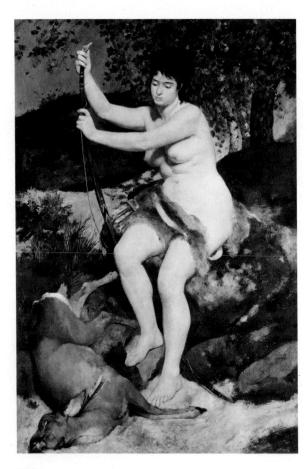

Renoir: *Diana* (Lise), d. 1867. 77 × 51¼″. Rejected by the Salon jury in 1867. National Gallery of Art, Washington, D.C. (Chester Dale Collection).

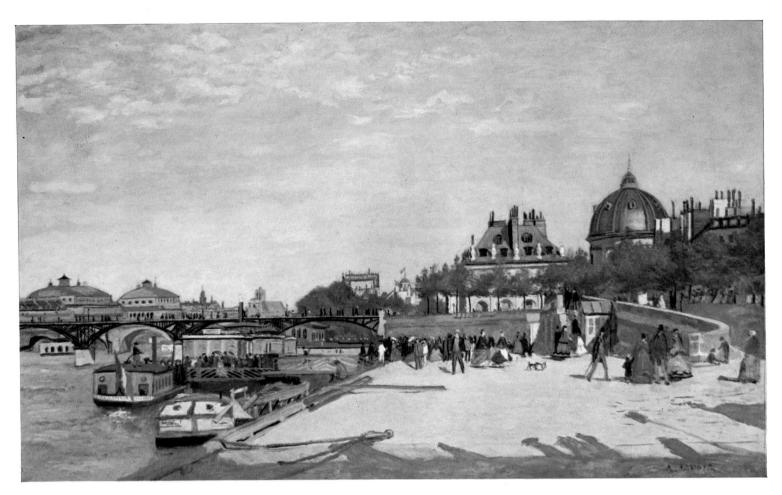

Renoir: The Pont des Arts, Paris, c. 1867. $24\frac{1}{2} \times 40\frac{1}{4}$ ". Norton Simon Foundation, Los Angeles.

snow scenes too. The poor fellow is very anxious to know what is happening in the studios: every day he asks me if I have news of you..."²⁹

What made Monet's position particularly precarious was the fact that Camille was expecting a child and that there seemed nowhere any hope for easier days ahead. To help him, Bazille decided to buy the Women in the Garden for the high price of 2,500 francs, to be paid, however, in monthly installments of 50 francs. Though his wealthy parents provided him with a sufficient allowance and though he was always certain to have a roof and bread—a certainty which his friends must have envied—Bazille was in no position to be generous, and even these 50 francs evidently taxed his monthly budget heavily. But he endeavored to do what he could and readily shared his meals and studio with any one of his three companions from Gleyre's. Yet in spite of his good intentions Bazille's response to letters begging for money was always slow, if it was made at all, a circumstance that often infuriated Monet. Since Bazille did not himself know what it meant to get up in the morning without a single penny in the

house, he somehow failed to realize, especially at a distance, how desperate the situation of his friends frequently was. And there also was a certain monotony in these constant cries for help addressed to him, the only person from whom the others dared expect some relief, a monotony that weakened Bazille's sensitiveness to these appeals. The result was some bitter quarrels with Monet, who reproached him for insufficient promptness; but the discord never lasted long, because Bazille's friendship and affability could not be seriously doubted.

Good will and affability, however, were not sufficient to pull Monet out of his predicament. Bazille's fifty francs a month, and the 200 francs for which Bazille managed to sell a still life by Monet to the Commandant Lejosne, were far from enough for Monet's own needs, not to speak of Camille's. Bazille therefore took it upon him to write directly to Monet's father and to explain to him the dire difficulties in which the son found himself. The answer was polite but in the nature of an ultimatum. Claude Monet was welcome in the house of his father's sister, Mme Lecadre, at Sainte-Adresse; there he would find a room and meals—of money he would receive none. As for Camille, the father calmly suggested that his son separate from her once and for all.³⁰ Obliged to yield, Monet had to leave Camille temporarily in Paris without any financial support, while he went to stay with his aunt in Sainte-Adresse. He could not even raise the train fare in order to visit her after she had given birth to their son Jean, in the month of July. Bazille agreed to be godfather to the child.

If Monet's situation could be further aggravated, this was done by the rejection dealt out to his *Women in the Garden*, submitted to a jury from which both Corot and Daubigny were absent that year. This decision was a particular blow to Monet's hopes of being able to sell some of his works, especially because the Salon of 1867 coincided with a new World's Fair in Paris. It is said that one of the jury members, asked why he was rejecting Monet's entry although the artist was making progress, tartly replied: "It is precisely because he is making progress that I am turning him down. Too many young people think only of pursuing this abominable direction. It is high time to protect them and to save art." 31

After Zola's vigorous campaign the previous year, which was followed by another series of articles on Manet early in 1867 in a periodical edited by Houssaye, the friends had been looking forward with some eagerness to learn the attitude the jury would adopt. Only too soon it became clear what this attitude was, and Zola informed Valabrègue: "Paul [Cézanne] is refused, Guillemet is refused, every one is refused; the jury, irritated by my Salon, has shut the door on all those who take the new road." The fate of Sisley, Bazille, Pissarro, and Renoir (in spite of the academic character of his Diana) was not different from that of the others. Again they signed a petition for a Salon des Refusés, but without believing that it would be granted.

The works submitted by Cézanne actually became the subject of wild rumors and even of a press notice by one Arnold Mortier, reprinted in April in Le Figaro: "I have heard of two rejected paintings done by M. Sésame (nothing to do with the Arabian Nights), the same man who, in 1863, caused general mirth at the Salon des Refusés—always!—by a canvas showing two pig's feet in the form of a cross. This time M. Sésame has sent to the exhibition two compositions which, though less queer, are nevertheless just as worthy of exclusion from the Salon. These compositions are

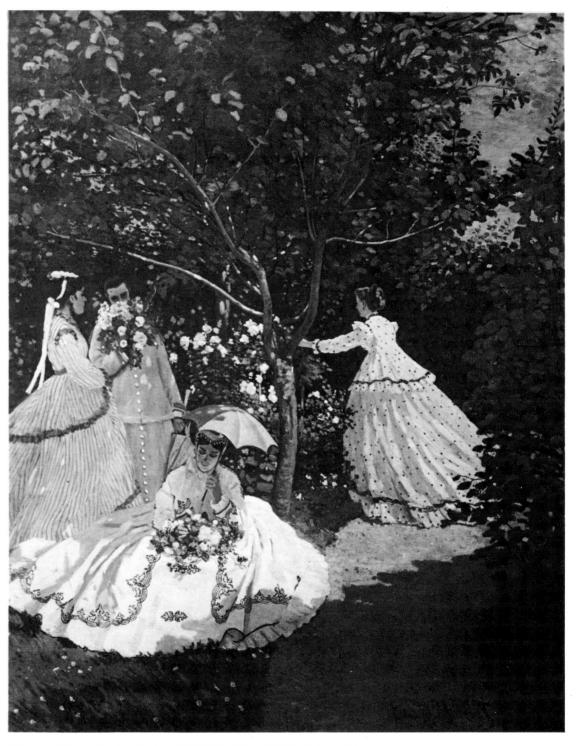

Monet: Women in the Garden, 1866-67. $100_4^4 \times 81_4^3$ ". Rejected by the Salon jury in 1867. Formerly in the collection of Bazille, later in that of Manet. Musée du Louvre, Paris.

CÉZANNE: The Wine Grog or Afternoon in Naples, 1876-77. $5\frac{1}{2} \times 9\frac{1}{2}$ ". Probably related to the painting rejected by the Salon jury in 1867. Present whereabouts unknown.

both entitled *The Wine Grog*. One depicts a nude man to whom a very dressed-up woman has just brought a wine grog; the other portrays a nude woman and a man dressed as a *lazzarone*; in this one the grog is spilt."³³

Zola immediately published a correction in Le Figaro, of which he was then a contributor, L'Evénement having folded after appearing for but one year. He insisted that Cézanne was "one of my childhood friends, a young painter whose strong and individual talent I respect extremely," and denied that he had "the slightest pig's foot in his artistic equipment, at least so far. I make this reservation because I do not see why one should not paint pig's feet just as one paints melons and carrots." Then he took the author to task for having added ironically that he was "convinced that the artist may have put a philosophical idea into his paintings." Obviously ignoring the case of Courbet, whose recent work he held in low esteem, Zola retorted bluntly: "That is an inappropriate conviction. If you want to find philosophical artists, look for them among the Germans, or even among our pretty French dreamers, but know that the analytical painters, the young school whose cause I have the honor to defend, are satisfied with the great realities of nature. Moreover, it is up to M. de Nieuwerkerke that the Wine Grog and Intoxication be exhibited. As you know, a number of painters have just signed a petition demanding the re-opening of the Salon des Refusés. Perhaps some day M. Arnold Mortier will see the canvases which he has so glibly judged and described."33

The Salon des Refusés, however, was not re-established, according to a communication from Count Nieuwerkerke which appeared in the press on April 21, 1867. Of the "young school" defended by Zola, only Degas, Berthe Morisot, Whistler, and Fantin had been successful with the jury; the latter exhibiting a portrait of Manet. Two family portraits by Degas were even commended by Castagnary for the "just sentiment of nature and of life" revealing the "remarkable aptitudes of this débutant." Yet the real point of interest of the exhibition was a memorial show for Ingres, so greatly admired by Degas, who had died earlier that same year. He had lived long

enough to see all that he believed in become synonymous with reaction and had been the powerless protagonist of a tradition that had lost every contact with life. But more important for the new generation were two one-man shows organized by Manet and Courbet.

Weary of constant rejections, Manet had decided not to submit anything to the jury and to follow instead Courbet's example of 1855 by building his own pavilion at the World's Fair where he could hang some fifty of his works.³⁵ Courbet himself did likewise, and their two shows became the center of attraction for anybody interested in the progress of those who had dethroned Ingres.

Zola, who was planning to write a study on Courbet and had asked Manet to illustrate his Contes à Ninon (neither of these projects was carried out), reviewed the official art section of the World's Fair in an article fraught with irony. Pretending to carefully select the artists whose works he planned to study, he allowed that his choice had actually been made by the members of the jury since the medals they had distributed obviously singled out "the flower among our painters, the exquisite masters who honor France, as one says. I am ready to believe that the jury was not in error and thus, speaking of those bemedaled painters, I shall present to my readers all the vivid and energetic personalities of contemporary art, arranged by order of their merit and splendor."³⁶ Zola then proceeded to discuss the "talents" of Meissonier, Cabanel, Gérôme, etc., mincing no words to condemn their anecdotal, uninspired, colorless, academic, painstaking but highly successful products. However, by limiting himself intentionally to the outstanding representatives of conventional art, Zola could not mention the works of his friends, and particularly Manet, as he had done in his previous Salon review. But then he had just published his articles on Manet in a pamphlet and knew, of course, that he would have ample opportunity to evaluate on the occasion of subsequent exhibitions—the efforts of the young school which, in his own words, he had "the honor to defend." Manet's one-man show thus received no specific support from Zola.

An explanatory notice, apparently written by Astruc, pointed out to the visitors of Manet's pavilion: "Since 1861, M. Manet has been exhibiting or attempting to exhibit. This year he decided to offer directly to the public a collection of his works. . . . The artist does not say, today: 'Come and look at works without fault,' but: 'Come and look at sincere works.' It is sincerity which endows works of art with a character that makes them resemble a protest, although the painter has only intended to convey his impression.—M. Manet has never desired to protest. On the contrary, it has been against him, who did not expect it, that there has been protest, because there exists a traditional teaching about forms, methods, aspects, painting; because those brought up on such principles do not admit any others. . . . To exhibit is the vital question . . . for the artist, because it happens that after several examinations people become familiar with what surprised them and, if you will, shocked them. Little by little they understand and accept it. . . . For the painter, it is thus only a question of conciliating the public, which has been his so-called enemy."³⁷

At the last minute Manet painted for his exhibition a large canvas representing the execution of Emperor Maximilian, a work inspired by the tragic events of June 1867 (and not unrelated to the treatment of a similar subject by Goya). Since France's prestige had been involved in the ill-fated Mexican adventure, the artist—for political reasons

—was prevented from showing this painting.³⁸ During the exposition Manet also painted a general panorama of the World's Fair, his first view of Paris, thus tackling this subject after Monet and Renoir had done so. In the right hand corner he introduced the famous balloon of his friend Nadar, an intimate of Baudelaire and Guys.

Manet's exhibition was much less of a success than he had expected. People again came more to laugh at his works than to study them seriously; even the praise of his admirers was moderate. Monet informed Bazille, who had left for Montpellier before the opening, that he did not consider Manet to be progressing, and Cézanne, who had remained in Aix, learned from a friend: "His paintings so amazed me that I had to make an effort to get used to them. All in all these pictures are very fine, very admirable in their exactness of tone. But his work has not yet reached its fullest bloom; it will become richer and more complete." As for Courbet, he did not even go to see the exhibition, delegating his sister instead and explaining to her: "I myself shouldn't like to meet this young man, who is of a congenial nature, hardworking, who tries to achieve something. I should be obliged to tell him that I don't understand anything about his painting and I don't want to be disagreeable to him." 40

Courbet's own exhibition was a disappointment for his friends but quite a success with the public. Monet thought the recent canvases downright bad, and one of Cézanne's friends, although deeply astonished by Courbet's "immense and integral power," found the latest paintings "awful: so bad they make you laugh." He considered Cézanne already better than both Manet and Courbet.

Courbet, this time, had constructed his pavilion of solid materials and decided to rent it after the closing of the exposition. This, together with their wholesale rejection, had inspired Monet and his friends with the resolution to organize henceforth exhibitions of their own, possibly in Courbet's pavilion. In a letter to his family, Bazille explained the project: "I shan't send anything more to the jury. It is far too ridiculous... to be exposed to these administrative whims.... What I say here, a dozen young people of talent think along with me. We have therefore decided to rent each year a large studio where we'll exhibit as many of our works as we wish. We shall invite painters whom we like to send pictures. Courbet, Corot, Diaz, Daubigny, and many others whom you perhaps do not know, have promised to send us pictures and very much approve of our idea. With these people, and Monet, who is stronger than all of them, we are sure to succeed. You shall see that we'll be talked about. . . . "41 But this letter was soon followed by another: "I spoke to you of the plan some young people had of making a separate exhibition. Bleeding ourselves as much as possible, we were able to collect the sum of 2,500 francs, which is not sufficient. We are therefore obliged to give up what we wanted to do. . . . "42

Although they had to drop their project, the friends never abandoned it in their hearts, for this seemed the only way to present themselves as a group. And they were indeed a little group by now, this "dozen young people" mentioned by Bazille. Besides the four companions from Gleyre's studio, there were Pissarro, whom Monet had met back in 1859 and who, in turn, had known Cézanne as early as 1861; Fantin, a friend of Renoir's since 1862, who was close to Manet; and Manet himself, to whom Cézanne, Pissarro, and Monet had been introduced in 1866; Guillemet, a friend of Manet and Cézanne; possibly Degas, for almost five years an intimate of Manet; and Berthe Morisot, although she knew only Fantin among the friends (she shortly was to

Photograph of Courbet, c. 1865.

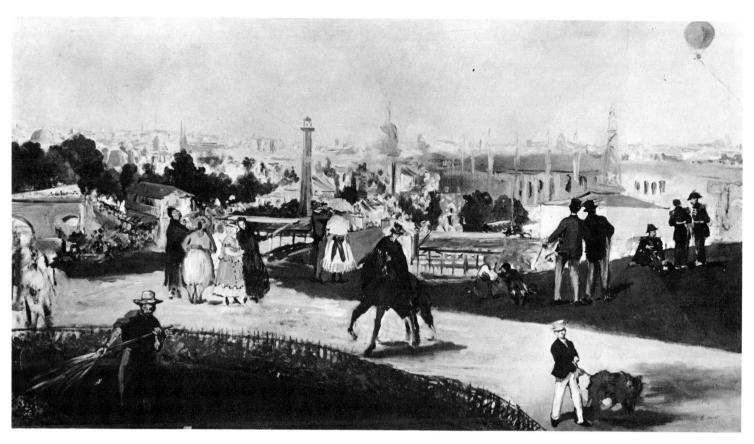

Manet: View of the Paris World's Fair, 1867. $42\frac{1}{2} \times 77\frac{1}{8}$ ". Nasjonal Galleriet, Oslo.

fall out with her teacher Oudinot and become friendly with Puvis de Chavannes and Degas). And there were others, such as the engraver Bracquemond, who had etched a portrait of Manet for the frontispiece of Zola's pamphlet on the artist, and Guillaumin, particularly close to Pissarro and Cézanne. Born at Moulins in 1841 and thus of the same age as Renoir, Bazille, and Berthe Morisot, Armand Guillaumin had come to Paris at sixteen to work in an uncle's shop. Since his family was opposed to his artistic vocation, he had taken employment with the services of the Paris municipality and for a number of years had labored like a slave, as he himself later put it, spending three nights a week on his job so that he could paint during the day.43 Extremely poor, Guillaumin belonged, with Monet, Renoir, and Pissarro, to the chronically impecunious members of the group, which he seldom joined on account of his work. Berthe Morisot, on the other hand, could be considered really wealthy, and the same applied to Manet, who had inherited a sizable fortune (although he was always in need of money), whereas Degas and Sisley were merely comfortable, their fathers' circumstances protecting them from material worries and enabling them to paint without any immediate need for selling their works. Bazille, similarly, was supported by his family, but his allowance does not seem to have been a large one, and Cézanne, in spite of his rich father, was even less well off; it had recently taken the intervention of Guillemet to obtain from the banker in Aix a bigger allowance for his son. Under these circumstances it seems truly amazing that the group had been able to raise 2,500 francs. Though they had fallen short of the goal, the friends now at least had the comforting certainty that older men like Courbet, Corot, Diaz, and Daubigny were wholeheartedly with them in their struggle.

"I believe," Manet wrote somewhat later to Fantin, "that, if we want to remain close together and above all not to grow discouraged, there would be a means of reacting against the mediocre crowd that is strong only because of its unity."

In the small group of friends Degas seems to have maintained the position of an outsider, and it is not even certain whether at that moment he knew many of the others. He did not have much in common with Manet's various acquaintances, being rather solitary by nature and little inclined to let anyone penetrate the privacy of his life and work. Sharing Manet's prejudices, he was not in the slightest attracted by work done out-of-doors, very seldom did landscapes, and focused his attention instead on the human figure. The portraits which he did of members of his family, or of friends chosen in the social circle in which he grew up, had led Duranty to state jokingly that Degas was "on the way to becoming the painter of high-life." This, however, was not exactly true, for what preoccupied Degas was not "high-life" but life in all its manifestations—contemporary life.

Degas had been deeply interested in certain remarks made by the Goncourt brothers in their new novel, Manette Salomon, published in 1866. The central figures of this book were artists, and one of them had in a long soliloquy expressed the authors' own credo: "All ages carry within themselves a Beauty of some kind or other, more or less close to earth, capable of being grasped and exploited-It is a question of excavation—It is possible that the Beauty of today may be covered, buried, concentrated—to find it, there is perhaps need of analysis, a magnifying glass, nearsighted vision, new psychological processes.—The question of what is modern is considered exhausted, because there was that caricature of truth in our time, something to stun the bourgeois: realism!—because one gentleman created a religion out of the stupidly ugly, of the vulgar ill-assembled and without selection, of the modern-but common, without character, without expression, lacking what is the beauty and the life of the ugly in nature and in art: style! The feeling, the intuition for the contemporary, for the scene that rubs shoulders with you, for the present in which you sense the trembling of your emotions and something of yourselfeverything is there for the artist. The nineteenth century not produce a painter!—but that is inconceivable—A century that has endured so much, the great century of scientific restlessness and anxiety for the truth-There must be found a line that would precisely render life, embrace from close at hand the individual, the particular, a living, human, inward line in which there would be something of a modeling by Houdon, a preliminary pastel sketch by La Tour, a stroke by Gavarni-A drawing truer than all drawing—a drawing—more human."46

Degas in his notebooks, from the late '60's on, had traced for himself a program similar in many points to that of the Goncourt brothers. "Do expressive heads (in the academic style), a study of modern feeling," he wrote. "Do every-kind of object in use, placed, associated in such a way that they take on the life of the man or

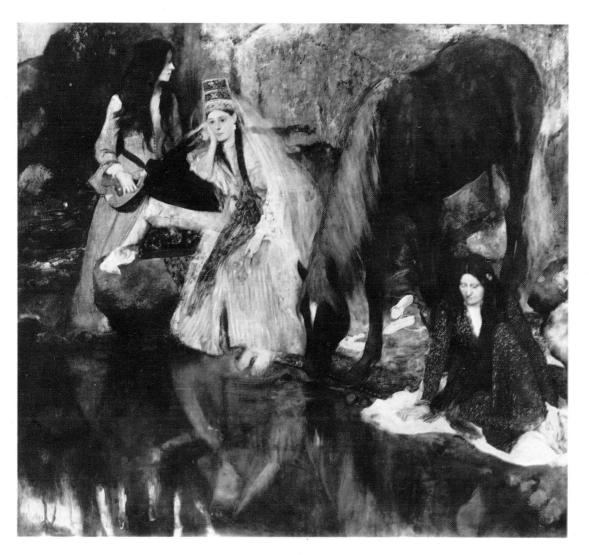

Degas: Mlle Fiocre in the Ballet "La Source," 1866-68. $51\frac{1}{8} \times 56\frac{8}{8}$ ". Exhibited at the Salon of 1868. Brooklyn Museum, New York.

woman, corsets that have just been removed, for instance, and that retain, as it were, the shape of the body, etc. . . ." He also jotted down: "Never yet have monuments or houses been done from below, from close to, as one sees them passing by in the street." And he set up a whole list of various series in which he might study contemporary subjects: one on musicians with their different instruments; another on bakeries seen from a variety of angles, with still lifes of all kinds of bread and tarts; a series on smoke, smoke of cigarettes, locomotives, chimneys, steamboats, etc.; a series on mourners in various kinds of black, veils, gloves, with undertakers; still other subjects, such as dancers, their naked legs only, observed in action, or the hands of their hair-dressers, and endless impressions, cafés at night with the "different values of the lamps reflected in the mirrors. . ." etc., etc. ⁴⁷

Many of the subjects listed here Degas was never to treat, others were to play a

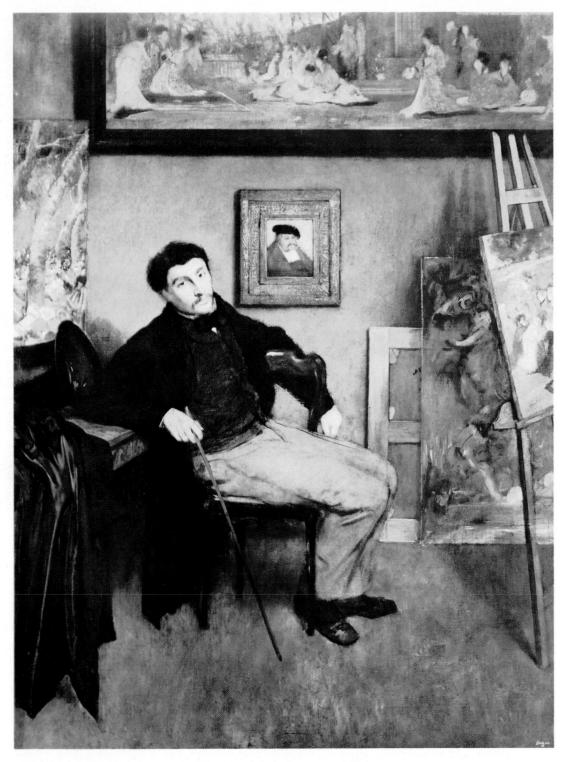

Degas: Portrait of the Painter James Tissot, 1868. $59\frac{1}{2} \times 44\frac{1}{4}$ ". Metropolitan Museum of Art, New York.

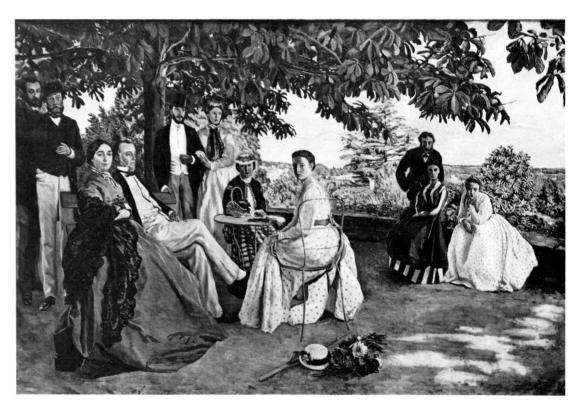

BAZILLE: The Artist's Family on a Terrace near Montpellier (second version). Exhibited at the Salon of 1868; retouched and dated 1869. (The painter himself appears at the extreme left.) $60\frac{3}{4} \times 91''$. Musée du Louvre, Paris.

dominant role in his work throughout his life, but, as he soon found out, more important than a great variety of subjects were the spirit, the inventiveness and the skill with which they were approached and treated. Curiously enough, the more original Degas was in his conception and composition, in what has been called the "mental side of painting," the less he seemed preoccupied with initiating a new technique or color scheme. Quite the opposite, he strove to remain within the path of tradition, as far as execution goes, and thus succeeded in giving even to the extraordinary a natural aspect.⁴⁸

Degas often explained: "No art was ever less spontaneous than mine. What I do is the result of reflection and study of the great masters; of inspiration, spontaneity, temperament I know nothing." He also said that "the study of nature is of no significance, for painting is a conventional art, and it is infinitely more worthwhile to learn to draw after Holbein." His main concern was thus to find that "living, human, inward line" of which the Goncourts had spoken, while the others concentrated on color and on the changing aspects of nature.

Bazille was spending the summer of 1867 on the estate of his parents near Montpellier. There he began work on a large composition grouping all the members of his

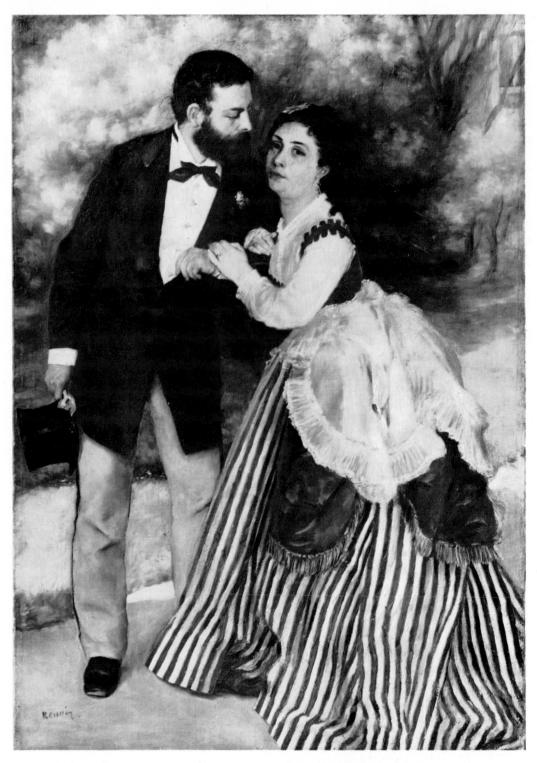

Renoir: Alfred Sisley and His Wife, 1868. $42\frac{1}{4} \times 30''$. Wallraf-Richartz Museum, Cologne.

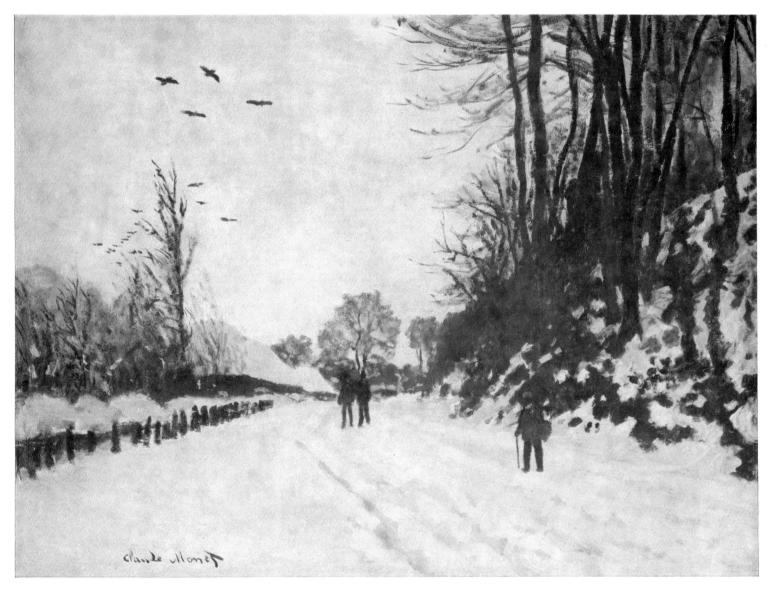

MONET: Road near Honfleur in the Snow, c. 1867. Collection Mr. and Mrs. Alex M. Lewyt, New York.

family on a shadowy terrace. Having neither the investigating mind of Degas nor the strong artistic temper of Monet nor the natural facility of Renoir, he tried to replace these by naive application and a sincere humility. As a result his canvas, although somewhat dry and stiff, is not devoid of an austere charm. Conscious of his shortcomings, Bazille knew that he had still to free himself from a certain awkwardness and hesitancy in order to develop his gifts fully.

Monet meanwhile had settled in Sainte-Adresse, where he was obediently staying with his aunt. He informed Bazille in June: "I've cut out a lot of work for myself; I

have about twenty canvases on the way, some stunning marines, and some figures, gardens and, finally, among my marines, I'm doing the regattas at Le Havre with many people on the beach and the ship lane full of little sails. For the Salon I am doing an enormous steamship, it's very curious."⁵¹

Renoir had again worked during the summer in Chailly; Berthe Morisot had returned to Brittany where she had also been the previous year; in July Sisley had taken his wife and infant son to Honfleur where he often saw Monet, who was also visited by Guillemet at Sainte-Adresse. Later Sisley joined Renoir near Fontainebleau, devoting himself to a landscape scene for the next Salon. In the forest Renoir, too, now painted a large full-length figure of a woman, executed entirely in the open but softer in line and color than Monet's Camille. His Lise, and the portrait of Sisley and his wife he was to do in 1868, are the first great pictures in which, notwithstanding traces of Courbet's influence, he affirmed his own personality. He achieved form exclusively through modeling and, what is more, he observed the interplay of colored shadows. The critic Bürger was the first to recognize this when he wrote concerning Renoir's Lise: "The dress of white gauze, enriched at the waist by a black ribbon whose ends reach to the ground, is in full light, but with a slight greenish cast from the reflections of the foliage. The head and neck are held in a delicate half-shadow under the shade of a parasol. The effect is so natural and so true that one might very well find it false, because one is accustomed to nature represented in conventional colors.... Does not color depend upon the environment that surrounds it?"52

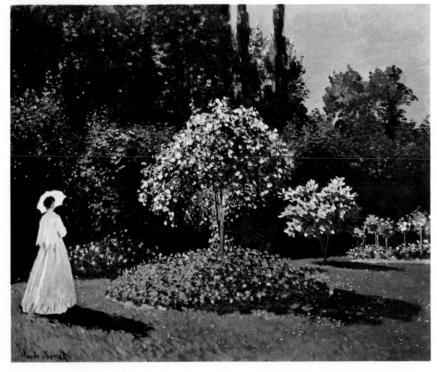

Monet: Young Woman in a Garden (Sainte-Adresse), c. 1867. $32\frac{1}{4} \times 39\frac{3}{8}$ ". Hermitage Museum, Leningrad.

Renoir: Lise, d. 1867. $71\frac{1}{2} \times 44\frac{1}{2}''$. Exhibited at the Salon of 1868. Folkwang Museum, Essen.

Left, Sisley: Still Life with Heron, 1867. $31\frac{7}{8} \times 39\frac{5}{8}$ ". Private Collection, Paris. Right, Bazille: Still Life with Heron, d. 1867. $39\frac{3}{8} \times 31\frac{1}{8}$ ". Musée Fabre, Montpellier. (Sisley and Bazille painted these still lifes while the latter was posing for his portrait by Renoir.)

Monet, suddenly, had to stop for awhile all work in the open, because of eye trouble, but when he came to visit his friends in Paris, late in the fall, Bazille wrote his sisters: "Monet has fallen upon me from the skies, with a collection of magnificent canvases... Counting Renoir, that makes two hard working painters I'm housing..., I'm delighted."53 During the winter of 1867-68 Bazille spent all his evenings with Edmond Maître. Together they played German music or went to concerts, occasionally accompanied by Renoir. When Bazille, soon afterwards, moved to a new studio on the rue de la Paix in the Batignolles quarter, Renoir continued to share his lodgings, whereas Monet returned to the coast.

Renoir, while staying with Bazille in his new studio, was soon to do a portrait of his host sitting in front of his easel. Sisley apparently had moved into the same house, for his address was identical with that of Bazille. He must have frequently visited the others and, in any case, simultaneously painted the still life of dead birds upon which Bazille was working as he sat for Renoir. Manet very much admired Renoir's likeness of Bazille at his easel, and Renoir probably presented it to him (although Manet may have purchased it in order to help his younger colleague). Manet himself did a portrait of his friend Zola at this time.

While living in the Batignolles quarter, Sisley painted his first cityscape, a view of Montmartre seen from the Cité des Fleurs. The hill of Montmartre, though not far

Renoir: Portrait of Frédéric Bazille at His Easel, d. 1867. $41\frac{7}{8} \times 29\frac{1}{4}$ ". Formerly in the collection of Manet. Musée du Louvre, Paris.

Far left, BAZILLE: The Artist's Studio, rue Visconti, Paris, 1867. 24\frac{5}{8} \times 18\frac{1}{4}". Collection Mr. and Mrs. Paul Mellon, Upperville, Va.

Left, Monet:
The Cradle—Camille with the
Artist's Son Jean, 1867.
45\frac{3}{4} \times 35''. Collection Mr. and
Mrs. Paul Mellon, Upperville, Va

from the Place de Clichy, appears so little built up that, except for a few houses in the foreground, it looks like a rural scene far removed from the bustling city (see p. 204).

The year 1868 did not start under too favorable auspices. Monet was still without money; he had left his aunt, and there was not even coal for Camille and the baby. In the spring, however, Boudin induced the organizers of an Exposition Maritime Internationale at Le Havre to invite Courbet, Manet, and Monet to participate. All three, as well as Boudin, were awarded silver medals. Monet also received from a M. Gaudibert a commission for a portrait of his wife, which he painted in a château at Etretat, near Le Havre.⁵⁴ But he remained depressed and wrote Bazille: "... all this is not enough to give me back my former ardor. My painting doesn't go, and I definitely do not count any more on fame. I'm getting very sunk. To sum up, I've done absolutely nothing since I left you. I've become utterly lazy, everything annoys me as soon as I make up my mind to work; I see everything black. In addition, money is always lacking. Disappointments, insults, hopes, new disappointments—you see, my dear friend. At the exhibition at Le Havre, I sold nothing. I possess a silver medal (worth 15 francs), some splendid reviews in local papers, there you are; it's not much to eat. Nevertheless, I've had one sale which, if not financially advantageous, is perhaps so for the future, although I don't believe in that any more. I have sold the Woman in Green [Camille] to Arsène Houssaye [inspector of Fine Arts and editor of L'Artiste], who has come to Le Havre, who is enthusiastic and wants to get me launched, so he says."55 Possibly upon Monet's recommendation, Houssaye also bought an early painting by Renoir.

Houssaye paid only 800 francs for *Camille* (the average wage for a work day was then about 5 francs), but even this seemed high compared to the prices which some seascapes by Monet were soon to bring at auction. After the closing of the exhibition in Le Havre, creditors had seized Monet's canvases, which were then acquired, according to Boudin, by M. Gaudibert for 80 francs apiece. Fenoir was not much better off; having exhausted his credit, he could not buy any more canvas and when he wanted to paint a large portrait of Jules Le Coeur's sister-in-law and her young son in their garden, he had to ask them to supply him with material. Fortunately Jules' brother Charles, who had built a private residence for Prince Bibesco in Paris, was able to obtain for him a commission for a ceiling decoration on which Renoir was working in the spring of 1868.²⁶

At least the news from the Salon jury was good that year. Daubigny was again a member and his influence made itself felt immediately. He himself took the trouble to drop a line to some of his protégés. "Dear M. Pissarro," he wrote, for instance, "your two pictures have been admitted. Yours sincerely, C. Daubigny." Monet may have received a similar message, although only one of his canvases was accepted. "Daubigny told me," Boudin informed a friend, "that he has had to fight to get one of his pictures admitted; that at first the *Ship* had been accepted and that, when the other came up in turn, Nieuwerkerke said to him: 'Ah no, we've had enough of that kind of painting.'" 56

As a matter of fact the Superintendent of Fine Arts was very dissatisfied with Daubigny's intervention. "M. de Nieuwerkerke complains of Daubigny," Castagnary explained in an article. "If the Salon this year is what it is, a Salon of newcomers; if the doors have been opened to almost all who presented themselves; if it contains

BAZILLE: Portrait of Alfred Sisley, 1867-68. $11 \times 12\frac{1}{4}$ ". Formerly Wildenstein Galleries, Paris (destroyed during World War II).

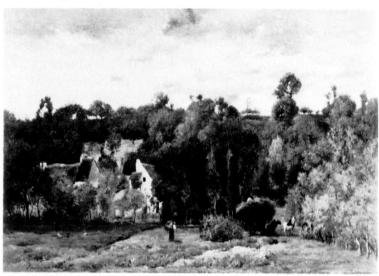

Left, Pissarro: The Côte du Jallais near Pontoise, d. 1867. 35 × 45\frac{5}{8}". Exhibited at the Salon of 1868. Metropolitan Museum of Art, New York (William Church Osborn Bequest). Right, Daubigny: L'Hermitage near Pontoise, d. 1866. 44\frac{1}{8} × 63\frac{1}{2}". Kunsthalle, Bremen.

1,378 more items than last year's Salon; if in this abundance of paintings, the official art cuts a rather poor figure, it is Daubigny's fault. . . . I do not know whether Daubigny has done all that M. de Nieuwerkerke attributes to him. I should gladly believe it, because Daubigny is not only a great artist, he is, further, a fine man who remembers the miseries of his youth and who would like to spare others the harsh ordeals which he himself underwent."58

On the whole the results of Daubigny's insistence and of his example were very satisfactory, except for Cézanne, who was rejected once more. Manet had two paintings admitted (among them his *Portrait of Zola*), so had Bazille (whose family group was received) and Pissarro (who exhibited two views of Pontoise); Degas, Monet, Renoir, Sisley, and Berthe Morisot were represented by one painting each: Degas by his *Portrait of Mlle Fiocre*, Renoir by *Lise*, Sisley by his forest scene, and Berthe Morisot by a landscape from Finistère (she was the only one of the group who still listed her teachers in the catalogue).⁵⁹ But the hanging committee counterbalanced Daubigny's liberalism by relegating the works of Renoir, Bazille, Monet, and Pissarro to the so-called *dépotoir*, also hanging Manet's canvases very badly. However, this did not prevent either Manet or the others from obtaining a certain success. Castagnary publicly protested against the unfavorable treatment their works received, complaining especially that Pissarro had seen his landscapes again "placed too high this year, but not high enough to prevent art lovers from observing the solid qualities that distinguish him." 60

Zola, optimistically, ventured to say that the public, although it did not yet understand, at least no longer laughed; it was true that for the first time his friends were gratified by benevolent press notices. Yet there were still numerous cynical attacks,

not only against Manet—who had become used to them—but also, for instance, against Renoir's *Lise*, notwithstanding the excellent impression the painting made on Bürger. The artist had his canvas described as "a fat woman splashed with white, whose author, Monsieur R. (he'll allow me to identify him only by his initial), evidently drew his inspiration no longer from the great examples of Courbet but from the curious models of Manet. And thus, from imitation to imitation, the realist school threatens to go down . . . in cascades."⁶¹

On the other hand, the aging but influential Théophile Gautier who, in 1861, had admired Manet's *Guitarero* but since then had shown no sympathy for the painter or his friends—although he supposedly liked Renoir—now published a surprisingly mellow statement: "Confronted with the startling examples [of the new art], those with some integrity ask themselves if, in art, one can understand anything but the works of the generation with which one is contemporaneous, that which was twenty when you were the same age. . . . It is probable that the paintings by Courbet, Manet, Monet, and *tutti quanti* contain beauties which escape us, the old romantic manes already mixed with silver strands." 62

While unfavorable comments always have a tendency to attract greater attention than do favorable ones, and while they generally create more harm than can be

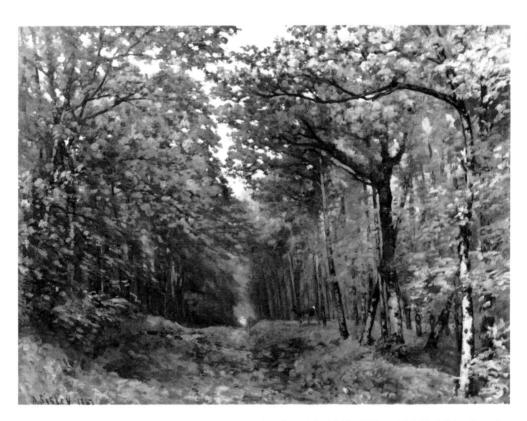

Sisley: Alley of Chestnut Trees near La Celle Saint-Cloud, d. 1867. $37\frac{1}{2} \times 48''$. Exhibited at the Salon of 1868. Southampton Art Gallery, England.

erased even by the most flattering notices, the important thing was that some good reviews did appear. Astruc was full of praise; so was Redon, turned art critic for the occasion, who commented in *La Gironde* on the paintings of Courbet, Manet, Pissarro, Jongkind, and Monet.

After declaring that the "great art" no longer existed, 63 Redon wrote: "We are witnessing the end of an old school, already and justly condemned, while here and there some forceful personalities try to impose themselves.... Let us admit, the best things are still to be found among the works of artists who are seeking revitalization at the fecund sources of nature. Their impulse has been a salutary one; it has given us some true painters, chiefly among the landscapists." Having insisted on the poetry and audacity of Corot, Redon devoted a long passage to Daubigny where he allowed: "It is impossible not to recognize the exact hour at which M. Daubigny has been working. He is the painter of a moment, of an impression," but Redon also added that "under the pretext of being true, those qualities absolutely necessary to any beautiful work: modeling, character, arrangement, ampleness of planes, thought, philosophy, have been banned from painting." However, since nature had become "the master and the one responsible for the effect it produces, the artist must above all be supple and submissive in front of it, obliterate the man so as to let the model shine, in a word—and this is a rare thing, difficult to acquire—he must have a great deal of talent without showing it." According to Redon, Courbet had this precious quality; in his works one could find "to the highest degree what used to be called aerial perspective and which is simply the result of a rigorously exact tone and well observed values." Proceding from Courbet to Manet, Redon was unexpectedly severe: "The weakness of M. Manet and of all those who, like him, want to limit themselves to the literal reproduction of reality, is to sacrifice man and his thought to good brush work, to the brilliant handling of a detail." In Manet's Portrait of Emile Zola, Redon saw mainly the qualities of a still life. On the other hand he was greatly taken by Pissarro's two landscapes. "The color is somewhat dull, but it is simple, large, and well felt. What a singular talent which seems to brutalize nature! He treats it with a technique which in appearance is very rudimentary, but this denotes, above all, his sincerity. M. Pissarro sees things simply; as a colorist he makes sacrifices which allow him to express more vividly the general impression, and this impression is always strong because it is simple."64 As to Monet, Redon recognized his "rare audacity" but regretted that his seascape was too large. The works exhibited by Degas, Renoir, Sisley, Berthe Morisot, and Bazille, however, drew no comments from Redon.

Zola also wrote a new Salon review, yet he made it a point (or was obliged) not to mention by name any of the official artists he loathed and whom he had treated so sarcastically the previous year. His articles, therefore, lack the combativeness of his earlier series, the more so as Manet seemed no longer so vehemently discussed as in 1866. "In my opinion, the success of Edouard Manet is complete," he stated. "I didn't dare to dream it would be so quick, so worthy." But Zola's loss of aggressive spirit was amply compensated by a more mature and understanding approach. Having devoted a special article to Manet, he followed it up with one on Pissarro which opened with a statement concerning those whom he called *les Naturalistes*:

"They form a group which grows every day. They are at the head of the [modern]

GILL: Caricature of Zola's portrait by Manet.

BERTALL: "If Gérôme or Cabanel happen to pass in reach of my walking stick, they better be careful." Caricature of Manet's portrait by Fantin-Latour.

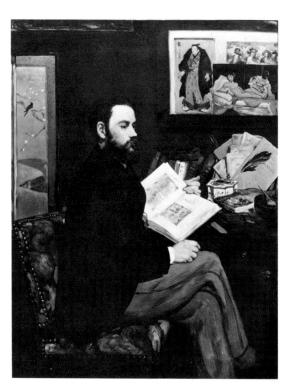

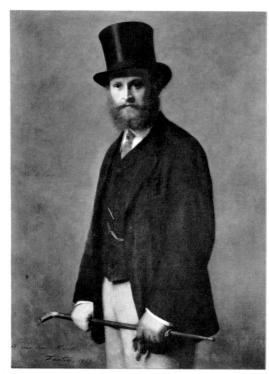

Right, Manet: *Emile Zola*, 1868. $57\frac{1}{4} \times 43\frac{1}{4}$ ". Exhibited at the Salon of 1868. Musée du Louvre, Paris (Gift of Mme Zola).

Far right, Fantin-Latour: Portrait of Edouard Manet, d. 1867. $46 \times 35\frac{1}{2}$ ". Exhibited at the Salon of 1867. Art Institute of Chicago (Stickney Fund).

movement in art, and tomorrow one will have to reckon with them. I am selecting one of them, the least known probably, but whose characteristic talent will serve to make known the entire group."65 Indeed, Zola seems to have undertaken his Salon review with the unique aim of drawing attention to his friends and those they admired. After declaring that a beautiful picture by Pissarro "is the act of an honest man," he discussed more or less extensively the works of Monet, Jongkind, Corot, and Courbet, mentioning in passing Renoir's Lise, whom he called "a sister of Claude Monet's Camille," as well as the paintings by Bazille, Degas, the two Morisot sisters, Boudin, and a few others. Only Sisley escaped his attention. That Zola should have singled out their entries to the exclusion of hundreds of others exhibited at the Salon can, no doubt, be attributed to Cézanne's influence—since Cézanne particularly admired Pissarro—and to the enlightening conversations he must have had with Manet while sitting for his portrait (Zola also related how he had watched the painter work on his likeness). In any case, by speaking of the "group" formed by those for whom, at the Salon, he felt "the greatest sympathy," Zola underlined the fact that a definite link existed among these artists, a link much stronger than that of chance encounters.

Next to Pissarro, Monet, too, and for the second time, obtained a certain success. "At the Salon, I ran into Monet who gives us all the example of the tenacity of his principles," noted Boudin. "There is always in his painting a praiseworthy search for *true tone*, which begins to be respected by everyone." ⁶⁶

But new difficulties awaited Monet after he had left Paris again. From Fécamp he wrote Bazille toward the end of June: "I am writing you a few lines in haste to ask

your speedy help. I was certainly born under an unlucky star. I have just been thrown out of the inn, and stark naked at that. I've found shelter for Camille and my poor little Jean for a few days in the country. This evening I'm leaving for Le Havre to see about trying something with my art lover. My family have no intention of doing anything more for me. I don't even know where I'll have a place to sleep tomorrow. Your very harassed friend—Claude Monet. P. S. I was so upset yesterday that I had the stupidity to throw myself into the water. Fortunately, no harm came of it."⁶⁷

Monet's patron in Le Havre, doubtless M. Gaudibert, was more sensitive than the painter's parents to his plight. He seems to have provided Monet with an allowance that permitted him to find temporary peace and new courage for his work. A letter to Bazille, dated September, 1868, is full of quiet contentment. "I am surrounded here with all that I love," Monet wrote from Fécamp. "I spend my time out-of-doors on the pebble-beach when the weather is stormy or when the boats are going out for fishing; or I go into the country, which is so beautiful here that I perhaps find it more agreeable in winter than in summer. And naturally I've been working all this time, and I believe that this year I'll do some serious things. And then in the evening, my dear friend, I find a good fire and a cozy little family in my cottage. If you could see your godson-how sweet he is at present. It's fascinating to watch this little being grow, and, to be sure, I am very happy to have him. I shall paint him for the Salon, with other figures around, of course. This year I shall do two pictures with figures, an interior with a baby and two women, and some sailors out-of-doors.68 And I want to do them in a stunning manner. Thanks to the gentleman of Le Havre who comes to my aid, I am enjoying the most complete tranquillity. Consequently, my wish would be to continue always this way in a hidden bit of quiet nature. I assure you that I don't envy your being in Paris. Frankly, I believe that one can't do anything in such surroundings. Don't you think that directly in nature and alone one does better? I'm sure of it; besides, I've always been of this mind and what I do under these conditions has always been better. One is too much taken up with what one sees and hears in Paris, however firm one may be; what I am painting here will have the merit of not resembling anyone, at least I think so, because it will be simply the expression⁶⁹ of what I shall have felt, I myself, personally. The further I go, the more I regret how little I know, that is what bothers me most."⁷⁰

Monet concluded by saying that since his paint shop had refused him further credit, he would like Bazille to send some of the canvases left behind in his studio. But this time Monet was careful to specify that he wanted only unused canvases or those of unfinished paintings. As to the finished ones, he asked Bazille to take good care of them: "I've lost so many that I cling to those that are left."

While Monet secluded himself in the country, the life of his friends continued with little change in Paris. Renoir portrayed the ice skaters in the Bois de Boulogne, but decided not to work out-of-doors again in cold weather. Always hard up, Guillaumin, who had left his job with the city in 1868, painted blinds for a living, as Renoir had once done. For a while Pissarro was obliged to join him in order to support his family, and Guillaumin did a portrait-sketch showing Pissarro at his commercial work.⁷¹ During that same winter, in the studio of the Belgian painter Stevens, Bazille frequently met Manet, to whom Fantin had introduced Berthe Morisot (her sister had married meanwhile and abandoned painting). She was

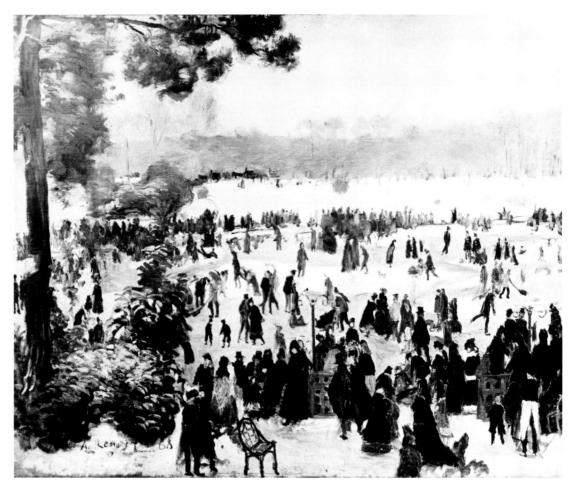

Renoir: Skating in the Bois de Boulogne, d. 1868. $28\frac{7}{8} \times 36\frac{1}{8}$ ". Formerly collection Robert von Hirsch, Basel.

deeply impressed by Manet's talent; he in turn was fascinated by her feminine charm and natural distinction.

Manet had spent the summer in Boulogne and made a two-day excursion to England. He had returned with a very favorable impression, both of the atmosphere of London and of the reception he had been given by British artists. "They don't have the kind of ridiculous jealousy that we have; they are almost all gentlemen," he wrote to Zola. And to Fantin he spoke of his conviction that "something could be done there," adding: "What I want right now is to earn money." His longing both for social and financial success induced him to submit to a ruse invented by Théodore Duret, a politician and journalist he had met in Madrid and who was one of the founders of the anti-imperial newspaper *La Tribune*, to which Zola contributed. Although at first not overly fond of Manet's art, he had just had his portrait painted by him. At Duret's suggestion, Manet signed the canvas unostentatiously, for his model meant to show it to all his bourgeois acquaintances as the work of any one of

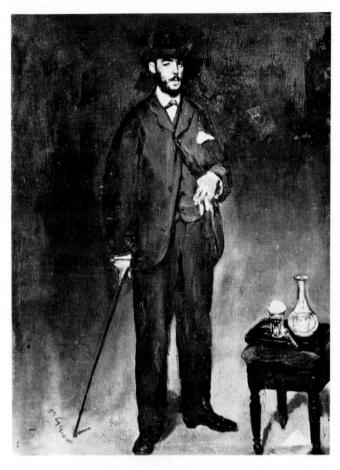

Manet: Portrait of Théodore Duret, d. 1868. 17 \times 13 3_4 ". Musée des Beaux-Arts de la Ville de Paris.

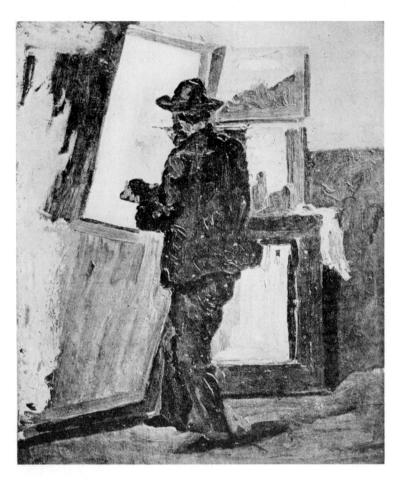

GUILLAUMIN: Pissarro Painting Blinds, c. 1868. 18\frac{1}{8} \times 15". Musée Municipal, Limoges.

the well-known Salon artists. Once the portrait had been duly appreciated, he intended to reveal the real painter's name, embarrass the "admirers" and oblige them to recognize Manet's talent. While Manet did not sign his painting in a dark spot, as Duret had wished,⁷⁴ he complied so far as to put his signature upside down, making it very difficult to decipher.

In the fall of 1868 Manet, who hated professional models, asked Berthe Morisot whether she would agree to pose for *The Balcony* (p. 221) — inspired by Goya's *Majas on a Balcony* — which he was then planning and in which Guillemet was also to figure. She accepted and, accompanied by her mother, regularly attended the sittings in his studio. She also appeared at the Thursday gatherings at which Manet and his wife received all their friends.

In the evenings at this time the painters frequently met in the Café Guerbois in the Batignolles quarter, and when Monet returned to Paris early in 1869, Manet invited him to join them there.

- Valabrègue to Marion, April 1866; see M. Scolari and A. Barr, Jr.: Cézanne in the Letters of Marion to Morstatt, 1865-1868. Magazine of Art, Feb., April and May 1938.
- 2 The catalogue of the Salon of 1866 lists among others Bazille (élève de Gleyre), 22, rue Godot-de-Moroy, Poissons; De Gas, 13, rue de Laval, Scène de Steeple-chase; Fantin-Latour (élève de son père et de Lecoq de Boisbaudran), 13, rue de Londres, Portrait de femme, étude, Nature morte; Monet, 1, rue Pigalle, Camille, Forêt de Fontainebleau; Morisot, (élève de Guichard et Oudinot), 16, rue Franklin, La Bermondière (Orne), Chaumière de Normandie; Pissarro (élève de A. Melbye), rue du Fond de l'Ermitage, Pontoise & Paris, chez M. Guillemet, 20, Grande rue, Batignolles, Bords de la Marne en hiver; Sisley (élève de Gleyre), 15, rue Moncey, Femmes allant au bois, paysage, Une rue de Marlotte, environs de Fontainebleau.
- 3 Bazille to his parents, May 4, 1866; see F. Daulte: Frédéric Bazille et son temps, Geneva, 1952, p. 50, note 1.
- 4 Letter by Mme F., sister of Renoir's friend J. Le Coeur, June 6, 1866; see *Cahiers d'Aujourd'hui*, Jan. 1921.
- 5 Cézanne to de Nieuwerkerke, April 19, 1866; see Cézanne, Letters, London, 1941, p. 70-71 [here newly translated].
- 6 On Duranty and Zola see Auriant: Duranty et Zola, La Nef., July 1946.
- 7 E. Zola: Proudhon et Courbet, reprinted in Mes Haines, Paris, 1867. (See also OeuvresComplètes, Paris 1927-1929.)
- 8 E. Zola: Un suicide, L'Evénement, April 19, 1866. (This article is not incorporated in the reprints of the series.)
- 9 E. Zola: Mon Salon, L'Evénement, April 27-May 20, 1866. Reprint: Mon Salon. Paris, 1866, later included in Mes Haines, Paris, 1867; see E. Zola: Oeuvres complètes, notes et commentaires de Maurice Le Blond, Paris, 1928. On Zola's art criticism see: Emile Zola: Salons, recueillis, annotés et présentés par F. W. J. Hemmings et Robert J. Niess, with an introduction by F. W. J. Hemmings, Paris-Geneva, 1959. On Zola's early years as writer, see also catalogue of the exhibition Emile Zola, Bibliothèque Nationale, Paris, 1952, No. 74.
- 10 Three of these letters are reproduced in Mon Salon, Paris, 1866, but were not incorporated in Mes Haines, Paris, 1867.
- 11 Bazille to his parents, April 16, 1886; see Daulte, op. cit., p. 52.
- 12 E. Zola: A mon ami Paul Cézanne, preface to: Mon Salon, reprinted in Mes Haines. On their friendship see J. Rewald: Cézanne, sa vie, son oeuvre, son amitié pour Zola, Paris, 1939 or: Paul Cézanne, New York, 1948.

- 13 W. Bürger: Salon de 1866; reprinted in Bürger: Salons, 1861-1868, Paris, 1870, v. II, p. 325.
- 14 Castagnary: Le Salon de 1866; reprinted in Salons (1857-1870), Paris, 1892, v. I, p. 224 and 240.
- 15 This is apparently the version formerly in the collection of G. de Bellio and now in the Museum Simu, Bucharest; see R. Niculescu: Georges de Bellio, L'ami des impressionnistes, Revue Roumaine d'Histoire de l'Art, v. I, no. 2, 1964.
- 16 Castagnary: Le Salon de 1863, op. cit., v. I, p. 105-106 and 140.
- 17 Castagnary: Le Salon de 1868, op. cit., v. I, p. 291.
- 18 Monet to Thiébault-Sisson, interview; see *Le Temps*, Nov. 27, 1900.
- 19 See de Trévise: Le pèlerinage de Giverny, Revue de l'art ancien et moderne, Jan., Feb. 1927; also Geffroy: Claude Monet, sa vie, son oeuvre, Paris, 1924, v. I, ch. VIII. On the composition of Monet's Women in the Garden, see G. Poulain: L'origine des "Femmes au jardin" de Claude Monet, L'Amour de l'Art, March, 1937.
- 20 There are several versions concerning this incident; see M. Elder: Chez Claude Monet à Giverny, Paris, 1924, p. 55-56. P. Valéry: Degas, Danse, Dessin, Paris, 1938, p. 21-22, reproduces the same story as told by Monet, except that the compliments come from Decamps instead of Diaz. According to M. de Fels: La vie de Claude Monet, Paris, 1929, p. 88, Latouche exhibited Women in the Garden and the blame came from Corot, the praise from Diaz. C. Geffroy, op. cit., v. I, ch. VIII, mentions Women in the Garden as exhibited by the dealer and laughed at by Manet. A similar version is given by W. Pach: Queer Thing, Painting, New York-London, 1938, p. 102-103. A. Alexandre: Claude Monet, Paris, 1921, p. 46, says that Manet made his remarks in connection with Monet's Déjeuner sur l'herbe, shown by Latouche. But in his interview with Thiébault-Sisson, op. cit., Monet speaks of a Seascape that was ridiculed by Manet. Since a letter by Monet to Bazille, June 25, 1867 (see G. Poulain: Bazille et ses amis, Paris, 1932, p. 92) confirms that Latouche had bought Monet's Garden of the Princess, there seems every reason to believe that this was the canvas shown in his window. However, the dealer may also have exhibited other paintings by Monet under similar circumstances. As a matter of fact, Boudin reports in 1869 in a letter to a friend (see G. Jean-Aubry: Eugène Boudin, Paris, 1922, p. 72) that Latouche was showing a study of Sainte-Adresse by Monet which attracted crowds in front of his window.

On Monet's early Paris views, one of which is dated

- 1866 though actually painted 1867 (reproduced p. 152), see J. Isaacson: Monet's Views of Paris, *Allen Memorial Art Museum Bulletin*, fall 1966.
- 21 In a letter to Bazille, spring 1868, Monet asks his friend for the following colors: ivory black, white lead, cobalt blue, lake (fine), yellow ochre, burnt ochre, brilliant yellow, Naples yellow, burnt Sienna. See Poulain, op. cit., p. 150.
- 22 See K. Osthaus: article in *Das Feuer*, 1920, quoted by Rewald: Cézanne, New York, p. 196.
- 23 Cézanne to Zola, Oct. 1866; see Cézanne, Letters, op. cit, p. 74.
- 24 Marion to Morstatt, see Scolari and Barr, op. cit.
- 25 Whistler to Fantin, fall 1867, see L. Bénédite: Whistler, Gazette des Beaux-Arts, Sept. 1, 1905.
- 26 On this subject see D. Cooper: Renoir, Lise and the Le Coeur Family, Burlington Magazine, May and Sept.-Oct. 1959.
- 27 See R. Gimpel: At Giverny with Claude Monet, Art in America, June 1927; see also R. Gimpel: Journal, Paris, 1963, p. 87. Information corroborated by R. Koechlin: Claude Monet, Art et Décoration, Feb. 1927.
- 28 Monet to Bazille, Dec. 22, 1866; see Poulain, op. cit., p. 70–71. Bazille was slow in fulfilling the request, which may explain why several of the pictures seem still to exist. Here is a list of some of the paintings for which Monet had asked: "Les deux grandes avenues de Fontainebleau de la même dimension; le tableau chinois où il y a des drapeaux [possibly the painting ill. p. 153]; le rosier; l'effet de neige tout blanc où il y a des corbeaux [possibly the winter landscape ill. p. 115]; la marine aux canots bleus [possibly the beach scene ill. p. 154]; Le Havre vu du lointain avec petites cabanes et mer à vagues blanche;... la femme blanche [possibly the painting ill. p. 180]."—Monet said he wanted to paint an important seascape on this last canvas.
- 29 Dubourg to Boudin, Feb. 2, 1867; see G. Jean-Aubry: Eugène Boudin, Paris, 1922, p. 64.
- 30 See A. Monet to Bazille, summer 1867; Poulain, op. cit., p. 74–77.
- 31 See M. Elder: Chez Claude Monet à Giverny, Paris, 1924, p. 39, also L. Vauxcelles: Un après-midi chez Claude Monet, *L'Art et les Artistes*, Dec. 1905. The objecting jury member was Jules Breton.
- 32 Zola to Valabrègue, April 4, 1867; see E. Zola: Correspondance (1858-1871), Paris, 1928, p. 299-300.
- 33 See J. Rewald: Paul Cézanne, New York, 1948, p. 64. Zola's notice appeared in *Le Figaro*, April 12, 1867, reprinted *ibid.*, p. 64-66.
- 34 Castagnary: Salon de 1867; reprinted in Castagnary: Salons, v. I (1857-1870), Paris, 1892, p. 247.
- 35 On the World's Fair and its art sections see F. Trapp: Expo' 1867 Revisited, *Apollo*, Feb. 1969.

- 36 Zola: Nos peintres au Champ de Mars. Since Zola had left *Le Figaro*, the article appeared in the short-lived daily, *La Situation*, July 1, 1867; it is reprinted *in Zola*: Salons, *op. cit.*, 1959, p. 107-115.
- 37 Notice for the catalogue of the Manet exhibition, Avenue de l'Alma, Paris, 1867, quoted by E. Bazire: Edouard Manet, Paris, 1884, p. 54, who also provides a catalogue of the exhibition.
- 38 On this subject see N. G. Sandblad: Manet—Three Studies in Artistic Conception, Lund, 1954, chapter: L'exécution de Maximilien.
- 39 Marion to Morstatt, Paris, Aug. 15, 1867; see Scolari and Barr, op. cit.
- 40 See G. Riat: Gustave Courbet, Paris, 1906, p. 146. The author does not indicate with which exhibition this episode is connected, but there seems reason to assume that it applies to Manet's show in 1867.
- 41 Bazille to his family, spring 1867; see Poulain, op. cit., p. 78–79. A similar idea had already been expressed by Cézanne's friend Marion, who wrote in April 1866: "All we have to do is to plan an exhibition of our own and put up a deadly competition against those blear-eyed idiots [of the Salon]." See Scolari and Barr, op. cit.
- 42 Bazille to his family, spring 1867; see Poulain, op. cit., p. 83.
- 43 The passage on Guillaumin is at variance with the first two editions of the present book; it is based on the artist's notes and on information provided by his daughter who insists that many of her father's biographers, even those who—like Dewhurst—wrote during the painter's lifetime, have committed serious errors.
- 44 Manet to Fantin, Aug. 28, 1868; see E. Moreau-Nélaton: Manet raconté par lui-même, Paris, 1926, v. I, p. 103.
- 45 Duranty quoted by Manet, ibid.
- 46 E. and J. de Goncourt: Manette Salomon. Paris, 1866, ch. CVI. On Degas' often expressed admiration for the Goncourts see J. Elias: Degas, Neue Rundschau, Nov. 1917. On the Goncourts as founders of literary "impressionism" see E. Köhler: Edmond und Jules de Goncourt—Die Begründer des Impressionismus, Leipzig, 1911.
- 47 Degas, notes; condensed from various notebooks in the Bibliothèque Nationale, dating from 1868 to 1883.
- 48 See P. Jamot: Degas, Paris, 1924, p. 49.
- 49 Quoted by G. Moore: Impressions and Opinions, London, 1891, ch. on Degas.
- 50 From a notebook of Berthe Morisot; see P. Valéry: Degas, Dance, Dessin, Paris, 1938, p. 148.
- 51 Monet to Bazille, June 25, 1867; see Poulain, op. cit., p. 92.
- 52 W. Bürger: Salon de 1868; reprinted in Salons, 1861-1868, Paris, 1870, v.II, p. 531.

- 53 Bazille to his sisters, fall 1867; see G. Poulain: Un Languedocien, Frédéric Bazille, La Renaissance, April 1927.
- 54 The portrait is now in the Louvre.
- 55 Monet to Bazille, spring 1868; see Poulain, op. cit., p. 149. According to Bürger, op. cit., v. I, p. 420, A. Houssaye had also written to Whistler in 1863, anxious to buy his White Girl at the Salon des Refusés. Apparently he did not offer enough money, since the deal was never concluded.
- 56 Boudin to Martin, 1868; see Jean-Aubry, op. cit., p. 71-72.
- 57 Unpublished document, found in the papers of Pissarro, courtesy the late Ludovic-Rodo Pissarro, Paris.
- 58 Castagnary: Le Salon de 1868, op. cit., v. I, p. 254.
- 59 The catalogue of the Salon of 1868 lists among others: Bazille, rue de la Paix 9, Batignolles, Etude de Fleurs, Portraits de la Famille [the artist later reworked the canvas and signed it in 1869]; De Gas, rue de Laval 13, Portrait de Mlle E. F. [Fiocre], à propos du Ballet "La Source"; Manet, rue St. Pétersbourg 39, Une jeune femme, Portrait de M. Emile Zola; Monet, Impasse Saint Louis 8, Batignolles, Navires sortant des jetées du Havre [his second painting was refused]; Morisot, rue Franklin 16, Passy (élève de Guichard et Oudinot), Ros-Bras, Finistère; Pissarro, Boulevard Rochechouart 108, Côte de Jallais and Hermitage (de Pontoise); Renoir, rue de la Paix 9, Batignolles [Bazille's address], Lise; Sisley, rue de la Paix 9, Batignolles, Avenue de Chataigners, près la Celle Saint-Cloud.
- 60 Castagnary: Le Salon de 1868; op. cit., v. I, p. 278.
- 61 F. de Lasteyrie in L'Opinion Nationale, June 20, 1868, quoted in J. Lethève: Impressionnistes et Symbolistes devant la presse, Paris, 1959, p. 50.
- 62 T. Gautier in Le Moniteur Universel, May 11, 1868, quoted ibid., p. 51.
- 63 This statement seems like an echo of what Baudelaire had written: "It is true that the great tradition has been lost and that the new one has not been made." Salon de 1846, Curiosités Esthétiques; Baudelaire: Oeuvres complètes, Paris, 1923, p. 196.
- 64 O. Redon: Le Salon de 1868, *La Gironde*, May 19, June 9 and July 1, 1868.
- 65 E. Zola: Salon de 1868, L'Evénement Illustré (a series of seven articles, reprinted in Zola: Salons, op. cit., p. 119-144). See also R. Walter: Critique d'art et vérité: Emile Zola en 1868, Gazette des Beaux-Arts, April 1969.
- 66 Boudin to Martin, May 4, 1868; see Jean-Aubry, op. cit., p. 68.
- 67 Monet to Bazille, June 29, 1868; see Poulain, op. cit., p. 119-120.
- 68 The interior, Le déjeuner, is now in the Staedelsche Institut in Frankfort-on-the-Main; the whereabouts of the other canyas is unknown.

- 69 Poulain, op. cit., p. 131 and in an article, La Renaissance, April, 1927, quotes this letter as saying in one case "impression," in the other "expression"; the word used by Monet was "expression" (information courtesy Gabriel Sarraute, Carcassone).
- 70 Monet to Bazille, Sept. 1868; see Poulain, op. cit., p. 130-132.
- 71 See G. Lecomte: Guillaumin, Paris, 1926, p. 9 and 26-27.
- 72 Manet to Zola, summer 1868; see Jamot, Wildenstein, Bataille: Manet, Paris, 1932, v. I, p. 84.
- 73 Manet to Fantin, summer 1868; see Moreau-Nélaton, op. cit., v. I, p. 104.
- 74 Duret to Manet, July 20, 1868; see A. Tabarant: Manet, histoire catalographique, Paris, 1931, p. 183-184. Tabarant was given access to Duret's private papers and has published many of them in various articles quoted throughout the present book. See also T. [Tabarant]: Quelques souvenirs de Théodore Duret, Bulletin de la vie artistique, Jan. 15, 1922 and Duret's own writings, listed in the bibliography.

CÉZANNE: Forest Scene, 1865-68. $25\frac{1}{2} \times 21\frac{1}{4}$ ". The Bernhard Foundation, Inc., New York.

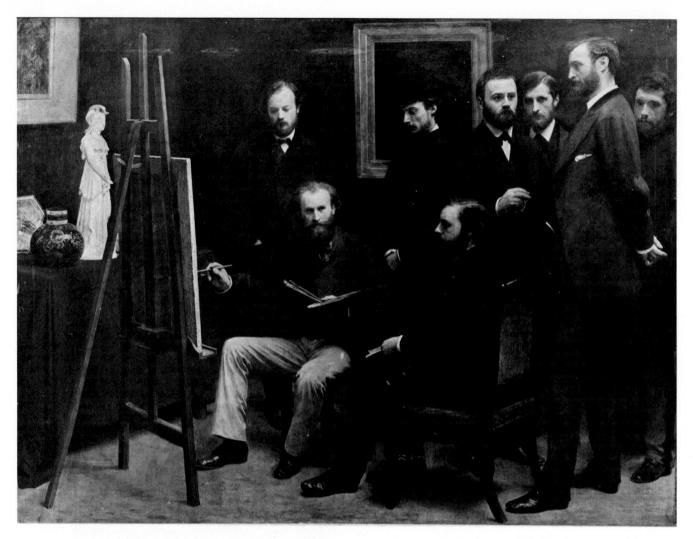

Fantin-Latour: A Studio in the Batignolles Quarter, 1870. 68½ × 82". From left to right: Scholderer, Manet, Renoir, Astruc (seated), Zola, Maître, Bazille, Monet. Exhibited at the Salon of 1870. Musée du Louvre, Paris.

BERTALL: "Jesus Painting among His Disciples" or "The Divine School of Manet," religious picture by Fantin-Latour. Caricature.

THE CAFÉ GUERBOIS

JAPANESE PRINTS

"LA GRENOUILLÈRE"

In the days of gaslight, when artists put down their brushes at dusk, they often spent the late afternoon and evening in one of the many cafés where painters, authors, and their fellows used to meet. Until 1866 Manet could be found as early as five-thirty on the terrace of the Café de Bade, but he soon abandoned this fashionable establishment in the center of Paris for another café, at number 11, Grande rue des Batignolles (later Avenue de Clichy). There, at the Café Guerbois, undisturbed by noisy crowds, Manet and all those who were immediately or indirectly interested in his efforts or in the new movement in general gathered around a few marble-top tables. Just as Courbet had held forth at his Brasserie, Manet now became the center of a group of admirers and friends. Astruc, Duranty, Silvestre, Duret, Guillemet, Bracquemond, and Bazille—accompanied by the Commandant Lejosne—were almost daily guests at the Café Guerbois; Fantin, Degas, and Renoir came frequently; Alfred Stevens, Zola, Edmond Maître, Constantin Guys appeared on occasion, and whenever they happened to be in Paris, Cézanne, Sisley, Monet, and Pissarro would drop in. Sometimes Nadar, too, showed up, a well-known Parisian figure of multiple talents. Journalist and caricaturist, he owed his reputation to his excellent photographs and even more to his frequent balloon ascensions, staged in the heart of Paris, with which, at one time, he had endeavored to finance the construction of a motorized hélicoptère.

At the Café, Thursday evenings had been set aside for regular gatherings, but any evening one was certain to find there a group of artists engaged in an animated exchange of opinions. "Nothing could be more interesting," Monet later remembered, "than these *causeries* with their perpetual clash of opinions. They kept our wits sharpened, they encouraged us with stores of enthusiasm that for weeks and weeks kept us up, until the final shaping of the idea was accomplished. From them we emerged with a firmer will, with our thoughts clearer and more distinct."²

Manet was not only the intellectual leader of the little group, he was, next to Pissarro, the oldest, being thirty-seven years old in 1869; Degas was thirty-five, Fantin thirty-three, Cézanne and Sisley were thirty; Monet and Renoir twenty-nine, Bazille was not yet twenty-eight. Surrounded by his friends, Manet, in the words of Duranty, was "overflowing with vivacity, always bringing himself forward, but with a

gaiety, an enthusiasm, a hope, a desire to throw light on what was new, which made him very attractive."

Dressed with great care, Manet was, according to Zola, "of medium size, small rather than large, with light hair, a somewhat pink complexion, a quick and intelligent eye, a mobile mouth, at moments a little mocking; the whole face irregular and expressive, with I-don't-know-what expression of sensitiveness and energy. For the rest, in his gestures and tone of voice, a man of greatest modesty and kindness."

Yet modesty and kindness seem to have been more the result of a perfect education than the reflection of Manet's inner nature. Not only was he ambitious and impetuous, but he showed even a certain disdain for anyone who did not belong to his own social sphere and had little sympathy for those members of the group who sought a new style entirely outside museum tradition. According to Armand Silvestre, one of the "regulars" of the Café Guerbois, Manet, though very generous and kind, "was naturally ironical in his conversation and frequently cruel. He had an inclination for punches, cutting and slashing with a single blow. But how striking were his expressions and often how just his observations!... He was the strangest sight in the world, his elbows on a table, throwing about his jeers with a voice dominated by the accent of Montmartre, close to that of Belleville [an even less refined popular quarterl. Yes, strange and unforgettable with his irreproachable gloves and his hat pushed back to the neck. . . . "5 His actual enemies Manet would crush by bons mots that were often witty, although seldom as sharp as those of Degas. Moreover, Manet did not permit contradiction or even discussion of his views. As a result he sometimes had violent arguments, even with friends. Thus a discussion once led to a duel between him and Duranty, in which Zola acted as second for the painter.6 Paul Alexis, a friend of both Cézanne and Zola, who also was often to be seen at the Café, reported that "completely ignorant of the art of fencing, Manet and Duranty threw themselves upon each other with such savage bravery that, when the four astonished seconds had separated them [Duranty being slightly wounded], their two swords appeared to have been turned into a pair of corkscrews. That very evening they had become the best friends in the world again. And the habitués at the Café Guerbois, happy and relieved, composed a triolet of nine lines in their honor..."

At another time Manet and Degas had a vehement run-in and subsequently returned the paintings each had given the other. When Degas thus received back the portrait he had done of Manet listening to his wife playing the piano, from which Manet had cut off the likeness of Mme Manet, the mutilation did anything but assuage his anger. He immediately added to the painting a piece of white canvas, apparently with the intention of redoing the part cut off, but never did so (p. 108).

Even when they were not actually quarreling, Degas and Manet retained a few "grudges." Manet never forgot that Degas had still been painting historical scenes when he himself was already studying contemporary life, whereas Degas was proud to have painted horse races long before Manet discovered them. Nor could he help noticing that Manet never did "a brushstroke without the masters in mind." Manet, on the other hand, confided to Berthe Morisot on the subject of Degas: "He lacks naturalness; he is incapable of loving a woman, even of telling her so...." Nevertheless, of all the painters at the Café Guerbois, Degas unquestionably was closest to Manet, both in taste and in the *esprit* with which he was so richly endowed.

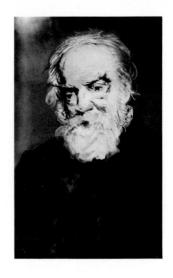

Manet: Constantin Guys, 1880. Pastel, $21\frac{3}{4} \times 13\frac{1}{8}$ ". Shelburne Museum, Shelburne, Vt.

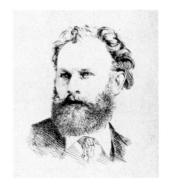

Bracquemond: Portrait of Edouard Manet, c. 1871. Etching.

Rather small, very slim, with an elongated head, "a high, broad, and domed forehead crowned with silky chestnut hair, with quick, shrewd, questioning eyes, deep-set under high arched eyebrows shaped like a circumflex, a slightly turned-up nose with wide nostrils, a delicate mouth half hidden under a small mustache," Degas had a somewhat mocking expression. He must have appeared almost frail compared with the others, especially as there was in his features as well as in his manners and his speech an aristocratic, even old-fashioned refinement that contrasted sharply with his surroundings at the Café. In his opinions and preferences he often stood alone, although it was not always clear where in him seriousness ended and irony began. To oppose him in a discussion was particularly difficult, not only because he had at his disposal a wide range of arguments, but because he little hesitated to confound his opponents with inescapable aphorisms, sometimes malicious, sometimes even cruel, always extremely clever.

Duranty noted apropos Degas: "An artist of rare intelligence, preoccupied with ideas, which seemed strange to the majority of his fellows. Taking advantage of the fact that there was no method or transition in his brain which was active and always boiling over, they called him the inventor of social chiaroscuro." One of Degas' favorite topics was, indeed, "the unsuitability of making art available to the lower classes and allowing the production of pictures to be sold for 13 sous." While such views must have been violently contested by the extremely social-minded Pissarro and Monet, Degas caused even more surprise by his tendency to consider seriously and even to defend the works of artists in whom his listeners were unable to discover any qualities. Apparently his great respect for the specific problems tackled made him indulgent toward the results obtained. Where the others saw only the ultimate failure, he remained conscious of the initial effort and was unable to withhold sympathy. Once in front of a landscape by Rousseau, questioned about the trouble in rendering details meticulously—in this case, the leaves of trees—his immediate answer was: "If it weren't trouble, it wouldn't be fun."

Degas "never remained at the Café for any length of time," Silvestre was to remember later: "... an innovator of sorts whose ironic modesty of bearing saved him from the hatreds that attach themselves to the boisterous ones." 5

Among the habitués of the Guerbois, Degas was particularly friendly with Duranty whose ideas often coincided with his own and who was brilliant enough not to be intimidated by the painter. Silvestre has described him as a gentle, sad, and resigned man of incredible delicacy, who "spoke slowly, very softly, with a kind of almost imperceptible British accent. Nothing that showed affluence, yet an exquisite propriety and an air of great dignity. Besides, he was an extremely sympathetic and distinguished person with a trace of bitterness. . . . How many disillusions one felt hidden behind his always discreet cheerfulness! He was blond, but his hair was already thinning, and he had vivid and mild blue eyes. His life seemed to be translated by his frequently dolorous smile." Yet in spite of his quiet manners, Duranty usually took issue with sharpness, basing his lucidly explained views on impeccable erudition.

Of the others only Bazille seems to have had enough education and taste for verbal skirmishes to engage such adversaries as Degas or Manet. Although apparently somewhat shy, Bazille was firm in his beliefs and stood up for them. From his letters

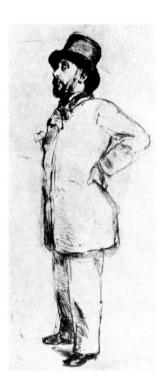

DESBOUTIN: Portrait of Edgar Degas, c. 1876. Etching.

it appears that his arguments had more of the logic and precision which distinguish a lawyer than the passion that might be expected from a young artist. He always went right to the center of the problem with a clarity of mind unblurred by sentimentalities, and he approached all questions with a matter-of-factness quite uncommon for his age.

When he later assembled notes for the central figure of one of his novels, Zola drew the following portrait of Bazille: "Blond, tall and slim, very distinguished. A little the style of Jesus, but virile. A very handsome fellow. Of fine stock, with a haughty, forbidding air when angry, and very good and kind usually. The nose somewhat prominent. Long, wavy hair. A beard a little darker than the hair, very fine, silky, in a point. Radiant with health, a very white skin with swiftly heightened color under emotion. All the noble qualities of youth: belief, loyalty, delicacy." 14

While Manet, Degas, and Bazille represented the same type of cultivated and wealthy bourgeois, most of their companions came from lower social rank. Cézanne, in spite of the fortune amassed by his father—a former hat-manufacturer—and in spite of his law studies, liked to exhibit rather rough manners or to exaggerate his southern accent out of defiance for the polished style of the others. It was as if he were not satisfied to show his contempt for official art only in his works, as if his entire being had to express a challenge, to underline his revolt. He willfully neglected his appearance and seemed to take pleasure in shocking. Monet later remembered, for instance, how Cézanne would shake hands with his friends but take off his hat in front of Manet and say: "I am not offering you my hand, Monsieur Manet, I haven't washed for eight days." ¹⁵

Cézanne was tall and thin, "bearded, with knotty joints, and a strong head. A very delicate nose hidden in the bristly mustache, eyes narrow and clear... Deep in his eyes, great tenderness. His voice was loud.... He was a little stoop-shouldered and had a nervous shudder which was to become habitual." He was not a frequent guest at the Café Guerbois, partly because he used to spend half the year in his native Aix, partly because he did not care for discussions and theories. If he showed any interest at all in what was going on around him, he would sit in a corner and listen quietly. When he spoke up, he did so with the vehemence of deep inner conviction, but often, when others expressed opinions radically opposed to his own, he simply got up abruptly and left the gathering without taking leave of anybody.

Cézanne's friend Zola, quite the contrary, assumed a prominent role in the group. Short, plump, and energetic, according to Silvestre, he was in those days, "still in a period of full struggle, but the conviction of a not too distant victory was plainly visible in the serenity of his gaze and the quiet firmness of his speech. One had to be blind not to sense the vigor of this man just by looking at him... His most striking features were the patient power of thought written on his forehead, as well as his restless and searching spirit borne out by his fine but irregular nose, finally the determined line of his mouth and a Caesarian chin... It was impossible not to expect from him something strong, willful, bravely opposing conventions, something personal and audacious. He always spoke with the calmness of people sure of themselves, in a voice that lacked sparkle but that was cutting and precise, expressing in a picturesque, but not unduly imaginary form ideas that were invariably clear."5

Zola had become the mouthpiece of the friends in the press and their ardent

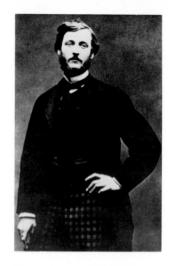

Photograph of Frédéric Bazille, c. 1869.

defender. Yet his adherence to the group had been dictated by his search for new forms of expression rather than by a full understanding of the artistic problems involved. His taste lacked both refinement and discrimination, but his heart was with those who, ridiculed by the masses, had set out in the pursuit of a new vision. He was happy to find in their theories many analogies to his own views on literature, and saw in their common struggle the promise of a common triumph. With enthusiasm and stubbornness he had embraced the cause of Manet and the others, eager not to miss any occasion for proclaiming his faith. "I was passionate in my convictions," he later wrote of those days, "I wanted to cram my beliefs down other people's throats."

Monet, too, had something of the fire of Zola, but was apparently unwilling to put himself forward. The almost brutal refusal to compromise which he had shown in his youth seems to have worn off with the years so full of bitter trials. Not that his views had changed or his self-confidence vanished, but he now was somehow less eager to manifest his robust pride. He who had been the leader of the little group of his friends thus became an unobtrusive guest at the Café Guerbois, more concerned with listening to the others than with contributing to the discussions. Having left school early, as had Renoir, he may have felt a certain lack of education that pre-

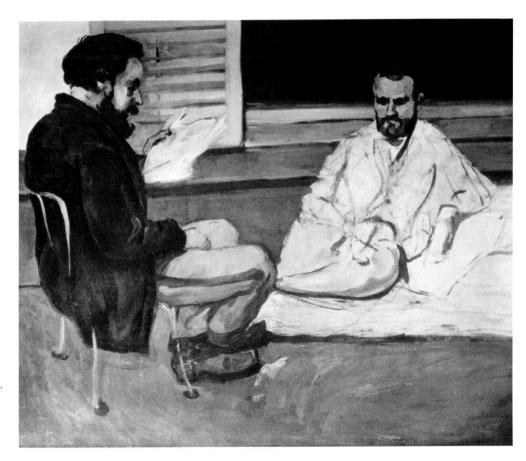

Cézanne: Paul Alexis Reading to Emile Zola, c. 1869. 51\frac{1}{8} \times 63''. Formerly in the collection of Emile Zola. Museu de Arte Moderna, São Paulo, Brazil.

Manet: Paris Café (Café Guerbois?), d. 1869. Pen and ink, $11\frac{5}{8} \times 15\frac{1}{2}$ ". Fogg Museum of Art, Cambridge, Mass. (Paul J. Sachs Collection).

vented his entering into the debates, just as his ignorance of the masters of the past deprived him of arguments in controversies for or against certain traditions. Yet his incomplete education does not appear to have elicited in him any regret; instead, he relied with superb confidence on his instincts. After all, it mattered little whether he won an argument or surprised the others by a witty remark. When he put up his easel somewhere in the open, no erudition, no cleverness would help him solve problems. The only experience he cared for was that which was gained through work: the perfect blending of his energetic temperament and the delicacy of his visual sensations, the complete command of his means of expression.

Although Manet and Degas did not show very much consideration for the pure landscapists, Monet needed the Café Guerbois in order to overcome the feeling of complete isolation which may have oppressed him occasionally during his retreats in the country. It was good for him, no doubt, to find there kindred spirits, cordial companions, and the assurance that ridicule or rejection were powerless against the determination to carry on. Together the friends constituted a movement; and in the end success could not be denied them.

Like Monet, Renoir was not the man to raise his voice in collective and noisy debates. He had formed himself as a young man, had read through many nights and later had studied ardently the masters of the Louvre. Though he could hardly compete with Manet or Degas, a natural and vivid intelligence helped him to grasp the essence of all problems that were presented. He had a great sense of humor, was

quick, witty, without too much passion, but hard to convince. He could listen to others and acknowledge the faultless structure of their arguments yet feel free to cling to his convictions, even if nobody shared them. When Zola reproached Corot for putting nymphs instead of peasant women into his landscapes, Renoir could not see why this should make any difference, so long as Corot's works satisfied him. And while the others stressed their independence, he never faltered in his belief that it was at the museum that one learned best how to paint. "I used to have frequent discussions on this subject," he said later, "with some of my friends who argued against me in favor of studying strictly from nature. They held against Corot his re-working his landscapes in the studio. They found Ingres revolting. I used to let them talk. I thought that Corot was right and in secret I delighted in La Source's pretty belly and in the neck and arms of Madame Rivière [both by Ingres]."18

Thin, nervous, modest, and poor, Renoir was always lively and full of an irresistible gaiety. His speech was more or less deliberately adorned with Parisian slang and he readily laughed at jokes even when they were not so clever as Degas' bons mots. He showed complete unconcern for solemn theories and deep reflections; they seemed to annoy him. Life was enjoyable, painting was an inseparable part of it and, to create a work of art, a happy mood seemed to him more important than any profound remark about the past, present, or future. He refused to consider himself a revolutionary, often repeating that he only "continued what others had done—and much better —before me."19 And he willingly confessed that he did not have "a fighter's spirit." Sisley, who when he worked with Renoir at Fontainebleau showed himself genial,

Right, Photograph of Alfred Sisley, c. 1872.

Far right, BAZILLE: Portrait of Auguste Renoir, 1867. $24\frac{1}{2} \times 20''$. Musée National des Beaux-Arts, Algiers.

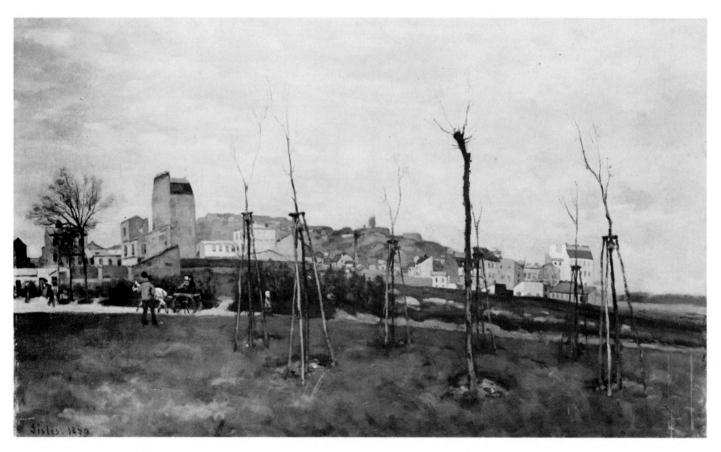

Sisley: View of Montmartre, d. 1869. $27\frac{1}{2} \times 46''$. Musée de Grenoble.

animated, full of fantasy, and whom Renoir loved precisely for his "undaunted good humor," seems to have come less frequently to the Café than the others. His natural timidity probably prevented him from attending these gatherings where the sparkling company must have paralyzed his gay disposition. As to Berthe Morisot, it was evidently "improper" for her to attend the meetings at the Café, but Degas and Manet doubtlessly kept her apprised of what was being discussed there.

There were still others who felt attracted to the gatherings at the Café Guerbois, among them Paul Guigou, a Provençal like Cézanne and five years his elder. He had been a student at the Aix university, had worked as a law clerk at Marseilles where he met Monticelli, and at local exhibitions had studied the paintings which Corot, Delacroix, Rousseau, Diaz, and others sent there. (Cézanne probably also visited these shows.) After several short stays in Paris where he had been impressed with Courbet's work, Guigou became acquainted, in 1859 at Marseilles, with the young Dr. Gachet, who had just finished his medical studies in Montpellier. When Guigou settled in Paris after deciding to be a full-fledged painter, he saw Gachet again and it was probably the latter who took him to the Café Guerbois. Guigou

had obtained a certain success at various Salons, notably in 1863, despite the fact that he devoted himself exclusively to plein-air painting, approaching nature as soberly as did Bazille, though with a somewhat more romantic sense of color and a technique of impasto that linked him to Monticelli. Yet the freshness of his perceptions and the freedom of his execution provided his work with a very personal note, somewhere between Corot and Courbet. At the Café Guerbois, Guigou became particularly friendly with Monet, Pissarro, and Sisley, as well as with Burty and Duret.²⁰

Widely divergent as they were in character and conceptions, the friends who met at the Café Guerbois nevertheless constituted a group, united by a common contempt for official art and a determination to seek the truth away from the beaten track, But since nearly every one of them was seeking it in a different direction, it was logical that they were not considered as a "school" and instead received the designation Le groupe des Batignolles. This neutral term simply underlined their affinities without limiting their efforts to any specific field. When Fantin undertook in 1869 to paint another of his group compositions, A Studio in the Batignolles Quarter, according to his own description, he showed, around Manet, seated in front of his easel: Renoir, "a painter who will get himself talked about"; Astruc, "a whimsical poet"; Zola, "a realistic novelist, great defender of Manet in the newspapers"; Maître, "a highly refined mind, amateur musician"; Bazille, "manifesting talent"; Monet, and the German painter Scholderer,²¹ (At Manet's request, it seems, Renoir was placed near him, but Duranty, originally included in the composition, was discarded.²²) For the first time Fantin neglected to depict himself in the midst of his fellows, as if he considered his place was no longer among them. He also omitted a rather prominent member of the group, Camille Pissarro.

The dean of the painters, two years older than Manet and eleven years older than

Guigou: Village d'Allauche, d. 1866. Panel, $7\frac{1}{8} \times 16\frac{1}{8}$ ". Private collection, Marseilles.

Fantin-Latour: Study for A Studio in the Batignolles Quarter, c. 1869. Charcoal and oil, $11\frac{1}{2} \times 15\frac{1}{2}$ ". At left, in top hat, Degas, eliminated from the final version, p. 196. Metropolitan Museum of Art, New York (gift of Mrs. H. M. Loewel in memory of her brother, C. W. Kraushaar).

Renoir, father of two children, Pissarro now lived with his little family in Louve-ciennes but paid frequent visits to Paris. He appears to have always been a welcome guest at the Café Guerbois, for there was no one among the painters and authors who did not feel deep esteem for this gentle and calm man, uniting a profound goodness with an indomitable spirit. More conscious than the others of the social problems of the times, he had nothing of Degas' casual frivolity or of Manet's occasional showmanship. Passionately interested in political questions, a socialist with strong anarchistic ideas, a convinced atheist, he linked the painters' struggle to the general position of the artist in modern society. But radical as his opinions were, they were free from hatred, and everything he said was illuminated by unselfishness, a purity of intention that commanded the respect of the others. They knew about his own difficulties and admired the complete lack of bitterness, indeed, the cheerfulness, with which he could discuss the most radical issues.

The son of Jewish parents, Pissarro had many of the characteristics of the Semitic type: abundant dark hair, a noble, aquiline nose, and large, somewhat sad eyes that could be both fiery and tender. His mind was clear, his heart generous. Those who came to know him felt not only respect for Pissarro but genuine affection. It was not chance that two of the most distrustful, most undependable members of the group, Cézanne and Degas, felt real friendship for him. Never flattering, never behaving with unwarranted harshness, he inspired complete confidence because in his actions and in his views he resembled the just of the Bible.

While Pissarro may have occasionally brought up political questions at the Café

Guerbois, the discussions centered more frequently upon theoretical or technical problems of painting. One of the subjects of wide interest to the artists was that of oriental art in general—they had been able to study it at the 1867 World's Fair—and of Japanese prints in particular.

As far back as 1856 Bracquemond had discovered a little volume of Hokusai, which had been used for packing china; he had carried it around with him for quite a while, showing it to everybody. A few years later, in 1862, M. and Mme Desoye, who had lived in Japan, opened La Porte Chinoise under the arcades of the rue de Rivoli, an oriental shop which soon attracted a great number of artists. Whistler began to collect blue and white china as well as Japanese costumes which he bought there. In 1865 he posed in a kimono for Fantin's Toast and exhibited the Princesse du Pays de Porcelaine (Jo dressed in oriental silks) at the Salon. Rossetti and Degas' friend Tissot also began to buy Japanese costumes; there is a painting of a Japanese subject on the wall of Tissot's studio in the portrait Degas painted of him in 1868 (see p. 176). In 1869 Fantin planned a composition with a nude, seen from the back, holding a Japanese fan; in the margin of one of his preparatory sketches he wrote: "Japanese box on Japanese books, Japanese prints, Whistler's robe [hung in the background]." Japanese objects, fans, and prints found their way into almost every studio. Monet and Renoir owned some, and there are two Japanese prints next to Zola's table in his portrait by Manet, Fantin, Manet, Baudelaire, and the Goncourt brothers were

PIETTE: Camille Pissarro at Work, c. 1870 (?). Gouache, $10\frac{3}{4} \times 13\frac{1}{4}$ ". Formerly collection Camille Pissarro. Present whereabouts unknown.

Far left, fashion print published in 1871 in *La Mode Illustrée*.

Left, Cézanne: Copy after fashion print, 1871. $23\frac{1}{4} \times 18\frac{1}{2}$ ". Formerly collection Mrs. Charles S. Payson, New York.

among those to be seen frequently at Desoye's.²³ According to Castagnary, the Batignolles group at one time was even called "the Japanese of painting."²⁴

Of the Batignolles group, Degas apparently showed the greatest interest in Japanese prints. Their graphic style, their subtle use of line, their decorative qualities, their daring foreshortenings and, above all, the way in which their principal subjects were often placed off-center, the whole composition and organization of space seem to have impressed him deeply. Some of these characteristics were to find an echo in his own works, but, unlike Tissot or Whistler, he did not make any direct use of picturesque Japanese subjects or elements. Quite the contrary, he endeavored to absorb those of the new principles which he could adapt to his own vision and used them, stripped of their fancy oriental character, to enrich his repertory. "From Italy to Spain, from Greece to Japan," he liked to say, "there is not very much difference in technique; everywhere it is a question of summing up life in its essential gestures, and the rest is the business of the artist's eye and hand."25

Cézanne does not seem to have been attracted by Eastern art, since it had no connection with the regions haunted by his fertile imagination. But prints in the cheap fashion journals to which his two young sisters subscribed interested him occasionally. When he fell short of inspiration, which did not happen often, he thought nothing of copying the insipid ladies in these plates, infusing them with a strange and dramatic power. Just as Manet frequently adopted certain elements from the masters, Cézanne found in these fashion prints pretexts for creations of his own.

Renoir, too, was very little interested in Japanese prints. He was at this period greatly impressed by Delacroix's treatment of oriental subjects and found in that

painter's odalisques and Algerian scenes more excitement and richer color schemes than in the meticulous harmonies from Japan. Pissarro, on the other hand, was inclined to admire the technical accomplishments in Japanese prints, being particularly interested in the various processes of the graphic arts. As for Monet, he apparently had admired Japanese prints in Le Havre at about the same time as Bracquemond had discovered them in Paris, and he later said: "Their refinement of taste has always pleased me and I approve of the suggestions of their aesthetic code, which evokes presence by means of a shadow, the whole by means of a fragment." 26

The subject of shadows may well have been under frequent discussion at the Café Guerbois; in fact, it constituted one of the painters' main problems. Manet liked to maintain that for him "light appeared with such unity that a single tone was sufficient to convey it and that it was preferable, even though apparently crude, to move abruptly from light to shadow than to accumulate things which the eye doesn't see and which not only weaken the strength of the light but enfeeble the color scheme of the shadows, which it is important to concentrate on."²⁷ But those among Manet's companions who had already worked out-of-doors, that is, all the landscapists in the group, must have objected to his manner of dividing a subject merely into lighted and shaded areas. Their experience with nature had taught them otherwise. Little by little they were abandoning the usual method of suggesting the third dimension by

Renoir: Winter Landscape, c. 1868. 19\(\frac{5}{8} \times 25\(\frac{5}{8} '' \). Collection Suzanne Eisendieck, Paris.

letting the so-called local color of each object become more somber as the object itself seemed further away from the source of light and deeper in the shadow. Their own observations had taught them that the parts in the shadow were not devoid of color nor merely darker than the rest. Being to a lesser degree penetrated by the light, the shaded areas did not, of course, show the same color values as those exposed to the sun, but they were just as rich in color, among which complementaries and especially blue seemed to dominate. By observing and reproducing these colors, it became possible to indicate depth without resorting to any of the bitumens customarily reserved for shadows. At the same time the general aspect of the work became automatically brighter. In order to study these questions further Monet, Sisley, and Pissarro began to devote themselves especially to winter landscapes. There could be no question that a shadow cast on snow was not bituminous and that, instead of the original white, there appeared in the shadowed region colors postulated by the atmosphere and by the object that barred the light. It thus became clear that surroundings exposed to light influence the colors of those parts remaining in the shade.

Many years later, toward the end of his life, Renoir was to expound on this question while examining a winter scene submitted by a young artist who had used a good deal of white to paint the snow. "White does not exist in nature," Renoir said. "You admit that you have a sky above that snow. Your sky is blue. That blue must show up in the snow. In the morning there is green and yellow in the sky. These colors also must show up in the snow when you say that you painted your picture in the morning. Had you done it in the evening, red and yellow would have to appear in the snow. And look at the shadows. They are much too dark. That tree, for example, has the same local color on the side where the sun shines as on the side where the shadow is. But you paint it as if it were two different objects, one light and one dark. Yet the color of the object is the same, only with a veil thrown over it. Sometimes that veil is thin, sometimes thick, but always it remains a veil. You should paint it that way; paint the object and then throw a veil over it.... Look at Titian, look at Rubens—see how thin their shadows are, so thin that you can look through them. Shadows are not black; no shadow is black. It always has a color. Nature knows only colors.... White and black are not colors."28

Although Renoir achieved transparent shadows only later in life, through the use of glazes, his concept of the color of shadows applied already to his works of those years when he, as well as Monet, Sisley, and Pissarro still used opaque pigments for their winter landscapes. This opacity did not prevent them from achieving subtle representations of atmospheric conditions in which, due to the observation of reflections, the shadows played a unifying role instead of dividing their paintings into zones of light and of darkness. These efforts found a sympathetic echo in the writings of Thoré-Bürger (who died in 1869) when he stated that "most landscapists stubbornly try to explain everything in their pictures rather than strive for an effect of the whole. They forget that the individuality of trees, fields, monuments, or figures is almost always drowned in the light or in the shadow, that is in the air. From near-by one sometimes perceives details, but at the slightest distance only the shapes of objects are revealed, leaving the rest to conjecture." Indeed, if shadow areas were to be seen as permeated by indirect light, the regions exposed to light lose in proportion their sharpness of focus, all forms being submerged in the reigning atmosphere.

Sisley: Early Snow at Louveciennes, c. 1870. $21\frac{3}{8} \times 28\frac{7}{8}$ ". Museum of Fine Arts, Boston (Bequest of John T. Spaulding).

As a result of these observations any discussion of the problems of light and shadow at the Café Guerbois became actually a debate for or against plein air. Although Manet, Degas, and Fantin did not conceal their opposition to working out-of-doors—partly because the old masters had never done so—Monet and his friends could not fail to praise the infinite variety of colors and the greater interpenetration of light and its reflections which their method permitted them to attain. Yet they themselves were still in a stage of experimenting, and Pissarro was to say many years later: "I remember that, though I was full of ardor, I did not have the slightest idea, even

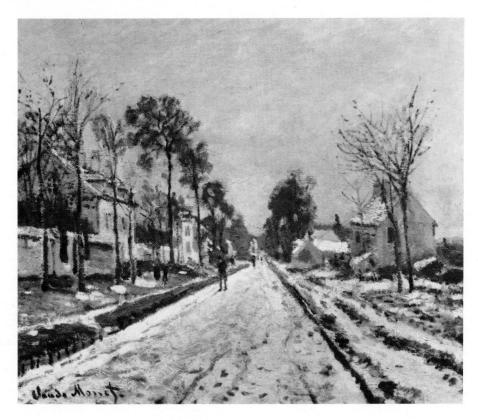

Monet: The Road to Versailles at Louveciennes—Snow-effect, 1869-70. $22 \times 25\frac{1}{2}$ ". Formerly owned by Faure. Collection Mr. and Mrs. Neison Harris, Chicago.

at the age of forty, of the profound aspect of the movement which we pursued instinctively. It was in the air."30

It seems certain that the word *impression* was frequently heard in the discussions of the painters. Critics had used it for some time to characterize the efforts of such land-scapists as Corot, Daubigny, and Jongkind. Rousseau himself had spoken of his attempts to remain faithful to the "virgin impression of nature," and Manet, though not primarily interested in landscapes, had insisted on the occasion of his large show in 1867 that his intention was "to convey his impression." Even a critic hostile to the group admitted that Manet caught "admirably the first impression of nature." According to the artist's friend Proust, Manet had been using the word *impression* for about ten years already.

In all likelihood the discussions at the Café Guerbois also touched on practical questions, especially on the tremendous difficulties experienced by all the members of the group who had to live from the proceeds of their work. Strong in their beliefs and convinced of creating works of real value, they naturally felt certain that through exhibiting their paintings they would be able to conquer the latent hostility of the

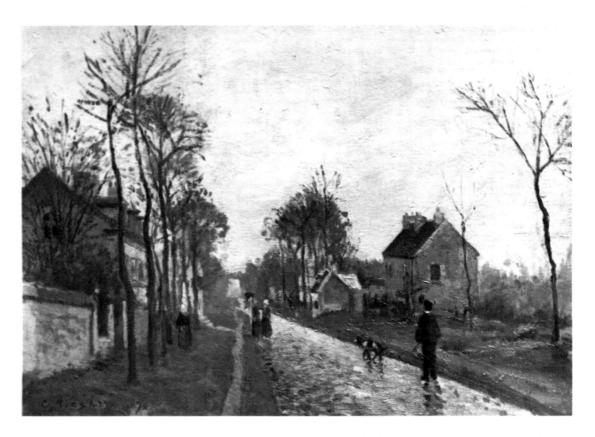

PISSARRO: The Road to Versailles at Louveciennes—Rain-effect, d. 1870. 15³/₄ × 22". Sterling and Francine Clark Art Institute, Williamstown, Mass.

public. Since it was the Salon jury which prevented them from approaching the public, it seemed logical that they should once again toy with the plan of exhibiting outside the Salon, although such a project had come to naught in 1867 for lack of funds. Paul Alexis was doubtless thinking of his friends debating such possibilities when, several years later, while speaking of an "artistic corporation" to be organized, he wrote that he had often heard similar ideas expressed in various forms. "I remember projects of annual or monthly contributions put forward in certain groups, of statutes outlined, of societies for exhibitions and sales ready to be founded." In one project, "each member would have contributed five francs every month and been entitled to show two of his works for permanent exhibition and sale; no preliminary inspection, no exclusions. . . ." Yet, according to Alexis, "there were still too many obstacles for such an association to be formed."³²

In the meantime the painters dealt directly with their rare clients. Almost every one of them knew a few collectors who occasionally bought paintings; the singer Faure and the bankers Hecht showed interest in Manet's works, another banker, Arosa, favored Pissarro, Monet had his patron Gaudibert in Le Havre, but there did

not exist as yet a real market for their canvases. There were practically no dealers interested in handling their works. Martinet did not make much progress in selling Manet's paintings, and Latouche was not to be relied upon either. When in 1869 he showed again in his window a view of Sainte-Adresse by Monet, there was, in the words of Boudin, "a crowd before the windows during the whole exhibition and, in the younger people, the unexpected element in this violent painting produced fanaticism," but the picture apparently was not sold. Cézanne had had a similar experience when a dealer in Marseilles exhibited one of his works. "The result was a great to-do," Valabrègue informed Zola. "People gathered in the street; the crowd was stupefied. They asked Paul's name; in this regard there was a slight succès de curiosité. But I believe that if the picture had been displayed much longer, people would have ended by breaking the glass and tearing the canvas to pieces." 34

The only regular dealer who at that time showed some interest in the works of the young men was père Martin, who used to handle occasionally the works of Corot and more or less exclusively those of Jongkind. Pissarro had begun to have dealings with him around 1868, yet Martin paid only from 20 to 40 francs, according to the size of the canvas, reselling at prices between 60 and 80 francs. Sisley did not obtain more, whereas père Martin apparently asked up to 100 francs for Monet's pictures, but was satisfied with 50 for canvases by Cézanne. When Monet, in 1868, wanted 100 francs for a landscape, the dealer only offered him 50 plus a small painting by Cézanne, a deal which Monet, who had grown fond of Cézanne's work, accepted.³⁵ There seemed little hope for the painters to command higher prices in the near future unless they managed to attract the public's attention and favor, which could be done only at the Salon.

The opinions concerning the Salon were rather divided in the Batignolles group. Renoir, who hated to "play the martyr," regretted his occasional rejections simply because to exhibit at the Salon seemed the natural thing to do.36 Manet used to proclaim that the "Salon is the real field of battle. It's there one must take one's measure."37 Since it was the only place where the artists could present themselves, Manet argued, they should accept the challenge of the public and the jury, and force their way, for there was no doubt that sooner or later their day would come. Cézanne advocated that the painters always send their most "offensive" pictures to the Salon. In doing so he radically departed from the established custom, already honored by Corot and Courbet, of submitting to the jury only the "tamest" works. This custom actually led many artists to distinguish between their paintings executed for the Salon and their regular work done without compromise. But Cézanne's purpose was less to be admitted to the Salon than to put the refusing jury into the wrong. Zola expected him to be refused for another ten years, and the painter himself apparently did not think otherwise. In the meantime he treated the jury to the strongest words in his extensive vocabulary and vowed: "They'll be blasted in eternity with even greater persistence!"38

Both Manet and Cézanne had sufficient resources to allow them to wait, and so had Degas, who even refused, in February 1869, a contract offered him by the Belgian art dealer Stevens, brother of the painter, which would have guaranteed him a yearly income of twelve thousand francs, a considerable amount at the time.³⁹ But for the others the question of participation in the Salon was not merely one of princi-

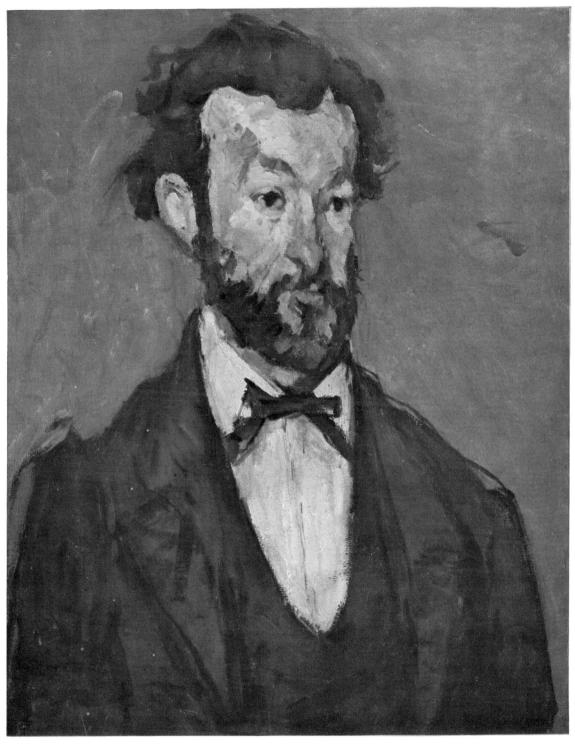

Cézanne: Portrait of Anthony Valabrègue, c. 1870. $24\frac{1}{2} \times 20''$. Collection Mrs. Hugo Moser, New York.

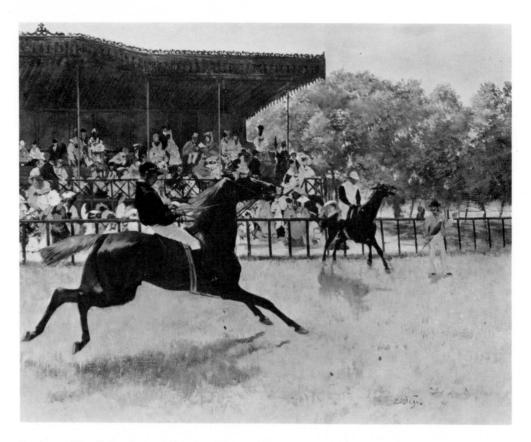

Degas: The False Start, 1869-72. $12\frac{5}{8} \times 15\frac{3}{4}$ ". Exhibited in London in 1872. Formerly owned by Hoschedé. Collection Mr. and Mrs. John Hay Whitney, New York.

ple. Besides being obliged to sell their works, they must have felt also that the endless struggle against the jury condemned them to isolation by depriving them of the only means to exhibit their canvases. Next to creating, nothing seemed more essential than to show the results of their efforts, to try at least to interest the public in their honest intentions, their ceaseless labor, and their new discoveries.

In 1869 a decree appeared which seemed to promise that admission to the Salon would at last be made easier. Beginning in that year all painters who had once been admitted to the Salon were entitled to participate in the election of two-thirds of the jury. This meant that, except for Cézanne, who had shown only at the Salon des Refusés, all the members of the Batignolles group could now take part in the voting. But Bazille, realistic as ever, told his parents: "I shall not vote, because I should prefer not to have any jury at all, and because the one which has been functioning for several years perfectly represents the majority." As a matter of fact the jury in 1869 did not differ substantially from that of previous years. Daubigny was again elected, so were Cabanel and Gérôme, but Corot was not. And their decisions were similar to those in the past. Stevens, who had tried to interest some jury members in the works of Bazille, was proud to announce that at least one of his

friend's canvases had been accepted. Degas and Fantin also had one work admitted and one rejected. Pissarro and Renoir figured in the catalogue with but one painting (Renoir's was a new portrait of Lise). Only Manet had two works accepted. Sisley and Monet were refused.⁴¹

"What pleases me," Bazille wrote to Montpellier, "is that there is genuine animosity against us; it is M. Gérôme who has done all the harm; he has treated us as a band of lunatics and declared that he believed it his duty to do everything to prevent our paintings from appearing; all that isn't bad." And he added: "I am as poorly hung as possible.... I have received a few compliments which have flattered me a lot, from M. Puvis de Chavannes [whom he had met at Stevens'], among others. The Salon as a whole is deplorably weak. There is nothing really fine except the pictures of Millet and Corot. Courbet's, which are very feeble for him, make the effect of masterpieces in the midst of the universal platitude. Manet is beginning to be a little more to the taste of the public."42

Berthe Morisot had not sent anything to the Salon that year, but a portrait of her appeared in Manet's Balcony (see p. 221). She went to see it on the opening day

Renoir: Summer (Lise), 1868. Exhibited at the Salon of 1869. Formerly collection T. Duret. Nationalgalerie, Berlin-Dahlem.

DEGAS: Mme Gaujelin, d. 1867. $23\frac{1}{2} \times 17\frac{1}{2}$ ". Exhibited at the Salon of 1869. Isabella Stewart Gardner Museum, Boston.

and wrote her sister Edma: "One of my first concerns was to make my way to the M room. There I found Manet, with a bewildered air. He begged me to go and look at his painting because he didn't dare put himself forward. I have never seen such an expressive face; he was laughing in an anxious way, at the same time insisting that his picture was very bad and that it was having a lot of success. I consider him indeed a charming person, who pleases me infinitely. His paintings as usual make the impression of a wild or even slightly green fruit; they are far from displeasing to me. I am strange rather than ugly [in the Balcony]; it seems that the epithet femme fatale has circulated among the curious.

"Friend Fantin cuts a rather dreary figure with a little insignificant canvas, placed unbelievably high.... Degas has a very pretty little portrait of an extremely ugly woman in black, wearing a hat and letting her shawl fall off, the whole thing against the background of a very light room, a fireplace in halftone in the background. It is very sensitive and distinguished.

"Tall Bazille has done something I consider fine: it is a little girl in a very light dress under the shadow of a tree, behind which one glimpses a village. There is a lot of light, of sun. He is attempting what we have so often tried, putting a figure out-of-doors; this time he seems to me to have succeeded." (See p. 223).

Berthe Morisot also informed her sister that "M. Degas appears very satisfied with his portrait... He came and sat beside me, pretending that he was making love to me, but this was limited to a long commentary on Solomon's proverb: 'Woman is the desolation of the just.'"⁴⁴

"Poor Manet is sad," she wrote a little later. "His show, as usual, was little appreciated by the public; but for him this is a continually new cause of astonishment. Nevertheless, he told me that I brought him luck and that he had had an offer for the *Balcony*. I should like it to be true for his sake, but I am very much afraid that his hopes will once more be disappointed."45

Indeed, the press was again hostile. Albert Wolff, a newcomer among the critics who was soon to acquire considerable status, distinguished himself by particularly ambiguous comments in which he recognized the artist's talent and simultaneously condemned his work. (This manner of showing a certain "open-mindedness" only to express prejudices more forcefully was becoming a favorite device with reactionary Salon reviewers.) "I do not have the honor of knowing M. Manet," Wolff wrote. "It seems that he is a charming man and, what is more, an homme d'esprit; add to these gifts of nature an indisputable artistic temperament and then ask yourself why, with all this, a painter arrives at such an uncouth art where, as in the green blinds of his Balcony, he degrades himself to the point of entering into competition with house painters. It is truly exasperating."⁴⁶

No wonder that Berthe Morisot's mother informed her daughter Edma, concerning Manet: "He tells you in a very natural way that he meets people who avoid him in order not to discuss his painting with him and that, observing this, he no longer has the courage to beg anyone to pose for him."⁴⁷

However, Manet was soon to have this "courage" again, for when he met Eva Gonzalès, the twenty-year-old daughter of a then well-known author, he was so fascinated by her dark beauty that he asked her whether she would agree to sit for him. Eva Gonzalès, who was painting under the supervision of the highly fashionable

Manet: La Brioche, 1870. $25\frac{5}{8} \times 31\frac{7}{8}$ ". Formerly owned by Faure. Collection David Rockefeller, New York.

Chaplin, thereupon left her teacher and entered Manet's studio, rue Guyot, as a pupil.⁴⁸

According to Burty, the lessons which Manet gave Eva Gonzalès were of a rather unorthodox nature (she was actually the only pupil whom he ever accepted). He would pace his studio, "arrange some grapes on the corner of a white tablecloth, a slice of salmon on a silver platter, as well as a knife, and say: 'Do this quickly! Don't pay too much attention to the background. Preoccupy yourself mostly with the values. Do you understand? When you look at this [still life], and especially when you think of representing it as you feel it, that is in such a way that it will make the same impression on the public as it does on you, then you do not perceive the lines on the wallpaper over there. Isn't that so? And when you contemplate the whole thing you wouldn't dream of counting the scales on the salmon, would you? You must see them in the form of small silver pearls against grey and rose colors!... As to the grapes! Are you going to count those grapes? Of course not. What is striking is their tone of light amber and the dust which models forms while softening them. It is the brightness of the tablecloth as well as the spots which are not directly touched by the light which have to be rendered.... The folds will establish themselves if you just put them where they belong. Oh! M. Ingres; he was strong! We are only children. He knew how to paint fabrics." "49

But in his own still lifes, of which Manet painted a certain number at that period, there are no reminiscences of Ingres. Superbly arranged, with colors blending here, opposing each other there, they are executed deftly and with astonishing subtlety (see p. 219). Their delicate harmonies, their sometimes restrained, sometimes lively brushwork which show the artist in full command of his technique, continue the famous lineage of French still life painting. If there is any connection with masters of the past, as indeed there is, they are Chardin and possibly Goya, who were certainly more inspiring than Ingres and whom Manet frequently equaled.

Meanwhile the portrait of Eva Gonzalès advanced only slowly. She is represented full figure, seated before an easel and painting not grapes but flowers in a vase. Like Berthe Morisot, whom Manet had painted shortly before, gracefully reclined on a sofa in his studio, Eva Gonzalès wears a white muslin dress with a dark ribbon around her waist. But while Berthe Morisot appeared relaxed, youthful, and dreaming, Eva Gonzalès is shown, on a canvas more than six feet high, in a somewhat contrived and solemn pose; although her brush touches the still life at which she supposedly works, her gaze is directed toward the onlooker. There is a certain air of an "official portrait" about this large painting which Manet, indeed, planned to show at the Salon (see p. 225).

Berthe Morisot, ardent but timid, seems to have resented the presence of her more worldly rival in the intimacy of Manet's studio and to have suffered from seeing the other replace her as a model. "... At the moment," she wrote to her sister, "all his admiration is concentrated on Mlle Gonzalès; but her portrait makes no progress. He tells me that he is at the fortieth sitting, and the head has again been scraped off. He is the first to laugh about it."50 "The Manets came to see us," she wrote a little later. "We went to the studio. To my great surprise and satisfaction, I received the highest praise. It seems that what I do is decidedly better than Eva Gonzalès. Manet is too frank for one to be mistaken about it. I am certain that it pleased him

Bertall: Caricature of Manet's *Balcony*, 1869.

Manet: The Balcony (Berthe Morisot, Antoine Guillemet, and the violinist Jenny Claus), 1869. $67\frac{3}{4} \times 49\frac{1}{4}$ ". Exhibited at the Salon of 1869. Musée du Louvre, Paris (Caillebotte Bequest).

Above, photograph of the motif, taken from the terrace of the Bazille home near Montpellier.

Left, Bazille: The Pink Dress, 1865. $58\frac{1}{8} \times 44''$. Musée du Louvre, Paris.

a lot. Only, I recall what Fantin says: 'He always finds good the painting of people he likes.' "50

Manet particularly admired a canvas Berthe Morisot had just painted in Lorient, representing her sister Edma against a view of the harbor (see p. 227), a work of exquisite freshness and subtle harmonies in which she had tried what Bazille had attempted in his Salon picture, to reproduce a figure in plein air. Overjoyed by Manet's appreciation, which was shared by Puvis de Chavannes, she presented the painting to him. Degas meanwhile painted Berthe's sister, Yves, Mme Gobillard (p. 226). "Your life, it seems to me, must be very charming at this moment," Berthe Morisot's sister Edma wrote to her from Lorient. "To chat with Degas while watching him draw, to laugh with Manet, to philosophize with Puvis, all these are things which deserve my envy...." It was probably after he had finished his portrait of Mme Gobillard that Degas, in 1869, undertook another trip to Italy.

Manet spent the summer of 1869 again at Boulogne. Observing the bathers on the beach and the people on the Channel boats for Folkestone, he now applied himself to the problems which had already preoccupied his friends at the Café Guerbois: to

BAZILLE: View of the Village, d. 1868. $52\frac{1}{8} \times 35\frac{5}{8}$ ". Exhibited at the Salon of 1869. Musée Fabre, Montpellier.

retain his impressions in small, rapidly painted canvases. In doing so he may also have remembered Castagnary's recent criticism of his pictures at the Salon:

"Until now Manet has been more fanciful than observant, more whimsical than powerful. His work is meager, if one prunes it of still lifes and flowers, which he handles as an absolute master. What does this sterility come from? From the fact that, while basing his art upon nature, he overlooks giving it the goal of the interpretation of life. His subjects are borrowed from the poets or taken from his imagination; he doesn't bother to discover them in the living figure of human society."52

In Boulogne during this summer Manet began to observe the life around him. And as he did so, the works he executed there lost that element of a "museum souvenir" which characterized so many of his large canvases. Yet Manet would have to work much more consistently in the open before he could tell his friend Antonin Proust: "Courbet once gave a superb reply when Daubigny complimented him on a study of the sea. 'This is not a study of the sea,' he said, 'it represents an hour.' That is what people do not sufficiently understand, that one does not paint a landscape, a seascape, a figure — one paints the impression of an hour of the day..." For the time being, however, Monet and his friends, who were much closer to Courbet than was Manet, followed these concepts more faithfully than did the author of Olympia.

Living in Bougival where he was frequently visited by Renoir who spent his summer quietly with Lise at his parents' house in Ville d'Avray, Monet was again in a desperate situation: no money, no paints, no hope. His new rejection by the jury had been a frightful blow. Remembering Arsène Houssaye's enthusiasm upon buying Camille in Le Havre and his advice that Monet should come and live in or near Paris,

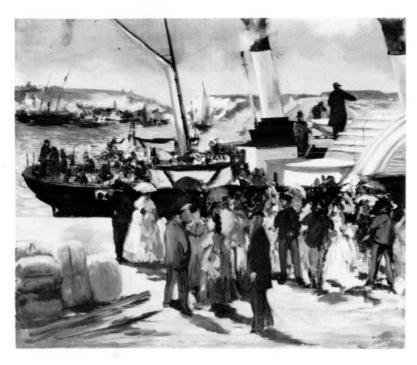

MANET: The Folkestone Boat, Boulogne, 1869. $23\frac{1}{2} \times 28\frac{7}{8}$. Philadelphia Museum of Art (Mr. and Mrs. Carroll S. Tyson Collection).

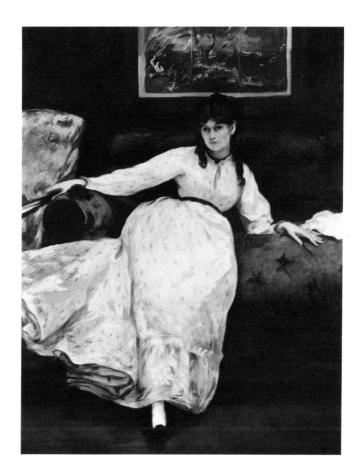

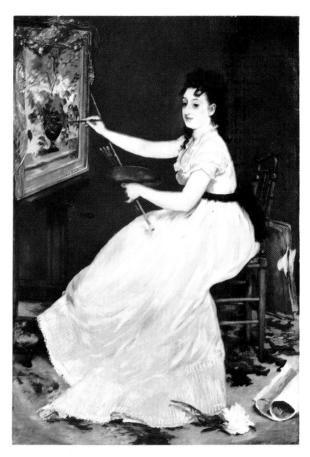

Left, Manet: Repose (Berthe Morisot), 1870. $61 \times 44\frac{1}{2}$ ". Exhibited at the Salon of 1873. Museum of Art, Rhode Island School of Design, Providence (Bequest of Edith Stuyvesant Vanderbilt Gerry). Right, Manet: Portrait of Eva Gonzalès, d. 1870. $78\frac{3}{4} \times 53\frac{1}{8}$ ". Exhibited at the Salon of 1870. National Gallery, London.

where it would be easier for him "to take advantage of my small talent," the painter now swallowed his pride and wrote in June to Houssaye: "M. Gaudibert has just now again had the kindness to enable me to settle here and send for my little family. The settling-in is finished and I am in very good condition and full of courage for work, but, alas, that fatal rejection has almost taken the bread out of my mouth; in spite of my not at all high prices, dealers and collectors turn their backs on me. Above all, it is saddening to see how little interest there is in a piece of art that has no list price. — I have thought, and I hope you will excuse me, that since you formerly found a canvas of mine to your taste, you might like to see the few that I have been able to save, for I thought that you would be good enough to come to my aid a little, since my position is almost desperate and the worst is that I cannot even work. It is unnecessary to tell you that I'll do anything at all and at any price in order to get out of such a situation and to be able to work from now on for my next Salon so that a similar thing doesn't occur." 54

Yet Arsène Houssaye does not seem to have done much for the artist or bought another of his works. Shortly afterwards Monet asked Bazille to send him paints, that he might at least continue to work. But in August paints were no longer his worry: "Renoir is bringing us bread from his house so that we don't starve," he wrote Bazille. "For a week no bread, no kitchen fire, no light — it's horrible."55 By the end of August, Monet had no colors left and could not continue to work. Bazille was apparently unable to help to any extent, for he had even pawned his own watch. As for Renoir, he was not much better off; he was in debt with his dealers and did not have enough money to stamp his letters to Bazille. "We don't eat every day," he wrote to the latter. "Yet I am happy in spite of it, because, as far as painting is concerned, Monet is good company." He added, however: "I do almost nothing because I haven't much paint."56

Notwithstanding his hopeless situation Monet did not lose faith, and Renoir later remembered gratefully that it was Monet who inspired him with new courage whenever he abandoned himself to despair.⁵⁷ Together the two friends frequented La Grenouillère (literally "frogpond"), a restaurant and bathing place on the small arm of the Seine at Croissy, not far from Chatou and its restaurant Fournaise on the one hand, and from Bougival farther up-stream on the other. Near Chatou the two branches of the river are crossed by the Paris-Saint Germain railroad, France's first, which stops at Rueil, on the right bank of the Seine.⁵⁸ Many Parisians availed them-

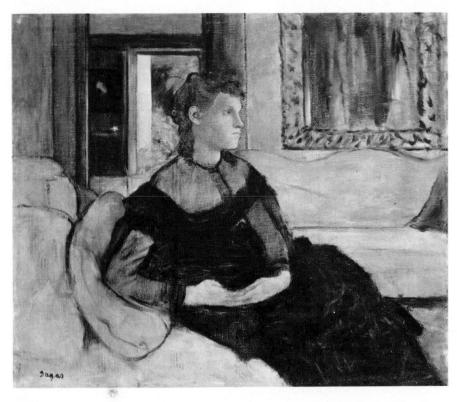

Degas: Portrait of Yves Gobillard (Berthe Morisot's sister), 1869. $21\frac{3}{8} \times 25\frac{5}{8}''$. Metropolitan Museum of Art, New York (Bequest of Mrs. H. O. Havemeyer).

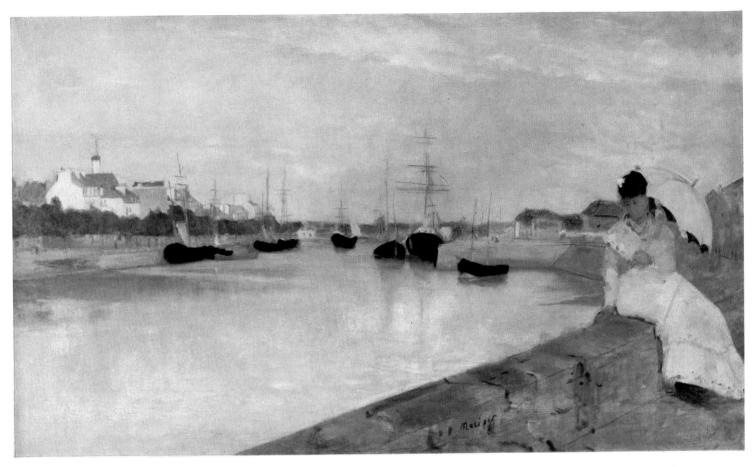

MORISOT: The Harbor of Lorient (with the artist's sister Edma at right), 1869. 174 × 29". Presented by the artist to Manet. Exhibited at the Salon of 1870. National Gallery of Art, Washington, D.C. (Ailsa Mellon Bruce Collection).

selves of the popular trains for outings at Chatou or its vicinity where rowboats were always in ample supply. In 1865 Bazille had written to his father: "Two friends and I won a first prize at the regattas in Bougival yesterday, as you may see from the newspapers. The name of the boat is *La Cagnotte*; unfortunately they do not print the names of the oarsmen." It does not seem unlikely that Monet and Renoir shared in this victory. At La Grenouillère they found attractive motifs formed by the river with its embarkations and by the gay bathing parties and picnicking crowds. But again work had to be interrupted and late in September Monet exclaimed in a letter to Bazille: "Here I'm at a halt, from lack of paints...! Only I this year will have done nothing. This makes me rage against everybody. I'm jealous, mean; I'm going mad. If I could work, everything would go all right. You tell me that it's not fifty, or a hundred francs that will get me out of this; that's possible, but if you look at it this way, there's nothing for me except to break my

head against a wall, because I can't lay claim to any instantaneous fortune.... I have indeed a dream, a picture of bathing at *La Grenouillère*, for which I've made some bad sketches, but it's a dream. Renoir, who has been spending two months here, also wants to do this picture."60

The study of water played an important role in the development of the style of Monet and his friends. In 1868 Monet had painted a picture of a woman seated on a river bank in which the reflections on the water became one of the main features. Just as snow scenes had permitted the artists to investigate the problem of shadows, the rendering of water offered an excellent opportunity to observe reverberations and reflections. Thus they could further develop their knowledge of the fact that so-called local color was actually a pure convention and that every object presents to the eye a scheme of colors derived from its proper hue, from its surroundings, and from atmospheric conditions. Moreover, the study of water gave pretext for the representation of formless masses livened only by the richness of nuances, of surfaces whose texture invited vivid brushstrokes.⁶¹

Monet had already made extensive use of vivid brushstrokes, and so had Renoir,

MONET: The River (the Seine at Bennecourt?), d. 1868. 32 × 39". The Art Institute of Chicago (H. and P. Palmer Collection).

Renoir: La Grenouillère, 1869. 26 \times 31 \S ". Nationalmuseum, Stockholm.

Monet: La Grenouillère, 1869. $29\frac{8}{8} \times 39\frac{1}{4}$ ". Metropolitan Museum of Art, New York (H. O. Havemeyer Collection).

who in Summer — a portrait of Lise (see p. 217) — exhibited at the Salon of 1869, had introduced large blotches into the background, representing leaves. At La Grenouil-lère the two friends used rapid strokes, dots, and commas to capture the glistening atmosphere, the movement of the water, and the attitudes of the bathers. What official artists would have considered "sketchiness" — the execution of an entire canvas without a single definite line, the use of the brushstroke as a graphic means, the manner of composing surfaces wholly through small particles of pigment in different shades — all this now became for Monet and Renoir not merely a practical method of realizing their intentions, it became a necessity if they were to retain the vibrations of light and water, the impression of action and life. Their technique was the logical result of their work out-of-doors and their efforts to see in subjects not the details they recognized but the whole they perceived. While Monet's execution was broader than Renoir's, his pigments were still opaque, whereas the other was using brighter colors and a more delicate touch.

From the weeks they spent together at La Grenouillère dates a real work-companionship between the two. Whether they studied the same flowers in the same vase or whether they put up easels in front of the same motif, Renoir and Monet, during the years ahead, were to paint more frequently the same subjects than any other

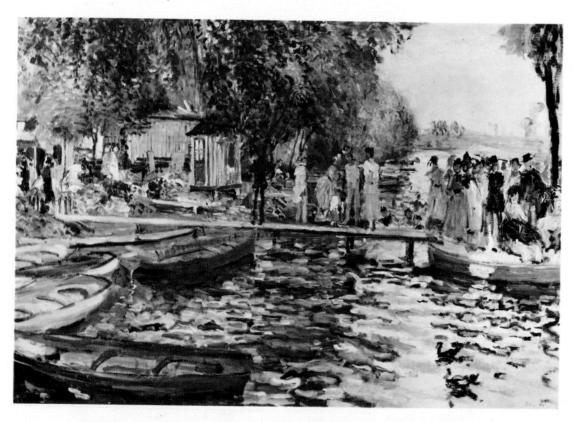

Renoir: La Grenouillère, 1869. $25\frac{5}{8} \times 36\frac{1}{4}$ ". Oskar Reinhart Foundation, Winterthur, Switzerland.

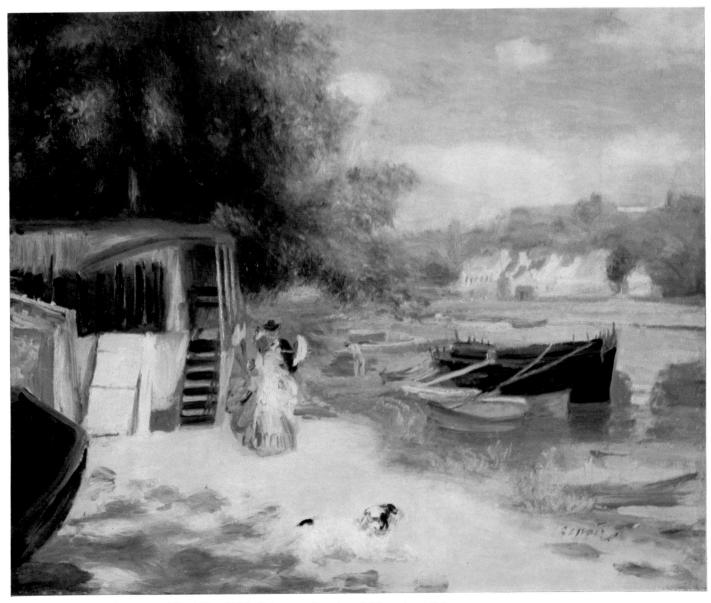

Renoir: La Grenouillère, c. 1869. 17 $\frac{3}{4} \times 21\frac{5}{8}''$. Private collection, Milwaukee, Wis.

Monet: Still Life, c. 1869 (?). Present whereabouts unknown.

members of their group. And in this communion of work they were to develop a style of expression which at times also brought them closer to each other than to the rest.

After having each painted two or more studies at La Grenouillère, Monet and Renoir separated in October 1869. Monet went to Etretat, where he met again with Courbet, thence to Le Havre, and in November settled with Camille and little Jean at Saint-Michel near Bougival, not far from Paris.

Upon his return to Paris, Renoir once more joined Bazille, who had just taken a new studio, rue de la Condamine, in the Batignolles quarter, close to the Café Guerbois. Bazille, too, had devoted the summer months to a study of bathers in the open. But in his large canvas, *Summer Scene*, the figures are not yet completely integrated with the landscape because the artist had not executed his canvas entirely out-of-doors and had used a more or less smooth brushwork for the bodies of his bathers, reserving small and vivid strokes for the grass, trees, and water, thus impairing the unity of the composition. Bazille now planned to paint a nude in his studio, a

Monet: The Artist's Family at Dinner, 1868–69. $20\frac{1}{8} \times 26''$. Collection E. G. Bührle, Zurich.

Monet: La Porte d'Amont, Etretat, c. 1868. $32 \times 39\frac{1}{2}$ ". Fogg Museum of Art, Cambridge, Mass. (Pulitzer Collection).

BAZILLE: Summer Scene, Bathers, d. 1869. $62\frac{1}{4} \times 62\frac{1}{2}$ ". Exhibited at the Salon of 1870. Fogg Art Museum, Cambridge, Mass. (Gift of M. and Mme F. Meynier de Salinelles).

room which so enchanted him that he made it the subject of a canvas, representing in the huge atelier a number of his friends. But unlike Fantin, who used to group his models almost solemnly, Bazille endeavored to show them with all the informality that reigned in his abode. While Maître plays the piano, Zola leans over a flight of steps, speaking to Renoir seated on a table; Manet looks at a canvas on an easel; Monet, smoking, watches from behind him, and Bazille stands close to them, palette in hand. After the artist had done the portraits of his companions, Manet took his friend's brushes and added Bazille's likeness to the canvas.⁶²

In May 1870, Bazille left his studio on the rue de la Condamine and crossed the

Seine to the rue des Beaux-Arts (near the rue Visconti where he had resided before), to live in the same house in which Fantin had his studio. Renoir did not accompany him to the other side of the river. While Bazille thus moved away from the Café Guerbois, a new guest appeared at this establishment. He was a strange and amusing man, Marcellin Desboutin, a painter, engraver, and author, but above all a Bohemian. Of vaguely noble origin, he had managed to lose a large fortune, to live in a huge castle in Italy until forced by his debts to sell it, to have a play accepted by the *Théâtre Français*, and to maintain a perfect dignity in spite of his more or less romantic rags. Full of original ideas and conversant in many fields of knowledge, he was extremely brilliant in society, especially when he could indulge himself in monologues. His presence was highly appreciated at the Café Guerbois.⁶³

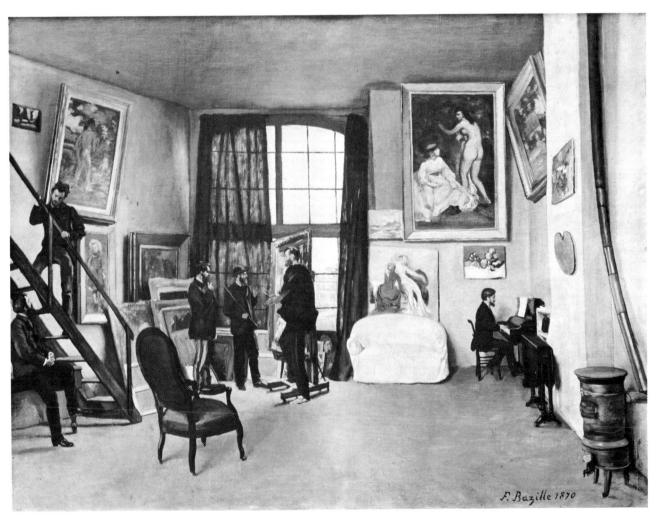

BAZILLE: The Artist's Studio, rue de la Condamine, Paris, d. 1870. 387 × 47". Musée du Louvre, Paris.

- 1 It is not known at what date exactly the artists began to come together at the Café Guerbois. Tabarant (Pissarro, Paris, 1924, p. 15) and Duret (Manet and the French Impressionists, London, 1910, p. 108) assert that they began to do so in 1866. Zola apparently went there from the beginning of 1866. It is known that until 1866 Manet had gone daily from 5:30 to 7 p.m. to the Café de Bade, 26 boulevard des Italiens (see Manet's letter to Zola, May 7, 1866; Jamot, Wildenstein, Bataille: Manet. Paris, 1932, v. I, p. 81). Already in the spring of 1868 a friend of Zola speaks of the Batignolles group (see Solari's letter to Zola; J. Rewald: Paul Cézanne, New York, 1948, p. 69). In 1868-69 Manet invited Monet to join his friends at the Café Guerbois and the group seems to have been really complete around 1869, when Monet, in turn, brought Renoir and Sisley there. A. Proust: Edouard Manet, Souvenirs, Paris, 1913, is obviously mistaken when he pretends that Manet already abandoned the Café Guerbois after 1865. On the Café Guerbois see A. Silvestre: Au pays du souvenir, Paris, 1892, ch. XIII: "Le Café Guerbois." The Café Guerbois was one of the largest such establishments in Paris; it later changed its name to Brasserie Muller; the latter closed its doors only a few years ago (information courtesy Me J. Ribault-Menetière, Paris). The Restaurant du Père Lathuile, favored by Manet, was very close to the Café.
- 2 Monet to Thiébault-Sisson; see Claude Monet, an interview, *Le Temps*, Nov. 27, 1900.
- 3 E. Duranty: Le pays des arts, Paris, 1881, p. 345.
- 4 E. Zola: Mon Salon, 1866; reprinted in Mes Haines, 1867, Paris.
- 5 Silvestre: Au pays du souvenir, Paris, 1892, ch. XIII.
- 6 This duel took place in the forest of Saint-Germain on Feb. 23, 1870. See Proust, op. cit., p. 38.
- 7 P. Alexis: article in Le Cri du Peuple, Jan. 8, 1885, quoted by D. Le Blond-Zola: Paul Alexis, ami des peintres, bohème et critique d'art, Mercure de France, March 1, 1939. The poem went: "Manet-Duranty sont deux gas/Qui font une admirable paire;/ Aux poncifs, ils font des dégats,/ Manet-Duranty sont deux gas./ L'Institut qui les vitupère/ Les méprise autant que Degas./ Parce qu'ils font des becs de gaz./ Manet-Duranty sont deux gas/Oui font une admirable paire."
- 8 From Berthe Morisot's notebook; see P. Valéry: Degas, Dance, Dessin, Paris, 1938, p. 148.
- 9 See B. Morisot's letter to her sister Edma, 1869, in D. Rouart: Correspondence de Berthe Morisot, Paris, 1950, p. 31.
- 10 P. Lafond: Degas, Paris, 1919, p. 99.

- 11 E. Duranty, op. cit., p. 335.
- 12 Manet to Fantin, Aug. 26, 1868; see E. Moreau-Nélaton. Manet raconté par lui-même, Paris, 1926, v. I, p. 102.
- 13 See Valéry, op. cit., p. 88.
- 14 E. Zola: Le Rêve; Oeuvres complètes, Paris, 1928; see Notes et commentaires de M. Le Blond, p. 232.
- 15 M. Elder: A Giverny chez Claude Monet, Paris, 1924, p. 48.
- 16 Excerpts from Zola's notes for his novels: L'Oeuvre and Le Ventre de Paris, quoted by Rewald, *op. cit.*, p. 58.
- 17 E. Zola: Preface for Nouveaux Contes à Ninon, 1874.
- 18 See A. André: Renoir, Paris, 1928, p. 56.
- 19 Ibid., p. 14.
- 20 On Guigou see F. Daulte: Un Provençal pur—Paul Guigou, Connaissance des Arts, April 1960; also catalogue of P. Guigou exhibition, Musée Cantini, Marseilles, Nov.-Dec. 1959, with chronology and bibliography.
- 21 Fantin to Edwards, June 15, 1871; see A. Jullien: Fantin-Latour, Paris, 1909, p. 74-75.
- 22 See Tabarant: Manet et ses oeuvres, Paris, 1947, p. 175.
- 23 See E. Chesneau: Le Japon à Paris, Gazette des Beaux-Arts, Sept. 1, 1878; H. Focillon: L'estampe japonaise et la peinture en occident, Congrès d'Histoire de l'Art, Paris, Sept.-Oct. 1921; also two articles by J. Sandberg: "Japonisme" and Whistler, Burlington Magazine, Nov. 1964, and: The Discovery of Japanese Prints in the XIXth Century before 1867, Gazette des Beaux-Arts, May-June 1968 (with additional bibliographical references); J. de Caso: 1861: Hokusai rue Jacob, Burlington Magazine, Sept. 1969; C. Ikegami: Le Japonisme de Félix Bracquemond en 1866, The Kenkyu (Kobe University), March 1969.
- 24 See Castagnary: Exposition du boulevard des Capucines—les impressionnistes, Le Siècle, April 29, 1874.
- 25 See G. Geffroy: La vie artistique, troisième série, Paris, 1894, p. 148.
- 26 See R. Marx: Maîtres d'hier et d'aujourd'hui, Paris, 1914, p. 292.
- 27 Proust, op. cit., p. 31-32. As early as 1864, Fantin had noticed that in one of his own paintings "the shadows are done with too much black; there is not enough yellow, red, blue." See Fantin-Latour, Carnet A, p. 54, Cabinet des Dessins, Louvre.
- 28 Notes taken during an interview in Munich in 1910 while Renoir examined some snow scenes submitted by German painters; courtesy Dr. Ernest L. Tross, Denver,

- Colorado, who served as interpreter on this occasion.
- 29 See P. Grate: Deux critiques d'art de l'époque romantique—Gustave Planche et Théophile Thoré, Stockholm, 1959.
- 30 Pissarro to his son, April 8, 1895; see C. Pissarro: Letters to His Son Lucien, New York, 1943, p. 265.
- 31 A. Wolff in *Le Figaro*, May 20, 1869, quoted by Tabarant: Manet, *op. cit.*, p. 160.
- 32 P. Alexis: Aux peintres et sculpteurs, L'Avenir National, May 5, 1873.
- 33 Boudin to Martin, April 25, 1869; see Jean-Aubry: Eugène Boudin, Paris, 1922, p. 72.
- 34 Valabrègue to Zola, Jan. 1867; see Rewald, op. cit., p. 68.
- 35 See Bulletin de la Vie Artistique, July 1, 1925, p. 294. On père Martin see Tabarant: Pissarro, Paris, 1924, New York, 1925.
- 36 See André, op. cit., p. 53. On the views Renoir held late in life on this subject, the artist's son Jean kindly wrote the author: "The only allusions to the Salon des Refusés which my father made that I can remember were concerned with Cézanne...who had repeatedly proclaimed and even written that, in art matters, he believed in the judgment of the public and in the artist's right to submit to this judgment. My father considered this idea childish, being suspicious of the public's taste, and particularly of modern crowds which, he thought, had lost the faculty to see, due to the utilization of so many standard objects and also because instruction in mathematics permits the evaluation of forms and distances according to formulas rather than with the senses. He frequently said that everything has to be learned, even how to enjoy a good meal; and to what a greater degree, how to derive pleasure from a painting of quality."
- 37 See Proust, op. cit., p. 43.
- 38 Cézanne quoted by Marion in a letter to Morstatt, April 1868; see M. Scolari and A. Barr, Jr.: Cézanne in the Letters of Marion to Morstatt, 1865-1868, *Magazine of Art*, Feb., April, May 1938.
- 39 See letter from Achille de Gas, Feb. 16, 1869, in P.-A. Lemoisne: Degas et son oeuvre, Paris, 1946, v. I, p. 63.
- 40 Bazille to his parents, spring 1869; see G. Poulain: Bazille et ses amis, Paris, 1932, p. 111.
- 41 The catalogue of the Salon of 1869 lists among others: Bazille, rue de la Paix 9, Batignolles, La vue du village [his second painting of a male nude was rejected]; De Gas, rue de Laval 13, Portrait de Mme G. [Gaujelin] [his second painting of Mme Camus at the Piano was rejected]; Manet, rue St. Pétersbourg 46, Le Balcon and Le déjeuner; Pissarro, chez Charpentier, Boulevard Montmartre 8, L'Ermitage [Pontoise]; Renoir, rue de la Paix 9, Batignolles [Bazille's address] (élève de Gleyre), En été, étude [Lise].

- 42 Bazille to his parents, spring 1869; Poulain, op. cit., p. 147-148.
- 43 B. Morisot to her sister Edma, May 1, 1869; see M. Angoulvent: Berthe Morisot, Paris, 1933, p. 30-32.
- 44 B. Morisot to the same, spring 1869; ibid., p. 28.
- 45 B. Morisot to the same, May 1869; ibid., p. 32-33.
- 46 A. Wolff in Le Figaro, May 1869; on Wolff (1835-1891) see G. Toudouze: Albert Wolff, Paris, 1883. On account of his violent articles, quoted later on, the impressionists considered him the critic who had hurt them most
- 47 Mme Morisot to her daughter Edma, May 23, 1869; see Angoulvent, op. cit., p. 33.
- 48 On Eva Gonzalès (1849–1883, she was eight years younger than Berthe Morisot), see the richly illustrated article by P. Bayle: Eva Gonzalès, *La Renaissance*, June 1932; also C. Roger-Marx: Eva Gonzalès, Paris, 1950, and catalogue of the exhibition Eva Gonzalès, Galerie Daber, Paris, May-June 1959.
- 49 P. Burty quoted by C. Roger-Marx, op. cit.
- 50 Letters by B. Morisot to her sister Edma, 1869; see Moreau-Nélaton, op. cit., v. I, p. 113.
- 51 Edma Pontillon to her sister, Berthe Morisot, 1869; see D. Rouart, op. cit., p. 31.
- 52 Castagnary: Salon de 1869, reprinted *in* Salons (1857-1870), Paris, 1892, v. II, p. 364.
- 53 Manet quoted by A. Proust, op. cit., p. 84.
- 54 Monet to A. Houssaye, June 2, 1869; see R. Chavance: Claude Monet, *Le Figaro illustré*, Dec. 16, 1926.
- 55 Monet to Bazille, August 9, 1869; see Poulain, op. cit., p. 157.
- 56 Renoir to Bazille, fall 1869; ibid., p. 155.
- 57 See André, op. cit., p. 60.
- 58 Topographical information courtesy Me J. Ribault-Menetière, Paris.
- 59 Bazille to his father, July 27, 1865; see Daulte: Frédéric Bazille et son temps, Geneva, 1952, p. 89, note 1.
- 60 Monet to Bazille, Sept. 25, 1869; see Poulain, op. cit., p. 160.
- 61 Bazille, for instance, noted in a sketchbook: "I must not forget to compare the color-value of bright water with that of sunlit grass." Poulain, op. cit., p. 153.
- 62 The identity of the different friends assembled in Bazille's studio has not been established with certainty. It is possible that instead of the identification here given one should read Monet for Zola, Sisley for Renoir, and Astruc for Monet; see Poulain, op. cit., p. 179.
- 63 On Desboutin see Clément-Janin: La curieuse vie de Marcellin Desboutin, Paris, 1922.

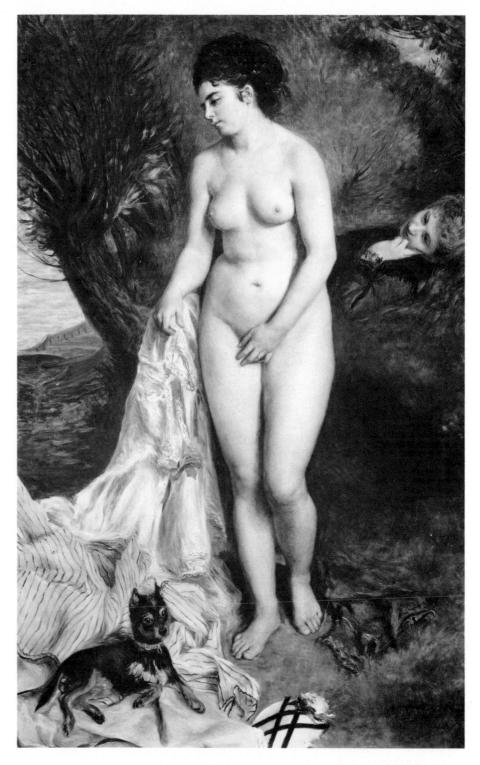

Renoir: Bather (Lise), d. 1870. $73\frac{1}{2}\times46\frac{1}{8}$ ". Exhibited at the Salon of 1870. Museu de Arte Moderna, São Paulo, Brazil.

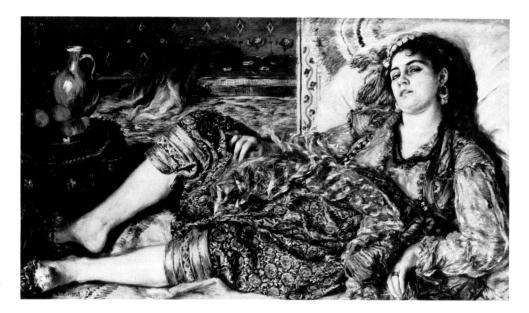

RENOIR: Woman of Algiers (Lise), d. 1870. 27 × 48½". Exhibited at the Salon of 1870. National Gallery of Art, Washington, D.C. (Chester Dale Collection).

VII 1870-1871

THE SALON OF 1870

THE FRANCO-PRUSSIAN WAR AND THE "COMMUNE"

MONET AND PISSARRO IN LONDON

The Café Guerbois probably saw a good deal of agitation early in 1870. Since the right to vote for the jury had been extended to every accepted artist, some of these had conceived the idea of presenting a list of their own candidates, a list conspicuous in its omission of any of the members of the Institute. Jules de la Rochenoire, a former pupil of Couture and friend of Manet, seems to have been the instigator. Among those whom a hurriedly formed committee slated for the jury were Corot, Daubigny, Millet, Courbet, Daumier, Manet, Bonvin, Amand Gautier, and some others. Manet immediately asked Zola to publish a notice in several newspapers, requesting the artists to vote for this list. But the plan failed miserably. Of those named, only Daubigny and Corot were elected, but these two had also figured on the official list. Although both of them received more votes than any other jury member,

Far left, Gonzalès: The Little Soldier, 1870. $51\frac{1}{4} \times 38\frac{5}{8}$ ". Exhibited at the Salon of 1870. Townhall of Villeneuve sur Lot, France.

Left, Manet: The Fifer, 1866. 63 × 38½". Rejected by the Salon jury in 1866. Musée du Louvre, Paris.

they were compromised by their agreement to head the dissenting and defeated list. Their authority was thus paralyzed, and when Daubigny was unable to have even one painting by Monet accepted, he resigned. "From the moment that I liked this picture," he explained," I wouldn't allow my opinion to be contradicted. You might as well say that I don't know my trade." Corot resigned along with Daubigny, but not because of any esteem for Monet.

It almost seems as if the jury members had particularly resented Daubigny's consistent defense of Monet, for of the entire Batignolles group he was singled out for special ostracism. Both of Monet's paintings were refused, whereas Manet, Berthe Morisot, Pissarro, Renoir, Sisley, and Fantin had two canvases accepted, Bazille and Degas one each.³ Manet exhibited his *Portrait of Eva Gonzalès*, who herself had a painting strongly influenced by Manet at the Salon. Renoir had sent a *Baigneuse* still slightly indebted to Courbet and a *Woman of Algiers* full of scintillating colors which openly proclaimed his admiration for Delacroix (Lise had posed for both these works). Sisley showed two views of the *Canal Saint-Martin* in Paris, Degas a portrait of a lady with a Japanese fan as well as a pastel likeness of Berthe Morisot's sister, Yves Gobillard, while Fantin was represented by *A Studio in the Batignolles Quarter* (p. 196) and *Reading* which was awarded a medal. Eva Gonzalès, who exhibited for the first time, sent in a pastel and a painting of a little boy in uniform, obviously reminiscent of Manet's *Fifer*, which had been rejected by the jury of 1866. Compared to

Right, Courbet: Portrait of a Man, c. 1865 (?). 76½ × 43¾". Musée Jenisch, Vevey, Switzerland.

Far right, Whistler: Portrait of Théodore Duret, 1883. 76½×35¾". Metropolitan Museum of Art, New York (Wolfe Fund).

Manet's broadly sweeping execution and the superb contrast of the dark figure set against a gray background (a masterful device previously used by Courbet and subsequently also employed by Whistler), the canvas of Eva Gonzalès appeared somewhat timid. Yet Castagnary lauded her work, only mildly chiding her for minor flaws. However, the critic was not fooled by the catalogue which still listed her as "pupil of Chaplin" and wrote: "It is very urgent for Mlle Eva Gonzalès to leave Manet to his faults. She paints in a rather somber manner and, like that artist, has a tendency to suppress the intermediate hues. This is a perilous slope at the bottom of which lies mannerism and not the sincere practice of art." To escape this danger, he gave her the same advice he had already given Manet, that of "painting in the open air, under the beautiful and true light of the sky."

Berthe Morisot had submitted to the jury a portrait of her sister Edma at a window, as well as a double portrait of her mother and her sister which had caused her a great deal of anxiety. Puvis de Chavannes having criticized the head of Mme Morisot, the artist retouched it and then asked Puvis to come and judge it again; but the latter had excused himself. "Until then my worries weren't too bad," she wrote a few days later to her sister. "Tired, nervous, I go to see Manet in his studio. He asks me how things are and—perceiving my indecision—says in high spirits: 'Tomorrow, after my shipment [to the Salon], I shall come to see your picture, and believe you me, I shall tell you what ought to be done.' The next day he arrives

around one o'clock, says that everything is fine, except for the lower part of the dress. He takes some brushes, puts in a few accents—mother is enraptured. But here my troubles begin: once he has started, nothing can keep him back; from the skirt he proceeds to the bodice, from the bodice to the head, from the head to the background. He is full of a thousand jests, laughs like a child, hands me the palette, takes it back . . . at last, by five in the afternoon, we had produced the prettiest little caricature that can be seen. They were waiting to take it away; he makes me put it willy-nilly on the pushcart and I remain behind, completely confounded. My only hope is that it will be rejected. Mother considers the whole adventure funny, though I find it rather distressing."5

Both paintings by Berthe Morisot were admitted, yet out of sympathy for her daughter's misery, Mme Morisot thought it best to withdraw the double portrait from the *Palais de l'Industrie*, where it was actually handed back to her.⁶ But fearing that Manet, who had meant to be so helpful, might be vexed, the artist eventually decided to exhibit it after all, and with resignation prepared herself for the expected attacks by the critics. These did not materialize, however, so that she finally reported to her sister: "I do not receive many compliments, as you can well imagine, but people are sufficiently kind not to leave me with any regrets. I except, of course, M. Degas, who has a supreme contempt for anything I may do. . . ."⁷

The Salon of 1870—which was to be the last Salon of the Second Empire—turned out to be a rather sumptuous affair.8 Its greatest attractions were a Salomé by a newcomer, Henri Regnault (soon to be killed on the battlefield), a painting of brilliant vulgarity,9 and a portrait by another young hopeful, Bastien-Lepage, "new meteor of realism," who cleverly and deceitfully debased the conquests of realism to the tastes of the day. Léon Bonnat, whom Degas had known in Italy, also received a good deal of attention with conscientiously executed but uninspired portraits (these had made such a reputation for him that in 1869 and 1870 he found himself elected to the jury). As always, the insipidities of the genre painters, among whom Monet's cousin Toulmouche occupied an enviable position, were the favorites of the general public, whereas Manet's works once again aroused the laughter of the crowds.

Bazille, for the first time, had a certain success. "I am delighted with my exhibition," he wrote his parents. "My picture is very well hung. Everybody sees it and talks about it. Often more bad than good is said of it, but at least I'm in the swim and whatever I shall show from now on will be noticed." 10

Berthe Morisot was not as lucky. Her Young Woman at the Window was hung "so high that it is impossible to appreciate it." She spent a whole day at the Salon, together with Puvis de Chavannes, although she was still somewhat resentful about the misadventure that had befallen her double portrait. "Fantin has a real success," she reported to her sister. "Manet is desperate on account of the space he occupies; yet his two pictures look very well and are, as usual, very much looked at... Mlle Gonzalès is tolerable, but nothing more."

The press was anything but friendly toward Manet. Albert Wolff set the tone in *Le Figaro*, calling the *Portrait of Eva Gonzalès* "an abominable and flat caricature in oils," while accusing the painter of producing "coarse images for the sole purpose of attracting attention."¹²

It was Duret, this time, who came to the defense of his friends in a series of Salon

REGNAULT: Salomé, d. 1870. 63 × 40½". Exhibited at the Salon of 1870. Metropolitan Museum of Art, New York (Gift of G. W. Baker).

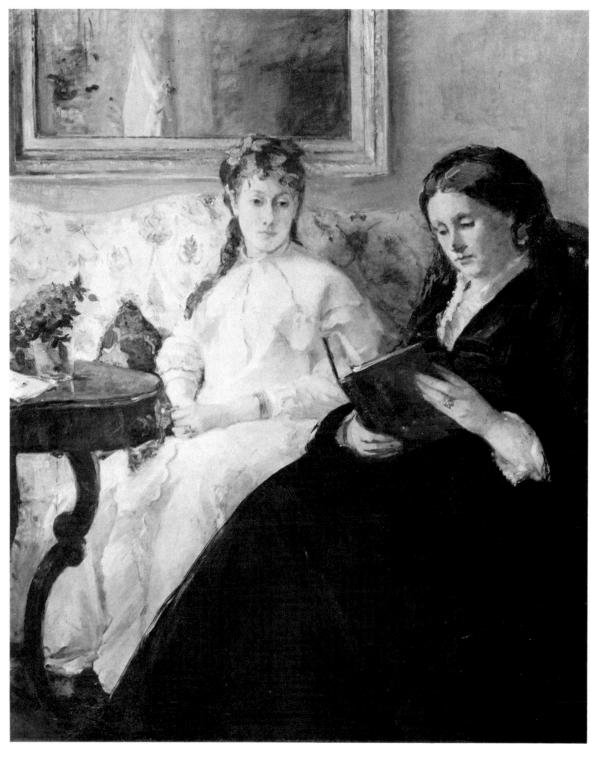

Morisot: The Artist's Sister Edma and Their Mother (retouched by Manet), 1870. $39\frac{1}{2} \times 32''$. Exhibited at the Salon of 1870. National Gallery of Art, Washington, D.C. (Chester Dale Collection).

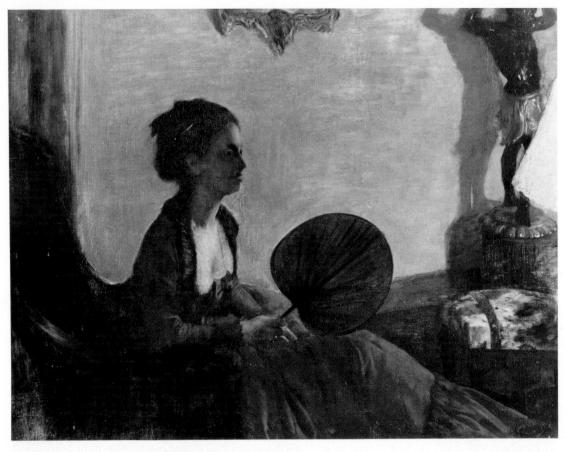

Degas: Portrait of Mme Camus, 1870. $28\frac{3}{4} \times 36''$. Exhibited at the Salon of 1870. National Gallery of Art, Washington, D.C. (Chester Dale Collection).

reviews concerned mainly with "those newcomers who seem to have the greatest future before them." He was full of praise for Pissarro—whose works, this time, seem scarcely to have been noticed by other critics—for Fantin and Degas, as well as for Guigou, but neglected to mention the paintings by Bazille, Renoir, Sisley, and Berthe Morisot. On the other hand, he devoted a special article to Manet.

"Only yesterday," Duret stated, "Courbet was ridiculed, yet now people outdo themselves praising him to the sky and burning incense on his altar. But then, his work has become a familiar sight, one has got used to him, and thus the efforts of routine (which scoffs at anything that is new) and of mediocrity (which hates anything that is original) have now been concentrated on the last arrival, on Manet... We shall therefore pause in front of the canvases of M. Manet, but we are not the only one to stand before them. Quite the contrary, we are surrounded by a crowd and immediately become aware that the good public which—only a little while ago—was enraptured with even the most insignificant imitations, here mocks our original artist, precisely because of his originality and invention...

"'Oh! How poorly drawn this is!' (That has been said of Delacroix for thirty years.)

"But this is not sufficiently finished; these are mere sketches!" (Only yesterday this was the constant complaint about Corot.)

"'Oh! Good God! How ugly these people are; what horrible models!' (This is still in part a condensation of bourgeois opinion concerning Millet, etc.)

"And thus it is going to be for M. Manet until the public, at last used to the composite of qualities and faults, of light and shadow which makes up his personality, will accept him and proceed to deride some other newcomer."

Duret's articles, however, almost did more harm than good since they appeared in an obscure weekly resolutely opposed to the régime. Duranty, reconciled at last, also published a long and excellent study on Manet, ¹⁴ and Arsène Houssaye finally pronounced in favor of his protégés Renoir and Monet. He did so in a letter to the Salon reviewer of *L'Artiste*, of which he himself was a leading contributor; although usually reserved in his judgments, this letter, which the reviewer quoted, shows Houssaye warmly supporting his young friends:

"The two true masters of this [Manet's] school," he wrote, "who, instead of saying 'art for art's sake,' say 'nature for nature's sake,' are Messieurs Monet (do not confuse with M. Manet) and Renoir; two true masters, like the Courbet of Ornans, by virtue

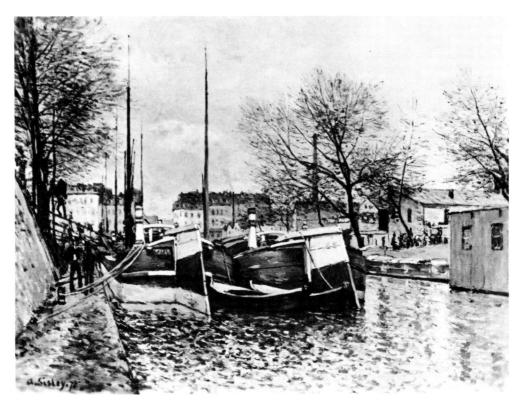

Sisley: *The Canal Saint-Martin*, *Paris*, d. 1870. $21\frac{5}{8} \times 29\frac{1}{8}$ ". Exhibited at the Salon of 1870; Oskar Reinhart Foundation, Winterthur, Switzerland.

of the brutal frankness of their brush. They tell me the jury has refused M. Monet; it had the good sense to receive M. Renoir. One can study the proud, painterly temperament which appears with such brilliance in a Woman of Algiers that Delacroix could have signed it. Gleyre, his master, must be thoroughly surprised to have formed such a 'prodigal son' who makes fun of all the laws of grammar because he dares to establish a law of his own. . . . Remember well, then, the names of M. Renoir and M. Monet. I have in my own collection the Woman in a Green Dress [Camille] by M. Monet and an early Bather by M. Renoir which, one day, I will give to the Luxembourg when that museum will open its doors to all the opinions of the brush. In the meantime they arouse admiration, I will not say among the French, who scarcely see anything except through convention, but among the Spanish and English, who salute a painting where there is one, that is to say, truth under the light." 15

Whereas these utterances must have appeared to the artists like a tremendous step toward recognition, Cézanne, always more blustering than any other member of the group, had remained faithful to his project of offending the jury rather than trying to be accepted by it. He therefore had waited until the very last day before delivering his paintings and had selected two canvases most likely to displease "those gentlemen." These were a Reclining Nude and a large portrait of his friend Achille Emperaire (more than six feet high), showing a dwarf whose musketeer's head dominates a fragile body with spindly limbs. This strange and almost grotesque figure, dressed in a blue flannel robe which opens above the knees to show long, purple drawers and red slippers, is seated in a huge, upholstered armchair of a flower design that, according to some, is actually a chaise-percée. It was a work of tremendous power and audacity compared to which Manet's efforts to be modern without leaving the path of tradition appeared almost conventional. No other member of the Batignolles group had yet dared to search for an expression so completely new, had used contrasts of color with such brutal force, had initiated a statement of such utter individuality. This statement—in spite of its romantic exaggerations—was saved from being gaudy through the miraculous cohesion of an unbridled instinct.

As to Cézanne's second picture, it apparently represented a nude of rather angular forms, lacking in all the elements of "charm," "grace," and "finish" so much appreciated by the jury. ¹⁶ The arrival of these two canvases caused a sensation. A journalist immediately reported the event in the press (illustrating his text with a caricature of the painter):

"The artists and critics who happened to be at the *Palais de l'Industrie* on March 20th, the last day for the submission of paintings, will remember the ovation given to two works of a new kind.... Courbet, Manet, Monet, and all of you who paint with a knife, a brush, a broom, or any other instrument, you are outdistanced! I have the honor to introduce you to your master: M. Cézannes [sic].... Cézannes hails from Aix-en-Provence. He is a realist painter and, what is more, a convinced one. Listen to him rather, telling me with a pronounced provençal accent: 'Yes, my dear Sir, I paint as I see, as I feel—and I have very strong sensations. The others, too, feel and see as I do, but they don't dare... they produce Salon pictures... I dare, Sir, I dare... I have the courage of my opinions—and he laughs best who laughs last!' "17

STOCK: Caricature of Cézanne with the paintings rejected by the Salon jury, 1870.

CÉZANNE: Portrait of Achille Emperaire, 1868-70. 78\frac{3}{4} \times 48''. Rejected by the Salon jury in 1870. Musée du Louvre, Paris.

Cézanne: The Black Clock, 1869-71. $21\frac{3}{4} \times 29\frac{1}{4}$ ". Formerly in the collection of Emile Zola. Collection Stavros Niarchos.

In spite of the rejection, which he had obviously expected, Cézanne remained in Paris for the Salon. On the last day of May he acted as best man at the wedding of Zola. A few weeks later, on June 28, Monet was married to Camille. Cézanne himself had met shortly before a young model, Hortense Fiquet, who had agreed to share his life. He was still in Paris or already on his way to Aix when, on July 18, 1870, France—in the words of its Premier Emile Olivier—"lightheartedly" declared war on Prussia over a question of prestige and the throne of Spain.

The outbreak of the war surprised Bazille at his parents' country house near Montpellier, where he was working. He seemed to be attaining finally that intimacy with nature which distinguished Pissarro, that ease of expression for which he may have envied Renoir, and that certainty of his own capacities which was Monet's strength. But in the face of the perils menacing his country he did not feel like painting any longer. On August 10 he enlisted in a regiment of Zouaves, well-known for the dangerous tasks it usually assumed.

Degas, who had been on the coast painting some broad studies in the open, returned to Paris. Monet remained in Le Havre. Renoir was offered by his patron, Prince

Bibesco, the possibility of joining his staff, but preferred to let fate decide. Inducted in July into a regiment of cuirassiers, he was sent to Bordeaux and from there to Vicen-Bigorre in the Pyrenees, near Tarbes, where he had to train horses although he completely lacked experience. Zola, as the only son of a widow, was exempt from military service and prepared to go to Marseilles. Cézanne, who once had drawn an "unlucky number" for conscription but for whom his father had bought a substitute, was not very eager to don a uniform. He left his parents' house in Aix and went to work in nearby L'Estaque on the Mediterranean shore, not far from Marseilles. where he lived with Hortense Figuet, hiding the liaison from his father. In L'Estaque, where Zola later joined him for a short while, Cézanne devoted his time mostly to landscape painting, endeavoring to replace the agitated conceptions of his imagination by faithful observation of the nature spread before him. In doing so he remembered that years ago Pissarro had already eliminated from his palette "black, bitumen, burnt sienna, and the ochres. 'Never paint except with the three primary colors [red, blue, yellow] and their immediate derivatives!" "he had told Cézanne.18 Although Cézanne did not yet proceed to a radical change in his color scheme, he nevertheless began to adopt the smaller brushstrokes of his friends and generally resorted to brighter harmonies. A new portrait of his friend Valabrègue shows this transition. While the face is modeled in small and bright touches, the rest is rendered in a sweeping style and in rather dark tones (see p. 215).

CÉZANNE: L'Estaque, c. 1871. 16³/₄ × 22". Formerly in the collection of Emile Zola. Private collection, Switzerland.

The war meanwhile was daily taking a turn for the worse. Opposed by an experienced enemy, superior in number and equipment, the French armies, completely unprepared, lacking the most essential supplies, commanded by incapable and even treacherous Court favorites, were engaged in a hopeless fight. Defeat followed defeat until the catastrophe of Sedan sealed France's fate. There, on September 2, 1870, Napoleon III surrendered. Two days later the Third Republic was proclaimed in Paris. Victor Hugo came back from exile. He was received in Paris by the new mayor of Montmartre, Georges Clemenceau, who had returned from the United States, where he had lived since 1865. And Gambetta exhorted his countrymen to unite against the powerful invader, to carry on to death and save the nation's honor.

In Aix-en-Provence, as everywhere throughout the country, France's defeat had its repercussions. When, on Sunday, September 4, toward ten o'clock in the evening, a telegram from Paris announced the Republic, the anti-imperialists of the town went en masse to the city hall where they proclaimed the fall of the local government and by popular acclaim elected a provisional municipal body. Among the newly chosen officials were Baille and Valabrègue, schoolmates of Cézanne, as well as the painter's father, then seventy-two years old (slated to be a member of the new Finance Committee). The election completed, a bust of Napoleon III and his portrait were destroyed. A few days later an appeal to the population was posted: "Let us arise, citizens, and march as one man! The Municipal Council of Aix calls you to the defense of your country; it assumes the responsibility of providing for the needs of the families of all those who will volunteer to bear arms to save France and gain respect for our glorious and pure Republic."

In spite of the seriousness of the situation, a friend of Cézanne's could not help writing Zola from Aix: "I am bored stiff here. I watch the revolution pass. In the gang are our admirable comrades, Baille and Valabrègue. They amuse me tremendously. Can you see those quitters from Paris who come here to stick their noses into the local government and vote resistance!" Since Aix was far removed from the danger zone, the local patriotic agitation did little, indeed, to lighten the burden of their crushed country. Baille and Valabrègue, taking part in the census for the organization of the National Guard, may well have prevented too thorough a search for their friend Cézanne. Although the latter found himself elected a member of the committee on the art school and the museum, he preferred to remain in L'Estaque and never attended any meetings (nor did his father ever appear at the gatherings of the Council of Finance).

Manet had sent his family to safety in the south of France. Like his friends Zola and Duret, he had always been an ardent republican and a profound admirer of Gambetta, and now he frequented political meetings in Paris with his brother Eugène and Degas. Whereas his two brothers and Guillemet joined the Mobile Guard, he enlisted in the artillery of the National Guard and became a staff officer, with Meissonier as his superior. Bracquemond, Puvis de Chavannes, Carolus-Duran, and Tissot also served in the same outfit. Degas, though hardly in favor of the Republic, enlisted in the infantry but was placed in the artillery because of a bad right eye. In his regiment he met a former school friend of his, the painter and engineer Henri Rouart, who from then on was to remain one of his closest companions.

As the Prussians advanced on Paris, Pissarro was obliged to flee Louveciennes

PISSARRO: Louveciennes, the Road to Versailles (the artist's wife and daughter), d. 1870. $40\frac{1}{8} \times 32\frac{1}{2}$ ". E. G. Bührle Foundation, Zurich.

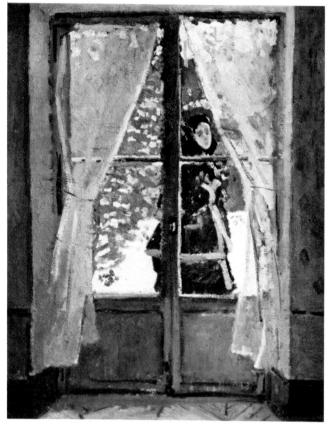

Monet: Mme Monet in a Red Cape, c. 1870 (?). $39\frac{1}{2} \times 31\frac{1}{2}$ ". Cleveland Museum of Art (Leonard C. Hanna, Jr., Bequest).

without being able to take with him the canvases representing almost his entire work done since 1855, as well as a certain number of paintings by Monet which the latter had left with him for safekeeping.²⁰ Pissarro and his family first took refuge at the farm of his friend Piette, at Montfoucault in Brittany, later leaving for London, where a half-sister lived and where his mother also went. Soon the Germans established a butcher-shop in Pissarro's house. Courbet in Paris became president of a commission to safeguard the nation's art treasures.²¹ He managed to place his own works in relative safety by depositing them in the new galleries of Durand-Ruel, rue Laffitte.

At the beginning of September, Monet witnessed at Le Havre a frantic rush onto boats sailing for England. Boudin contemplated going to London but later decided in favor of Brussels, where some of his friends had fled. Diaz went there too. Monet finally decided to leave behind his wife and child, whom he had been painting frequently on the beach, and managed to reach London.²² Daubigny and Bonvin, among others, also went to England.

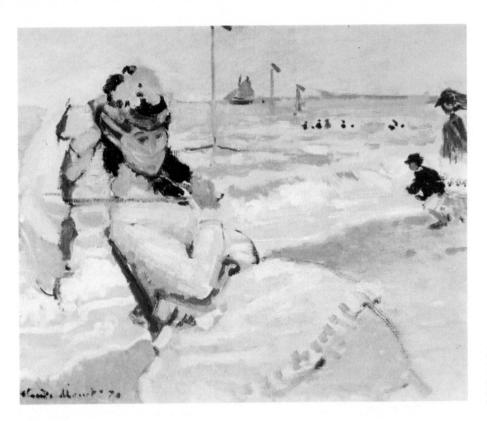

Monet: On the Beach (Mme Monet), d. 1870. 15 × 18½". Collection Mr. and Mrs. John Hay Whitney, New York.

Corot fled from his house in Ville d'Avray to Paris and offered a large amount of money for the manufacture of cannon in order to chase the Prussians from Ville d'Avray forest. On the nineteenth of September the siege of Paris began. Three weeks later Gambetta left the city by balloon to organize resistance in the provinces. The government was established in Bordeaux, and Zola went there to become secretary to the cabinet minister Glaize-Bizoin, whom he had met, together with Duret, as a contributor to the anti-imperial *Tribune*.

With guns booming in the distance day in, day out, Manet, his brother, Degas, and Stevens sometimes gathered in Passy at the Morisots, Berthe having refused to leave Paris. Her mother, in a letter to her two other daughters, thus described one of their visits: "M. Degas was so impressed by the death of one of his friends, the sculptor Cuvelier,²³ that he was quite impossible. Manet and he almost got into a fight over questions of defense and the use of the National Guard, although both of them were ready to fight until the bitter end to save the country. M. Degas has enlisted in the artillery but has not yet heard a single gun fired, according to what he says; he is anxious to hear the noise in order to find out whether he can stand the detonation of those heavy pieces."²⁴

Edouard and Eugène Manet did their best to persuade the Morisots to leave. "The account which the Manet brothers gave us of all the horrors to which we might be exposed was almost enough to discourage even the most hardy. You know how they

usually exaggerate; for the moment they see everything in the blackest colors." ²⁴ But Berthe Morisot did not have too high an opinion of her warrior-friends. She considered Degas "always the same, a little mad but charmingly witty," whereas she was to say later of Manet that "he spent the time of the siege changing uniforms." ²⁵ Indeed, when Manet sent by balloon (this service was organized by his friend Nadar) a message to Eva Gonzalès, who had fled to Dieppe, he told her: "Degas and I are volunteers with the *artillerie canonniers*; I expect that upon your return you will do a portrait of me in my greatcoat." ²⁶

In November, Manet wrote to his wife: "My knapsack is equipped with everything necessary for painting and I shall begin soon to do some sketches from nature." But the grimness of the situation seems to have prevented him from painting. "The Café Guerbois is my only distraction," he said a little later, "and that is getting pretty monotonous." 28

On November 28, Frédéric Bazille was killed in the battle of Beaune-la-Rolande. In Paris hunger and epidemics slowly began their terrible reign. Manet informed his wife that people were eating cats, dogs, and rats; the lucky ones would obtain horse meat. In a letter to Eva Gonzalès he complained that donkey meat was too

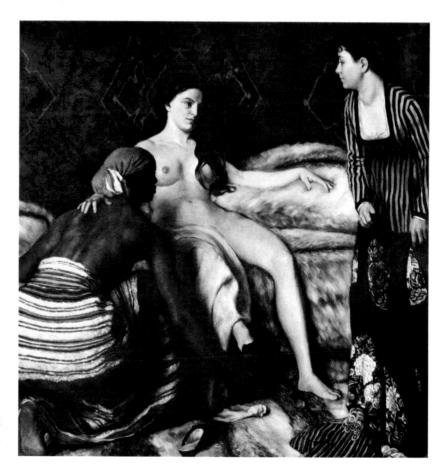

BAZILLE: La Toilette, d. 1870. Rejected by the Salon jury in 1870. $52\frac{7}{8} \times 50\frac{7}{8}$ ". Musée Fabre, Montpellier.

expensive.²⁹ Bitter cold was soon added to the trials of the Parisians. And on January 5, 1871, the Prussians began to bombard the city. Food supplies now gave out completely. The enemy guns blasted Paris day and night. On January 28 the French capital surrendered. France had lost the war. On March 1 German troops symbolically occupied Paris for forty-eight hours while the city's streets remained empty. (The day before the German's arrival, the young poet Paul Verlaine, an ardent admirer of Wagner, is supposed to have consoled himself with the thought: "At least we'll hear some good music." ³⁰)

Renoir was greatly relieved when at last he received news from Paris and replied to a letter from Charles Le Coeur: "If you knew how anxious I am to return. I can hardly wait.... I was really quite upside-down during the siege, me who was indulging in all kinds of good things while you were dying of hunger. How often did I not say: 'If only it were possible to send them some stuff!' I wasn't even hungry and should have liked to desert in order to suffer with you. Just the same I must say that I was not happy during those four months while I was without any letters from Paris; I had some more or less serious trouble, could neither eat nor sleep. And finally I treated myself to dysentery from which I might have died had not my uncle taken me to Bordeaux, which reminded me a little bit of Paris and where at last I saw other things besides soldiers, and thus rapidly recovered." There had apparently been a severe epidemic, for Renoir's comrades had practically given him up since, as he wrote, "they were used to see us Parisians die. A large quantity of them reposes in the shadow of the Libourne cemetery." 31

In London, meanwhile, Monet again lived through difficult days until he encountered Daubigny, who was then painting scenes on the Thames which met with great success in England. Daubigny was moved by Monet's distress and introduced him, in January 1871, to his dealer, Paul Durand-Ruel, who had also fled to London after sending ahead most of his pictures. He had just opened a gallery in New Bond Street. It seems that Daubigny went so far as to offer to replace by his own canvases those of Monet which Durand-Ruel might not be able to sell.³² But Daubigny did not need to insist much. Durand-Ruel had already been attracted by the few paintings by Monet which had occasionally appeared at the Salon and was glad to meet the young artist. As a matter of fact, the review of the Salon of 1870 in the Revue internationale de l'art et de la curiosité, edited by Durand-Ruel, had stressed the importance not only of Pissarro, Degas, and Manet, but of Monet as well, in spite of the fact that his canvases had been rejected.

It seemed only natural that, as son of the man who for many years had been the dealer of the Barbizon painters and had—by obstinacy and courage—contributed to their final recognition, Paul Durand-Ruel should now take some interest in the successors of Corot, Daubigny, and Courbet among the new generation. Thus when, in January 1871, Pissarro came to his gallery in New Bond Street and left a canvas, he immediately received the heartening reply:

"My dear Sir, you brought me a charming picture and I regret not having been in my gallery to pay you my respects in person. Tell me, please, the price you want and be kind enough to send me others when you are able to. I must sell a lot of your work here. Your friend Monet asked me for your address. He did not know that you were in England."33

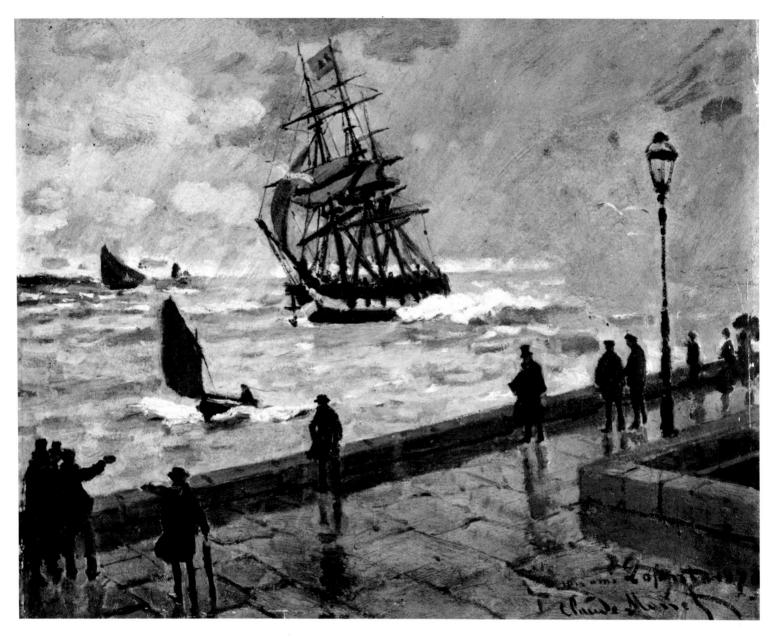

Monet: Jetty at Le Havre, d. 1870. $19\frac{3}{4} \times 24$ ". Presented by the artist to his friend Antoine Lafont, witness at his wedding. Private collection, Switzerland.

Durand-Ruel subsequently bought two canvases by Pissarro, paying 200 francs apiece, which was more than the artist used to obtain from père Martin in Paris; he paid 300 francs for the paintings of Monet. When he organized the first exhibition of the Society of French Artists, which he had founded in London, Durand-Ruel included a view of the harbor of Trouville by Monet (which the artist had doubtlessly brought with him) and two landscapes by Pissarro: *Upper Norwood* and *Snow Effect*

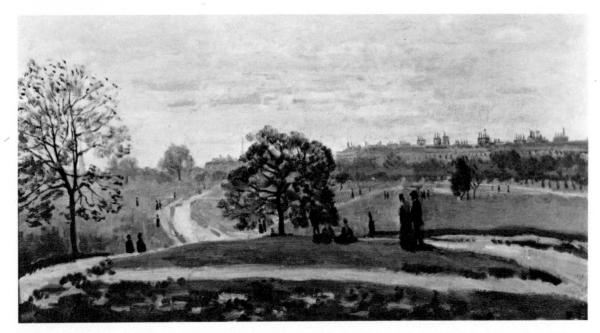

Monet: Hyde Park, London, 1871. $15\frac{3}{4} \times 28\frac{3}{4}$ ". Museum of Art, Rhode Island School of Design, Providence (Gift of Mr. and Mrs. Murray S. Danforth).

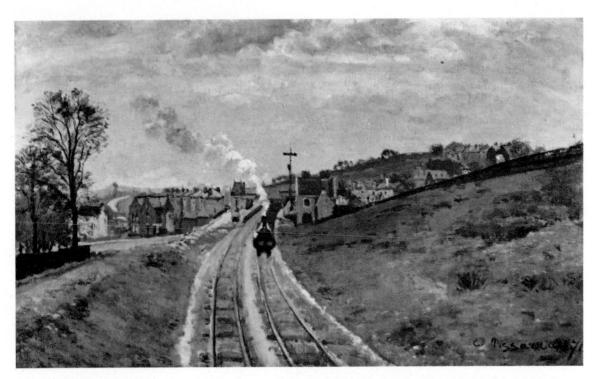

Pissarro: Penge Station, Upper Norwood, d. 1871. $17\frac{1}{2} \times 28\frac{1}{2}$ ". Courtauld Institute Galleries, London.

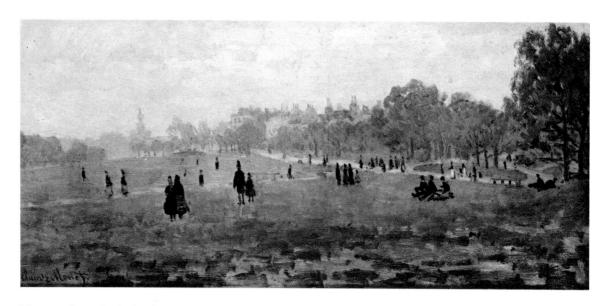

Monet: Green Park, London, 1871. $13\frac{1}{2} \times 28\frac{5}{8}$ ". Philadelphia Museum of Art (Wilstach Collection).

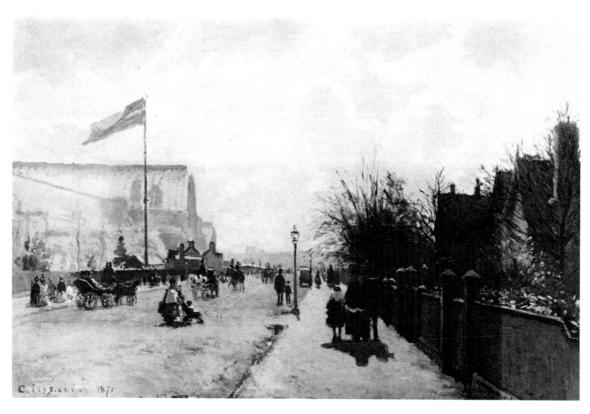

PISSARRO: Crystal Palace, London, d. 1871. $18\frac{7}{8} \times 28\frac{3}{4}$ ". The first picture by the artist purchased by Durand-Ruel. The Art Institute of Chicago (Gift of Mr. and Mrs. B. E. Bensinger).

(probably also painted in England). But in spite of all his efforts, he was unable to sell their works.³⁴

Monet and Pissarro were extremely happy to find each other in London and began to meet frequently. Pissarro later remembered: "Monet and I were very enthusiastic over the London landscapes. Monet worked in the parks, whilst I, living at Lower Norwood, at that time a charming suburb, studied the effect of fog, snow, and springtime. We worked from nature.... We also visited the museums. The watercolors and paintings of Turner and of Constable, the canvases of Old Crome, have certainly had influence upon us. We admired Gainsborough, Lawrence, Reynolds, etc., but we were struck chiefly by the landscape painters, who shared more in our aim with regard to plein air, light, and fugitive effects. Watts, Rossetti, strongly interested us amongst the modern men."35 Yet Pissarro emphasized that "Turner and Constable, while they taught us something, showed us in their works that they had no understanding of the analysis of shadow, which in Turner's painting is simply used as an effect, a mere absence of light. As far as tone division is concerned, Turner proved the value of this as a method, among methods, although he did not apply it correctly and naturally."36 Monet likewise stated in later years that Turner's art had had a limited bearing on his evolution. Both he and Pissarro, through direct observation, had already in 1870 come closer to nature than Turner, whose work—Monet did not conceal this in remarks to friends—"was antipathetic to him because of the exuberant romanticism of his fancy."37

The two friends had, in the words of Pissarro, "the idea of sending our studies to the exhibition of the Royal Academy. Naturally we were rejected." Each of them, however, was represented by two pictures in the French section of the International Exhibition at South Kensington in 1871, probably due to Durand-Ruel's good offices. Yet their works seem to have passed unnoticed. Indeed, there seemed to appear nowhere any proof for Houssaye's recent contention that the "English salute a painting where there is one," It aleast not so far as Monet and Pissarro were concerned. Had it not been for Durand-Ruel's encouragements and financial support, they might have become even more disheartened, for the news from France, as was to be expected, was not reassuring. Pissarro, who had asked one of his acquaintances—the painter Béliard—for a detailed report, received a letter late in February:

"All your friends are well. Manet left for the south [to join his family] a few days ago. Zola..., back in private life, is staying at Bordeaux awaiting events. He asks me to send you his regards. Guillemet is well, Guillaumin also. Duranty is always the same. Cézanne is in the south; Degas is a bit mad, Duranty tells me. I haven't seen Fantin, Sisley, Renoir for an age. Monet, I believe, is in Dieppe or in England. Oudinot is working at the city hall, and I'm not working at all. No coal!—... I have no news of your house at Louveciennes! Your blankets, suits, shoes, underwear, you may go into mourning for—believe me—and your sketches, since they are generally admired, I like to think will be ornaments in Prussian drawing rooms. The nearness of the forest will no doubt have saved your furniture.

"Daubigny has just come back from London, where he earned a lot of money—I think that your mother will do well to stay in London until things are settled. There is reason to believe that the peace treaty will be signed, but many complications may arise, both before and after...."39

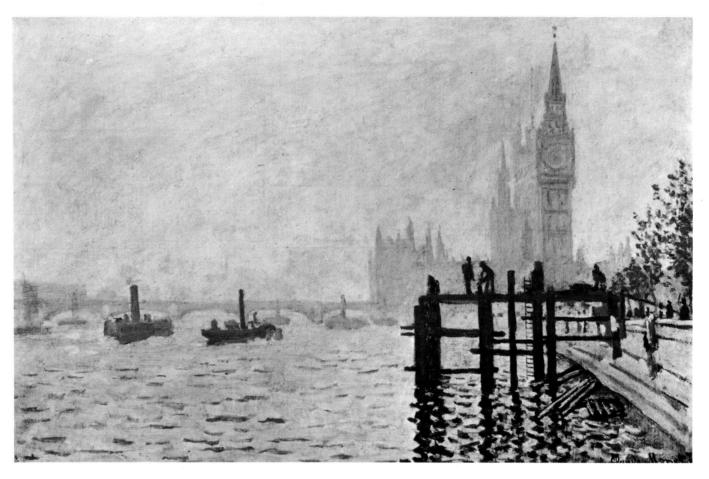

Monet: The Thames and the Houses of Parliament, London, d. 1871. $18\frac{3}{4} \times 25\frac{1}{2}$ ". Formerly Ernest Hoschedé Collection. National Gallery, London (Lord Astor of Hever Bequest).

Indeed, fate still held plenty of events in store. In March the exasperated population of Paris opposed certain military measures by the new government, which thereupon fled to Versailles, while the *Commune* was proclaimed in the capital. Courbet who, earlier that year, had refused the cross of the Legion of Honor, now was elected a representative of the people and also became president of a general assembly of artists in whose name he abolished the Academy in Rome, the *Ecole des Beaux-Arts*, the Fine Arts section of the Institute, and all medals, etc., distributed at the Salons. But the status of the Salon jury remained unchanged. Among those who most regularly attended the reunions of the artist assembly were Amand Gautier and Berthe Morisot's former teacher Oudinot.⁴⁰

Renoir was back in Paris by March 18, when the insurrection broke out, and found himself threatened with compulsory enrollment decreed by the *Commune*. Unable to join his mother in nearby Louveciennes, all exits from the city being blocked by federal guards, he remembered having met before the war the Police Commissioner

of the revolutionary government. He had no difficulty obtaining a pass to leave the capital, but was warned that should this paper be found on him by the Versailles troops, he was liable to be shot. Yet when he subsequently did get into trouble, he was rescued from further complications by his patron, Prince Bibesco.⁴¹

In Louveciennes, according to the recollections of his brother Edmond, Renoir saw Sisley who, although a British subject, had preferred to remain in France.⁴² Renoir was delighted to discover that his friend had canvas, colors, and brushes; together the two set out to work in and around Louveciennes and Marly. Renoir eventually was also reunited with Lise after their long separation and painted a new portrait of her. Later on in the summer of 1871 he joined once more his friend Jules Le Coeur, probably in Marlotte.

Sisley found himself deeply affected by the war and its aftermath. His father fell ill and died shortly after having suffered such serious financial losses that he was practically ruined. The painter thus suddenly was forced to fend for himself, his wife, and two small children, a situation for which he was ill prepared.⁴³ Possibly as a consequence of these reverses he decided to remain at Voisins-Louveciennes, where he had rented a small house on the rue de la Princesse, rather than to return to the city.

In Paris meanwhile, Courbet, designated as Curator of Fine Arts, became involved in the destruction of the Vendôme Column, considered a symbol of wars of aggression and a glorification of the Bonaparte dynasty. The Column was re-erected after the downfall of the *Commune*. This downfall occurred in the wake of a new investment of Paris, this time by troops of the Versailles government, which started to bombard the city during the first days of May. The troops entered Paris on May 21, and terrible reprisals began. For one week the capital was literally drenched in blood. On May 28 all resistance ceased. Ten days later Courbet was arrested.

Manet, whose friend Théodore Duret had barely escaped execution during the Commune, returned to Paris before the last street battles of May and recorded these conflicts in two lithographs. Zola had arrived in the capital four days before the insurrection and remained there until the middle of May. Degas, having left Paris after the armistice, spent the months of the Commune with his friends the Valpinçons at their estate in the country, where he is supposed to have painted a portrait of their young daughter. Berthe Morisot had gone with her parents to join Puvis de Chavannes at Saint-Germain, just outside the city. At about the same time Pissarro's patron Arosa welcomed to Paris his godson, Paul Gauguin, who had just finished conscription service as a sailor and who now entered the banking firm of Bertin on Arosa's recommendation.

Pissarro, in London, continued to receive rather unpleasant news from France. The owner of his house in Louveciennes informed him that the "Prussians have caused plenty of havoc. . . . Some of the pictures we have taken good care of, only there are a few which these gentlemen, for fear of dirtying their feet, put on the ground in the garden to serve them as a carpet." 44 And Duret wrote to Pissarro after the suppression of the Commune: ". . . . Dread and dismay are still everywhere in Paris. Nothing like it has ever been known. . . . I have only one wish and that's to leave, to flee from Paris for a few months. . . . Paris is empty and will get still emptier. . . . As for painters and artists, one might think there had never been any in Paris." 45 Duret mentioned to Pissarro his intention of going to London, whereupon the

Right, Daumier: *The Inheritance*, 1871. Lithograph.

Far right, Manet: *The Barricade* (scene of the repression of the Paris *Commune*), 1871. Lithograph.

painter answered, in June: "... I'm here for only a very short time. I count on returning to France as soon as possible. Yes, my dear Duret, I shan't stay here, and it is only abroad that one feels how beautiful, great, and hospitable France is. What a difference here! One gathers only contempt, indifference, even rudeness; among colleagues there is the most egotistical jealousy and resentment. Here there is no art; everything is a question of business. As far as my private affairs, sales, are concerned, I've done nothing, except with Durand-Ruel, who bought two small pictures from me. My painting doesn't catch on, not at all; this follows me more or less everywhere.... Perhaps in a short while I'll be in Louveciennes; I've lost everything there. About forty pictures are left to me out of fifteen hundred."46

When Duret met Pissarro a little later in London, he was enthusiastic about the painter's recent work but found the situation in England almost worse than Pissarro had described it. "The English, with regard to French artists, like only Gérôme, Rosa Bonheur, etc.," he wrote to Manet. "Corot and the other great painters don't exist as yet for them. Things here are the way they were twenty-five years ago in Paris. . . ."47 Leaving Great Britain for the United States on a trip around the world, Duret was happy to report that in the New World, besides many bad pictures, he had also seen some good ones. "The modern French school is getting in here now," he stated. "I saw again in Boston Courbet's *Curée*. It is really a masterpiece. I also saw in Boston some very beautiful Troyons. . . . A Courbet and some Troyons compensate for many errors of taste." While Duret was writing these lines to Manet, Courbet,

Daubigny: The Mills of Dordrecht, d. 1872. $33\frac{1}{2} \times 57\frac{1}{2}$ ". Detroit Institute of Arts.

Monet: Mill in Zaandam, 1871-72. 19 $\frac{1}{4} \times 29\frac{3}{4}$ ". Collection the Earl of Jersey, Jersey. 262

Monet: Canal in Zaandam, 1871-72. $17\frac{1}{2} \times 28\frac{1}{2}$ ". Collection Mr. and Mrs. Clifford W. Michel, New York.

in Paris, was put in prison to await trial for active participation in the *Commune* and especially for the destruction of the Vendôme Column, for which he denied any responsibility.⁴⁹

Monet had left England in the meantime but instead of returning to France had first made a trip to Holland. This he had done possibly on the advice of Daubigny, if not actually invited by him, for the latter did work in Holland during the years 1871 and 1872; he even purchased one of Monet's views of the canal of Zaandam. Monet was to remain in Holland until the end of the year, attracted by the picturesque windmills with their red wings, the immensity of the skies over the flat lands, the canals with their boats, the cities with their houses that seemed to grow out of the water—all this often presenting itself in a great variety of greys, the kind of tonal values to which Boudin had been so sensitive.

Finally Pissarro, too, packed up. By the end of June 1871, he was back in Louve-

ciennes. A painting he did shortly after his return of the *Road to Rocquencourt* seems to be filled with a certain cheerfulness, a quiet but glowing assurance, a feeling that appears to be stronger than the lyricism of his earlier works because it attains serenity.

Pissarro had expressed the ardent hope that "Paris will recover her supremacy," 46 and he now found a France united in the desire to rebuild what was destroyed and to reassume the place she had occupied in the world. A public loan by the government was oversubscribed two and a half times; the enormous amount of reparations requested by the Prussians was paid within the shortest possible time, and throughout the entire country, liberated from an incompetent monarch, deeply humiliated on the battlefield, but proud of its new republic, there seemed to reign a new spirit, a new will for great achievements. In science, in art, in literature, in the field of engineering, great projects were formed and their realization begun with confidence. "It is our reign coming," Zola announced to Cézanne in July 1871.50

And Berthe Morisot's friend, Puvis de Chavannes, expressed in a painting *Hope*—although in a somewhat anemic style—the spirit of a vanquished country that faced its destiny with faith reborn (p. 267).

Yet among the French intellectuals many seem to have been somewhat apprehensive of the future. The much hailed birth of the Third Republic could not detract from the painful memories of a military defeat and the savage repression of the

Pissarro: The Road to Rocquencourt, d. 1871. 20¼ × 30″. Private collection, New York.

Degas: Portrait of Hortense Valpinçon, 1869-71. 29\(\frac{3}{4}\times 44\(\frac{3}{4}\)''. Minneapolis Institute of Arts (John R. Van Derlip Fund)

Commune. Nor was the new regime itself as yet securely established; quite the contrary, its survival often appeared in doubt while reactionaries and liberals desperately fought for supremacy and the parliament became a battleground for bitter struggles around democratic institutions. Eventually Thiers, first president of the young Republic, was to be ousted by the conservatives and replaced by Marshal Mac-Mahon, Duke of Magenta, one of the victors of the Crimean war who—his supporters hoped—would use the army for a coup d'état and restore the Monarchy (which Durand-Ruel, for one, strongly favored). No wonder that under these circumstances Armand Silvestre echoed the fears expressed at the Café Guerbois when he gloomily asked himself: "What will become of thought condemned to live through these currents? French art and its sacred interests, will they survive this catastrophe for long?"51

Zola, however, was more optimistic. When, shortly after the war, he evaluated the artistic situation, he unhesitatingly proclaimed: "The hour is well chosen to state

Pissarro: Path above Pontoise, c. 1871. $20\frac{1}{2} \times 32$ ". Brooks Memorial Art Gallery, Memphis, Tenn. (Gift of Mr. and Mrs. Hugo Dixon).

some truths. After each social disaster there appears a certain stupor, a desire to return to untarnished reality. The false basis on which one has lived has crumbled, and one looks for firmer ground to build upon more solidly. All great literary and artistic blossomings have taken place in periods of complete maturity or else after violent upheavals. I confess hoping that from all this blood and all this stupidity will emerge a large current, once the Republic will have pacified France. And those pariahs of late, those whose talents were denied, that group of naturalists of recent times will now come to the fore and will continue [in art] the scientific movement of the century."⁵²

While the Germans rejoiced in their easy victory over the corrupt Second Empire, Friedrich Nietzsche had the courage to tell his countrymen:

"Public opinion in Germany appears almost to prohibit speaking of the evil and

dangerous consequences of wars, and above all of a victoriously ended war.... Nevertheless, it must be said: a great victory is a great danger. Human nature bears it with more difficulty than defeat, and it even seems to be easier to obtain victory than to carry it off in such a manner that it is not changed to defeat. Of all the dangerous consequences following upon the late war with France, the most dangerous is perhaps that widespread, even general error that German culture has likewise been victorious in this battle and that it has a right to the palms awarded such success. This illusion is extremely harmful, not because it is an illusion—for there are some beneficent illusions—but because it is on the way to transform our victory into a complete defeat.... There cannot be any question of the victory of German culture for the very simple reason that French culture continues to exist and that we depend on it as in the past."53

During the decades ahead not only Germany but the entire world was to depend upon the culture of France, and in perhaps no field was her lead to be less disputed than in that of the arts. But it took many years before her role and that of her painters were to be universally recognized, almost as many—if not more—as it took France herself to become aware of her greatest artists.

Puvis de Chavannes: Hope, $1872.\ 27\frac{1}{2} \times 31\frac{1}{8}$ ". (The model for this painting was Emma Dobigny who also posed for Corot and Degas.) Musée du Louvre, Paris.

- 1 Corot, on his bulletin, crossed out the name of Manet and replaced it with that of Eugène Isabey.
- 2 See A. Alexandre: Claude Monet, Paris, 1921, p. 61.
- 3 The catalogue of the Salon of 1870 lists among others: Bazille, rue des Beaux-Arts 8, Scène d'été [his second painting, La Toilette, was rejected]; De Gas, rue de Laval 13, Portrait de Mme C...[Camus]; Fantin-Latour, rue des Beaux-Arts 8, La lecture [which was awarded a medal], Un atelier aux Batignolles; Manet, rue St. Pétersbourg 49, La lecon de Musique, Portrait de Mlle E. G. [Gonzalès]; Morisot, rue Franklin 16, Portrait de Mmes *** [the artist's mother and sister Edma Pontillon], Jeune femme à sa fenêtre [her sister Edma at Lorient]; Pissarro, à Louveciennes et à Paris chez M. Martin, rue Laffitte 52 [this was the address of the dealer père Martin], Automne and Paysage; Renoir, chez M. Bazille, rue des Beaux-Arts 8 (élève de Gleyre), Baigneuse and Femme d'Alger; Sisley, Cité des Fleurs 27, Péniches sur le Canal St. Martin and Vue du Canal St. Martin.
- 4 Castagnary: Salon de 1870, reprinted in Castagnary: Salons (1857-1870), Paris, 1892, p. 429. C. Lemonnier (see note 8) also exhorted the artists to paint "in the streets" and represent their contemporaries in their garb.
- 5 B. Morisot to her sister Edma, March 1870; see D. Rouart: Correspondence de Berthe Morisot, Paris, 1950, p. 36-37.
- 6 See letter of Mme Morisot to her daughter Edma, March 27, 1870; *ibid.*, p. 40.
- 7 B. Morisot to her sister Edma, May 1870; ibid., p. 40.
- 8 On the Salon of 1870 see J.-E. Blanche: Les Arts Plastiques—La Troisième République, 1870 à nos jours, Paris, 1931, p. 3-16; C. Lemonnier: Propos d'art, reprinted in Lemonnier: Les peintres de la vie, Paris, 1888, p. 79-143; B. de Mezin: Promenades en long et en large au Salon de 1870, in Le Vélocipède illustré, Paris, 1870.
- 9 Thomas Eakins, then a pupil of Gérôme, admired this work tremendously.
- 10 Bazille to his parents, May 16, 1870; see F. Daulte: Frédéric Bazille et son temps, Geneva, 1952, p. 80.
- 11 B. Morisot to her sister Edma, beginning of May 1870; see Rouart, op. cit., p. 38-39.
- 12 A. Wolff in *Le Figaro*, May 13, 1870, quoted by A. Tabarant: Manet et ses oeuvres, Paris, 1947, p. 175-176.
- 13 T. Duret: Salon de 1870, L'Electeur Libre, May-June 1870; reprinted in Duret: Critique d'avant-garde, Paris, 1885, p. 3-53.
- 14 Duranty: M. Manet et l'imagerie; quoted by Tabarant, op. cit., p. 176-177.

- 15 A. Houssaye, quoted by K. Bertrand: Le Salon de 1870, L'Artiste, 9e série, v. XIII, 1870, p. 319-320; quoted in J. C. Sloane: French Painting—Between the Past and the Present, Princeton, 1951, p. 202-203. Sloane justly points out that Houssaye's "reference to the flexibility of English and Spanish taste in comparison to the stiffness of the French is most refreshing. The chauvinism of Parisian criticism in this period is so blatant as to be quite painful. . . . It is, of course, well known that Courbet had a strong following in Germany, Belgium, and Holland at the very time his countrymen were trying to discredit his most important pictures." Although Manet had been enchanted with his reception by British art circles in 1868, Rossetti's opinions of recent French painting were definitely hostile, nor were the experiences Monet and Pissarro were to have in London very encouraging. No proof can be found for Houssaye's assertion that the Spanish and English showed more understanding than the French.
- 16 On this painting see M. Bodelsen: Gauguin's Cézannes, Burlington Magazine, May 1962.
- 17 See J. Rewald: Un article inédit sur Paul Cézanne en 1870, Arts [Paris], July 21-27, 1954.
- 18 See J. Gasquet: Cézanne, Paris, 1921, p. 90.
- 19 Marius Roux to Zola, Sept. 1870; see Rewald: Paul Cézanne, New York, 1948, p. 87. For further details see Rewald: Paul Cézanne—New documents for the years 1870-1871, Burlington Magazine, April 1939.
- 20 See A. Tabarant: Pissarro, Paris, 1924, p. 18.
- 21 See A. Darcel: Les musées, les arts et les artistes pendant le siège de Paris, *Gazette des Beaux-Arts*, Oct., Nov. 1871.
- 22 An often repeated version has it that Monet went first to Holland, but there is no evidence to support it. G. Geffroy: Claude Monet, sa vie, son oeuvre, Paris, 1924, v. I, p. 58 asserts that Monet went to Holland with Pissarro and that they travelled together to England, but Pissarro did not go to Holland in 1870 and only learned in Jan. 1871 of Monet's presence in London through Durand-Ruel. Among Monet's paintings done in Holland there seem to be none dated 1870 and those dated 1871 must have been done the latter part of that year, after he left England. In his interview with Thiébault-Sisson, Monet asserts that he went directly to England.
- 23 An animaliste with whom Degas had made his first sculptures of horses; see Rewald: Degas, Works in Sculpture, New York, 1944, 1956.
- 24 Mme Morisot to her daughters, Oct. 18, 1870; see Rouart, op. cit., p. 44.

- 25 B. Morisot to her sister Edma, Feb. 21, 1871; *ibid.*, p. 48.
- 26 Manet to Eva Gonzalès; see C. Roger-Marx: Eva Gonzalès, Paris, 1950.
- 27 Manet to his wife, Nov. 19, 1870; see Moreau-Nélaton, op. cit., v. I, p. 124.
- 28 Manet to his wife, Nov. 23, 1870; ibid., p. 125.
- 29 See Manet's letters to his wife and to Eva Gonzalès quoted by Moreau-Nelaton, op. cit., p. 121-127.
- 30 Verlaine quoted by J. Claretie: La vie à Paris—1880, Paris, n.d. [1881], p. 505.
- 31 Renoir to Charles Le Coeur, March 1, 1871; see D. Cooper: Renoir, Lise and the Le Coeur Family, II, Burlington Magazine, Sept.-Oct. 1959.
- 32 See M. de Fels: La vie de C. Monet, Paris, 1929, p. 130.
- 33 Durand-Ruel to Pissarro, Jan. 21, 1871; see L. Venturi: Les Archives de l'Impressionnisme, Paris-New York, 1939, v. II, p. 247-248.
- 34 See: Mémoires de Paul Durand-Ruel in Venturi, ibid., p. 175-180. A note on p. 176 specifies that the first exhibition, organized in 1870, contained one painting by Monet and two by Pissarro, whereas the second show of 1871 included works by Monet, Pissarro, Sisley, Renoir, Manet, and Degas. But D. Cooper: The Courtauld Collection, London, 1954, p. 22, footnote, asserts that the second exhibition did not feature any impressionist works. This would seem more plausible, as it appears unlikely that Durand-Ruel should have taken to London canvases by Sisley, Renoir, Manet, and Degas, whom he had not yet met. According to the catalogue excerpts of the eleven exhibitions organized by Durand-Ruel in London between 1870 and 1875 -as given by Cooper-these artists were shown there after the dealer had returned to Paris and made their acquaintance; their paintings thus appear only from 1872 on.
- 35 Pissarro to Dewhurst, Nov. 1902; see W. Dewhurst: Impressionist Painting, London-New York, 1904, p. 31-32.
- 36 Pissarro to his son, May 8, 1903; see Camille Pissarro, Letters to His Son Lucien, New York, 1943, p 355-356. Concerning Turner's influence on Monet and Pissarro, it should be recorded that Paul Signac, who knew Pissarro well, later attributed to it a much greater importance than did the painters themselves, when he wrote: "... In London... they study his works, analyzing his technique. They are first of all struck by his effects of snow and ice. They are astonished at the way in which he has succeeded in giving the feeling of the whiteness of the snow, they who until now have not been able to achieve it with their large spots of

- white spread out flat with broad brush-strokes. They come to the conclusion that this marvelous result is obtained, not by a uniform white but by a number of strokes of different colors, placed one beside the other and reproducing at a distance the desired effect." (P. Signac: De Delacroix au Néo-impressionnisme, Paris, 1899.)
- 37 See R. Koechlin: Claude Monet, Art et Décoration, Feb. 1927.
- 38 See Cooper: Courtauld, op. cit., p. 23.
- 39 Béliard to Pissarro, Feb. 22, 1871; quoted from the partly unpublished original found among Pissarro's papers.
- 40 See A. Darcel; Les musées, les arts et les artistes pendant la Commune, Gazette des Beaux-Arts, Jan., Feb., March, May, June 1872.
- 41 See G. Rivière: Renoir et ses amis, Paris, 1921, p. 13-14.
- 42 This statement is at variance with the first two editions of the present book according to which Sisley had fled to London and there painted a view of the Thames. But F. Daulte: Alfred Sisley—Catalogue raisonné, Lausanne, 1959, asserts that the date of this painting should be read 1874 instead of 1871. Fifty years later, however, Durand-Ruel said in an interview that Sisley was introduced to him by Monet in London. See F. F. [Fénéon]: Les grands collectionneurs—M. Paul Durand-Ruel, Bulletin de la vie artistique, April 15, 1920.
- 43 See Daulte: Sisley, op. cit., p. 28.
- 44 Mme Ollivon to Pissarro, March 27, 1871; see L. R. Pissarro and L. Venturi: Camille Pissarro, Paris, 1939, v. I, p. 23-24: see also a letter by J. Grave, published in Bulletin de la vie artistique, April 1, 1924.
- 45 Duret to Pissarro, May 30, 1871; quoted from the partly unpublished original found among Pissarro's papers.
- 46 Pissarro to Duret, June 1871; see Tabarant, op. cit., p. 20.
- 47 Duret to Manet, Liverpool, July 7, 1871; see A. Tabarant: Manet et Théodore Duret, L'Art Vivant, August 15, 1928.
- 48 Duret to Manet, New York, Aug. 9, 1871; ibid.
- 49 On Courbet's role, the *Commune*, the Vendôme Column, the painter's arrest etc., see G. Mack: Gustave Courbet, New York, 1951.
- 50 Zola to Cézanne, July 4, 1871; see A. Vollard: Paul Cézanne, Appendix II.
- 51 A. Silvestre: Portraits et souvenirs, Paris, 1891, p. 40.
- 52 Zola: Causerie du dimanche, Le Corsaire, Dec. 3, 1872; quoted in Zola: Salons, edited by F. W. J. Hemmings and R. J. Niess, Geneva-Paris, 1959, preface, p. 25.
- 53 F. Nietzsche: David Strauss, the confessor and writer, in Thoughts Out of Season, part I; Complete Works, v. IV, New York, 1911, p. 4-5 [here newly translated].

Monet: Blue House at Zaandam, 1871-72. $17\frac{3}{4} \times 23\frac{7}{8}$ ". Formerly Ernest Hoschedé collection; auctioned in 1874 for 405 francs. Private collection, London.

VIII 1872-1873

THE YEARS AFTER THE WAR

AUVERS-SUR-OISE

ANOTHER SALON DES REFUSÉS (1873)

Toward the end of 1871 almost all the friends were back in Paris or its vicinity and began to meet again at the Café Guerbois. Zola, however, although he lived in the Batignolles quarter, made less frequent appearances, being hard at work on his series of novels, the Rougon-Macquart, the publication of the first volume of which had been interrupted by the war. Cézanne, returned from the south, now occupied a small apartment opposite the Halle aux Vins in Paris where, in January 1872, Hortense Fiquet gave birth to a child who received the name of his father, Paul Cézanne. At about the same time Monet arrived from Holland, and Boudin informed a friend: "He is very well settled and appears to have a strong desire to make a position for himself. He has brought from the Netherlands some very beautiful studies, and I believe that he is destined to fill one of the first places in our school."

No sooner was he back than Monet, together with Boudin and Amand Gautier, went to pay a visit to Courbet, who, after several months in prison, had been transferred to a nursing home for reasons of health. They were among the very few who remembered their debt of gratitude, now that Courbet had been condemned for his participation in the *Commune* and for the destruction of the Vendôme Column. Courbet was deeply moved by their solicitude at a moment when most of his acquaintances were careful to forget him. Manet, for instance, having followed the sessions of the National Assembly in Versailles, had written in August 1871 to Duret, who was then in New York: "... You mention Courbet. His conduct before the War Council was that of a coward and he no longer deserves any attention." In spite of the fact that Durand-Ruel never had felt any sympathy for Courbet's political ideas, he was among those who refused to abandon the painter; he bought a large number of his works. (While in Ste.-Pélagie prison Courbet had painted mostly still lifes, among them one combining a colorful bouquet with a portrait of Whistler's mistress, Jo, whose gaudy beauty apparently still haunted his memory.)

After his return to France, Paul Durand-Ruel continued to invest heavily in the works of the Barbizon masters, some of whom sold exclusively to him. But he also showed an increasing interest in the efforts of the younger men. When Monet and Pissarro introduced friends to him, especially Sisley and Degas, he immediately

bought several of their canvases. In January 1872, Durand-Ruel discovered two paintings by Manet in the studio of the then popular Stevens, with whom Manet had left some of his work in the hope that he might find a buyer. The dealer not only acquired these but the very next day visited Manet's studio, where he bought the entire lot of canvases he found, altogether twenty-three paintings, for which he paid 35,000 francs. Manet's prices varied from 400 to 3,000 francs, this amount being asked for the Spanish Guitar Player (p. 53), the first picture ever exhibited by Manet at the Salon, for Mademoiselle V. in the Costume of an Espada (p. 83), from the Salon des Refusés, and for the Combat of the Kearsarge and the Alabama (p. 107). Among the paintings sold were also the Spanish Dancers (p. 78) and the Bullfight (p. 127).³ This transaction had hardly been concluded when Durand-Ruel returned and bought several other canvases which Manet had hastily retrieved from various friends. Among these was the Concert in the Tuileries Gardens (p. 77). In the exhibitions which Durand-Ruel organized in London during the year 1872 Manet was represented by thirteen paintings, Pissarro by nine, Sisley by six, Monet by four, Degas by three, and Renoir whom the dealer met in March 1872 — by his early *Pont des Arts* (p. 167), Durand-Ruel's first purchase from the artist, for which he paid 200 francs. In 1873 and again in 1874 he showed their works in London, albeit not as many of them.4

Through these mass acquisitions of paintings by the members of the Batignolles group Durand-Ruel began to link his career definitely with that of the young painters, although he had not yet been able to sell any of their works. But it was his conviction that "a true picture dealer should also be an enlightened patron; that he should, if necessary, sacrifice his immediate interest to his artistic convictions, and prefer to oppose, rather than support the interests of speculators."⁵

Durand-Ruel's purchases brought not only financial but also moral support to the painters. This may have been one of the reasons why, with the exception of Manet, those who were in contact with him — Monet, Pissarro, Sisley, and Degas — seem not to have sent anything to the Salon of 1872. Manet, Renoir, and possibly Cézanne, however, true to their convictions, submitted their works to the jury. So did Berthe Morisot. But at that time neither she nor Cézanne nor Renoir had as yet had any dealings with Durand-Ruel. While Manet and Berthe Morisot saw their works accepted, Renoir's canvas was turned down. Courbet's works also were rejected. because Meissonier, a jury member, opposed their admission for purely political reasons. The jury, which acceded to his views, was no longer elected by all admitted artists, a new ruling having again restricted the right to vote to those who had received medals. As was to be expected, a protest was launched by a number of artists, and a claim for a new Salon des Refusés was put forward, but to no avail. The Director of Fine Arts of the Republic adopted an attitude identical with that of the Superintendent under Napoléon III. Some artists even went so far as to "regret the passing of the Empire and M. de Nieuwerkerke," as Paul Alexis was shortly to state.

The painting which Renoir had unsuccessfully submitted, *Parisian Women Dressed as Algerians*, a work strongly influenced by Delacroix, was one of the two last canvases for which Lise posed. The artist also painted her portrait in a white shawl which he presented to her, possibly as a wedding gift. Indeed, in April 1872, Lise Tréhot married a young architect, a friend of Jules Le Coeur, and seems never to have seen Renoir again.⁷

RENOIR: Portrait of Lise in a White Shawl, c. 1872. 22 × 18½". Collection Mr. and Mrs. Emery Reves.

COURBET: Still Life Painted in Ste.-Pélagie Prison, 1871. 23½ × 28¾". The Norton Simon Foundation, Los Angeles.

After the closing of the Salon, Manet went to Holland to study particularly the art of Frans Hals in Haarlem. Monet also returned to that country to paint more views of canals, boats, and windmills. Berthe Morisot, deeply depressed by the general situation, made a short trip to Spain. Duret, though financially affected by the *Commune*, which had ruined one of his debtors, pursued his world tour and, after leaving the United States, visited Japan, China, Java, and India.

Degas meanwhile continued to roam behind the scenes of the Paris Opera, where shortly before the war Stevens had brought Bazille. But while Bazille had been disappointed by backstage life, Degas discovered there a whole series of new subjects, seen from various angles, which offered unusual aspects and lent themselves admirably to the kind of pictorial exploration of which he had always dreamt. He made friends with a member of the orchestra, Désiré Dihau, and introduced his portrait into several compositions in which the stage acts as the background with the musicians and their instruments as foreground. Sometimes he also showed a number of spectators, choosing them from among his friends such as Manet's patron, the banker Hecht, or the engraver Viscount Lepic, whom Monet and Bazille had met in Gleyre's studio ten years before. Hecht and Dihau thus appear attending a presentation of *Robert le Diable*, an extremely popular opera by Meyerbeer

DEGAS: The Orchestra of the Paris Opera (at the left the composer Emmanuel Chabrier, in the center the bassoonist Désiré Dihau), 1868-69. $22\frac{1}{2} \times 18\frac{1}{2}$ ". Formerly Dihau collection. Musée du Louvre, Paris.

which Cézanne liked so much that he remembered its arias for many years later. Painted in 1872, *Robert le Diable* must have been purchased immediately by Durand-Ruel, for he exhibited it that same winter in London.

Degas also paid frequent visits to the classes where the ballet master of the Opera trained groups of young girls, the so-called *rats*, for their difficult and graceful task.

As if they all felt an urge to go abroad in the first year following the war, Degas, after Duret, Manet, Berthe Morisot, and Monet, decided to leave France. In the fall of 1872 he accompanied his brother René to New Orleans, where their mother had

Degas: The Ballet of "Robert le Diable" (in the center, with opera glasses, the banker Albert Hecht), d. 1872. $26 \times 21\frac{1}{8}$ ". Exhibited in London in 1872. Metropolitan Museum of Art, New York (H. O. Havemeyer Collection).

been born and where his two brothers had established themselves as cotton merchants. During a short stop-over in New York he wrote his father: "Immense city, immense activity. In physiognomy and general aspect much closer to us than to the English." After his arrival in Louisiana he informed a friend: "How many new things I've seen! How many projects it has put into my head.... I've already given them up: I want to see nothing but my corner and dig away obediently. Art doesn't grow wider, it recapitulates. And, if you will have comparisons, I shall tell you that in order to produce good fruit, one must grow espalier-fashion. You remain there throughout

DEGAS: Portraits in an Office—Cotton Exchange in New Orleans (at left, leaning against a window, the artist's brother Achille; in the foreground, in top hat, his uncle, Michel Musson; in the center, reading a newspaper, his brother René), d. 1873. $29\frac{1}{8} \times 36\frac{1}{8}$ ". Musée Municipal, Pau (purchased in 1878).

life, arms outspread, mouth open to take in what passes, what is around you, and to live from it.... So I am hoarding projects which would require ten lives to put into execution. I shall abandon them in six weeks, without regret, to return to and to leave no more my home."9

Degas was greatly attracted by the beauty of the Negro women, the colonial houses, the steamboats, the fruit merchants, the picturesque gowns, the orange trees, and so on, yet he felt that it was impossible to paint in New Orleans as he had done in Paris, and that a long sojurn would be necessary for him to grasp the true character of this new world. He thought of Manet, who, better than he, might have painted beautiful things there. But for himself he realized that "one likes and one makes art only of that to which one is accustomed. The new captivates and bores in turn." He therefore satisfied himself with painting some sketches and a view of the interior

Photograph of Michel Musson, c. 1876.

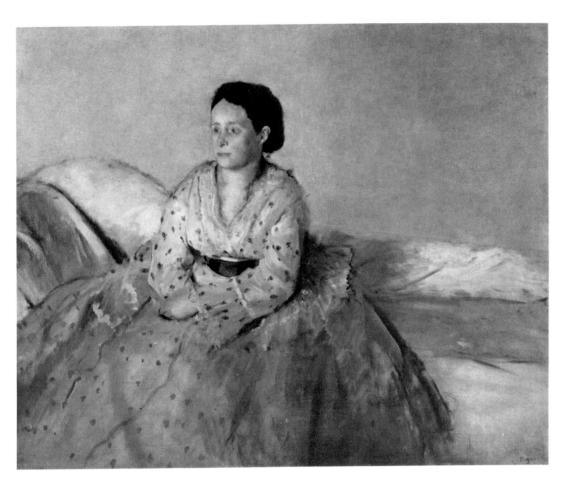

Degas: Mme René De Gas, née Estelle Musson, the artist's cousin and sister-in-law, painted in New Orleans, 1872-73. 29 × 36". National Gallery of Art, Washington, D.C. (Chester Dale Collection).

DEGAS: *Young Woman with* Fan (Mathilde Musson Bell), d. New Orleans 1872. Pencil and colored crayons, $12\frac{1}{2} \times 9\frac{1}{2}$ ". Collection Mr. and Mrs. Richard L. Selle, New York.

of a cotton dealer's office, that of his uncle, Mr. Musson. He also did a few family portraits, a task he could not refuse. Among these portraits was that of his blind cousin, Estelle Musson, who was his sister-in-law, having married René De Gas (she was then expecting her fourth child, for whom the painter was to be godfather).

Early in 1873 Degas sailed back to France. In the autumn he was deeply affected by the burning of the Paris Opera, which deprived him of one of his favorite objects of study. But as soon as the dancing classes were installed in new, temporary quarters, he began again to paint the little rats, the musicians, and the ballet master. Here he found what interested him most: movement — but not a free and spontaneous one, quite the contrary — precise and studied exercises, bodies submitted to rigorous discipline, gestures dictated by an inescapable law, as were the movements of the horses he liked to observe at the races. In the same way in which he followed these horses, registering every one of their attitudes in his memory so as to be able to paint

them in the studio, he took only occasional notes at the dancing classes, relying on his memory for the works he planned. Whereas his friends insisted with growing emphasis that they could represent what they saw only by studying the subject while they worked, Degas adopted the opposite principle and showed an increasing tendency to observe without actually painting and to paint without observing.

When Edmond de Goncourt paid the artist a visit early in 1874, he noted in his journal: "Yesterday I spent the afternoon in the studio of a painter named Degas. After many attempts, many bearings taken in every direction, he has fallen in love with the modern and, in the modern, he has cast his choice upon laundresses and dancers. I cannot find his choice bad, since I, in *Manette Salomon*, have spoken of these two professions as ones that provide for a modern artist the most picturesque models of women in this time.... And Degas places before our eyes laundresses and laundresses, while speaking their language and explaining to us technically the downward pressing and the circular strokes of the iron, etc., etc. Next dancers file by. It is the foyer of the dancing school where, against the light of a window, fantastically silhouetted dancers' legs are coming down a little staircase, with the brilliant spot of red in a tartan in the midst of all those white, ballooning clouds. . . . And right before us, seized upon the spot, is the graceful twisting of movements and gestures of the little monkey-girls.

"The painter shows you his pictures, from time to time adding to his explanation by mimicking a choreographic development, by imitating, in the language of the dancers, one of their arabesques — and it is really very amusing to see him, his arms

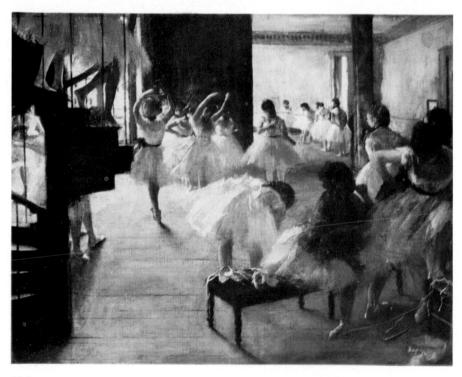

DEGAS: Foyer de Danse, c. 1873. $18\frac{3}{4} \times 24\frac{1}{2}$ ". Corcoran Gallery of Art, Washington, D.C. (W. A. Clark Collection).

Degas: Le Foyer, c. 1871. Panel, $7\frac{3}{4} \times 10\frac{5}{8}$ ". Metropolitan Museum of Art, New York (H. O. Havemeyer Collection—purchased through Mary Cassatt).

curved, mixing with the dancing master's esthetics the esthetics of the artist.... What an original fellow, this Degas — sickly, hypochondriac, with such delicate eyes that he fears losing his sight [ever since his military service in 1871 Degas had complained of eye trouble and said that he had only a few good years left], and for this very reason is especially sensitive and aware of the reverse character of things. He is the man I have seen up to now who has best captured, in reproducing modern life, the soul of this life."11

At about the same time that Degas returned to France, Duret too arrived, particularly enthusiastic about what he had seen in Japan and eager to provide his friends with new details about that strange country. Yet Degas and Duret did not find many of their friends in Paris. Except for Manet and Renoir there was actually no

Photograph of the Pont Neuf, c. 1860.

Renoir: The Pont Neuf, d. 1872. $29\frac{1}{4} \times 36\frac{1}{2}$ ". National Gallery of Art, Washington, (Ailsa Mellon Bruce Collection).

one: Pissarro had settled in Pontoise, where Cézanne had joined him. Sisley, after having worked in Argenteuil, was in Louveciennes, and Monet, back again from Holland, now lived in Argenteuil. Here, after their repeated separations, Monet's wife became again his favorite model. He painted pictures of his garden with colorful flower beds, in many of which Camille appears (p. 282–283). His pigments are still opaque and put on quite heavily, but their brightness conveys intensely the vibrant sensation of summertime in the country.

Renoir was the only one not to have completely abandoned the city. As a result of Durand-Ruel's first acquisitions, he had taken a large studio in the rue St. Georges; it was Degas who now introduced Renoir to Duret.

Renoir had remained in Paris for various reasons. Only there could he find occasional commissions for portraits, meet the slowly growing number of collectors interested in the group, and have models pose in his studio. Besides, to his enchanted eye Paris had no less charm than a field of poppies or a hill by a river, and it

offered the added attraction of gay animation, of that easygoing, colorful, and radiant life which he liked to share and to record. There were buildings and water and trees, elegant and charming women, graceful girls, and pretty children; there were sunshine and good humor, all the things he loved, that excited his eyes and his heart, and found their way onto his canvases. Thus he painted the crowd on the sun-bathed Pont Neuf, while standing at a window on the second floor of a small café opposite the bridge. To his brother Edmond fell the task of stopping the passers-by momentarily and making them "pose." While Edmond Renoir asked this gentleman the time and that lady where such and such a street was located, insisting upon some unneeded bit of information, the painter had time to sketch the person. And in this spontaneous way the cheerfulness of the hour was preserved in Renoir's work.¹²

Although deeply attached to the city, Renoir frequently left Paris to join Monet in Argenteuil. On the banks of the Seine in the outskirts of the capital, Argenteuil at that period offered all the advantages of a suburb with a variety of open-country motifs, but its main attraction for the painters was the broad river with sailing boats and picturesque bridges. Monet had rented a little house close to the water, and whenever Renoir came to stay with him they again put up their easels in front of the same views, studying the same motifs. They both now adopted a comma-like brush-stroke, even smaller than the one they had chosen for their works at La Grenouillère, a brushstroke which permitted them to record every nuance they observed. The surfaces

MONET: The Pont Neuf, 1873. 21 × 29". Collection Mr. and Mrs. Emery Reves.

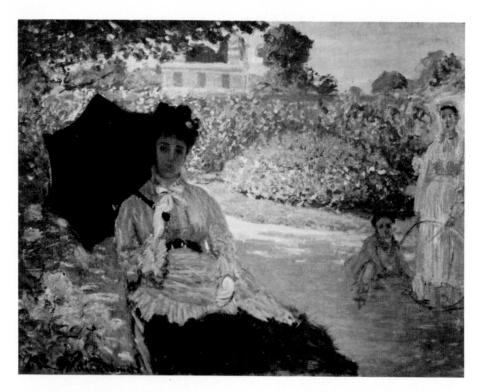

Monet: Mme Monet and Her Son in the Garden, d. 1873. $23\frac{1}{4} \times 31\frac{1}{4}$ ". Collection Bührle Family, Zurich.

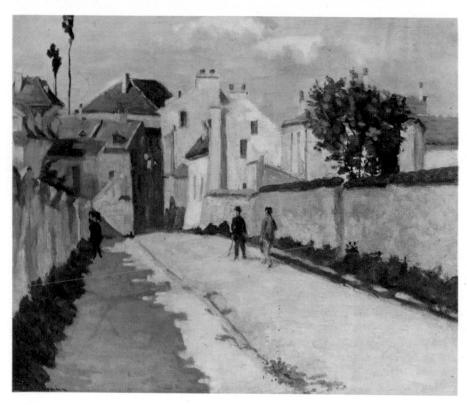

Guillaumin: Street in Vanves, c. 1872-73. 19¾ × 24″. Private collection, England.

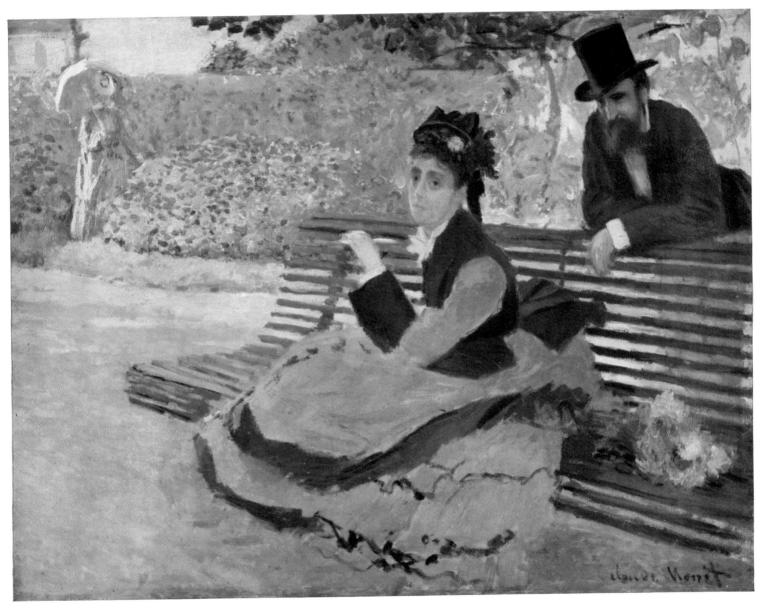

Monet: Mme Monet on a Garden Bench, 1872-73. $23\frac{3}{8} \times 31\frac{1}{4}$ ". Collection the Honorable Walter Annenberg, Palm Springs, Calif.

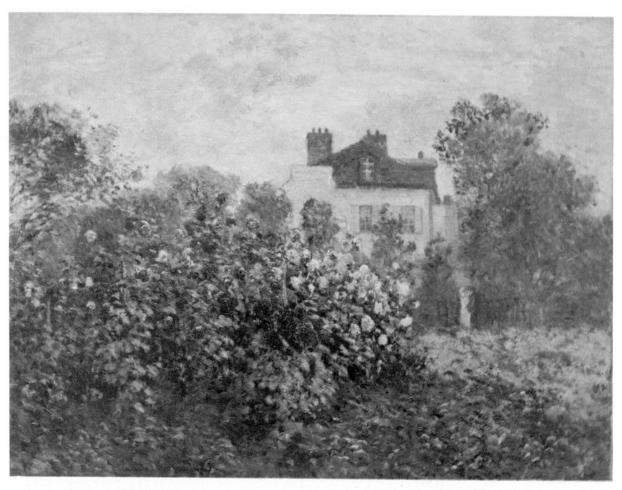

Monet: The Artist's Garden in Argenteuil, d. 1873. $23\frac{1}{2} \times 31\frac{1}{2}$ ". Monet probably did this canvas while posing for Renoir's painting reproduced opposite. Collection Mrs. Janice Levin Friedman, New York.

of their canvases were thus covered with a vibrating tissue of small dots and strokes, none of which by themselves defined any form. Yet they contribute to recreating the particular features of the chosen motif and especially the sunny air which bathed it, and marked trees, grass, houses, or water with the specific character of the day, if not the hour. Nature was no longer, as for the Barbizon painters, an object susceptible of interpretation; it became the direct source of pure sensations, reproduced by the technique of small dots and strokes which — instead of insisting on details — retained the general impression in all its richness of color and life.

At this period Renoir did a portrait of Monet while painting in his garden at Argenteuil, and each executed a landscape of a house on a duck-pond in which their technique is almost identical. (When, forty years later, one of their canvases

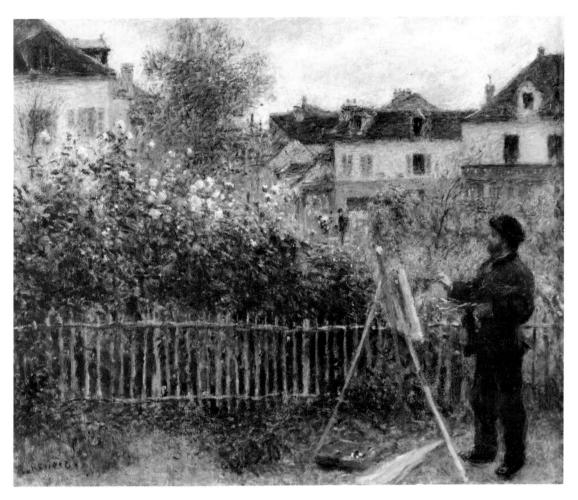

Renoir: Monet Working in His Garden in Argenteuil, 1873. $19\frac{3}{4} \times 42$ ". The Wadsworth Atheneum, Hartford, Conn. (Bequest of Anne Parrish Titzell).

turned up at Durand-Ruel's, neither of the two, at first, was able to identify its author. While Renoir often selected sun-drenched vistas with pronounced oppositions of light and shadow, as well as the inherent gay mood of bright summer days — painted at high noon when the shadows were shortest — Monet usually preferred the more subtle atmosphere of overcast skies, a preference which Sisley frequently shared. Monet thus painted a view of the Pont Neuf from exactly the same angle which Renoir had adopted, but he depicted his subject in the subdued bluish tones of a rainy day. Whereas his canvases of Holland and of Camille in the garden had distinguished themselves by forceful accents, some paintings done in Le Havre and Rouen in 1872 present almost exclusively modulations of soft, greyish tonalities. Among the works painted from his window in Le Havre were two

Renoir: Duck Pond, 1873. $20 \times 24\frac{1}{2}$ ". Collection Mr. and Mrs. Emery Reves.

Monet: $Duck\ Pond$, d. 1873. 21 $\frac{1}{4} \times 25\frac{5}{8}''$. Private collection, Paris.

Sisley: Country Road, Springtime, d. 1873. $20\frac{7}{8} \times 28\frac{3}{4}$ ". Collection Sidney Shoenberg, St. Louis, Mo.

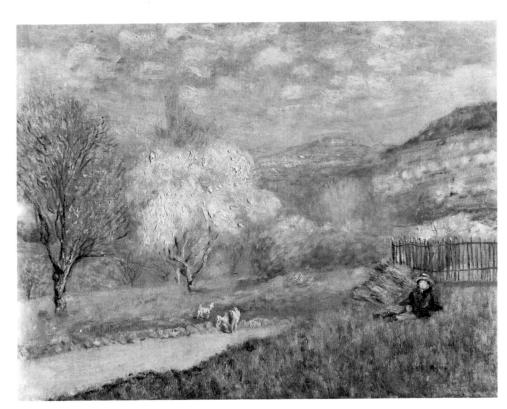

Renoir: Country Road, Springtime, 1873. $18 \times 24\frac{1}{4}$ ". Private collection, England.

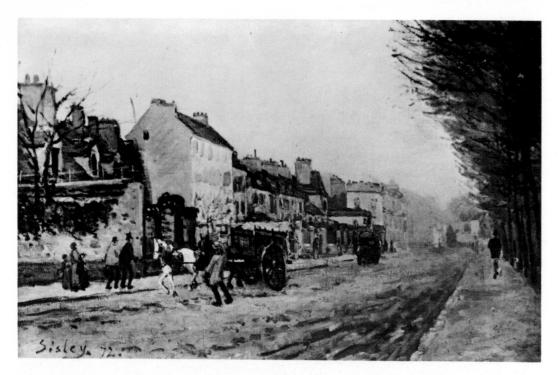

Sisley: Boulevard Héloïse in Argenteuil, d. 1872. $15\frac{3}{8} \times 24''$. National Gallery of Art, Washington, D.C. (Ailsa Mellon Bruce Collection).

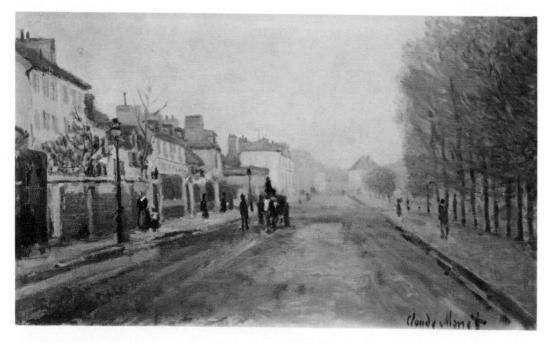

Monet: Boulevard Héloïse in Argenteuil, 1872. 13 $\frac{3}{4} \times 23\frac{1}{4}$ ". Collection Mr. and Mrs. Paul Mellon, Upperville, Va.

views of the harbor, one with a rising, one with a setting sun shining through the fog (p. 316 and 317) which, in the artist's own words, were impressions of mist.

In the spring of 1873 Renoir and Sisley once more worked together, as they had done so frequently in earlier days. Both painted a road on a hillside with flowering trees. The year before, Sisley and Monet had put their easels next to each other for a view of a street in Argenteuil.

Timid and modest, burdened with financial preoccupations to which he was much less accustomed than his chronically poor friends, Sisley began to isolate himself after having found in the works of his comrades, and particularly Monet, directions for a new approach to nature. Among the landscapes he painted during this period — he seldom did anything else — are two aspects of a path between gardens and houses executed at different seasons. As Monet had done and continued to do, Sisley began to study the changes of color and form which summer and winter bestow upon the same motif. It had taken him longer than the others to liberate himself completely from the influence of Corot, but now that he had done so there appeared in his canvases a note of daring, a fertile confidence. In close communion with nature he found the strength of feeling and expression which he had lacked before. Some

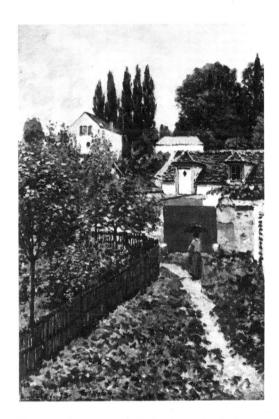

Sisley: Louveciennes, Fall, d. 1873. $25\frac{5}{8} \times 18\frac{1}{8}$ ". Private collection, Tokyo.

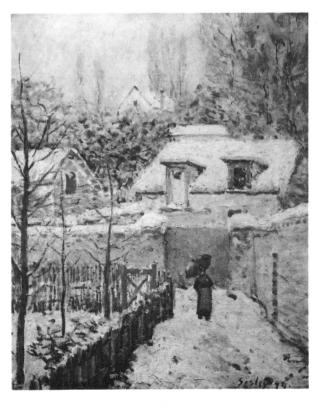

Sisley: Louveciennes, Winter, d. 1874. $21\frac{5}{8} \times 18\frac{1}{8}$ ". The Phillips Collection, Washington, D. C.

of his paintings are surprisingly high in key and this sudden outburst of color — masterfully handled — seems like the revelation of a new personality (see frontispiece). In others, notably several done at Argenteuil, he reverts to softer color schemes, rich in silvery greys, but these are handled with such subtleness that any danger of monotony is avoided; instead a gentle and new lyricism pervades his work. Sisley's paintings now radiate assurance, an eagerness for discovery, and the enjoyment of a newly won freedom. One of his Argenteuil views of the Seine must have particularly pleased Manet who acquired it, unless it was presented to him by the painter. (In view of Sisley's straitened circumstances, however, it is more likely that Manet purchased it in order to discreetly help the other).

Like Sisley, Berthe Morisot displayed new qualities of color and brushwork in her pictures done in 1872-73. When she painted a view of Paris seen from the Trocadéro (p. 292), somewhat similar to that in which Manet had represented the World's Fair of 1867 (p. 173), Corot's influence was still evident in the low-keyed harmonies, although the execution was much freer than her former master's. The treatment of large planes with sketchy indications of details revealed an audacity strangely combined with the general charm of her work. Without losing anything of the freshness and delicacy which had distinguished her previous paintings, she soon added to these the same confidence displayed by Sisley; she did not hesitate to use color more daringly and to adopt a technique of broad and fluent brush strokes, better suited to retain on

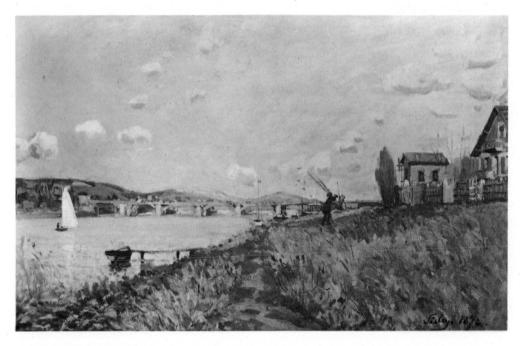

Sisley: The Bridge of Argenteuil, d. 1872. 15\(\frac{1}{4}\times 24\)". Formerly collection Edouard Manet. Brooks Memorial Art Gallery, Memphis, Tenn. (Gift of Mr. and Mrs. Hugo Dixon).

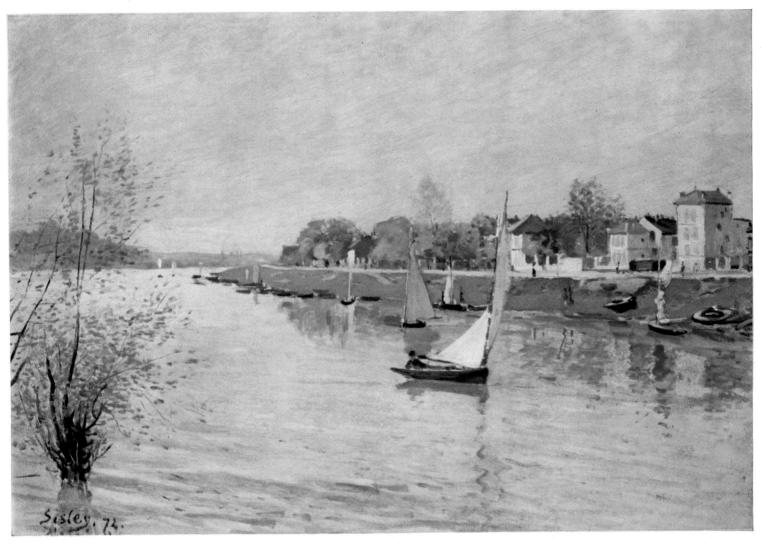

Sisley: The Seine at Argenteuil, d. 1872. $19\frac{5}{8} \times 28\frac{3}{4}$ ". The Bernhard Foundation, Inc., New York.

canvas the image of her immediate perceptions. Beyond the stage of early promises, her talent now emerged as that of a major artist in full possession of her means, gifted with an extraordinary sensitivity that lacked neither assurance nor temerity.

In Pontoise, meanwhile, Pissarro had gathered a small group of companions, all younger men who looked to him for advice and guidance. Urged by Pissarro, Cézanne had joined him with his little family. Guillaumin, obliged to re-enter the Administration des Ponts et Chaussées in order to earn a living, managed somehow to devote all his spare time to painting in the company of his friends. Béliard was there too, and in September 1872 Pissarro proudly informed Antoine Guillemet:

"Béliard is still with us. He is doing very serious work at Pontoise.... Guillaumin has just spent several days at our house; he works at painting in the daytime and at his ditch-digging in the evening, what courage! Our friend Cézanne raises our expectations and I have seen, and have at home, a painting of remarkable vigor and power. If, as I hope, he stays some time at Auvers, where he is going to live, he will astonish a lot of artists who were in too great haste to condemn him." 14

Since he had first met him, ten years before, Pissarro had never failed in his conviction that Cézanne was endowed with extraordinary gifts, even if Manet and others did not share this view. He was happy now to see his protégé gain control of his ebullient temperament in intimate contact with nature, but he was too modest to insist on the part he himself played in this decisive period of Cézanne's evolution. Cézanne, however, willingly recognized that his new approach to nature was based on Pissarro's experience. He even went so far as to copy one of his mentor's views of Louveciennes, 15 appropriating to a great extent Pissarro's technique of small strokes as well as substituting the study of tones for modeling. Not only did he

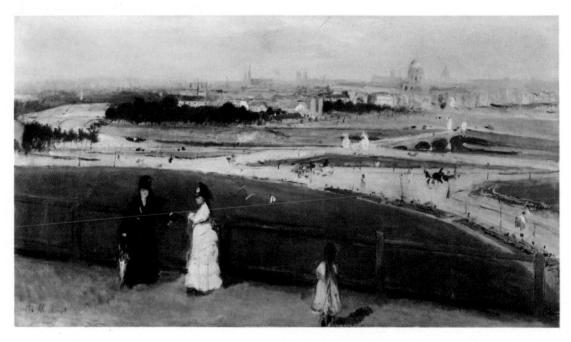

Morisot: Paris Seen from the Trocadéro, 1872. 18½ × 32″. Formerly collection Georges de Bellio. Collection Mr. and Mrs. Hugh N. Kirkland, Palm Beach, Fla.

Morisot: On the Balcony, Paris, 1872. $23\frac{1}{2} \times 19''$. Collection Mr. and Mrs. Henry Ittleson, Jr., New York.

abandon his fiery execution, he now also followed the other's example by freshening his palette.

Just as Monet and Renoir occasionally chose the same motif, Cézanne and Pissarro now sometimes worked side by side. In this way Cézanne became intimately familiar with the methods and conceptions of his friend. Thus they painted a view of a suburban street in winter, as well as other subjects around Pontoise or nearby Auvers-sur-Oise. "We were always together," Pissarro remembered later, "but what cannot be denied is that each of us kept the only thing that counts, the unique sensation." When Zola and Béliard were surprised by the similarity of some of their works, Pissarro pointed out that it was wrong to think "that artists are the sole inventors of their styles and that to resemble someone else is to be unoriginal." Conscious of the give-and-take between painters who work together, Pissarro later acknowledged having been influenced by Cézanne even while influencing him.

Pissarro was developing in those years a style that, for all its poetic values, showed firmness of form and expression. "You haven't Sisley's decorative feeling nor Monet's fanciful eye," Duret said in one of his letters to Pissarro, "but you have what they have not, an intimate and profound feeling for nature and a power of brush, with the result that a beautiful picture by you is something absolutely definitive. If I had a piece of advice to give you, I should say: Don't think of Monet or of Sisley, don't pay attention to what they are doing, go on your own, your path of rural nature. You'll be going along a new road, as far and as high as any master." But when Duret, in his admiration for Pissarro's work, began to deprecate Monet, the painter immediately replied: "Aren't you afraid that you are mistaken about Monet's talent, which in my opinion is very serious and very pure? It is a highly conscious art,

CÉZANNE: Street in Pontoise, Winter, 1873. $15\frac{1}{4} \times 18\frac{1}{2}$ ". Collection Bernheim-Jeune, Paris.

PISSARRO: Street in Pontoise, Winter, d. 1873. $21\frac{1}{8} \times 29\frac{1}{2}$." Collection Mrs. Florence L. Gould, New York.

PISSARRO: Chestnut Trees at Louveciennes, d. 1872. $16\frac{1}{8} \times 21\frac{1}{4}$ ". Collection Mr. and Mrs. Alex M. Lewyt, New York.

based upon observation and derived from a completely new feeling; it is poetry through the harmony of true colors." ¹⁸

There was in Pissarro's approach to nature a humility which the others did not seem to possess to the same degree and which they admired, for they knew that it offered the key to a real penetration. Both Monet and Sisley adopted a similar attitude, as far as their temperaments allowed, but none came closer in humility to Pissarro than Paul Cézanne.

Early in 1873 Cézanne left Pontoise for Auvers, only a few miles up the Oise River. Daubigny lived there, yet it was not his presence which attracted Cézanne but Dr. Gachet's. An eccentric person vitally interested in art, the doctor had not given up his concern for advanced ideas, especially in painting, which had led him in his student days to the Andler Keller. He later had been among the habitués of the Café Guerbois and had become a close friend of Guillaumin and Pissarro, whose mother he had attended as early as 1865. After serving as a medical major in the National Guard during the war, Gachet had acquired a beautiful house on a hillside overlooking the Oise Valley, where his ailing wife and their two children went to live, while he himself continued to practice in Paris, spending three days every week with his family.¹⁹ Though the doctor did some painting himself, he was particularly interested in the art of etching and had installed in his house a comfortable studio which he readily shared with his friends, lending them his copper plates and presses. Cézanne was to take full advantage of Gachet's hospitality. The only etchings he ever did — one of them a portrait of Guillaumin — were made in the doctor's house. He also painted there a number of still lifes, for which Madame Gachet picked and arranged the flowers in various beautiful Delft vases.²⁰

The physician was slowly assembling a collection of works by his friends. When Guigou, demobilized and back in Paris, had suddenly died in December 1871 at the

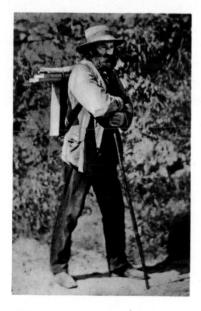

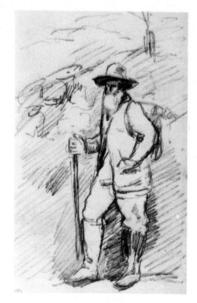

Far left, Photograph of Paul Cézanne on his way to work near Pontoise, c. 1874.

Left, Cézanne: Pissarro on His Way to Work, c. 1874. Pencil, $7\frac{3}{4} \times 4\frac{1}{2}$. Musée du Louvre, Paris.

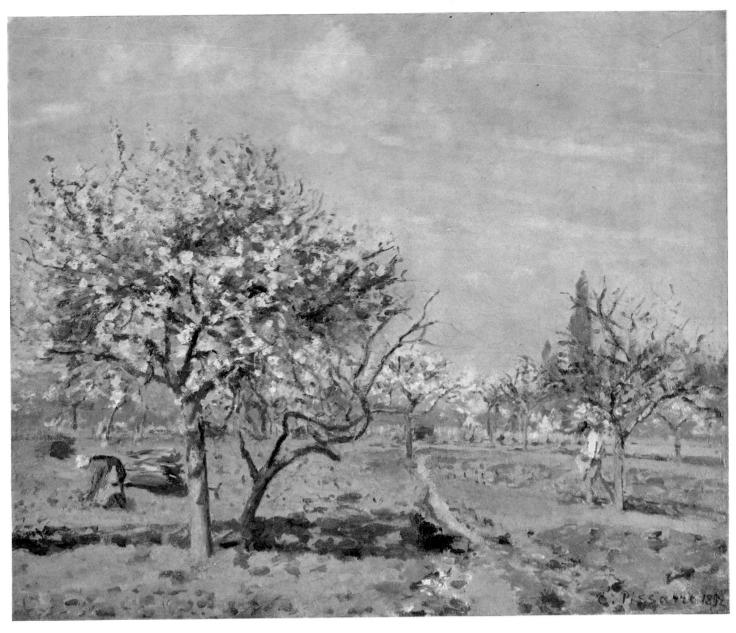

PISSARRO: Orchard in Bloom, Louveciennes, d. 1872. $17\frac{3}{4} \times 21\frac{5}{8}''$. National Gallery of Art, Washington, D.C. (Ailsa Mellon Bruce Collection).

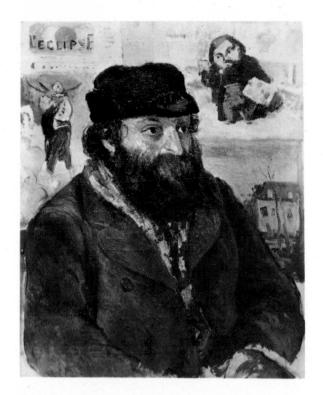

PISSARRO: Portrait of Paul Cézanne, 1874. $29\frac{1}{4} \times 24$ ". Formerly collection Robert von Hirsch, Basel.

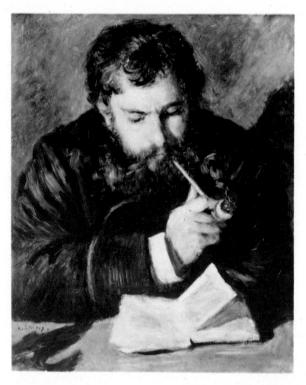

Renoir: Portrait of Claude Monet, 1872. $23\frac{3}{4} \times 19''$. Collection Mr. and Mrs. Paul Mellon, Upperville, Va.

age of thirty-seven, Gachet bought a number of his studies. Among the works by Cézanne which he now acquired was a strange composition entitled A Modern Olympia, which seemed to be a parody of Manet's painting. In it on a large couch appears a nude woman whom a gentleman in the foreground watches admiringly. This gentleman bears a strong resemblance to Cézanne himself. In the right corner there is a huge bouquet of scintillating flowers in brilliant colors. The canvas is spirited in execution and remarkably free in handling for Cézanne at that stage of his development (see p. 323).

In fact this picture was far from typical of the paintings he did at Auvers. At this time he commonly worked out-of-doors, and his outdoor interests dictated a quite different style. Whereas Pontoise was a town with rural character, Auvers was little more than a village of thatched cottages on unpaved country lanes. Here Cézanne could work at ease without being watched by curious spectators, whether he painted on the road that led to Gachet's house or out in the fields. And he did so with untiring effort, never quite satisfied with the results achieved. He was proceeding with extreme slowness, and the realization of his *sensations* seems to have been obtained often through many difficulties. His previous independence of nature was now replaced by a scrupulous fidelity to his observations. According to a note jotted down

by Dr. Gachet, Cézanne went twice daily to his motifs, "one for the morning, one for the afternoon; one for grey weather, one for sunshine; it happened frequently that he struggled desperately with a canvas, working on it from one season to the next, from one year to the following, to the extent that a spring picture of 1873 finally became a snow effect in 1874."²¹ While there is no actual proof of such extreme procedure, it is nonetheless true that Cézanne's canvases of Auvers are frequently covered with heavy layers of pigment, for although he had adopted Pissarro's small brush strokes, he used to put touch upon touch in a constant endeavor to improve, to add, to record every nuance he perceived. But despite his laborious technique and strenuous efforts, the paintings Cézanne did in Auvers retain a certain spontaneity. So intense were his impressions, so tremendous his will to penetrate the secrets of nature, so humble his attempt to retain his sensations, that even countless hours of work upon the same canvas did not destroy the naïveté and truth, the delicacy and power of his perceptions.

It is said that Daubigny once watched Cézanne work and could not restrain his

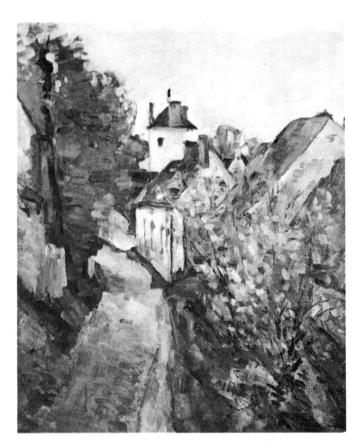

CÉZANNE: The House of Dr. Gachet at Auvers, c. 1874. $24\frac{7}{8} \times 20\frac{3}{4}$ ". Collection Mrs. Mary Fosburgh, New York.

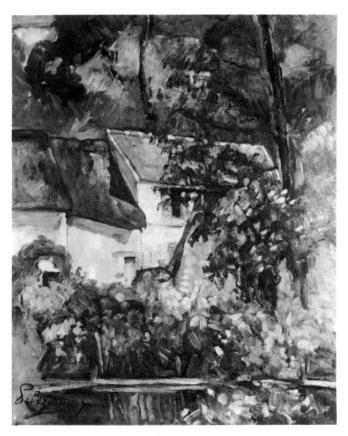

CÉZANNE: The House of Père Lacroix, Auvers, d. 1873. $24\frac{1}{4} \times 20''$. National Gallery of Art, Washington, D.C. (Chester Dale Collection).

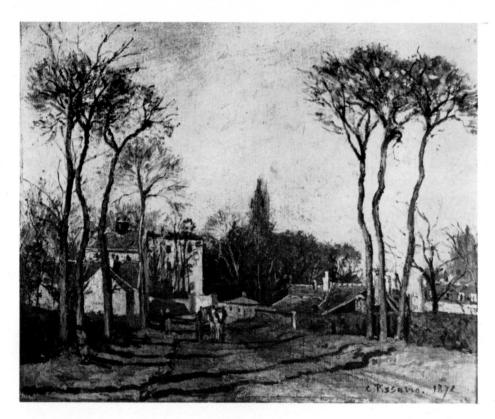

PISSARRO: Entrance to the Village of Voisins, d. 1872. $18\frac{3}{8} \times 22''$. Musée du Louvre, Paris.

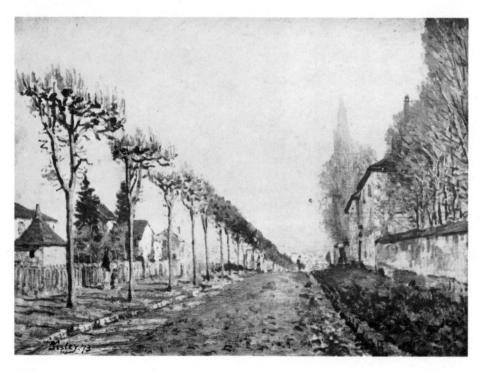

Sisley: The Road to Sèvres at Louveciennes (The House of Mme Du Barry), d. 1873. $21\frac{1}{4} \times 28\frac{3}{4}$ ". Musée du Louvre, Paris.

enthusiasm. "I've just seen on the banks of the Oise an extraordinary piece of work," he told a friend. "It is by a young and unknown man: a certain Cézanne!"²²

Cézanne's financial position was far from easy at that time. Not daring to confess to his father the circumstances of his private life, he was obliged to subsist on his bachelor's allowance. Fortunately Dr. Gachet helped him by occasional purchases, and Pissarro introduced him to the color-grinder père Tanguy. Before the war Tanguy had been a traveling paint salesman and had often appeared with his merchandise in Fontainebleau forest or on the outskirts of Paris, where he met Pissarro, Renoir, Monet, and other artists.²³ A volunteer with the troops of the Commune, he had been taken prisoner by the Versailles army, condemned, and deported. Only the intervention of Degas' friend Rouart had saved him from a death sentence. It was after his return to Paris, where he rented a small shop in the rue Clauzel, that père Tanguy was recommended to Cézanne by Pissarro, who tried to help him out of sympathy for his political views (his colors being of doubtful quality). Tanguy immediately took a fancy to Cézanne; he agreed to provide him with paints and canvases in exchange for some paintings. Cézanne wanted to make a similar arrangement with his grocer in Pontoise, but the latter was less ready to accept works instead of payment; after consulting Dr. Gachet and Pissarro, however, he was persuaded to take Cézanne's pictures.

Pissarro's own credit had risen very suddenly, early in 1874, when some of his paintings, possibly "pushed" by Durand-Ruel, brought unexpectedly high prices at an auction sale in Paris. Delighted, Pissarro wrote to Duret: "The reactions from the sale are making themselves felt as far as Pontoise. People are very surprised that a canvas of mine could go for as much as 950 francs. It was even said that this is astonishing for a straight landscape." Shortly afterwards he remarked in another letter to Duret: "You are right, my dear Duret, we are beginning to make our breakthrough. We meet a lot of opposition from certain masters, but mustn't we expect these differences of view, when we arrive — as intruders — to set up our little banner in the midst of the fray? Durand-Ruel is steadfast; we hope to advance without worrying about opinion." 25

Pissarro had every reason to be confident in Durand-Ruel's tenacity, for the dealer was then preparing the publication of a huge catalogue in three volumes with three hundred reproductions of the choicest paintings in his possession. Among them were twenty-eight works by Corot, twenty-seven by Millet, twenty-six by Delacroix, twenty by Rousseau, ten by Troyon and by Diaz, seven by Courbet and by Manet, and also five by Pissarro, four by Monet, three by Sisley, and two by Degas. Only Renoir was not yet represented. (Whereas Durand-Ruel had shown at least one painting by Renoir in London in 1872, he exhibited none there in 1873, as compared to five canvases by Sisley, four each by Monet, Pissarro, and Degas, and two by Manet, who had been particularly well represented the previous year.⁴)

The introduction to Durand-Ruel's voluminous catalogue was written by the poet and critic Armand Silvestre who, as a frequent guest at the Café Guerbois, personally knew all the young painters and had listened to their discussions and theories. He therefore not unexpectedly insisted that there was a logical line of development and progress which led from Delacroix, Corot, Millet, and Courbet to the next generation, the Batignolles group. Recommending the publication to his

readers, he wrote: "It is to the public that these endeavors are directly submitted, to the public which makes reputations even though appearing only to accept them, and which does not fail to turn away, one day, from those who are satisfied to serve its taste, toward those who make an effort to guide it." ²⁶

Examining the works of his friends, Silvestre stated: "At first glance one has difficulty in distinguishing what differentiates the painting of M. Monet from that of M. Sisley and the latter's manner from M. Pissarro's. A little study will soon teach you that M. Monet is the most adept and daring, M. Sisley the most harmonious and hesitant, M. Pissarro the most genuine and naïve.... In looking at their painting, what strikes you first of all is the immediate caress which the eye receives from it — it is above all harmonious. What next distinguishes it is the simplicity of the means of harmony. One discovers soon, in fact, that its whole secret is a very delicate and very exact observation of relationships of tone." And the author added: "What apparently should hasten the success of these newcomers is that their pictures are painted according to a singularly cheerful scale. A 'blond' light floods them and everything in them is gaiety, clarity, spring festival...." 26

While Silvestre was certain that these painters would soon be recognized, Manet, in his eyes, had already won his battle against a refractory public. "The moment has come for the public to be convinced, enthusiastic, or disgusted, but not dumbfounded," he wrote. "Manet still belongs in the field of discussion, but no longer of bewilderment."²⁶

Indeed, at the Salon of that very year, 1873, Manet was to obtain his first great success since 1861. Besides his full-length portrait of Berthe Morisot, painted in 1870 (see p. 225), he exhibited *Le Bon Bock*, which represented the engraver Bellot sitting at a table in the Café Guerbois. The good-naturedness of the heavy man, the nonchalance of his attitude, the simplicity of the subject highly pleased the public and even those critics who had heretofore manifested only contempt for the artist. Manet's friends, however, missed in this portrait his usual vigor and temperament, regretting the old-master aspect of this work. When Albert Wolff triumphantly announced that Manet had put "some water into his *bock*," Alfred Stevens, alluding to the influence which Manet's recent study of Frans Hals had had upon this painting, wittily replied: "Some water? It's pure Haarlem beer." 28

Manet was deeply vexed by these remarks but was equally angry with his Batignolles colleagues for keeping away from the Salon. Indeed, of the group Manet was practically alone there (with the exception of Berthe Morisot, who exhibited a pastel); although his success flattered his pride, he was indignant about the isolation into which his friends seemed to be forcing him, and bitterly accused them of having "left him in the lurch."²⁹

But this was not quite true. Whereas Monet, Sisley, and Pissarro had abstained from submitting anything to the jury, Renoir had presented two canvases (one of them a huge but somewhat conventional painting of a woman and a boy — young Joseph Le Coeur — riding in the Bois de Boulogne), which had been rejected. The works of Manet's pupil Eva Gonzalès, of Degas' friend Henri Rouart, and of Jongkind were also among those refused.³⁰

The numerous rejections unleashed a tempest of protestations, exactly as they had done ten years before, and once again the administration yielded. But in order to

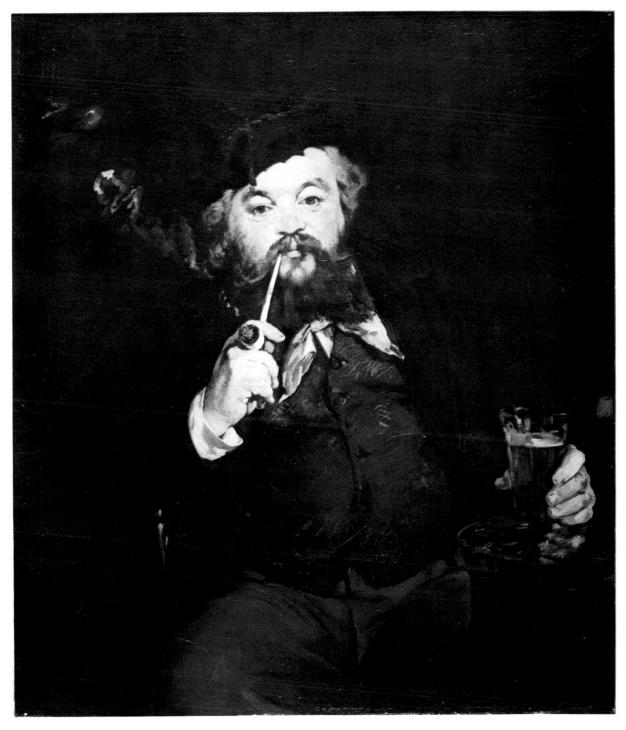

Manet: Le Bon Bock—The Engraver Bellot at the Café Guerbois, d. 1873. $37 \times 32\frac{5}{8}$ ". Exhibited at the Salon of 1873; bought by Faure the same year. Philadelphia Museum of Art (Mr. and Mrs. Carroll S. Tyson Collection).

avoid the "scandal" of the Salon des Refusés of 1863, this time the rejected artists were invited, early in May 1873, to submit their works to another and more liberal jury that would select the entries to be shown in an exhibition announced as Exposition artistique des oeuvres refusées, which was to open May 15. History repeated itself when the majority of rejected artists preferred, as in 1863, not to participate in this show so as to escape unpleasantness. There was even a project of imitating the official Salon by distributing medals for the best among the refused paintings (for which a generous American offered to donate the metal), but this idea was soon abandoned since it met with little approval among the exhibitors. The show, which was held in wooden barracks behind the Palais de l'Industrie, proved such a success that at the end of the first month the whole exhibition, increased by further works, was moved to more spacious quarters. The public throughd to the exposition and the critics devoted much space to it. Renoir's paintings — hung near those of his friend Jules Le Coeur were rather favorably reviewed; Philippe Burty, a friend of the Goncourt brothers, and Castagnary praised his work highly, and his large canvas was subsequently purchased by Henri Rouart.31

Zola who, the previous year, had written an admiring article on Jongkind — one of the rejected of 1873 — did not publish any comments on the new Salon des Refusés or the success of his friend Manet. It is true that a Parisian daily, to which he had contributed since December 1872, had been suppressed after the appearance of his third article, judged too violent and that — under a virgin Republic scarcely more lenient than the defunct Empire — he seems to have met great difficulties in finding newspapers that would entrust him with regular columns. For a few months, in 1873, he became theatrical reporter for L'Avenir National, and it was probably due to his recommendation that his young friend Alexis was charged with the Salon review, although the latter's qualifications for art criticism were rather scanty.

Alexis wrote at length about Manet, but confessed that he was not fully enthusiastic about Le Bon Bock, thus repeating opinions which he had most certainly heard among the habitués of the Café Guerbois. He further echoed their views when he stated that Manet's portrait of Berthe Morisot "has by far not met with the same favor. The crowd remains restive and suspicious in front of this work; yet it would appear to us that it shows much better the personal and original note of the artist." Alexis also announced a special study on the rejected artists which, however, did not appear because the paper ran into some legal trouble and was suspended for two weeks, with the result that Alexis' series did not go beyond three articles. Yet he managed to say at least this for Manet and his friends: "Without taking myself for a prophet, I foresee the emergence of a generation of radicals in art (I don't want to use the poorly defined word of réalistes), sons of contemporary science, lovers of experimental truth and accuracy, who repudiate conventional 'beauty,' the classical ideal, and romantic attitudes, carrying only the banner of sincerity and life."33 (In passing, Alexis described the works of a young Italian artist, de Nittis, a friend of Degas and Manet, as "less painting than pastry.")

The almost unanimous praise for *Le Bon Bock*, even from reactionary quarters, was only slightly disturbed by a few isolated attacks, such as one from the architect Garnier, designer of the new Paris Opera. At the end of ten long articles on the Salon, so rambling that they continued to appear after the exhibition itself had closed, he

Renoir: The Horsewoman, 1873. 29 × 15." Formerly owned by Le Coeur. Musée du Louvre, Paris.

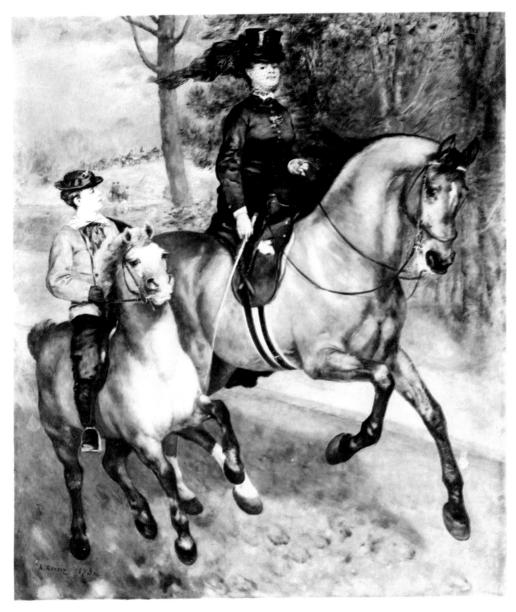

Renoir: A Morning Ride in the Bois de Boulogne, d. 1873. 8' $6\frac{3}{4}$ " \times 7' 5". Rejected by the Salon jury in 1873; exhibited at the Salon des Refusés, 1873. Kunsthalle, Hamburg.

asserted that since works like Berthe Morisot's likeness had been accepted by the jury, "none of the other canvases shown in the barracks of the *Refusés* should have been excluded."³⁴

Due to a printing error, a periodical announced in June that a collector had offered 120,000 francs for *Le Bon Bock*. This mistake was corrected by the editor in the next

issue with the following note: "One should read 12,000 francs. I would not have rectified this error if Manet had not appeared at the office, brandishing my article and summoning me to name the madman willing to pay 120,000 francs for his picture." 35

If anything could have conclusively decided his friends against attempting in the future to exhibit at the Salon (Renoir's good fortune among the *Refusés* notwithstanding), it was precisely the success obtained by Manet's *Bon Bock*. It became increasingly evident that the jury had no intention of liberalizing its views and that only a certain compromise with tradition would open the Salon doors to them. Less than ever were they inclined to seek such a compromise or to paint "tame" pictures for the jury while otherwise remaining faithful to their concepts. (A possible exception was Renoir who, though he had been rejected both in 1872 and 1873, was too carefree to mind.) Indeed, the exhibition of rejected paintings was no solution to their problem and it seemed wiser, in the end, to abandon the Salon altogether, as Monet advocated, than to gratuitously antagonize the jury, as Cézanne liked to do, or to try to conciliate it, as Manet did more or less consciously. In spite of the popularity of the new *Salon des Refusés*, this way of approaching the public constituted, after all, only an administrative "boon" from which no permanent benefit was to be derived.

The rare critics who sided with the rejected artists saw this clearly. Castagnary, reviewing the Salon, raised once more — as he had done in 1862 — a series of objections against the Exposition des Refusés which, behind a veil of broadmindedness, merely perpetuated the tyranny of the jury. Declaring himself in favor of jury-free exhibitions where artists could present themselves without interference, Castagnary considered the Salon des Refusés an insufficient substitute since the painters, rejected by the jury, arrived before the public in the position of those who "appeal a conviction" and thus were "running the double risk of being passed over in silence or being included in the general condemnation with which all grotesque and ridiculous works necessarily meet." He felt that in order to deal the jury a deserved and definitive blow, a severe choice of three hundred superior paintings should have been made among the refused ones which, opposed to the three hundred bad or mediocre canvases accepted by the jury as a result of privileges and favors, would have exposed the partiality of the judges. But with the defection of many rejected artists, shunning the not altogether favorable publicity of a Salon des Refusés, and — at the same time — the inclusion of innumerable inferior works through which the administration endeavored to justify the severity of its jury, the whole affair lost much of its pungency. Thus the physiognomy of the Salon des Refusés found itself altered and "its protest-value weakened." Yet, despite these shortcomings, Castagnary concluded on a prophetic note: "The jury and the administration, gleefully rubbing their hands, imagine in vain that they have escaped the sentence which threatens them; they will not emerge as victors for this trial."36

Paul Alexis gave a different twist to the entire question which can not have displeased his friend and countryman Cézanne when, on the very day the Salon was opened, he proclaimed unequivocally: "The jury is innocent, because in art matters no jury can be other than ignorant and blind. Instead of attacking it — which doesn't help any — let's be practical and abolish it!" 37

- 1 Boudin to Martin, Jan. 2, 1872; see G. Jean-Aubry: Eugène Boudin, Paris, 1922, p. 79.
- 2 Manet to Duret, Aug. 20, 1871; see Tabarant: Manet et ses oeuvres, Paris, 1947, p. 191.
- 3 See: Mémoires de Paul Durand-Ruel in L. Venturi: Les Archives de l'Impressionnisme, Paris-New York, 1939, v. II, p. 189-192; also E. Moreau-Nélaton: Manet raconté par lui-même, Paris, 1926, v. I, p. 132-133.
- 4 For the impressionist works shown at these exhibitions see D. Cooper: The Courtauld Collection, London, 1954, p. 22, note 1.
- 5 Article in *Revue internationale de l'art et de la curiosité*, Dec. 1869, quoted by Venturi, *op. cit.*, v. I, p. 17-18.
- 6 P. Alexis: Paris qui travaille, III, Aux peintres et sculpteurs, L'Avenir National, May 5, 1873.
- 7 Her husband died in 1902; she herself outlived Renoir but before her death, in 1922, burned all her papers, photographs, letters, thus leaving no trace of her 1865-1872 relationship with Renoir—by then world famous—except for the many paintings he had done of her. She did, however, preserve the canvases she had received from him and never parted with them. See D. Cooper: Renoir, Lise and the Le Coeur Family, Burlington Magazine, May and Sept.-Oct. 1959.
- 8 Degas to his father, New York, Oct. 24, 1872; see J. Fevre: Mon oncle Degas, Geneva, 1949, p. 30.
- 9 Degas to Frölich, New Orleans, Nov. 27, 1872; see Lettres de Degas, Paris, 1945, p. 21-25. On Degas in New Orleans see J. Rewald: Degas and his Family in New Orleans, *Gazette des Beaux-Arts*, Aug. 1946; also: Degas—His Family and Friends in New Orleans, exhibition catal., Isaac Delgado Museum, New Orleans, May-June 1965.
- 10 Degas to H. Rouart, New Orleans, Dec. 5, 1872; see Lettres, op. cit., p. 25-29.
- E. de Goncourt, Journal, Feb. 13, 1874; see Journal des Goncourt, v. V, 1872-1877, Paris, 1891, p. 111-112.
- 12 See Edmond Renoir's recollections in Rewald: Renoir and his Brother, Gazette des Beaux-Arts, March 1945.
- 13 On this subject Léon Werth was to write subsequently: "Renoir and Monet painted at the same time the same subject: foliage, water, ducks. Forty years later [that is around 1913] one of the two paintings happens to be at Durand-Ruel's. Is it the canvas by Monet? Is it the one by Renoir? Neither Monet nor Renoir, consulted in turn, were able to establish the attribution. Monet himself told me this." (Werth: Bonnard le peintre, Galerie Charpentier, Paris, 1945.) However, the artists were eventually able to identify the author of the unsigned

- painting, possibly because Monet's canvas turned out to be signed and dated. Renoir thereupon seems to have signed his work, for its signature appears to have been added years after the execution of the painting.
- 14 Pissarro to Guillemet, Sept. 3, 1872; see Rewald: Paul Cézanne, New York, 1948, p. 93-94.
- 15 The two pictures are reproduced in *La Renaissance*, special issue: Cézanne, May-June 1936.
- 16 Pissarro to his son, Nov. 22, 1895; see Camille Pissarro, Letters to His Son Lucien, New York, 1943, p. 276.
- 17 Duret to Pissarro, Dec. 6, 1873; see L. Venturi and L. R. Pissarro: Camille Pissarro, son art, son oeuvre, Paris, 1939, v. I, p. 26.
- 18 Pissarro to Duret, May 2, 1873: ibid., p. 25.
- 19 On Gachet see V. Doiteau: La curieuse figure du Dr. Gachet, Aesculape, Aug.-Sept. 1923, and Tabarant's review of this article, Bulletin de la vie artistique, Sept. 15, 1923. Also: Van Gogh et les peintres d'Auvers chez le Docteur Gachet, special issue of L'Amour de l'Art, 1952; Rewald: Gachet's Unknown Gems, Art News, March 1952; catalogue of the exhibition "Van Gogh et les peintres d'Auvers-sur-Oise," Musée de l'Orangerie, Paris, Nov. 1952-Feb. 1953; P. Valery-Radot: Une figure originale de médecin-artiste, La Presse Médicale, Sept. 6, 1952; as well as the writings of Gachet's son, Paul Gachet: Cézanne à Auvers, Paris, 1952; Van Gogh à Auvers, Paris, 1953; Souvenirs de van Gogh et de Cézanne, Paris, 1953; Paul van Ryssel—Le Docteur Gachet graveur, Paris, 1954; Deux amis des impressionnistes-Le Docteur Gachet et Murer, Paris, 1956; and Lettres impressionnistes au Dr Gachet et à Murer, Paris, 1957. Also V. van Gogh's letters to his brother Theo written in Auvers and Rewald: Post-Impressionism—From van Gogh to Gauguin, New York, 1956, ch. VIII.
- 20 Many objects used by Cézanne for his still lifes were presented by the doctor's son to the Louvre.
- 21 Dr. Gachet quoted in P. Gachet: Le Docteur Gachet et Murer, op. cit., p. 56.
- 22 See J. Laran: Daubigny, Paris, n.d. [1912], p. 12.
- 23 On Tanguy see O. Mirbeau: Des artistes, Paris, 1922, v. I, p. 181-186; E. Bernard: Julien Tanguy, Mercure de France, Dec. 16, 1908; T. Duret: Van Gogh, Paris, 1919, ch. IV; G. Coquiot: Vincent van Gogh, Paris, 1923, p. 138-139; C. Waern: Notes on French Impressionists, Atlantic Monthly, April 1892 [quoted p. 556]; A. de Goaziou: Le "père Tanguy," Paris, 1952; H. Perruchot: Le père Tanguy, L'Oeil, June 15, 1955; J. Rohde: Journal fra en Rejse i 1892, Copenhagen, 1955, p. 88-92 [in Danish; quoted p. 557 of the present book]; and M.

- Bodelsen: Early Impressionist Sales 1874-94 in the Light of Some Unpublished 'procès-Verbaux,' *Burlington Magazine*, June 1968.
- 24 Pissarro to Duret, beginning 1874; see A. Tabarant: Pissarro, Paris, 1924, p. 24. (Five canvases by Pissarro had brought 270, 320, 250, 700, and 950 francs respectively.) This letter has always been dated 1873, but M. Bodelsen, op. cit., has established that it refers to the Hoschedé sale of Jan. 13, 1874; on this sale see also p. 309-310.
- 25 Pissarro to Duret, Feb. 2, 1874; Tabarant, op. cit. p. 21 (originally published as written in 1873—see note 24).
- 26 A. Silvestre, introduction to: Galerie Durand-Ruel, recueil d'estampes, Paris, 1873, v. I. (The three volumes have never actually been put on the market.)
- 27 A. Wolff in *Le Figaro*, May 12, 1873; see Tabarant: Manet et ses oeuvres, Paris, 1947, p. 205-206.
- 28 See T. Duret: Manet, Paris, 1919, p. 104.
- 29 See L. Vauxcelles: Un après-midi chez Claude Monet, L'Art et les Artistes, Dec. 1905.
- 30 On this subject see Tabarant: Manet, op. cit., p. 204-205; also E. Chesneau: Notes au jour le jour sur le Salon de 1873, Paris-Journal, May 11 and 17, 1873.

- 31 See O. Reuterswärd: Renoir ou le triomphe du refus, Arts (Paris), Feb. 29, 1952. Claretie commented in his review: "Infatuated with the art of Carolus-Duran, M. Renoir brushes improbable horsewomen, impossible horses, and dresses with yellow ribbons of a singular éclat," subsequently adding: "However, I have since seen his lovely Opera dancers [sic, see p. 319] of a type which M. Degas so cleverly carries off." J. Claretie: Salon de 1873, XIII—Le Salon des Refusés, reprinted in L'Art et les Artistes Français contemporains, Paris, 1876, p. 162.
- 32 See F. W. J. Hemmings: Emile Zola critique d'art, foreword to Emile Zola: Salons, Geneva-Paris, 1959, p. 24 and 26.
- 33 P. Alexis: Le Salon, L'Avenir National, May 19, June 2 and 17, 1873.
- 34 Garnier quoted *in* Tabarant: Manet, *op. cit.*, p. 210. Tabarant reproduces all critical comments on Manet's 1873 Salon contributions, p. 205-212.
- 35 Ibid., p. 212.
- 36 Castagnary: Le Salon de 1873; reprinted in Castagnary: Salons, v. II, 1872-1879, Paris, 1892, p. 62-63.
- 37 Alexis: Paris qui travaille, III, op. cit.

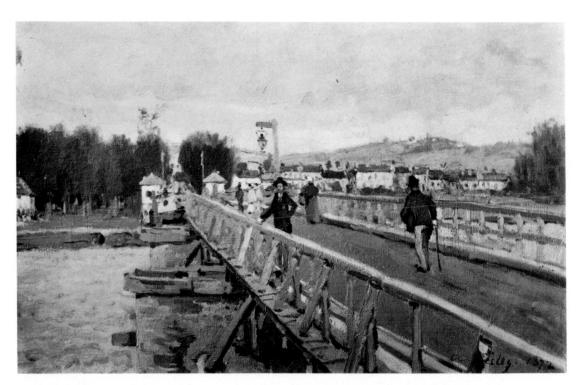

Sisley: Wooden Bridge at Argenteuil, d. 1872. 15 × 23\frac{8}{8}". Musée du Louvre, Paris.

THE FIRST GROUP EXHIBITION (1874)

AND THE ORIGIN OF THE WORD "IMPRESSIONISM"

In 1873 Monet took up once more the idea he and Bazille had cherished back in 1867 — that of opening a group exhibition at their own expense. No doubt he was prompted by his awareness that even such "liberal" ventures as the new *Salon des Refusés* did not basically affect the much despised jury system of the Salon.

In May 1873—shortly before the *Salon des Refusés* opened its doors—Paul Alexis, in an article doubtlessly written at the instigation of his painter friends, not only favored the suppression of the jury but also stated that, "like any other corporation, the artistic corporation has much to gain by organizing immediately its own syndicate" and by presenting independent shows. Alexis even alluded to the projects previously discussed at the Café Guerbois.¹ Monet replied instantly to this suggestion:

"A group of painters assembled in my home has read with pleasure the article which you have published in *L'Avenir National*. We are happy to see you defend ideas which are ours too, and we hope that, as you say, *L'Avenir National* will kindly give us assistance when the society which we are about to form will be completely constituted."²

In publishing this letter, Alexis appended a note saying that "several artists of great merit" had already joined Monet, naming among others Pissarro, Jongkind, Sisley, Béliard, Amand Gautier, and Guillaumin. He added: "These painters, most of whom have previously exhibited, belong to that group of naturalists which has the right ambition of painting nature and life in their large reality. Their association, however, will not be just a small clique. They intend to represent interests, not tendencies, and hope for the adhesion of all serious artists."

There seemed to be no reason why such a venture should not be successful and should not attract public interest, for the friends had slowly found a nucleus of collectors, and their prices were rising. Monet obtained 1,000 to 1,500 francs for his early canvases, Pissarro 500 for recent ones. It is true that Manet charged much more. When, in November 1873, the baritone Jean-Baptiste Faure from the Paris Opera acquired no fewer than five of his paintings, the artist received 2,500 francs for Lola de Valence, 4,000 for Le Déjeuner, and 6,000 for Le Bon Bock (p. 303); the story of the 12,000 offer for the latter was probably altogether a hoax. Faure's purchases immediately led to accusations that the famous singer had indulged in such eccentricity merely as a publicity stunt. However, early in 1874, at an auction sale

of the collection of Ernest Hoschedé, director of a Paris department store who also occasionally wrote art criticism, works by Pissarro, Sisley, Monet (see p. 270), and Degas commanded relatively high prices. Degas, in 1873, also saw one of his pastels purchased by an American, Miss Louisine Waldron Elder, who was to become Mrs. H. O. Havemeyer. She made this acquisition on the advice of her friend Mary Cassatt, a young painter from Pittsburgh, who had exhibited at the Paris Salon since 1872. Miss Cassatt had not yet met Degas but had already singled him out for admiration, doubtlessly upon seeing his works at Durand-Ruel's. "The first sight of Degas' pictures," she wrote years later, "was the turning point in my artistic life."

While the painters found in their modest sales an argument for a successful exhibition of the group, Duret took an opposite view and pronounced himself strongly against this project. "You have still one step to take," he wrote in February 1874 to Pissarro, "that is to succeed in becoming known to the public and accepted by all the dealers and art lovers. For this purpose there are only the auctions at the Hôtel Drouot and the big exhibitions in the *Palais de l'Industrie* [where the Salons were held]. You possess now a group of art lovers and collectors who are devoted to you and support you. Your name is familiar to artists, critics, a special public. But you must make one more stride and become widely known. You won't get there by exhibitions put on by special groups. The public doesn't go to such exhibitions, only the same nucleus of artists and patrons who already know you.

"The Hoschedé sale did you more good and advanced you further than all the special exhibitions imaginable. It brought you before a mixed and numerous public. I urge you strongly to round that out by exhibiting this year at the Salon. Considering what the frame of mind seems to be this year, your name now being known, they won't refuse you. Besides, you can send three pictures—of the three, one or two will certainly be accepted. Among the 40,000 people who, I suppose, visit the Salon, you'll be seen by fifty dealers, patrons, critics who would never otherwise look you up and discover you. Even if you only achieve that, it would be enough. But you'll gain more, because you are now in a special position in a group that is being discussed and that is beginning to be accepted, although with reservations.

"I urge you to select pictures that have a subject, something resembling a composition, pictures that are not too freshly painted, that are already a bit staid.... I urge you to exhibit; you must succeed in making a noise, in defying and attracting criticism, coming face to face with the big public. You won't achieve all that except at the Salon."

Yet Pissarro chose not to heed this advice. Instead he strongly supported Monet's plan for a separate group exhibition. In doing so he may have been prompted by essentially practical considerations, for early in 1874 Durand-Ruel had suddenly been obliged to suspend all further acquisitions. The business boom of unexpected intensity which France had enjoyed shortly after the disastrous war, and which may explain the high prices for paintings obtained at various auctions, had come to a sudden end late in 1873 and was followed by a great depression. Moreover, Durand-Ruel's efforts to sell the works of the young painters had not only encountered enormous obstacles but had made him lose the confidence of many collectors who refused to share his admirations and even thought him mad. The steady growth of his unsaleable stock had brought him into serious difficulties; he was now forced

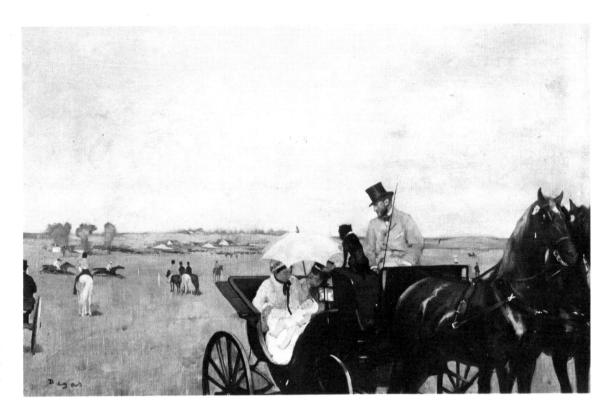

Degas: Carriage at the Races (Paul Valpinçon with his family), 1870-72. 14\frac{3}{8} \times 22''. Exhibited in London, 1872, and in the first impressionist show, 1874. Formerly Faure collection. Museum of Fine Arts, Boston (Arthur Gordon Tompkins Residuary Fund).

to sell at a loss some major works of the Barbizon painters in order to meet his obligations. In these circumstances he was obliged, temporarily, to abandon the Batignolles group, although he succeeded in persuading Faure to buy a certain number of their canvases. (In the winter of 1875 Durand-Ruel finally had to close his London gallery.) In their again uncertain situation after a few years of relative stability, the friends became doubly eager to appeal to the large public through a manifestation which promised to have more prestige than their participation at the Salon ever could, especially because it would permit them to show more canvases than the three newly allowed at the Salon, and their works would not be scattered.

Monet's plan was therefore well received by his comrades, but the actual formation of the group involved various complications since each of the painters had his own ideas about how the exhibition should be organized. The former plan of inviting older men like Corot, Courbet (now an exile in Switzerland), Daubigny, and others seems to have been abandoned, possibly because some of these men no longer wished to be associated with the Batignolles group. In any case, there was no question of admitting just about anybody, as Paul Alexis' article had led to believe.

The first dissent arose when Degas expressed fear that the exhibition might be considered a manifestation put on by refusés, even though the friends were determined not to send any works to the Salon and to open their show two weeks before the official exhibition. Berthe Morisot, who had always been admitted, courageously accepted this principle and, in joining the others, decided to submit no more to the

jury. Degas, however, did not change his opinion. He insisted that the friends invite as many artists as possible, preferably some who showed at the Salon, so as not to give the enterprise too revolutionary a character. The others argued that an exhibition limited to the members of their group would present greater unity and more strongly underline the specific nature of their efforts. To this Degas retorted that they would make themselves less conspicuous and have a better chance of being considered favorably if they associated themselves with artists whose tendencies seemed less offensive to the general public. Thereupon the others suspected that Degas, being himself only vaguely in sympathy with their studies of nature, did not care to identify himself with them unless he was certain not to be alone in their midst. If Degas' proposal finally prevailed, it was for the very practical reason that a greater number of participants would automatically reduce the cost to each exhibitor.

Pissarro's friend Piette, meanwhile, voiced objections of a different kind. "You are trying to operate a useful reform," he wrote to Pissarro, "but it can't be done; artists are cowards.... Where are those who protested against the exclusion of Courbet from the exhibition in Paris...? Should not all painters have objected massively by abstaining? Of solidarity there is not a shred in France. You and some other ardent, generous, and sincere spirits, you will have given a legitimate impulse. Who will follow you? The gang of incapables and blunderers. Then, as these will gain in strength, they will be the ones to abandon you.... I would say nothing against an association restricted to people of talent, who work, are loyal, and inspired by enlightened daring, such as you and some of those around you. I would anticipate much of an association of this kind and do believe that it would be profitable and just to establish it, but I am distrustful of the mass of those idle and perfidious colleagues without moral or political convictions who only want to use others as stepping stones." Pissarro, however, was much less pessimistic than his friend.

Pissarro had some experience with questions of organization, for as early as 1860 he had become a member of the Association des Artistes Peintres d'histoire et de genre, Sculpteurs, Graveurs, Architectes et Dessinateurs, founded in 1844 for the purpose of providing assistance and old-age pensions from funds constituted by annual dues. He now insisted that a cooperative association be formed, and proposed as a model the charter of a professional bakers' union, which he had studied at Pontoise and which he read to his friends. To these he added, on his own, regulations loaded with prohibitions and penalties. But Renoir, out of horror of administrative rules, succeeded in defeating this suggestion. It was agreed simply that each painter turn over to a common fund one-tenth of the income from possible sales.

On Pissarro's proposition a joint-stock company was founded, with shares, monthly installments, articles of partnership, regulations for subscriptions, etc. Renoir became a member of the management.

Pissarro also suggested a system designed to give equal chances for good position and thus eliminate the almost inevitable battles about hanging: a drawing of lots was to determine the place for each canvas unless the exhibitors preferred to decide the positions by vote. In order to obtain a more harmonious display, a compromise was adopted by which the paintings were first to be classified by size, and only then would lots decide where they should hang.9

The founding charter is dated December 27, 1873.¹⁰ Among the initial members

CÉZANNE: Portrait of Camille Pissarro, c. 1873. Pencil, $3\frac{7}{8} \times 3\frac{1}{8}$ ". Private collection, New York.

were Monet, Renoir, Sisley, Degas, Berthe Morisot, Pissarro, the latter's friends Béliard and Guillaumin (there seems to have been some opposition to Guillaumin's admission), and Degas' friends Lepic, Levert, and Rouart. Béliard and Rouart were named to serve on the inaugural committee. Several newspapers subsequently announced the formation of the group.

Once all these details were agreed upon, the group had to secure a proper location for their exhibition. This presented itself in the form of the studios just vacated by the photographer Nadar, who, according to Monet, lent them the premises without fee. They were located on the second floor of a building in the rue Daunou, which formed an angle on the boulevard des Capucines, right in the heart of Paris. It was a series of large rooms on two floors with red-brown walls that received the light from windows, as in an apartment. A broad staircase led from the boulevard des Capucines directly to these galleries.

The location of these premises induced Degas, still anxious to give a "neutral" character to the project, to propose that the group call itself *La Capucine* [nasturtium] and that this flower be used as an emblem on the posters announcing the exhibition. But this was not accepted. Renoir was also against a title with a precise signification. "I was afraid," he later explained, "that if we were called merely *Some* or *Certain*, . . . critics would immediately begin talking about a 'new school'." It was finally agreed that the group be called simply *Société anonyme des artistes peintres, sculpteurs, graveurs, etc.*

It was then that an active campaign to recruit participants began among the initial members. As was to be expected, Degas tried particularly hard to obtain further adherents. He succeeded in persuading his Italian friend de Nittis (whom Alexis and the others held in low esteem), and insisted that he send "something important." True to the line he had taken in the discussions with his colleagues, he told de Nittis: "Since you are exhibiting at the Salon, people who are not conversant with things won't be able to say that ours is an exhibition of rejected artists." 12

Degas also tried to enlist Tissot and Legros, both of whom had definitely settled in London. "See here, my dear Tissot," he wrote, "don't hesitate or try to avoid the issue. You just have to exhibit on the boulevard. It'll do you good (it is a way for you to show yourself in Paris, which people say you are evading) and will be good for us, too. Manet seems to become obstinate in his decision to remain apart; he may very well regret it. Yesterday I inspected the installation of the locale, the wall hangings and the effect of daylight. It's altogether as good there as anywhere else. And now Henner (elected an auxiliary member of the Salon jury!), wants to show with us. I am agitated and work quite hard and rather with success, I believe. Already the notices in the newspapers begin to contain more than just an announcement, and while they do not dare yet devote an entire column with a special article, they appear willing to give us more space.

"The realist movement no longer needs to fight with others. It is, it exists, it has to show itself separately. There has to be a realist Salon. Manet doesn't understand that. I definitely believe him to be much more vain than intelligent.

"... Exhibit. Stay with your country and with your friends. I assure you that the whole thing makes more progress and is better received than I would have thought." And Degas added: "I have not yet written to Legros. Try to see him and to stir his interest. One absolutely counts on him. All he has to do is to deposit his 60 francs.

Pissarro: Portrait of Paul Cézanne, c. 1874. Pencil, 7\supers \text{\lambda}\supers 4\supers ". Musée du Louvre, Paris.

The better part of the money is almost gathered. The *general impression* is that it is a good thing, is right, and is undertaken simply. It may be that we will fall on our faces, as one says. But the merit will still be ours."¹³

Pissarro invited Cézanne yet apparently had some difficulty in getting several of the others to agree to his participation, for they feared that the public might be too outraged by his canvases. But Pissarro—who had already overcome the objections raised against Guillaumin's admission—now supported by Monet, pleaded the cause of Cézanne with so much conviction that his friend was finally accepted, in spite of the fact that Degas is supposed to have shown little enthusiasm.

Whereas Cals and the sculptor Ottin, among the members, were both over sixty, only Boudin, of the artists of the older generation, accepted an invitation to exhibit with the group, doubtless at the request of Monet. On the other hand there seems to have been no more question of Jongkind, whose adherence Alexis had announced and who, having been rejected in 1873, at the age of fifty-four, must have appeared as a likely prospect. Since Monet cannot have failed to urge his former mentor to join the group of his friends, it is probable that Jongkind decided to abstain for reasons of his own.

Cals, on the other hand, though ten years older than Jongkind, resolutely joined his younger colleagues and wrote to a friend who criticized his adhesion: "How come you, who are so advanced in politics, are so reactionary in art matters? You do not go beyond Cabanel or Bouguereau, because there you see a kind of well-defined form, yet you don't perceive how hollow and devoid of any sentiment their works are! The others may be Bohemians, if you wish, but at least there is a vigor that I do not find in those who are considered the heads of the modern French school. Sad school of castrates! What, above all, prompted me to join [the independent artists] was my belief that only one thing can save our art, and that is the rigorous application of the principle of liberty.... Oh! if only I were twenty years younger, with what ardor would I not have thrown myself into the fray! But I am exhausted, at the end of my rope.... And you want me to ask an Albert Wolff to come to my studio and look at my poor things? No! I do not have any pride in the little I may have accomplished, ... but I have self-respect.... Let me tell you that I have only total contempt for those...pen-pushers who are treated with so much consideration for fear of the stupidities they fish out of their ink-wells."14

Prompted by such or similar considerations, there were altogether twenty-nine old or young participants when, at the last minute, Bracquemond resolved to show with the group. Degas immediately wrote him:

"A line from Burty informs me that yesterday he made a new adherent of you, my dear Bracquemond, and that you would like to arrange for a talk. First, we are going to open on the 15th [of April]. Therefore, we must hurry. You should have your things in by the 6th or 7th, or even a little later, but in plenty of time so that we can have the catalogue by opening day. There is space there (boulevard des Capucines, Nadar's old studio) and a unique location, etc., etc., etc... I suggest that you meet me... at that very place. You will see the spot; we can afterwards discuss things if it is still necessary. We are gaining a famous recruit in you. Be assured of the pleasure and good you are doing us. (Manet, stirred up by Fantin and confused by himself, is still holding out, but nothing seems to be final in that direction.)"15

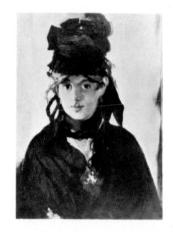

Manet: Portrait of Berthe Morisot, d. 1872. $21\frac{5}{8} \times 15$ ". Private collection, Paris.

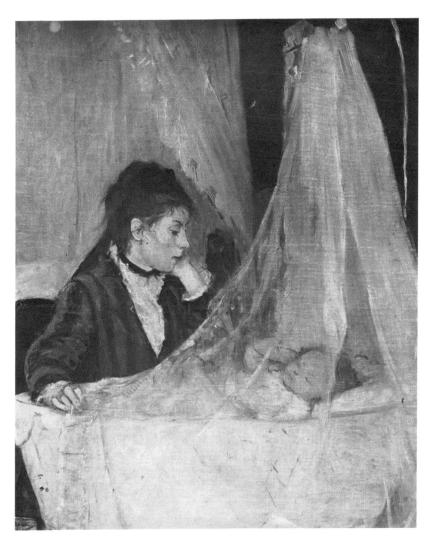

MORISOT: The Cradle, 1873. $22\frac{1}{2} \times 18\frac{1}{2}$ ". Exhibited in the first impressionist show, 1874. Musée du Louvre, Paris.

Although Degas hoped until the very last that Manet would join the group, the painter of the *Bon Bock* had no intention of doing so. One of the reasons given when he was invited to exhibit with the others was: "I'll never commit myself with M. Cézanne." But his more decisive arguments were the same as those of Duret in trying to convince Pissarro that only participation in the Salon could bring real recognition. Manet thought along the same lines. Pointing to the recent success of his *Bon Bock*, he repeated over and over to Renoir and Monet: "Why don't you stay with me? You can see very well that I am on the right track!" And to Degas he said: "Exhibit with us; you'll receive an honorable mention." Manet was particularly insistent in trying to persuade Berthe Morisot not to show with the others. But all his efforts were in vain. Eva Gonzalès, on the other hand, stuck to her master.

Fantin, for reasons similar to those of Manet, also abstained from exhibiting with his former comrades, as did Legros and Tissot, in spite of Degas' urgent appeals.

Henner, too, eventually decided against joining the group. So did Antoine Guillemet, who likewise preferred success at the Salon to an act of independence. Corot, incidentally, approved of Guillemet's decision and told him: "My dear Antoine, you have done very well to escape from that gang." ¹⁷

The "gang" brought together 165 works for exhibition. Of these Cézanne showed three: two landscapes of Auvers and his Modern Olympia; Degas ten paintings, drawings, and pastels of races, dancers, and laundresses; Guillaumin three landscapes; Monet five paintings, among them some of his early works, and seven pastel sketches; Berthe Morisot nine paintings, water colors, and pastels; Pissarro five landscapes; Renoir six canvases, including his Loge and Dancer, and one pastel; Sisley five landscapes. The remaining 111 works were by the other participants: Astruc (the critic, who occasionally did sculpture and painted), Attendu, Béliard, Boudin, Bracquemond, Brandon, Bureau, Cals, Colin, Debras, Latouche, Lepic, Lépine, Levert, Meyer, de Molins, Mulot-Durivage, de Nittis, A. Ottin, L. Ottin, Robert, and Rouart. Of these, as Castagnary shortly pointed out, Boudin, Lépine, Brandon, Colin, Cals, and Bracquemond had already achieved a certain renown. (There were also some members of the association who paid their dues but did not participate in the exhibition.) Of these and the exhibition.

The artists showed not only works owned by them but borrowed a few paintings from various friends. Dr. Gachet lent Cézanne's *Modern Olympia* (p. 323) and a land-

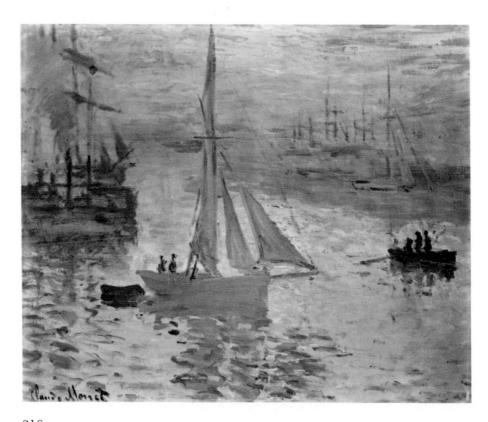

Monet: Impression, Sunrise (Le Havre), 1872. $19\frac{1}{2} \times 25\frac{1}{2}$ ". Exhibited in the first impressionist show, 1874. Private collection, Paris.

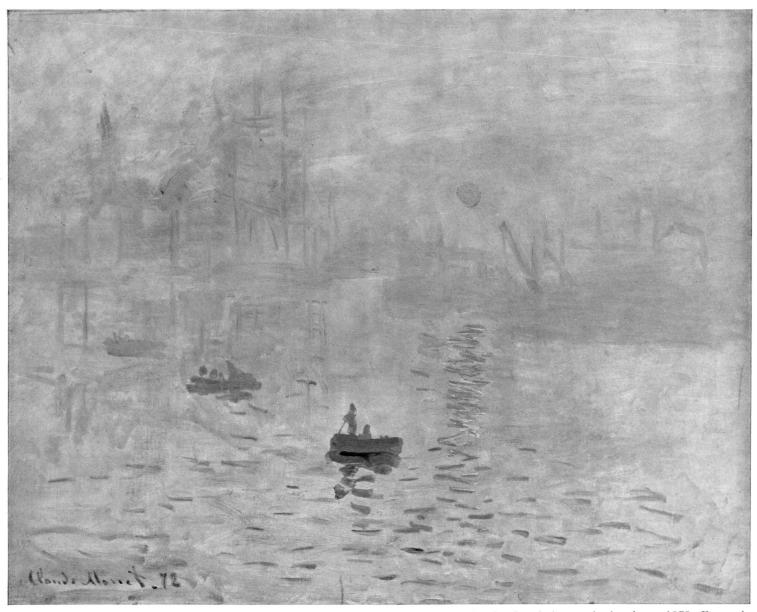

Monet: Impression, Setting Sun (Fog), (Le Havre), d. 1872. $19\frac{1}{2} \times 25\frac{1}{2}$ ". Exhibited in the fourth impressionist show, 1879. Formerly Collections Ernest Hoschedé and G. de Bellio. Musée Marmottan, Paris.

scape by Guillaumin, Faure two works by Degas—who also asked Rouart for the loan of a canvas—Manet the painting *Hide-and-Seek* by Berthe Morisot (p. 331), and Durand-Ruel two of Sisley's landscapes.

Renoir's brother Edmond was entrusted with the task of editing the catalogue. He had great difficulties with Degas, who was ready only at the last minute. Whereas Monet was perfectly on time, he did not cause any less trouble, for he sent too many paintings and upset Edmond Renoir by the monotony of his titles: *Entrance of a Village, Leaving the Village, Morning in a Village...* When Edmond Renoir objected, the painter calmly told him: "Why don't you just put *Impression!*"²¹

Monet later explained that he had selected for the exhibition a painting done in Le Havre from his window: the sun appearing in damp vapors, in the foreground a few shipmasts pointing. "I was asked to give a title for the catalogue; I couldn't very well call it a view of Le Havre. So I said: 'Put *Impression*.'"²² Indeed, the painting was catalogued as *Impression*, *Sunrise* (it was one of two views which Monet had painted in 1872).²³

A committee, of which Auguste Renoir was a member, supervised the hanging. But the others soon tired of the job and left Renoir practically alone to arrange the show. One of his main problems was apparently to achieve some kind of unity with the widely divergent works. When he could find no place for one of the more or less academic canvases by de Nittis, who had gone to England, he simply left it out. It was only hung, doubtless upon Degas' insistence, a few days after the opening when—as de Nittis later complained—the critics and the first visitors had come and gone.¹²

The opening took place on April 15, 1874. The exhibition was to last for one month; the hours were from ten to six and also—as an innovation—in the evenings from eight to ten. The entrance fee was one franc, catalogues being sold for fifty centimes. From the beginning the exhibition seems to have been well attended, but the public went there mainly to laugh. Someone invented a joke to the effect that these painters' method consisted in loading a pistol with several tubes of paint and firing at a canvas, then finishing off the work with a signature. The critics were either extremely harsh in their comments or simply refused to consider the show seriously. On April 25 there appeared in the *Charivari* an article signed by Louis Leroy which, under the title "Exhibition of the Impressionists," summed up the attitude of both its author and the general public.

"Oh, it was indeed a strenuous day," wrote the critic, "when I ventured into the first exhibition on the boulevard des Capucines in the company of M. Joseph Vincent, landscape painter, pupil of [the academic master] Bertin, recipient of medals and decorations under several governments! The rash man had come there without suspecting anything; he thought that he would see the kind of painting one sees everywhere, good and bad, rather bad than good, but not hostile to good artistic manners, to devotion to form, and respect for the masters. Oh, form! Oh, the masters! We don't want them any more, my poor fellow! We've changed all that.

"Upon entering the first room, Joseph Vincent received an initial shock in front of the *Dancer* by M. Renoir.

"What a pity,' he said to me, 'that the painter, who has a certain understanding of color, doesn't draw better; his dancer's legs are as cottony as the gauze of her skirts.'

"'I find you hard on him,' I replied. 'On the contrary, the drawing is very tight.'

Renoir: Dancer, d. 1874. $55\frac{7}{8} \times 36\frac{5}{8}$ ". Exhibited in the first impressionist show, 1874. National Gallery of Art, Washington, D.C. (Widener Collection).

"Bertin's pupil, believing that I was being ironical, contented himself with shrugging his shoulders, not taking the trouble to answer. Then, very quietly, with my most naïve air, I led him before the *Ploughed Field* of M. Pissarro. At the sight of this astounding landscape, the good man thought that the lenses of his spectacles were dirty. He wiped them carefully and replaced them on his nose.

"'By Michalon!' he cried. 'What on earth is that?'

"'You see . . . a hoar-frost on deeply ploughed furrows."

"Those furrows? That frost? But they are palette-scrapings placed uniformly on a dirty canvas. It has neither head nor tail, top nor bottom, front nor back."

"'Perhaps . . . but the impression is there.'

"'Well, it's a funny impression! Oh . . . and this?"

"'An Orchard by M. Sisley. I'd like to point out the small tree on the right; it's gay,

but the impression...?

"'Leave me alone, now, with your impression . . . it's neither here nor there. But here we have a *View of Melun* by M. Rouart, in which there's something to the water. The shadow in the foreground, for instance, is really peculiar.'

"'It's the vibration of tone which astonishes you."

"'Call it the sloppiness of tone and I'd understand you better—Oh, Corot, Corot, what crimes are committed in your name! It was you who brought into fashion this messy composition, these thin washes, these mud-splashes against which the art lover has been rebelling for thirty years and which he has accepted only because constrained and forced to it by your tranquil stubbornness. Once again, a drop of water has worn away the stone!"

"The poor man rambled on this way quite peacefully, and nothing led me to anticipate the unfortunate accident which was to be the result of his visit to this hair-raising exhibition. He even sustained, without major injury, viewing the Fishing Boats Leaving the Harbor [possibly the painting reproduced p.155 bottom] by M.Claude Monet, perhaps because I tore him away from dangerous contemplation of this work before the small, noxious figures in the foreground could produce their effect.

"Unfortunately, I was imprudent enough to leave him too long in front of the

Boulevard des Capucines, by the same painter.

"'Ah-ha!' he sneered in Mephistophelian manner. 'Is that brilliant enough, now! There's impression, or I don't know what it means. Only, be so good as to tell me what those innumerable black tongue-lickings in the lower part of the picture represent?'

"'Why, those are people walking along,' I replied.

"'Then do I look like that when I'm walking along the boulevard des Capucines? Blood and thunder! So you're making fun of me at last?'

" 'I assure you, M. Vincent. . . . '

"'But those spots were obtained by the same method as that used to imitate marble: a bit here, a bit there, slap-dash, any old way. It's unheard-of, appalling! I'll get a stroke from it, for sure.'

"I attempted to calm him by showing him the St. Denis Canal by M. Lépine and the Butte Montmartre by M. Ottin, both quite delicate in tone; but fate was strongest of all: the Cabbages of M. Pissarro stopped him as he was passing by and from red he became scarlet.

"'Those are cabbages,' I told him in a gently persuasive voice.

"'Oh, the poor wretches, aren't they caricatured! I swear not to eat any more as long as I live!"

"Yet it's not their fault if the painter....

"Be quiet, or I'll do something terrible."

CÉZANNE: La maison du pendu, Auvers, 1873-74. $22\frac{1}{4} \times 26\frac{3}{4}$ ". Exhibited in the first impressionist show, 1874. Purchased by Count Doria; later Chocquet collection. Musée du Louvre, Paris.

"Suddenly he gave a loud cry upon catching sight of the Maison du pendu by M. Paul Cézanne. The stupendous impasto of this little jewel accomplished the work begun by the Boulevard des Capucines: père Vincent became delirious.

"At first his madness was fairly mild. Taking the point of view of the impressionists, he let himself go along their lines:

"'Boudin has some talent,' he remarked to me before a beach scene by that artist; but why does he fiddle so with his marines?"

"'Oh, you consider his painting too finished?"

"'Unquestionably. Now take Mlle Morisot! That young lady is not interested in reproducing trifling details. When she has a hand to paint, she makes exactly as many brushstrokes lengthwise as there are fingers, and the business is done. Stupid people who are finicky about the drawing of a hand don't understand a thing about impressionism, and great Manet would chase them out of his republic.'

"Then M. Renoir is following the proper path; there is nothing superfluous in his *Harvesters* [p. 332]. I might almost say that his figures....

"'... are even too finished."

"'Oh, M. Vincent! But do look at those three strips of color, which are supposed to represent a man in the midst of the wheat!'

"There are two too many; one would be enough."

"I glanced at Bertin's pupil; his countenance was turning a deep red. A catastrophe seemed to me imminent, and it was reserved for M. Monet to contribute the last straw.

"'Ah, there he is, there he is!' he cried, in front of No. 98. 'I recognize him, papa Vincent's favorite! What does that canvas depict? Look at the catalogue.'

" 'Impression, Sunrise.'

"'Impression — I was certain of it. I was just telling myself that, since I was impressed, there had to be some impression in it... and what freedom, what ease of workmanship! Wallpaper in its embryonic state is more finished than that seascape."

"In vain I sought to revive his expiring reason... but the horrible fascinated him. *The Laundress*, so badly laundered, of M. Degas drove him to cries of admiration. Sisley himself appeared to him affected and precious. To include his insanity and out of fear of irritating him, I looked for what was tolerable among the impressionist

CÉZANNE: A Modern Olympia, 1872-73. 18½ × 22". Exhibited in the first impressionist show, 1874 (lent by Dr. Gachet). Musée du Louvre, Paris (gift of Paul Gachet).

pictures, and I acknowledged without too much difficulty that the bread, grapes and chair of *Breakfast*, by M. Monet,²⁴ were good bits of painting. But he rejected these concessions.

"'No, no!' he cried. 'Monet is weakening there. He is sacrificing to the false gods of Meissonier. Too finished, too finished! Talk to me of the *Modern Olympia*! That's something well done.'

"Alas, go and look at it! A woman folded in two, from whom a Negro girl is removing the last veil in order to offer her in all her ugliness to the charmed gaze of a brown puppet. Do you remember the *Olympia* of M. Manet? Well, that was a masterpiece of drawing, accuracy, finish, compared with the one by M. Cézanne.

"Finally the pitcher ran over. The classic skull of père Vincent, assailed from too many sides, went completely to pieces. He paused before the municipal guard who watches over all these treasures and, taking him to be a portrait, began for my benefit a very emphatic criticism:

"'Is he ugly enough?' he remarked, shrugging his shoulders. 'From the front, he has two eyes... and a nose... and a mouth! Impressionists wouldn't have thus sacrificed to detail. With what the painter has expended in the way of useless things, Monet would have done twenty municipal guards!'

"'Keep moving, will you!' said the 'portrait.'

"You hear him — he even talks! The poor fool who daubed at him must have spent a lot of time at it!"

"And in order to give the appropriate seriousness to his theory of esthetics, père Vincent began to dance the scalp dance in front of the bewildered guard, crying in a strangled voice:

"'Hi-ho! I am impression on the march, the avenging palette knife, the Boulevard des Capucines of Monet, the Maison du pendu and the Modern Olympia of Cézanne. Hi-ho! "'25"

The day after this article appeared, the painter Latouche wrote to Dr. Gachet: "Today, Sunday, it is my turn to serve [as guardian] at our exhibition. I keep an eye on your Cézanne [*The Modern Olympia*] but do not guaranty for its safety; I fear that it may be returned to you torn to pieces."²⁶

Rumors about Leroy's article spread even beyond France. When a friend from Italy uneasily approached de Nittis, the latter replied from London: "I repeat that I haven't seen the exhibition and have not received any letters from Degas.... I can tell you, however, that had there been only the paintings by Degas, a drawing by Bragmond [sic], and a portrait by Mlle Morisot, things which I have seen, it would have been enough to justify the entrance fee of one franc — without even mentioning Pissarro, Monet, and Sisley, who are landscapists of very estimable qualities and who are very interesting. These are being attacked — and with good reason — because they resemble each other a bit too much (they all derive from Manet) and because sometimes they happen to be shapeless, so predominant is their desire of exclusively sketching reality. Those are the excesses of the school, but this doesn't mean that one can judge, deriding everything without taking the trouble to examine...."27

Evidently worried by the reviews, Berthe Morisot's mother asked her daughter's former teacher, Guichard, a friend of Corot, to go to the exhibition and report back

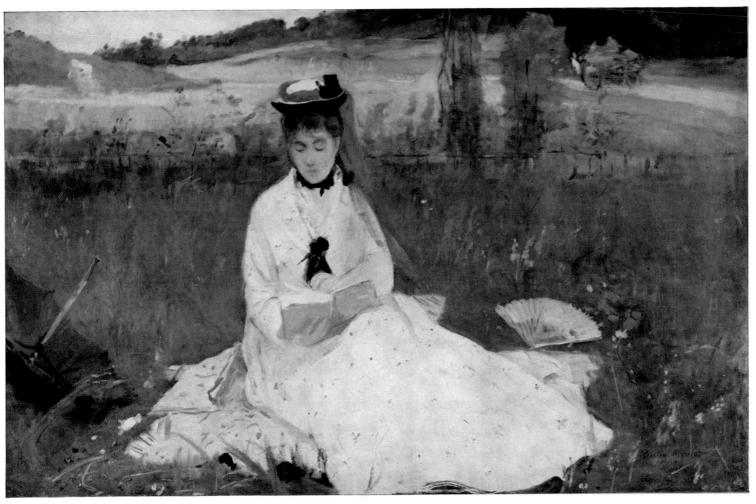

Morisot: The Artist's Sister, Mme Pontillon, Seated on the Grass, 1873. 17\(\frac{3}{4} \times 28\(\frac{1}{2}\)". Cleveland Museum of Art (gift of Hanna Fund).

to her. She did not have to wait long for his reply. "I have seen the rooms at Nadar's," he wrote, "and wish to give you immediately my sincere impression. When I entered, I became anguished upon seeing the works of your daughter in those pernicious surroundings. I said to myself: 'One doesn't live with impunity among madmen. Manet was right in opposing her participation.' After examining and analyzing conscientiously, one certainly finds here and there some excellent fragments, but they all have more or less cross-eyed minds." And both as friend and painter, Guichard advised Berthe Morisot to break completely "with the so-called school of the future." ²⁸

Of course, the young woman did nothing of the kind, yet it seemed conclusive that Duret and Manet had been right in counseling against a separate exhibition.

At the very moment when Durand-Ruel was unable to help them, and when a financial success was even more important than one of prestige, the group had gained nothing but ridicule. It could have been of small comfort to them that Manet had fared little better at the Salon, the jury having accepted only his Railroad and a watercolor (Eva Gonzalès was altogether rejected). But worse, the critics did not fail to establish Manet's connection with the group in spite of his efforts to detach himself from it.29 The result could hardly have been different had he actually exhibited with his friends. An American critic, once more confusing Manet and Monet, informed the readers of Appletons' Journal that the author of one "fearful daub" at the Salon, called The Railroad and representing a young girl and a child, "both cut out of sheet-tin apparently," had also shown two pictures, Breakfast and the Boulevard des Capucines, at "that highly comical exhibition, gotten up by the Anonymous Society of Painters and Sculptors." He added that they had been "two of the most absurd daubs in that laughable collection of absurdities."30 Although avoiding this mistake, one of the best-known Paris Salon reviewers could not help stating: "M. Manet is among those who maintain that in painting one can and ought to be satisfied with the impression. We have seen an exhibition by these impressionalists on the boulevard des Capucines, at Nadar's. M. Monet — a more uncompromising Manet — Pissarro, Mlle Morisot, etc., appear to have declared war on beauty."31

It must have been particularly humiliating for Manet to have two of his three canvases rejected at the very time the others opened their jury-free show. Degas' sarcastic remarks about his "stubborn vainglory" notwithstanding, Manet's persistence in showing at the Salon was not dictated solely by his thirst for honors. Just as Cézanne, in 1866, had clamored for the re-establishment of a Salon des Refusés, even at the risk of finding himself there alone, so Manet was determined not to abandon the official exhibitions despite the threat of finding himself completely isolated as representative of new tendencies. Although the nominal "head" of the Batignolles group, he was ready to go his way alone, lest he be accused of abandoning his chosen field of battle. To him the true and final vindication could only come through the Salon. Whether the others agreed or not with his views, there was no denying that it took a certain courage for a man of Manet's stature to perennially submit to the judgment of a hostile jury which held — if not his talent — at least his reputation in its hands. And this jury, obviously angered by Manet's success of the preceding year, came near to closing altogether the doors of the 1874 Salon to him.

Besides some trusted friends among the critics who protested the jury's iniquitous decision, a new voice now came to the artist's defense, that of his recent friend Stéphane Mallarmé, then still comparatively unknown, who concluded his article in an anything but widely read periodical: "The jury has nothing to say but: 'This is a picture,' or else: 'This is not a picture.' It has no right to hide them. As soon as certain tendencies, until then latent in the public, have found in a painter their artistic expression or their beauty, it is necessary that the latter be introduced to the former; not to present one to the other is to transform a blunder into an injustice and a lie.... The crowd, from whom one can conceal nothing since everything emanates from it, will recognize itself later on in the accumulated and surviving oeuvre, and

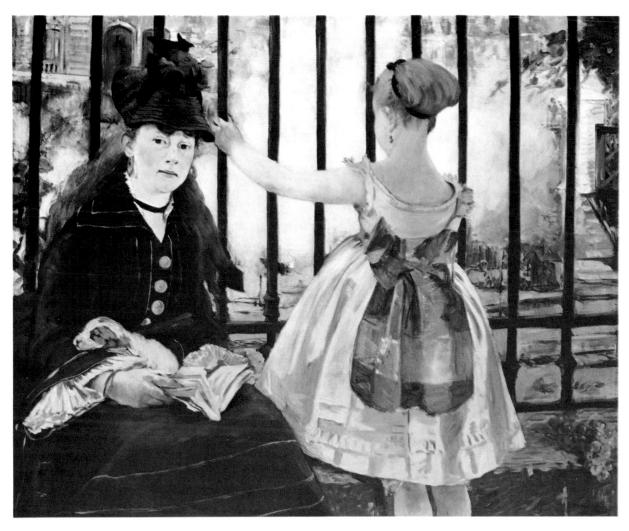

Manet: The Railroad, 1873. $37\frac{1}{4} \times 45$ ". Exhibited at the Salon of 1874. National Gallery of Art, Washington, D.C. (gift of Horace Havemeyer in memory of his mother Louisine W. Havemeyer).

its detachment from things past will then be all the more absolute. To gain a few years on M. Manet, what a sad policy!"32

For the time being, however, the crowd, supreme judge in an indefinite future, unequivocally sided with the jury. And crowds there were at the Salon. Zola was soon to calculate that the number of daily visitors was between 8,000 to 10,000 and that altogether 400,000 persons visited the exhibition during its run. These throngs looked at some 4,000 works of art; among them Manet's paintings were "intruders" and appeared doubly "ridiculous" compared to their neighbors, which more or less catered to the lowest tastes. It is not surprising, then, that Zola should have

welcomed the decision of "a group of painters, excluded each year from the Salon... to organize its own exhibition. It is a very reasonable resolution which can only be applauded."³³

Yet the visitors to the group show were obviously much less numerous. From 175 on the first day their number dwindled to 54 on the last. In the evenings the attendance usually varied between ten and twenty but on some days did not exceed two. Altogether some 3500 persons came to see the show over a period of four weeks and among these were many whose visit was motivated by curiosity rather than by the desire to seriously study the works exhibited.

Years later Zola was to describe in a novel the atmosphere of an exhibition resounding with the guffaws of curiosity-seekers: "These laughs were no longer smothered by the handkerchiefs of the ladies, and the men distended their bellies the better to give vent to them. It was the contagious mirth of a crowd which had come for entertainment, was becoming excited by degrees, exploded apropos of nothing, and was enlivened as much by beautiful things as by execrable ones.... They nudged each other, they doubled up... every canvas had its appreciation, people called each other over to point out a good one, witty remarks were constantly being passed from mouth to mouth... expressing the sum total of asininity, of absurd commentary, of bad and stupid ridicule that an original work can evoke from bourgeois imbecility."³⁴

"Public conscience was indignant," one critic later reminisced. "This was awful, stupid, dirty; this painting had no common sense." Consequently many of the so-called serious critics refused to review the exhibition. If they mentioned it at all, it was in derision. "Shall we speak of M. Cézanne?" one of them wrote. "Of all known juries, none ever imagined, even in a dream, the possibility of accepting any work by this painter who used to present himself at the Salon carrying his canvases on his back like Jesus his cross. A too exclusive love of yellow has up to now compromised the future of M. Cézanne."

Whereas many of the prominent critics chose to remain silent, various friends of the painters, including Philippe Burty and Armand Silvestre, reviewed the exhibition favorably. But even they did not indulge in unmitigated praise. Silvestre, for instance, poetically described their works, saying: "A blond light bathes them and everything is joyousness, clarity, feasts of spring, golden evenings, or blooming appletrees. Their canvases of modest dimensions . . . seem to open windows on a gay countryside, on the river carrying hasty boats, on the sky streaked with light vapors, on cheerful and charming outdoor life." Yet he pursued: "They do not select their sites with the preoccupations of ancient landscapists. Quite the contrary, and in this I find their affectation altogether awkward. If its reason is the philosophical concept that in nature everything is of equal beauty, artistically this idea is wrong. Supposed to demonstrate the wide range of their means of interpretation, it actually underlines the manual aspect of their technique, thus showing how little advanced their attempt as yet is and how it still needs a master capable of summarizing, formulating, and consecrating it." 37

After discussing mainly the works of Monet, Renoir, Sisley, Pissarro, and Degas, blending praise with reservations, Silvestre concluded with the statement: "This exhibition deserves to be seen. It might have gained by being less eclectic, if one may

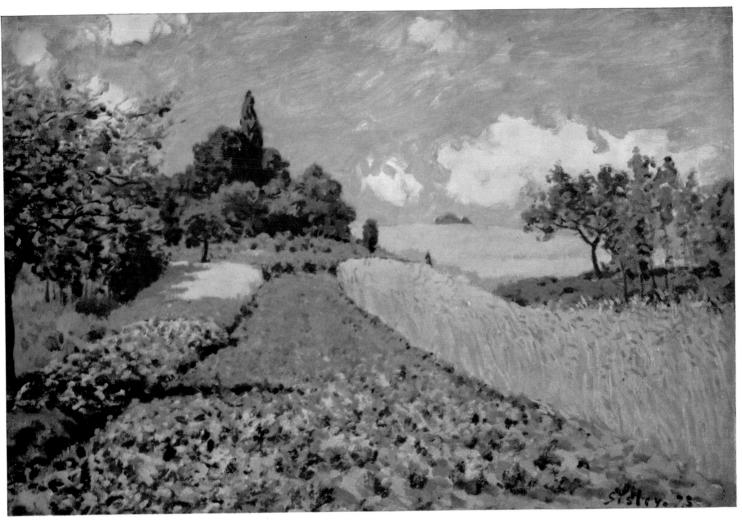

Sisley: Wheatfields near Argenteuil, d. 1873. 19\(\frac{3}{4} \times 28\(\frac{3}{4}'' \). Purchased by Durand-Ruel in 1874. Kunsthalle, Hamburg.

call eclecticism a complete indifference for the relative merits of the works shown. It won't do to open the doors to anybody who is not in a position to be accepted by the Salon [was this a reference to Cézanne?] since that is not necessarily a sign of genius. Such a demonstration would rapidly cease being a true artistic manifestation should it spread beyond the specific school which is its raison d'être."³⁷

Castagnary, whose often expressed sympathy for new efforts and particularly for the sincere study of nature had gained him in conservative circles the reputation of being "a chimney-sweeper for the love of soot," also expressed certain qualms, but not before having acclaimed the initiative of the painters as a step in the right direction. He actually exaggerated when he wrote that "in order to bar the road to those four young men [Pissarro, Monet, Sisley, Renoir] and that young lady [Berthe Morisot], the jury has for four or five years accumulated stupidities, piled up abuses

of power, and compromised itself so extensively that today there is not a single person in France daring to speak in its favor." To better demonstrate the injustice of the jury, Castagnary exclaimed: "Here is talent, and even much talent. These youths have a way of understanding nature which is neither boring nor banal. It is lively, sharp, light; it is delightful. What quick intelligence of the object and what amusing brushwork! True, it is summary, but how just the indications are!

"... The common concept which united them as a group and gives them a collective strength in the midst of our disaggregate epoch is the determination not to search for a smooth execution, but to be satisfied with a certain general aspect. Once the impression is captured, they declare their role terminated.... If one wants to characterize them with a single word that explains their efforts, one would have to create the new term of *Impressionists*. They are impressionists in the sense that they render not a landscape but the sensation produced by a landscape."38

Yet here Castagnary ceased to agree with the artists. "What is the value of this novelty?" he asked. "Does it constitute a real revolution? No, because the principle and — to a large extent — the forms of art remain unchanged. Does it prepare the emergence of [new] a school? No, because a school lives on ideas and not on material means, distinguishes itself by its doctrines and not by a technique of execution. But if it does not constitute a revolution and does not contain the seed of any school, what then is it? It is a manner and nothing else...." And having thus defined the new tendency, Castagnary predicted: "Within a few years the artists who today have grouped themselves on the boulevard des Capucines will be divided. The strongest among them . . . will have recognized that while there are subjects which lend themselves to a rapid 'impression,' to the appearance of a sketch, there are others and in much greater numbers that demand a more precise impression.... Those painters who, continuing their course, will have perfected their draftsmanship, will abandon impressionism as an art really too superficial for them." Then, taking exception to Cézanne's Modern Olympia, which actually was in no way typical of the works shown by the friends, Castagnary pursued: "As to the others who - neglecting to ponder and to learn - pursue the impression to excess, the example of M. Cézanne can reveal to them as of now the lot which awaits them. Starting with idealization, they will arrive at that degree of unbridled romanticism where nature is merely a pretext for dreams and where the imagination becomes powerless to formulate anything but personal, subjective fantasies without any echo in general reason, because they are without control and without possible verification in reality."38

At the same time several other critics for republican papers experienced a strange dilemma. On the one hand—like Castagnary—they strongly approved the undertaking of the "artists thirsting for independence, who have decided to reply with scorn to the obstinate contempt shown them by the official jury"; on the other hand they did not like the exhibition any better than their more reactionary colleagues, advanced political opinions not necessarily being conducive to an understanding of unconventional art (as Cals also discovered). Thus, while commending the principle of the venture, one of them told his readers:

"Soil three quarters of a canvas with black and white, rub the rest with yellow, distribute haphazardly some red and blue spots, and you'll obtain an *impression* of spring in front of which the adepts will be carried away by ecstasy. The famous

Salon des Refusés, which one cannot recall without laughing... was a Louvre compared to the exhibition on the boulevard des Capucines." And leaning heavily on his bourgeois prejudices, the same author concluded: "We have heard these painters debating — they and their admirers — at public auctions where their pictures do not sell, at the dealers on the rue Laffitte who pile up their rough drafts, always hoping for a favorable occasion which will certainly never come. We have listened to them developing their theories while considering with an air of superb pity the works which we habitually admire, full of scorn for anything that, through study, we have learned to love." ³⁹

"Our exhibition goes well," Pissarro wrote early in May from Pontoise to Duret, but since he could not have forgotten his friend's objections, it is likely that this was meant in bitter irony. "It is a success," he added. "The critics are devouring us and accuse us of not studying. I am returning to my work — this is better than reading [their comments]. One learns nothing from them."40

Indeed, the only thing to be learned from the critics was how to suffer the sting of their attacks and carry on just the same, accomplishing a task which more than any other required serenity. Yet this is easier said than done. The reviewers' blatant injustices or perfidious insinuations, their cruel sarcasms or vulgar mockeries find artists particularly vulnerable since their selfless devotion to their ideals leaves them

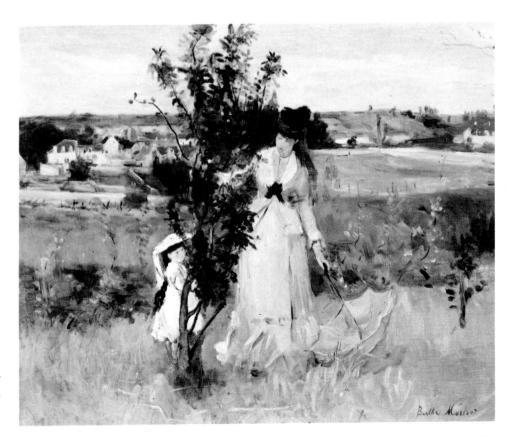

Morisot: *Hide-and-Seek*, 1873. 18×21½". Exhibited in the first impressionist show, 1874 (lent by Edouard Manet). Collection Mr. and Mrs. John Hay Whitney, New York.

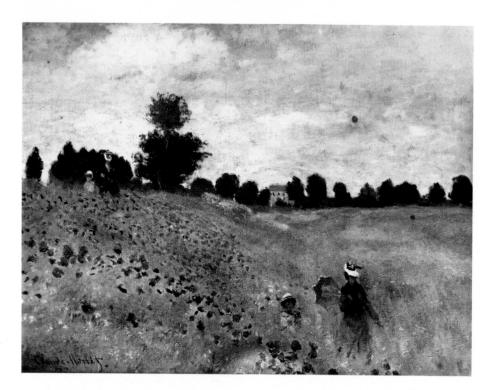

Monet: Wild Poppies, d. 1873. $19\frac{3}{4} \times 25\frac{5}{8}$ ". Possibly included in the first impressionist show. Musée du Louvre, Paris.

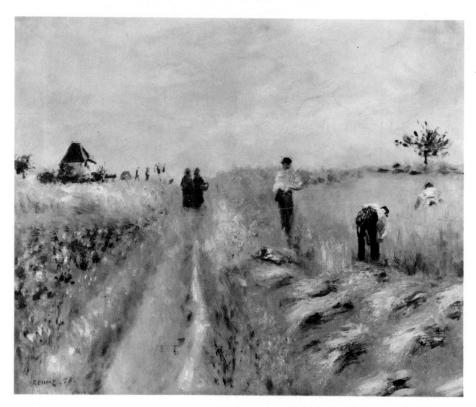

Renoir: Harvesters, d. 1873. $22\frac{7}{8} \times 28\frac{1}{2}$ ". Exhibited in the first impressionist show, 1874. Collection Bührle Family, Zurich.

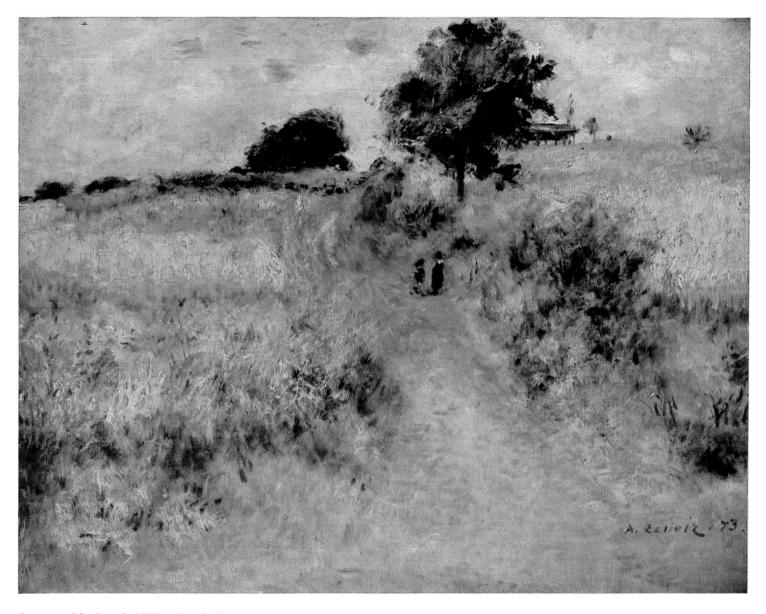

Renoir: Meadow, d. 1873. 18 $\frac{1}{2}\times24\frac{1}{8}''$. Collection Dr. Peter Nathan, Zurich.

ill-prepared for such baseless assaults. It requires tremendous courage and limitless faith to overcome such adversities; to find the necessary strength the individual has to draw on his reserve of vitality, a reserve better poured into his work. How hard it must be for the timid, and even for the self-confident and ambitious, for the poor, and even for the rich, to stand up under constant derision without being paralyzed in their creative efforts! This is not merely a question of right or wrong, it is a question of sensitivity exposed to merciless poundings. It is also an experience which, translated into everyday life, poses uncounted problems. To arise in the morning of a beautiful day, filled with eagerness and joy for the work ahead, and to read at the breakfast table shameless and stupid criticisms which accuse one of painting in a state of delirium tremens . . . that is more than enough to ruin the day if not the entire week. Few are the creators in literature, in art, or elsewhere who are impervious to ridicule and rudeness, who have the faculty of simply shrugging them off.41 And as if it were not enough to dampen their ardor through these offenses, the critics also seriously impair their material existence, since biting comments are hardly designed to encourage collectors to invest money in works publicly disparaged.

While some paintings were sold at the exhibition of the group, no record of the actual transactions seems to exist. It is known that Count Doria purchased Cézanne's Maison du pendu for 300 francs, although this sale is not mentioned in the society's financial report. The report merely indicates that 360 francs were earned in form of commissions on sales, which amounted to 10% of the price. Of these 360 francs, 100 came from Sisley's sales, 20 from Monet's, 18 from Renoir's, and but 13 from Pissarro's; the balance came from various other exhibitors. Boudin, Degas, and Berthe Morisot notably did not make any sales.⁴² In view of these meager results Renoir found himself unable to obtain 500 francs for his Loge, exhibited at Nadar's, for which his brother and a new model, Nini, had posed. The painter eventually pressured grumbling père Martin into paying 425 for it, the amount he desperately needed for his rent. But Martin now firmly refused to handle Pissarro's canvases and went so far as to tell everyone that the artist had no chance of getting out of the rut if he continued to paint in his "heavy, common style with that muddy palette of his." ⁴³

After the closing of the exhibition, Renoir, Latouche, and Béliard, members of the "Control Committee," assisted by the treasurer, A. Ottin, prepared a financial statement for the constituents of their society. From this statement it appeared that the general expenses for the exhibition (rent, decorators, light, posters, policemen, insurance, wages, etc.) had amounted to 9,272.20 francs. The receipts (entrance fees, catalogue sales, commissions on sales, and small gifts) plus shares bought by members in lieu of dues represented a total of 10,221.40, so that there remained a balance of 949.20 francs to which were to be added 2,359.50 in outstanding shares. While this may have looked well on paper, the fact was that the great majority of the thirty participants in the show did not even earn enough to pay for their annual dues of 61.25 francs.

After the exhibition Cézanne left suddenly for Aix and Sisley, invited by the singer Faure, went for four months to England (where he saw little of his relatives, who considered him queer). Duret, fearing that his friend Pissarro might be discouraged, sent him a long letter to Pontoise in which he tried to sum up the situation: "You have succeeded after quite a long time in acquiring a public of select and tasteful

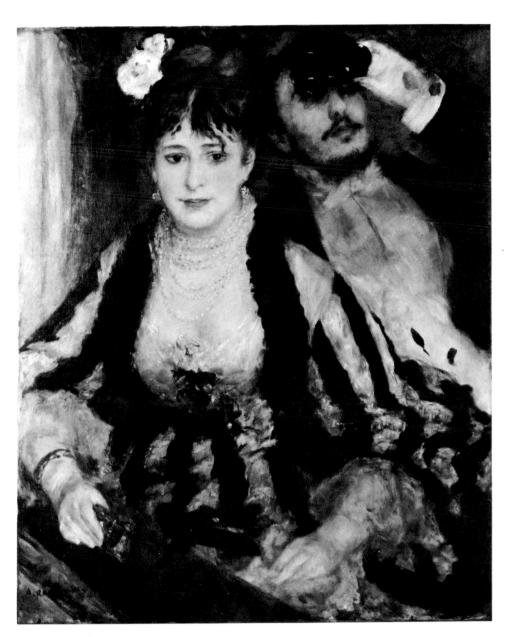

Renoir: La Loge, d. 1874. $31\frac{1}{2} \times 25$ ". Exhibited in the first impressionist show, 1874. Formerly with *père* Martin. Courtauld Institute Galleries, London.

art lovers, but they are not the rich patrons who pay big prices. In this small world, you will find buyers in the 300, 400, and 600 franc class. I am afraid that before getting to where you will readily sell for 1,500 and 2,000, you will need to wait many years. Corot had to reach seventy-five to have his pictures get beyond the 1,000 franc note.... The public doesn't like, doesn't understand good painting; the medal is given to Gérôme, Corot is left behind. People who know what it's all about and who defy ridicule and disdain are few, and very few of them are millionaires.

Which doesn't mean that you should be discouraged. Everything is achieved in the end, even fame and fortune, and while counting upon the judgment of connoisseurs and friends, you compensate yourself for the neglect of the stupid."44

Cézanne, whose father must have been confirmed in his pessimism concerning his son's talent by the reactions to the latter's first appearance before the public, seems to have accepted the situation with a sense of humor. He, too, wrote to Pissarro, informing him that the curator of the Aix museum, "impelled by a curiosity aroused by the Parisian newspapers," had asked to see his canvases. "To my assertion that on seeing my productions he would not have a very accurate idea of the progress of evil and that he ought to see the works of the great Parisian criminals, he replied: 'I am well able to conceive of the dangers run by painting when I see your assaults.' Whereupon he came over and when I told him, for instance, that you replaced modeling by the study of tones, and was trying to explain this to him by reference to nature, he closed his eyes and turned his back. But he said he understood, and we parted well satisfied with each other."45

Pissarro's situation meanwhile became so critical that he had to leave Pontoise and with his wife and children take refuge in Brittany where his wealthy friend Piette offered him hospitality on his large farm at Montfoucault. He therefore was absent when, on December 10, 1874, Renoir called the members of the society to a general assembly to be held on December 17 in his studio, 35 rue Saint-Georges. Present were Béliard, Bureau, Cals, Colin, Degas, Latouche, de Molins, Monet, A. and L. Ottin, Robert, Rouart, and Sisley. Having named Renoir president of the meeting, they listened to the treasurer's report and learned that, after paying all external debts, the liabilities of the association still amounted to 3,713 francs (money advanced by members), whereas only 277.99 remained in the till. Thus every member owed 184.50 francs for the payment of internal debts and in order to reestablish the operating fund. In view of these conditions, it appeared urgent to liquidate the society. This solution was proposed, voted upon, and adopted unanimously. It was decided that the amounts paid by some members as their dues for the second year would be returned to them and a committee of liquidation was named, composed of Bureau, Renoir, and Sisley.46

Thus ended the gallant enterprise of the group. Yet none seems to have regretted it. "What I have suffered is beyond words," Pissarro wrote a few years later to a friend. "What I suffer at the actual moment is terrible, much more than when I was young, full of enthusiasm and ardor, convinced as I am now of being lost for the future. Nevertheless, it seems to me that I should not hesitate, if I had to start over again, to follow the same path."⁴⁷

The term "impressionism," coined in derision, was soon to be accepted by the friends. In spite of Renoir's aversion to anything that might give them the appearance of constituting a new "school" of painting, in spite of Degas' unwillingness to admit the designation with regard to himself, and in spite of Zola's persistence in calling the painters "naturalists," the new word was there to stay. Charged with ridicule and vague as it was, "impressionism" seemed as good a term as any other to underline the common element in their efforts. No one word could be expected to define with precision the tendencies of a group of men who placed their own sensations above

Degas: The Pedicure (Josephine Balfour, New Orleans), d. 1873. Paper on canvas, $24\frac{1}{2}\times18\frac{1}{2}''$. Musée du Louvre, Paris.

any artistic program. Yet whatever meaning the word might have had originally, its true sense was to be formulated not by ironical critics but by the painters themselves. Thus it was that from among their midst — and doubtless with their consent — came the first definition of the term. It was one of Renoir's friends who proposed it, writing a little later: "Treating a subject in terms of the tone and not of the subject itself, this is what distinguishes the impressionists from other painters." 48

In their efforts to do this, and to find a form closer to their first impression of the appearance of things than had ever been achieved, the impressionists had created a new style. Having freed themselves completely from traditional principles, they had elaborated this style so as to be able to follow unhampered the discoveries made by their intense sensibilities. And in doing so they had openly renounced even the pretense of recreating reality. Rejecting the objectivity of realism, they had selected one element from reality — light — to interpret all of nature.⁴⁹

Their new approach to nature had prompted the painters gradually to establish a new palette and create a new technique appropriate to their endeavor to retain the fluid play of light. The careful observation of colored light appearing in a scene at a particular moment had led them to do away with the traditional dark shadows and to adopt bright pigments. It had also led them to ignore local colors, subordinating the abstract notion of local tones to the general atmospheric effect. By applying their paint in perceptible strokes, they had succeeded in blurring the outlines of objects and merging them with the surroundings. This method had further permitted introducing one color easily into the area of another without degrading or losing it, thus enriching the color effects. But, above all, the multitude of obvious touches and the contrasts among them had helped to express or suggest the activity, the scintillation of light and to recreate it to a certain extent on canvas. 50 Moreover, the technique of vivid strokes seemed best suited to their efforts to retain rapidly changing aspects. Since the hand is slower than the eye, which is quick to perceive instantaneous effects, a technique which permitted the painters to work rapidly was essential if they were to keep pace with their perceptions. Alluding to these problems, Renoir used to say, "out-of-doors one is always cheating." 51 Yet their "cheating" merely consisted in making a choice among the multitude of aspects which nature offered, in order to translate the miracles of light into a language of pigment and two dimensions, and also to render the chosen aspect with the color and the execution that came closest to their impression.

The public, obviously, was not yet ready to accept their innovations, but the impressionists, having tested their methods individually and together, knew that they had accomplished a great step forward in the representation of nature since the days of their masters, Corot, Courbet, Jongkind, and Boudin. The general hostility could not shake their convictions but it could and did make life miserable for them. Yet they stoically accepted, without ever deviating from their chosen path, a situation which obliged them to create in a void. If it took courage to enter upon a way of poverty, how much more was needed to continue for many years making unbelievable efforts without any encouragement? Such a decision required the strength to overcome one's own doubts and to progress with no other guide than oneself. Without hesitation the impressionists continued in complete isolation their daily efforts toward creation, like a group of actors playing night after night to an empty theater.

de Nittis: Horsewomen in the Bois de Boulogne, d. 1874. 13×9¾". Present whereabouts unknown.

NOTES

- 1 P. Alexis: Paris qui travaille, III, Aux peintres et sculpteurs, L'Avenir National, May 5, 1873.
- 2 Monet to Alexis, May 7, 1873; letter published in L'Avenir National, May 12, 1873.
- 3 Alexis in L'Avenir National, May 12, 1873.
- 4 On the Hoschedé sale see M. Bodelsen: Early Impressionist Sales 1874-94 in the Light of Some Unpublished 'procès-verbaux,' *Burlington Magazine*, June 1968; see also Pissarro's letters to Duret, quoted p. 301, and p. 308, note 24.
- 5 Duret to Pissarro, Feb. 15, 1874; see L. Venturi and L. R. Pissarro: Camille Pissarro, son art, son oeuvre, Paris, 1939, v. I, p. 33-34.
- 6 On the various periods of booms and depressions in France see S. B. Clough: France, A History of National Economics, New York, 1939, ch. VII.
- 7 Piette to Pissarro, summer 1873; see J. Rewald: Camille Pissarro, New York, 1963, p. 24-26.
- 8 See G. Rivière: Renoir et ses amis, Paris, 1921, p. 43-44. For different charter projects see the French edition of the present book: Paris, 1955, appendix, p. 358-364.
- 9 Castagnary commented that the enterprise "rests on an excellent basis. All the associates have equal rights, maintained by an administrative council of fifteen elected members, one third of which is renewed every year. The works are grouped according to size: the small ones to be hung beneath the large—the whole in alphabetical order; the letter with which to begin being drawn by lot. Under no circumstances will there be more than two rows of pictures." Castagnary: Exposition du boulevard des Capucines—Les impressionnistes, Le Siècle, April 29, 1874 (this article is not reprinted in Castagnary: Salons).
- 10 Information courtesy Oscar Reuterswärd, Stockholm.
- 11 See A. Vollard: Renoir, ch. VII.
- 12 See J. de Nittis: Notes et Souvenirs, Paris, 1895, p. 237.
- 13 Degas to Tissot [Feb.-March] 1874; see Degas Letters, Oxford, 1947, p. 38-40.
- 14 Cals to his friend J. Troubat, Honfleur, Oct. 6, 1879; see catalogue of exhibition: Honfleur et ses peintres, Musée Municipal, Honfleur, 1934, p. 11-13.
- 15 Degas to Bracquemond, March 1874; see Lettres de Degas, Paris, 1945, p. 18-20.
- 16 See M. Elder: Chez Claude Monet à Giverny, Paris, 1924, p. 49.
- 17 See L. Vauxcelles: Un après-midi chez Claude Monet, L'Art et les Artistes, Dec. 1905.

- 18 See J. Elias: Degas, Neue Rundschau, Nov. 1917.
- 19 For a summarized catalogue of the exhibition see L. Venturi: Archives de l'Impressionnisme, Paris, 1939, v. II, p. 255-256. In the catalogues of the group shows only titles—and occasionally lenders—were given, but neither dimensions nor dates. It therefore is not always possible to identify the exhibited works, especially since the artists did not show only recent canvases. Also, paintings were sometimes added or changed during the run of the exhibitions and, in other instances, works listed in the catalogue were not shown at all (Degas often announced more entries than he actually sent).
- 20 A list of expenditures and receipts of the Société, dated May 27, 1874 (French edition, op. cit., p. 366), names the following dues-paying members who had not participated in the exhibition: Beaume, Mettling, Grandhomme, Gilbert, Feyen-Perrin, and Guyot; but Bracquemond, who had shown with the group, is not listed.
- 21 Unpublished recollections of Edmond Renoir.
- 22 See M. Guillemot: Claude Monet, La Revue illustrée, March 15, 1898.
- 23 There exists some confusion as to the identity of the painting Impression, soleil levant, exhibited in 1874. It has generally been assumed (the first editions of the present book also asserted this) that the picture which was to become the origin of the word "impressionism" was the one belonging to G. de Bellio. Yet this canvas does not feature the "pointing shipmasts in the foreground" mentioned by the artist, and the sun seems to be setting rather than rising. Moreover, Monet-who never showed the same picture twice in the group exhibitions—listed in the catalogue of the fourth show in 1879: Effet de brouillard, impression, owned by M. de Bellio. This work (reproduced p. 317) thus cannot have been the one exhibited in 1874. The painting shown that year in the first group exhibition must have been another view of a similar subject, also painted in 1872 (reproduced p. 316). This latter canvas, originally $21\frac{1}{4} \times 25\frac{5}{8}$ ", was subsequently reduced by Monet and is now the same size as the de bellio *Impression*, that is, $19\frac{1}{2} \times 25\frac{1}{2}$. Information courtesy Daniel Wildenstein, New York.

At the Hoschedé sale of 1878, at which de Bellio purchased his *Impression*, the picture was catalogued as L'Impression. Soleil couchant; see Bodelsen, op. cit.

- 24 This was an early canvas, Le déjeuner; see p. 195, n. 68.
- 25 L. Leroy: L'exposition des impressionnistes, *Charivari*, April 25, 1874.
- 26 Latouche to Dr. Gachet, April 26, 1874; see P. Gachet: Le Docteur Gachet et Murer, Paris 1956, p. 58.

- 27 De Nittis to a friend, London, [April-May] 1874; quoted by A. Longhi in his introduction to the Italian edition of the present book: Storia dell' Impressionismo, Florence, 1949, p. XIV-XV. De Nittis himself became a victim of the bad faith of a critic unwilling to "take the trouble to examine" his works shown with the group. This critic praised his paintings exhibited at the Salon but called the four views of Naples at Nadar's, which the artist considered very carefully executed, "formless daubs."
- 28 Guichard to Mme Morisot [April-May 1874]; see J. Baudot: Renoir, ses amis, ses modèles, Paris, 1949, p. 57.
- 29 Three years later a "poetic" critic was to write: "Qui donc jette la pierre à l'impressionnisme?/C'est Manet/Qui donc, dans sa fureur, cri au charlatanisme?/C'est Manet/Et pourtant...qui donna le premier branle au schisme?/Tout Paris le connaît/Manet, encore Manet." H. Polday: Le Salon humoristique, Paris, 1877, quoted by Jamot, Wildenstein, Bataille: Manet, Paris, 1932, v. I, p. 95.
- 30 The Salon of 1874; unsigned letter from Paris, May 25, 1874, Appletons' Journal, June 20, 1874. On the other hand one of the rare reviewers who liked Monet's Boulevard des Capucines at the group show misspelled the artist's name as Manet, so that the latter gathered some praise to which he was not entitled; E. Chesneau in Paris-Journal, May 7, 1874, quoted by J. Lethève: Impressionnistes et Symbolistes devant la presse, Paris, 1959, p. 69-70.
- 31 J. Claretie: Le Salon de 1874, reprinted in Claretie: L'art et les artistes français contemporains, Paris, 1876.
- 32 S. Mallarmé: Le jury de peinture pour 1874 et M. Manet, La Renaissance Artistique et Littéraire, April 12, 1874; quoted in H. Mondor: Vie de Mallarmé, Paris, 1941, p. 355-356.
- 33 E. Zola: Deux expositions d'art au mois de mai, Le Messager de l'Europe [St. Petersburg], June 1876; reprinted in Zola: Salons, edited by F. W. J. Hemmings and R. J. Niess, Geneva-Paris, 1959, p. 175 (retranslated from the Russian).
- 34 Zola: L'Oeuvre, 1886; see Oeuvres complètes, Paris, 1927-1929, p. 135 and 138.
- 35 F. O'Squarre: Les Impressionnistes, Courrier de France, April 6, 1877.
- 36 E. d'H. [d'Hervilly]: L'Exposition du Boulevard des Capucines, Le Rappel, April 17, 1874.

- 37 A. Silvestre: Chronique des Beaux-Arts—Physiologie du refusé—L'exposition des révoltés, L'Opinion Nationale, April 22, 1874.
- 38 Castagnary: Exposition du boulevard des Capucines— Les impressionnistes, *Le Siècle*, April 29, 1874.
- 39 E. Cardon: Avant le Salon—L'Exposition des Révoltés, La Presse, April 29, 1874.
- 40 Pissarro to Duret, May 5, 1874; see Rewald: Paul Cézanne, New York, 1948, p. 102.
- 41 Nietzsche has analyzed the vulnerability of creators in *Ecce Homo*, paragraph 5, when mentioning that "absurd irritability of the skin in respect to pin pricks. One experiences a kind of distress when confronted with a lot of small things, and this seems to be caused by the enormous squandering of all defensive forces that is one of the conditions of every creative action... The little defensive mechanisms are thus abolished in a certain way...."
- 42 See financial statement in the French edition of the present book, op. cit., p. 365-367.
- 43 See A. Tabarant: Pissarro, Paris, 1924, p. 44.
- 44 Duret to Pissarro, June 2, 1874; see Venturi and Pissarro, op. cit., v. I, p. 34.
- 45 Cézanne to Pissarro, June 24, 1874; see Paul Cézanne, Letters, London, 1941, p. 97-98 (here newly translated).
- 46 See minutes of the General Assembly, Dec. 17, 1874, in the French edition of the present book, *op*, *cit.*, p. 368-369.
- 47 Pissarro to Murer [summer 1878]; see Tabarant, op, cit., p. 43.
- 48 G. Rivière: L'Exposition des Impressionnistes, L'Impressionniste, April 6, 1877; quoted in Venturi: Archives, op. cit., v. II, p. 309.
- 49 On the foregoing see Venturi: The Aesthetic Idea of Impressionism, *The Journal of Aesthetics*, Spring 1941, and Venturi: Art Criticism Now, Baltimore, 1941, p. 12.
- 50 On the foregoing see J.C. Webster: The Technique of Impressionism, a Reappraisal, *College Art Journal*, Nov. 1944.
- 51 See R. Régamey: La formation de Claude Monet, Gazette des Beaux-Arts, Feb. 1927.

X 1874-1877

ARGENTEUIL

CAILLEBOTTE AND CHOCQUET

AUCTION SALES AND FURTHER EXHIBITIONS

FIRST ECHOES ABROAD

DURANTY'S PAMPHLET "LA NOUVELLE PEINTURE"

Probably no single place could be identified more closely with impressionism than Argenteuil where, at one time or another, practically all of the friends worked but where, in 1874 particularly, Monet, Renoir, and Manet went to paint. After the closing of their exhibition, Monet again had trouble with his landlord, and it was Manet who, through friends of his, found him a new house in Argenteuil. Renoir made frequent visits there, once more painting at Monet's side, choosing the same motifs; eventually Manet himself decided to spend several weeks at Gennevilliers (where his family owned property) on the other bank of the Seine river, opposite Argenteuil. In July Zola complained to Guillemet: "I do not see anybody, am without any news. Manet, who is painting a study at Monet's in Argenteuil, has disappeared. And since I don't often go to the Café Guerbois, that's about all the information I have."

It was in Argenteuil, where he watched Monet paint, that Manet was definitely convinced by work done out-of-doors. He adopted brighter colors and a smaller touch but, less interested than Monet in pure landscape paintings, preferred to study people in the open. Using models or friends for his compositions, he placed them against natural backgrounds—gardens, shores, or river—attempting to achieve the unity of central figures and landscape surroundings which had already preoccupied Bazille, Monet, Renoir, and Berthe Morisot. Manet thus painted in Monet's garden the latter's wife and son under a tree, with Monet himself appearing at the left. When Renoir arrived and found Manet working while the others posed, he could not resist the charm of the scene and asked Monet for his palette, a canvas, and paints, so as to do the same motif at Manet's side. Monet later remembered that Manet began to observe Renoir "out of the corner of his eye and from time to time would approach the canvas. Then, with a kind of grimace, he passed discreetly close to me to whisper

Manet: Claude Monet, 1880. Brush and ink, $3\frac{3}{4} \times 3\frac{1}{2}$ ". Formerly collection Robert von Hirsch, Basel.

MONET: Manet Painting in Monet's Garden in Argenteuil, 1874. Formerly collection Max Liebermann.

in my ear, indicating Renoir: 'He has no talent at all, that boy! You, who are his friend, tell him please to give up painting.' "3 This remark, if it was actually made, can only reflect Manet's irritation at a moment of rivalry before the same subject, for he seems to have been genuinely fond of Renoir and had heretofore frequently expressed his liking for him, particularly when he had urged Fantin to put Renoir close to him for the composition of A Studio in the Batignolles Quarter (p. 196); moreover, Manet owned at least one painting by Renoir in addition to works by Sisley and Berthe Morisot (he was soon to acquire several paintings by Monet).

Renoir, in any case, seems to have been well satisfied with his painting, brushed in merely one sitting. Since it represented Monet's wife, he immediately offered it to his companion, who little by little accumulated a small collection of portraits of Camille, executed by himself and by Renoir. There existed among these three a close friendship, knit together through bad and happy days, to which Camille's quiet charm, Monet's realistic outlook, and Renoir's happy unconcern must have given a peculiar character both of intimacy and of contrast. Renoir always delighted in rendering the likenesses of his friends and did portraits of Sisley and Cézanne besides the more numerous ones of Monet and his wife.

The robust strength of Claude Monet's character and talent apparently impressed Manet and inspired in him a certain admiration. Whereas Manet could not help being deeply concerned with the attitude of the public, Monet, in spite of all his difficulties, remained superbly indifferent to success and, notwithstanding his ambitions, showed himself preoccupied solely with his art. In his Argenteuil paintings

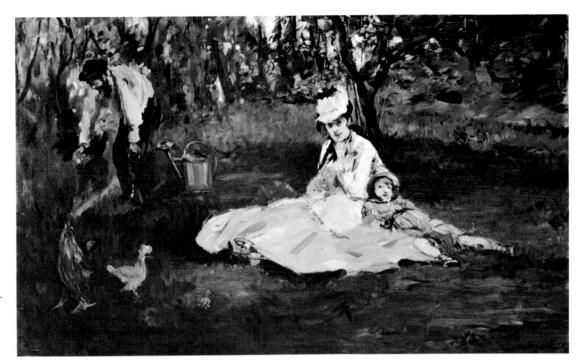

Manet: The Monet Family in Their Garden in Argenteuil, 1874. 24 × 34¼". Metropolitan Museum of Art, New York (Bequest of Joan Whitney Payson).

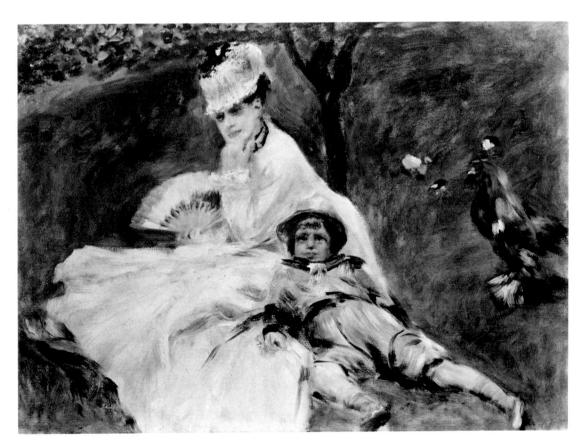

Renoir: Mme Monet and Her Son in Their Garden at Argenteuil, 1874. 20 × 27¼". Formerly collection Claude Monet. National Gallery of Art, Washington, D.C. (Ailsa Mellon Bruce Collection).

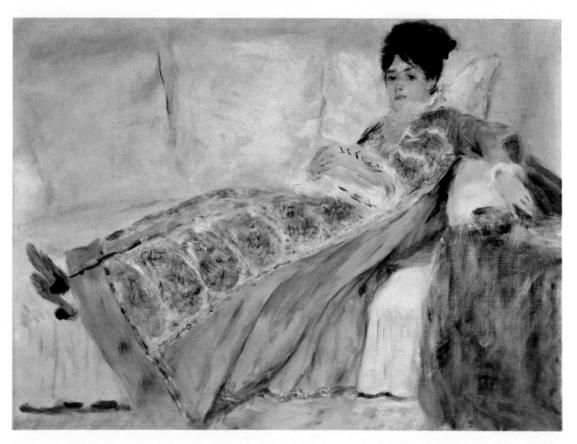

Renoir: Mme Monet Reading "Le Figaro." c. 1874. 21 × 28¼". Calouste Gulbenkian Foundation, Lisbon.

Renoir: Mme Monet, c. 1874. $14\frac{3}{8} \times 12\frac{7}{8}$ ". Collection Arturo Peralta Ramos, New York.

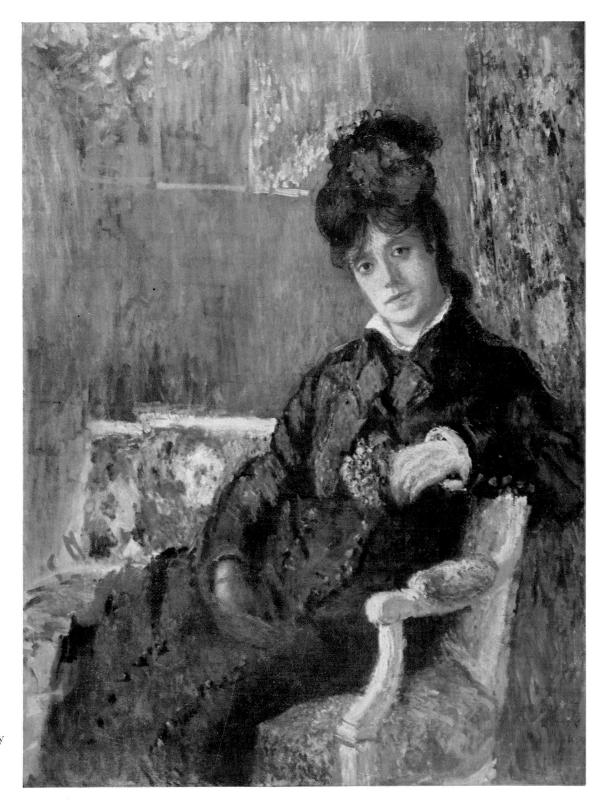

Monet: Portrait of Camille (the artist's wife), 1875-76. 46 × 35". Brandeis University Art Collection, Waltham, Mass. (Gift of Mrs. Nate B. Spingold).

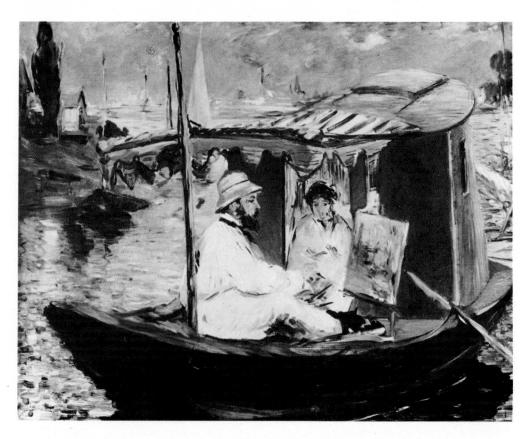

Manet: Monet Working on His Boat in Argenteuil, 1874. 32 × 39¼". Formerly in the Chocquet collection. Bayerische Staatsgemäldesammlungen, Munich.

of 1874 Monet achieved a greater luminosity than ever before. His colors became brighter and richer, his execution full of vigor. His effects were not, like those of Manet, provided by brilliant accents in generally low-keyed harmonies; the whole scale of his values was concentrated on the greatest purity of high colors, among which the brightest constituted the dominant note.

During the summer which they spent together at Argenteuil, Manet painted several portraits of Monet and his wife, whom he represented twice in Monet's boat-studio. Undoubtedly inspired by Daubigny's famous *Botin*, Monet had a similar boat constructed, large enough so that he could even sleep there. From this floating studio he liked to observe "the effects of light from one twilight to the next..." Monet later made trips with his boat, once taking his family all the way down the Seine to Rouen. In many of the paintings which he did in Argenteuil the little vessel is to be seen, with its wooden cabin of blue-green, anchored among the idle sailing boats.

Although he never mentioned the fact, it seems possible that Monet was helped in the construction of this boat by an Argenteuil neighbor with whom he became acquainted during this period. Gustave Caillebotte, an engineer, was a specialist in ship building and owner of several yachts; he also painted in his spare time.⁵ Their common enthusiasm for painting and for navigation soon created between the two men a bond, which Caillebotte immediately extended to Renoir, who from then on used to go sailing with him on the Seine.

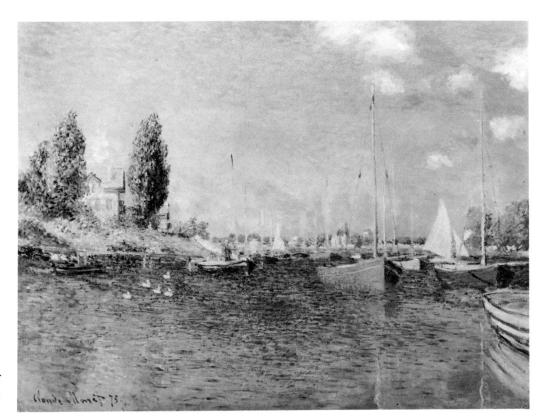

Monet: Boats at Argenteuil, d. 1875 (compare with landscape background in Manet's painting on opp. page). $21\frac{1}{4} \times 25\frac{1}{2}$ ". Fogg Museum of Art, Cambridge, Mass. (Maurice Wertheim Collection).

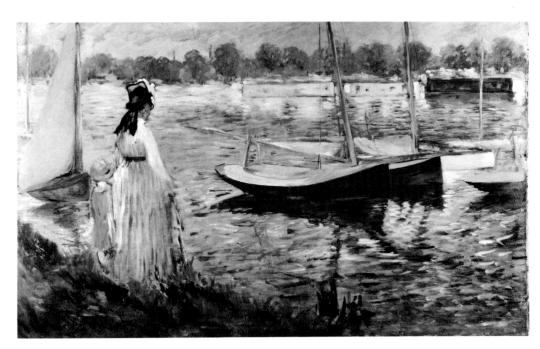

Manet: The Seine at Argenteuil, d. 1874. $24 \times 39_8^{3}$ ". Collection Lady Aberconway, England.

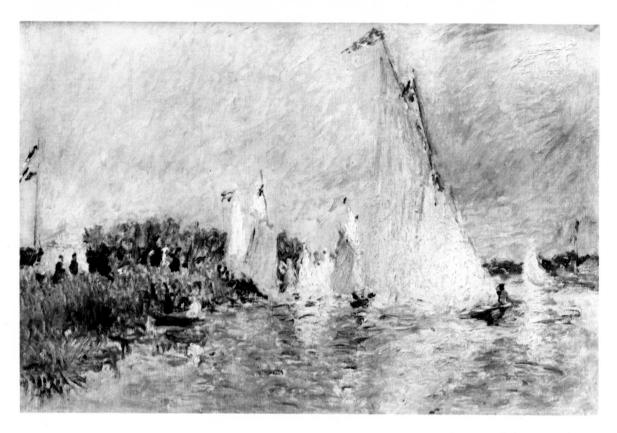

Renoir: Sailboats at Argenteuil, c. 1874. National Gallery of Art, Washington, D.C. (Ailsa Mellon Bruce Collection).

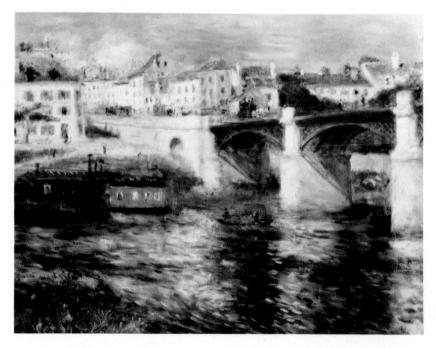

Renoir: Bridge near Paris, c. 1875. $20\frac{1}{2} \times 26$ ". Sterling and Francine Clark Art Institute, Williamstown, Mass.

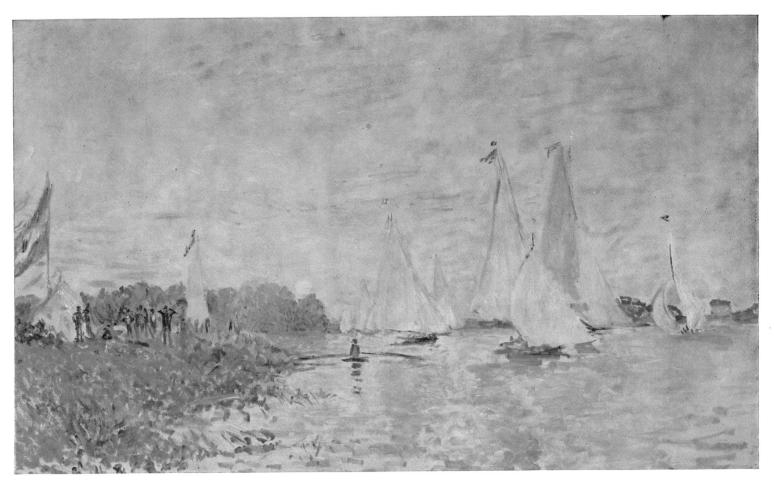

Monet: Sailboats at Argenteuil, c. 1874. $23\frac{1}{2} \times 38\frac{3}{4}$ ". Private collection, New York.

A bachelor, wealthy, living quietly outside Paris, cultivating his garden, painting, and building ships, Caillebotte was a modest man whose calm existence seems to have been radically changed by his new friendships. Not unlike Bazille in social position and character—with the same clear mind, dispassionate approach, and deeprooted loyalty—he was now to take in the group the place left vacant since Bazille's death: the place of a comrade and a patron. He began to buy works by Renoir and Monet, acquiring them both because he liked them and in order to help. And his help was sorely needed.

Only Renoir was able occasionally to sell some pictures, partly because he painted portraits and nudes besides landscapes, partly because his works had a pleasing character, a charm which sometimes was not denied even by those who objected to impressionism in general. But for the others, and particularly Monet, the situation was often critical, the more so as Durand-Ruel was in no position to assist them. Meanwhile living expenses were steadily rising, threatening their bare existence.

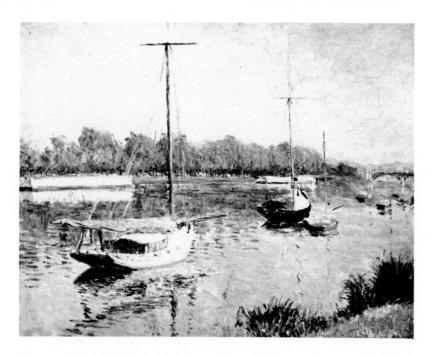

Photograph of Gustave Caillebotte.

"Everything is going up here in a frightening manner," one of Pissarro's aunts wrote to a nephew in St. Thomas, "beginning with taxes on rents, which have nearly doubled, and on food in general. The new taxes imposed since the war have produced a rise in price for all commodities. To give you an idea: coffee for which one used to pay 2 francs a pound is 3 francs 20 centimes; wine has gone from 80 centimes to 1 franc a litre; sugar from 60 to 80 centimes; meat has gone sky high; cheese, butter, eggs have gone up in proportion. By means of the greatest economy, one doesn't die, but fares badly. Business is at a standstill and our young people are sad."

Cézanne, however, seems not to have been overly sad, notwithstanding his marked failure at the group exhibition. In the autumn of 1874 he informed his mother: "Pissarro... is in Brittany, but I know that he has a good opinion of me who have a very good one of myself. I am beginning to consider myself stronger than all those around me, and you know that the good opinion I have of myself has only been reached after mature consideration. I must always work, but not in order to achieve the polish which is admired by imbeciles [this is obviously a reply to the criticisms that had been directed against him]. This finish which is commonly so much appreciated is really only the result of handwork and renders all work resulting from it inartistic and common. I must strive to complete a picture only for the pleasure of giving added truth and mastery. And believe me, the hour always comes when one gains recognition; then one has admirers far more fervent and convinced than those who are attracted only by empty appearances." Yet in spite of his confidence,

Cézanne added: "It is a very bad time for selling; all the bourgeois are unwilling to spend their sous, but this will end. . . . "7

Indeed, the public showed less interest in art than ever, and what interest existed was confined exclusively to the academic painters, whose works seemed to constitute secure investments. "You need a stiff dose of courage to keep hold of your brush in these times of neglect and indifference," Boudin wrote to a friend. In their desperate situation Renoir convinced Monet and Sisley that the best way to raise some money would be to organize an auction sale of a number of paintings at the Hôtel Drouot, where all Paris auctions take place under government supervision. The three friends were joined by Berthe Morisot, who in December 1874 had married Manet's brother Eugène. She did not actually need the money but was unwilling to remain aloof while her colleagues faced new trials. Determined to share whatever fate had in store for them, she bravely took part in the venture.

Auction sales organized by artists themselves were still an unusual thing; according to Ernest Chesneau, the painters took their cue from Daubigny who had arranged a successful auction the previous year at the Hôtel Drouot. It may also have been that the unexpected prices of the Hoschedé sale, early in 1874, prompted Renoir and his friends to try their luck, as Duret already had advised Pissarro to do.9

In order to help them gain public attention, Manet wrote a letter on behalf of his colleagues to the much feared, much read, but little liked Albert Wolff, critic for the *Figaro*, who called himself the wittiest man in Paris. His sharp tongue made or ruined reputations of the day. "My friends MM. Monet, Sisley, Renoir, and Mme Berthe Morisot," Manet explained, "are going to have an exhibition and sale at the Hôtel Drouot. One of these gentlemen is to bring you the catalogue and an invitation. He has asked me for this letter of introduction. You do not as yet, perhaps, appreciate this kind of painting; but you will like it some day. And it would be very kind of you to mention it a little in the *Figaro*." ¹⁰

The notice which subsequently appeared in the *Figaro* hardly came up to Manet's expectations. "Perhaps there is here some good business for those who are speculating upon art in the future," it read, with this reservation: "The impression which the impressionists achieve is that of a cat walking on the keyboard of a piano or of a monkey who might have got hold of a box of paints."

The auction took place on March 24, 1875. It included seventy-three works, of which Sisley contributed twenty-one, Monet and Renoir twenty each, and Berthe Morisot twelve (among them seven pastels and watercolors). In his introduction to the catalogue Philippe Burty stated: "Lovers of art who attentively follow the modern movement remember the exhibition organized last year on the boulevard des Capucines by a group of artists systematically excluded from the Salon. About one hundred works, differing as to personal expression, but conceived according to the same general line of thought, had been assembled for a special purpose. This purpose was achieved. The show attracted those whose opinions count and prevail; it received advice or praise from independent critics. This test was to be repeated in the spring of this year. It is to be hoped that the various obstacles with which it has met will not delay it beyond the coming fall. Meanwhile, the artists invite the public to the Hôtel Drouot." Commenting upon the paintings, Burty added: "They are like little fragments of the mirror of universal life, and the swift and colorful, subtle and charm-

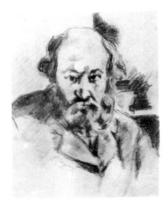

CÉZANNE: Self Portrait, c. 1875. Pencil, 5×6 ". Present whereabouts unknown.

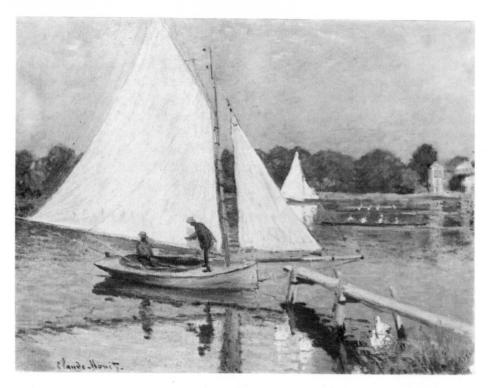

Monet: Sailboats at Argenteuil, 1873-74. $24 \times 32\frac{1}{2}$ ". Private collection, Paris.

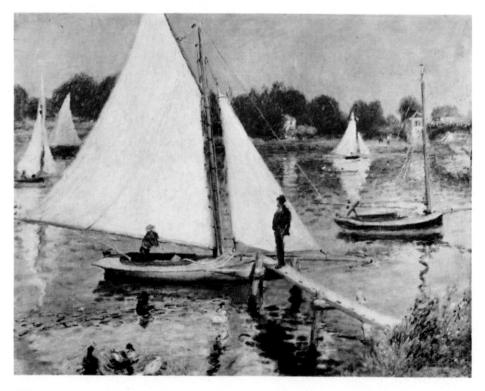

Renoir: Sailboats at Argenteuil, $1873-74.\ 20\times26''$. Portland Art Museum, Ore.

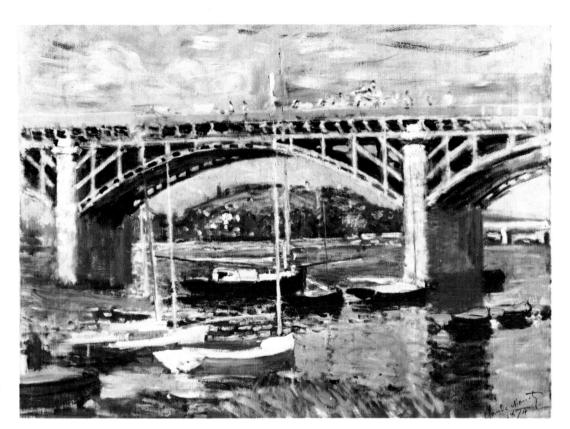

Monet: The Argenteuil Bridge, d. 1874. $22\frac{7}{8} \times 31\frac{1}{2}$ ". Bayerische Staatsgemäldesammlungen, Munich.

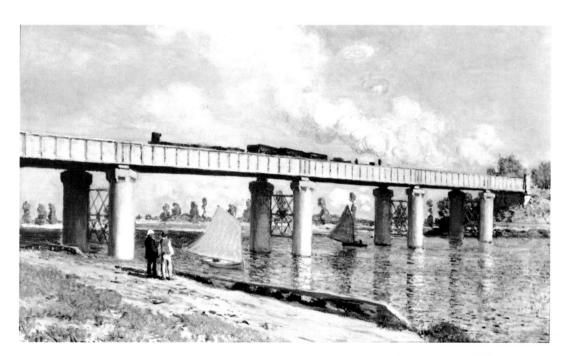

Monet: The Railroad Bridge at Argenteuil, 1875. $23\frac{3}{4} \times 38\frac{3}{4}$ ". Collection Mr. and Mrs. Sidney R. Barlow, Beverly Hills, Calif.

ing things reflected in them well deserve our attention and our admiration."12

The sale, at which Durand-Ruel officially assisted in the capacity of expert, became the scene of unprecedented violence. According to his reminiscences, the auctioneer was obliged to summon the police to prevent the altercations from degenerating into fist fights. The public, exasperated by the few defenders of the unfortunate exhibitors, wanted to obstruct the sale and howled at each bid.¹³ Unable to buy anything for himself, Durand-Ruel was the powerless witness of this spectacle and saw the paintings of his friends sell for practically nothing. However, he bought back for them a number of canvases, for which the bids hardly covered the cost of the frames. Indeed, he had taken the precaution of ordering expensive frames and suspected that many bidders were more attracted by them than by the paintings.

Berthe Morisot obtained relatively the best prices, an average of 250 francs for her oils, the highest bid being 480, the lowest 80 francs. Monet's canvases reached a total of 4,665 francs, with bids varying between 165 and 325, the average being 233 francs. Sisley came next with a total of about 2,500 francs; his paintings, among them several recent ones done in England as well as one with the ominous title Impression, fetched bids between 50 and 300 francs, the average being but 122. Renoir, surprisingly enough, obtained the lowest prices. Half of his twenty paintings did not even reach 100 francs and several had to be bought back by him. Thus he did not pocket the total of 2,250 francs at which his works were knocked down and his average of 112 francs was less than half of Monet's. And yet among his paintings were his early large Paris view with the Pont des Arts (p. 167) which sold for 70 francs, a small version of the Loge exhibited at Nadar's, an important canvas, La Source, which he decided to keep because it brought only 110 francs, ¹⁴ and the Pont Neuf (p. 280) which reached 300 francs, his highest bid. The net result of the sale was about 11,500 francs (this amount including the works bought back by the artists); the average price per canvas—not counting Berthe Morisot's pastels and watercolors—was around 160 francs [100 francs of the period were the equivalent of about 250 nouveaux francs or approximately \$50 today]. The artists had not only seen their paintings go for less than half of what they had obtained before, they had again exposed themselves to ridicule, thus doubly damaging their chances of selling directly to collectors.

As one of the newspapers reported the event: "We had good fun with the purple landscapes, red flowers, black rivers, yellow and green women, and blue children which the pontiffs of the new school presented to the admiration of the public." 15

Among those who bravely tried to push the bids and acquire some canvases were Houssaye and the critic Chesneau, Degas' friends Rouart and Hecht, as well as Hoschedé, still an inveterate collector. Duret and Caillebotte probably were present though they did not make any purchases. Monet, Renoir, and Sisley bought back some works under their own names, as did Eugène Manet for his wife Berthe Morisot. There also appeared at the sale a man unknown to any of them, Victor Chocquet. He subsequently told Monet that he had wished to visit the exhibition at Nadar's but that friends had dissuaded him. They had not been able to keep him away from the sale where, however, he bought nothing.

A modest chief supervisor in the customs administration, Chocquet had the spirit of the true collector, preferring to make his discoveries for himself, taking as his guide

Daumier: Public Sale at the Hôtel Drouot, Paris, 1863. Woodcut.

Daumier: Before the Auction, 1863. Woodcut.

Renoir: *Mme Chocquet*, d. 1875. $28\frac{3}{4} \times 23\frac{3}{8}$ ". Staatsgalerie, Stuttgart.

Renoir: Victor Chocquet, c. 1875. $18 \times 14\frac{1}{4}$ ". Fogg Art Museum, Cambridge, Mass. (G. L. Winthrop Bequest).

only his own taste and pleasure, never thinking of speculation, and wholly uninterested in what others did or thought. Although his resources were limited, he had lovingly brought together through the years a collection of works by Delacroix. He could not forget that thirteen years earlier the aging Delacroix had declined to paint a portrait of his wife; this time he was to take no chances. Having detected in Renoir's canvases certain qualities that reminded him of his idol, he wrote to him the very evening after the sale. "He paid me all sorts of compliments on my painting," Renoir later remembered, "and asked me if I would consent to do a portrait of Mme Chocquet." Renoir immediately accepted. Shortly afterward he met Chocquet in his apartment on the rue de Rivoli, overlooking the Tuileries Gardens, in order to arrange for the sittings. The collector begged him to have his wife pose in such a manner, against a wall of the room, that one of his Delacroix paintings would appear in the portrait. "I want to have you together, you and Delacroix," he explained.¹⁷

Renoir was deeply touched by the sincerity, the enthusiasm, the warmth of Chocquet. A close friendship soon developed between them, and Renoir subsequently did two portraits of the collector. The artist was eager to introduce his new patron

Guillaumin: The Seine at Charenton, d. 1878. 23\sum_8 \times 39\sum_8". Musée du Louvre, Paris.

to his friends, for such was their spirit of comradeship that none ever thought only of himself but always tried to let the others benefit from new acquaintances. No matter how urgently any one of them might need to make a sale, he never failed to share with the rest of the group the benefits of a newly won supporter, even advising the others as to the prices they might charge. Manet himself would occasionally hang canvases by his colleagues in his studio where they might be seen by prospective buyers. It thus seemed only natural for Renoir to take Chocquet to Tanguy's small shop in order to show him some of Cézanne's paintings.

In spite of his meager allowance Cézanne was better off than the others, for he had at least a certain fixed amount to count on. He was living in 1875 on the quai d'Anjou in Paris, next to Guillaumin, in whose company he occasionally painted on the Seine quais or in the suburbs. Renoir knew that nothing could mean more to him than to find an admirer, particularly since Cézanne lived in much greater isolation than the

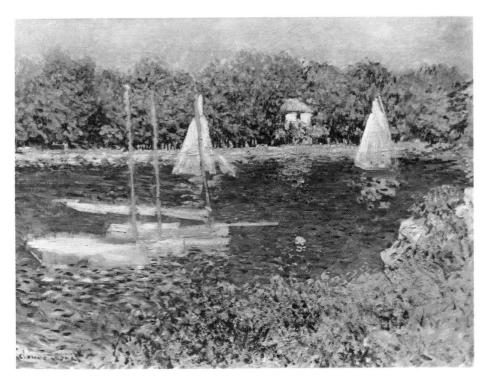

Monet: Basin at Argenteuil, c. 1874. $20\frac{7}{8} \times 28\frac{3}{8}$ ". Museum of Art, Rhode Island School of Design, Providence.

Sisley: Boats at Anchor, Argenteuil, c. 1874. $11\frac{3}{8} \times 14\frac{3}{8}$ ". Private collection, Paris.

Sisley: Port-Marly, d. 1875. $21\frac{1}{4} \times 25\frac{5}{8}$ ". Formerly owned by Count Doria. Collection Mr. and Mrs. Neison Harris, Chicago.

others and had fewer friends with whom to share the good opinion he had of himself (an opinion which not unfrequently gave way to deep depressions). Chocquet, if he responded to Cézanne's art, could become an important factor in the painter's life. And Renoir had guessed right. At Tanguy's, Chocquet immediately acquired one of Cézanne's canvases, exclaiming: "How nice this will look between a Delacroix and a Courbet." A little later the collector met Cézanne through Renoir, and Cézanne in turn took Chocquet for lunch to Monet's. Upon being introduced to Monet, Chocquet said with tears in his eyes: "When I think of how I have lost a year, how I might have got to know your painting a year sooner! How could I have been deprived of such a pleasure!" 18

Renoir apparently was the only member of the group who in 1875—while the auction sale was being prepared—submitted once again to the verdict of the jury. But he did not have any more luck than in 1873. "I hear," Edmond Maître noted early in April in his diary, "that Renoir has been rejected at the Salon and also that there is question of an exhibition of the *Refusés* under the tutelage of the administration." Obviously considering that such an exhibition would prove more useful to his friend than the group show at Nadar's, Maître added: "I shall advise Renoir to take advantage of this occasion; the protection of the State always has to be accepted in France and it does no harm if an exposition of *Refusés* benefits from official patronage. A picture has to be seen at all costs, as Fantin says." Renoir definitely shared this view, yet no exhibition of rejected works seems to have been organized that year.

Cézanne: Turning Road, c. 1877. $18\frac{7}{8} \times 23\frac{1}{4}$ ". Present whereabouts unknown.

Guillaumin: Turning Road, c. 1877. $18\frac{1}{8} \times 21\frac{5}{8}$ ". Collection Dir. Johannes Schröder, Essen.

Manet: Boating at Argenteuil, 1874. $38\frac{1}{8} \times 51\frac{1}{4}$ ". Exhibited at the Salon of 1879. Metropolitan Museum of Art, New York (H. O. Havemeyer Collection).

In order to forestall a refusal, Manet sent only one canvas to the Salon of 1875, a sunlit painting executed at Argenteuil the preceding summer. Although admitted, his work again became the subject of violent attacks. Castagnary thereupon gave vent to his indignation. "Hasn't Manet deserved a medal after the many years during which he has exhibited at the Salon?" the critic asked. "He is the head of a school and exercises an indisputable influence on a certain group of artists. Due to this fact alone his place is secure in the history of contemporary art. The day when one wants to write about the evolutions or deviations of French painting in the 19th century, one may neglect M. Cabanel, but one will have to take M. Manet into account "20

Zola who, thanks to Turgenev, had found an outlet in Russia and had become correspondent for the *Messager de l'Europe* of Saint-Petersburg, a position he was to hold for several years, wrote a long article on the Salon in which he tried to familiarize his Russian readers with the general situation of the art world in France. He spoke

of the prevailing anarchy of artistic tendencies, resulting from the defeat of academic traditions and from the triumphs of romanticism and realism in whose wake all new endeavors should be accepted as foreboding of a great regeneration. After deploring the death of such masters as Delacroix, Rousseau, Millet, and Corot²¹ (he also counted Courbet, exiled in Switzerland, among those who had passed away), Zola expressed hope in the genius of the future who, according to him, had not yet appeared on the scene. Scorning the official painters, and especially Cabanel, he reported that their smallest pictures reached insane prices, that many of them worked for exportation, that each year great numbers of their canvases were shipped to America and elsewhere, while even their most insignificant sketches found their way to England. But he insisted that—these deplorable practices notwithstanding—one should not speak of the decadence of France since new forces were at work which, after the turmoil that had taken place in science, politics, history, and literature, were now accomplishing a revolution. He spoke admiringly of Puvis de Chavannes, whose talent had escaped academic influences, and of Manet, interested mainly in the

Gonzalès: A Loge at the Théâtre des Italiens, c. 1874. $38\frac{5}{8} \times 51\frac{1}{4}$ ". Rejected by the Salon jury in 1874, exhibited at the Salon of 1879. Musée du Louvre, Paris.

Renoir: Claude Monet Reading, 1872. $24 \times 19\frac{5}{8}$ ". Musée Marmottan, Paris (Bequest of Michel Monet).

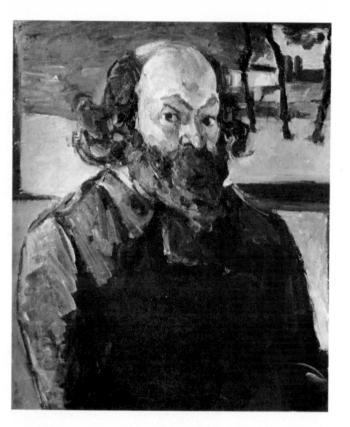

Cézanne: Self Portrait, 1875-76. $25\frac{3}{4} \times 20\frac{7}{8}$ ". Collection J. Laroche, Paris (promised to the Musée du Louvre).

truth of general impressions rather than in polished details that tend to disappear at a distance. Like Castagnary he described Manet as head of a group of artists to which the future belonged. He mentioned in passing his friends Fantin and Guillemet, who were slowly achieving recognition at the Salon. (Guillemet's success prompted Cézanne to write to Pissarro: "This proves that by following the path of virtue, one is always rewarded by man though not by art."²²) Zola terminated his long article by saying that "somewhere perhaps, in Paris, in a gloomy studio, the great and expected talent is already at work on canvases which the juries will refuse for twenty years but which will eventually radiate as the revelation of a new art."²³ Wasn't the inference of this conclusion that, in Zola's mind, neither Monet nor Renoir, certainly not Cézanne, and not even Manet represented this herald of art reborn?

Undaunted by their misfortunes, the impressionists carried on throughout 1875, not so much in gloomy studios as out in the open. Pissarro returned to Pontoise where, in August 1875, assisted by a painter named Alfred Meyer, he formed a new artistic society, L'Union, which supposedly was to replace the one dissolved in December 1874. Among those who had exhibited with the impressionist group and who joined

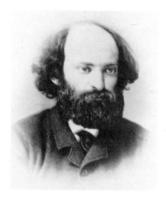

Photograph of Paul Cézanne, c. 1875.

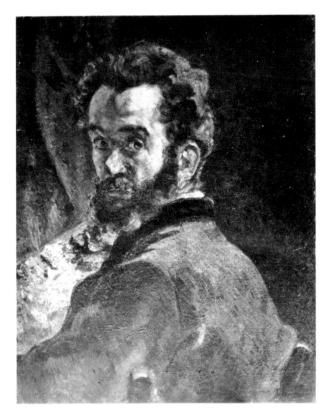

Guillaumin: Self Portrait, 1878. $23\frac{5}{8} \times 19\frac{5}{8}$ ". Van Gogh Foundation, Amsterdam.

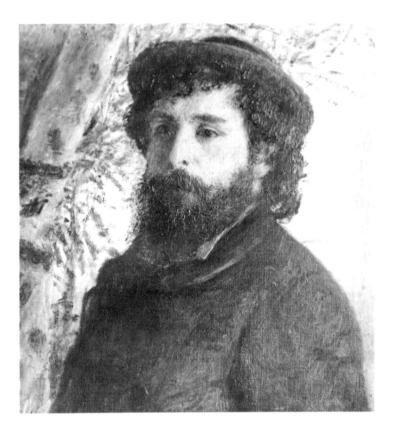

Renoir: Claude Monet (detail), d. 1875. 33 $\frac{3}{4} \times 24$ ". Musée du Louvre, Paris.

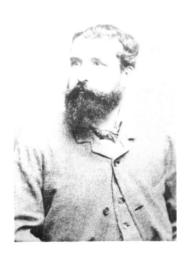

Photograph of Claude Monet, 1877.

the new association were Cézanne, Guillaumin, Béliard, and Latouche. In the fall, Pissarro left once more for the hospitable roof of his friend Piette, regretting that he was prevented from painting figure studies in the fields because he had no money for models. Cézanne remained in Paris, pursuing his work, occasionally in the company of his neighbor Guillaumin. Sisley settled at Marly where he executed some of his most serene landscapes. Degas continued to paint dancers and portraits. Renoir seems to have stayed mostly in Paris after a sordid incident had ended his friendship with the Le Coeur family.²⁴ Monet lived precariously at Argenteuil where since July his wife was ailing. Yet neither her illness nor the continual threats of his landlord could prevent him from working. During the winter he was once more to devote himself to painting snow scenes.

The year 1875 was a particularly thorny one for Monet. Time and again he was obliged to borrow money from various friends and acquaintances. On several occasions he asked Manet for help, writing in June: "It's getting more and more difficult. Since day before yesterday, not a cent left and no more credit, neither at the butcher nor the baker. Although I have faith in the future, you see that the

present is very painful.... Could you possibly send me by return mail a 20-franc note? That would help me for the moment."25

In the fall of 1875 Manet left for a short trip to Venice. Whenever he was unable to assist his friend, Monet's urgent appeals went out to others, such as the Rumanian Georges de Bellio, who had bought one of his *Impression* paintings of Le Havre (p. 317): "I am as unhappy as can be; my things will be sold forcibly at the very moment when I hoped to straighten out my affairs. Once on the street and with nothing left, there will only be one thing for me to do: to accept an employment, whatever it may be. That would be a terrible blow. I don't even want to think of it and am making a last attempt. With 500 francs I can save the situation. I have about twenty-five canvases left. I shall give them to you at that price. In taking them you would save me."²⁶

Since the number of his supporters was very limited, Monet was constantly obliged to approach the same persons. If it was not Manet or de Bellio, it was Zola, whose novels began to sell slowly, although he was far from earning much, or else Duret, Caillebotte, who prevailed upon de Nittis to buy several of Monet's pictures, ²⁷ Hoschedé, the singer Faure, Dr. Gachet, or Chocquet.

Great as his admiration was for both Monet and Renoir, Victor Chocquet's real enthusiasm was for Cézanne, who painted several portraits of him but never any of

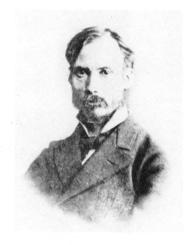

Photograph of Auguste Renoir, c. 1895 (?).

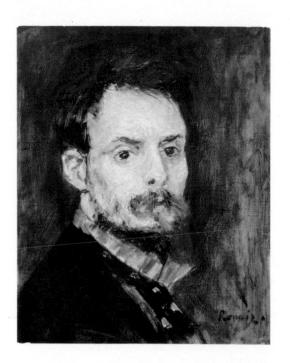

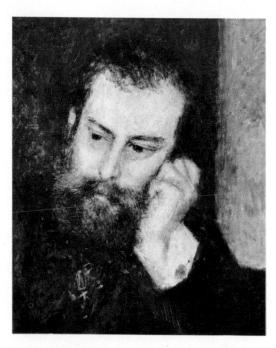

Left, Renoir: Self Portrait, c. 1875. $15\frac{1}{2} \times 12\frac{1}{2}$ ". Formerly collection G. de Bellio. Sterling and Francine Clark Art Institute, Williamstown, Mass. Right, Renoir: Alfred Sisley (detail), c. 1874. $25\frac{5}{8} \times 21\frac{1}{4}$ ". Exhibited at the third impressionist show, 1877. Art Institute of Chicago (Mrs. L. L. Coburn Collection).

 $\textbf{Sisley: Road at Louveciennes, 1875. 15} \times 21\frac{1}{4}". \textbf{ The Lazarus Phillips Family Collection, Montreal.}$

his wife. During the long years of their friendship Chocquet was to add a considerable number of Cézanne's works to his collection of Delacroix, rounding this out by a certain number of canvases by the other impressionists, particularly Renoir and Monet.²⁸

Meeting Chocquet was practically the only benefit the friends drew from their sale in 1875. The pitiful prices obtained apparently prompted them to revise their plan of holding another group exhibition in the spring of that same year, a plan which Burty had announced in his introduction to the catalogue. Only in 1876 did they decide to approach the public with a second show. But the number of participants was considerably smaller this time than the first, since many of the former exhibitors did not care to compromise themselves again in the company of the impressionists.

De Nittis had not forgotten the ill treatment he had suffered; besides, he had set his heart on the Legion of Honor and therefore stayed away. Astruc and sixteen others did likewise, among them Bracquemond and Boudin. Guillaumin, whose job had prevented him from doing much painting, did not participate. Nor did Cézanne, who was again in the South and had resolved to send a painting to the Salon. But he soon informed Pissarro that "a certain letter of rejection has been sent me. This is neither new nor astonishing."²⁹ On the other hand Degas' friends Lepic, Levert, and Rouart were present again, and there were even some newcomers: Caillebotte—recommended by Renoir—Desboutin, Legros (who still lived in England where Pissarro had met him in 1871), Degas' friend Tillot and a few others. Pissarro, whose new association apparently could not yet afford its own show, remained with the group, as did Béliard. Manet declined once more to join his friends, although the jury had refused both paintings he had sent to the Salon: Le linge¹⁴ and L'artiste, a portrait of Marcellin Desboutin. Eva Gonzalès had been accepted and exhibited as "pupil of Manet."

Outraged by his rejection, Manet invited the public to his studio, where in April he showed the canvases turned down by the jury and where thousands of people came to see them.³⁰ The artist's gesture of defiance astonished the press which scoffingly commented: "The jury has done him the favor of refusing his two entries and thus has revived his popularity in the art world of the *brasseries*. But why didn't he favor the exhibition of his brothers and friends, the impressionists, with his two paintings? Why does he act as a lone wolf? This is ingratitude. With what luster wouldn't the presence of M. Manet have endowed the *cenaculum* of artistic rogues who proudly call themselves *impressionists* and who are going to hold up their banner in firm hands until the day when they will finally have learned to draw and to manipulate paint brushes, if ever that day dawns."³¹

Like Manet, the impressionists opened their exhibition in April; it was held at Durand-Ruel's gallery, 11 rue Le Peletier, and comprised 252 works by twenty participants. This time the painters grouped their entries by artists rather than mingling them. Degas was represented by more than twenty-four works, ³² including *Portraits in an Office*, painted in New Orleans (p. 276), and compositions of washerwomen; Monet showed eighteen paintings, many of which were lent by the singer Faure, who had followed Durand-Ruel's advice and begun to invest in his canvases; there was also one landscape lent by Chocquet. The canvas of Monet which attracted the greatest attention was entitled *Japonnerie* and represented a young woman in a

Photograph of Berthe Morisot, 1875.

Desboutin: Edouard Manet, 1876. Etching. Davison Art Center, Wesleyan University, Middletown, Conn.

Manet: The Artist (Marcellin Desboutin), d. 1875. 77 × 51\frac{3}{8}". Rejected by the Salon jury in 1876. Museu de Arte Moderne, São Paulo, Brazil.

richly embroidered kimono³³; it was sold for the high price of 2,000 francs. Berthe Morisot figured in the catalogue with seventeen works. Pissarro sent a dozen canvases, one of which belonged to Chocquet and two to Durand-Ruel. Renoir had fifteen paintings in the exhibition, of which no less than six were owned by Chocquet (one was apparently his portrait). There were eight landscapes by Sisley. Manet again lent one painting, Renoir's portrait of Bazille (p. 183).³⁴

Victor Chocquet did more than lend pictures; he devoted all his time and energy

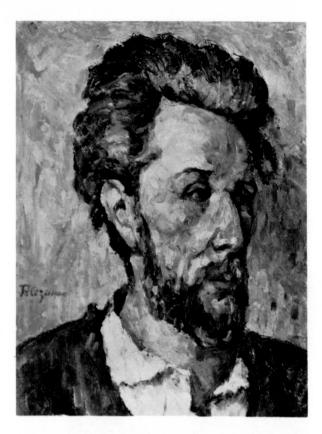

CÉZANNE: Victor Chocquet, 1876-77. $18\frac{1}{4} \times 14''$. Exhibited at the third impressionist show, 1877. Collection Lord Rothschild, London.

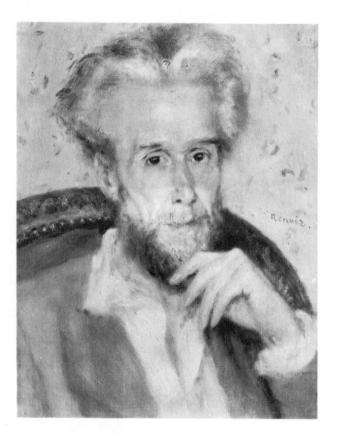

Renoir: Victor Chocquet, c. 1875. $18\frac{3}{8} \times 14\frac{3}{8}$ ". Possibly included in the second impressionist show, 1876. Oskar Reinhart Foundation, Winterthur, Switzerland.

to the show. "He turned into a kind of apostle," Duret later said. "One by one he took hold of the visitors he knew and insinuated himself with many others in order to persuade them of his convictions, to make them share his admiration and pleasure. It was a thankless task.... But Chocquet was not to be disheartened. I remember having witnessed how he tried to sway well-known critics—such as Albert Wolff—and hostile artists who had come merely in a spirit of disparagement." 35

Altogether fewer visitors attended this exhibition than the first one, but the daily press was as violent as before.³⁶ The general attitude was reflected in a widely read article by Albert Wolff, who had remained insensitive to Chocquet's efforts (it was even said that upon leaving the show he asked to have his entrance fee of 50 centimes refunded).

"The rue Le Peletier has bad luck," Wolff wrote in *Le Figaro*. "After the Opera fire, here is a new disaster overwhelming the district. At Durand-Ruel's there has just opened an exhibition of so-called painting. The inoffensive passer-by, attracted by the flags that decorate the façade, goes in, and a ruthless spectacle is offered to his dismayed eyes: five or six lunatics—among them a woman—a group of unfor-

tunate creatures stricken with the mania of ambition have met there to exhibit their works. Some people burst out laughing in front of these things—my heart is oppressed by them. Those self-styled artists give themselves the title of non-compromisers, impressionists; they take up canvas, paint, and brush, throw on a few tones haphazardly and sign the whole thing.... It is a frightening spectacle of human vanity gone astray to the point of madness. Try to make M. Pissarro understand that trees are not violet, that the sky is not the color of fresh butter, that in no country do we see the things he paints and that no intelligence can accept such aberrations! Try indeed to make M. Degas see reason; tell him that in art there are certain qualities called drawing, color, execution, control, and he will laugh in your face and treat you as a reactionary. Or try to explain to M. Renoir that a woman's torso is not a mass of flesh in the process of decomposition with green and violet spots which denote the state of complete putrefaction of a corpse!... [see p. 387].

"And it is this accumulation of crudities which is shown to the public, with no thought of the fatal consequences that may result! Yesterday a poor soul was arrested in the rue Le Peletier, who, after having seen the exhibition, was biting the passers-by. Seriously, these lunatics must be pitied; benevolent nature endowed some of them with superior abilities which could have produced artists. But in the mutual admiration of their common frenzy the members of this group of vain and blustering extreme mediocrity have raised the negation of all that constitutes art to the height

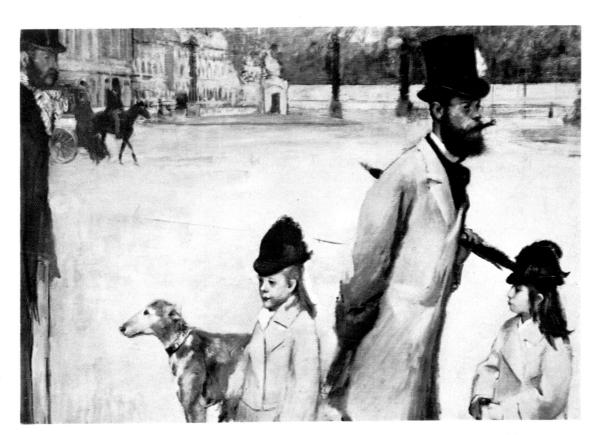

DEGAS: Place de la Concorde, Paris (Viscount Lepic and his daughters), c. 1875. $31\frac{3}{4} \times 47\frac{3}{8}$ ". Apparently destroyed during World War II.

of a principle: they have attached an old paint rag to a broomstick and made a flag of it. Since they know perfectly well that complete absence of artistic training prevents them from ever crossing the gulf that separates an effort from a work of art, they barricade themselves within their lack of capacity, which equals their self-satisfaction, and every year they return, before the Salon opens, with their ignominious oils and watercolors to make a protest against the magnificent French school which has been so rich in great artists.... I know some of these troublesome impressionists; they are charming, deeply convinced young people, who seriously imagine that they have found their path. This spectacle is distressing...."³⁷

It seems that after reading this article, Berthe Morisot's husband, Eugène Manet, had to be dissuaded from provoking Wolff to a duel.

There were, of course, also favorable reviews, but these—more often than not—appeared in poorly distributed publications, such as the short-lived *L'Esprit Moderne* in whose last issue a very young and completely unknown critic courageously extoled the painters. He drew attention to their difficulties, to the many studies which had been necessary for obtaining any results (no other reviewer had ever been willing to grant that impressionist art was based on long years of study), to the evolution of their intelligences, which originally had taken their start from a completely false point of view (that of the *Ecole des Beaux-Arts*), and also to their will-power and abnegation.³⁸ But scarcely anybody appears to have read Georges Rivière's comments.

An unexpected echo of the show is to be found in a report which Henry James sent from Paris to the New York Tribune: "An exhibition for which I may at least claim that it can give rise (at any rate in my own mind) to no dangerous perversities of taste is that of the little group of the Irreconcilables-otherwise known as the 'Impressionists' in painting. . . . I have found it decidedly interesting. But the effect of it was to make me think better than ever of all the good old rules which decree that beauty is beauty and ugliness ugliness, and warn us off from the sophistications of satiety. The young contributors to the exhibition of which I speak are partisans of unadorned reality and absolute foes to arrangement, embellishment, selection, to the artist's allowing himself, as he has hitherto, since art began, found his best account in doing, to be preoccupied with the idea of the beautiful. The beautiful, to them, is what the supernatural is to the Positivists—a metaphysical notion, which can only get one into a muddle and is to be severely let alone. Let it alone, they say, and it will come at its own pleasure; the painter's proper field is simply the actual, and to give a vivid impression of how a thing happens to look, at a particular moment, is the essence of his mission. This attitude has something in common with that of the English Pre-Raphaelites, twenty years ago, but this little band is on all grounds less interesting than the group out of which Millais and Holman Hunt rose to fame. None of its members shows signs of possessing first-rate talent, and indeed the 'impressionist' doctrines strike me as incompatible, in an artist's mind, with the existence of first-rate talent. To embrace them you must be provided with a plentiful absence of imagination. But the divergence in method between the English Pre-Raphaelites and this little group is especially striking, and very characteristic of the moral differences of the French and English races. When the English realists 'went in,' as the phrase is, for hard truth and stern fact, an irresistible instinct of righteousness caused them to try and purchase forgiveness for their infidelity to the old more or

Bastien-Lepage: Albert Wolff. 12×10". Present whereabouts unknown.

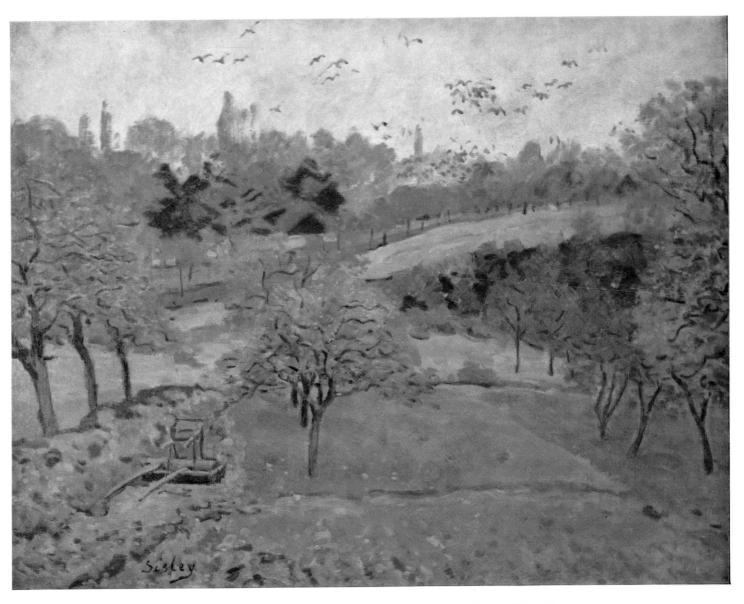

 $Sisley: \textit{Landscape, Louveciennes, Autumn, c. 1875. } 20 \times 25\frac{1}{2}". \ Collection \ Mrs. \ Fernand \ Leval, \ New \ York.$

less moral proprieties and conventionalities, by an exquisite, patient, virtuous manipulation—by being above all things laborious. But the Impressionists, who, I think, are more consistent, abjure virtue altogether, and declare that a subject which has been crudely chosen shall be loosely treated. They send detail to the dogs and concentrate themselves on general expression. Some of their generalizations of expression are in a high degree curious. The Englishmen, in a word, were pedants, and the Frenchmen are cynics."³⁹

While American readers were thus apprised of the new art movement (which certainly had nothing to do with Pre-Raphaelism), Zola's Russian subscribers received somewhat more accurate information, despite the fact that the French novelist agreed with Henry James concerning the absence of first-rate talents among the members of the impressionist group. After objecting to the iniquity of Manet's rejection by the jury and reviewing the Salon in general, Zola devoted a section of his article to the group exhibition, speaking kindly of Béliard, severely of Gustave Caillebotte—whose unimaginative verisimilitude he likened to photography—and praising Berthe Morisot, Pissarro, Renoir, and Sisley, but above all, Monet. Yet he was unaccountably sharp toward Degas. "The trouble with this artist," Zola wrote, "is that he spoils everything when it comes to putting a finishing touch to a work. His best pictures are among his sketches. In the course of completing a work, his drawing becomes weak and woeful; he paints canvases like his *Portraits in an Office (New Orleans)*, half way between a seascape [?] and a newspaper reproduction. His artistic perceptions are excellent, but I fear that his brushes will never become creative." "40

These comments were definitely at variance with most criticisms, which usually treated Degas better than his landscapist colleagues because his accent on drafts-manship appeared more convincing and certainly more obvious. But then Zola may have finally espoused the concepts of his friends and thus have come to realize that Degas did not participate in their plein-air innovations. In any case his characterization of Degas recalls Cézanne's general remarks on the "polish which is admired by imbeciles."

In Scandinavia, too, there now appeared an article attempting to acquaint Swedish readers with the endeavors of the impressionists. It was written by August Strindberg, not yet thirty, who did not see the group show but was taken by a painter friend to the Durand-Ruel galleries. Later he remembered: "We saw very beautiful canvases, signed mostly by Manet and Monet. But since I had other things to do in Paris than to look at pictures, I glanced at this new art with calm indifference. The next day, however, I went back, without really knowing why, and I discovered 'something' in those bizarre manifestations. I saw people swarming on a wharf, but I did not see the crowd itself; I saw a train rushing through a Norman landscape, the movement of wheels in the street, awful portraits of only ugly persons who hadn't known how to pose quietly. Captivated by these extraordinary paintings, I sent a report to a newspaper of my country in which I tried to translate the sensations which I felt the impressionists had wished to convey, and my article had a certain success as something utterly incomprehensible." 41

The strange group of Henry James, Zola, and Strindberg, turned art critics to discuss impressionism for audiences in the United States, Russia, and Sweden, was joined that very year of 1876 by Stéphane Mallarmé, who wrote for the *Art Monthly Review* of London a lengthy article on "The Impressionists and Edouard Manet." It was doubtless due in part to his friendship with Manet that he succeeded better than the others in explaining how the painters achieved their aims. As a matter of fact, he is the only one of these writers to have truly understood the originality of the impressionists.

"As no artist has on his palette a transparent and neutral color answering to open air," Mallarmé stated, "the desired effect can only be obtained by lightness or

Caillebotte: Man at a Window, d. 1875. $46 \times 32\frac{1}{2}$ ". Exhibited at the second impressionist show, 1876. Private collection, Paris.

heaviness of touch, or by the regulation of tone. Now Manet and his school use simple color, fresh, or lightly laid on, and their results appear to have been attained at the first stroke, that the ever-present light blends with and vivifies all things. As to the details of the picture, nothing should be absolutely fixed in order that we may feel that the bright gleam which lights the picture, or the diaphanous shadow which veils it, are only seen in passing, and just when the spectator beholds the represented subject, which being composed of a harmony of reflected and ever-changing lights, cannot be supposed always to look the same, but palpitates with movement, light, and life... That which I preserve through the power of Impressionism is not the material portion which already exists, superior to any mere representation of it, but the delight of having recreated nature touch by touch. I leave the massive and tangible solidity to its fitter exponent, sculpture. I content myself with reflecting on the clear and durable mirror of painting, that which perpetually lives yet dies every moment, which only exists by the will of Idea, yet constitutes in my domain the only authentic and certain merit of nature—the Aspect."⁴²

But Mallarmé's sensitive and lucid definition could do little for his friends. In France, at least, the new attempt of the painters again appeared to have been in vain. Yet, while most of the Parisian critics found no words harsh enough to describe their work, their influence began to make itself felt even among the official art at the Salon. Castagnary was one of the first to acknowledge this fact when he wrote: "The salient feature of the present Salon is an immense effort to obtain light and truth. Everything that suggests the conventional, the artificial, the false, is out of favor. I saw the first dawn of this return to frank simplicity, but I did not think its progress had been so rapid. It is conspicuous, it is startling, this year. The younger artists have flung themselves into it to a man and, without suspecting it, the crowd acknowledges that the innovators have the right on their side. . . . Well, the impressionists have had a share in this movement. People who have been to Durand-Ruel's, who have seen the landscapes, so true and so pulsating with life, which MM. Monet, Pissarro, and Sisley have produced, entertain no doubts as to that."⁴³

But the change that was taking place at the Salon, for all its indebtedness to impressionism, had only a superficial connection with it. A new generation of artists was trying to accommodate the impressionist discoveries to the corrupt taste of the public. It invented a hybrid art—if art it can be called—in which an academic conception was allied with an occasionally impressionistic execution. It used fewer bituminous colors and sometimes visible brushstrokes—not in order to remain close to nature, observed on the spot, but as a welcome means of infusing dying academicism with a semblance of new life. The impressionists, instead of benefiting from this development, rather suffered from it, since public approval went to the opportunists, not to them. Their position was changed little by their second exhibition, but at least there was no deficit this time. Guillaumin, who had not been able to show with the group, informed Cézanne, who had not participated either, that things had gone rather well; whereupon Cézanne reported to his parents:

"The rent for the premises where the show was held amounted to 3,000 francs. Only 1,500 were paid down, and the owner [Durand-Ruel] was to retain the balance from the entrance fees. Not only was this balance raised, but even the 1,500 francs advanced by the artists in equal shares were reimbursed, plus a dividend of 3 francs; it's true

that this doesn't mean much, yet it's a nice beginning. Also the artists of the official exhibition, learning of this modest success, have tried to rent the premises, but these had already been reserved for next year by the exhibitors of this one. According to what Guillaumin told me, I am one of three new members who will be admitted to the association; Monet defended me warmly in the course of a dinner meeting, which took place after the exhibition and during which a certain Lepic protested against my admission."⁴⁴ (It may well be that Cézanne's father, obliged to cover his son's share of the deficit of the first impressionist show—184.50 francs—had insisted that the painter not participate anymore in such unrewarding ventures. This might explain Cézanne's absence from the second show and his eagerness in apprising the old banker of how "successful" it had been.)

Manet, who at least enjoyed financial security, was scarcely better off than the others as far as satisfactions of amour propre were concerned. He decided to spend the summer of 1876 at Mongeron outside Paris, on the estate of the collector Hoschedé. There he again met Carolus-Duran, who lived nearby, and painted a portrait of him. Carolus-Duran had long since abandoned the path of original work and study to follow the road of easy success. Owing to his dexterity he had been quick to achieve fame as a society painter, and Manet could not help but admire the career his colleague had made for himself. At the bottom of his heart Manet desired the same kind of success. To be accepted by the crowd, to obtain a social position as a painter, to receive medals from the jury and possibly the red ribbon of the Legion of Honor from the government—this seemed to him the ultimate goal for an artist of his time. Since so many mediocrities managed to realize these aspirations, he did not see why he, superior to them, should not eventually be rewarded in the same way. But in spite of his determination his moment had not yet come.

Teased by his ambitions, Manet tried to keep close to those who decided success at the Salon, renewing his friendship with Carolus-Duran and even beginning a portrait of the critic Albert Wolff, who, however, soon tired of sitting. But not all his portraits were inspired by the desire to court antagonistic yet influential personalities. That same year Manet also did a likeness of Mallarmé, whom Victor Hugo called "my dear impressionist poet" and whose translation of Poe's Raven Manet had illustrated two years before. Notwithstanding his careful efforts to become "acceptable" to the officials, Manet continued to prove his warm sympathy for Monet who, in July 1876, was once more threatened with eviction. The sale of his Japonnerie, the high price of which had caused a sensation, apparently was not enough to keep Monet afloat; it may actually have stirred his creditors into renewed aggressiveness.

Cézanne was working during the summer at L'Estaque, where he painted two views of the Mediterranean for Chocquet while the latter provided him with newspaper clippings concerning the impressionist exhibition and other related happenings in Paris. It was from L'Estaque that Cézanne wrote in July to Pissarro: "[Here] it is like a playing card, red roofs against the blue sea. If the weather is favorable, I shall perhaps carry them [the pictures for Chocquet] through to the end. Up to the present I have done nothing. Motifs can be found here which would require three or four months' work, and that is possible because the vegetation doesn't change. It is composed of olive and pine trees which always preserve their foliage. The sun is so terrific that it seems to me as if the objects were silhouetted not only in black and

CAROLUS-DURAN: Edouard Manet, d. 1877. Etching. Davison Art Center, Wesleyan University, Middletown, Conn.

Manet: Illustration for Poe's *The Raven*, 1874-75. Lithograph. Metropolitan Museum of Art, New York (Dick Fund).

CÉZANNE: L'Estaque, 1876-78. $16\frac{1}{2} \times 23\frac{1}{4}$ ". Formerly owned by Chocquet. The Bernhard Foundation, New York.

white, but in blue, red, brown, and violet. I may be mistaken, but this seems to me to be the opposite of modeling. How happy our gentle landscapists of Auvers would be here...."45

Pissarro appears to have informed Cézanne about some internal dissensions which were beginning to make themselves felt in the impressionist group. Its unity was threatened by the activities of Pissarro's own dissident society, *L'Union*, whose secretary, Meyer, was intriguing against the impressionists and especially Monet.

"If I dared," Cézanne answered Pissarro, "I should say that your letter bears the

mark of sadness. Pictorial business does not go well; I am much afraid that you are rather gloomily influenced by this but am convinced that it is only a passing thing." Admitting that he preferred to exhibit with Monet rather than with the less homogenous and talented rival group of *L'Union*, Cézanne went on to say that too many successive exhibitions seemed bad to him (an opinion which Renoir shared) yet expressed hope for some kind of compromise; in any case he intended to show his best works with the impressionists rather than with *L'Union.*46 He concluded: "I shall end by saying with you that since there is a common tendency amongst some of us, let us hope that necessity will force us to act jointly and that self-interest and success will strengthen the ties which good will, as often as not, is unable to consolidate."45

While this discussion between Cézanne and Pissarro remained an internal affair, Degas' somewhat heretical views—or at least what the others thought to be his views —were to find their way into print when Duranty published a pamphlet on the group. Taking issue with an article by the painter-author Fromentin, who had regretfully stated that plein air in painting was assuming an importance which it did not deserve⁴⁷ (Henry James' essay had been based on Fromentin's comments), Duranty treated the whole question of "new painting"—he was careful not to use the word impressionism, particularly distasteful to Degas—in a booklet entitled La nouvelle peinture: à propos du groupe d'artistes qui expose dans les galeries Durand-Ruel. It is impossible to say to what extent Duranty's pamphlet reflects the opinions of Degas, but it is certain that his pamphlet was not, as some charged, actually the work of the painter. Ever since he had edited his magazine Réalisme, twenty-five years before, Duranty had been interested in underlining certain common tendencies in the writing and art of his time. One of the forerunners of the naturalistic movement in literature, which now centered around Zola and in which he himself occupied only a minor position, Duranty-like the Goncourts-had discovered in the life around him ideas for realistic novels and had also found there subjects for the artists. Back in 1856 he had proclaimed:

"I have seen a form of society, various actions and events, professions, faces, and milieux. I have seen comedies of gesture and countenance that were truly paintable. I have seen a large movement of groups formed by relations among people, where they met on different levels of life—at church, in the dining room, the drawing room, the cemetery, on the parade-ground, in the studio, the Chamber of Deputies, everywhere. Differences in dress played a big role and corresponded to the variations in physiognomy, carriage, feeling, and action. Everything appeared to me arranged as if the world had been made expressly for the joy of painters, the delight of the eye."48

Among Duranty's painter friends Degas seemed the only one who shared his interest in daily life, in the exact description of people and things. After Courbet it was he who first had the idea of removing the partition which separated the artist's studio from ordinary life. It was he also who had tried to represent the individuals of his time in their typical attitudes, their professional actions; who was able, in Duranty's words, to reveal through a simple gesture an entire range of feeling.

Approaching pictorial art with a literary and social bias conditioned by his former association with and admiration for Courbet, Duranty saw in Degas above all the commentator of modern life, just as Edmond de Goncourt had done. It was this limited but sincere appreciation of his efforts which had brought him Degas' friend-

DESBOUTIN: Edgar Degas, 1876. Etching, $3\frac{3}{8} \times 2\frac{3}{4}$ ".

ship. It is possible, of course, that as a result of this friendship some of Degas' own ideas were instrumental in the shaping of Duranty's opinions. Yet this does not mean that the painter guided the author's pen.

After attacking the *Ecole des Beaux-Arts*, chiefly with the help of quotes from Lecoq de Boisbaudran, Duranty set out to prove that the new art movement had its roots in the more or less recent past, pointing to Courbet, Millet, Corot, Chintreuil, Boudin, Whistler, Fantin, and Manet, even including among its ancestors Ingres, who never "cheated when confronted with modern forms"— a statement which might have been suggested by Degas. Duranty also voiced the hope that some of the younger men among the initiators and their companions might join the group in the years to come, again doubtless expressing the wishes of the painter.

"It is a great surprise," Duranty wrote, "in a period like this, when there has seemed to be nothing left to discover... to see new ideas suddenly arise.... A new branch has developed on the old trunk of art." Then he pointed to the new qualities of this group of artists: "A color scheme, a kind of drawing, and a series of original views.... In the field of color they have made a genuine discovery whose origin cannot be found elsewhere.... The discovery properly consists in having recognized that full light decolorizes tones, that sunlight reflected by objects tends, by virtue of its clarity, to bring them back to the luminous unity which dissolves its seven spectral rays into a single colorless refulgence, which is light. From intuition to intuition, they have succeeded little by little in splitting up sunlight into its beams, its elements, and in recomposing its unity by means of the general harmony of the colors of the spectrum which they spread on their canvases. From the point of view of delicacy of eye, of subtle penetration of the art of color, it is an utterly extraordinary result. The most erudite physicist could not quarrel with their analysis of light." 49

While discussing modern drawing, Duranty credited Degas especially with new concepts and new ideas and defended plein-air painting against the reproach of lack of finish, explaining that its essence was to capture the instant. It was in his summary that he finally showed his half-hearted adherence, insinuating reservations which Degas apparently shared. He said that the group of painters was made up of "original personalities along with eccentric and ingenuous characters, visionaries alongside profound observers, naive ignoramuses alongside scholars who want to find again the naiveté of the ignorant; real painting delight, for those who know and like it, beside unfortunate attempts which irritate the nerves [this was apparently meant for Cézanne]; there is a leavening idea in one brain, almost unconscious daring bursting from another brush. That is the company.

"Will these painters become the primitives of a great artistic renaissance?" Duranty asked. "Will they simply be the victims of the first rank, fallen in the front line of fire, whose bodies, piled in the ditch, will form the bridge over which are to pass the fighters who will come after?" And Duranty concluded: "I wish the fleet fair wind, so that it may be carried to the Hesperides; I urge the pilots to be careful, resolute, and patient. The voyage is dangerous and they should have embarked in large and more solid ships; some of the vessels are very small, shallow, and fit only for coasting. Let us remember that, on the contrary, it is a question of ocean-wide painting!"50

These last words, with the lack of confidence they implied, the impressionists considered particularly badly timed. But their resentment was directed even more to

Desboutin: Edmond Duranty, c. 1876. Etching.

Degas than to the author, since they recognized the attitude of the painter in Duranty's limited approval and careful reservations. Renoir, without showing his feelings, was extremely annoyed, while Monet treated the publication with mute disdain.⁵¹ Attacked by their adversaries and ill supported by their friends, the painters could find hope and relief only in their own work.

In spite of continual worries the year 1876 was to be an especially fertile one for the impressionists. In Marly heavy floods provided Sisley with subjects for a series of paintings which were to remain among the best he ever did. Pissarro, once more back in Pontoise, painted landscapes, river views, still lifes, and portraits in a particularly vigorous style. After having executed views of the Tuileries Gardens during the early summer—observed from Chocquet's apartment—Monet returned to Argenteuil where, later on, he left his wife to accept an invitation from Hoschedé (to whom Sisley also once paid a visit). At Mongeron, which Manet had left in the meantime, Monet painted some decorative panels for Hoschedé, as well as a number of land-scapes, several of which his host acquired. Upon his return, Monet moved with his small family to Paris, 26 rue d'Edimbourg, taking a studio at 17 rue Moncey, next door to the house where Sisley had lived ten years before. At about this time he met the American painter John Singer Sargent who was to become a close friend.

Sisley: Flood at Port-Marly, d. 1876. $23\frac{5}{8} \times 31\frac{7}{8}$ ". Exhibited at the second impressionist show, 1876. Musée du Louvre, Paris.

Monet: Gare St. Lazare, Paris, d. 1877. $32\frac{1}{2} \times 39\frac{3}{4}$ ". Fogg Art Museum, Cambridge, Mass. (Maurice Wertheim Collection).

What may have prompted Monet to settle again in Paris was the fact that he felt attracted by the railroad station of St. Lazare. The huge enclosure, with its glass roof against which the heavy locomotives threw their opaque vapor, the incoming and outgoing trains, the crowds, the contrast between the limpid sky in the background and the steaming engines—all this offered unusual and exciting subjects, and Monet untiringly put up his easel in different corners of the station. As Degas liked to do, he explored the same motif from a variety of angles, proceeding with both vigor and

subtlety to seize the specific character of the place and its atmosphere. Duranty might have hailed in these works the conquest of one of the most typical scenes of modern life—a scene never before treated by artists—had it not been that Monet's approach was devoid of any social consciousness. He found in the railroad station a pretext rather than an end in itself; he discovered and probed the pictorial aspects of machinery but did not comment upon its ugliness or usefulness or beauty, nor upon its relationship to man. (Zola, in 1890, was to devote a novel to the subject of trains and conductors.)

Degas, too, kept on investigating new milieux, yet his interest remained centered around man and his psychological problems. He began to frequent music halls, café concerts, and circuses, once more attracted by the attitudes of performers obeying a merciless routine. "You need natural life," he told his colleagues, "I, artificial life."52 But the difference between him and the impressionists was not entirely defined by this statement. "I always tried," Degas later explained to the English painter Sickert, "to urge my colleagues to seek for new combinations along the path of draftsmanship, which I consider a more fruitful field than that of color. But they wouldn't listen to me, and have gone the other way."53 Degas apparently considered their approach to nature too passive and disapproved of their complete fidelity to a chosen motif. Their principle of not omitting or changing anything, their sole preoccupation with their immediate sensations made them, in his eyes, slaves of the chance circumstances of nature and light. "It is very well to copy what one sees," he said to a friend; "it's much better to draw what one has retained in one's memory. It is a transformation in which imagination collaborates with memory. One reproduces only that which is striking; that is to say, the necessary. Thus, one's recollections and invention are liberated from the tyranny which nature exerts."54

Degas was master of his inspiration. He felt free to modify the features of his subjects according to compositional need, as he had done in a series representing the same foyer de danse, where the room, in each picture, shows a variety of details not to be found in the other canvases. But while the impressionists, bound by their sensations, were obliged to finish their paintings on the spot—whether in one or in several sessions—and were prevented from retouching them later, Degas' method of work carried with it an imprecation of which he became the victim: the curse of perfectionism. Never satisfied with his paintings, he hated to sell and was often reluctant to exhibit them, continually planning improvements. This tendency led him, for instance, to make a curious deal with Manet's patron Faure, who in 1874 bought back from Durand-Ruel six canvases which Degas regretted having sold and returned them to the painter so that he might rework them. In exchange Degas promised to paint four large compositions for the singer. Two of these were delivered in 1876. After waiting eleven more years for the remaining two, Faure finally haled Degas into court in order to obtain satisfaction.⁵⁵

It was around 1876 that Degas seems to have given up the greater part of his fortune to ease the financial predicament of one of his brothers, who supposedly lost everything by imprudent speculation in American securities. Degas would never speak of such private affairs, yet it is known that he began from then on to depend on occasional sales. He did not have much trouble in finding buyers and obtaining reasonably high prices, but he was now obliged—much to his regret—to part with his works. Although the two facts may not be related, he started at this time doing more and more pastels,

Degas: The Café-Concert, Les Ambassadeurs, 1876-77. Pastel on monotype, $14\frac{3}{4}\times10\frac{3}{4}$ ". Probably exhibited at the third impressionist show, 1877. Musée de Lyon.

DEGAS: Miss La La at the Cirque Fernando, 1879. $47 \times 31\frac{1}{4}$ ". Exhibited at the fourth impressionist show, 1879. National Gallery, London.

which are a kind of momentary expression and bear little retouching. In this medium he achieved steadily growing freedom of expression, at the same time showing a predilection for more vivid colors and for effects less sophisticated than in his oils.

In his studio in the rue St. Georges, Renoir meanwhile devoted himself mostly to portraits and nudes. He had met M. Charpentier, publisher of Zola, Maupassant, and Daudet, who commissioned him to do likenesses of his wife. Charpentier, related through his wife to Count Doria—owner of Cézanne's Maison du pendu—with whom he was not on speaking terms, had moved in 1875 into a palatial house on the rue de Grenelle where he and his wife soon gave notable receptions at which all leading figures of French letters and politics appeared, occasionally joined by artists. According to Edmond de Goncourt's diary, Gambetta highly appreciated these soirées because the Charpentiers succeeded in an undertaking until then unknown in France (though not unusual in England), that of "assembling and bringing into

Renoir: The Artist's Studio, rue St. Georges, Paris, 1876, 18\(^8\) \times 15\(^4\)''. (From left to right: Lestringuez, Rivière, Pissarro, the musician Cabaner; in the foreground, Cordey). Formerly collection Eugène Murer. Collection Antonio Santamarina, Buenos Aires.

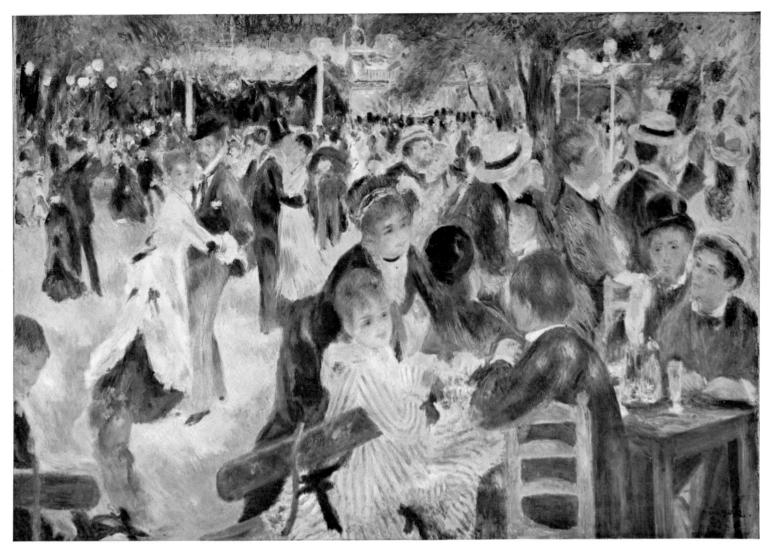

Renoir: Dancing at the Moulin de la Galette, Montmartre, d. 1876. $31 \times 44\frac{3}{4}$ ". Formerly in the Chocquet collection. (A larger version, exhibited at the third impressionist show, 1877, was bequeathed to the Louvre by Caillebotte.) Among the dancers are Renoir's friends Franc-Lamy, Goeneutte, Rivière, Gervex, Cordey, Lestringuez and Lhote (see p. 386). Collection Mr. and Mrs. John Hay Whitney, New York.

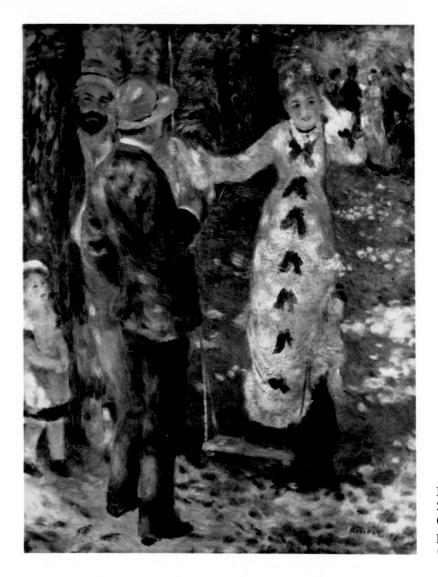

RENOIR: La Balançoire (The Swing), d. 1876. $36\frac{1}{2} \times 28\frac{1}{2}$ ". Painted in Renoir's garden, rue Cortot, Montmartre. Exhibited at the third impressionist show, 1877. Musée du Louvre, Paris (Caillebotte Bequest).

contact people of different opinions who respect and appreciate each other while, of course, maintaining their own views."57

At the auction of 1875, Charpentier had purchased one of Renoir's more expensive paintings, for which he bid 180 francs. Very pleased with the picture, he had wished to meet the artist and thus had taken the initiative in a friendship that was to become particularly gratifying for the painter. It was possibly Charpentier's patronage which enabled Renoir to rent—for 100 francs a month—a small house with a garden on the heights of Montmartre, rue Cortot. His studio on the rue St. Georges had become, in the late afternoons, the gathering place for a number of friends. These included Maître, Duret, and Chocquet, as well as several young newcomers, among them the painters Franc-Lamy and Cordey. They had been students at the *Ecole des Beaux-Arts* in the classes of Ingres' disciple Lehmann, until they had staged, along with

others, a revolt against their master. Since Lehmann refused to resign, and the director of the *Ecole* denied them permission to enroll in other classes, they left the institution. The entire group of insurgents then wrote an eloquent letter to Manet, asking him to accept them as pupils in an *atelier libre* under his direction. But Manet declined, partly, no doubt, for fear of alienating official sympathy and partly because he may have felt little inclination to try anew a venture in which Courbet had already failed.

Franc-Lamy and Cordey, with their friends Rivière and Lestringuez, now became daily visitors at Renoir's. After the latter had spent some weeks with Daudet at Champrosey, they followed him to Montmartre. The large garden—an abandoned park, rather—behind his house in the rue Cortot offered Renoir ample opportunity to paint in the open. His friends readily posed for him, as did a young actress, Mlle Samary, whom Renoir had apparently met through the Charpentiers and whose beauty and radiant smile were famous on and off stage. It was in his garden and with his friends as models that Renoir now painted *La Balançoire*. But his large composition, *Le bal au Moulin de la Galette*, which he executed at the same period, was done nearby,

Renoir: First Outing, 1875-76. $25\frac{3}{2} \times 19\frac{3}{4}$ ". Tate Gallery, London.

on the grounds of the well-known establishment itself, where his friends helped Renoir carry the canvas each day. Again, Franc-Lamy, Cordey, Rivière, Lestringuez, and the latter's friend Lhote posed for him, while Renoir recruited their dancing partners from among the young girls who came to waltz every Sunday at the old *Moulin*.⁵⁹

In these works and in others painted at this time Renoir showed himself preoccupied with a special problem. Placing his models under trees, so that they were sprinkled with spots of light falling through the foliage, he studied the strange effects of green reflections and luminous speckles on their faces, dresses or nude bodies. His models thus became merely media for the representation of curious and momentary effects of light and shadow which partly dissolved forms and offered to the observer the gay and capricious spectacle of dancing light. Monet, too, occasionally studied similar effects. At the group exhibition in the spring, Albert Wolff had derided one of Renoir's nudes painted in this vein, while Zola had noticed a canvas by Monet, "a woman clad in white, seated in the shadow of foliage, her dress sprinkled with luminous spangles like large drops." 60

Monet, in Paris, continued to experience the same difficulties which may actually have driven him from Argenteuil. "Can you and would you do me a great favor?"

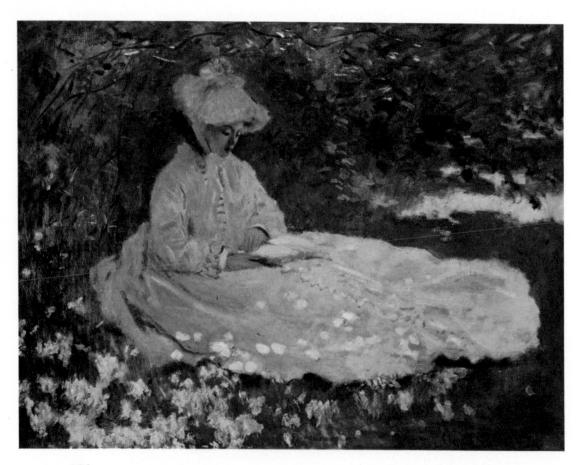

Monet: Woman in a Garden, Springtime, c. 1875. $19\frac{5}{8} \times 25\frac{3}{4}$ ". Exhibited in the second impressionist show, 1876; subsequently bought by Mary Cassatt. Walters Art Gallery, Baltimore.

Renoir: Nude in the Sun, 1875-76. $31\frac{1}{2} \times 25\frac{1}{4}$ ". Exhibited in the second impressionist show, 1876. Musée du Louvre, Paris (Caillebotte Bequest).

he now wrote to Zola. "If I haven't paid tomorrow night, Tuesday, the sum of 600 francs, our furniture and all I own will be sold and we'll be out on the street. I haven't a single *sou* of this amount. None of the transactions on which I had counted can be concluded for the moment. It would pain me deeply to reveal the situation to my poor wife. I am making a last attempt and am turning to you in the hope that you may possibly lend me 200 francs. This would be an installment which may help me obtain a delay. I don't dare to come myself; I would be capable of seeing you without daring to tell you the real purpose of my visit. Please send me word and, in any case, don't speak about this, for it is always a fault to be in need."61

Though Zola apparently was able to assist Monet discreetly, his straitened circumstances were no secret to his entourage since he constantly had to approach the same prospective benefactors, to whom he now added Charpentier. Besides, the general situation was anything but promising and even Manet began to feel the effects of adverse conditions. In the fall of 1876 Berthe Morisot's husband informed her: "The entire clan of painters is in distress. The dealers are overstocked. Edouard [Manet] speaks of watching his expenses and giving up his studio. Let's hope that the buyers will return, but it's true that the moment is not favorable."⁶²

Caillebotte, however, remained helpful. He had made it a principle—as did de

Bellio—to buy especially those works of his friends which seemed particularly unsaleable, and thus acquired both Renoir's Balançoire and Le bal au Moulin de la Galette (a smaller version of which was bought by Chocquet). While timid in his own works and impressed by Duranty's pamphlet, Caillebotte—whom some called a "pupil of Degas"—readily admired the daring of his friends. In the short time since he had met them, Caillebotte had already assembled such a collection that he began to plan its final disposition. In November 1876, though he was then only twenty-seven, he wrote his will, leaving all his pictures to the State with the condition that they be ultimately hung in the Louvre; he named Renoir as executor. Haunted by the presentiment of an early death, Caillebotte was particularly anxious to provide financial security for a new group exhibition. Indeed, the first paragraph of his will read: "I desire that from my estate the necessary sum be taken to arrange in 1878, under the best possible conditions, an exhibition of the painters who are called Les Intransigeants or Les Impressionnistes. It is rather difficult for me to fix that sum now; it may amount to thirty or forty thousand francs, or even more. The painters to take part in this

CÉZANNE: Bathers, 1875-76. $31\frac{1}{8} \times 38\frac{1}{4}$ ". Exhibited at the third impressionist show, 1877. Formerly collections Cabaner and Caillebotte. Barnes Foundation, Merion, Pa.

Cézanne: Bathers (small version), 1875-76. $13 \times 16\frac{1}{8}$ ". Formerly collection Victor Chocquet. Fondation Jean-Louis Prevost, Geneva.

exhibition are Degas, Monet, Pissarro, Renoir, Cézanne, Sisley, Berthe Morisot. I name these, not to the exclusion of others."63

Having thus made generous provisions for the future, Caillebotte continued to devote his disinterested efforts to the present. It was largely due to his untiring enthusiasm and tenacity that the third exhibition of the group was organized—not in 1878, as he had planned—but as early as the spring of 1877. "We are having some trouble about our exhibition," he wrote in January to Pissarro, from whom he had just bought another painting. "Durand-Ruel's entire premises are rented for a year [This contradicts Cézanne's letter to his parents.]... Let's not get discouraged; even now several arrangements offer possibilities. The exhibition will take place; it must...."

Meanwhile the moving force behind the rival society L'Union, Alfred Meyer, sought to steal a march on the impressionists by organizing his exhibition before theirs, just as the impressionists themselves always endeavored to precede the Salon with their shows. Indeed, L'Union succeeded in opening its first manifestation on February 15 at the Grand Hôtel, on the boulevard des Capucines near the Paris Opera, but at the last minute Pissarro, Cézanne, and Guillaumin resigned from the association and thus did not exhibit with it.65 The show does not seem to have received much press coverage; Louis Leroy devoted eight insignificant lines to it.

At first the impressionists planned to hold their exhibition in a barrack especially built for the occasion on the vacant lot of the former opera house, but eventually they found an empty apartment on the second floor of a building, 6 rue Le Peletier, the same street where Durand-Ruel's galleries were located. Its large and well lighted rooms with high ceilings offered long walls particularly suited for the purpose. Caillebotte, who knew the owner of the building, advanced money for the rent. His diplomatic attitude prevented too many controversies among the exhibitors, and the preparations advanced rather smoothly. The invitations to participants were mailed by Renoir and Caillebotte, who also summoned the members of the group to a meeting where various pending problems were to be discussed. Degas urged all his friends to appear, informing them: "A big question is to be debated: whether one can show at the Salon and also with us. Very important!"66 Degas must have startled the others with his radical departure from the viewpoint he had defended in 1874—when he had sought to enlist precisely those of his friends who showed at the Salon, such as de Nittis. But he did obtain satisfaction. A resolution was adopted, restraining those who showed with the group from exhibiting at the Salon. However, Degas lost out when he energetically opposed the plan of calling the event Exposition des Impressionnistes. Although he argued that this word really meant nothing, he could not prevent the others from adopting this title and thus accepting for the first time—much to the delight of Louis Leroy—the name given them in derision.

"The exhibition is scheduled for April 1st," Guillaumin wrote late in February to Dr. Gachet. The expenses, which will probably be rather heavy, are to be borne by the two or three capitalists of the gang (as an advance). They will be reimbursed with the entrance fees. Should a deficit remain, it will have to be met by the exhibitors under conditions which have not yet been fixed. I can't say more, but I think that in calling on Renoir at 35 rue St. Georges, you'll obtain all possible information because it's there that the show is being fabricated."

RENOIR: Study for Dancing at the Moulin de la Galette, c. 1875. $11\frac{1}{2} \times 9\frac{1}{4}$ ". Collection the late E. M. Remarque, Switzerland.

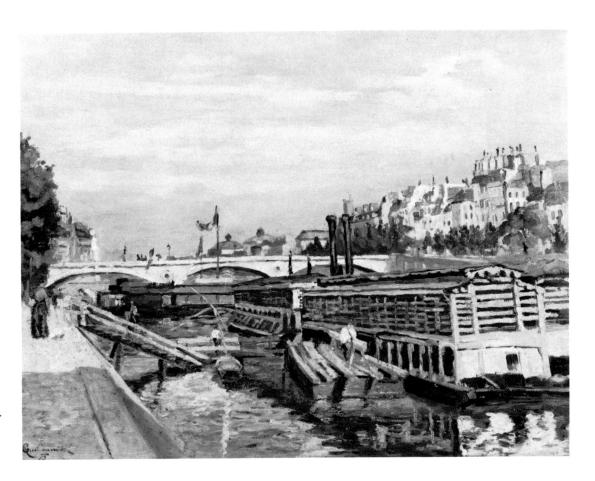

Guillaumin: The Pont Louis-Philippe, Paris, d. 1875. 18 × 23¾". National Gallery of Art, Washington, D.C. (Chester Dale Collection).

Only eighteen painters took part in the exhibition of 1877. Several of the participants in former shows, like Béliard (member of L'Union) and Degas' friend Lepic, dropped out, but there were also a few newcomers. Renoir invited his recent acquaintances Franc-Lamy and Cordey, while Pissarro introduced his old friend Piette. Both Guillaumin and Cézanne again joined the others. Although Cézanne violated the new rules by submitting to the Salon, he must have been deemed eligible because the jury had not once accepted any of his work. The complete list of exhibitors comprised Caillebotte, Cals, Cézanne, Cordey, Degas, Franc-Lamy, Guillaumin, Jacques-François (pseudonym for a woman painter), Levert, Maureau (a friend of Degas), Monet, Morisot, Piette, Pissarro, Renoir, Rouart, Sisley, and Tillot.

More than two hundred and thirty works were put on exhibit, each of the impressionists contributing a larger number than before. Cézanne showed three water-colors—two of which he called *Impression d'après nature*—and over a dozen paintings, mostly still lifes and landscapes (which he designated as "studies from nature"), as well as a composition of bathers and a portrait of Victor Chocquet. Degas sent in twenty-five paintings, pastels, and lithographs, mostly of dancers, scenes from café concerts, and women washing themselves; he also exhibited a likeness of his friend Henri Rouart. Guillaumin was represented by twelve oils. Monet had thirty paintings in

the show, among them several landscapes from Montgeron and no fewer than eight views of the Gare St. Lazare. Of his canvases, eleven were lent by Hoschedé, two each by Duret, Charpentier, and Manet (who owned an Argenteuil landscape), and three by G. de Bellio. Pissarro's contribution consisted of twenty-two canvases, landscapes of Auvers, Pontoise, and Montfoucault (where Piette lived); three of them were lent by Caillebotte. Among Renoir's twenty-one paintings were his Balançoire and Le bal au Moulin de la Galette, as well as portraits of Mme Charpentier, her little daughter, Mlle Samary, Sisley, and Mme Daudet; there also were several flower pieces, landscapes and heads of young girls. Sisley showed seventeen landscapes of the environs of Paris, among them a view of the Flood at Marly. Of his works, three were lent by Hoschedé, three by G. de Bellio, two by Charpentier, one by Duret, and another, the Bridge of Argenteuil, by Manet (see p. 290). Caillebotte's major work was a view of the Pont de l'Europe, a bridge behind St. Lazare station.68

The hanging committee was composed of Renoir, Monet, Pissarro, and Caillebotte. In the first room they placed works by Monet, Caillebotte, and Renoir; the second was devoted to a large decorative composition by Monet, Les dindons blancs, Renoir's Balançoire, and other canvases by these two as well as by Pissarro, Sisley, Guillaumin, Cordey, and Franc-Lamy. The vast drawing room in the center of the apartment had one entire wall occupied by the paintings of Cézanne and another reserved for those of Berthe Morisot; both thus occupied places of honor. This room was completed by Renoir's Bal au Moulin de la Galette and a large landscape by Pissarro. The adjoining room contained further works by Monet, Sisley, Pissarro, and Caillebotte, while a smaller gallery at the end of the apartment had been more or less completely given over to Degas.⁶⁹

The opening took place early in April. There was a large attendance, and the public seemed less mocking than at the previous exhibitions. But with a few exceptions the press in the days following rivaled each other in stupid attacks and facile jokes, a monotonous repetition of its former comments.70 The artists, who had hoped to meet this time with a little more comprehension, believing that their repeated manifestations might overcome the general hostility and earn them at least the consideration owed to serious effort, were soon faced with another laughing crowd. Cézanne's works especially excited general hilarity. No one was more outraged by the attitude of the public than Victor Chocquet, who had recently resigned from his position with the customs and thus was able to spend all his time at the exhibition. Renoir's friend Rivière later told how the collector tried relentlessly to convince stubborn visitors: "He challenged the laughers, made them ashamed of their jokes, lashed them with ironical remarks; in animated, daily repeated discussions, his adversaries never had the last word. Scarcely would he have left one group when he would be discovered some place else, dragging a perverse art lover almost by force before the canvases of Renoir, Monet, or Cézanne and trying to make the other share his admiration for these disgraced painters. He found eloquent phrases and ingenious arguments to convince his listeners. With clarity he explained the reasons for his partiality. Persuasive, vehement, domineering in turn, he devoted himself tirelessly, without losing the urbanity which made him the most charming and formidable of opponents."71

According to Duret's recollections, Victor Chocquet thus made quite a reputation

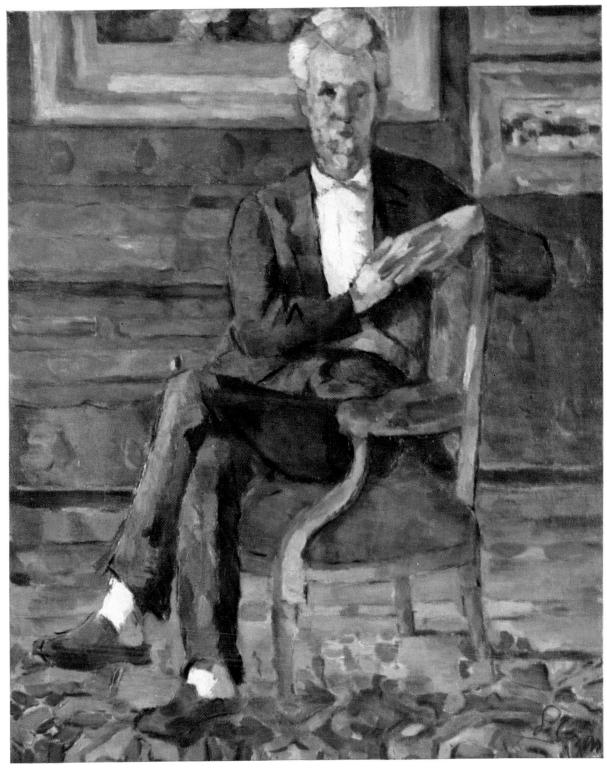

Cézanne: Victor Chocquet in an Armchair, c. 1877. $17\frac{3}{4} \times 14\frac{1}{2}$ ". Columbus Gallery of Fine Arts, Ohio.

for himself and "as soon as he appeared, people amused themselves by teasing him on his favorite subject. He was always ready for them. He always found the right word where his painter-friends were concerned. He was above all untiring on the matter of Cézanne, whom he put among the greatest. Many visitors were entertained by Chocquet's enthusiasm which seemed to them a form of mild insanity."³⁵

Chocquet's efforts were reinforced by Georges Rivière, to whom Renoir suggested issuing a small paper to defend the painters and answer the attacks of A. Wolff and his like (as a matter of fact, the original charter of the Co-operative had foreseen in 1873 "the publication, as soon as possible, of a periodical exclusively concerned with art"). Thus, for the duration of the show, Rivière brought out L'Impressionniste, journal d'art, writing most of the articles himself, occasionally aided by Renoir.72 Rivière asserted that his friends had adopted the name "Impressionist" so as to assure the public that in their exhibition would be found no historical, biblical, oriental, or genre pictures. This essentially negative explanation was motivated apparently by the unwillingness of the painters to come forth with any theoretical explanations of their efforts. However, in the absence of these, Rivière's support of the painters and especially his high praise of Cézanne aroused little attention. His writing was somewhat amateurish and his connection with the impressionists was too obvious to make his enthusiasm convincing to the reader. As to the critics, they did not bother answering his counter-attacks or replying to his assertion that "the press is always behind the times. Instead of guiding the public, it follows it. Never has a newspaper discovered that an artist has talent...."

Zola also wrote a review of the show. He called Monet the outstanding personality among the exhibitors and, rather surprisingly, went on: "Next I wish to name M. Paul Cézanne who is certainly the greatest colorist of the group. There are, in the exhibition, some Provençal landscapes of his which have a splendid character. The canvases of this painter, so strong and so deeply felt, may cause the bourgeois to smile, but they nevertheless contain the makings of a great artist...." Having thus at last found a few kind words for his old friend, Zola praised the works of Renoir, Berthe Morisot, Degas, Pissarro, Sisley, and Caillebotte, concluding: "The proof that the impressionists constitute a movement is that the public, though laughing, throngs to their exhibition. One counts more than 500 visitors a day. That is success.... Not only will the expenses be covered, but there might even be a profit...."

In the words of Duret, "the majority of the visitors were of the opinion that the exhibiting artists were perhaps not devoid of talent and that they might have executed good pictures if they had been willing to paint like the rest of the world, but that above all they were trying to create a rumpus to stir up the crowd."⁷⁴Rivière's paper must simply have been considered as part of that rumpus. After the exhibition closed, Arsène Houssaye, patron of Monet and Renoir, commissioned Rivière to write an article on the show for *L'Artiste*, but asked that he refrain from discussing Pissarro and Cézanne so as not to upset his readers.⁷⁵

On the last day of April, closing date of the show, the friends again decided to hold an auction. Neither Berthe Morisot nor Monet took part in it. Instead, Pissarro participated this time, as did Caillebotte, who had no reason to do so except that he intended to stand by the others. As was to be expected, the results of the second auction were not very different from those of the first.⁷⁶

Policeman: "Lady, it would be unwise to enter!"

"But these are the colors of a corpse!" Painter: "Indeed, but unfortunately I can't get the smell."

Two caricatures by Cham, published in *Le Charivari* on the occasion of the third impressionist show, 1877.

- 1 In a letter of Jan. 21, 1922, Monet specified that "Manet never lived at Argenteuil or its vicinity. He often came to see me, that's all." He also wrote that he had lived at Argenteuil from 1871 to 1878, first in a house which, before the war of 1870, had been inhabited by the painter Théodule Ribot, and after one or two years in another house on the Voie des Bancs. See Monet's letter to R. Laurent, Beaux-Arts, Jan. 31, 1941; also R. Walter: Les maisons de Claude Monet à Argenteuil, Gazette des Beaux-Arts, Dec. 1966. Actually the artist moved to Paris in the fall of 1876.
- 2 Zola to Guillemet, July 23, 1874; see Emile Zola: Salons, edited by F. W. J. Hemmings and R. J. Niess, Geneva-Paris, 1959, p. 25-26.
- 3 See M. Elder: Chez Claude Monet à Giverny, Paris, 1924, p. 70. Tabarant: Manet et ses œuvres, Paris, 1947, ch. XXX, denounces this anecdote as spurious.
- 4 Elder, ibid., p. 35.
- 5 Born in 1848 (as was Gauguin), Caillebotte was eight years younger than Monet. His first known paintings date from 1872. In 1873 his father, a judge, had died, leaving him and his brother a considerable fortune. That same year he had been admitted to the Ecole des Beaux-Arts where he had worked for a short time under Bonnat.
- 6 Letter of Mme Lopes-Dubec to her nephew Eugène Petit, Jan. 31, 1874; unpublished document, courtesy the late Mr. Maurice Petit, St. Thomas, Virgin Islands.
- 7 Cézanne to his mother, Sept. 26, 1874; see Paul Cézanne, Letters, London, 1941, p. 98-99 [here newly translated].
- 8 Boudin to Martin, Nov. 9, 1876; see G. Jean-Aubry: Eugène Boudin, Paris, 1922, p. 83.
- 9 See M. Bodelsen: Early Impressionist Sales 1874-94 in the Light of Some Unpublished "procès-verbaux," Burlington Magazine, June 1968.
- 10 Manet to A. Wolff, March 19 [1875]; see E. Moreau-Nélaton: Manet raconté par lui-même, Paris, 1926, v. II, p. 41. The author dates this letter 1877, on the assumption that it was written for the second auction held by Manet's friends. This second auction, however, was not organized by Monet, Sisley, Renoir, and Morisot, but by Caillebotte, Pissarro, Sisley, and Renoir. Moreover, the 1877 auction took place on May 28, whereas the 1875 sale was held on March 24, five days after the writing of Manet's letter.
- 11 "Masque de Fer" in *Le Figaro*; quoted by G. Geffroy: Claude Monet, sa vie, son oeuvre, Paris, 1924, v. I, ch. XIII.
- 12 P. Burty, introduction to the catalogue: Vente du 24 mars

- 1875—Tableaux et aquarelles par Cl. Monet, B. Morisot, A. Renoir, A. Sisley.
- 13 P. Durand-Ruel: Mémoires, in Venturi: Les Archives de l'Impressionnisme, Paris-New York, 1939, v. II, p. 201. On the sale see also ibid., p. 290-291 and 300; Geffroy, op. cit., v. I, ch. XIII; R. Marx: Maîtres d'hier et d'aujourd'hui, Paris, 1914, p. 309; A. Vollard: Renoir, ch. VIII; M. Angoulvent: Berthe Morisot, Paris, 1933, p. 50-51.
- 14 Now in the Barnes Foundation, Merion, Pa.
- 15 Gygès, article in *Paris-Journal*, March 1875; quoted in J. Lethève: Impressionnistes et Symbolistes devant la presse, Paris, 1959, p. 75.
- 16 For the procès-verbal of the sale see Bodelsen, op. cit.
- 17 See Vollard, op. cit., ch. VIII, and, for a similar version, M. Denis: Nouvelles Théories, Paris, 1922, p. 115-116.
- 18 See F. Fels: Claude Monet, Paris, 1925, p. 16.
- 19 E. Maître, diary entry of April 9, 1875; see F. Daulte: Frédéric Bazille et son temps, Geneva, 1952, p. 60, note 1. The only other mention of the fact that Renoir, in 1875, submitted to the Salon jury and was rejected is to be found in T. Duret: Les peintres impressionnistes, Paris, 1878, p. 27.
- 20 Castagnary: Salon de 1875; reprinted in Castagnary: Salons, 1872-1879, v. II, Paris, 1892, p. 178.
- 21 Both Manet and Redon went to Corot's funeral in February 1875.
- 22 Cézanne to Pissarro, June 24, 1874; see Cézanne, Letters, op. cit., p. 96-97 [here newly translated].
- 23 Zola: Une exposition de tableaux à Paris, Messager de l'Europe, Saint-Petersburg, June 1875; reprinted in E. Zola: Salons, op. cit., p. 147-168.
- 24 See D. Cooper: Renoir, Lise and the Le Coeur Family, Burlington Magazine, Sept.-Oct. 1959.
- 25 Monet to Manet, June 28 [1875?]; see A. Tabarant: Autour de Manet, L'Art Vivant, May 4, 1928. The author dates this letter 1873, but it is more likely that it was written after their work together at Argenteuil in 1874 had brought the two men closer to each other.
- 26 Monet to de Bellio [undated]; see: La grande misère des impressionnistes, *Le Populaire*, March 1, 1924. According to R. Niculescu: Georges de Bellio, L'ami des impressionnistes, *Revue Roumaine d'Histoire de l'Art*, v. 1, no. 2, 1964, this letter was written toward the end of 1877.
- 27 De Nittis acquired over the years four paintings by Monet and two by Berthe Morisot, because—as he

- explained—he liked them, and not in order to increase his "standing" with the impressionists who preferred the collector de Nittis to the artist.
- 28 In the sale of Chocquet's collection after the death of his widow were over 35 paintings by Cézanne, 12 by Monet, 14 by Renoir, 5 by Manet, 1 by Pissarro, and 1 by Sisley. On Chocquet see J. Rewald: Chocquet and Cézanne, Gazette des Beaux-Arts, July-Aug. 1969 (with further bibliography).
- 29 Cézanne to Pissarro, April 1876; see Cézanne, Letters, op. cit., p. 101.
- 30 See Moreau-Nélaton, op. cit., v. II, p. 37-38; A. Proust: Edouard Manet, souvenirs, Paris, 1913, p. 79-82; and Tabarant: Manet et ses œuvres, op. cit., p. 279-281.
- 31 Bernadille, article in *Le Français*, April 21, 1876: quoted *in* Tabarant: Manet et ses oeuvres, *op. cit.*, p. 286.
- 32 On Degas' entries see P.-A. Lemoisne: Degas et son œuvre, Paris, 1946, v. I, p. 237, note 114 and the artist's notebook no. 7, p. 74, at the Bibliothèque Nationale, Paris.
- 33 Now in the Museum of Fine Arts, Boston. On this painting see the catalogue of the Monet exhibition, Tate Gallery, London, Sept.-Nov. 1957, No. 46.
- 34 For a condensed catalogue see Venturi: Archives, v. II, p. 257-259. Venturi's indication that Bazille was represented at the show is an error due to the fact that Renoir exhibited his *Portrait of Bazille* (information courtesy O. Reuterswärd, Stockholm).
- 35 Duret, introduction to the catalogue of the Chocquet sale, Paris, Galerie Georges Petit, July 1-4, 1899.
- 36 For articles on the exhibition see Venturi: Archives, v. II, p. 286, 296, 301-305; Geffroy, op. cit., v. I, ch. XIV; P.-A. Lemoisne: op. cit., v. I, p. 237-238, notes 115 and 116; also Lethève, op. cit., p. 76-81.
- 37 A. Wolff, article in *Le Figaro*, April 3, 1876; quoted in Geffroy, op. cit., v. I, ch. XIV.
- 38 See Rivière: Les Intransigeants de la peinture, L'Esprit Moderne, April 13, 1876. (This important article—Rivière's first—is not quoted in Venturi's and Lethève's surveys of contemporary comments.) For another well-meaning mention of the impressionists see M. Proth: Voyage au Pays des Peintres, Salon de 1876, Paris, 1876, p. 139.
- 39 H. James: Parisian Festivity, *New York Tribune*, May 13, 1876; reprinted *in James*: The Painter's Eye, edited by J. L. Sweeny, New York, 1956, p. 114-115.
- 40 Zola: Deux expositions d'art au mois de mai, Messager de l'Europe, Saint Petersburg, June 1876; reprinted in Zola: Salons, op. cit., p. 171-196.
- 41 A. Strindberg to Gauguin, Feb. 18, 1895; see J. de

- Rotonchamp: Paul Gauguin, Paris, 1924, p. 149-150. The article which Strindberg sent to Stockholm was titled "From the Café de l'Ermitage to Marly-le-Roi"; reprinted in Strindberg: Kulturhistorika Studier, Stockholm, 1881. It represents, however, an attempt at writing in an "impressionist" style rather than a discussion of impressionist painting.
- 42 S. Mallarmé: The Impressionists and Edouard Manet, Art Monthly Review, v. 1, no. 9. This article exists only in its English version, the original French text having been lost. See J. C. Harris: A Little-Known Essay on Manet by Stéphane Mallarmé, Art Bulletin, Dec. 1964.
- 43 Castagnary: Salon de 1876; reprinted in Castagnary, op. cit., p. 213-214.
- 44 Cézanne to his parents, Sept. 10, 1876; see J. Rewald: Une lettre inédite de Paul Cézanne in [Festschrift] Für D.-H. Kahnweiler, Stuttgart, 1966, p. 242-248.
- 45 Cézanne to Pissarro, July 2, 1876; see Cézanne, Letters, op. cit., p. 102-103 [here newly translated].
- 46 This passage of Cézanne's letter, *ibid.*, p. 103-104, is here given an interpretation at variance with the first editions of the present book, based on facts concerning *L'Union* which have since come to light and clarify Cézanne's sometimes obscure allusions.
- 47 Fromentin, in one of the installments of his: Les Maîtres d'Autrefois, published by La Revue des deux Mondes on Feb. 15, 1876, had stated, without expressly naming the impressionists, that "plein air, diffused light, the real sun, take today in painting and in all paintings an importance which never before had been accorded to them and which, let us say this frankly, they do not deserve."
- 48 E. Duranty quoted by himself *in*: La nouvelle peinture, Paris, 1876, p. 31. See the new edition of this pamphlet, Paris, 1946, p. 48.
- 49 As a matter of fact, the scientific analysis of light was to be introduced into painting by Seurat some ten years later.
- 50 Duranty: La nouvelle peinture, Paris, 1876, 1946.
- 51 See G. Rivière: Renoir et ses amis, op. cit., p. 102.
- 52 See G. Moore: Impressions and Opinions, New York, 1891, p. 308.
- 53 W. Sickert: Degas, Burlington Magazine, Nov. 1917.
- 54 G. Jeanniot: Souvenirs sur Degas, La Revue Universelle, Oct. 15, Nov. 1, 1933. See also J. Rewald: The Realism of Degas, Magazine of Art, Jan. 1946. For comparisons of impressionist landscapes with photographs of the motifs see E. Loran: Cézanne's Composition, Berkeley, 1943; F. Novotny: Cézanne und das Ende der wissenschaftlichen Perspektive, Vienna, 1938; Rewald: Cézanne; L. Venturi: Paul Cézanne, Paris, 1939; Venturi:

- Archives, op. cit.; W. Seitz: Monet, New York, 1960. See also illustrated articles by E. Johnson in *The Arts*, April 1930 and by Rewald in *L'Amour de l'Art*, Jan. 1935, *Art News*, March 1-14, 1943, Oct. 1-14, 1943, Feb. 15-29, 1944, Sept. 1-14, 1944.
- 55 See Lettres de Degas, Paris, 1931, footnote p. 16.
- 56 See Moore, op. cit., p. 310, and Rewald: Degas and his Family in New Orleans, Gazette des Beaux-Arts, Aug. 1946.
- 57 E. de Goncourt, diary entry of Jan. 19, 1877; quoted in M. Robida: Le Salon Charpentier et les impressionnistes, Paris, 1958, p. 8. On this subject see also P. Alexis: Manet, Revue Moderne et Naturaliste, 1880, p. 289-295.
- 58 On Renoir's studios rue St. Georges and rue Cortot see Rivière: Renoir et ses amis, op. cit., p. 56 and 61-67.
- 59 On Renoir's garden rue Gortot and on the Moulin de la Galette see *ibid.*, p. 121-137; also catalogue of the John Hay Whitney Collection, Tate Gallery, London, Dec. 1960–Jan. 1961.
- 60 See Zola: Deux expositions d'art au mois de mai, op. cit., p. 195. Robida's contention, op. cit., p. 65 and 124, that behind Zola's support of the impressionists, "if we look better, we discover quickly the influence and advice of Charpentier," is of course ridiculous and amply contradicted by facts and dates.
- 61 Monet to Zola, no date [winter 1876-77, the address given being 17 rue Moncey]; unpublished document preserved among Zola's papers at the Bibliothèque Nationale, Paris.
- 62 Eugène Manet to Berthe Morisot, Sept. 1876; see D. Rouart: Correspondance de Berthe Morisot, Paris, 1950, p. 88.
- 63 See A. Tabarant: Le peintre Caillebotte et sa collection, Bulletin de la vie artistique, Aug. 1, 1921; Caillebotte's will is partly translated in G. Mack: Cézanne, New York, 1936, p. 331-332. On the Caillebotte bequest see also G. Bazin: French Impressionists in the Louvre, New York, 1958.
- 64 Caillebotte to Pissarro, Jan. 24, 1877; unpublished letter found among Pissarro's papers.
- 65 See Guillaumin's letter to Dr. Gachet, Feb. 24, 1877, in Lettres impressionnistes au Dr. Gachet et à Murer, Paris, 1957, p. 73.

- 66 Degas to Berthe Morisot, no date [beginning of 1877]; see Rouart, op. cit., p. 92.
- 67 Guillaumin to Dr. Gachet, Feb. 24, 1877; see op. cit., p. 72-73.
- 68 For a condensed catalogue see Venturi: Archives, v. II, p. 262-264.
- 69 On the exhibition see Rivière, op. cit., p. 156-165; Rivière: Le maître Paul Cézanne, Paris, 1923, p. 84-85; and Geffroy, op. cit., ch. XIX.
- 70 For press comments see Venturi: Archives, v. II, p. 291-293, 303-304, 330; M. Florisoone: Renoir, Paris, 1938, p. 162-163; Lethève, op. cit., p. 82-87; for articles on Degas' works see Lemoisne, op. cit., v. I, p. 240-243, notes 120-127. Lethève quotes Leroy's statement on Renoir's portraits in Le Charivari: "How many studies at the morgue has it taken in order to obtain such results!" Besides the caricatures by Cham reproduced p. 394, Le Charivari also published others by the same author, in one of which an impressionist painter tells his model: "Madame, a few tones in the face are lacking for your portrait. Couldn't you first spend a couple of days on the bottom of a river?" Another announces that the "police commissioner has required the addresses of the models so as to have them buried immediately in view of their advanced state of putrefaction."
- 71 Rivière: Renoir et ses amis, op. cit., p. 40.
- 72 For extensive excerpts from L'Impressionnisme, journal d'art, see Venturi: Archives, v. II, p. 306-329 and Lethève, op. cit., p. 88-91.
- 73 Zola in Le Sémaphore de Marseille, April 19, 1877; reprinted in Oeuvres Complètes, Paris, 1969, p. 974.
- 74 See Duret: Les peintres impressionnistes, Paris, 1878.
- 75 See Rivière: Renoir et ses amis, op. cit., p. 165-166.
- 76 According to Geffroy, op. cit., v. I, ch. XIX, Pissarro's landscapes brought between 50 and 260 francs, Renoir's canvases between 47 and 285 francs, Sisley's between 105 and 165 francs, while Caillebotte obtained up to 655 francs. The forty-five canvases sold totaled 7,610 francs, the average price paid being 169 francs. The procès-verbal of this sale has been lost: for the catalogue and further details see M. Bodelsen, op. cit.

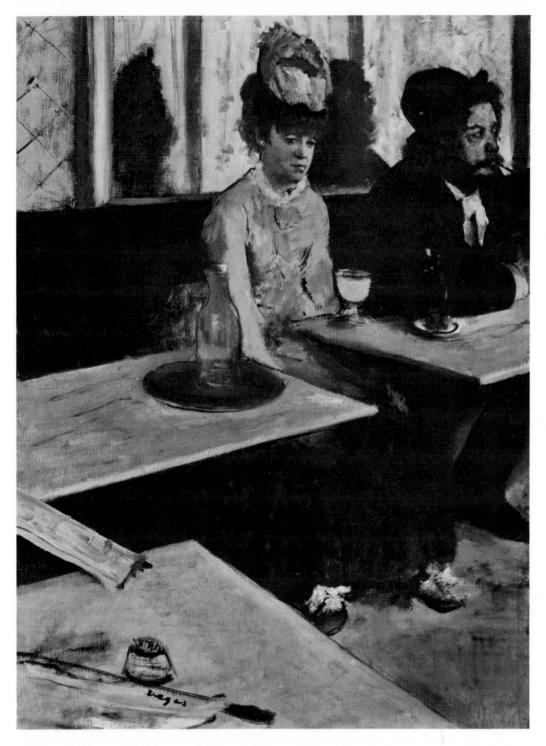

DEGAS: L'Absinthe (the actress Ellen Andrée and Marcellin Desboutin at the Café de la Nouvelle-Athènes), 1876. $37 \times 27\frac{1}{2}$ ". Probably exhibited at the second impressionist show, 1876. Musée du Louvre, Paris.

XI 1877-1879

THE CAFÉ DE LA NOUVELLE-ATHÈNES

RENOIR, SISLEY, AND MONET AT THE SALON

A NEW ART CRITIC: HUYSMANS

SERIOUS DISAGREEMENTS

Marcellin Desboutin, who thoroughly disliked the rowdy neighborhood of the Café Guerbois, had begun to patronize the quieter Café de la Nouvelle-Athènes, on the place Pigalle, not far from the Cirque Fernando where Renoir and Degas occasionally went. When, about 1876, Degas painted a portrait of Desboutin and the actress Ellen Andrée, entitled *L'Absinthe*, he represented them at the Nouvelle-Athènes. The others little by little followed him and established their evening quarters there, although the company was not altogether the same as that which had frequented the Café Guerbois.

The Nouvelle-Athènes distinguished itself, among other things, by a painted ceiling which featured a huge dead rat. Under Napoléon III it had been a gathering place for intellectuals of the opposition, such as Duranty, Courbet, Castagnary, Gambetta, Daudet, Nadar, and their friends. The politicians among them, who in those days clamored for liberty, had risen to power during the Third Republic and their group was slowly being replaced by that of Manet and his fellows, of whom Duranty seemed the sole link with the former habitués.

Among the impressionists only Renoir, who continued to live in Paris, appeared more or less frequently at the café which was situated half-way between his old studio on the rue St. Georges and his new one on the height of Montmartre. Pissarro came whenever he was in town, that is, once a month. Monet showed up every now and then, while Sisley was almost never to be seen at the Nouvelle-Athènes, nor was Cézanne, who joined the others only when his friend, the eccentric but amiable musician Cabaner, succeeded in bringing him along.² Guillaumin, still working for a living and painting in his free hours, had no time to waste at the café.

Next to Desboutin, the most regular patrons of the Nouvelle-Athènes were Manet and Degas. In the latter's company sometimes could be found his young friends and followers, the painters Forain, Raffaëlli, and Zandomeneghi. The engraver Henri Guérard, who in 1878 married Eva Gonzalès, was likewise a frequent guest. So were

MANET: Jean de Cabannes (called Cabaner), 1880. Pastel, 21¼ × 13¾". Musée du Louvre, Paris.

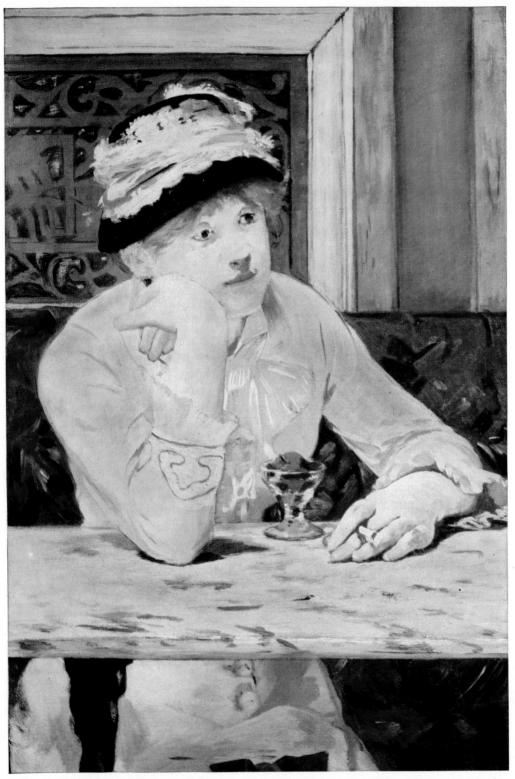

Manet: The Plum, 1877. $29\frac{1}{8}\times19\frac{1}{4}$ ". National Gallery of Art, Washington, D.C. (Collection Mr. and Mrs. Paul Mellon).

a few critics, poets, and authors, among them—besides Duranty—Armand Silvestre and Burty, as well as Ary Renan, Jean Richepin, Villiers de l'Isle-Adam, Zola's friend Alexis, and others. Manet's former model, Victorine Meurent,³ was also to be seen at the café. A young Irishman, George Moore, who had come to Paris in 1873 to study painting under Cabanel but had given it up a few years later, used to meet the others there and join in their conversations.

George Moore, then in his middle twenties, was later described by Duret as a golden-haired fop of whom nobody thought anything, but who, in spite of a certain snobbishness, was welcome everywhere because his manners were amusing and his French very funny. Manet liked him and sketched three portraits of him, yet the likeness which he intended to paint of Moore against the background of the Nouvelle-Athènes, where they had first met, did not satisfy the artist and was ultimately destroyed. When Moore began to write, Degas was quick to break with him because of his innate horror of art criticism and his conviction that literature had done only harm to art. Moreover, Degas was incensed by Moore's mentioning his family's financial affairs.

Although Moore did not frequent the Nouvelle-Athènes for very long, it was he who later gave the most vivid description of the café and its guests. There was a partition rising a few feet over the hats of the men sitting at the usual marble tables, separating the glass front from the main body of the café. Two tables in the right-hand corner were reserved for Manet, Degas, and their friends. Moore noticed Manet's square shoulders that swaggered as he crossed the room; he admired the finely cut face from whose prominent chin a closely cut blond beard came forward, and the aquiline nose, the clear grey eyes, the decisive voice, the remarkable comeliness of the well-knit figure, scrupulously but simply dressed. He was impressed by the frank passion in Manet's convictions, his loyal and simple phrases, clear as well-water, sometimes a little hard, sometimes even bitter.⁵

"Occasionally, in the evening, I see Manet, Duranty, etc. at the Nouvelle-Athènes," Alexis reported to Zola. "The other day there was a big discussion concerning an artistic congress which has been announced. Manet declared that he planned to go there, address the meeting and pounce upon the *Ecole des Beaux-Arts*. Pissarro, listening to this, appeared vaguely disturbed. Duranty—as the sage Nestor he is—called Manet back to more practical means."

If George Moore is to be believed, Manet was in despair because he could not paint atrocious pictures like Carolus-Duran and be feted and decorated with the Legion of Honor; yet his vanity was rendered attractive and engaging by a strange boyishness of disposition.⁵ As a matter of fact, far from painting "atrocious" pictures, Manet was enjoying a phase of particularly felicitous creation. After a series of portraits and outdoor scenes such as the impressionists favored, he returned, in 1877, to subjects of contemporary life. One of these, *The Plum*, shows a young model at the Café de la Nouvelle-Athènes. While the mood of sadness, dejection, and "modern spleen" is not unlike that of Degas' *L'Absinthe*, the execution is much more lively. There is no emphasis on diagonals and shadows which Degas used to dramatize the composition; instead forms are modeled softly by masterful brushwork.

Although Zola does not seem to have come to the Nouvelle-Athènes, Manet apparently remained in touch with him. He must have read Zola's latest novel,

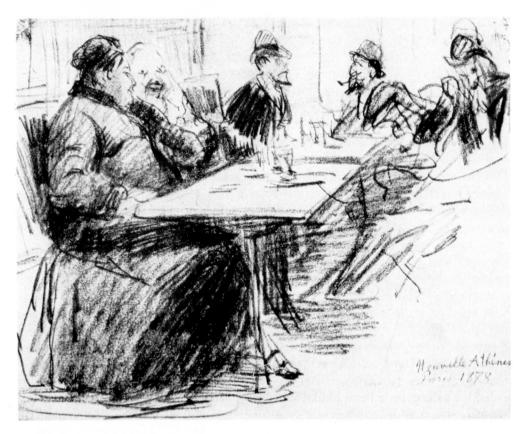

DEGAS: The Café de la Nouvelle-Athènes, d. 1878. Pencil. Present whereabouts unknown.

Far left, Manet: George Moore at the Nouvelle-Athènes, c. 1879. Oil sketch on canvas, $25\frac{3}{4} \times 32''$. Metropolitan Museum of Art, New York (Gift of Mrs. Ralph J. Hines).

Left, Manet: George Moore, 1879. Pastel, 21×14 ". Metropolitan Museum of Art, New York (H. O. Havemeyer Collection).

M. Manet étudiant la belle nature.

M. Manet Studying the Beauties of Nature. Caricature published in Le Charivari, April 25, 1880.

Manet: Nana, 1877. $59 \times 45\frac{5}{8}$ ". Kunsthalle, Hamburg.

L'Assommoir, published in installments from April 1876 to January 1877, in which a small girl, Nana, emerge toward the end of the story as an alluring creature bent on achieving her goals through the liberal use of her natural assets. Manet seems to have known of Zola's plan to make her the heroine of his next book, Nana, that was to appear only in 1879. In any case, the painter decided to represent a young woman powdering herself in a painting which he also called Nana. It depicts a Parisian cocotte dressing under the stern glance of her sponsor. The latter's figure is cut in half by the frame, a device borrowed from Japanese prints and frequently used by Degas. The picture, rejected in 1877 by the Salon jury on moral grounds (lascivious nudes of Magdalenas, Venuses, or young brides were considered acceptable, but not this portrayal for which the notorious mistress of a foreign prince had posed in a fashion-

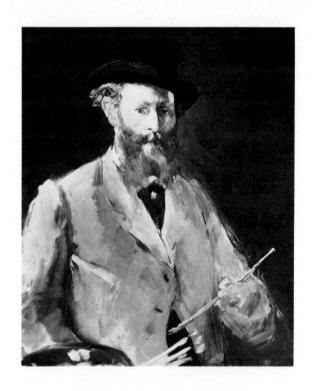

Far left, Manet: Self Portrait, 1878. 34×28". Collection Mr. and Mrs. John L. Loeb, New York.

Left, photograph of Edouard Manet.

able *déshabillé*), was subsequently displayed in the window of an elegant gallery on the boulevard des Capucines where it created quite a stir. Zola's friend Joris-Karl Huysmans extensively praised it in an article published in Brussels.⁷ Yet this was not the kind of success the painter desired.

Manet's undisguised craving for the red ribbon brought about a violent run-in with Degas when their mutual friend, de Nittis, received the Legion of Honor in 1878. Degas had no sympathy for such weaknesses, not from modesty, but because his immense pride made him independent of external signs of success and even led him to avoid anything that might distinguish him from the anonymous crowd. His disdain for de Nittis' satisfaction was without limit, and he made no secret of it. De Nittis later recalled that Manet "listened to him with that young, mischievous boy's smile, a bit mocking, which drew back his nostrils.

"'All that contempt, my boy,' Manet told Degas, 'is nonsense. You have it, that is the point; and I congratulate you with all my heart.... If there were no rewards, I wouldn't invent them; but they exist. And one should have, when possible, everything that singles you out.... It is one step ahead.... It is another weapon. In this beastly life of ours, which is wholly struggle, one is never too well armed. I haven't been decorated? But it is not my fault, and I assure you that I shall be if I can and that I shall do everything necessary to that end.'

"'Naturally,' Degas interjected furiously, shrugging his shoulders. 'I've always known how much of a bourgeois you are.' "8

According to Moore, Degas would come to the Nouvelle-Athènes late in the

Right, Desboutin: Auguste Renoir, 1877. Etching, $6\frac{1}{4} \times 4\frac{3}{8}$ ". New York Public Library.

Far right, Manet: Marcellin Desboutin, c. 1875. Watercolor, $8\frac{1}{4} \times 5\frac{1}{8}$ ". Fogg Art Museum, Cambridge, Mass. (G. L. Winthrop Bequest).

evening, about ten o'clock. For those who knew him, his round shoulders, his rolling gait, his pepper-and-salt suit, and his bright masculine voice were brimming with individuality. His silhouette was still slim and youthful although he was graying. In the words of a mischievous journalist, Degas was "aggressive, easily became excited, and frequently spoke well of himself to create a lasting impression."

Just as the Café Guerbois had had its duel, the habitués of the Nouvelle-Athènes were treated to a similar event when, in 1880, a disrespectful though rather harmless article by the twenty-year-old critic Félicien Champsaur prompted Forain to provoke the author. The conditions of their encounter raised many an eyebrow and were duly reported in the press. Duels being outlawed in France, the antagonists and their witnesses had to travel to Belgium for the occasion, yet the duration of the fight was strictly limited to fifteen minutes. The outcome is not known, but the incident brought into the limelight the small café where, according to one writer, "more than once the entire studio of Bouguereau is being devoured at lunch-time in lieu of radishes, while Bonnat's studio is reserved for the dessert."

With books and cigarettes the time passed in agreeable estheticisms at the café: Manet loud, declamatory; Degas sharp, more profound, scornfully sarcastic; Duranty clearheaded, dry, full of repressed disappointment. Pissarro, looking like Abraham—his beard was white and his hair was white and he was bald, though at the time he was not yet fifty—sat listening, approving of their ideas, joining in the conversation quietly. No one was kinder than Pissarro, Moore later remembered. He would always take the trouble to explain to students from the *Ecole des Beaux-Arts* why their teacher

Jules Lefebvre was not a great master of drawing.¹⁰ Pissarro's innate pedagogical gifts expressed themselves on every occasion with soft insistence and perfect clarity. "He was so much a teacher," Mary Cassatt later stated, "that he could have taught stones how to draw correctly."¹¹

Mary Cassatt, who first met Degas around 1877, spoke quite differently of him, in spite of her deep admiration for his work. "Degas is a pessimist," she wrote to a friend, "and dissolves one so that you feel after being with him: 'Oh, why try, since nothing can be done!' And this effect Gustave Moreau so felt that after a long friend-ship he said: 'After all, I may be wrong, but I see things a certain way and must work that way, and I simply cannot see you, you upset and discourage me.'"12

As a matter of fact, Degas cared little to stimulate others, nor was he interested in initiating the new generation. It was enough for him to advise beginners to burn their model-stool¹³ and to work from memory. His young painter friends may have done so, but they were apparently unable to blot from their memory the works of Degas they had studied: their efforts relied more or less heavily on Degas' guidance. While Degas seemed not to mind this at all, his impressionist friends felt somewhat uneasy on the subject of his eager imitators.

Renoir came often to the café. What most struck Moore was the hatred with which he denounced the nineteenth century—the century in which, he used to say, there was no one who could make a piece of furniture or a clock that was beautiful and that was not a copy of an old one. Indeed, Renoir began to show an increasing interest in craftsmanship, which was to find its expression in his own efforts.¹⁴

Cézanne's rare visits to the Nouvelle-Athènes did not go unnoticed. "If this can interest you," Duranty wrote to Zola, "Cézanne has appeared recently at the little café on the place Pigalle; he was attired in one of his costumes of olden times: blue overall, jacket of white linen completely covered with smudges from his brushes, etc., a battered old hat. He had a certain success. But those are dangerous demonstrations." ¹⁵

This flouting of conventions was "dangerous" in the sense that it encouraged all sorts of rumors to circulate about Cézanne (rumors to which Edmond Duranty himself was not alien¹6). It is not surprising, then, that George Moore, who never met the painter, later wrote: "We used to hear about him—he used to be met on the outskirts of Paris wandering about the hillsides in jack-boots. As no one took the least interest in his pictures, he left them in the fields. . . . It would be untrue to say that he had no talent, but whereas the intention of Manet and of Monet and of Degas was always to paint, the intention of Cézanne was, I am afraid, never very clear to himself. His work may be described as the anarchy of painting, as art in delirium." Thus legends began to be spun about Cézanne as soon as he went into retreat.

While the evenings at the café were passed in lively discussions, all the landscapists who were absent from Paris continued their bitter struggle for existence and lived often without knowing where their next meal would come from. The vicious reviews, the ridiculous prices obtained at auctions, the criticisms of *père* Martin, maddening in themselves, had above all one terrible repercussion: they meant less bread. There was a dreadful monotony in the suffering of these painters, an unbearable successsion of events which seemed to push them ever deeper into misery with nowhere the slightest sign of relief.

Cézanne: Self Portrait with a Straw Hat, 1877-80. $13\frac{3}{8} \times 10\frac{1}{4}$ ". Collection William S. Paley, New York.

Far left, Cassatt: *Torero*, Seville, d. 1873. 32¼ × 25¼". Art Institute of Chicago (Mrs. Sterling Morton Bequest).

Left, Cassatt: Woman Reading, d. 1876. $13\frac{5}{8} \times 10\frac{1}{2}$ ". Museum of Fine Arts, Boston (John T. Spaulding Collection).

By now impressionism had become thoroughly notorious in Paris. Newspapers carried caricatures of impressionist painters and the artists even became the subject of jokes on the stage. Degas' friend, the playwright Halévy, was one of the authors of a comedy put on with great success in October 1877. The central figure of this comedy, La Cigale, was an "impressionist" painter whose works could be contemplated both in the normal way and upside down; a landscape with a white cloud, for instance, became, if turned around, a seascape with a sailing boat. Degas contributed a scenic sketch for the studio set, since—as he explained to Halévy—"in spite of my bad eyesight, it pleases me a lot to do it..." 18

Yet, at the very moment when public favor seemed more and more elusive, after the most representative exhibition ever held by the impressionists had failed to produce the expected change of attitude, two new recruits presented themselves to the group. One was the young American painter, Mary Cassatt, whose work Degas had noticed earlier when she had shown at the Salon of 1874. Although since then her admiration for Courbet, Manet, and especially Degas had been steadily growing, she had continued to send to the Salon. She had done so with indifference, however, after a portrait rejected in 1875 had been accepted the following year simply because she had darkened the background in obedience to academic convention. But in 1877 the jury again refused a painting of hers. A mutual friend subsequently brought Degas to her studio; he invited her to join the group and to take part in its shows. "I accepted with delight," she later explained. "At last I could work in complete independence, without bothering about the eventual judgment of a jury." 19

Except for her strong urge toward independence, nothing appears to have pre-

destined Miss Cassatt to abandon the quiet life of a lady painter exhibiting at the Salon for the ungrateful role of a woman adhering to the most ridiculed band of artists. The daughter of a wealthy Pittsburgh banker, she had traveled extensively in Europe since about 1868, had visited France, Italy, Spain, and Holland, had studied the old masters there and had returned to Paris in 1874 in order to enter the studio of Chaplin, the former master of Eva Gonzalès. But, with increasing experience and passionate self-criticism, she began to feel that she could never express herself freely in following the beaten track. She had become a painter more or less against her father's will and, at the age of thirty-two, she now decided to go where her intuition led her, whether or not it was consistent with her background. She managed to draw the almost impossible line between her social life and her art, never compromising with either. Although at no time a real pupil of Degas, she was particularly influenced by him. She shared his intellectual quality and his emphasis on draftsmanship, but to these she added a mixture of sentiment and crispness which was all her own.

At about this same time Pissarro met, apparently through his patron Arosa, the latter's godson, Paul Gauguin, by then a well-to-do stock broker. It was doubtless Arosa who first stimulated the former sailor's interest in art; his daughter, Marguerite Arosa, was an artist and taught the young man how to paint in oil.²⁰ Gauguin also met at the bank where he worked another employee, Schuffenecker, who devoted his spare time to painting. After his marriage, in 1873, Gauguin, who was then

Photograph of Paul Gauguin, bank agent, 1873.

Gauguin: The Seine in Paris, Winter, d. 1875. $25\frac{1}{4} \times 36\frac{1}{4}$ ". Musée du Louvre, Paris.

Gauguin: Farmhouse in Osny near Pontoise, d. 1879. $12\frac{1}{2} \times 18\frac{7}{8}$ ". Exhibited in the fifth impressionist show, 1880. Collection Alberto Phelps, Caracas, Venezuela.

twenty-five years old, had continued to draw and to paint. In 1876 he had submitted a landscape to the Salon, which was accepted. Yet he was quick to discover in the impressionist exhibitions an art which appealed more strongly to him than anything he had ever seen before. Little by little he began to buy works by Jongkind, Manet, Renoir, Monet, Pissarro, Sisley, and Guillaumin, as well as by Cézanne (spending 15,000 francs on his collection).²¹ Impressionist paintings thus became the framework of his life and compelled him to similar directions in his own efforts. Feeling the need for professional advice, Gauguin was glad to meet Pissarro, always approachable and willing to help. Through him Gauguin made somewhat later the acquaintance of Guillaumin and Cézanne. Although Pissarro became Gauguin's teacher and endeavored to develop his gifts through close contact with nature, it was Cézanne who most deeply impressed Gauguin.

Cézanne spent part of the year 1877 with Pissarro at Pontoise, where they painted again side by side. Cézanne also worked with Guillaumin in the park at Issy-les-Moulineaux, just outside Paris. "I am not too dissatisfied," he wrote to Zola, "but it appears that profound desolation reigns in the impressionist camp. Gold is not exactly flowing into their pockets and the pictures are rotting on the spot. We are living in very troubled times and I do not know when unhappy painting will regain some of its lustre."²²

Cézanne was more and more strongly aware of an urge to isolate himself, to work in the South, far from the distracting noise and discussions and intrigues of Paris, to advance on his own, unconcerned with the opinions of others. There, in his native Aix, he believed that he would best be able to devote himself to his chosen task, that

PISSARRO: Orchard in Pontoise, Quai de Pothuis, d. 1877. $26\frac{1}{8} \times 32\frac{1}{2}$ ". Exhibited in the fourth impressionist show, 1879. Musée du Louvre, Paris (Caillebotte Bequest).

CÉZANNE: Orchard in Pontoise, Quai de Pothuis, 1877. $20 \times 24\frac{1}{2}$ ". Formerly in the collection of Camille Pissarro. Collection Mrs. Alexander Albert, San Francisco.

of "making out of impressionism something solid and durable like the art of museums."23

Monet's situation, meanwhile, did anything but improve. In the fall of 1877 he was once more obliged to go begging for help. He asked Chocquet "to be good enough to take one or two daubs which I'll let you have at any price you may make: 50 francs, 40 francs, whatever you are able to pay, because I can't wait any longer."²⁴ Toward the end of 1877 Monet, whose wife was again expecting, became so weary of the struggle that he began to lose faith in the future. It was then that Manet conceived a plan for rescuing him. "I went to see Monet yesterday," he wrote to Duret. "I found him quite broken down and in despair. He asked me to find him someone who would take ten or twenty of his pictures at 100 francs each, the purchaser to choose which he liked. Shall we arrange the matter between us, say 500 francs each? Of course nobody, he least of all, must know that the offer comes from us. I had thought of some dealer or collector, but I foresaw the possibility of a refusal. It is unhappily necessary to be as well informed as we are in order to bring off—in spite of the repugnance we may feel—an excellent business transaction and, at the same time, to do a good turn to a man of talent."²⁵

Duret, apparently, was in no position to associate himself with Manet in this, whereupon Manet decided to act alone. On January 5, 1878, he undertook in writing to pay Monet 1,000 francs "against merchandise." This probably enabled the painter to settle his most urgent debts in Argenteuil and pay advance rent for a house in Vétheuil, on the banks of the Seine, farther away from Paris than Argenteuil and offering more plain country motifs, more solitude. Yet before he could leave Paris, Monet went again through dire moments. At the beginning of February he turned to Dr. Gachet, informing him that the delivery was expected any day and that he needed money, although he still owed the doctor some. "Would you once more lend me 100 francs and come to see me in Paris as soon as you wish, to reimburse yourself with a painting? You would do me a great favor and at the same time would give courage and a feeling of security to my poor wife who is tormented by the thought of not having the basic necessities for the great event."²⁷ Gachet sent 50 francs which obviously did not last long. Early in April Monet appealed once more to Zola: "Can you help me? We haven't a single sou in the house, not even anything to keep the pot boiling today. On top of this my wife is ailing and needs care, for, as you perhaps know, she has given birth to a superb boy. Could you lend me two or three *louis*, or even only one?... I ran around all day yesterday without being able to find a cent."28

When the time finally came for the move to Vétheuil, another urgent request went out to Dr. Gachet: "I came to ask you for a favor yet didn't dare, and now I am in a cruel situation; our furniture has been loaded on the van but I can't pay the moving men, not one sou." 29

And things were to get still worse. In April 1878, speculating on possible gains, Faure sold some of his pictures at auction. The results were depressing. The absence of adequate bids obliged the singer to buy most of the paintings back, and the prices for those actually sold did not even cover expenses. Two months later Hoschedé, ruined, was forced by a court judgment to sell the new collection he had assembled since his auction in 1874. It comprised, among others, five canvases by Manet, sixteen

PISSARRO: Mlle Marie Murer, d. 1877. Pastel, $23\frac{3}{4} \times 19\frac{1}{2}$ ". Exhibited at the fourth impressionist show, 1879. Private collection, New York.

Renoir: Mlle Marie Murer, c. 1877. 24\frac{3}{4} \times 20". (Eugène Murer commissioned this portrait for 100 francs.) National Gallery of Art, Washington, D.C. (Chester Dale Collection).

by Monet, thirteen by Sisley, and nine by Pissarro. The bids were again catastrophically low.³⁰ Though the average for Manet's works reached 583 francs, this was much less than what Durand-Ruel had originally paid the artist for them (and what Hoschedé had subsequently paid Durand-Ruel). Monet's paintings averaged only 150 francs (among them were St. Germain l'Auxerrois, p. 152, The Thames, p. 259, and Impression, p. 317). Sisley's works, which included Flood at Port-Marly (p. 378), brought an average of but 112 francs, yet the artist appeared satisfied, having apparently expected even less. Renoir, represented by only three paintings, saw these go for 31, 42, and 84 francs. Worst hit was Pissarro, whose nine canvases netted a total of 404 francs, one landscape being sold for 7 francs, another for 10.

"The Hoschedé disaster will evidently disturb the camp of our intransigent friends," Duranty wrote to Zola, "but they are regaining some possibilities from Chocquet's side, whose wife—I am told—will some day have an income of 50,000 francs." However, having retired, Chocquet meanwhile lived in somewhat straitened circumstances and was able to spend only 153 francs for two paintings by Monet at the sale. Among the other buyers were Faure, de Bellio, Hecht, Durand-Ruel, Duret, Mary Cassatt (she bought a canvas by Monet and another by Berthe Morisot), as well as an acquaintance of the artists, Murer, who spent 21 francs for a painting by Sisley. Deeply discouraged, Pissarro wrote to him after the auction: "I had at last discovered an enthusiast, but the Hoschedé sale finished me off. He will buy some inferior pictures of mine, which he will be able to get at a low price at the Hôtel Drouot. Here I am still without a cent." Pissarro was now again reduced to accepting 50 to 100 francs for his canvases, if he could sell them at all.

In the spring of 1878 Duret came to the aid of his friends by publishing a pamphlet, Les peintres impressionnistes, in which he tried to convince the public that innovators are always laughed at before they are recognized. Duret devoted short biographical notices and commentaries to Monet, Sisley, Pissarro, Renoir, and Berthe Morisot, thus for the first time singling out these five as the true impressionists, the leaders of the group. He endeavored to prove that their efforts were not opposed to tradition but in harmony with it, adding the contemporary link to a great past. He also insisted that there were already critics like Burty, Castagnary, Chesneau, and Duranty, authors like Daudet, d'Hervilly, and Zola, collectors like de Bellio, Charpentier, Chocquet, Faure, and others, who appreciated the impressionists, and he concluded by predicting that the day would come when their art would be generally accepted.

Shortly after this pamphlet appeared Manet informed Duret that he had met some of the impressionists, who had been filled with new hope by this promise of better days ahead. "And they need it badly," Manet added, "for the pressure is tremendous at the moment." 33

Among the collectors of impressionist works listed by Duret figured a new name, that of Eugène Murer, who had only recently assumed the role of art patron.³⁴ A former school friend of Guillaumin, Murer was a pastry cook and owner of a small but flourishing restaurant. Through Guillaumin he met Pissarro and Renoir and asked them to decorate his shop; he also bought some of their canvases, often by offering meals in exchange. But when he commissioned them to do portraits of himself and his sister, the painters had trouble in getting him to agree to their modest prices. Renoir's friend Rivière later accused Murer of having extended help only at

the most desperate moments, when the artists were ready to accept anything.³⁵ Every Wednesday the painters met for dinner at his place, the most frequent guests being Guillaumin, Renoir, Sisley, Guérard (Eva Gonzalès' husband), Cabaner, and père Tanguy. Pissarro, Monet, and Dr. Gachet also came occasionally, as did Champfleury, the etcher Bresdin (Redon's master), Hoschedé, and Cézanne, followed somewhat later by Renoir's friends Cordey and Franc-Lamy.

Toward the end of November 1877, Murer tried to help both Pissarro and Sisley; he hung in his house a series of paintings by the latter, hoping to sell them, and simultaneously organized a lottery among his regular clients with one of Pissarro's canvases as the first prize. Tickets sold for 1 franc. The winner turned out to be a maid-servant who preferred a large cream puff to the picture; Murer obliged by consenting to the trade.³⁶ In December Murer also bought four small paintings from Monet for 200 francs; thenceforth he was among those to whom Monet appealed for help in moments of distress.

In the course of the year 1878 Murer repeatedly assisted Pissarro, whose letters became increasingly gloomy. "I am going through a frightful crisis," he wrote to Murer, "and I don't see a way to get out of it.... Things are bad." Pissarro owed money to the butcher, the baker, everywhere, and his wife, expecting her fourth child, was completely discouraged. "My work is done without gaiety," he explained, "as a result of the idea that I shall have to give up art and try to do something else, if it is possible for me to begin over again. Depressing!"³⁷

Accused by Duret of not being a good salesman, Pissarro swallowed his pride and replied: "I'll do anything within my power in order to make some money, and I'll even renew business relations with père Martin, if the opportunity should come up. But you must realize that it is very hard for me, after he has run me down so, because he didn't hesitate to say that I was lost for good.... All my customers are convinced of it. I was even afraid that you might have been influenced by him...."38

Although Duret considered Monet a smart businessman, the latter was by no means better off. His colleagues felt that he was almost too smart and reproached him for trying too hard to sell his works during their exhibitions. It is true that adversity had not affected his pride nor his sense of values and that even in most difficult moments Monet usually remained quite levelheaded; he simply refused to let himself be taken in on account of his predicaments or to accept help at too high a price. In spite of his crying debts, for instance, he proposed in 1878 to reimburse Dr. Gachet for a loan rather than let him choose paintings at a disadvantageous rate, and he also wrote unabashedly to Murer who—having advanced money and waited some time—finally helped himself to several canvases: "You won't be angry if next time I shall offer you a selection among pictures of smaller dimensions.... I hope you will understand this for, after all, you wouldn't want me to make you a present." 39

In August 1878, it was Sisley's turn to seek help. He asked Duret whether he did not know someone willing to pay him 500 francs monthly for half a year, in return for thirty canvases. "For me," he explained, "it is a question of not letting the summer pass without working seriously, free of worry, to be able to do good things, convinced that in the fall things will be better." Duret, who had not been able to associate himself with Manet in support of Monet, now found among his business connections a man willing to buy seven paintings by Sisley.

PISSARRO: Eugène Murer, d. 1878. $26\frac{7}{8} \times 22\frac{1}{2}$ ". (Murer objected to the painter's price of 150 francs for this portrait.) Museum of Fine Arts, Springfield, Mass.

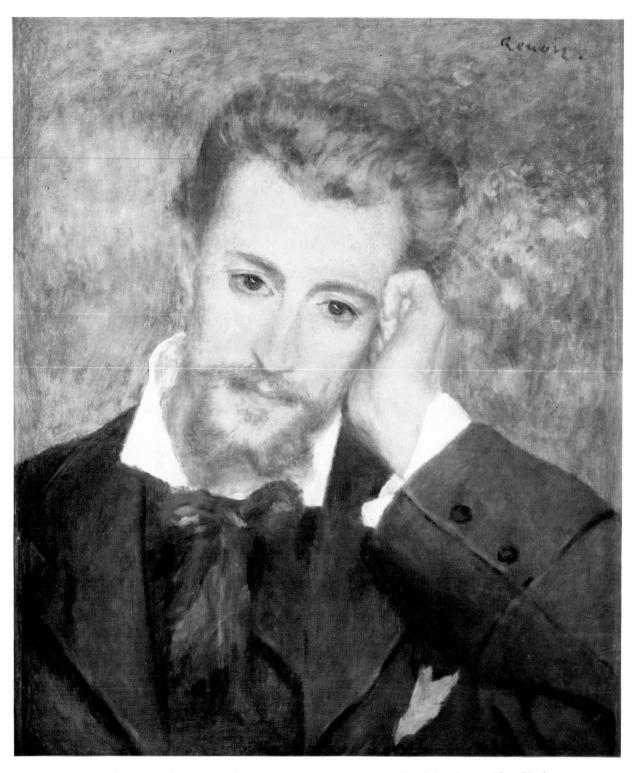

Renoir: Portrait of Eugène Murer, c. 1877. $18\frac{1}{2} \times 15\frac{1}{4}$ ". Collection Mrs. Enid A. Haupt, New York.

Even Cézanne had serious financial troubles in 1878 and, like Pissarro and Monet, thought of giving up painting to earn a living otherwise. His father had opened a letter addressed by Chocquet to the painter and had found in it a mention of "Madame Cézanne and little Paul." The old banker was furious, promising to "rid" the son of his dependents. In the face of evidence the painter denied everything, whereupon his father reduced his allowance from 200 francs a month to 100, arguing that a bachelor could well get along on that. Cézanne turned immediately to Zola, appealing to his friendship "to use your influence to find me a position, if you think such a thing possible."⁴¹

Zola had just obtained his first great success with the novel L'Assommoir and was about to buy with his royalties a little country place in Médan, on the Seine. He persuaded Cézanne not to provoke a complete rupture with his father and offered help. While Cézanne remained in Aix with his parents, playing as best he could a role of unconcern, Zola for almost a year supported Hortense Fiquet and the child, who lived in Marseilles.

Renoir was not less depressed than his friends. Since he—like the others—had made so little headway in their exhibitions, he decided in 1878 to send again a painting to the Salon. He later explained his decision to Durand-Ruel by stating: "There are in Paris scarcely fifteen art-lovers capable of liking a painting without Salon approval. There are 80,000 who won't buy an inch of canvas if the painter is not in the Salon. . . . Furthermore, I don't want to descend to the folly of thinking that anything is good or bad according to the place where it is hung. In a word, I don't want to waste my time in resentment against the Salon: I don't even want to give that impression. I believe one must do the best painting possible. That's all. Well, if I were accused of neglecting my art or, by idiotic ambition, of making sacrifices against my convictions, then I should understand the carpers. But since that doesn't come into the question, there is nothing to say against me. . . . My submitting to the Salon is entirely a business matter. In any case, it is like certain medicines: if it doesn't do any good, it doesn't do any harm."⁴²

Designating himself in the catalogue as pupil of Gleyre, Renoir saw his *Tasse de chocolat* (for which a new model, Margot, had posed) admitted to the Salon, while Manet did not submit anything to the jury. He thought of organizing again an exhibition of his own, but nothing came of it.

When the impressionists met in Paris toward the end of March 1878 to decide about a fourth group exhibition, they were faced with Renoir's defection and also with a series of other problems, ranking high among them the fact that a new World's Fair was to be held in Paris that same year. The jury of the art section had once more succeeded in excluding from the exposition not only the great living, but also the great dead: Delacroix, Millet, Rousseau, et al. Durand-Ruel thereupon determined to organize a show of his own, dedicated to these men and various masters of the Barbizon school. He was able to assemble no less than 380 outstanding works.⁴³ Sisley proposed that the impressionists hold a show of their own at Durand-Ruel's, but the others, doubtful of its success amidst the agitation of a World's Fair, preferred to have no exhibition at all.

"Useless to count on our exhibition," Pissarro wrote to Murer. "It would be a fiasco at Durand-Ruel's, where our most renowned masters are gathered; not a living

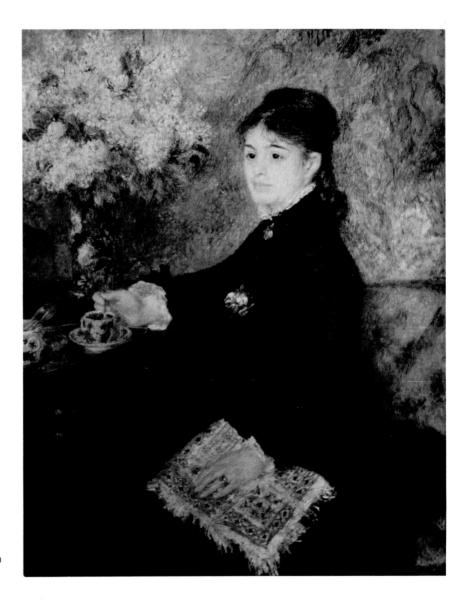

RENOIR: The Cup of Chocolate (Margot), 1877. $39\frac{3}{8} \times 31\frac{7}{8}$ ". Exhibited at the Salon of 1878. Private collection, Detroit.

soul—the most complete indifference. People have had enough of this dreary art, this over-particular, dull painting which requires attention, thought. All that is too serious. As a result of progress, we are supposed to see and feel without effort, and above all to enjoy ourselves. Besides, is art necessary? Is it edible? No. Well then!"44

For his exhibition Durand-Ruel had been obliged to borrow pictures from his clients, as he no longer owned enough important works himself. The preceding years had abounded in difficulties for him, too. One by one the Barbizon masters had died, Millet in 1874, Corot in 1875, Diaz in 1876, Courbet in 1877, Daubigny in 1878; Daumier was blind and ill. The various sales which had followed the disappearance of these painters had thrown a large quantity of their works upon the market and, with this, prices had gone down while the demand began to dwindle. Moreover, the depression which had followed the war showed no indication of subsiding. At the same

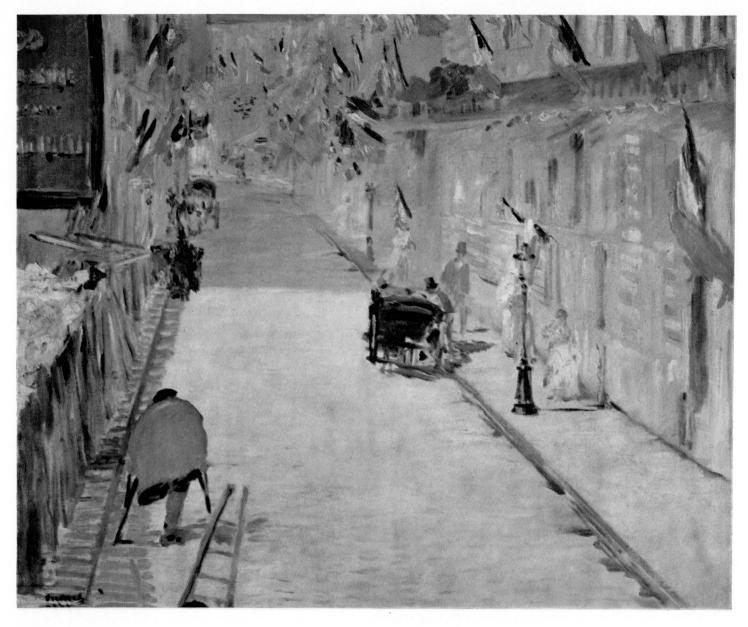

Manet: Rue Mosnier, Paris, Decorated with Flags, 1878. $25\frac{5}{8} \times 31\frac{7}{8}$ ". Collection Mr. and Mrs. Paul Mellon, Upperville, Va.

Opposite, Monet: National Holiday, rue St. Denis, Paris, 1878. $32 \times 19\frac{3}{4}$ ". Exhibited at the fourth impressionist show, 1879. Collection Lucien Lindon, Paris.

time Durand-Ruel's most serious Parisian rival, Georges Petit, increased his activity, yet still waited for some kind of official recognition before he felt ready to approach the impressionists. Fortunately, there were signs of a growing interest in the United States; American dealers began to buy paintings by Corot and Troyon in increasing quantities, though they were as yet unwilling to take an interest in more advanced works. (Referring to the impressionists, one New York colleague was shortly to warn Durand-Ruel: "These paintings will never be good for our market.")

Zola, in a new article for Russian consumption, spoke admiringly of the masters exhibited by Durand-Ruel, attacked once more the official painters, castigated the false "originality" of Carolus-Duran, demolished the fabulous reputation Meissonier had made for himself with minutely executed historical scenes, and for the first time found some words of appreciation for Gustave Moreau's strange and symbolic compositions, although he realized that the artist's concepts were diametrically opposed to his own. Simultaneously, Zola regretted that, "alas, our landscape school is not exactly flourishing . . ." and concluded by quoting his friend Duret's recent pamphlet on the impressionists, while repeating once more that the new movement had not yet produced a real genius.⁴⁵

Meanwhile, on June 30th, coincidentally with the opening of the World's Fair, the Republic celebrated its first Fête Nationale since the war and the Commune. Monet was back in Paris for the occasion and painted two views of streets decked with flags. Manet did likewise, painting from his window in the rue Saint-Pétersbourg two different aspects of the rue Mosnier (today rue de Berne), in one of which the sundrenched emptiness of the street, seen from above, is animated by sparkling tricolors. Brushed with the deftness demanded by a motif that combined static forms with animated color accents, the picture shows Manet, in subject as well as execution, extremely close to his impressionist friends.

At the same time Renoir temporarily deserted the plein-air when he accepted a major commission from Charpentier, that of painting a large portrait of Mme Charpentier and her children in her small, so-called Japanese salon. Mme Charpentier wore a long black dress by Worth which in itself was a challenge to the impressionist palette. Renoir's portrait lacks the spontaneous quality of most of his works, since he obviously proceeded with restraint and much application, refraining from abandoning himself to the happy, random discoveries of his sensibility. The colors are toned down, except for the blue dresses of the children, and little of his natural gaiety appears in this painting; instèad, a somewhat solemn opulence prevails. Renoir clearly aimed at a stately effect, and this he achieved. Marcel Proust, who later greatly admired the canvas in the publisher's house, was particularly receptive to "the poetry of an elegant home and the exquisite gowns of our time" which Renoir had rendered. Proust also spoke in this context of the "awakening to love and to beauty by an artist who can paint anything. The elegance—in which he can find such beautiful subjects—will be provided by people somewhat richer than he, in whose homes he will meet what he does not have in his studio (that of an unrecognized genius who sells his canvases for fifty francs): a salon with furniture upholstered in antique silks, many lamps, lovely flowers, beautiful fruit, attractive dresses."46 It seems questionable, however, whether Renoir's sensuous delight in his work was more readily stimulated by lace gowns from Worth and expensive tapestries than by the

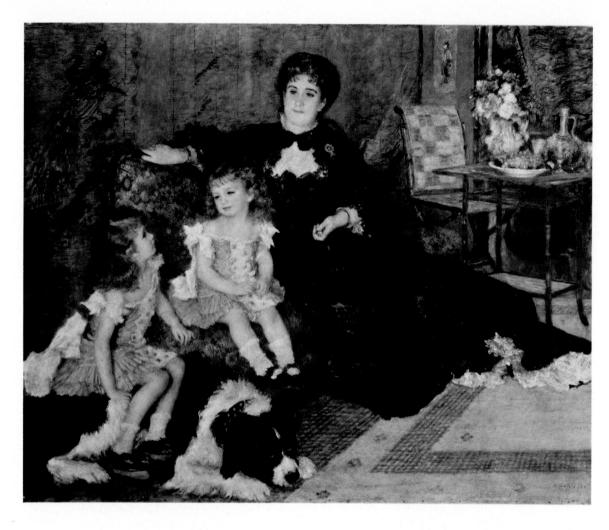

RENOIR: Mme Charpentier and Her Children, d. 1878. $60\frac{1}{2} \times 74\frac{7}{8}$ ". Exhibited at the Salon of 1879. Metropolitan Museum of Art, New York (Wolfe Fund, 1907).

gay ribbons on a *midinette's* self-made hat, the nacreous skin of a young model, or the working class couples whom he watched dance at the Moulin de la Galette. In any case, his excursion into the alien but captivating world of luxury was paid not 50 francs but 1000, an unusually generous fee which he deeply appreciated. (On the other hand, according to Zola, Meissonier thought nothing of asking 100,000 francs for his works.)

Mme Hoschedé, who also had been living in a well furnished house, left her husband during the summer of 1878 — shortly before or after the disastrous sale of his collection — and with her six children joined Monet at Vétheuil, there taking care of the painter's wife whose weak condition had failed to improve after her delivery. By the end of the year Monet found himself again without money, too poor to buy canvas or paints. "I am no longer a beginner," he wrote on December 30, 1878, to G. de Bellio, "and it is sad to be in such a situation at my age [he was then thirty-eight], always obliged to beg, to solicit buyers. At this time of the year I feel doubly crushed by my misfortune and 1879 is going to start just as this year ends, quite deso-

Photograph of Georges de Bellio, c. 1865.

Manet: Lise Campineano (great-niece of G. de Bellio), 1878. $22 \times 18\frac{1}{2}$ ". William Rockhill Nelson Gallery of Art, Kansas City, Missouri (Nelson Fund).

Photograph of Lise Campineano, c. 1878.

lately, especially for my loved ones to whom I cannot give the slightest present."47

From Sèvres Sisley wrote a short while later to Duret: "I am tired of vegetating, as I've been doing for so long. The moment has come for me to make a decision. It is true that our exhibitions have served to make us known and in this have been very useful to me, but I believe we must not isolate ourselves too long. We are still far from the moment when we shall be able to do without the prestige attached to official exhibitions. I am, therefore, determined to submit to the Salon. If I am accepted — there are possibilities this year — I think I'll be able to do some business. . . . "48 Renoir also sent again to the Salon. So did Cézanne; when Pissarro invited the latter to participate in a new group show, he received the reply: "I think that, amidst all the difficulties caused by my submitting to the Salon, it will be more suitable for me not to take part in the impressionists' exhibition." 49

In spite of the absence of Renoir, Sisley, Cézanne, and Berthe Morisot (who abstained because she was pregnant), the friends went ahead with their fourth exhibition, to be held at 28 avenue de l'Opéra. Though a newcomer to the group, Mary Cassatt informed an American painter: "There are so few of us that we are each required to contribute all we have. You know how hard it is to inaugurate anything like independent action among French artists, and we are carrying on a despairing fight and need all our forces, as every year there are new deserters." 50

This time it was decided, at the insistence of Degas, to drop the word "impressionist" from the announcements. At first Degas had suggested a compromise, proposing a poster reading:

4e Exposition
faite par
un groupe d'artistes indépendants
réalistes
et
impressionnistes⁵¹

but in order not to complicate matters, it was agreed to speak simply of a "Group of Independent Artists." And Armand Silvestre thereupon informed the public: "You are invited to attend the funeral service, procession, and interment of the impressionists. This painful invitation is tendered to you by the *Independents*. Neither false tears nor false rejoicing. Let there be calm. Only a word has died... These artists have decided, after serious conference, that the term which the public adopted to indicate them signified absolutely nothing and have invented another."⁵² But in spite of this change of name, the painters continued to be known as impressionists.

Disheartened by his continual bad luck, Monet, in March, informed de Bellio: "I am completely disgusted and demoralized by the existence I have been leading for so long. If that's all one has achieved at my age, there is no hope left. Unhappy you are, unhappy you will always be. Each day brings its torments and each day new difficulties arise from which we will never escape. That's why I am giving up the struggle as well as all hope; I don't have the strength to work any more under these conditions. I hear that my friends prepare a new exhibition this year; I renounce taking part in it, not having done anything that's worth being shown."53

After having originally been the one who started the group on its exhibitions,

Degas: L'Etoile, c. 1878. Pastel on monotype, 15×11 ". Philadelphia Museum of Art (Bequest of Charlotte Dorrance Wright).

Monet had little by little abandoned active participation in the preparation of these shows, which had been taken over by the more or less opposed factions of Renoir and Degas. But Caillebotte would not allow his friend to abstain altogether. While Monet did not even leave Vétheuil to look after his own interests, Caillebotte took care of everything, borrowed pictures from Monet's collectors, looked after the frames, wrote eager letters and tried to rouse his comrade's courage. "If you could see how youthful Pissarro is!" he exclaimed.⁵⁴

There were only fifteen exhibitors this time: Bracquemond and his wife, Caillebotte, Cals, Degas, Monet, Pissarro, Piette (who had recently died), Rouart, Tillot, and — among the newcomers — Lebourg and three friends of Degas: Forain, Zandomeneghi, and Mary Cassatt, who showed a Woman with Fan in a vermilion frame and a Box at the Opera in a green one. Degas had also wished to introduce another friend of his, Raffaëlli, but this suggestion apparently was turned down. Ten days before the opening it was decided to invite a sixteenth participant, Paul Gauguin, who immediately replied to Pissarro: "I accept with pleasure the invitation which you and M. Degas were kind enough to send me and, of course, under these circumstances shall observe all the rules established by your association [meaning not to exhibit at the Salon]. In taking this decision, I hold my dues at your disposal."55 But Gauguin arrived too late to have his name listed in the catalogue.

Degas: Ballet at the Opera, 1878-80. Pastel, $13\frac{3}{8} \times 27\frac{1}{2}$ ". Collection Mr. and Mrs. Leigh B. Block, Chicago.

To make up for those who were absent, Pissarro exhibited thirty-eight works (seven of which were lent by Caillebotte), Monet twenty-nine, and Degas listed twenty-five in the catalogue.⁵⁶ On the opening day, April 10, a jubilant note from Caillebotte went out to Vétheuil:

"We are saved. By five o'clock this afternoon the receipts were more than 400 francs. Two years ago on the opening day — which is the worst — we had less than 350.... There's no need to point out to you certain ridiculous circumstances. Don't think, for instance, that Degas sent his twenty-seven or thirty pictures. This morning there were eight canvases by him. He is very trying, but we have to admit that he has great talent."⁵⁴

Probably not the least surprise for the painters was a very favorable article by Duranty, free of any trace of his customary reservations. After explaining that the "independents, impressionists, realists, and others" (thus using the designation suggested by his friend Degas) formed a group of diversified tendencies, united by the determination not to exhibit at the Salon, he launched into praise of Monet and Pissarro, before lauding Degas and his circle, especially Miss Cassatt.⁵⁷ In general, however, the press was again hostile, but visitors came in greater numbers.

Among the visitors were three young students from the *Ecole des Beaux-Arts*: Georges Seurat, then nineteen years old, and his friends Ernest Laurent and Aman-Jean. Tired of the teachings of their professor Henri Lehmann, which had already led to the recent uprising of Renoir's new friends, they received a profound and salutary shock from the exhibition, to the extent that they decided to leave the *Ecole*, take a studio together and work on their own. At the same time they studied the works of Puvis de Chavannes as well as of those impressionists who were absent from the group show, particularly Renoir.⁵⁸

"The receipts continue good," Caillebotte announced on May 1 to Monet, "we have now about 10,500 francs. As for the public — always in a gay mood. People have a good time with us..." When the exhibition closed on May 11 there remained, with expenses covered, more than 6,000 francs. Some of the exhibitors wanted to keep this as a reserve in order to guarantee future exhibitions, but since few works had been sold, the majority voted for distribution of the money. Each participant received 439 francs. With this amount Miss Cassatt bought two paintings, one by Monet and one by Degas.

Meanwhile the Salon had been opened. Cézanne had been rejected once more, as well as Sisley, but Manet and Renoir were represented. (Eva Gonzalès exhibited, again as "pupil of Manet," a canvas strongly influenced by him, p. 361.) Renoir had sent a portrait of Jeanne Samary and his large group portrait of Mme Charpentier and her children, as well as two pastels. Whereas the likeness of the actress had been relegated to the third row, the dépôtoir, Mme Charpentier had seen to it that her portrait received a favorable place in the center of a wall. There can be little doubt that the success this canvas obtained was partly due to the prestige of the sitter. The critics unanimously acclaimed the painting; for the first time Renoir could feel he had almost arrived. Castagnary, still hostile to Manet, whom he accused of making concessions to the bourgeois, highly praised Renoir's "agile and intellectual brush," his "lively and happy grace," the enchantment of his color.⁵⁹

Zola, who wrote only a comparatively short article for his Russian periodical, did

Cassatt: Woman in Black at the Opera, 1880. 32×26 ". Museum of Fine Arts, Boston (Charles Henry Hayden Fund).

not mention Renoir's picture in spite of his friendship for Charpentier. He alluded in passing to the show of the impressionists and defined their concepts as "the study of the changing aspects of nature according to the countless conditions of hour and weather.... They pursue the analysis of nature all the way to the decomposition of light, to the study of moving air, of color nuances, of incidental transitions of light and shadow, of all the optical phenomena which make an horizon appear variable and so difficult to represent." He spoke once more of Manet (who had two canvases accepted that year, one of which, painted at Argenteuil in 1874, actually was more characteristic of impressionism than was Renoir's large portrait group), calling him the chief of the impressionists, and also discussed Monet's work.⁶⁰

Zola's article — quite unexpectedly — was to create a certain stir in Paris. Retranslated from the Russian, a passage of it was published in a French periodical and subsequently reprinted in the widely read daily, *Le Figaro*, under the malicious heading: *M. Zola has broken with Manet*. The passage quoted read:

"... All the impressionists are poor technicians. In the arts as well as in literature form alone sustains new ideas and new methods. In order to assert himself as a man of talent, an artist must bring out what is in him, otherwise he is but a pioneer. The impressionists, as I see it, are precisely pioneers. For a moment Manet inspired great hopes, but he appears exhausted by hasty production; he is satisfied with approximations; he doesn't study nature with the passion of true creators. All these artists are too easily contented. They woefully neglect the solidity of works meditated upon for a long time. And for this reason it is to be feared that they are merely preparing the path for the great artist of the future expected by the world."

With both Manet and Zola still controversial figures and anathema to conservative circles, this "revelation" was not without piquancy. The novelist immediately wrote to the painter, explaining: "I read with stupefaction the notice in *Le Figaro* announcing that I have broken with you, and am anxious to send you a cordial handshake. The translation of the quotation is not exact; the meaning of the passage has been forced. I spoke of you in Russia as I have spoken in France, for thirteen years, with solid sympathy for your talent and for your person." At Manet's request this letter was published by the newspaper.⁶¹

Zola's somewhat meek explanation seems surprising. The translation of the passage was perfectly correct except for one detail: Zola had written *Monet* where the Russian review had printed Manet. But why didn't the author say so? One might suppose that he did not wish to hurt Monet — of whose difficulties he was obviously aware — were it not that he was shortly to repeat the same statements in an article written for, and appearing in France.

Although, in 1879, Zola did not comment on art matters in Paris, he did impose upon the daily *Le Voltaire* (which published in installments his tremendously successful new novel, *Nana*) the choice of an untried Salon reviewer, Joris-Karl Huysmans. The latter, then still attached to the group of literary "naturalists" whom Zola gathered round him in his recently acquired home at Médan, made a noteworthy début as an art critic. So much so that a mutual friend on the paper's staff soon reported to Zola: "You can't imagine the horror — and the word is not exaggerated — the horror with which our articles inspire the entire editorial office. It shouts 'sacrilege'... and speaks of the reviews of our friend with intonations of despair that could make one

Guillaumin's Studio, d. 1878. $35 \times 29''$. Collection Mr. and Mrs. Paul Mellon, Upperville, Va.

die of laughter."62 The editor eventually found a solution by publishing simultaneously a more conventional series of reviews by a more conventional critic, a certain Pothey. But unlike Zola who, in 1866, had cut short his reviews rather than accept such conditions, Huysmans took the situation with a sense of humor and later explained that "as a result of numerous complaints which the series of articles provoked in the world of painters, the director of *Le Voltaire* found it necessary to assuage some of the wounds that had been opened; after the distribution of bread rations [official commissions] and medals to the lame and the beggars of art, M. Pothey was requested to prepare some compresses."63

Compresses were certainly called for as Huysmans charged into the ranks of recognized masters with an outspokenness, a devastating irony, and such beautifully direct aim that many reputations of the day were left in shreds. Yet his articles were not merely a dressing down of false glories, they also distinguished themselves by a number of pertinent remarks. He noticed, for instance, a certain parallel between modern painting and literature when he said: "I have often thought with surprise of the opening which the impressionists as well as Flaubert, de Goncourt, and Zola have created in art. The naturalist school has been revealed to the public by them; art has been turned upside-down, enfranchised from the bondage of official institutions." He spoke of impressionism as offering "an astonishingly just vision of color; a disregard for conventions adopted centuries ago to reproduce this or that light effect; work in the open and search for true tonalities; movement of life; large brush strokes; shadows established with complementaries; preoccupation with the whole [of a subject], rendered through simple means."64

Huysmans commended Manet's works and those by his pupil Eva Gonzalès. He was particularly eloquent concerning Degas (not represented at the Salon) as the observer of contemporary life, the painter of "civilized carnation." Also expressing esteem for Mary Cassatt and Puvis de Chavannes, he showed himself overly fond of Raffaëlli, admitted to the Salon after being turned down by the impressionists. Huysmans' appreciations were still too much colored by literary considerations and an exaggerated emphasis on subject matter, which led him to overlook the fact that art demands an indelible unity between theme, concept, and execution. Whereas Raffaëlli's "modernism" was confined to his subjects, that of Degas — stripped of all anecdotal implications — was the natural consequence of his genius. Indeed, Degas' choice of contemporary subjects was inseparable from his daring composition, superb deftness of brush, powerfully accentuated contrasts allied with subtle color harmonies, and freedom of expression that invested his work with the attraction of a newly discovered reality. Yet what errors of judgment Huysmans may have committed were compensated for by a courageous statement made in connection with the multitude of military paintings at the Salon: "In my mind patriotism is a negative quality in art...." he wrote. "Through their marvelous canvases Delacroix and Millet have rendered greater services to France than all the generals and statesmen." But he agreed with Zola that the genius of impressionism had not yet appeared on the scene.64

That Huysmans did not find much to say about Renoir's large picture and that his comments were tempered with reservations was probably all to the best, since praise from this quarter might have appeared highly suspicious. It was more impor-

Degas: At the Races, c. 1878. $7\frac{1}{2} \times 9\frac{1}{2}''$. Private collection, New York.

Monet: Winter in Vétheuil, 1878. 23½ × 39″. Albright-Knox Art Gallery, Buffalo.

tant for the painter to be applauded by less heretical reviewers, as indeed he was. "Renoir has a big success at the Salon," Pissarro wrote to Murer. "I believe he is launched. So much the better! Poverty is so hard."65

Some time after the closing of the Salon, Manet, who had been only moderately successful with the press, decided to sound his chances in the new world by exhibiting there his *Execution of Emperor Maximilian*. The canvas was taken by the singer Emilie Ambre on a concert tour in the States. In New York the press showed both astonishment and admiration; some painters were excited. Five hundred posters were displayed, but the response of the public was unenthusiastic and expenses were not covered. In Boston a mere fifteen to twenty persons daily came to see the painting; again a deficit was registered and the exhibition planned in Chicago was prudently called off. Finally Mlle Ambre brought the canvas back to France.⁶⁶

Meanwhile Renoir's patroness, Mme Charpentier, had been instrumental in setting up a new weekly, *La Vie Moderne*, devoted to artistic, literary, and social life, which her husband started in the spring of 1879.⁶⁷ The painter's brother, Edmond, took charge of an exhibition room on the editorial premises and began to organize one-man shows of minor works. This was still so unusual that *La Vie Moderne* published a notice to explain its undertaking:

"How often people interested in art have told us how much they should like to visit the studio of this or that artist if they did not hesitate to go there on their own, which they can really do only on condition of having themselves announced as prospective buyers, especially if they have no occasion of being introduced by a mutual friend. Well then, our exhibitions will merely transfer momentarily the artist's studio to the boulevard, to a hall where it will be open to everyone, where the collector can come when he pleases, thus avoiding possible friction and having no fear of imposing." 68

Monet: Vétheuil in Summer, d. 1880. $25\frac{3}{4} \times 39\frac{1}{2}$ ". Metropolitan Museum of Art, New York (Bequest of William Church Osborn).

The first show, devoted to de Nittis, was highly successful, being visited by 2000 to 3000 people daily. In June 1879 it was succeeded by a presentation of pastels by Renoir, accompanied by a comprehensive article in *La Vie Moderne*, in which Edmond Renoir studied his brother's work.⁶⁹ The painter suggested that an exhibition of works by his less fortunate comrade Sisley be held, but this project was to be carried out only in 1881.

Sisley's rejection by the Salon jury, to which he had not submitted since before the war of 1870, was not only humiliating (being known, of course, to his friends whom his decision had prevented him from joining), it also added to his financial calamities. Evicted from the house in which he lived at Sèvres, he was able to find new lodgings in the same locality only with the help of Charpentier.

In Vétheuil, meanwhile, Monet carried on his work notwithstanding his profound discouragement, painting fields of poppies and views of the Seine. He had to pawn his last possessions in order to pay for his wife's illness. Her condition was certainly not improved by worries and privations; during her thirteen years at Monet's side she had hardly known any sunny days. When she finally died early in September 1879, a short letter implored de Bellio: "I come to ask you for another favor; this would be to retrieve from the pawnshop the locket for which I am sending you the ticket. It is the only souvenir that my wife had been able to keep and I should like to tie it around her neck before she leaves forever." Yet harassed though he was, Monet could not help painting. And when he contemplated Camille at daybreak on her deathbed, he noticed — in spite of all his grief — that his eyes perceived more than anything else the different colorations of her young face. Even before he decided to record her likeness for the last time, his painter's instinct had seen the blue, yellow, and grey tonalities cast by death. With horror he felt himself a prisoner of his visual

Renoir: Boating Party at Chatou, d. 1879. $31_8^7 \times 39_4^4$ ". (In the foreground, Gustave Caillebotte.) National Gallery of Art, Washington, D.C. (Gift of Sam A. Lewisohn).

experiences and compared his lot to that of the animal which turns a millstone.71

Monet remained at Vétheuil throughout the year and even during the winter, Mme Hoschedé attending his household and his two small sons. When the Seine froze over, he dug his easel into the ice so as to be able to paint the congealed land-scape. Later on, after thaw had set in, he depicted the ice floes on the river, once more attracted by the subtle variations of predominantly white motifs.

Renoir, too, earlier that year, had mourned the loss of a loved one, his young and favorite model Margot, to whose bedside he repeatedly and urgently called Gachet. He was so distraught that he lost his taste for work. When Gachet, due to an accident, was unable to attend the girl, Renoir turned to Georges de Bellio, a convinced homeopath like Gachet. But Margot could not be saved.⁷²

During the summer of 1879 Renoir spent some time at Berneval on the Normandy coast, paying a visit to a new friend, Paul Bérard, at the latter's château at Wargemont, near Dieppe. Through Charpentier the artist had met the Bérards and some of their friends who were to become his customers. An intimate friendship soon developed, with Renoir spending frequent sojourns at Wargemont and painting a series of portraits of the four Bérard children as well as of his hostess. He also executed numerous still lifes and landscapes at Wargemont, either in the garden of the château or in its vicinity. Later on Renoir returned once more to Chatou where he painted Boating Party at Chatou, a feast of gay sunlight and radiant water that shows him preoccupied with the same problems tackled in La Balançoire and Le Bal au Moulin de la Galette.

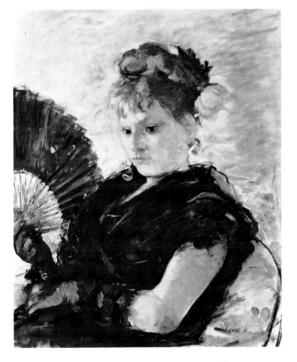

Right, Renoir: Portrait of Margot, c. 1878. 18½×15″. Presented by the artist to Dr. Gachet. Musée du Louvre, Paris (Gift of Paul Gachet).

Far right, Morisot: Girl with Fan, c. 1878. $23\frac{1}{4} \times 19\frac{1}{4}$ ". Collection Mr. and Mrs. Alex M. Lewyt, New York.

Renoir's sudden success at the Salon must have given Monet food for thought; he now wondered if their struggle for independence had not been sterile, if success could ever be obtained outside the Salon. Should he too break with the self-imposed rules of the group? Renoir, after all, had always kept himself aloof from any rigid line of conduct, confessing frankly, "I have never been able to know the day before what I'd do the next day."⁷⁴ But Monet's case was different. He had been the initiator and one of the staunchest supporters of the impressionist exhibitions. To him, opposition to the jury had been more than a necessity, it had been an article of faith. To abandon these principles now would seem an admission of failure. Yet, above the question of principle, there was also the problem of the future. For more than twenty years he had toiled without progressing much in public favor; he had even lost some of the sympathy he had won at the beginning. Could he afford to pursue deliberately a course which alienated the esteem of the majority? The time had come when he had to grasp success regardless of where it offered itself, and since the Salon seemed to promise better luck, he had apparently no choice except to seek it there. Monet therefore resolved in 1880 to submit two canvases to the jury.

Monet's decision met with the most profound contempt on the part of Degas. In a letter to Duret, Monet complained that his friends treated him as a renegade and explained that he had taken this step mainly in the hope that Durand-Ruel's competitor, Petit, might make some purchases, once Monet's canvases had been admitted to the Salon.⁷⁵ (Sisley had given the same reason to justify his abandoning the group.⁷⁶) As a matter of fact, Monet had sold three pictures to Petit in January 1880, a still life for 500 francs and two snow scenes for 300 (Petit had also bought three of his paintings at the ill-fated Hoschedé sale of 1878); it is not unlikely that Petit had promised further acquisitions on condition that the painter reappear at the Salon. But superbly indifferent to Monet's motivations, Degas saw only his infidelity, his loathsome compromise with officialdom. He accused Monet of "frantic log-rolling" and refused to have anything more to do with him. Of the original group there now remained only Pissarro, Berthe Morisot, Degas, Caillebotte, Guillaumin, and Rouart. With the exception of Pissarro none of them depended on sales, and their scorn of the jury, admirable as it was, had nothing of the heroism displayed by Pissarro, who, in renouncing possible success at the Salon, chose indefinite poverty.

RAFFAËLLI: Man Having Just Painted His Fence. Present whereabouts unknown.

- 1 See F. Champsaur: Le Rat Mort, Revue Moderne et Naturaliste, Oct. 1880.
- 2 On Cabaner see G. Rivière: Renoir et ses amis, Paris, 1921, ch. VII; G. Moore: Confessions of a Young Man, London, 1888, ch. VI; P. Gachet: Cabaner, Paris, 1954.
- 3 On Victorine Meurent see A. Tabarant: Celle qui fut "L'Olympia," *Bulletin de la vie artistique*, May 15, 1921.
- 4 On Moore see D. Cooper: George Moore and Modern Art, *Horizon*, Feb. 1945.
- 5 The foregoing is quoted freely from Moore: Reminiscences of the Impressionist Painters, Dublin, 1906, p. 12-14 and 24, as well as from the same author's: Modern Painting, New York, 1898, p. 30-31.
- 6 Alexis to Zola, Aug. 9, 1879; unpublished document, preserved among Zola's papers at the Bibliothèque Nationale, Paris. On the subject of Duranty, Moore subsequently wrote: "Duranty used to stay with us for an hour or so every night; a quiet, elderly man who knew that he had failed, and whom failure had saddened." (Vale, London, 1914.)
- 7 On this subject see A. Tabarant: Manet et ses oeuvres, Paris, 1947, p. 305-306.
- 8 J. de Nittis: Notes et souvenirs, Paris, 1895, p. 187-188. On the relationship between Manet and Degas see also F. F. [Fénéon]: Souvenirs sur Manet (interview of Henri Gervex), Bulletin de la vie artistique, Oct. 15, 1920.
- See J. Claretie: La vie à Paris—1880, Paris, n.d. [1881], p. 499-505.
- 10 The foregoing is quoted freely from Moore: Reminiscences of the Impressionist Painters, op. cit., p. 24 and 39, as well as from the same author's: Impressions and Opinions, New York, 1891, ch. Degas.
- 11 See A. Segard: Mary Cassatt, Paris, 1913, p. 45.
- 12 Mary Cassatt to an American friend, letter quoted by A. D. Breeskin in the introduction to the catalogue of the Cassatt exhibition, Wildenstein Galleries, New York, Oct.-Dec. 1947, p. 20. But she also was to say, in 1915, "the first sight of Degas' pictures was the turning point in my artistic life."
- 13 See H. Detouche: Propos d'un peintre, Paris, 1895, p. 86.
- 14 Renoir later expressed his views on craftsmanship in his introduction to Cennino Cennini's "Livre d'Art," Paris, 1911. See also J. Renoir: Renoir, Paris, 1962.
- 15 Duranty to Zola [1878]; see Auriant: Duranty et Zola, La Nef, July 1946.
- 16 Duranty used some traits of Cézanne for a rather plump

- caricature in his novel: Le peintre Louis Martin, published posthumously *in* Le pays des arts, Paris, 1881. See J. Rewald: Paul Cézanne, New York, 1948, p. 127-129.
- 17 Cooper's contention op. cit. that Moore confused Cézanne with van Gogh when he characterized the former as a "rough, savage creature" appears definitely contradicted by Duranty's description (note 15), with which Moore must have been familiar when he wrote the passage quoted here from his Reminiscences.
- 18 Degas to Halévy, 1877 and *not* 1888 as supposed by Guérin; see Lettres de Degas, p. 119-120, and Rivière: Mr. Degas, Paris, 1935, p. 88-89. According to Sacha Guitry (*Bulletin de la vie artistique*, March 1, 1925, p. 118) Monet and Renoir painted scenic decorations for the third act of *La Cigale*, but this seems extremely doubtful.
- 19 See Segard, op. cit., p. 8; also G. Biddle: Some Memories of Mary Cassatt, *The Arts*, Aug. 1926.
- 20 On Gauguin as banker see C. Chassé: Le sort de Gauguin est lié au Krach de 1882, Connaissance des Arts, Feb. 1959. On his artistic beginnings see the interview with his son Pola in M. Malingue: Encore du nouveau sur Gauguin, L'Oeil, Oct. 1959.
- 21 See M. Bodelsen: Gauguin, the Collector, Burlington Magazine, Sept. 1970.
- 22 Cézanne to Zola, August 24, 1877; see Cézanne, Letters, London, 1941, p. 106-107.
- 23 See M. Denis: Théories, 1890-1910, Paris, 1912, p. 242.
- 24 Monet to Chocquet, fall 1877; see J. Joëts: Les impressionnistes et Chocquet, L'Amour de l'Art, April 1935.
- 25 Manet to Duret, winter 1877; see T. Duret: Manet and the French Impressionists, Philadelphia-London, 1910, p. 73-74. Duret dated this letter 1875, but Tabarant (Autour de Manet, L'Art Vivant, May 4, 1928) has furnished proof that it must have been written late in 1877.
- 26 See Tabarant, ibid. It seems doubtful, however, whether Manet actually took some of Monet's paintings in exchange, for at the time of Manet's death in 1883, Monet still owed him money while his estate did not list any particular number of works by Monet.
- 27 Monet to Dr. Gachet, Feb. 9 [1878]; see P. Gachet: Lettres impressionnistes au Dr. Gachet et à Murer, Paris, 1957, p. 114.
- 28 Monet to Zola, April 7 [1878]; unpublished document preserved among Zola's papers at the Bibliothèque Nationale, Paris.
- 29 Monet to Dr. Gachet, no date [spring 1878]; see Lettres impressionnistes, op. cit., p. 115.

- 30 On the Faure and Hoschedé sales see Mémoires de Paul Durand-Ruel in L. Venturi: Les Archives de l'Impressionnisme, Paris-New York. 1939, v. II, p. 204-205 and 206-207. On Hoschedé see also Tabarant's notice quoted by Auriant, op. cit.; the second Hoschedé sale took place on June 5-6, 1878. For more complete information on it see especially M. Bodelsen: Early Impressionist Sales 1874-94 in the Light of Some Unpublished 'procèsverbaux,' Burlington Magazine, June 1968.
- 31 Duranty to Zola [summer 1878]; see Auriant, op. cit. On Chocquet's situation see J. Rewald: Chocquet and Cézanne, Gazette des Beaux-Arts, July-Aug. 1969.
- 32 Pissarro to Murer, summer 1878; see A. Tabarant: Pissarro, Paris, 1924, p. 38.
- 33 Manet to Duret, summer 1878; see Kunst und Künstler, March 1914, p. 325-326.
- 34 On Murer see P. Gachet: Deux amis des impressionnistes-le Docteur Gachet et Murer, Paris, 1956, and Lettres impressionnistes au Dr. Gachet et à Murer, op. cit., also Rivière, op. cit., p. 79-80; G. Geffroy: Claude Monet, sa vie, son oeuvre, Paris, 1924, v. II, ch. IX; C. Pissarro: Letters to His Son Lucien, New York, 1943; Duret: Les peintres impressionnistes, ch. on Sisley; Coquiot: Vincent van Gogh, Paris, 1923, p. 239-241; but especially Tabarant: Pissarro, 1924, whose book is based partly on Murer's private papers. See also Murer's letter to Duret, July 18, 1905 in L'impressionnisme et quelques précurseurs, Bulletin des expositions, III, Jan. 22-Feb. 13, 1932, Galerie d'Art Braun & Cie., Paris. Paul Alexis published an article on Murer's collection, in Le Cri du Peuple, Oct. 21, 1887, according to which Murer then owned 8 paintings by Cézanne, 25 by Pissarro, 16 by Renoir, 10 by Monet, 28 by Sisley, 22 by Guillaumin, etc. This article is reproduced in P. Gachet: Deux amis des impressionnistes, op. cit., p. 170-173.
- 35 See Rivière, op. cit., p. 79-80; this allegation has been denied by P. Gachet: Deux amis des impressionnistes, op. cit., notably p. 159.
- 36 See Gachet, ibid., p. 157-158.
- 37 Pissarro to Murer, 1878; see Tabarant: Pissarro, op. cit., p. 40, 41.
- 38 Pissarro to Duret, Nov. 1878; ibid., p. 43.
- 39 Monet to Murer, Dec. 16, 1878; see P. Gachet: Lettres impressionnistes, op. cit., p. 119-120.
- 40 Sisley to Duret, Aug. 18, 1878; see Duret: Quelques lettres de Manet et de Sisley, Revue Blanche, March 15, 1899.
- 41 Cézanne to Zola, March 23, 1878; see Cézanne, Letters, op. cit., p. 109.
- 42 Renoir to Durand-Ruel, March 1881; see Venturi: Archives, v. I, p. 115.

- 43 See Mémoires de Durand-Ruel, ibid., v. II, p. 209.
- 44 Pissarro to Murer, spring 1878; see Tabarant: Pissarro, op. cit., p. 41-42.
- 45 See E. Zola: L'Ecole française de peinture à l'Exposition de 1878, Le Messager de l'Europe, July 1878; reprinted in E. Zola: Salons, Geneva-Paris, 1959, p. 199-222.
- 46 M. Proust quoted in M. Robida: Le Salon Charpentier et les impressionnistes, Paris, 1958, p. 56.
- 47 Monet to G. de Bellio, Dec. 30, 1878; see: La grande misère des Impressionnistes, Le Populaire, March 1, 1924. See also C. Richebé: Claude Monet au Musée Marmottan Académie des Beaux-Arts, 1959-60.
- 48 Sisley to Duret, March 14, 1879; see Duret: Quelques lettres de Manet et de Sisley, op. cit.
- 49 Cézanne to Pissarro, April 1, 1879; see: Cézanne, Letters, op. cit., p. 136.
- 50 Mary Cassatt to J. Alden Weir, Paris, March 10 [1879]; see F. A. Sweet: Miss Mary Cassatt, Oklahoma, 1966, p. 48 (where the letter is ascribed to 1878).
- 51 Unpublished project found in Degas' carnet 5 at the Bibliothèque Nationale, Paris [Dc 327d]. According to a list of names in the same sketchbook, Degas apparently recommended the inclusion not only of Raffaëlli but also of Cazin and Lhermitte. This list further mentions Morisot, Cézanne, Béliard, Levert, and Guillaumin, former associates, none of whom was to participate in the group show of 1879.
- 52 A. Silvestre: Le monde des arts, La Vie Moderne, April 24, 1879.
- 53 Monet to G. de Bellio, March 10, 1879; see: La grande misère des Impressionnistes, op. cit.
- 54 For Caillebotte's letters to Monet concerning this exhibition, see Geffroy, op. cit., v. II, ch. VII.
- 55 Gauguin to Pissarro, April 3, 1879; unpublished document found among Pissarro's papers.
- 56 For a condensed catalogue see Venturi: Archives, v. II, p. 262-264. Venturi's list does not carry the name of Gauguin whose participation, however, is confirmed by a mention in Duranty's review (see note 57).
- 57 See Duranty: La quatrième exposition faite par un groupe d'artistes indépendants, Chronique des Arts et de la Curiosité, supplement of La Gazette des Beaux-Arts, April 19, 1879; partly quoted in the new edition of Duranty: La Nouvelle Peinture, Paris, 1946, appendix. For articles on the show by A. Wolff and A. Silvestre see P.-A. Lemoisne: Degas et son oeuvre, Paris, 1946, v. I, p. 245-246, notes 130-131.
- 58 See L. Rosenthal: Ernest Laurent, Art et Décoration, March 1911 (article brought to my attention by W. I.

- Homer, Princeton). According to Laurent's recollections, Seurat knew Renoir—who did not participate in the exhibition—and now and then went to him and his friends for encouragement. However, the accuracy of this information may be doubted; it has not been mentioned in the writings on Seurat by his personal friends and it is known, on the other hand, that Renoir did not care for Seurat's work (see C. Pissarro: Letters to His Son Lucien, New York, 1943, p. 120).
- 59 See L. Bénédite: "Madame Charpentier and Her Children" by Auguste Renoir, *Burlington Magazine*, Dec. 1907. For further reviews see J. Lethève: Impressionnistes et Symbolistes devant la presse, Paris, 1959, p. 106.
- 60 See Zola: Nouvelles artistiques et littéraires, Le Messager de l'Europe, July 1879; reprinted in Zola: Salons, op. cit., p. 225-230.
- 61 On this subject see F. W. J. Hemmings: Emile Zola critique d'art, introduction to: Zola, Salons, op. cit., p. 28-31; also I. N. Ebin: Manet et Zola, Gazette des Beaux-Arts, 1945, p. 357-378.
- 62 Céard to Zola, May 19, 1879; see R. Baldick: Vie de J. K. Huysmans, Paris, 1958, p. 66.
- 63 Footnote by Huysmans for the reprint of his articles in Huysmans: L'Art Moderne, Paris, 1883, p. 73-74.
- 64 Huysmans: Le Salon de 1879 (11 articles); reprinted in Huysmans: L'Art Moderne, op. cit., p. 9-95.
- 65 Pissarro to Murer, May 27, 1879; see Tabarant: Pissarro, op. cit., p. 45.
- 66 See E. Moreau-Nélaton: Manet raconté par lui-même, Paris, 1926, v. II, p. 75-76.

- 67 On La Vie Moderne see Rewald: Renoir and His Brother, Gazette des Beaux-Arts, March 1945.
- 68 Notice in *La Vie Moderne* quoted by H. Perruchot: La vie de Manet, Paris, 1959, p. 286, note 3.
- 69 Edmond Renoir's article on his brother is reprinted in Venturi: Archives, v. II, p. 334-338.
- 70 Monet to G. de Bellio, Sept. 5, 1879; see: La grande misère des Impressionnistes, op. cit., and Richebé, op. cit.
- 71 See G. Clemenceau: Claude Monet, Paris, 1928, p. 19-20. Clemenceau quotes Monet as speaking of a person "very dear to him" without naming Camille, but this incident unquestionably refers to her. The painting is now in the Louvre.
- 72 See Renoir's letters to Dr. Gachet in: Lettres impressionnistes, op. cit., p. 81-85.
- 73 On this friendship see M. Bérard: Un Diplomate ami de Renoir, *Revue d'Histoire Diplomatique*, July-Sept. 1956.
- 74 Renoir to Monet, August 23, 1900; see Geffroy, op. cit., v. II, ch. V.
- 75 See Monet's letter to Duret, spring 1880, quoted in H. Graber: Pissarro, Sisley, Monet, nach eigenen und fremden Zeugnissen, Basel, 1943, p. 225-226.
- 76 Sisley wrote on March 28, 1879, to Charpentier: "Since I decided to exhibit at the Salon I find myself more isolated than ever." See R. Huyghe: Unpublished Letters of Sisley, Formes, March 1931.

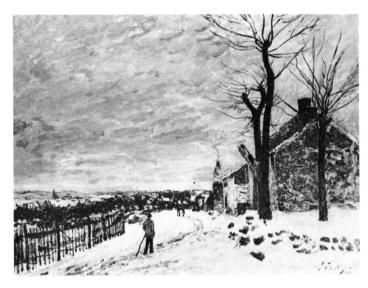

SISLEY: Snow at Veneux-Nadon, 1880. $21\frac{5}{8} \times 29\frac{1}{8}$ ". Musée du Louvre, Paris.

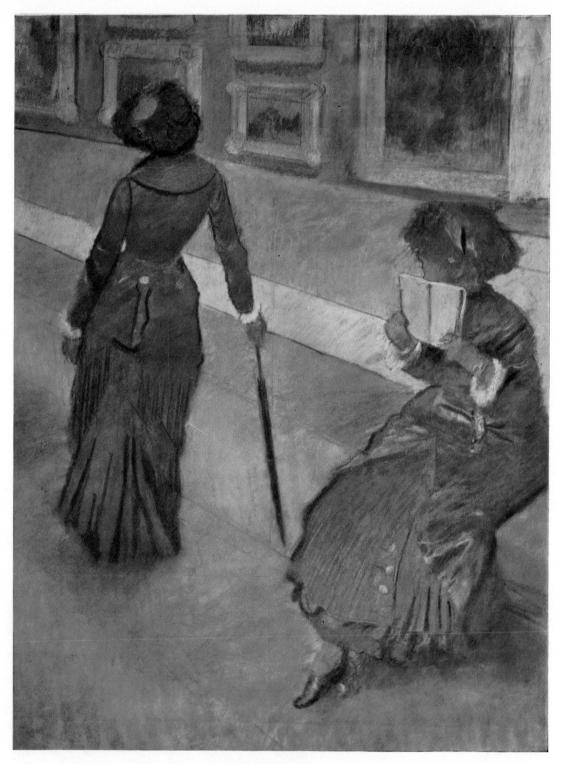

Degas: Mary Cassatt at the Louvre, 1880. Pastel, $27 \times 204'''$. Private collection, New York.

MORE EXHIBITIONS AND DIVISIONS OF OPINION

THE DEATH OF MANET

With Renoir, Sisley, Cézanne, and now also Monet absent, the fifth exhibition of the group, organized in 1880, was indeed no longer an impressionist show. It included Bracquemond and his wife, Caillebotte, Guillaumin, Lebourg, Berthe Morisot, Degas with his friends: Miss Cassatt, Forain, Levert, Rouart, Zandomeneghi, Tillot, and two newcomers invited by him, Raffaëlli and Vidal; finally, there was Pissarro, with his pupil Gauguin, as well as a third newcomer, Vignon.¹

The show, held at 10 rue des Pyramides throughout the month of April, was announced on Degas' advice as an exhibition of "Independent Painters." But Degas was defeated in a discussion concerning the posters and wrote bitterly to Bracquemond:

"It opens the first of April. The posters will be up tomorrow or Monday. They are in bright red letters against a green background. There was a great fight with Caillebotte about whether or not to publish names. I had to give in to him and allow them to appear. When will there be an end of this star billing? Mlle Cassatt and Mme Morisot were definitely against being on the posters. . . . All good reason and good taste are powerless against the others' inertia and Caillebotte's stubbornness. Next year I shall surely arrange it so that this doesn't continue. I am upset, humiliated by it."

Degas' new protégé, Raffaëlli, contributed no less than thirty-five works, a fact which seems to have surprised the old-timers. They heartily disliked his weak attempts to combine a diluted impressionism with both anecdotic and realistic subjects. Degas himself once more neglected to send the works he had announced in the catalogue, for instance, a statuette in wax of a young dancer to which he had devoted considerable time. However, he did send, though after the opening, a portrait of Duranty which had been promised for the previous exhibition. (Duranty died suddenly nine days after the opening,³ and Degas apparently wanted to pay a last tribute to his friend.) Zandomeneghi exhibited among others a strange portrait of Paul Alexis, standing against a wall to which were affixed innumerable birdcages. Guillaumin, Berthe Morisot, and Pissarro were represented by over a dozen works each. Pissarro, who had experimented in etching with Degas and Miss Cassatt, showed also several prints mounted on yellow paper and surrounded by purple frames; for his paintings he adopted white frames such as Whistler had occasionally used. Gauguin presented a still life, several landscapes (some of which he had painted while in Pontoise with Pissarro), and a carefully polished marble bust.4

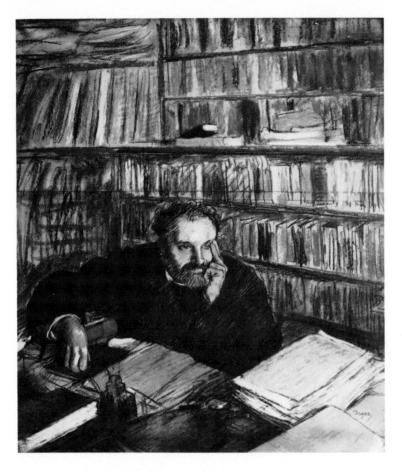

DEGAS: Edmond Duranty in His Study, d. March 25, 1879. Pastel, $20\frac{1}{2} \times 18''$. Collection Mr. and Mrs. Julian Eisenstein, Washington, D.C.

The public was smaller than before. One day there appeared a sixteen-year-old boy whose enthusiasm for new art had been awakened by Charpentier's periodical, *La Vie Moderne*; but when the youngster started making sketches after Degas' works, he was shown to the door by Gauguin with the words: "One doesn't copy here, sir." Several years later Gauguin was to learn that his victim was Paul Signac.⁵

The tenor of the press was given by Albert Wolff in his customarily insidious way: "I paid a visit to the exhibition of those artists who call themselves Independents or Impressionists. Their small annual show was opened April 1 on a tenantless second floor, rue des Pyramides. I wasn't too keen to see those things; next to some very interesting sketches one only finds canvases without the slightest value, works by madmen who mistake pebbles for pearls. I make an exception of M. Degas and Mme Berthe Morisot. The rest is not worth viewing and even less discussing. It is pretentious nonentity.... Why does a man like M. Degas remain in this agglomeration? Why doesn't he follow the example of Manet who long ago deserted the impressionists?..."6

Since the first shock produced by the impressionists had worn off, general hostility was replaced by indifference. As Duranty had already done in 1879, the critics sym-

pathetic to the group began to distinguish between those of the exhibitors who were true impressionists and the others who had little to do with the movement. Armand Silvestre insisted that Pissarro at least had remained faithful to impressionism. Huysmans, little attracted by landscapes because they did not offer his imagination pastures fertile enough for his literary dreams, devoted a long article to the show. He started on the premise that the impressionists had established that strong sunlight has a discoloring effect and that the shape and color of an object varies according to whether it is seen indoors or outdoors. However, he hastened to add that the attempt at "representing beings and things dissolved in the powdery sparkles of light, or of showing them in their crude colors, without gradations, without half tones, beneath certain straight rays of the sun which shorten and almost suppress shadows, as in Japanese prints," had scarcely yet succeeded. Though he approved of their tendency to observe the modified aspects of nature according to season, climate, hour of day, greater or lesser intensity of light, etc., he felt that the impressionists had not achieved this aim. He found their colors too loud, considered them too heavy-handed, insufficiently talented, awkward to the point of being brutal. He went so far as to say that "the study of these works belongs principally to the domain of physiology and medicine," and also spoke of the painters' "indigomania." Even his occasional praise was full of reticences and, more often as not, followed by virulent reproach. Brilliant as Huysmans had been when he castigated the official masters, perceptive as he still was in analyzing the essence of impressionism, he revealed himself strangely incapable of appreciating the achievements of the artists. Showing no understanding for the various impressionists, least of all Berthe Morisot, he instead hailed Degas and his associates, Forain, Raffaëlli, and Zandomeneghi.7 Indeed, the exhibition was clearly divided into two opposing factions, with Pissarro, Berthe Morisot, Guillaumin, and Gauguin in the minority.

Photograph of Edmond Duranty.

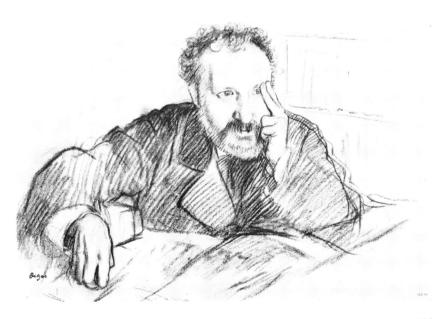

Degas: Edmond Duranty, c. 1879. Pencil, $12\frac{1}{8} \times 18\frac{1}{8}$ ". Metropolitan Museum of Art, New York.

Odilon Redon (whose works Huysmans was soon to champion) deplored, in his diary, what he called the decline of Berthe Morisot's exquisite talent but showed himself greatly impressed with Degas. Sympathetic though he was to the endeavors of the impressionists, his own inclinations led him to object to what he considered their limitations. Impressionism, he noted, "is a very legitimate mode of painting when applied mainly to the representation of external objects under the open sky. However, I do not believe that all which palpitates under the brow of a man who meditates and listens to his inner voices — nor do I believe that thought, taken for itself — can gain much from this tendency of observing only what is happening outside of our walls. On the contrary, the expression of life can appear but in chiaroscuro. Thinkers prefer the shade, stroll through it, are at ease in it, as if their brains found their natural element there. All well considered, these very worthy painters do not sow particularly rich fields in the domain of art. 'Man is a thinking being.' Man will always be there — whatever the role played by light, it won't be able to turn him aside. To the contrary, the future belongs to a subjective world.''8

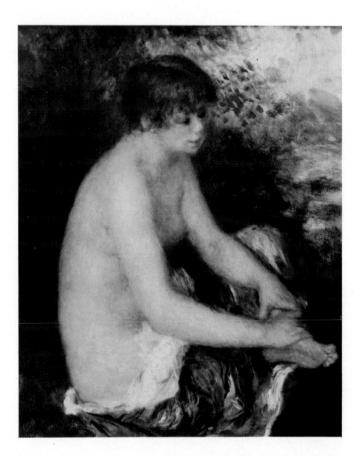

Left, Renoir: Bather, 1879-80. $18\frac{1}{4} \times 15\frac{1}{4}$ ". Albright-Knox Art Gallery, Buffalo. Right, Renoir: Girl with Cat (Angèle), d. 1880. $47\frac{1}{4} \times 36\frac{1}{4}$ ". Exhibited at the Salon of 1880. Sterling and Francine Clark Art Institute, Williamstown, Mass.

Monet: The Break-up of the Ice Near Vétheuil, d. 1880. $26\frac{3}{4} \times 35\frac{1}{2}$ ". Calouste Gulbenkian Foundation, Lisbon.

Impressionism, no longer the keynote of the group exhibition, woefully misunderstood by Huysmans, its very essence questioned by Redon, did not fare too well at the Salon either. The more important of the two landscapes submitted by Monet, Floating Ice on the Seine, was rejected. Renoir's two canvases were accepted, but only one of these, a girl with a cat in her arms asleep on a chair, was representative of his impressionist style. Manet exhibited a rather conventional portrait of his friend Antonin Proust, now member of the French Chamber of Deputies, and a couple dining, Chez le père Lathuile, painted in the open. Sisley was not represented. The jury considered awarding Manet a second-class medal, but finally did not do so, much to the disappointment of the artist, whose health was failing.

For the Salon of 1880, at which a new administrator had introduced some unwelcome reforms, Renoir elaborated a project of his own with more liberal statutes, subsequently published by Murer. Renoir suggested that the Salon should be divided into four sections, each of which would grade its contingent of entries — limited to a thousand works — according to their merits, hanging them either in an "honor hall" or in a "hall of extremists." The four sections were to be devoted to (a) members of the Institute and artists who had previously won medals, (b) aliens, (c) idealists, historical and genre painters, etc., (d) naturalists, impressionists, still lifes, and so on. Each section was to be formed by no more than four hundred members and was to name its own jury. Works not accepted were to be assembled for a final review by

all four juries and then to be exhibited in special rooms with the label: "Not classified"; these works were not to be listed in the catalogue.9

Although Murer, in making public this project, invited adherents to send in their signatures, the plan does not seem to have aroused much interest. Meanwhile, at the Salon itself, Renoir's and Monet's paintings were far from being hung in an "honor hall." But Huysmans who, in a new and biting Salon review, deplored precisely the haphazard and incongruous fashion in which the entries had been grouped, did not mention the injustice that had been meted out the two impressionists. (He was concerned mainly with the works of Gustave Moreau whose mysticism strongly appealed to his own as yet hidden inclinations.¹⁰) Actually the pictures of Renoir and Monet were so badly displayed that the two painters conceived the idea of protesting to the recently appointed Minister of Fine Arts, asking for a promise of better treatment in the future. They sent a copy of their letter to Cézanne with the request that he forward it to Zola. They hoped that Zola, whose name now carried weight, would publish it in one of the papers to which he contributed and would add a few words of his own to show "the importance of the impressionists and the real interest which they have aroused."11 Zola indeed published a series of three articles, under the title Le naturalisme au Salon — he still preferred this designation to the word impressionism but these articles did not exactly come up to the expectations of the artists.

Since fame had begun to reward Zola's stubborn efforts, he had become more and more convinced of the all-embracing mission of "naturalism." He had not forgotten that he and the painters had once started together, unknown but confident, and he now measured their achievements against the success obtained. The impressionists had failed, as he saw it, not because the public was blind — since the same public, and even such critics as A. Wolff, admired his own novels — but because, it seemed to him, they had not attained complete expression. These considerations explain Zola's patronizing attitude toward his former comrades-in-arms. In his articles Zola began with disapproval of the separate group exhibitions, thus revoking the endorsements he had previously published in Russia, but which had remained unknown in France.

Zola now claimed that "M. Degas alone has derived a true benefit from the private exhibitions of the impressionists; and the reason for this must be sought in his talent. M. Degas was never one of those persecuted by the official Salons. He was accepted, and even relatively well shown. But since his artistic temperament is a delicate one, since he does not have an impressive power, the crowd passed before his pictures without seeing them. Quite understandably the artist was annoyed and realized that he would gain certain advantages by showing with a small group, where his fine, carefully executed paintings could be seen and studied by themselves. And indeed, as soon as he was no longer lost in the crowd of the Salons, he was known to everyone: a circle of fervent admirers gathered round him."¹²

Joining Manet in his thesis that the battle for recognition ought to be fought at the Salon, Zola was pleased to see that Renoir had been the first to return and was now followed by Monet, although they had thus become "renegades." After admitting that the latest reforms had not improved the Salon, Zola approached the question which had prompted Monet and Renoir to ask for his intervention. "Many painters," he wrote, "come to me complaining: 'It's an outrage; you should write this, you should write that.' I smile. I try to make them understand that their talent is not

MOREAU: Galatea. Water-color, 13 × 8". Present whereabout unknown.

affected by these problems. The Salons — whatever the good or bad principles according to which they are organized — remain until now the best way for an artist to make himself known. There are, no doubt, some bruised self-respects, there are annoyances and all the injuries of art battles, but what does it matter! It's enough to paint great works; even if they are rejected for ten years, badly hung for ten more, they always end by obtaining the success which they deserve." This fatalistic attitude, this confidence in the judgment of time — which had served well his own reputation — certainly sounded peculiar coming from the once ardent fighter for progress, the foe of injustice, the determined opponent of bourgeois prejudices.

But worse was still to come. Having stated that Monet had originally started by showing at the Salon some favorably noticed works, Zola deplored that the subsequent rejections of the jury had irritated the artist to the extent of prompting him to remain aloof from the official exhibitions. This, according to the novelist, was "a mistake in conduct, a lack of skill in stubbornness." (Did this mean that an artist had to behave cleverly besides having talent?) If Zola was to be believed, Monet — had he continued his struggle at the Salon — would already have achieved the position to which he was entitled. After protesting, at last, the unfavorable spot in which his lone picture was hung, and Renoir's similarly poor treatment, and after speaking well of these works, Zola repeated what he had previously told his Russian readers and what had been considered aimed at Manet: "Monet has given in too much to his facility of production. Too many informal drafts have left his studio in difficult hours, and that is not good; it pushes an artist on the slope of unworthy and cheap creation. If one is too easily contented, if one sells sketches that are hardly dry, one loses the taste for works based on long and thoughtful preparation. . . ."12

It was evidently impossible for Zola to judge otherwise. His own work was accomplished by dint of extensive research, application, and effort. Through interviews and correspondence, through reading up on related matters and visiting the places he wished to describe (descending into coal mines or riding on locomotives), Zola used to assemble notes for each novel which frequently exceeded in volume the book for which they were gathered. Edmond de Goncourt, in his intimate journal, called him an "engine greased for industrial labor." Zola's earnest and honest endeavor to write the natural and social history of a family — the Rougon-Macquarts — against a contemporary background, his effort to be a novelist as well as a historian of his time, to found his writings on documentation rather than imagination or poetic license, and his need for scrupulous preparation could not help him understand the tendencies of a painter whose aim was precisely a technical fluency which would permit him to capture rapidly the fleeting aspects of nature. The novelist completely failed to comprehend that Monet and his friends chose the representation of nature, and Manet or Degas contemporary subjects, because this was a natural thing for them to do, not a pre-established program for the ulterior motive of providing future generations with a pictorial account of their days. Whatever value their works might have as historical documents, this was not a quality with which they were primarily concerned.

Terminating his articles which thus presented impressionism seen through the eyes of a literary historiographer accentuating premises that were alien to its essence, Zola rightfully proclaimed that the impressionist group no longer existed while its influ-

Manet: Antonin Proust, 1880. $51\frac{5}{8} \times 38\frac{1}{4}$ ". Exhibited at the Salon of 1880. Toledo Museum of Art, Ohio.

Degas: At the Milliner's, c. 1882. Pastel, $27\frac{5}{8} \times 27\frac{3}{4}$ ". (Mary Cassatt posed for this picture.) The Museum of Modern Art, New York (Gift of Mrs. David M. Levy).

ence could be felt everywhere, even among official painters. "The real misfortune," he concluded, repeating the arguments of Duranty, of his own Russian articles, and of Huysmans, "is that no artist of this group has achieved powerfully and definitely the new formula which, scattered through their works, they all offer. The formula is there, endlessly diffused; but in no place, among any of them, is it to be found applied by a master. They are all forerunners. The man of genius has not arisen. We can see what they intend, and find them right, but we seek in vain the masterpiece that is to lay down the formula.... This is why the struggle of the impressionists has not reached a goal; they remain inferior to what they undertake, they stammer without being able to find words." 12

The impression Zola's articles made upon the painters apparently was summed up in a letter Manet wrote to Duret. Although he was not immediately concerned — Zola having spoken warmly of his achievements and salutary influence — Manet seems to have severely criticized the novelist. But in a second letter he asked Duret to destroy the first one, explaining: "...It appears that I am in the wrong, yet I had not judged Zola's article from a personal standpoint but had thought it contained too much eclecticism. We have so much need of being defended that a little radicalism would have done no harm, it seems to me..."¹³

There was something tragic in the misunderstanding, the lack of comprehension, which slowly but surely drew the former comrades apart. The disintegration of the impressionist group was further underlined by Monet, who, in answer to the partial refusal which the jury returned to him, organized in June 1880 an important one-man show at *La Vie Moderne*, ¹⁴ where Manet had had an exhibition in April; this show made a deep impression on young Signac. When Monet was asked whether he had ceased to be an impressionist, his reply was: "Not at all. I am still and I always intend to be an impressionist . . . but I see only very rarely the men and women who are my colleagues. The little clique has become a great club which opens its doors to the first-come dauber. . . . "¹⁵ Whether this was meant for Raffaëlli or for Gauguin is hard to decide, but the fact remains that Monet's remark certainly did not help to smooth his relations with the others.

"What is to become of our exhibitions? This is my well-considered opinion: we ought to continue, and continue only in an artistic direction, the sole direction — in the final sense — that is of interest to us all. I ask, therefore, that a show should be composed of all those who have contributed real interest to the subject, that is, you, Monet,

Photograph of Emile Zola.

Renoir, Sisley, Mme Morisot, Mlle Cassatt, Cézanne, Guillaumin; if you wish, Gauguin, perhaps Cordey, and myself. That's all, since Degas refuses a show on such a basis. I should rather like to know wherein the public is interested in our individual disputes. It's very naive of us to squabble over these things. Degas introduced disunity into our midst. It is unfortunate for him that he has such an unsatisfactory character. He spends his time haranguing at the Nouvelle-Athènes or in society. He would do much better to paint a little more. That he is a hundred times right in what he says, that he talks with infinite wit and good sense about painting, no one doubts (and isn't that the outstanding part of his reputation?). But it is no less true that the real arguments of a painter are his paintings and that even if he were a thousand times right in his talk, he would still be much more right on the basis of his work. Degas now cites practical necessities, which he doesn't allow Renoir and Monet. But before his financial losses was he really different from what he is today? Ask all who knew him, beginning with yourself. No, this man has gone sour. He doesn't hold the big place that he ought according to his talent and, although he will never admit it, he bears the whole world a grudge.

"He claims that he wanted to have Raffaëlli and the others because Monet and Renoir had reneged and that there had to be someone. But for three years he has been after Raffaëlli to join us, long before the defection of Monet, Renoir, and even Sisley. He claims that we must stick together and be able to count on each other (for God's sake!); and whom does he bring us? Lepic, Legros, Maureau.... (Yet he didn't rage against the defection of Lepic and Legros, and moreover, Lepic, heaven knows, has no talent. He has forgiven him everything. No doubt, since Sisley, Monet, and Renoir have talent, he will never forgive them.) In 1878 [he brought us] Zandomeneghi, Bracquemond, Mme Bracquemond; in 1879 Raffaëlli... and others. What a fighting squadron in the great cause of realism!!!!

"If there is anyone in the world who has the right not to forgive Renoir, Monet, Sisley, and Cézanne, it is you, because you have experienced the same practical demands as they and you haven't weakened. But you are in truth less complicated and more just than Degas... You know that there is only one reason for all this, the needs of existence. When one needs money, one tries to pull through as one can. Although Degas denies the validity of such fundamental reasons, I consider them essential. He has almost a persecution complex. Doesn't he want to convince people that Renoir has Machiavellian ideas? Really, he is not only not just, he is not even generous. As for me, I have no right to condemn anyone for these motives. The only person, I repeat, in whom I recognize that right is you. I say the only person; I do not recognize that right in Degas who has cried out against all in whom he admits talent, in all periods of his life. One could put together a volume from what he has said against Manet, Monet, you...

"I ask you: isn't it our duty to support each other and to forgive each other's weaknesses rather than to tear ourselves down? To cap it all, the very one who has talked so much and wanted to do so much has always been the one who has personally contributed the least.... All this depresses me deeply. If there had been only one subject of discussion among us, that of art, we would always have been in agreement. The person who shifted the question to another level is Degas, and we would be very stupid to suffer from his follies. He has tremendous talent, it is true. I'm the first to

RAFFAËLLI: Sculptor in His Studio. Present whereabouts unknown.

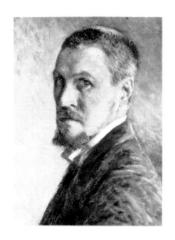

Caillebotte: Self Portrait, 1889. $17\frac{3}{8} \times 13\frac{3}{8}$ ". Private collection, Paris.

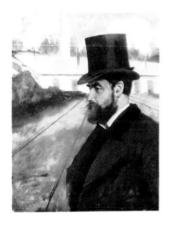

Degas: Henri Rouart, c. 1877. $25\frac{5}{8} \times 19\frac{5}{8}$ ". Probably exhibited at the third impressionist show, 1877. Carnegie Institute Museum of Art, Pittsburgh, Pa.

proclaim myself his great admirer. But let's stop there. As a human being, he has gone so far as to say to me, speaking of Renoir and Monet: 'Do you invite those people to your house?' You see, though he has great talent, he doesn't have a great character.

"I shall sum up: do you want an exclusively artistic exhibition? I don't know what we shall do in a year. Let us first see what we'll do in two months. If Degas wants to take part, let him, but without the crowd he drags along. The only ones of his friends who have any right are Rouart and Tillot..."

Yet Pissarro could not take it upon him to "leave friends in the lurch" and stood by Degas. "He's a terrible man, but frank and loyal," he used to say, and he always remembered that Degas had helped him repeatedly in difficult moments. Moreover, Caillebotte's proposition had been entirely his own; it was by no means certain that Renoir and Monet would return to the group under any circumstances. It seemed hardly wise, therefore, to break with Degas. "I don't know what I shall do," Caillebotte thereupon replied. "I don't believe that an exhibition is possible this year. But I certainly shan't repeat the one held last year."

The chances for a sixth exhibition of the group appeared slim, yet it was organized in spite of the absence of Renoir, Monet, Sisley, Cézanne, and now also Caillebotte. It was held during the month of April, 1881, again at 35 boulevard des Capucines, but not, this time, in Nadar's studio; it took place in an apartment facing a courtyard on the second floor of a building under construction. The rooms were crowded with pictures, the light was not very good, and the show had little resemblance to the first exhibition of the impressionists. 19 Degas sent only half a dozen works (mostly sketches) and his wax statuette of a little dancer dressed in a real skirt, her hair tied with a real silk ribbon.²⁰ It seems somewhat perplexing that Degas, having become the center of dissent, should have selected mostly minor works — his statuette excepted — but then he may not have wished to exploit his "victory" by too weighty a participation. Berthe Morisot did not contribute any more works than Degas. Mary Cassatt exhibited studies of children, of interiors, and of gardens, Pissarro showed the largest contingent, being represented by twenty-seven paintings and pastels accentuated by frames of complementary colors, while most of the other exhibitors favored white or natural wood moldings to avoid the too lively gold and the too rich ornaments of conventional frames. Two of Pissarro's pictures were lent by Miss Cassatt, one by Rouart, and one by Gauguin. Gauguin himself exhibited cight canvases, of which one belonged to Degas; he also showed two sculptures. (That same year Gauguin carved a wooden box with reliefs of ballet girls after studies by Degas and in 1882 he dedicated and offered to Pissarro a relief of a girl combing her hair.²¹)

Again two distinct factions were present at the 1881 exhibition: Pissarro and Berthe Morisot, Guillaumin, Gauguin, and Vignon on the one side, Degas with Mary Cassatt, Forain, Raffaëlli, Rouart, Tillot, Vidal, and Zandomeneghi on the other. And a third group was constituted by those who exhibited or tried to exhibit at the Salon: Renoir, Monet, Sisley, and Cézanne. There was every sign that Zola and Duranty had been right in stating that the impressionist group no longer existed.

The critics did not fail to notice the incompleteness of the group.²² While they remarked that plein-air painting was now being practiced by many an official artist, they wondered what had become of Monet, Renoir, Sisley, and Caillebotte.

Those in sympathy with the group congratulated the painters who had remained faithful to the association. Among these Pissarro drew especially favorable comments, due partly to his extensive participation, but Mary Cassatt also obtained considerable success. Degas' statuette disconcerted most commentators and Gauguin's sculptures altogether failed to please. Most critics agreed that the show did not reveal anything startling or new.

Jules Claretie, in his widely read column in *Le Temps*, hailed Raffaëlli who, as he had already stated the previous year, was "no impressionist at all"; he found little to say about the others, except to follow more or less Zola's objections when he wrote: "What would one say of writers who took it into their heads to publish their penciled notes, their sallies, their impressions jotted down in telegraphic style? One would ask them to kindly edit and complete these. It would be mere politeness towards the public if the 'independent' painters consented to push their works beyond the stage of simple sketches. Quite slyly they stop where the real difficulties begin..." As a matter of fact, Claretie considered that "the greatest originality of these revolutionaries consists in the moldings around their pictures, which are white, gold frames having been abandoned by them."23

And Albert Wolff pontificated in *Le Figaro*: "Renoir or Claude Monet, Sisley, Caillebotte, or Pissarro, it's all the same thing; what is particularly strange about these Independents is that they are just as prone to routine as are the painters who do not belong to their brotherhood. Who has seen one picture by an Independent has seen the works of all of them..." ²²⁴ It mattered little to this critic that, with the exception of Pissarro, none of the artists mentioned by him were represented in the show.

Strangely enough, it was this truncated exhibition which prompted Huysmans to proclaim that impressionism had at last come into its own. Now he found "fully realized the new formula quested for so long a time." Little did he suspect that it was his own concepts which had evolved, that he had finally become used to the new art; rather than acknowledge the direction taken by his personal evolution he credited the painters with unusual accomplishments.

"One fact is dominant," he wrote, "the blossoming of impressionist art which has reached maturity with M. Pissarro. As I have said many times, until the present the retina of the painters devoted to impressions had been overstrained. Although it did capture all the variations of colors in bright light, it could not express them; the nervous papillas had reached such a state of irritability that we almost abandoned hope. In other words, pure impressionist art was heretofore stammering, but suddenly—miraculously—it has started to speak and does so quite coherently. Also, two artists who previously hesitated to walk on their own...now advance resolutely, Mlle Cassatt and M. Gauguin. On the other hand the talent of M. Raffaëlli has reached fullness and M. Degas unexpectedly gratifies himself with doing sculpture, thereby opening up new possibilities."25

Huysmans spoke at length about Degas' statuette, "the only really modern attempt of which I know in sculpture," but doubted that it would be appreciated. "It seems," he added, "that M. Degas, by an excess of modesty or pride, holds success in haughty contempt; well then, I very much fear that once more—on the subject of this work—he won't have occasion to fume against the taste of the crowds."

Degas: Studies for sculpture. Chalk and pastel, $18 \times 22\frac{1}{2}$ ". Collection Sir Max Rayne.

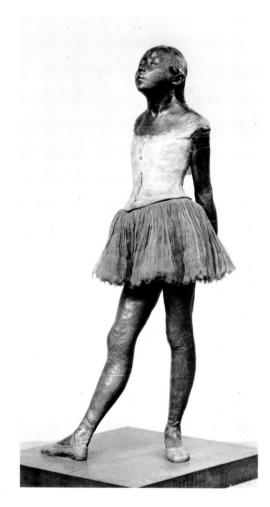

DEGAS: Young Dancer, 1880-81. Bronze, 39" high. Cast after the original in colored wax with gauze skirt exhibited at the sixth impressionist show, 1881 (now collection Mr. and Mrs. Paul Mellon, Upperville, Va.). Metropolitan Museum of Art, New York (H. O. Havemeyer Collection).

Degas: Studies for sculpture. Pastel. Present whereabouts unknown.

This time Huysmans did not only discuss the entries of Degas and his friends, such as Raffaëlli and Forain, he also dealt extensively with Pissarro, whose greatness he seemed finally to grasp, though his appreciation was expressed with a somewhat condescending tone: "M. Pissarro may now be classed among the number of remarkable and audacious painters we possess. If he can preserve his perceptive, delicate, and nimble eye, we shall certainly have in him the most original landscapist of our time." Huysmans further spoke of Guillaumin and of Gauguin, heaping some rather extravagant praise on the latter. A nude for which Gauguin's maid had sat—supposedly a former model of Delacroix's—inspired the writer to long considerations on nudity in modern art. The absence of any attempt to prettify, to idealize the woman's body, unlatched the enthusiasm of Huysmans, who now turned his back on Moreau's symbolism and seemed to remember Zola's precepts of naturalisme.

"I do not hesitate to assert," Huysmans wrote, "that among contemporary artists who have painted nudes, none has as yet furnished such a vehement note of realism, and I do not except Courbet among these painters.... Here is a girl of our days, a girl who doesn't pose for an audience, who is neither lascivious nor affected, who is simply occupied with mending her clothes.... Oh, the nude woman! Who has painted her as she is, superb and real, without premeditated arrangements, without adulteration of her features and her flesh?"25 Just as Huysmans now exaggerated the merits of Pissarro by forgetting Monet's role as a landscapist, he presently gave Gauguin credit for a feat that was then being accomplished more consequently by Degas, who, with much more acuteness, with a much surer sense for typical bearing and movements, with an infinitely greater instinct for form and composition, had discovered the naked body as a "modern" subject. Where Gauguin had merely painted conscientiously an accidentally nude model whose task of mending could just as well have been performed while dressed, Degas was exploring nudity as an essential condition, was studying the many gestures pertinent to the state of nakedness.

The success of Gauguin and Pissarro at the group exhibition was followed by similar successes of Manet and Renoir at the Salon, where the epigoni of impressionism were now triumphant. In 1881 an important change took place in the status of the official exhibition. The State finally abandoned its supervision; an artists' association was formed and entrusted with the organization of the yearly Salons. Every artist whose work had been accepted once was entitled to participate in the election of the jury. Although this opportunity to rid the jury of its most reactionary members was not fully exploited by the voters and many of the academic teachers at the *Ecole des Beaux-Arts* were re-elected, the new jury was nonetheless somewhat more liberal (among its members was Guillemet). Manet even obtained, albeit with difficulty, the necessary votes for a second-class medal.²⁶

Manet's modest progress at the Salon and Huysmans' "conversion" to impressionism were accompanied by a much more far-reaching event: at long last the affairs of Durand-Ruel began to take a turn for the better. The effects of the crisis of 1873 had worn off; business began to recover. There was extensive railway building in France, the stock exchange was feverish with speculation (Gauguin probably earned a lot of money at that time), new companies were founded, and credit was greatly expanded. In 1880 a recently won friend, Feder, had put large amounts at Durand-Ruel's disposal which made possible several important trans-

Gauguin: Camille Pissarro, d. 1880. Pencil, $8\frac{7}{8} \times 7\frac{7}{8}$ ". Collection Fru Urban Gad, Copenhagen.

Gauguin: *Nude*, d. 1880. $45 \times 314''$. Exhibited at the sixth impressionist show, 1881. Ny Carlsberg Glyptotek, Copenhagen.

actions and at the same time enabled him to help the impressionists. He immediately purchased works from Sisley, the poorest and least successful of them all. In 1881 he began once more to acquire regularly the paintings of Monet, Pissarro, and Renoir. He also bought Degas' works whenever the latter wanted to sell. Durand-Ruel offered decent prices and instead of purchasing individual paintings often arranged monthly payments according to the painters' needs. They, in turn, sent him more or less their entire output; accounts were settled periodically. Thus they were able to work without too much worry. "I am not rolling in money," Pissarro wrote to Duret, "I am enjoying the results of moderate but steady sales. I dread only a

repetition of the past."²⁷ Under these circumstances the general outlook took on a better light, and work was accomplished in a happier frame of mind.

Renoir began to travel. Early in 1881 he went to Algiers, attracted by the colorful Orient that had played such an important role in Delacroix's art; there he painted a Fantasia (see p. 462) which shows him following in the older master's footsteps. In Algiers, Renoir met Lhote, Lestringuez, and Cordey. In Paris meanwhile his friend, the art historian and banker Ephrussi, had been requested to send two portraits by Renoir to the Salon; they were admitted.

Shortly before the opening of the Salon, Renoir left Algiers. By Easter he was back in the capital, or rather in Chatou and Bougival, where he went to work with renewed enthusiasm. Duret had invited him to a trip across the Channel, but after having lunched with Whistler at Chatou and probably questioned him about the young English ladies and their charms, Renoir decided to stay. "I am struggling with trees in bloom, with women and children, and I don't want to look any further," he explained to Duret, adding: "Nevertheless, I constantly have regrets. I think of the trouble I have given you for nothing and I wonder if you will easily swallow my

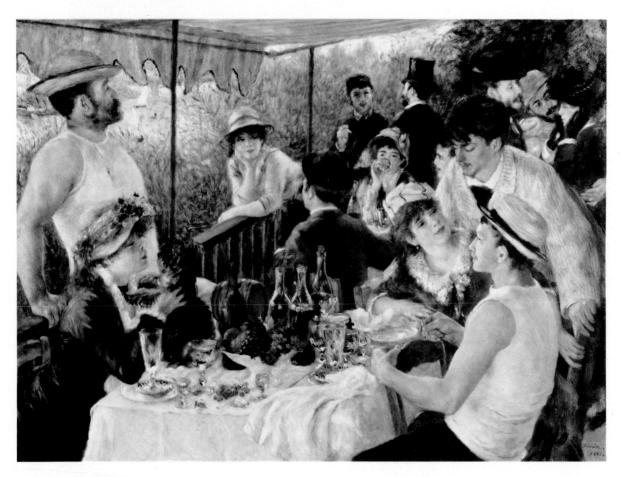

Renoir: Le déjeuner des canotiers, d. 1881. $51\frac{3}{8} \times 69\frac{1}{4}$ ". Exhibited at the seventh impressionist show, 1882. The Phillips Collection, Washington, D.C.

Renoir: Arab Boy, d. 1882. $21 \times 11\frac{1}{2}$ ". Collection Mr. and Mrs. Sidney F. Brody, Los Angeles.

pretty woman's whims, and yet in the midst of all this I am continually catching glimpses of charming English girls. What a misfortune always to hesitate, but that is the basis of my character, and as I grow older I am afraid I won't be able to change. The weather is very fine and I have some models. This is my only excuse."28

It seems, however, that Renoir had an even better excuse. In the large canvas which he then painted at the restaurant Fournaise on the small island of Chatou, close to the bridge, there appears for the first time a young woman, Aline Charigot, who was to become his wife in 1890. This composition, Le déjeuner des canotiers, belongs in the same category with Le bal au Moulin de la Galette and with the Boating Party at Chatou, executed two years before. It is another effort to seize the animated outdoor mingling of people in an atmosphere glistening with sunshine and joy of living. Once more Renoir's friends posed for him. Opposite the future Mme Renoir, who holds a little dog, appears Caillebotte, seated backwards on a chair (he seems to be represented younger than he actually was at that time); next to Caillebotte sits Angèle, the model whom Renoir had painted asleep in a chair with a cat on her lap; in the background, with a top hat, stands Ephrussi, on the right are Lestringuez, and Lhote in a straw hat (see p. 454).²⁹

Though Renoir had renounced a trip to England, Sisley crossed the Channel and spent the summer on the Isle of Wight. His exhibition at La Vie Moderne, early that year, had been only moderately successful and his summer voyage turned into a fiasco when the expected material did not arrive and he was prevented from painting on the Isle of Wight for lack of canvas. In Pontoise, meanwhile, Pissarro again gathered his friends around him. Cézanne was there, and so was Gauguin, watching Cézanne's efforts to find a unique expression for his rich sensations. In his own works Gauguin was somewhat influenced by Cézanne, while coming steadily closer to Pissarro's technique and palette. He did so quite voluntarily, for it was far from Pissarro's intention to press his conceptions on others. The advice he offered Gauguin cannot have been very different from that he gave his sons, who had begun to draw and to paint (his oldest, Lucien, was then nineteen). "Scorn my judgment," he told them. "I have such a longing for you all to be great that I cannot hide my opinions from you. Accept only those that are in accord with your sentiments and mode of understanding. Although we have substantially the same ideas, these are modified in you by youth and a milieu strange to me; and I am thankful for that; what I fear most is for you to resemble me too much. Be bold, then, and to work!..."30

A young painter of his acquaintance later noted down the more specific advice given by Pissarro, advice which seems to sum up the concepts and methods of all the impressionist landscapists. This was the gist of what Pissarro told him: "Look for the kind of nature that suits your temperament. The motif should be observed more for shape and color than for drawing. There is no need to tighten the form which can be obtained without that. Precise drawing is dry and hampers the impression of the whole, it destroys all sensations. Do not define too closely the outlines of things; it is the brush stroke of the right value and color which should produce the drawing. In a mass, the greatest difficulty is not to give the contour in detail, but to paint what is within. Paint the essential character of things, try to convey it by any means whatsoever, without bothering about technique. When painting, make a choice of subject, see what is lying at the right and at the left, then work on everything

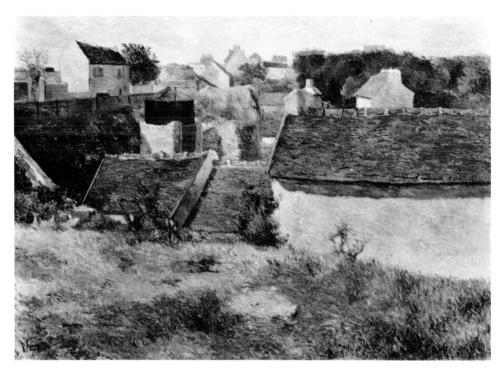

Gauguin: Houses in Vaugirard (Paris), d. 1880. $31\frac{7}{8} \times 45\frac{5}{8}$ ". Collection Sam Spiegel, New York.

Photograph of the subject (from an old postcard).

simultaneously. Don't work bit by bit, but paint everything at once by placing tones everywhere, with brush strokes of the right color and value, while noticing what is alongside. Use small brush strokes and try to put down your perceptions immediately. The eye should not be fixed on one point, but should take in everything, while observing the reflections which the colors produce on their surroundings. Work at the same time upon sky, water, branches, ground, keeping everything going on an equal basis and unceasingly rework until you have got it. Cover the canvas at the first go, then work at it until you can see nothing more to add. Observe the aerial perspective well, from the foreground to the horizon, the reflections of sky, of foliage. Don't be afraid of putting on color, refine the work little by little. Don't proceed according to rules and principles, but paint what you observe and feel. Paint generously and unhesitatingly, for it is best not to lose the first impression. Don't be timid in front of nature: one must be bold, at the risk of being deceived and making mistakes. One must have only one master — nature; she is the one always to be consulted."

But Gauguin had not yet enough confidence in his own gifts to be bold and preferred to follow his master. After he had returned from his holidays to Paris and to the bank, he missed Pissarro so much that he complained in a letter: "There is a theory I have heard you profess, that to paint it is absolutely necessary to live in Paris, so as to keep up with ideas. No one would say so at this moment when the rest of us poor wretches are going to the Nouvelle-Athènes to be roasted, while you are not concerned for a single instant with anything except living as a hermit.... I hope to see you turn up one of these days." Gauguin also inquired: "Has M. Cézanne found the exact formula for a work acceptable to everyone? If he discovers the prescription for compressing the intense expression of all his sensations into a single and unique procedure, try to make him talk in his sleep by giving him one of those mysterious homeopathic drugs, and come immediately to Paris to share it with us." Cézanne, nervous and suspicious, did not take this pleasantry too well and seriously began to fear that Gauguin was out to "steal" his sensations.

Manet's bad health impelled him to heed his doctor's advice and take some rest in the country. In 1880 he had gone to Bellevue in the outskirts of Paris; in 1881 he rented a house with a garden in Versailles. "The country has charms only for those who are not obliged to stay there," he complained to Astruc, but he tried to make the best of it. Prevented from working on large canvases, he began to paint in his garden and to observe the phenomena of light which so attracted the impressionists. In doing so he completely adopted their technique of small and vivid strokes as well as their bright colors. The various corners of his garden in Versailles, which he painted, registering every shift of light, are represented in a truly impressionist fashion. They show his virtuosity combined with a close observation of nature. The happy results, however, did not prevent Fantin from accusing Manet of degenerating through "contact with those dilettantes who produce more noise than art." ³⁴

After his return to Paris, Manet had the pleasant surprise of seeing his old friend Antonin Proust become Minister of Fine Arts in a cabinet formed by Gambetta. One of Proust's first acts was to acquire for the State a series of paintings by Courbet, the contents of whose studio were then being sold at auction. Proust also put both Faure and Manet on the list of those to be decorated with the Legion of Honor. Renoir, who received these bits of news at Capri, was delighted. "I have wanted

Manet: The Artist's Garden in Versailles, 1881. $25\frac{5}{8} \times 31\frac{7}{8}$ ". Collection Mrs. John Barry Ryan, New York.

for a long time to write you about Proust's nomination," he informed Manet in December, "and I haven't done so. However, an old number of the *Petit Journal* has just come into my hands, referring with delight to the purchase of paintings by Courbet, something that gives me intense pleasure; not for Courbet's sake, the poor fellow, who cannot enjoy his triumph, but for the sake of French art. So there is at last a cabinet minister who suspects that painting exists in France. And I was expecting to see in the following issues of the *Petit Journal* your nomination as Knight of the Legion of Honor, which would have brought applause from me on my distant island. But I hope it is only being delayed and that when I return to the capital I shall have to salute you as the painter beloved of everyone, officially recognized. . . . I don't think you will imagine that there is a single complimentary word in my letter. You are the happy fighter, without hatred for anyone, like an ancient Gaul; and I like you for that gaiety maintained even in the midst of injustice." 35

From Capri (where this letter was mailed) Renoir went to Palermo and there, on January 15, 1882, the day after Wagner had finished *Parsifal*, he painted during

Renoir: Gondola in Venice, 1881. 211 × 253". Collection Philip Levin, New York.

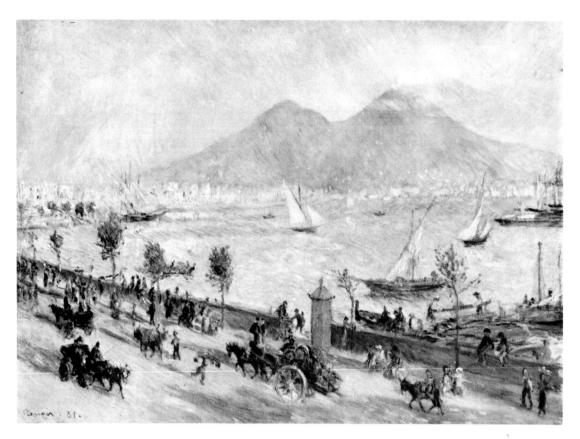

Renoir: The Bay of Naples, d. 1881. $22\frac{7}{8} \times 31\frac{1}{2}$ ". Sterling and Francine Clark Art Institute, Williamstown, Mass.

RENOIR: Drawing after his Portrait of Richard Wagner, $11 \times 8\frac{1}{2}$ ". Published in La Vie Moderne, 1883. Collection Hans Reinhart, Winterthur, Switzerland.

a short sitting a portrait of the composer, who was unwilling to grant more than thirty-five minutes.³⁶ Wagner, as Renoir reported to a friend, "was in a jolly mood, but I was very nervous and I regret that I am not Ingres."³⁷ The German master who, during his conversation with the painter, indulged in his usual anti-Semitic utterances, cared little for Renoir's portrait and after the latter's departure launched into a series of disparaging remarks on the vain and arrogant French. Yet it seems unlikely that these were directly brought about by Renoir's behavior, since the artist had endeavored to be quite deferential. After all, he had made the special trip to Palermo at the suggestion of his old friend Judge Lascaux, provided with letters of introduction, and cannot have failed to remember earlier years when Bazille, Fantin-Latour, and Edmond Maître—all devoted admirers of Wagner—had taken him to the composer's first concerts in Paris.

After this short interlude, Renoir returned to Naples, where he had stopped on his way south, attracted by the city, the bay and Vesuvius, as well as by the museum. But the reason that had prompted his trip to Italy was Renoir's desire to study the

works of Raphael; he had done this in Rome, after having spent some time in Venice painting the Lagoon, admiring Veronese and Tiepolo. His mind was full of all these new impressions, and from Naples he wrote to Durand-Ruel: "I have been to see the Raphaels in Rome. They are wonderful and I should have seen them before. They are full of knowledge and wisdom. Unlike me, he did not seek the impossible. But it's beautiful. I prefer Ingres for oil painting. Yet the frescoes are admirable in simplicity and grandeur." As for his own efforts, he was little satisfied. "I am still suffering from experimenting. I'm not content and I am scraping off, still scraping off. I hope this craze will have an end.... I am like a child in school. The white page must always be nicely written and bang—a blot. I am still at the blotting stage—and I'm forty."38

In spite of all his dazzling and new impressions Renoir could not help but write from Naples to the collector Deudon: "I feel a little lost when away from Montmartre.... I am longing for my familiar surroundings and think that even the ugliest Parisian girl is preferable to the most beautiful Italian."³⁹

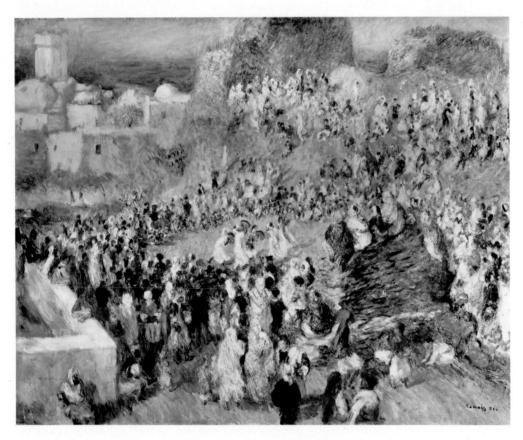

Renoir: Fantasia, Algiers, d. 1881. 28\frac{1}{4} \times 35\frac{1}{4}". Musée du Louvre, Paris.

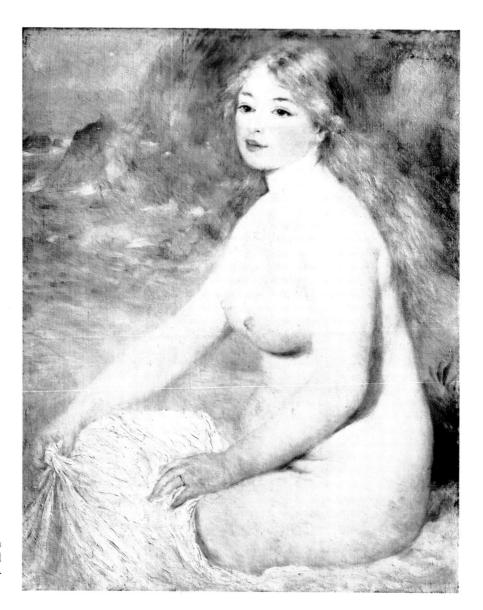

Renoir: Bather, supposedly painted in Naples, 1881. $32\frac{1}{8} \times 25\frac{3}{4}$ ". Sterling and Francine Clark Art Institute, Williamstown, Mass.

On his way back, Renoir met Cézanne in Marseilles and decided to stay with him for a short while at L'Estaque. There he found natural scenery which does not change much with the seasons (it was late in January 1882) and is bathed every day in the same strong light. Enchanted, he delayed his return to Paris, where Mme Charpentier was expecting him to do a pastel portrait of her daughter. "I am in the process of learning a lot," he explained to her, "and the longer I take, the better the portrait will be.... I have perpetual sunshine and I can scrape off and begin again as much as I like. This is the only way to learn, and in Paris one is obliged to be satisfied with little. I studied a great deal in the Naples museum; the

RENOIR: Crags at L'Estaque, d. 1882. $25\frac{3}{4} \times 32''$. Museum of Fine Arts, Boston.

Pompeii paintings are extremely interesting from every point of view; then too, I am staying in the sun, not to do portraits in full sunlight, but, while warming myself and observing a great deal, I shall, I believe, have acquired the simplicity and grandeur of the ancient painters. Raphael, who did not work out-of-doors, nevertheless studied sunlight, for his frescoes are full of it. Thus as a result of seeing the out-of-doors, I have ended up by not bothering any more with the small details that extinguish rather than kindle the sun."⁴⁰

While in L'Estaque, Renoir fell seriously ill with pneumonia. Cézanne and his old mother hurried to his side and nursed him with a devotion that deeply touched him; in a letter to Chocquet he expressed his gratitude for their tender care. During this illness Renoir received—and with rather bad humor—an invitation from Caillebotte to participate in a seventh show of the impressionist group.

Toward the end of 1881 Caillebotte had set out once more to organize a new exhibition for his friends. He went to see Rouart, who, inclined to be conciliatory, promised to persuade Degas to separate from Raffaëlli. But these efforts failed, and Caillebotte bitterly informed Pissarro: "Degas won't give up Raffaëlli for the simple reason that he is asked to, and he'll do it all the less, the more he is asked to do

so."41 Discouraged, Pissarro passed on this news to Gauguin, who wrote him on December 14:

"Last night Degas told me in anger that he would hand in his resignation rather than send Raffaëlli away. If I examine calmly your situation after ten years during which you undertook to organize these exhibitions, I immediately perceive that the number of impressionists has progressed, their talent increased, their influence too. Yet on Degas' side—and thanks only to his volition—the tendency has been getting worse and worse: each year another impressionist has left and been replaced by nullities and pupils of the *Ecole* [des Beaux-Arts]. Two more years and you will be left alone in the midst of these schemers of the worst kind. All your efforts will be destroyed, and Durand-Ruel, too, on top of this. In spite of all my good will I cannot continue to serve as buffoon for M. Raffaëlli and company. I beg you to accept my resignation. From now on I shall remain in my corner." And Gauguin added: "I

CÉZANNE: Ravine near L'Estaque, c. 1879. 28\(^3\) \times 21\(^4\) ". Formerly collection Victor Chocquet. Collection John A. and Audrey Jones Beck, Houston.

Degas: Laundresses, 1882. 32\frac{1}{4} \times 29\frac{1}{2}''. Formerly collection J.-B. Faure. Norton Simon Collection, Los Angeles.

466

believe that Guillaumin feels the same way, but I do not wish in any way to influence his decision."42

It was certainly not lightheartedly that Gauguin took this step. To him the exhibitions of the group were vital, since they offered the sole possibility to show his work which, little by little, was absorbing the greater part of his energies. Confronted with the defection of Caillebotte and Gauguin, Pissarro found himself in a difficult position. He could not deny that Gauguin was right and that—after the successive departures of Cézanne, Sisley, Renoir, Monet, Caillebotte, now followed by Gauguin and possibly Guillaumin—he would remain alone with Berthe Morisot to represent the impressionist element in a group invaded by Degas' adepts. Thus he had no choice but to accept the conditions of Caillebotte and Gauguin, to renounce Degas' participation and try to reassemble the old group as far as could be done.

"You will say that I am always impetuous and that I want to hurry things," Gauguin insisted in a new letter to Pissarro, "but you will nevertheless have to admit that in all this my calculations were correct... Nobody will ever convince me that, for Degas, Raffaëlli is not merely a pretext for a break; that man has a perverse spirit which destroys everything. Think about it all, and *let's act*, I entreat you."43

Caillebotte immediately proposed that they organize an exhibition grouping Pissarro, Monet, Renoir, Cézanne, Sisley, Berthe Morisot, Gauguin, himself, and Miss Cassatt if she would consent to show without Degas. Pissarro accepted and went to invite Berthe Morisot. She was in Nice; Manet received him instead and then wrote his sister-in-law: "I have just had a visit from that difficult fellow Pissarro who talked to me about your next exhibition; those gentlemen do not give the impression of being of one mind. Gauguin plays the dictator; Sisley, whom I also saw, would like to know what Monet is to do. As for Renoir, he hasn't yet returned to Paris."44

Meanwhile Caillebotte had written to Monet, who was working at Dieppe whence he answered that the show should be done either properly or not at all, without promising his participation. Renoir replied that he was ill and unable to come; he too, it seems, expressed little inclination to take part. Disgusted with his lack of success, Caillebotte was ready to give up.

At this moment, apparently, Durand-Ruel took the matter into his own hands. Since he was again the dealer who exclusively handled the pictures of the impressionists, he was not only annoyed by their disputes but actually interested in the projected exhibition. He had just been dealt a terrible blow: the flurry of prosperity inaugurated in 1880 was followed by a crash in 1882 with a series of bankruptcies. Among the bankrupt figured Durand-Ruel's friend Feder, and this put the dealer under obligation to return the money Feder had advanced. Yet Durand-Ruel was determined not to let this interfere with his plans. He himself now wrote to Monet and Renoir, pressing them to join the others. Renoir's answer was that he would follow Durand-Ruel in whatever projects he had, but declined to deal with his colleagues. He was sour because the show had been discussed without him, because he had not been invited to the three previous exhibitions, and because he suspected that he was asked only to fill a gap. He wrote several ill-tempered letters to Durand-Ruel, explaining that he was again exhibiting at the Salon and refusing to join in

any show of the so-called *Indépendants*. He first accepted the idea of a group formed exclusively by Monet, Sisley, Berthe Morisot, Pissarro, and Degas, then voiced distrust of Gauguin and Pissarro, making some disagreeable comments on the latter, finally accusing him of political and revolutionary tendencies with which he would have nothing to do. Yet he definitely authorized Durand-Ruel to show pictures of his, owned by the dealer, on condition that they be listed as loaned by Durand-Ruel and not by himself.⁴⁵

Monet's answer was more or less the same. He refused to be associated with artists who did not belong to the real impressionist group. But upon Durand-Ruel's insistence he, too, felt embarrassed in declining an invitation from the man who had done so much for him and his comrades. Since Pissarro had asked that next to the old-timers three of his friends—Guillaumin, Gauguin, and Vignon—be admitted, Monet specified that he had nothing against these men but felt himself bound to Caillebotte. He was ready to take part, and even to separate himself from Caillebotte, if Pissarro would abandon his protégés. 46 Pissarro thereupon wrote directly to Monet toward the end of February 1882:

"I confess that I do not understand anything anymore. For two or three weeks now I have been making great efforts—in conjunction with our friend Caillebotte—to arrive at an understanding in order to reassemble our group as homogeneously as possible. Obviously an error must have slipped into the letter which M. Durand-Ruel wrote you, for you may well imagine that we have never separated Caillebotte from our group. Since yesterday I have been anxiously awaiting your reply so as to rush to him and start the job together. This, by the way, had been agreed upon long ago with Caillebotte, who is on our side. His only condition is that we should have you with us. We barely have time left. Please reply immediately if you are joining us. Besides, here is the list of participants:

1. Monet	5. Caillebotte	8. Vignon
2. Renoir	6. Mme Morisot	9. Gauguin
3. Sisley	(if possible)	10. Cézanne
4. Pissarro	7. Guillaumin	(if possible)

"Thus we are eight this year. Caillebotte has agreed with me on this list which represents a group defending the same ideas in Art with more or less talent. We cannot insist on equal talent [this was probably meant in defense of Gauguin], but it is already an important factor not to include anything that mars the whole.

"For Durand-Ruel as well as for us the exhibition is a necessity. Personally I should be disconsolate not to satisfy him. We owe him so much that we can't refuse him this satisfaction. Sisley absolutely agrees with me; we are getting along famously.... Renoir is very ill at L'Estaque; it is difficult to capture his interest for our projects, but we are awaiting word from him just the same. Cézanne wrote me that he had no pictures! Mme Morisot is traveling; since she doubts of your participation, she has reserved her decision. I am thus waiting for your reply...."⁴⁷

Monet's answer was simply that he could accept only if Renoir also was willing. Finally, in a new letter to Durand-Ruel, Renoir agreed to show with the others after explaining once more his attitude: "I hope indeed that Caillebotte will exhibit, and I also hope that these gentlemen will drop this ridiculous title *Indépendants*.

Manzi: Edgar Degas, d. 1885. Present whereabouts unknown.

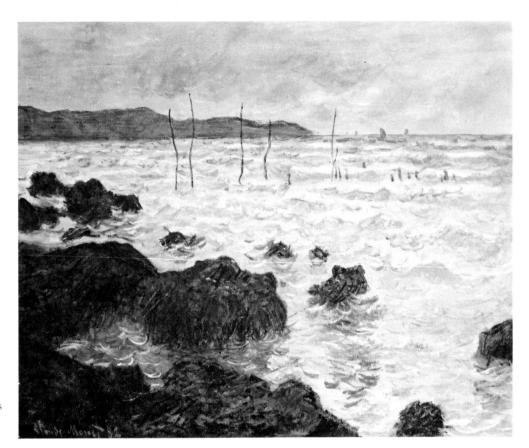

Monet: Fishing Nets at Pourville near Dieppe, d. 1882. 23³/₄ × 32". Lazarus Phillips Family Collection, Montreal.

Eventually Monet yielded, and with him Renoir, who even apologized for some nasty remarks made during his illness. But Renoir was unable to attend the exhibition. In March he left L'Estaque and returned to Algiers. Berthe Morisot also joined while remaining in the South. As for Degas, he definitely declined to participate in the show since his followers were barred. Mary Cassatt loyally went into "exile" with him. Although Rouart had personally paid the rent for the premises (leased for three years for a fee of 6000 francs), he withdrew together with Degas. As for Manet, he replied with his customary refusal when Pissarro once again tried to obtain his participation, and this in spite of the fact that he could now have shown with the group as well as at the Salon. His brother Eugène apprised his wife: "Pissarro had suggested to Edouard that he take part in the exhibition. I believe he now bitterly regrets to have declined. He seems to have hesitated a good deal."

Photograph of Auguste Renoir, 1880-85.

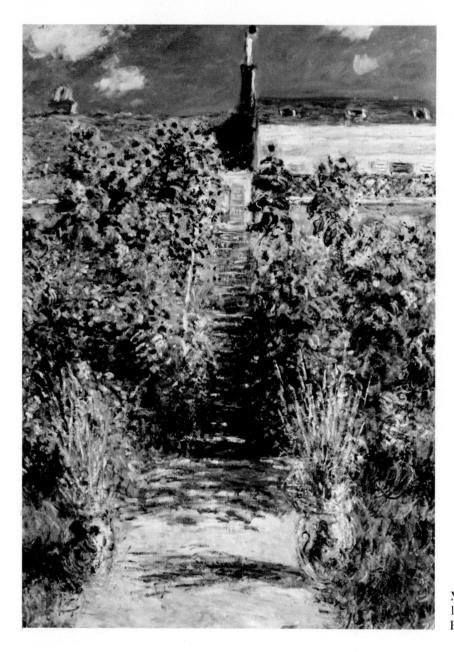

Monet: The Artist's Garden at Vétheuil, 1881. $39\frac{1}{2} \times 31\frac{1}{2}$ ". The Norton Simon Foundation, Los Angeles.

The exhibition was opened on March 1, 1882, at 251 rue St.-Honoré. Eugène Manet went there and informed Berthe Morisot: "I found the whole brilliant crowd of impressionists at work hanging a great many pictures in an enormous room.... Degas remains a member, pays his subscription, but doesn't exhibit. The association keeps the name, *Indépendants*, with which he adorned it..."⁵⁰

Never had the impressionists organized an exhibition so lacking in alien elements, never had they been so much to themselves. After eight years of common struggle they managed at last (but with what difficulties!) to stage an exhibition which truly

represented their art. "I am convinced," Pissarro contentedly wrote to de Bellio who was in Rumania, "that you would have been pleased with the over-all aspect of our show, for this is the first time that we do not have any too strong stains to deplore. Monet has a magnificent group: admirable seascapes, landscapes with a new accent, the execution more baffling than ever. Renoir, though ill in Marseilles, is admirably represented by portraits of children, young girls, his *Canotiers*, studies from Algiers, etc., all this extremely curious, full of piquancy. Sisley has no less than some thirty canvases of a very British savoriness; as to Mme Berthe Morisot... you know her great talent well enough [de Bellio had purchased three of her paintings from the 1876 group show], no need to attempt a description which would be impossible, only art critics can indulge in such fancies!"51

Pissarro himself participated with twenty-five oils and eleven gouaches (Durand-Ruel refused his request to present these in white frames). Monet exhibited thirty paintings, mostly landscapes and still lifes. Renoir's share was twenty-five canvases, including *Déjeuner des canotiers* (p. 454). Sisley was represented by twenty-seven works, Berthe Morisot by nine, Gauguin by thirteen, Caillebotte by-seventeen, Vignon by fifteen, and Guillaumin by thirteen paintings and as many pastels.⁵² The catalogue listed very few lenders; most of the exhibited works belonged to Durand-Ruel, who soon had every reason to be satisfied. The press was less aggressive this time; there appeared even a series of favorable notices, and several new buyers turned up.

Sisley: Fields at Veneux-Nadon, 1881. $23\frac{5}{8} \times 31\frac{7}{8}$ ". Exhibited in the seventh impressionist show, 1882. Collection Georg Sulzer, Winterthur, Switzerland.

Yet the battle was far from won. Jules Claretie chuckled about the internal difficulties of the group and told his readers: "Some opportunists found themselves among the rebels. There were squabbles or near squabbles. M. Degas, the painter of dancers, withdrew; Miss Cassatt followed M. Degas; M. Raffaëlli followed Miss Cassatt. These are artists of rare talent whom the Independents will be unable to replace [in writing this, the author thought particularly of Raffaëlli]." Claretie concluded by saying that the participants of the exhibition were "people with right ideas and wrong colors. They reason well but their vision is faulty. They show the candor of children and the fervor of apostles. It is of the gray-haired ones that I think, like M. Pissarro. One might be tempted to admire them, these naifs!"53

Among the visitors to the exhibition were, without a doubt, Seurat and Signac, who did not yet know each other and who came to study once more the works of their elders. A recently appointed young employee of the War Ministry, Félix Fénéon, also closely examined the paintings shown.

"Duret, who knows what he is talking about," Eugène Manet wrote to his wife, "says that this year's exhibition is the best your group has ever had. That is also my opinion."⁵⁴ And since Berthe Morisot found herself detained in the south, he sent her a summary report on the various participants:

"Sisley is the most complete and shows great progress. He has a lake or canal bordered by trees which is an authentic masterpiece. Pissarro is more uneven; however, there are two or three figures of peasant women in landscapes, vastly superior to Millet in the veracity of draftsmanship and coloration. Monet has some weak things next to some excellent ones, especially winter landscapes; a river carrying ice floes, altogether beautiful. The picture of *Canotiers* by Renoir looks very well; the views of Venice are wretched like real knitwear; a landscape with palms is very well carried off; two female figures are very lovely. Gauguin and Vignon are very mediocre. Vignon has slipped back into his imitation of Corot. . . . Caillebotte has some figures, blue like ink, very boring, and several excellent small pastels of landscapes. Durand-Ruel is taking care of everything and seems to have worked on the press. Wolff has shown and praised the exhibition to some friends; he asked for your pictures."55

In a new review Huysmans disagreed practically point by point with Eugène Manet's perceptive appraisals. He began by regretting the absence of "contemporary" subjects such as he admired in the works of Degas, Raffaëlli, Forain, etc., and showed himself annoyed by the predominance of pure landscapes. "The circle of modernism," he wrote, "has really been too much restricted and one can not sufficiently deplore this diminution which vile quarrels have brought about in the collective effort of the little group....Oh, the devil! we abominate each other but march in closed ranks against the common enemy; we may even insult each other—afterwards, if we wish, behind the scene—yet we proceed together, since it is foolish to disseminate one's forces when one fights, few in number, against the large crowd. To thus deny admission to a group under the pretext of obtaining a greater homogeneousness of works ... one fatally arrives at monotony of subjects, uniformity of methods, and, to say it bluntly, the most complete sterility." 56

Caillebotte's paintings Huysmans considered the most interesting from the point of view of subject matter. He could not find any progress in Gauguin's work, con-

Forain: Dancer, d. 1881. $12\frac{7}{8} \times 9\frac{3}{8}$ ". Present whereabouts unknown.

PISSARRO: Peasant Girl Drinking Her Coffee, 1881. $25\frac{1}{8} \times 21\frac{3}{8}$ ". Exhibited in the seventh impressionist show, 1882. Art Institute of Chicago (Potter Palmer Collection).

Cassatt: The Loge, c. 1882. $31\frac{1}{2} \times 25\frac{1}{4}$ ". National Gallery of Art, Washington, D.C. (Chester Dale Collection).

sidered Berthe Morisot's oils, as always, too sketchy, approved not quite whole-heartedly of Guillaumin's evolution, remained appreciative of Pissarro's contribution, was only half convinced of Sisley's originality, but this time discovered qualities in Monet's canvases, attributing these to a change in the artist's attitude. As to Renoir, Huysmans thought that he had at last come into his own, although he did not like his *Canotiers* for a rather peculiar reason: according to him the young women in the picture, although "spruce and gay, do not exhale the odor of Parisian girls; they are vernal harlots freshly arrived from London." 56

When, a little later, Huysmans published his art criticism written between 1879 and 1882 under the title *L'Art Moderne*, Pissarro took the liberty of telling him that he underestimated Monet's talent and of asking point blank: "Why is it that you do not say a word about Cézanne whom all of us recognize as one of the most astounding and curious temperaments of our time and who has had a very great influence on modern art?" 57

To this reproach Huysmans replied: "Let's see, I find Cézanne's personality congenial, for I know through Zola of his efforts, his vexations, his defeats when he

tries to create a work! Yes, he has temperament, he is an artist, but in sum, with the exception of some still lifes, the rest is—to my mind—not likely to live. It is interesting, curious, suggestive in ideas, but certainly he is an eye case, which I understand he himself realizes.... In my humble opinion the Cézannes typify the impressionists who didn't make the grade. You know that after so many years of struggle it is no longer a question of more or less manifest or visible intentions, but of works which are full of serious results, which are not monsters, odd cases for a Dupuytren museum of painting." [Dupuytren was the founder of a medical museum of anatomy.]⁵⁸

Huysmans also pointed out that Cézanne had not exhibited since 1877 and that he therefore had no place in a collection of exhibition reviews. It was true, of course, that the artist, who was then in his early forties, had shown only twice in Paris: three paintings in 1874 and thirteen paintings plus three watercolors in 1877. As Durand-Ruel probably shared Huysmans'—and Zola's —opinion of Cézanne, for whose work he had not yet manifested any interest, he apparently had not insisted on the painter's participation in the seventh group show. But it may also have been that Cézanne, who had informed Pissarro that he had nothing "ready," did not

CÉZANNE: Still Life, c. 1880. $18\frac{1}{2} \times 22\frac{1}{8}$ ". Formerly in the collection of Paul Gauguin (see also p. 561). Private collection, Paris.

CÉZANNE: Self Portrait with Black Hat, c. 1880. 24 × 20". Kunstmuseum, Bern.

Renoir: Paul Cézanne, d. 1880. Pastel, $21\frac{3}{4} \times 17\frac{1}{4}$ ". Formerly owned by Victor Chocquet. British Rail Pension Fund.

wish to join the others in the eternal hope of being admitted to the Salon. And this satisfaction he was to obtain, for the first time in his life, precisely in 1882. After his works had been once more rejected, Antoine Guillemet made use of a prerogative granted all jury members, that of having admitted without discussion the work of one of their students. Consequently Cézanne's name was accompanied in the catalogue by the mention: "pupil of Guillemet."

Cézanne, who had returned to Paris for the Salon, soon learned from his friend Chocquet that the latter's widowed mother-in-law had died in Normandy; her sole heir, Mme Victor Chocquet, now came into a sizable fortune. But first the Chocquets had to leave for Yvetot and Hattenville where the deceased had owned properties and where the collector apparently invited the painter to visit him. Indeed, during the summer of 1882, Cézanne not only worked once more with Pissarro in Pontoise but also seems to have done several landscapes in Hattenville.

While Cézanne's canvas at the Salon went totally unnoticed, the trend toward brighter colors became ever more obvious. "One thing strikes me at the Salon," Edmond de Goncourt confided to his diary in 1882, "that is the influence of Jongkind. At the present every landscape of any value derives from that painter...." It would have been more correct, however, to trace the new tendencies to Jongkind's

pupil Monet and his comrades. Henri Houssaye saw this and wrote that same year: "Impressionism receives every form of sarcasm when it takes the names Manet, Monet, Renoir, Caillebotte, Degas—every honor when it is called Bastien-Lepage, Duez, Gervex, Bompard, Danton, Goeneutte, Butin, Mangeant, Jean Béraud, or Dagnan-Bouveret." But an American historian expressed the opinion of the general public and, elaborating on Houssaye's statement, explained: "There is cause for this different estimate. The latter painters have a nicety of finish, a delicacy of treatment wholly unknown to the former, which they carry out under the impressionists' doctrine of light and color." Thus so-called "nicety of finish" caused the imitators to find acceptance, whereas Manet and the others had to struggle for recognition.

At the Salon of 1882 Manet, now hors concours, exhibited a large canvas, Le Bar aux Folies-Bergère, an ambitious composition painted with tremendous virtuosity. Once more he revealed the power of his brush, the subtlety of his observation, and the courage to be unconventional. Like Degas he had remained consistently interested in contemporary subjects—he even planned to paint an engineer on a locomotive—yet he approached these not with the eye of a cold observer but with the brilliant enthusiasm of an explorer on the trail of new aspects of life. As a matter of fact, Degas did not like his last painting, calling it "dull and subtle." Le bar aux Folies-Bergère had cost Manet great efforts, for he began to suffer severely from locomotor ataxia. He was disappointed when the public again refused to understand his work, seeing in it the subject rather than its masterly rendition. In a letter to Albert Wolff he could not keep from saying half jokingly and half in earnest: "I shouldn't mind reading, while I'm still alive, the splendid article which you will write about me once I am dead." 62

After the closing of the Salon, Manet was at last officially nominated *Chevalier de la Légion d'Honneur*. Great as was his satisfaction, it was tinged with some bitterness. When the critic Chesneau congratulated him and also conveyed the best wishes of Count Nieuwerkerke, Manet bluntly replied: "When you write to Nieuwerkerke, you may tell him that I appreciate his kind thought, but that he might have conferred the decoration. He could have made my fortune; and now it is too late to compensate for twenty years' lack of success. . . . "63

Manet spent another summer close to Paris, at Rueil, too ill to engage in any absorbing work. He did pastels and watercolors, wrote charming letters to many of his elegant lady friends, begged them to visit him, to come and sit for portraits. When he returned to Paris in the fall, his friends began to be alarmed about his condition. The winter brought no improvement. Early in 1883 his strength visibly abandoned him and he soon had to stay in bed. As a result of paralysis, gangrene threatened his left leg; two surgeons advised amputation. Dr. Gachet, a convinced homeopath, was opposed to the intervention and argued that Manet would never be able to endure life on crutches. In April he was operated upon, but the amputation failed to save him. On his sickbed he was haunted by the thought of Cabanel and his perpetual hostility. "That man has good health," he groaned. These were among his last words. Manet died on April 30, 1883.64 "He was greater than we thought," Degas mournfully admitted.

The sad news reached Monet at Giverny, where he was just moving from Poissy. He left everything and hurried to Paris. The funeral took place on May 3. The

Manet: The Bar at the Folies-Bergère, d. 1882 (but painted in 1881). $37_4^3 \times 50''$. Exhibited at the Salon of 1882. The Home House Trustees, London (Courtauld Collection).

pall-bearers were Antonin Proust, Claude Monet, Fantin-Latour, Alfred Stevens, Emile Zola, Théodore Duret, and Philippe Burty. Proust spoke a few words full of emotion. Among those who attended were Pissarro, Cézanne, and doubtless also Berthe Morisot, who lost more than a brother-in-law. Eva Gonzalès was unable to come; she had just given birth to a child and learned of Manet's death while still in bed. Grief-stricken, she insisted on making a funeral wreath for her master. A few days later, on May 5, she died within a few seconds of an embolism.

Albert Wolff's obituary article would not have satisfied Manet; it was extremely reticent. Indeed, Wolff said that Manet had painted altogether two canvases likely to go one day to the Louvre and concluded: "To die at fifty and to leave behind two excellent works which deserve to be admitted among the manifestations of

French art, that is sufficient glory for an artist." Soon, however, a noticeable change could be observed in the general attitude toward the painter. The prices of his pictures began to rise and less than one year after his death a large memorial show was prepared (with the active assistance of Berthe Morisot and her husband) to be held—of all places—at the *Ecole des Beaux-Arts*. The officials were now eager to seize their share of Manet's mounting fame. Pissarro witnessed this evolution with sadness and disgust. 66

Fénéon, who had conceived a passion for new art and begun to combine his drab occupation at the War Ministry with first attempts as a reviewer of exhibitions (though he still somewhat lacked discrimination), published what was possibly the most pertinent comment on the Manet retrospective: "If I had to give any advice to the public which today, in front of the master's works, opens wide and blissfully its bovine eyes, I should incite it to check a little its tardy admiration and to endeavor conscientiously to understand the paintings of those artists who drew inspiration from Manet without copying him, who—in the sincere expression of modern life—sometimes surpassed their initiator; I refer to the gallant clan of impressionists, to Camille Pissarro, Raffaëlli, Renoir, Mary Cassatt, Claude Monet, J.-L. Forain, Degas, de Nittis, Berthe Morisot, and Sisley."67

The retrospective, whose catalogue featured an introduction by Zola, was followed by an auction sale of the contents of Manet's studio. "The Manet exhibition went well," Renoir reported to Monet. "There were always enough people so that one didn't get the horrible impression of two visitors lost in a large hall.... It provided Wolff with an opportunity to pose himself as the champion of the feeble and the revolutionary."68 As for the sale, which took place on February 4 and 5, 1884, it yielded results which Renoir considered beyond all expectations. The total reached 116,637 francs, but the artist's family bought back a good many works.⁶⁹ Among the buyers were few dealers, except for Durand-Ruel; of collectors there was the usual group composed of de Bellio, Duret, Faure, Hecht, etc., with a few artists such as Guérard, Degas, Sargent, and the composer Chabrier. 70 Caillebotte, whose collection contained few pictures by Manet since he bought mostly in order to help his friends when in need, purchased The Balcony (p. 221) for 3000 francs, and Victor Chocquet, his wife's inheritance apparently settled, was able to acquire the canvas of Monet painting in his boat (p. 346) for 1150 francs. Albert Wolff availed himself of the occasion to write yet another article on Manet, calling the auction "one of the most charming follies of our times" and declaring that "relatively insane" prices had been paid for "the most insignificant things." With his customary perfidy the critic exclaimed: "Heaven knows how I loved Edouard Manet, and if this sale can assure the future of his widow, it will make me deeply happy. But now that the maneuver is accomplished, I beg permission to put things back into their place. . . . " Whereupon Wolff explained that the affair had been manipulated by Durand-Ruel, who had acted as expert at the auction. "It seemed to me that his visible smile of satisfaction was the greater the more the object which he placed under the hammer was untidy."71

There appeared a dreadful cynicism in Manet's posthumous fate, made even more unbearable by the fact that the impressionists—due to the financial reverses suffered by Durand-Ruel—again had to struggle with misery.

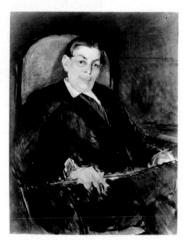

Manet: Portrait of Albert Wolff (unfinished), 1877. $34\frac{1}{2} \times 28$ ". Formerly collection Justin K. Thannhauser, New York.

NOTES

- 1 For a condensed catalogue of the exhibition see L. Venturi: Les Archives de l'Impressionnisme, Paris-New York, 1939, v. II, p. 264-265. For the first time Cals, who died later that year, did not participate.
- 2 Degas to Bracquemond, March 1880; see Lettres de Degas, Paris, 1931, p. 31-32.
- 3 On Duranty's death see J. Claretie: La vie à Paris—1880, Paris, n.d. [1881], p. 77-88.
- 4 See Ch. Gray: Sculpture and Ceramics of Paul Gauguin, Baltimore, 1963, No. 1.
- 5 See G. Besson: Paul Signac, Paris, 1950, p. 1 (the date of the exhibition is given as 1879 instead of 1880).
- 6 A. Wolff in Le Figaro, April 9, 1880.
- 7 See J. K. Huysmans: L'exposition des indépendants en 1880; reprinted in Huysmans: L'Art Moderne, Paris, 1883, p. 99–139. See also H. Amer: Huysmans et la peinture, Cahiers de la Tour Saint-Jacques, III, 1963.
- 8 O. Redon: Réflexions sur une exposition des impressionnistes, April 10, 1880; in Redon: A soi-même, Paris, 1922, p. 154-156.
- 9 See P. Gachet: Deux amis des impressionnistes—le Docteur Gachet et Murer, Paris, 1956, p. 165-167, where Renoir's project, originally published in *La Chronique des Tribunaux*, May 23, 1880, is reprinted.
- 10 On this subject see J. Rewald: Post-Impressionism— From van Gogh to Gauguin, New York, 1956, ch. III.
- 11 Cézanne to Zola, May 10, 1880; see: Cézanne, Letters, London, 1941, p. 145-146.
- 12 Zola: Le naturalisme au Salon (4 articles), Le Voltaire, June 18-22, 1880; reprinted in E. Zola: Salons, Geneva-Paris, 1959, p. 233-254.
- 13 Manet to Duret, June 1880 (Cabinet des Dessins, Musée du Louvre); see Rewald: Paul Cézanne, New York, 1948, p. 125; on Cézanne's reaction see *ibid.*, p. 125. See also J. Lethève: Impressionnistes et Symbolistes devant la presse, Paris, 1959, p. 113-116.
- 14 Not a single painting was sold at this exhibition, but after it closed Mme Charpentier offered 1,500 francs for Floating Ice on the Seine, doubtless the very one turned down by the Salon jury. Although the artist had priced the painting at 2,000 francs, he accepted the offer, a quite generous one at the time. See M. Robida: Le Salon Charpentier et les impressionnistes, Paris, 1958, p. 82.
- 15 See E. Taboureux: Claude Monet, La Vie Moderne, June 12, 1880.
- 16 Caillebotte to Pissarro, Jan. 24, 1881; unpublished document found among Pissarro's papers.

- 17 See Pissarro's letter to Mirbeau, Oct. 11, 1891; Cabinet des Dessins, Musée du Louvre, Paris.
- 18 Caillebotte to Pissarro, Jan. 1881; unpublished document found among Pissarro's papers.
- 19 For a condensed catalogue see Venturi: Archives, op. cit., v. II, p. 265-267. The exhibition also featured several works by Cals, who had just died,; these are not listed in the catalogue.
- 20 See Rewald: Degas—Works in Sculpture, New York, 1944, 1957.
- 21 The two sculptures exhibited are reproduced in Gray, op. cit., Nos. 3 and 4; the box, ibid., is No. 8, and the relief No. 7. According to Pissarro's son, the late Ludovic Rodo, his father also owned in Osny [1883] a bust of Mme Gauguin.
- 22 For reviews concerning particularly Degas see P.-A. Lemoisne: Degas et son oeuvre, Paris, 1946, v. I, p. 245-246, notes 130-131.
- 23 J. Claretie, article published in *Le Temps*, reprinted in Claretie: La vie à Paris, 1881, Paris, 1882, p. 149-150.
- 24 A. Wolff in Le Figaro, March 2, 1881.
- 25 Huysmans: L'exposition des Indépendants en 1881; reprinted in L'Art Moderne, op. cit., p. 249-282.
- 26 See A. Tabarant: Manet et ses oeuvres, Paris, 1947, p. 406-408.
- 27 Pissarro to Duret, Feb. 24, 1882; see A. Tabarant: Pissarro, Paris, 1924, p. 46.
- 28 Renoir to Duret, Easter 1881; see M. Florisoone: Renoir et la famille Charpentier, L'Amour de l'Art, Feb. 1938.
- 29 J. Renoir in his book on his father: Renoir, Paris, 1962, p. 204, has given a different identification of the sitters.
- 30 Pissarro to his son, Sept. 18, 1893; see Camille Pissarro, Letters to His Son Lucien, New York, 1943, p. 216.
- 31 From the unpublished private notes of the painter Louis Le Bail, who received Pissarro's advice during the years 1896-97. At about the same time Louis Le Bail also met Monet, who told him: "One ought to be daring in the face of nature and never be afraid of painting badly nor of doing over the work with which one is not satisfied, even if it means ruining it. If you don't dare while you are young, what are you going to do later?"
- 32 Gauguin to Pissarro, summer 1881; partly unpublished document, found among Pissarro's papers.
- 33 Manet to Astruc, summer 1880; see E. Moreau-Nélaton: Manet raconté par lui-même, Paris, 1926, v. II, p. 68.
- 34 See Pissarro's letter to his son, Dec. 28, 1883; op. cit., p. 51.

- 35 Renoir to Manet, Dec. 28, 1881; see Moreau-Nélaton, op. cit., v. II, p. 88.
- 36 On the subject of this portrait see W. Schuh: Renoir und Wagner, Erlenbach-Zürich-Stuttgart, 1959.
- 37 See A. Vollard: Renoir, ch. XI and Renoir's letter published in *L'Amateur d'Autographes*, 1913, p. 231-233.
- 38 Renoir to Durand-Ruel, Nov. 21, 1881; see Venturi: Archives, op. cit., v. I, p. 116-117.
- 39 See M. Schneider: Lettres de Renoir sur l'Italie, L'Age d'or, No 1, 1945. See also B. E. White: Renoir's Trip to Italy, Art Bulletin, Dec. 1969.
- 40 Renoir to Mme Charpentier [beginning 1882]; see Florisoone, op. cit.
- 41 Caillebotte to Pissarro [winter 1881-82]; unpublished document found among Pissarro's papers.
- 42 Gauguin to Pissarro, Dec. 14, 1881; unpublished document found among Pissarro's papers.
- 43 Gauguin to Pissarro, Jan. 18, 1882; unpublished document found among Pissarro's papers.
- 44 Manet to Berthe Morisot [beginning 1882]; see M. Angoulvent: Berthe Morisot, Paris, 1933, p. 62.
- 45 For Renoir's letters to Durand-Ruel, concerning this exhibition, see Venturi: Archives, op. cit., v. I, p. 119-122.
- 46 For Monet's letters to Durand-Ruel, concerning this exhibition, see *ibid.*, p. 227-230.
- 47 Pissarro to Monet [end of Feb. 1882]; see J. Joëts: Lettres inédites de Pissarro à Claude Monet, L'Amour de l'Art, III, 1946.
- 48 Renoir to Durand-Ruel [end of Feb. 1882], not included in Venturi: Archives: see Catalogue d'Autographes No. 61, Marc Loliée, Paris, 1936, p. 35.
- 49 Eugène Manet to Berthe Morisot [spring 1882]; see D. Rouart: Correspondence de Berthe Morisot, Paris, 1950, p. 106.
- 50 Eugène Manet to Berthe Morisot, March 1, 1882; ibid., p. 103.
- 51 Pissarro to de Bellio, April 3, 1882; see R. Niculescu: Georges de Bellio, l'ami des impressionnistes, *Revue roumaine d'histoire de l'art*, v. 1, no. 2, 1964.
- 52 For a condensed catalogue of the exhibition see Venturi: Archives, op. cit., v. II, p. 267-269.
- 53 Claretie, article in *Le Temps*, reprinted in Claretie: La vie à Paris, 1882, Paris, 1883.

- 54 Eugène Manet to Berthe Morisot [March 1882]; see Rouart, op. cit., p. 110.
- 55 Eugène Manet to Berthe Morisot [March 1882]; ibid., p. 104.
- 56 Huysmans, article on the exhibition of 1882, reprinted in L'Art Moderne, Paris, 1883, appendix, p. 285-301.
- 57 Pissarro to Huysmans, quoted from a draft dated May 15, 1883; see Rewald: Paul Cézanne, New York, 1948, p. 129.
- 58 Huysmans to Pissarro [end of May 1883]; *ibid.*, p. 129 [here newly translated].
- 59 On this subject see J. Rewald: Chocquet and Cézanne, Gazette des Beaux-Arts, July-Aug. 1969.
- 60 H. Houssaye, article of 1882 quoted in C. H. Stranahan: A History of French Painting, New York, 1888, p. 463.
- 61 C. H. Stranahan, ibid., p. 463.
- 62 Manet to A. Wolff, May 1882; see Wolff's article in Le Figaro, May 1, 1883.
- 63 Manet to Chesneau [summer 1882]; see Moreau-Nélaton, op. cit., v. II, p. 90.
- 64 On the circumstances of Manet's death see A. Tabarant: Manet se sut-il amputé? Bulletin de la vie artistique, March 1, 1921; also the same author's: Manet et ses oeuvres, op. cit., p. 472-475.
- 65 A. Wolff in Le Figaro, quoted by Tabarant, ibid., p. 476.
- 66 See Pissarro's letter to his son Lucien, Dec. 28, 1883; op. cit., p. 73.
- 67 F. Fénéon: A l'exposition d'Edouard Manet, La Libre Revue, April 1884; reprinted in Fénéon: Oeuvres, Paris, 1948, p. 105.
- 68 See Renoir's letters to Monet [end of Jan. and beginning of Feb. 1884]; J. Baudot: Renoir et ses amis, ses modèles, Paris, 1949, p. 58-59. On the Manet retrospective see Tabarant: Manet et ses oeuvres, op. cit., p. 490-497.
- 69 On the Manet sale see Tabarant, ibid., p. 498-502, but especially M. Bodelsen: Early Impressionist Sales 1874-94 in the Light of Some Unpublished 'procès-verbaux,' Burlington Magazine, June 1968.
- 70 On this subject see R. Delage: Chabrier et ses amis impressionnistes, L'Oeil, Dec. 1963.
- 71 Wolff, article in *Le Figaro*, Feb. 7, 1884; quoted by Baudot, op. cit., p. 60-64.

XIII 1883-1885

DISSATISFACTION AND DOUBTS

GAUGUIN IN COPENHAGEN

REDON

SEURAT AND SIGNAC

THE SOCIÉTÉ DES INDÉPENDANTS (1884)

The crash of 1882 and the new blow suffered by Durand-Ruel slowly revealed repercussions: the dealer no longer was able to pay his painters regularly nor could he take all their work. But he did his best to hold out against odds. His position was rendered even more difficult by the increasing activity of his sole great rival, Georges Petit, who in 1882 had founded with de Nittis L'Exposition Internationale,1 which immediately attracted elegant crowds to his luxurious galleries. Monet and Pissarro, impressed by Petit's sumptuous display, even asked Durand-Ruel whether he might not organize a new group show in his opponent's gallery. But Durand-Ruel, having just established new quarters on the boulevard de la Madeleine, was naturally opposed to this. Apparently unwilling to go through another ordeal of arranging a group exhibition, Durand-Ruel decided instead to put up a series of one-man shows, although Monet was only moderately in favor of this venture. Doubtless remembering the meager results yielded by the various one-man shows organized at La Vie Moderne, Sisley came out strongly against the project. "All precedents prove that collective exhibitions have been more frequently successful and that it has generally been quite different with one-man shows," he wrote to the dealer. And alluding to Durand-Ruel's new and larger galleries he pursued: "I do not believe that at the moment when we cease being nomads and have a definitive establishment in a good location, we should think of starting another type of exhibition or try something different. To me, our interest as well as yours is not so much to display many paintings as to do what it takes to sell those we produce. To obtain this result, a group exhibition with a small number of well-chosen works by each would be more effective and certain to succeed."2

In spite of these objections, Durand-Ruel went ahead with his plan, starting with a Boudin exhibition early in 1883, then opening a show of Monet's works in March

(the painter complained that it had not been properly prepared), of Renoir's in April, Pissarro's in May, and Sisley's in June.³ Degas seems to have come out so-strenuously against a retrospective that he was not included in the series of exhibitions. These did not attract great interest. The fact is that one-man shows were not yet very popular and that the critics devoted much more space to larger exhibitions, such as the Salon, particularly since there were fewer of them (at one time Castagnary had noticed with surprise that within several weeks Parisians were presented with the "unaccustomed spectacle" of six major exhibitions).

At the same time Durand-Ruel renewed his efforts to propagate impressionism abroad. During the summer of 1882 he had organized a small exhibition in London, followed by a larger one in 1883, which lasted from April to July at Dowdeswell's galleries in New Bond Street. It included eleven works by Pissarro, nine by Renoir (among them views of Venice and *Dance at Bougival*), eight by Sisley, seven each by Monet and Degas, three each by Berthe Morisot and Manet (one of these was *Le Chemin de Fer*, p. 327), and two by Mary Cassatt.⁴ Pissarro's eldest son, Lucien, who had just arrived in London to try his luck there, in May reported to his father:

"There is not a single newspaper which doesn't give its opinion on your exhibition. The majority does not like your [the impressionists'] painting and uses the eternal objection: 'It isn't finished.' But aside from this, all publications especially concerned with art are very favorable. I met M. Duret at the exhibition... he is rather satisfied with the London show; people talk about it, come to see, and laugh—that's already something. There were always crowds every time I went. I believe that next year it will be indispensable to have a well organized manifestation, that is, in a large and well decorated hall with the pictures intelligently displayed. I must tell you that one is obliged to view the paintings from too close-by, and you can imagine the fright which your execution causes."

As a matter of fact, only recently Londoners had been treated to a much more elaborate show of etchings by Whistler who, according to Lucien Pissarro, had stolen the idea of uniformly colored wall coverings from the impressionists. The young man described the room as "completely white with lemon yellow borders; the drapes yellow velvet with Whistler's butterfly [insignia] embroidered on the corners. The chairs are yellow with white straw. The floor is covered with a yellowish Indian matting; there are yellow earthen vases with a kind of yellow dandelion. Finally, the ushers are dressed in white and yellow. This arrangement gives the room an air of great joyousness."

Camille Pissarro replied that indeed he and his friends had been the first to experiment with colors, that he had once had a lilac room bordered with canary yellow, "without butterflies." As to Whistler's arrangement, he feared it was too "puffish," adding however: "We little, rejected painters lack the means to carry out our concepts of decoration. As for urging Durand-Ruel to hold an exhibition in premises decorated by us, it would, I think, be wasted breath. You saw how I fought with him for white frames and finally had to abandon them. No! I don't think that Durand-Ruel could be won over."

The London critics, who had not liked Whistler's display, cared even less for the show of the impressionists. The *Morning Post* considered the exhibition meritorious for "having provided the London season with a new sensation, which, besides its

Whistler's "Butterfly" signature.

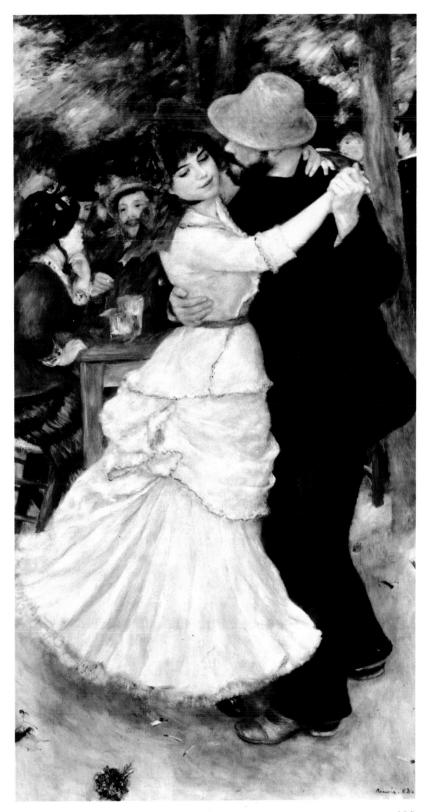

Renoir: Dance at Bougival, d. 1883. (Suzanne Valadon posed for this painting with Renoir's brother.) $70\frac{7}{8} \times 38\frac{1}{2}$ ". Museum of Fine Arts, Boston.

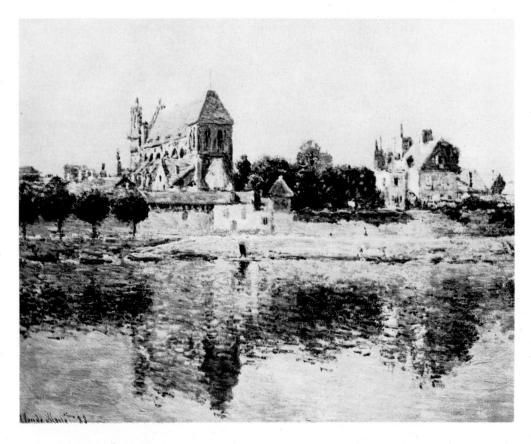

Monet: The Church at Vernon, d. 1883. $25\frac{1}{2} \times 32$ ". Collection Mrs. John Barry Ryan, New York.

novelty, has the pleasant recommendation of being also mirth-provoking...it is something for Londoners to have in their midst a source of comic entertainment, which Parisians heartily enjoy."8

The more seriously inclined critics deplored—like Huysmans—the prevalence of landscapes, preferred the figure paintings by Manet, Renoir, and especially Degas, yet went so far as to admit that Monet's pictures were "full of glowing colour and liquid light." There were even some commentators who judged the show dispassionately and arrived at the conclusion that "when fault-finding is over there remains great reason to welcome the Exhibition as a whole. It sets before us much better than has hitherto been set before us the aims and achievements of a modern school of undoubted importance. The Impressionists are not all that narrow and ill-informed [as] partisan advocacy has represented them to be... With all their deficiencies, they are individual, brilliant, engaging. They are a force to be reckoned with. And one of the greatest causes of their force is that it is the life of their own day that has inspired their art."

While such appraisals counter-balanced utterances like Holman Hunt's who felt called upon to "warn the world that the threat to modern art, meaning nothing less than its extinction, is Impressionism," 10 they did not carry enough weight to

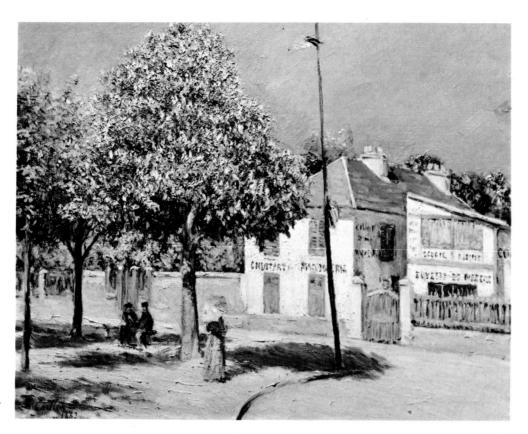

Caillebotte: Street in Argenteuil, d. 1883. 25\(^5_8 \times 32\)\(^4_1''\). Private collection, Paris.

encourage prospective buyers. Sales were nil, possibly also because Durand-Ruel now was asking higher prices; he demanded as much as 2,000 francs for Sisley's paintings. The prices for Berthe Morisot's works varied between 500 and 1,200 francs (Manet had advised her to ask high prices although he himself had continued to sell his own canvases to Faure for comparatively modest sums). As for Renoir, he informed Durand-Ruel that he planned to sell his pictures from Italy very dearly because they had cost him a great deal of effort and money. He promised to be more "reasonable" for the paintings he would do in Paris. In spite of his difficulties the dealer refused to be discouraged and actually planned further exhibitions abroad. But confronted with the financial fiasco, the painters felt gloomy again. Monet was particularly depressed because his works had never before met with so much indifference. A letter which he received from Camille Pissarro could hardly cheer him up:

"As to giving you news of our relations with Durand-Ruel," Pissarro wrote in June 1883, "I can only make guesses. Besides, the trouble we have in seeing any money come in is enough to show that the situation is difficult; we all suffer from it.... I know that sales are at a standstill, in London and in Paris. My show did nothing as far as receipts are concerned.... As for Sisley, it is even worse—nothing, nothing at all. Some of our pictures have been sent to Boston.... There is also

question of an exhibition in Holland. You see Durand-Ruel is really very active and anxious to push us at any cost. . . . I certainly hear other dealers, brokers, and artspeculators saying: 'He will only last another week,' but that kind of talk has been going on for several months. Let's hope it is only a bad crossing. . . . '12

While Durand-Ruel's multiple efforts failed to reap any fruit, the painters once more experienced agonizing uncertainties, had once more to borrow money, if they could find it, to lose days and weeks chasing after possible buyers, to beg friends to purchase on humiliating terms, to rely on the generosity of Caillebotte and a few others, but above all to work without any peace of mind. Moreover, most of them were profoundly dissatisfied with their work.

Pissarro, who had left Pontoise for nearby Osny, where Gauguin joined him, was hesitant. The compliments which he received at his show in May 1883 did not quiet his doubts. "The ones I value most," he wrote his son Lucien, "came from Degas, who said he was happy to see my work becoming more and more pure. The etcher Bracquemond, a pupil of Ingres, said—possibly he meant what he said—that my work shows increasing strength. I will calmly tread the path I have taken, and try to do my best. At bottom, I have only a vague sense of its rightness or wrongness. I am much disturbed by my unpolished and rough execution; I should like to develop a smoother technique, while retaining the old fierceness. . . . "13 Pissarro considered himself sad, tame and lusterless next to the éclat of Renoir.

Renoir, at the same time, was equally assailed by doubts. The study of Raphael and the Pompeian frescoes had left a deep impression and made him wonder whether he had not neglected drawing too much. "Around 1883," he later acknowledged, "a sort of break occurred in my work. I had gone to the end of impressionism and I was reaching the conclusion that I didn't know how either to paint or to draw. In a word, I was at a dead end." He destroyed a number of canvases and set out with determination to acquire the draftsmanship which he thought he lacked. Turning toward line as a means of discipline, he applied himself to simplifying forms at the expense of color. Searching at times for a sober, at times for an elegant line, he tried to imprison breathing forms in strict contours—but did not always completely escape the danger of rigidness and dryness.

For guidance Renoir now turned once more to the works of the masters of the past, to the museum. And he remembered also that Corot had once told him that one can never be sure about what one does out-of-doors, that one must always go over it in the studio. He began to realize that while working in the open he had been too preoccupied with the phenomena of light to devote enough attention to other problems. "While painting directly from nature," he stated, "the artist reaches the point where he looks only for the effects of light, where he no longer composes, and he quickly descends to monotony." So great was his dissatisfaction with what he had achieved hitherto that he was seized by an actual hatred for impressionism. As an antidote he painted several canvases in which every detail—including tree leaves—was first carefully drawn with pen and ink on the canvas before he took his brushes and added color. But at the same time he complained of having lost much time by working in the studio and regretted not having followed Monet's example. In an effort to reconcile these opposite conceptions, he labored for three years on

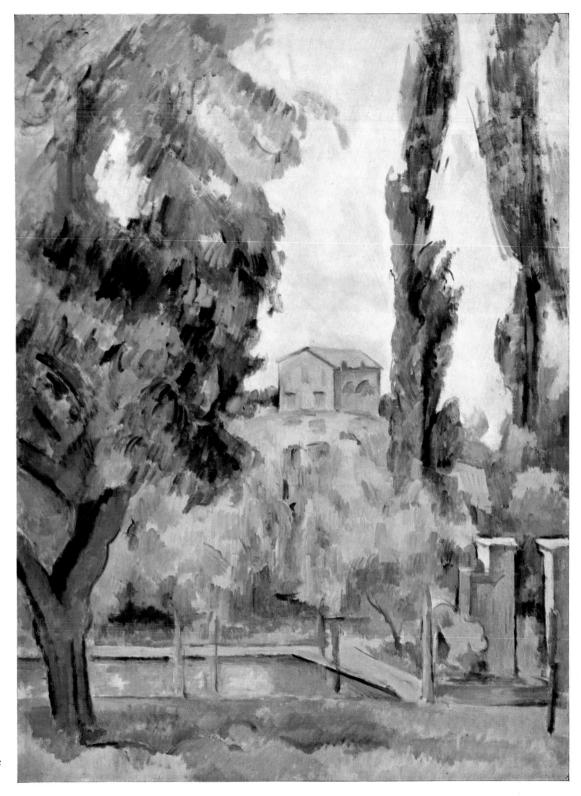

Cézanne: House on a Hill near the Jas de Bouffan, c. 1885. $29\frac{1}{8} \times 21\frac{5}{8}$ ". Private collection, United States.

PISSARRO: Portrait of Gauguin. GAUGUIN: Portrait of Pissarro, c. 1883. Pencil, $12\frac{3}{8} \times 19\frac{3}{8}$ ". Musée du Louvre, Paris.

a large canvas of bathers (p. 546) in which he tried to escape impressionism and to re-establish the link with the eighteenth century; he actually based his composition on a relief by Girardon. He also painted a series of nudes and three large panels of dancers, for which Suzanne Valadon posed, a young model who customarily worked for Puvis de Chavannes. (One of the three paintings, *Dance at Bougival*, had been shipped to the London exhibition as soon as it was ready.)

Like Renoir, Monet was dissatisfied with his work and destroyed several canvases in a sudden fit of discontent, later regretting his action. He began to rework many of his recent canvases in a constant effort to improve them, complaining in a letter to Durand-Ruel: "I have more and more trouble in satisfying myself and have come to a point of wondering whether I am going crazy or whether what I do is neither better nor worse than before, but that the fact is simply that I have more difficulty now in doing what I formerly did with ease."¹⁶

In December 1883 Monet and Renoir left together for a short trip to the Côte d'Azur, in search of new motifs. (There they met Cézanne briefly, probably in Marseilles.) Monet was immediately taken with the beauty of the Mediterranean landscape, with the violence of its blues and pinks. He decided to return there early the following year but was careful to beg Durand-Ruel not to reveal his plans to anybody, explaining frankly: "Nice as it has been to make a pleasure-trip with Renoir, just so would it be upsetting for me to travel with him to work. I have always worked better alone and from my own impressions." The old community of work had ceased to exist. The rift among the painters was no longer merely one of personal antagonism: they began to abandon the common ground, each searching in a different direction.

It seems symbolical that some of the painters now established themselves farther away from Paris and that their contact thus became less frequent. In 1883—discarding Sisley's advice to fix himself at Moret—Monet had moved to Giverny, where he lived with Mme Hoschedé, who was to become his second wife. Giverny, halfway down the Seine to Rouen, offered a great variety of subjects with the river, the countryside and especially the garden of Monet's house. The year before, Sisley had settled on the other side of Paris, at Saint-Mammès near Moret, close to the Loing canal, the Seine, and Fontainebleau forest. In 1884 Pissarro rented a house in Eragny, three times as far from Paris as Pontoise. Cézanne remained for increasingly long intervals in the South, working in Aix, particularly on his father's estate, Le Jas de Bouffan, or in neighboring towns and villages. To keep in touch to some extent, the painters and their friends, such as Duret, Mallarmé, Huysmans,

PISSARRO: Road to Pontoise in Osny, d. 1883. $16\frac{1}{2} \times 13''$. Collection Mr. and Mrs. Jacques Gerard, New York.

Gauguin: Road to Pontoise in Osny, d. 1883. $14\frac{1}{8} \times 10\frac{1}{2}$ ". Present whereabouts unknown.

et al., decided to meet at least once every month in Paris at "impressionist dinners," but these gatherings were seldom complete. Cézanne could not attend, and Pissarro often found himself unable to raise the necessary money.

At these dinners Degas apparently showed himself less entertaining, more morose than before. He went through a period of discouragement and looked upon himself almost as an old man, now that he had reached fifty. Explaining his state of mind, he wrote to a friend: "... One closes, like a door, and not only upon friends. One cuts off everything around one and, when quite alone, extinguishes, in a word, kills oneself, out of disgust. I was so full of projects; here I am blocked, powerless. And furthermore, I've lost the thread. I always thought I had time; what I didn't do, what I was prevented from doing—in the midst of all my difficulties and in spite of the weakness of my eyes—I never gave up hope of starting one fine day. I hoarded all my plans in a cupboard of which I always carried the key with me, and I've lost that key. Lastly, I feel that the state of coma I am in I shan't be able to throw off. I shall keep myself occupied, as those who do nothing say, and that will be all." 18

Degas spent the summer of 1884 with the Valpinçons at Ménil-Hubert, modeling there a large bust of their daughter Hortense, which was destroyed while being cast in plaster.

Renoir continued to lead an unsettled life, traveling much and repeatedly visiting his friends, the Bérards, at Wargemont. It was from La Roche-Guyon near Giverny, where he spent the summer of 1885 (and where Cézanne joined him before visiting Zola at Médan), that Renoir announced to Durand-Ruel his having finally found the style which satisfied him: "I have taken up again, for good, the old painting soft and gracious. . . . It is nothing new, but it is a continuation of the pictures of the eighteenth century." Monet meanwhile—also travelling frequently, looking for new subjects—progressed in an opposite direction, accentuating his colors and modeling forms more vigorously; Sisley tried to renovate his style on similar lines. As for Pissarro, he was still undecided.

Pissarro had spent the fall of 1883 in Rouen where Murer had opened a hotel. Gauguin, after having tried to lease rooms for his wife and children from Dr. Gachet at Auvers,²⁰ eventually decided to go with his family to Rouen also, explaining to Pissarro that the city was full of wealthy people who might well be induced to buy some paintings. The recent crash had forced Gauguin to abandon the bank and he now was able to "paint every day." Since Paris was too expensive for a man with five children (the last one only a few weeks old), who no longer earned his livelihood, the painter moved to Rouen early in 1884. "Gauguin disturbs me very much," Pissarro wrote to his eldest son. "He is so deeply commercial, at least he gives that impression. I haven't the heart to point out to him how false and unpromising his attitude is. True, his needs are great, his family being used to luxury; just the same his attitude can only hurt him. Not that I think we should not try to sell, but I regard it a waste of time to think only of selling; one forgets one's art and exaggerates one's value."21 Moreover, Pissarro was faced with the unpleasant task of explaining to Gauguin that he, Monet, and Renoir had decided not to hold a new exhibition in 1884. Recognizing that Gauguin had still his reputation to make, he knew that this would be a blow.

Gauguin: Country Lane, d. 1884. $28\frac{1}{4} \times 23\frac{1}{2}$ ". Collection Mrs. S. E. Worms, New York.

Monet: Cap Martin, near Menton, d. 1884. 26\(^3_4\) \times 33". Museum of Fine Arts, Boston (Julia Cheney Edwards Collection).

Pissarro had fewer illusions about Rouen than Gauguin. When Murer suggested in 1884 organizing a small exhibition of Pissarro's works at his hotel, where he generally displayed part of his own collection, the artist replied with bitterness: "I don't believe in the possibility of selling pictures at Rouen. You may be certain, my dear friend, that at the sight of my recent studies the collectors will throw rotten apples. Think that in Paris we are still outcasts, beggars. No! it is impossible that an art which disturbs so many old convictions should obtain any approval, and particularly in Rouen, the home of Flaubert, whom they don't dare acknowledge!!"22

But at first Gauguin seems to have been well pleased with Rouen since he found satisfaction in his own work. Pissarro advised him to try to be "less monotonous," and Gauguin replied: "In order to express one's thought, one has to be sure of one's execution; I have not yet found there what I really want. I shall have to apply myself for some more time."²³

Soon, however, Gauguin was to be disappointed by the citizens of Rouen. Unable to sell anything, living on his meager savings, he saw his reserves dwindle rapidly. And his Danish wife, whom Murer described as "charming, very pleasant, not at all pretentious and with rather simple tastes," found herself unhappy and completely uprooted. Her husband harshly reproached her for not getting adjusted to

their new circumstances, but her real problem seems to have been that of getting used to the idea of being married to an unsuccessful artist instead of a well-to-do business man. Pissarro, whose wife was expecting their sixth child, insisted on warning his friend. "Tell Gauguin," he wrote to Murer in August 1884, "that after thirty years of painting . . . I am turning my pockets inside out. Let the younger generation remember!"22

Eventually Mme Gauguin had enough of Rouen and left with three of their children for Denmark, where she planned to earn money by giving French lessons while staying with her family. Her secret hope apparently was that her relatives might help Gauguin with a Scandinavian business career and thus persuade him to abandon art. After selling his life insurance at a heavy loss, the painter remained for a few more months at Rouen, but finally—and reluctantly—went to join his wife in Copenhagen, where he arrived early in December of 1884. He had made a contract with a French manufacturer of awnings but could not find any market for them in Denmark.

Pissarro (a Danish subject by virtue of his birth in the Danish West Indies) and Schuffenecker, Gauguin's erstwhile associate at the bank who had left the stock market to become an art teacher, kept him informed about Paris events. When Pissarro wrote about their periodic dinners, Gauguin replied: "You are right, the impressionist gang, to get together once a month. I hope that you will come to understand that in union lies strength, but that all individuality and privilege must be replaced by a cohesion of ideas. Whatever Degas may say (you know the result to which his separatist ideas have led him), one must have faith in a principle, even if this principle should be modified according to the times. I hope that you won't defer introducing Guillaumin [to the monthly gatherings]; let the others consult their conscience and they will see that a place is owed him among you. Do you have the pretension of remaining three or four impeccables, without leaving room for some younger and less experienced ones, whose convictions can add to the nucleus? One always needs somebody who is smaller than oneself."24 In pleading for Guillaumin, Gauguin indirectly defended his own position in the group, since he had often been treated as a late-comer and secondary member, who had nothing original to contribute.

Gauguin was delighted to learn from Pissarro that Monet had been invited to participate in Petit's Exposition Internationale. "The reception of Monet is indeed an important event," he wrote. "But just the same I fear that this is a personal success and not one for impressionism in general. In spite of this it is a forward tendency that should be greeted with pleasure." Since Degas obviously had not failed to decry Monet's decision to accept, Gauguin pursued: "On the other hand, Degas' conduct becomes more and more absurd which, by the way, is as it should be: people who ambition a reputation for their esprit show in their conduct an absurd stupidity. You may well believe me, Degas has greatly harmed our movement, although I know that—fortunately—art has not suffered from this. You will see that Degas is going to end his days more unhappy than the others, wounded in his vanity for not being the first and only one. A time will come when he won't be asked for anything anymore—and then he will complain about all of humanity."25

Gauguin: Portrait of the Artist's Son Clovis, c. 1882. Pastel, $10\frac{3}{4} \times 10^{"}$. Private collection, New York.

Discussing his recent work and answering some of Pissarro's observations, Gauguin went on: "My Rouen series, of which you speak, is merely a passage, or rather the basis for what I have caught a glimpse of: that is very dull painting... without apparent deviation [from the dullness], but its lustreless aspect doesn't frighten me, as I feel that this is necessary for me. I say necessary because—not having much practice and my art being more one of thought than of acquired technique—I needed a point of departure opposed to that which I hate in the painters who are after effects and artifices.

"I have worked little in Denmark...however, recently the greens have grown and I have attached myself to the plein-air. Without effort or set will to paint lightly and luminously, I have arrived at a result quite different from that of Rouen. I believe that I can say that there is an enormous progress. I feel it, my work is more subtle, brighter, more luminous, although the method did not change: colors closely related, very little distant from each other. In Rouen I did not catch the cold tones

Gauguin: View of Rouen, d. 1884. $36\frac{1}{2} \times 29''$. Private collection, United States.

Gauguin: The "Queen's Mill" in Oestervold Park, Copenhagen, d. 1885. $36\frac{2}{8} \times 28\frac{7}{8}$ ". Ny Carlsberg Glyptotek, Copenhagen.

Gauguin: Still Life, d. 1885. $25\frac{5}{8} \times 22\frac{7}{8}$ ". Formerly collection Arthur Sachs, Cannes.

in the sky, in the greens, and in the grounds. You may be reassured, Danish painting does not terrorize me in comparison to my own; on the contrary, its lack of vigor has inspired me with such a disgust that more than ever I am convinced that there is no such thing as exaggerated art. I even believe that salvation lies only in the extreme; any middle road leads to mediocrity."25

In a letter to Schuffenecker, Gauguin wrote at the same time: "So far I have only incurred some debts and have lived miserably on 1,300 francs from a Manet which I sold. Since I am not very thrifty by nature, you can imagine that I have great worries. In spite of that I am more enraged than ever for the artistic battle. I shall be notorious all over Copenhagen and have for friends many young painters and for enemies the old daubers and other impotents who fear me like the pest and whom I knock with all my might."²⁶

Though Gauguin often reveled in antagonisms, his position in a foreign country whose language he did not speak certainly was not made easier by his uncompromising—not to say haughty—attitude. Moreover, frictions with his in-laws soon made life unbearable for him. An exhibition which he was invited to hold at the "Society of the Friends of Art" met with hostile visitors and complete silence in the press.²⁷ Gauguin later complained that favorable articles had been suppressed and also alleged that no framemaker dared work for him for fear of losing his local customers, that no art dealer would handle his canvases. Gauguin was so unnerved by the unfriendly atmosphere that he even imagined himself persecuted by the Danish Academy, which supposedly ordered his exhibition closed after a few days. Actually it was scheduled to run for but one week early in May 1885, like most shows put up by the Society. Shortly after it was over, Gauguin wrote to Schuffenecker:

"The young people who come after us will be more radical and you'll see that in ten years we will appear to have been extreme only for our own period. Here it is like anywhere else; I meet painters who say that they do not see nature the way we do, but that doesn't keep them from consulting us. The other day I caught one doing a painting for an exhibition with a picture of mine he had borrowed from me and which, it is true, he doesn't understand, he says. Can you imagine: impressionist colors with a drawing of the *Ecole des Beaux-Arts*. I can assure you that I am beside myself every day."²⁶

That the Danes knew little or nothing about impressionism cannot surprise. When, in 1882, the Danish author Georg Brandes (whose brother Edvard, writer and journalist, was in 1887 to marry Mette Gauguin's sister Ingeborg, previously married to the Norwegian painter Fritz Thaulow) saw his first impressionist paintings in Germany, his reaction had not been very different from Strindberg's and he had reported from Berlin:

"A wealthy Russian gentleman, a resident of this city, some months ago purchased in Paris ten or so paintings and some watercolors by French impressionists.... These pictures are the first of their kind to reach Berlin, and since not only the method of painting is quite unknown here but the canvases themselves are in strong contrast to the traditions of the German school of art, the owner of the paintings and his friends have had much amusement in showing them to German artists and observing their reactions....

"Impressionism aims at rendering the fleeting impact which our surroundings

Morisot: In the Dining Room (the artist's maid in her house, rue de Villejuste, Paris), 1884. $24\frac{1}{2} \times 19\frac{3}{4}$ ". National Gallery of Art, Washington, D. C. (Chester Dale Collection).

make upon us. The pictures reproduce objects as they appear when viewed from a distance, not as they would appear under closer scrutiny.... This method leaves out a number of details and above all tries to capture a whole, a mood, declaring a painting 'finished' as soon as this aim apparently has been achieved, regardless of how incomplete it may seem according to ordinary conceptions....

"After the few examples we have seen here of the production of the new school, it seems to me to be more suited to provide a useful element of fermentation than to triumph unconditionally. Painters such as de Nittis [always he!] who, without completely siding with the impressionists, have let themselves be influenced by and have learnt much from them, seem to have a future, but it is hardly likely that pure impressionism as such could ever be a dominant style. For this it is too close to dilettantism. Its main principle throws open the gateway to preciousness and slovenliness; one must fear that the works of its masters will drown in the flood of its amateurs.

"Artistically, the distance between Paris and Berlin is such that not one out of

forty painters here had seen an impressionist painting before. The first reaction was one of astonishment, almost consternation, even on the part of the youngest and most impressionable artists. Some did not know whether to take this seriously; one naively asked the owner whether he had really paid for this mess of paint. However, even those who, at the beginning, had been among the most amazed and dismayed, came back after several days and asked to see the pictures once more. The impression had not left them a moment's peace and they will, I think, in the end include some of the new ideas in their own works."²⁸

According to Brandes, Adolph Menzel, the grand old master of German art, appeared particularly unable to appreciate the impressionists, although his own work was by no means devoid of audacity, sense of color, and freedom of execution. Manet, who supposedly had said of Menzel that he was a "great artist but his paintings are bad," in turn did not overly impress Menzel. Yet Menzel did express some liking for Manet's Folkestone Boat (p. 224) which, in the words of Brandes, "represents a steamboat that has just anchored at a river bank; people swarm in the foreground, in front of the ship, the stern being equally crowded. This throng of people which, seen at close range, only consists of spots and blotches of color, Menzel acknowledged as cleverly done since, when viewed at a distance, it gives the impression of turbulent life. He also endorsed, even with some enthusiasm, the vivid and striking way in which the opposite side of the river and the sky are depicted. The figures in the foreground, however, were—and I think with some justification—repellent and incomprehensive to him." Menzel further declared of "one of the ladies' works [probably Berthe Morisot's] that something might yet come of her, especially if she could discard her crude and repugnant technical mistakes."28 It seems strange that neither Menzel nor Brandes found anything to say about Degas, whose superb draftsmanship could not have escaped them. Degas, in any case, was the only impressionist to admire Menzel.29

Brandes wound up his report by admitting that "several impressionist landscapes are extremely fascinating. One by Monet conveys the whole, blinding effect of the midday sun shining on a lush meadow where a young lady is strolling on a summer day; this effect is rendered with a startling force that I have never seen equalled. Another painting, by Sisley, of a coastline with villas by the sea is so delicately light and shimmering, so harmonious in composition, that one could find no fault with it. Here is no attempt to paint anything which could not at will be made out by the naked eye. The painting achieves its effect by means of its airy lightness and unique harmony." But the author nevertheless concluded: "It seems to be a fad of the impressionists to depict a group of figures which would have a good effect as part of a larger composition, and then to demand that this group be considered as a picture all by itself. In this lies more stubbornness than real strength and ability. One does avoid any form of strict arrangement but winds up with emptiness and haphazard effects." ²⁸

It does not seem impossible that the Russian gentleman who in 1882 introduced impressionism to Germany was actually acting on behalf of Durand-Ruel, in line with the latter's efforts to make his painters known outside of France. In the fall of 1883 he presented an exhibition of impressionists at the Gurlitt galleries in Berlin (shown there as belonging to a German private collector), which caused a sensation

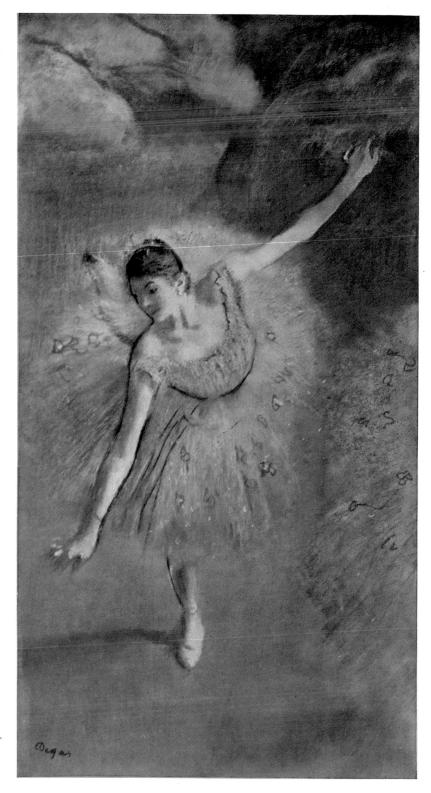

Degas: Blue Dancer, c. 1883. Pastel, 28×15". Metropolitan Museum of Art, New York (Bequest of Joan Whitney Payson).

although it drew severe comments from Menzel. Le Figaro now patriotically felt called upon to defend the French artists, and Albert Wolff, without batting an eyelid, wrote: "These painters, some of whom are masters, are so well established in Paris that there is little point in again evaluating them... No doubt the great Menzel is completely wrong about some of the canvases that were exhibited." 30

Since the impressionists still met with strong opposition abroad and were so little known even to young artists, Gauguin obviously would have had difficulty in provincial Copenhagen in imposing himself as a painter, even if his attitude had been a more conciliatory one. Discouraged though he was and much as he hated the Danes, he managed to paint some twenty canvases and made innumerable drawings, particularly of his children. His wife was earning 60 francs a month (she was translating a novel by Zola), and he was earning nothing.

"I am at this moment at the end of my courage and resources," he wrote in the spring of 1885 to Pissarro. "The misery in a foreign town, without credit or money! Every day I ask myself whether I should not climb into the attic and put a cord around my neck. What prevents me from doing so is painting, yet here precisely lies the stumbling-block. My wife, the family, everybody reproaches me for that confounded art, pretending that it is a disgrace not to earn one's living. But the faculties of a man cannot suffice for two things, and I can only do one thing: paint. Anything else renders me stupid. Paint—I don't even have money to buy colors, therefore I have confined myself to drawing; it's less expensive. . . . And I cannot sell anything, neither drawing nor painting, not even for 10 francs. In a little while I shall send different things to Paris. Please ask Durand-Ruel to take something at any price so that I can buy colors." 25

By summer the situation became untenable. Gauguin resolved to return to France with one of his sons, leaving his wife and the other children in Copenhagen.

During the spring of 1884, while Gauguin was still in Rouen, Paris had been the scene of new turmoil in the art world. Because the Salon jury once more attempted to strangle unorthodox efforts—despite its new, more liberal rules—hundreds of rejected artists had come together and founded a *Groupe des Artistes Indépendants*, consciously or not usurping the name under which, at Degas' request, the impressionists had exhibited for several years. But this new group was not constituted by kindred spirits; to the contrary, it was pledged to admit anybody wishing to join. Its first exhibition, which opened on May 15, 1884, in a barrack in the Tuileries gardens that had been set up as the temporary quarters of a post office, presented a conglomeration of highly dissimilar works. The participants were not all artists rejected by the jury, since many who had not tried to gain admission to the Salon now showed with the new group. Jules Grévy, President of the Republic, after having announced that he would attend the opening, decided to stay away.

Among the exhibitors was Odilon Redon who, after a long period of silent creation outside of any of the general artistic trends, was only slowly emerging from seclusion. He had been past forty when, in 1881, he had held his first and modest one-man show at *La Vie Moderne*, composed of drawings and lithographs. It had met with "a coldness and reserve which will remain an enigma to me," as the artist was to say. Yet Huysmans had hastily added a footnote of seven lines to his Salon review of 1881 to speak of the strange newcomer. When, in 1882, Redon had exhibited

REDON: Left, The monster looked at everything with horror, 1886. $9\frac{7}{8} \times 7\frac{1}{4}$ ". Gift of Mrs. John D. Rockefeller, Jr. Center, Cyclops, 1883. $8\frac{3}{8} \times 7\frac{7}{8}$ ". Gift of Victor S. Riesenfeld. Right, Upon waking I perceived the goddess of the intelligible . . . , 1885. $10\frac{1}{2} \times 8\frac{1}{2}$ ". Mrs. John D. Rockefeller, Jr., Purchase Fund. Three lithographs in the collection of the Museum of Modern Art, New York.

again some twenty charcoal drawings on the premises of another publication, the newspaper *Le Gaulois*, a little-known literary critic and admirer of Huysmans, Emile Hennequin, had gone to visit the artist and had subsequently written a penetrating study of his work. It was the first understanding appraisal of Redon's awesome and mysterious art, equally distant from impressionism and from official art, a circumstance which kept him in isolation. Undeterred by the artist's position as an outsider, Hennequin had marveled at the "majestic, delicate, subtle, perverse, and seraphical" elements in Redon's drawings and lithographs, admiring their "treasures of dreams and suggestions" as well as the "impeccable draftsmanship which forces the eye to accept the most bizarre deformations of real beings..." 33

Huysmans, who unquestionably read Hennequin's article, now also wrote more extensively on Redon, precisely because the "treasures of dreams and suggestions" struck a responsive chord in his own imagination, just as Gustave Moreau's weird and fantastic world had already done. Though he had previously reproached the landscapists of the impressionist group for not sufficiently representing the life of their times, Huysmans now conceived an increasing enthusiasm for Redon, whose inscrutable and haunting creations were even less concerned with actuality; indeed, Redon was bent solely on exploring the fathomless depth of a soul both tormented and serene. It is true that Huysmans' own evolution as a novelist was detaching him at that moment from Zola's "naturalism" and that he was beginning to work on A Rebours [Against the Grain] in the course of which he spoke admiringly of Redon and Moreau. This novel, published in 1884, was to become a decisive factor in the approaching dawn of literary symbolism, already announced more or less imper-

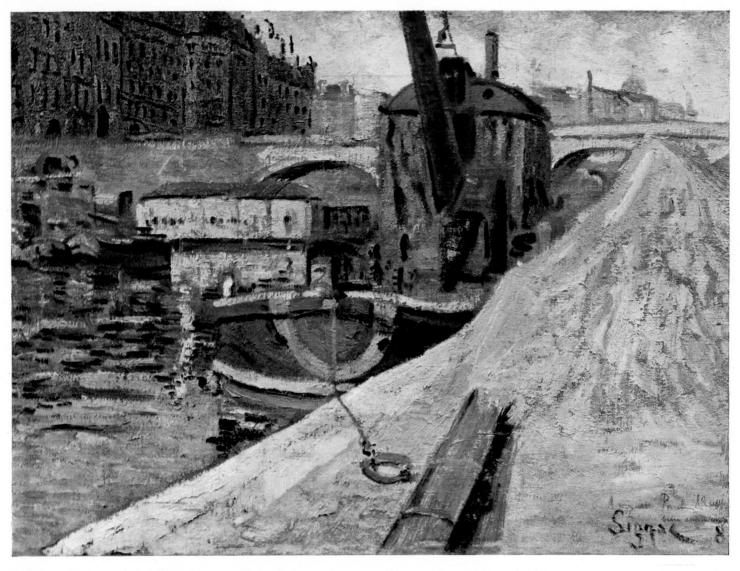

Signac: Le pont Louis-Philippe, Paris, d. 1884. Dedicated to Paul Alexis. 13 × 18". Collection Mr. and Mrs. Ludwig Neugass, New York.

ceptively in Mallarmé's esoteric and still little appreciated writings. Mallarmé himself soon was to discover the art of Redon and be greatly attracted by it.³⁴

Discouraged by the general apathy which met his work, Redon set his hope in the new generation of artists which, he thought, would better understand him. It was thus no wonder that he should have resolved to exhibit at the first show of the new independent group, composed to a great extent of younger men. Among these was the twenty-year-old Paul Signac who had intensively studied the impressionists and who particularly admired Monet, even approaching the latter after his one-man show at *La Vie Moderne* in 1880.

"Frankly, this is my position," Signac had written to Monet. "I have been painting for two years and my only models have been your own works; I have been following the wonderful path you broke for us. I have always worked regularly and conscientiously, but without advice or help, for I do not know any impressionist painter who would be able to guide me, living as I am in an environment more or less hostile to what I am doing. And so I fear I may lose my way and I beg you to let me see you, if only for a short visit. I should be happy to show you five or six studies; perhaps you would tell me what you think of them and give me the counsel I need so badly, for the fact is that I have the most horrible doubts, having always worked by myself, without teacher, encouragement, or criticism." 35

It is not known whether Monet received Signac, for he was little prone to giving advice and usually told those who came to consult him: "I advise you to paint the best way you can, as much as you can, without being afraid to paint bad pictures.... If your painting does not improve of itself... then there is nothing to be done.... I can't do anything about it." 36

Unable to approach his chosen master, Signac eventually struck up a fast friend-ship with Guillaumin, working at his side and following his example more closely than Monet's in a series of vibrant Paris landscapes, brushed with great ardor and a predilection for forceful colors. Some of these he exhibited with the Independents. As to Guillaumin, he was the only member of the impressionist group who chose to participate in the new venture. Not being too closely linked with the others, he felt no compunction about showing with the *Groupe des Artistes Indépendants*.

It was at the first exhibition of this group that Signac noticed a large painting of bathers hung in the canteen, apparently not having been judged worthy of more

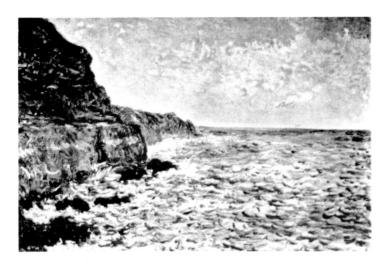

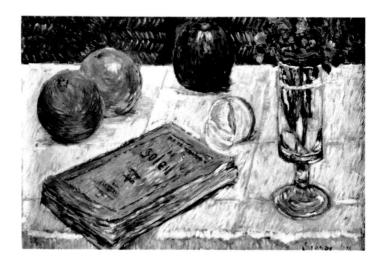

Left, Signac: Coast at Port-en-Bessin, d. 1883. Formerly collection Félix Fénéon. Present whereabouts unknown. Right, Signac: Still Life, d. 1883. 12\frac{1}{4} \times 18\frac{1}{4}". Nationalgalerie, Berlin-Dahlem.

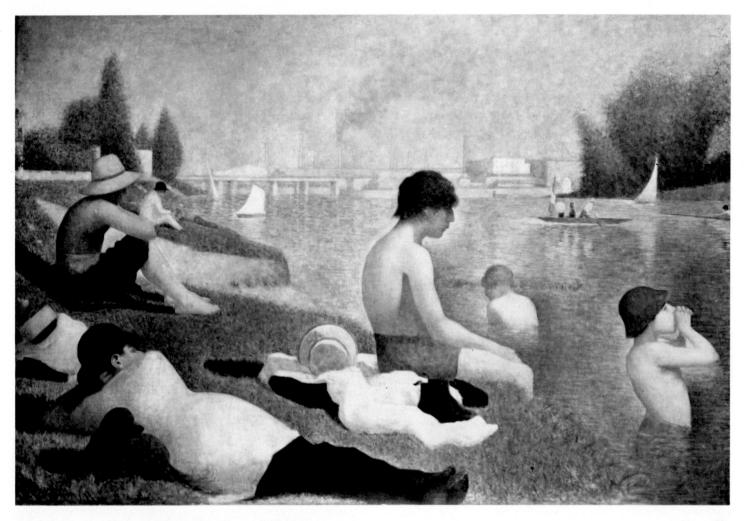

SEURAT: Une Baignade, 1883-84. $79 \times 118\frac{1}{2}$ ". Rejected by the Salon jury; exhibited at the first show of the Independents, 1884, and in New York, 1886. National Gallery, London.

dignified display. He immediately observed that *Une Baignade*, by Georges Seurat, was painted "in great flat strokes, brushed one over the other, fed by a palette composed, like Delacroix's, of pure and earthy colors. By means of these ochres and browns the picture was deadened and appeared less brilliant than the works the impressionists painted with a palette limited to prismatic colors. But the understanding of the laws of contrast, the methodical separation of elements—light, shade, local color, and the interaction of colors—as well as their proper balance and proportion gave this canvas its perfect harmony."³⁷

Though the colors of *Une Baignade*, indeed, were not very lively, Seurat was perfectly familiar with the works of the impressionists, having visited their group show in 1879 and doubtlessly the subsequent exhibitions, as well as the Durand-Ruel

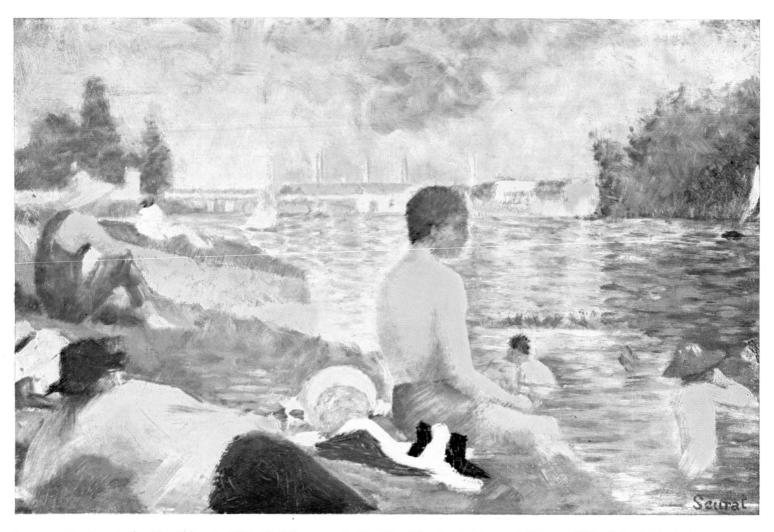

Seurat: Final study for Une Baignade, 1883-84. Oil on wood, $6\frac{1}{4} \times 9\frac{3}{4}$ ". The Art Institute of Chicago (Gift of the Adele R. Levy Fund).

galleries. He later was to insist that as early as 1876 (when he was sixteen years old), he had considered "the purity of the spectral element as the keystone of the technique," adding: "since I have been holding a brush, I have been searching on this basis for a formula of optical painting (1876-1884)."38

In school Seurat had already studied the writings of Charles Blanc. During his years at the *Ecole des Beaux-Arts* he had been infused with a pious devotion to Ingres, yet while he copied Ingres' drawings and absorbed the religion of the classical line, he had also carefully analyzed the paintings of Delacroix, had read with avidity the writings of the Goncourt brothers, and had studied scientific treatises on color harmonies by Chevreul, whose theories had already interested Delacroix. These preoccupations had led him to conceive the idea of reconciling art and science, an

idea inseparable from the general trend of the time to replace intuition by knowledge and to apply the results of incessant research to all fields of activity. Taking advantage of the discoveries of Chevreul and others—notably the American physicist Ogden N. Rood, whose color-wheel Seurat copied—he had limited his palette to the four fundamental colors and their intermediate tones: blue, blue-violet, violet, violet-red, red, red-orange, orange, orange-yellow, yellow, yellow-green, green, green-blue and blue again. These he mixed with white, but to assure the benefits of luminosity, color, and harmony, he did not mix the colors among themselves.

Between 1881 and 1883 Seurat had devoted himself mainly to drawing, achieving in black and white a technique all his own though not unrelated—in the balance of dark masses and light surfaces—to the drawings of Millet and Redon. Having thus systematically reduced the problem of opposition to its simplest expression, he subsequently proceeded to experiment with color. While his first attempts in oils, in his own words, dated from 1876 (the year of the second impressionist group show), it was around 1882 that he began intensively to paint sketches from nature on small wooden panels. Curiously enough, among his favorite haunts were the surroundings of Fontainebleau forest and especially Chailly where the Barbizon painters and the impressionists had preceded him.³⁹ Though not all of the panels he executed there in rapid strokes are bright in color, some distinguish themselves by a purity and luminosity which equals, if it does not surpass, that of the impressionists, who were

Seurat: Two conté crayon studies for *Une Baignade*, 1883-84. Left, $12\frac{5}{8} \times 9\frac{1}{2}$ ". Collection S. A. Morrison, London. Right, $9\frac{1}{2} \times 12\frac{1}{4}$ ". Yale University Art Gallery, New Haven, Conn.

Seurat: *Haystack*, c. 1882: $12\frac{3}{4} \times 18''$. Private collection, Paris.

Seurat: The Gardener, c. 1882. Oil on wood, $6\frac{1}{4} \times 9\frac{3}{4}$ ". Private collection, Paris.

much less concerned than young Seurat with the use of uniformly unadulterated pigments.

In 1883 Seurat had seen his entries to the Salon rejected by the jury, with the exception of a large portrait drawing of his friend Aman-Jean. That same year he began work on his first large composition, *Une Baignade*, more akin in concept and execution to the murals of Puvis de Chavannes than to the paintings of the impressionists. Abandoning the spontaneous expression of sensations hailed by the latter—and which he himself practiced in his small panels—Seurat, in *Une Baignade*, left nothing to chance or improvisation; he found in the observation of optical laws a discipline and a means to new achievements. He made numerous drawings for this composition and also painted a series of small studies for it, executed in the same vibrant tonalities he had used previously. But since he hoped to see the large canvas accepted by the jury, he made certain "concessions" which explain why Signac considered the colors of *Une Baignade* too earthy. In spite of these concessions the painting was not admitted to the Salon, as a result of which the artist decided to show it with the new independent group.

Except for Signac, *Une Baignade* did not attract much attention. Félix Fénéon, however, noticed it. "Though I did not commit myself in writing," he later explained, "I then completely realized the importance of this painting." And Paul Alexis, who still occasionally dabbled in art criticism, wrote with surprising insight: "This is a false Puvis de Chavannes. What funny male and female [sic] bathers! But it is painted with so much conviction that it appears almost touching and I don't quite dare poke fun at it." ⁴¹

Signac and Seurat met at the numerous meetings before and during the exhibition at which the members of the group thrashed out their differences (by comparison the antagonisms of the impressionists seemed like child's play). Indeed, the self-appointed administrators of the organization proceeded with the utmost fantasy and unconcern for rules; Fénéon later called them "jolly good fellows escaped from some vaudeville show."⁴² It was impossible to obtain a financial report, although the funds constituted by entrance fees and dues were considerable. Dues were eleven francs, but for undisclosed reasons receipts were delivered for ten francs only. Irate members soon discovered that the ledger, jotted on the margins of a newspaper, featured such expenses as a fishing rod and a bribe for a concierge. Since all money had been disposed of in such unorthodox fashion, the treasurer simply threatened with a gun those who clamored for an accounting. After the meetings, various members caned each other in the street and fisticuffs in the exhibition halls also were not infrequent. Moreover, the administrators maddened the local police commissioner by demanding one another's arrest.⁴³

Under these circumstances, on June 9, 1884, after the show had been open for little over three weeks, a general meeting of all members, presided over by Redon, convinced that no orderly account could be expected from the administrative committee, voted to remove that committee and agreed to found the Société des Artistes Indépendants, which second organization was duly constituted on June 11 before a notary. "This society," said the preamble, "stands for the suppression of juries and proposes to help artists to freely present their work before the bar of public opinion." Thus, slightly more than twenty years after the first Salon des Refusés, a permanent

SEURAT: Paul Alexis, 1888. Conté crayon. Present whereabouts unknown.

Seurat: Men Building a Fence, c. 1882. Oil on wood, $6 \times 9\frac{7}{8}$ ". Collection the late Mrs. Arthur Lehman, New York.

institution was finally set up to stem the abuses of power committed by the Salon jury and to open its doors to all artists without discrimination.

Meanwhile, at the Salon of 1884, Puvis de Chavannes, after long years of public indifference, obtained his first great success with a huge composition, *The Sacred Wood Dear to the Arts and the Muses*, of which a young painter, Henri de Toulouse-Lautrec, immediately brushed an irreverent parody. At the same Salon Fantin-Latour distinguished himself by a competent though somewhat dry portrait, Whistler made an impression with his likeness of Carlyle, and both de Nittis and Forain were noticed. This Salon moved the Belgian novelist, Camille Lemonnier, to state that "every work of art really strong is more likely to repel through its severity than to seduce by its niceties." Yet he did not know that these comments, at that very moment, applied—more than to anything else—to Seurat's *Baignade*, shown with the Independents.

A close friendship soon developed between Seurat and Signac. They discussed

Monet: Cliffs at Dieppe, d. 1882. $26\frac{1}{8} \times 32\frac{1}{2}$ ". Collection Mrs. Janice Levin Friedman, New York.

interminably all questions of mutual interest and Signac began to investigate the various theories of color with which Seurat was preoccupied. The latter, on Ascension Day, 1884, began working on a new large composition, A Sunday Afternoon on the Island of La Grande Jatte, for which he again made small sketches out-of-doors, painted in an impressionist technique, but which, like Une Baignade, was entirely executed in his studio. Once more he refused to tax his ingenuity by retaining fugitive effects, endeavoring instead to integrate what he observed on the spot into a rigorously planned harmony of lines and colors. Seurat was to maintain later that he had worked simultaneously on the large composition and on the preparatory studies, as if these had been designed to fill in any information required as the need arose, rather than to provide him with random elements from which to choose whatever could be useful for his big canvas. Eliminating non-essentials, insisting on contours and structure, carefully and scientifically observing the interaction of colors, Seurat avoided the sensuous charm so fascinating to the impressionists and sacrificed instantaneous sensations to an almost rigid stylization.⁴⁵

In December 1884, when the new Société des Artistes Indépendants organized its first exhibition (thenceforth its shows were planned to open regularly in the spring), Seurat and Signac, as well as Guillaumin, Redon, and Gauguin's friend Emile Schuffenecker, participated. Seurat contributed a series of small panels, doubtlessly studies for La Grande Jatte, and a landscape representing the site of his large com-

SEURAT: Fishing Fleet at Port-en-Bessin, 1888. $21\frac{1}{2} \times 25\frac{1}{2}$ ". Museum of Modern Art, New York (Lillie P. Bliss Collection.)

position without any figures. This canvas impressed the critic Roger Marx, who had already favorably commented on Seurat's work and who now lauded this painting for its "striking aerial transparency, over which the lively light of a hot summer sun plays freely; all this is done in a sincere and candid style which reveals a depth of conviction that one regrets not finding among certain 'converts to impressionism.' "46

During the winter, while Gauguin endured the hostile atmosphere of Copenhagen, Seurat pursued work on his *Grande Jatte*, which was ready in March 1885, the date set for the next show of the Independents. But lack of funds prevented its being held and Seurat left for Grandcamp on the Atlantic coast, there to paint a series of seascapes. At the same time Signac, in Paris, met Camille Pissarro in Guillaumin's studio and told him about his own and Seurat's research. In October, Guillaumin also introduced Seurat to Pissarro at the Durand-Ruel galleries. In discussions with Signac and Seurat, who belonged to the generation of his son Lucien, Pissarro gained a new outlook and discovered the constructive element for which he had been searching. He found in their theories scientific means to guide his perceptions and replace his instinctive approach to nature by a rigorous observation of the laws of colors and contrasts.

Dissatisfied for some time with what he considered his "rough" execution, Pissarro was particularly receptive to an innovation which Seurat had introduced into his

PISSARRO: Springtime in Eragny, d. 1886. 21¼×26″. Brooks Memorial Art Gallery, Memphis, Tenn. (Gift of Mr. and Mrs. Hugo Dixon).

recent landscapes from the coast. Indeed, Seurat had been experimenting there with small, comma-like strokes, occasionally in the form of dots, applied over a first layer of largely brushed pigments. These tiny particles facilitated the interpenetration of light and shade and their subtle reflections and interactions. Their mixture, accomplished optically (that is, in the eyes of the onlooker placed at a proper distance) conferred upon his work a certain austerity, an atmosphere of quiet and stability. Seurat was so pleased with this discovery that he now completely reworked his *Grande Jatte*, which he had previously considered terminated, covering the original layer of paint with a minute tissue of small dots.

Pissarro likewise decided to replace the "disorder" of impressionist brush strokes by a meticulous execution of carefully posed dots. Early in 1886, upon seeing Pissarro's first canvas in this novel technique (*La Grande Jatte* was not to be ready before the late spring), Signac in turn was won over by it and began work on two landscapes near Clichy in the pointillist manner; these were done in March-April 1886.³⁸ When Durand-Ruel expressed astonishment at Pissarro's radical change of style, the painter explained to him that what he wanted from now on was "to seek a modern synthesis by methods based on science, that is, based on the theory of colors developed by Chevreul, on the experiments of Maxwell and the measurements of O. N. Rood⁴⁷; to substitute optical mixture for the mixture of pigments, which means to decompose tones into their constituent elements, because optical

Seurat: Complete study for La Grande Jatte, 1884-85. 27\(^3_4\) × 41". Metropolitan Museum of Art, New York (Bequest of Sam A. Lewisohn).

Seurat: Conté crayon studies for La Grande Jatte, 1884-85; Lady with Parasol, $12\frac{1}{4} \times 9\frac{1}{2}$ ". Museum of Modern Art, New York (Mrs. John D. Rockefeller, Jr., Bequest); Landscape with Dog, $16\frac{1}{8} \times 24\frac{3}{8}$ ". British Museum, London (César M. de Hauke Bequest).

mixture stirs up luminosities more intense than those created by mixed pigments." And with characteristic modesty Pissarro insisted: "It is M. Seurat, an artist of great merit, who was the first to conceive the idea and to apply the scientific theory after having made thorough studies. I have merely followed his lead...."48

Upon Gauguin's return from Denmark in the summer of 1885, Guillaumin and Schuffenecker must have told him about the new Société des Artistes Indépendants. Gauguin considered showing with this organization the following year, but abandoned the thought, possibly because its jury-free exhibitions were flooded with daubs, so that little prestige was to be gained from participating in its manifestations (Gauguin, indeed, had higher ambitions). During the fall, through Pissarro, Gauguin was doubtlessly also apprised of the latter's evolution and of Seurat's new ideas, yet he decided not to follow his former master in his venture.

Without any funds, having to care for his small son Clovis whom he had brought back with him from Copenhagen and who soon fell seriously ill, Gauguin was in a desperate position. He found himself reduced to accepting a job as a bill-poster in order to earn a few pennies. Fortunately a friend invited him for several months to Dieppe, where he stayed from July to October 1885, complaining that the country-side did not offer any attractive motifs. He also made a short excursion to London and there studied English art. While in Dieppe, Gauguin met Degas and quarreled with him. It may be that, like Pissarro, Degas objected to Gauguin's desire to succeed quickly, for Gauguin later said: "As for Degas, I don't care at all and am not going to spend my life fiddling over one detail with a model for five sittings; the way things are, it's too expensive." 49

Apparently Gauguin had expected Durand-Ruel to take some interest in his work and to make an arrangement with him like the one he had with most of the impressionists, providing him with a small but regular income. But from what Pissarro told him now he was obliged to give up this hope. As a matter of fact, the dealer was constantly on the verge of ruin. He later confessed that he owed more than a million francs in 1884.50 "I wish I were free to go and live in the desert!" he exclaimed, and more than once he had to tell his painters: "I am terribly sorry to leave you without a penny, but I have nothing at all at the present moment. I must even meet misfortune with a smile and have to give the appearance of being almost rich."51 His competitors did all in their power to contribute to Durand-Ruel's downfall. They threatened, for instance, to get hold of all the impressionist pictures they could and to sell them, without frames, at the Hôtel Drouot. This measure was designed to devaluate his enormous stock. While in the end his adversaries did not dare to resort to such extremes, they tried to discredit Durand-Ruel in an affair of fakes. He was able, however, to clear himself and to prove that he was the victim of intrigues.52 It was no wonder that under these conditions Durand-Ruel had often nothing to offer but promises when the painters asked for much-needed help. At one point Renoir spontaneously proposed that Durand-Ruel sacrifice his paintings, if this could bring relief, offering to furnish new and better ones; yet the dealer refused the suggestion, determined in his own interest and in that of the artists to hold their prices.

Miss Cassatt did what she could to ease the critical situation—it seems that she even lent money to Durand-Ruel. Besides, she not only bought paintings for herself and

Gauguin: Beach at Dieppe, d. 1885. $28\frac{1}{8} \times 28\frac{1}{8}$ ". Ny Carlsberg Glyptotek, Copenhagen.

her family (her brother was a high official of the Pennsylvania Railroad system), she also tried to interest her American friends and acquaintances in the work of her colleagues: first the Havemeyers of New York, later the Stillmans and the Whittemores. Pissarro used to leave canvases with her which she would try to show and sell at tea parties, or she would send prospective buyers directly to the studios of the painters. But once, when she advised somebody to visit Degas, the latter said something about her art that deeply embarrassed her, and for several years she stopped seeing him.⁵³

The apparently hopeless circumstances notwithstanding, Durand-Ruel vigorously disapproved of Monet's going over to his most formidable rival when the painter accepted to show at Petit's *Exposition Internationale*. But Monet argued that it would be a good thing for the artists to detach themselves from their dealer. While he admired Durand-Ruel's courage and devotion, he felt that the public lacked confidence because Durand-Ruel—and he alone—handled the works of the impressionists. By establishing contact with other merchants he hoped to convince collectors that impressionism was not merely a whim of Durand-Ruel's. Renoir was soon to follow Monet's example and—like Gauguin—Sisley and Pissarro approved of their friends' reasoning.

Since 1881, Monet had returned each year to the coast, particularly to the

Degas: Portrait of Mary Cassatt, c. 1884. $28\frac{1}{2} \times 22\frac{3}{4}$ ". Collection André Meyer, New York.

Monet: Boats at Etretat, d. 1884. $28\frac{1}{2} \times 36\frac{1}{4}$ ". Collection Mr. and Mrs. John Hay Whitney, New York.

various places where he had worked in his youth with Boudin, Jongkind, and Courbet. Thus he now painted again at Etretat, Le Havre, Fécamp, etc., though not attaching himself to the subjects he had treated before. Overcoming his doubts and self-criticism, he oscillated between works of great subtlety (which doubtless were not alien to Gauguin's attempts at painting "monotonously") and canvases done with tremendous vigor and forceful colors. It was at Etretat that Guy de Maupassant watched him in 1885, later remembering:

"I often followed Claude Monet in his search of impressions. He was no longer a painter, in truth, but a hunter. He proceeded, followed by children [possibly his own and Mme Hoschedé's] who carried his canvases, five or six canvases representing the same subject at different times of day and with different effects. He took them up and put them aside in turn, according to the changes in the sky. Before his subject, the painter lay in wait for the sun and shadows, capturing in a few brush strokes the ray that fell or the cloud that passed.... I have seen him thus seize a glittering shower of light on the white cliff and fix it in a flood of yellow tones which, strangely, rendered the surprising and fugitive effect of that unseizable and dazzling brilliance. On another occasion he took a downpour beating on the sea in his hands and dashed it on the canvas—and indeed it was the rain that he had thus painted...."54

A little later Monet was to begin painting his first pictures of haystacks near his

home in Giverny, in a similar fashion devoting several canvases to the same motif and faithfully observing the changes in aspect and color which his subject underwent between dawn and dusk.

Pissarro was not fortunate enough to be able to concentrate on his work. Unable to live on what Durand-Ruel gave him, he often had to spend weeks in Paris, running from one small dealer to another in a desperate effort to sell some paintings. There was little or no demand for them. Occasionally Portier, formerly connected with Durand-Ruel, would buy a small canvas or a gouache; Beugniet, another dealer, would object to Pissarro's already low prices, and the artist even had to leave pictures on consignment with his framer, Clozet. At the same time a young Dutchman, Theo van Gogh, an employee of the large Boussod & Valadon gallery, tried to interest his superiors in impressionist paintings. Since he could not obtain funds for purchases, he had at first to content himself with pictures that were consigned to him. In 1884 he had been able to sell a landscape by Pissarro for which the owner wanted 125 francs and for which he found a buyer at 150 francs. The following year, Sisley consigned a winter scene to him for 300 francs, which he sold at 400. He also disposed of one canvas each by Monet and Renoir in 1885.

When, in the fall of 1885, Durand-Ruel received an invitation from the American Art Association to organize a large exhibition in New York, he seized the opportunity with a determination steeled by despair. But the painters manifested little confidence. Why should the Americans show more comprehension and sympathy than their own countrymen? And while their dealer prepared to select three hundred of their best paintings, they began instead to discuss the possibility of a new group exhibition. There had been none since 1882. In December 1885 Pissarro approached Monet. "For some time there has been much talk about a show," he wrote, "it is discussed on every side. I paid a visit to Miss Cassatt.... From the very first we spoke about the show. Can't we come to an understanding about it? All of us, Degas, Caillebotte, Guillaumin, Berthe Morisot, Miss Cassatt and two or three others would make an excellent nucleus for a show. The difficulty is in coming to an agreement. I think that, on principle, we should not arrange it as a show of only ourselves, that is, the Durand-Ruel element among us. The exhibition ought to come from the initiative of the artists and should, above all, prove this by its make-up. What do you think about it?"55

Pissarro evidently had a special reason for insisting that the next show not be formed exclusively by what he called the "Durand-Ruel element." He wished to introduce his new friends, Seurat and Signac, among his old associates, hoping to infuse the already so disparate group with some fresh blood. Since he had joined Seurat, Pissarro began to consider his former comrades romantic impressionists, thus emphasizing the difference in principle which separated them from the new phalanx of scientific impressionists.

NOTES

- 1 The by-laws of the society specified that the members would invite twelve artists each year, three of them to be French.
- 2 Sisley to Durand-Ruel, Nov. 5, 1882; see L. Venturi: Les Archives de l'Impressionnisme, Paris-New York, 1939, v. II, p. 56.
- 3 On these exhibitions see: Mémoires de Paul Durand-Ruel in Venturi, op. cit., v. II, p. 212-213; ibid., letters by Monet, Renoir, and Sisley to Durand-Ruel. Also C. Pissarro: Letters to His Son Lucien, New York, 1943, and G. Geffroy: Claude Monet, sa vie, son oeuvre, Paris, 1924, v. I, ch. XXIV.
- 4 On this exhibition and press comments see D. Cooper: The Courtauld Collection, London, 1954, p. 23-27.
- 5 Lucien Pissarro to his father, London, May 11, 1883; see C. Pissarro: Lettres à son fils Lucien, Paris, 1950, p. 44 (the American edition, op. cit., does not contain Lucien Pissarro's letters to his father).
- 6 Lucien Pissarro to his father, London, Feb. 26, 1883; *ibid.*, p. 31.
- 7 Camille Pissarro to his son Lucien, Feb. 28, 1883; *ibid.*, p. 32-33 (passage not quoted in the American edition).
- 8 Article in the *Morning Post*, London. April 26, 1883; quoted by Cooper, *op. cit.*, p. 23-24.
- 9 Article in *The Standard*, London, April 25, 1883; *ibid.*, p. 26-27.
- 10 Holman Hunt, quoted ibid., p. 27.
- 11 At the "Foreign Exhibition" in Boston, which opened in Sept. 1883, Pissarro was represented by six works, Monet, Renoir, and Sisley each by three, and Manet by two. On this show see H. Huth: Impressionism comes to America, Gazette des Beaux-Arts, April 1946.
- 12 Pissarro to Monet, June 12, 1883; see Geffroy, op. cit., v. II, ch. III.
- 13 Pissarro to his son Lucien, May 4, 1883; see American edition, op. cit., p. 30.
- 14 See A. Vollard: Renoir, ch. III.
- 15 See A. Fontainas: The Encounter of Ingres and Renoir, Formes, March 1931; also T. de Wyzewa: Pierre Auguste Renoir, L'Art dans les deux Mondes, Dec. 6, 1890.
- 16 Monet to Durand-Ruel, Dec. 1, 1883; see Venturi: Archives, op. cit., v. I, p. 264.
- 17 Monet to Durand-Ruel, Jan. 12, 1884; ibid., p. 267-268.
- 18 Degas to Lerolle, Aug. 21, 1884; see Lettres de Degas, Paris, 1945, p. 80.

View of the Dowdeswells Galleries in London.

- 19 Renoir to Durand-Ruel, fall 1885; see Venturi: Archives, op cit., v. I, p. 131.
- 20 See Murer's letter to Dr. Gachet; Lettres impressionnistes au Dr. Gachet et à Murer, Paris, 1957, p. 168 (erroneously dated June 12, 1890 instead of 1883).
- 21 Pissarro to his son Lucien, Oct. 31, 1883; see American edition, op. cit., p. 44.
- 22 Pissarro to Murer, Aug. 8, 1884; see Tabarant: Pissarro, Paris, 1924, p. 48.
- 23 Gauguin to Pissarro, spring 1884; unpublished document found among Pissarro's papers.
- 24 Gauguin to Pissarro, Copenhagen, Jan. 30, 1885; unpublished document found among Pissarro's papers.
- 25 Gauguin to Pissarro, Copenhagen [spring 1885]; unpublished document found among Pissarro's papers.
- 26 Gauguin to Schuffenecker, Copenhagen, May 17, 1885; partly unpublished document, courtesy Dr. Haavard Rostrup, Copenhagen.
- 27 On this exhibition and on Gauguin's sojourn in Copenhagen see H. Rostrup: Gauguin et le Danemark, *Gazette des Beaux-Arts*, Jan.-April 1956 [issued in 1958].
- 28 G. Brandes: Japanesik og impressionistik Kunst, Oct. 30, 1882; published in Brandes: Berlin som tysk Rigshovestad, Copenhagen, 1885, p. 535-539.

The "wealthy Russian gentlemen" mentioned by Brandes may have been Carl Bernstein, a cousin of Renoir's friend Ephrussi, who settled in Berlin before 1885; see M. Liebermann: Gesammelte Schriften, Berlin, 1922, p. 121-131.

- 29 On the attitude of the impressionists toward Menzel see Pissarro's letters, op. cit., American edition, p. 45-46. A large exhibition of Menzel's work was held in Paris in 1885.
- 30 See quotation of Wolff's article, ibid., p. 45, note 2.
- 31 Redon to Hennequin, Aug. 25, 1882; see Auriant: Des lettres inédites d'Odilon Redon, *Beaux-Arts*, June 7 and 14, 1935.
- 32 See Huysmans: L'Art moderne, Paris, 1882, p. 215, note l.
- 33 E. Hennequin: Odilon Redon, La Revue Littéraire et Artistique, March 4, 1882, extensively quoted in A. Mellerio: Odilon Redon, Paris, 1923. On this subject see also J. Rewald: Quelques notes et documents sur Odilon Redon, Gazette des Beaux-Arts, Nov. 1956.
- 34 On Redon's friendship with Hennequin, Huysmans, and Mallarmé see R. Bacou: Odilon Redon, Geneva, 1956, vol. I, ch. VII.
- 35 Signac to Monet, n.d. [1881-82]; see Geffroy, op. cit., v. I, ch. XXVI.
- 36 See Geffroy, *ibid.*, v. II, ch. XXXIII, also v. I, ch. XXXII.
- 37 P. Signac: De Delacroix au Néo-impressionnisme, Paris, 1899, ch. IV.
- 38 See Seurat's letter to Fénéon [June 20, 1890], quoted in H. Dorra and J. Rewald: Seurat—L'oeuvre peint, Paris, 1960, p. XXVII, note 34.
- 39 On Seurat's early work see ibid., as well as R. L. Herbert: Seurat in Chicago and New York, Burlington Magazine, May 1958; W. I. Homer: Seurat's Formative Period—1880-1884, The Connoisseur, Aug.-Sept. 1958; and R. L. Herbert: Seurat's Drawings, New York, 1946.
- 40 Fénéon, letter to the author; see Rewald: Georges Seurat, New York, 1943, p. 76, note 53.
- 41 P. Alexis: A minuit—les Indépendants, Cri du Peuple, May 17, 1884; quoted with other comments in Dorra and Rewald, op. cit., p. 102.
- 42 See Fénéon: L'impressionnisme aux Tuileries, L'Art Moderne, Sept. 19, 1886; reprinted in Fénéon: Oeuvres

- plus que complètes, Geneva-Paris, 1971, p. 53-58.
- 43 See Signac's letter to Coquiot in Coquiot: Seurat, Paris, 1924, p. 140, with the report to the Paris Municipal Council of July 2, 1885, ibid., p. 142-148. On the Indépendants see also Coquiot: Les Indépendants, Paris, 1921; P. Angrand: Naissance des Artistes Indépendants 1884, Paris, 1965; P. Angrand: La Rétrospective des Indépendants, Europe, May-June 1965; and H. Certigny: La vérité sur le douanier Rousseau (Addenda No. 2), Lausanne, 1971.
- 44 See C. Lemonnier: Salon de 1884 in Lemonnier: Les peintres de la vie, Paris, 1888, p. 288-290.
- 45 See J. J. Sweeney: Plastic Redirections in 20th Century Painting, Chicago, 1934, p. 7-10.
- 46 R. Marx: L'exposition des Indépendants, Le Voltaire, Dec. 10, 1884. The painting is in the collection of Mr. and Mrs. John Hay Whitney, New York.
- 47 On Rood's own attitude towards impressionism and neo-impressionism see R. Rood: Professor Rood's Theories on Colour and Impressionism, *The Script*, April 1906.
- 48 Pissarro to Durand-Ruel, Nov. 6, 1886; see Venturi: Archives, op. cit., v. II, p. 24.
- 49 Gauguin to Schuffenecker [late 1889]; unpublished document found among Schuffenecker's papers.
- 50 See F. F. [Fénéon]: Les grands collectionneurs, M. Paul Durand-Ruel, Bulletin de la vie artistique, April 15, 1920.
- 51 Durand-Ruel to Pissarro, Nov. 1883; see Pissarro, op. cit., American edition, p. 60.
- 52 See Venturi: Archives, op. cit., v. II, p. 249-252.
- 53 See G. Biddle: Some Memories of Mary Cassatt, *The Arts*, Aug. 1926.
- 54 G. de Maupassant: La vie d'un paysagiste, Le Gil Blas, Sept. 28, 1886, reprinted in Maupassant: Oeuvres complètes, Couard, v. II, p. 85-86; quoted by W. C. Seitz: Claude Monet—Seasons and Moments, New York, 1960, p. 20; see also R. Lindon: Etretat et les peintres, Gazette des Beaux-Arts, April 1958.
- 55 Pissarro to Monet, Dec. 7, 1885; see Geffroy, op. cit., v. II, ch. III.

XIV 1886

THE EIGHTH AND LAST IMPRESSIONIST EXHIBITION DURAND-RUEL'S FIRST SUCCESS IN AMERICA GAUGUIN AND VAN GOGH

Berthe Morisot and her husband, Eugène Manet, took it upon themselves, early in 1886, to visit their friends and begin discussing a new group exhibition, after Pissarro had already consulted Miss Cassatt and Monet. The task was particularly complicated, for not only was there the eternal question of Degas and his circle, but this time there was also Pissarro's request that Seurat and Signac be admitted, a request which met with little or no sympathy. Moreover, Degas insisted that the exhibition be held from May 15 to June 15, that is, while the official Salon was open, and this seemed absurd to the others. In February the situation reached a deadlock; both Berthe Morisot and Monet seemed to abandon hope. Guillaumin tried to act as go-between for the different parties. The difficulty for him as well as for Pissarro lay in the fact that if Degas, Miss Cassatt and Berthe Morisot abstained, there was almost no one left to advance the necessary funds and take the risk of a possible loss. When discussions were taken up again, they soon centered around the admission of Seurat's large canvas, *La Grande Jatte*.

Early in March, Pissarro wrote his son Lucien of the troubles he was having with Manet's brother: "... I had a violent run-in with M. Eugène Manet on the subject of Seurat and Signac. The latter was present, as was Guillaumin. You may be sure I rated Manet roundly-which will not please Renoir. But anyhow, this is the point: I explained to M. Manet, who probably didn't understand anything I said, that Seurat has something new to contribute which these gentlemen, despite their talent, are unable to appreciate, that I am personally convinced of the progressive character of his art and certain that in time it will yield extraordinary results. Besides I am not concerned with the appreciation of artists, no matter whom. I do not accept the snobbish judgments of 'romantic impressionists' to whose interest it is to combat new tendencies. I accept the challenge, that's all. But before anything is done they want to stack the cards and ruin the exhibition. M. Manet was beside himself! I didn't calm down. They are all underhanded, but I don't give in. Degas is a hundred times more loyal. I told Degas that Seurat's painting was very interesting. 'I would have noted that myself, Pissarro, except that the thing is so big!' Very well, if Degas sees nothing in it so much the worse for him. This simply means

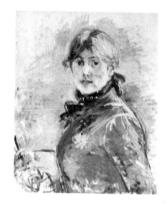

MORISOT: Self Portrait, 1885-86. $24 \times 19\frac{3}{4}$ ". Private collection, Paris.

there is something precious that escapes him. We shall see. M. Manet would have liked to prevent Seurat from showing his figure painting [La Grande Jatte]. I protested against this, telling Manet that in such a case we would make no concessions, that we were willing, if space were lacking, to limit our paintings ourselves, but that we would fight anyone who tried to impose his choice on us. But things will arrange themselves somehow!"

It was finally decided that Pissarro, Seurat, and Signac were to show by themselves in a room which would also contain the first watercolors and woodcuts of Pissarro's son Lucien, who closely followed his father and Seurat.

In spite of the tremendous hardships he had undergone both in Copenhagen and since his return to France, Gauguin was ready for the new exhibition with a series of recent paintings. He now introduced to the others his friend and former colleague at the bank, Emile Schuffenecker, one of the participants in the first show of the Independents, and whose work showed just as little personality as Vignon's did. To Pissarro's dismay, Berthe Morisot and her husband agreed to admit Schuffenecker.

It is not known whether it was the inclusion of Gauguin and Schuffenecker that prompted Monet to abstain from the exhibiton; more likely it was the presence of Seurat and Signac which brought about his decision. Caillebotte took his stand with Monet. After some hesitation Renoir also announced that he would not show with the group; Sisley likewise refused to join the others. Monet decided instead to participate again in Petit's Exposition Internationale where Renoir now followed him. Raffaëlli, too, chose to exhibit at Petit's. He had doubtless become aware of the fact that he was not particularly welcome among most of the members of the group and—in view of his rising success—may even have considered their company somewhat compromising. Two years before, he had already dissociated himself from the impressionists and their principles.² Since Raffaëlli preferred

Far left, La Maison Dorée, boulevard des Italiens.

Left, Le Café Tortoni, boulevard des Italiens.

Vignon: Landscape, d. 1883. $14 \times 17\frac{1}{2}$ ". Ny Carlsberg Glyptotek, Copenhagen.

Schuffenecker, Winter Landscape, d. 1887. $18\frac{1}{8} \times 21\frac{5}{8}$ ". Hirschl & Adler Galleries Inc., New York.

showing at the *Exposition Internationale*, Degas now was willing to drop him, the more so as nobody apparently asked him to do this.

"We are opening on the 15th," Degas wrote early in May to Félix Bracquemond. "Everything is being done at once! You know that we uphold the condition [for participants] not to send anything to the Salon. You do not fulfill this condition, but how about your wife? Monet, Renoir, Caillebotte, and Sisley have not answered the call. Expenses are covered through an arrangement which I have no time to explain. In case entrance fees do not cover these expenses, we'll pass the hat among the exhibitors. The premises are not as large as they should be, but are admirably situated. Indeed, it is the second floor of the Maison Dorée [a famous restaurant] at the corner of the rue Laffitte [and the boulevard des Italiens]. The Jablochkof Company is proposing to install electric light for us."

Among Degas' friends, Mme Bracquemond, Miss Cassatt, Forain, Rouart, Tillot, and Zandomeneghi took part in the show. Introduced by Guillaumin, whom he had obviously known at the constituent meetings of the *Société des Artistes Indépendants*, Odilon Redon joined as a newcomer (he only exhibited drawings which were hung in a hallway). There was also a last minute inclusion, a Countess de Rambure, of whom, as Fénéon put it, "the catalogue does not dare to mention the works." Of previous occasional participants only Vignon showed up.

While the painters were busily preparing their eighth group exhibition, Durand-Ruel was assembling the three hundred canvases which he intended to take to America. Pissarro succeeded in persuading him to accept some pre-pointillist works of Signac and Seurat; the latter entrusted the dealer with his *Baignade* from the first Salon of the Independents. In March 1886 Durand-Ruel left for New York

DEGAS: At the Milliner's, d. 1882. (Mary Cassatt posed for this pastel.) $30 \times 34''$. Exhibited at the eighth impressionist show, 1886. Metropolitan Museum of Art, New York (H. O. Havemeyer Collection).

with a fine selection from his large stock: approximately fifty paintings by Monet, forty-two by Pissarro, thirty-eight by Renoir, seventeen by Manet, twenty-three by Degas, fifteen by Sisley, nine by Berthe Morisot, as well as twenty-three by Boudin, etc.⁵ On the success of this venture depended not only his own future but to a certain extent also that of his artists.

Whereas Durand-Ruel's exhibition in New York was announced as Works in Oil and Pastel by the Impressionists of Paris, the painters themselves banned once more the word "impressionist" from their posters and instead simply called their show Eighth Exhibition; the word "independent" had to be dropped on account of the new association. The show was scheduled to run during the period chosen by Degas, from May 15 to June 15.6

Degas exhibited two pastels of women at the milliner's (Mary Cassatt sometimes posed for him, trying on hats) and a series of seven pastels, entitled: "Series of nudes of women bathing, washing, drying, rubbing down, combing their hair or

Cassatt: Morning Toilet, 1886. $29\frac{1}{2} \times 24\frac{1}{2}$ ". Exhibited at the eighth impressionist show, 1886; formerly owned by Degas. National Gallery of Art, Washington, D.C. (Chester Dale Collection).

DEGAS: After the Bath, c. 1885. Pastel, $29\frac{1}{8} \times 23\frac{7}{8}$ ". Exhibited at the eighth impressionist show, 1886. Metropolitan Museum of Art, New York (H. O. Havemeyer Collection).

having it combed." In these pastels he endeavored to depict nudes from an entirely new point of view. "Hitherto," he explained, "the nude has always been represented in poses which presuppose an audience." Instead of showing the undressed models in attitudes chosen by the artist, and conscious of their nakedness, he preferred to observe them while they were naked in a natural way, "as if you looked through a keyhole." He installed tubs and basins in his studio and watched the models engaged in ablutions and personal care.

Pissarro, Guillaumin, and Gauguin each showed about twenty paintings and

pastels. Those of Pissarro were representative of his new manner; among the works of Gauguin were several done in Rouen, in Normandy, Brittany, and also in Denmark. Berthe Morisot had a dozen paintings and a series of watercolors and drawings. Seurat, too, sent some drawings, a number of landscapes painted at Grandcamp, where he had spent some summer months in 1885, and his large canvas, *La Grande Jatte*, showing in a hieratic and simplified composition a group of Sunday strollers on the lawns and beneath the trees on the island of La Grande Jatte, at Asnières, near Paris, with boats floating by. Among the people walking in the shade there figured a lady holding a little monkey on a leash.

The new show met with considerable advance curiosity aroused by rumors concerning Seurat's large composition. George Moore was told by a friend that there was a huge canvas in three tints: pale yellow for the sunlight, brown for the shadow, and all the rest sky-blue. Besides, there was said to be a lady with a ring-tailed monkey, the tail of which was three yards long. Moore hurried to the opening. Although the painting did not quite correspond to the description, there was indeed the monkey, and there were enough other strange things to justify laughter, "boisterous laughter, exaggerated in the hope of giving as much pain as possible."8

Signac later recalled that on the day of the opening Manet's friend Stevens "continually shuttled back and forth between the Maison Dorée and the neighboring Café Tortoni to recruit those of his cronies who were sipping on the famous terrace, and brought them to look at Seurat's canvas to show how low his friend Degas had fallen in welcoming such horrors. He threw his money on the turnstile and did not even wait for change, in such a hurry was he to bring in his forces."9

The exhibition, in which the impressionist element was represented only by Berthe Morisot, Guillaumin, and Gauguin, aroused many discussions. "Our exhibition has re-opened—and favorably—the whole question of impressionism," Gauguin wrote his wife. "I have had a great success with artists. M. Bracquemond, the engraver, has purchased with enthusiasm a picture for 250 francs and has put me in touch with a ceramist [Chapelet], who plans to do art vases. Enchanted with my sculpture [Gauguin exhibited a monochrome relief in wood of 1882, lent by Pissarro], he wants me to make models for him this winter according to my fancy." ¹⁰

Some visitors were shocked by Degas' nudes and considered them obscene, but Huysmans subsequently praised them in his highly imaginative prose as products of an "attentive cruelty, a patient hatred." He saw in Degas' pastels a kind of "retaliation," the artist's desire "to throw in the face of his century the most excessive outrage, the destruction of the invariably respected idol: woman..." Yet he concluded: "If ever works were chaste, definitely chaste, without dilatory precautions and without artifice, these certainly are! They even glorify the scorn of the flesh as no artist, since the Middle Ages, has dared to express it."

Much as Degas' pastels were discussed, the real center of attraction was the room in which the works of Seurat and his followers were hung, a room too narrow to permit them to be seen to full advantage. Most visitors were amused and some were intrigued by these paintings, but few—with the exception of several artists greatly attracted by the novel technique—recognized their profound originality. When the Belgian poet, Emile Verhaeren, spoke admiringly of them, laughter and ridicule were heaped upon him.

Desboutin: Edgar Degas Reading, c. 1884. Present whereabouts unknown.

Degas: Woman Bathing, 1884. Pastel, $29_8^7 \times 33_8^{7''}$. Collection Mr. and Mrs. Joseph H. Hazen, New York.

What added to the general confusion was the fact that the public and the critics were unable to distinguish between the works of Seurat, Signac, and the two Pissarros. The novelty of pictures produced by different artists working with an identical palette and relying on a common method was too striking to allow the visitors to take note of subtle differences of personal quality. With Seurat's *Grande Jatte* dominating the room, the intensity of Signac, the naive lyricism of Camille Pissarro were ignored, and the critics were able to claim that the new method had completely destroyed the personalities of the painters who employed it. George Moore at first even looked for some hoax and—since the pictures were hung low—had to go down on his knees and examine closely the canvases before he was able to distinguish between the works of Pissarro and Seurat.¹²

The critics, with their disinclination for careful investigation, were quick to greet this new art with their customary witticisms. But even serious and open-minded writers could not hide their disapproval, seeing in these works only "exercises of highly mannered virtuosos." Pissarro's newly won friend, the novelist Octave Mirbeau, went so far as to question Seurat's sincerity. This attitude appears to have been typical of the few admirers whom Pissarro had acquired after thirty years of painting. Nobody was ready to follow him onto the new road which he had chosen. It seemed as if he would have to begin his struggle all over again, surrounded by men young enough to be his sons.

Signac: Gas Tanks at Clichy, d. 1886. $25\frac{1}{2} \times 32''$. Exhibited at the eighth impressionist show, 1886. National Gallery of Victoria, Melbourne.

Pissarro: Apple Pickers, d. 1886. $50\frac{3}{8} \times 50\frac{3}{8}$ ". Private collection, Japan.

On closing day the various participants "disbanded like real cowards," in the words of Seurat. Although Degas had announced that he would come at 6:00 P.M., Pissarro, Guillaumin, and Seurat, urged by Gauguin, did not wait for him but attended instead the opening of Petit's *Exposition Internationale* in nearby rue de Sèze.

When Durand-Ruel returned to Paris, a few days after the exhibition at the Maison Dorée had closed, various rumors immediately circulated in the art world; some said that he had made a fortune in America; others pretended that he had engaged in sharp practice and had been forced to decamp. What Durand-Ruel had to tell was much less spectacular, but it was reassuring: he came home from his trip with the conviction that great things were to be expected from America, and while the immediate results of his exhibition were rather limited, the outlook seemed particularly bright.

The reception given to Durand-Ruel in New York had been much friendlier than he had dared expect, although of course there had been hostile elements. "The coming of the French Impressionists," the *New York Daily Tribune* had announced, "has been preceded by much violent language regarding their paintings. Those who have the most to do with such conservative investments as the works of Bouguereau, Cabanel, Meissonier and Gérôme have imparted the information

SEURAT: A Sunday Afternoon on the Island of La Grande Jatte, 1884-86. $81\frac{4}{4} \times 120\frac{4}{4}$ ". Exhibited at the eighth impressionist show, 1886. Art Institute of Chicago (Helen Birch Bartlett Memorial Collection).

that the paintings of the Impressionists partake of the character of a 'crazy quilt,' being only distinguished by such eccentricities as blue grass, violently green skies and water with the coloring of a rainbow. In short it has been said that the paintings of this school are utterly and absolutely worthless." 14 Yet the general public had refused to follow the arguments of these "connoisseurs," partly because of Mary Cassatt's unceasing attempts to interest her countrymen in impressionist art. She was joined in her endeavors by John Singer Sargent who tried to win admirers particularly for Manet and Monet, as well as by other painters, such as William M. Chase and J. Alden Weir, who had been asked by the New York collector Erwin Davis to buy pictures for him in Paris (Davis was one of the lenders to the show). But more important even was the fact that Durand-Ruel was already known in America as the early defender and dealer of the by then highly popular Barbizon school. This reputation had led the American public to the very realistic conclusion a conclusion which the French had failed to draw—that since he so consistently supported his new friends, their works ought to have some value. Both critics and visitors thus approached his show without prejudice. "Don't think that the Americans are savages," Durand-Ruel wrote to Fantin. "On the contrary, they are less ignorant, less bound by routine than our French collectors."15

Anxious to soften the "shock" which the canvases of Manet, Degas, Renoir, Monet, Sisley, Pissarro, Berthe Morisot, Guillaumin, Signac, Seurat, and Caillebotte were likely to produce, Durand-Ruel had not only included paintings by Boudin, Lépine, and others in his exhibition, but had added to these some more academic works. This precaution, however, proved to be unnecessary, and the *New York Daily Tribune* went so far as to write with regard to the champions of Bouguereau and Cabanel: "We are disposed to blame the gentlemen who purvey pictures for the New York market for leaving the public in ignorance of the artists represented at the exhibition in the American Art Galleries." 14

There were, naturally, some whose comments showed little difference from those in the French papers. The Sun spoke of "the lumpy and obnoxious creations of Renoir, the degenerate and debased pupil of so wholesome, honest and well-inspired a man as Gleyre." Its critic also stated that Degas "draws badly," that Pissarro's landscapes are "fantastic and amusing; sometimes he is serious but without intending apparently to be so," that "there is a great deal of bad painting" in Sisley's canvases and that Seurat's "monstrous picture of The Bathers... is conceived in a coarse, vulgar and commonplace mind, the work of a man seeking distinction by the vulgar qualification and expedient of size." But in general the American reviewers showed an uncommon comprehension and instead of laughing stupidly made an honest effort to understand. From the first they conceded: "It is distinctly felt that the painters have worked with decided intention, that if they have neglected established rules it is because they have outgrown them, and that if they have ignored lesser truths, it has been in order to dwell more strongly on larger." 17

The general tenor of the press comments, reflecting the reaction of the visitors, was that American artists could learn many technical lessons from the pictures and that this exhibition offered, from the early works by Manet to the large canvas by Seurat, a unique opportunity to study the "uncompromising strength of the impressionistic school." While characterizing this school as "communism incarnate, with

the red flag and the Phrygian cap of lawless violence boldly displayed," the critic of Art Age, for instance, readily admitted that there was a great knowledge of art and an even greater knowledge of life in Degas' work, that Renoir could sound a vigorous and virile note and that the landscapes of Monet, Sisley, and Pissarro were full of a heavenly calm and wholly lovely. The Critic even proclaimed: "New York has never seen a more interesting exhibition than this." 17

Two weeks after the opening, which had taken place on April 10, the *Tribune* announced that seven or eight pictures had been sold. So lively was the interest in the show that it was decided to have it run for another month. Owing to other commitments of the American Art Galleries, it was taken late in May to the National Academy of Design; this practically amounted to an official blessing. Before Durand-Ruel finally returned to France, the American Art Association itself bought a number of canvases and arranged for him to come back in the fall with a new exhibition. Durand-Ruel thus had every cause to be confident of the future and to consider his American venture as the long awaited turn of the tide.¹⁹

Except for good reasons to be hopeful, Durand-Ruel did not have much to show his painters when he returned to Paris. His expenses had been heavy, and he was not yet in a position to meet their requests for money. Moreover, his success had unleashed again the jealousy of his opponents. There was some talk of their buying directly from the impressionists and forcing them to break with Durand-Ruel, so as to seize the American market which he had now opened. Meanwhile the dealers in New York, who had taken his failure for granted and were aroused by the unexpected results of his exhibition, were busy in Washington obtaining new customs regulations and thus succeeded in delaying his second show. The difficulties were far from over, but Durand-Ruel remained confident and told his painters not to be discouraged. Yet Pissarro, Monet, and Renoir wondered whether or not he would be able to hold out for a definite financial success. All they gained was the reassuring conviction: "If we are not saved by Durand-Ruel, someone will take us up, since our work is sure to sell in the end." For the moment, however, they were again more or less abandoned to their own devices.

During Durand-Ruel's absence, Monet, without funds from his dealer, had sold several canvases through Georges Petit at very satisfactory prices (he charged dealers up to 1,200 francs for his paintings). He had also participated, together with Renoir, in an exhibition organized by a new association, *Les Vingt*, in Brussels, a group destined to unite the very active vanguard elements in Belgium with those in other countries.²¹ Success had somehow changed Monet's attitude; he now showed himself more exacting in his dealings with Durand-Ruel, sometimes being almost rude in his directness. He reproached the dealer for sending his paintings to America or leaving them as security with his creditors so that he was left with no stock to show to the French public. Pissarro also voiced dissatisfaction with Durand-Ruel's handling of his work and would have liked to conclude a contract with some other dealer if he had only been able to find one sufficiently interested in his art.

Gauguin meanwhile decided, possibly at the suggestion of Guillaumin, to show in the fall of 1886 with Seurat and Signac at the *Salon des Indépendants*, but eventually had a violent discussion with the "little green chemists who pile up tiny dots,"²² as he called them, and abstained. Renoir joined Monet and exhibited with him at

Paul Durand-Ruel, etching (author unknown).

Monet: Self Portrait, 1886. $22 \times 18\frac{1}{2}$ ". Private collection, France.

Petit's Exposition Internationale. Durand-Ruel, who went to see his latest pictures there, did not like them, nor did he like the new divisionist paintings which Pissarro showed him. It must have been particularly confusing for him to see the end of impressionism openly proclaimed in their works and to experience the loss of Monet's friendship at the very moment when the long expected victory seemed so near.

As if to emphasize the final breakup of the group, Félix Fénéon published, in a pamphlet entitled Les Impressionnistes en 1886, a series of exhibition reviews in which he drew up categories and underlined the differences which divided the various painters. Having admired Seurat's Baignade when it was first shown with the Independents, Fénéon had met the artist at the eighth show of the impressionist group and become fast friends with him, although Seurat was rather shy and haughty, secretive and suspicious. But Fénéon's enthusiasm for his Grande Jatte must have broken down Seurat's defenses, the more so as his lot had been ridicule rather than comprehension. Through Seurat, Fénéon also became acquainted with Signac and Pissarro, carefully listening to the explanations of the three painters and studying their theories. One of the promotors of the new literary symbolism which openly erupted that very year in a number of manifestoes, articles, and newly founded periodicals, Fénéon now undertook to further the works and ideas of his new friends in some articles which bear the seal of quaint, symbolist syntax.²³

With a few sentences, Fénéon retraced the history of the movement. "During the heroic period of impressionism," he wrote, "the crowds always saw Edouard Manet in the first line... yet in reality the mutation which transformed the bituminous author of *Le Bon Bock* into a painter of light... was accomplished under the influence of Camille Pissarro, of Degas, of Renoir, and above all of Claude Monet; they were the heads of the revolution of which he became the herald. Renoir and Monet are absent from the rue Laffitte, as are Raffaëlli, Cézanne, Sisley, and Caillebotte. In spite of these gaps the new exhibition is quite explicit: Degas, who repudiates the designation *impressionist*, is there with characteristic works; Mme Morisot as well as Gauguin and Guillaumin represent impressionism as it was shown in previous manifestations; Pissarro, Seurat, and Signac innovate."²⁴

Fénéon greatly appreciated Degas' contribution, was critical of Forain, spoke shortly of Mary Cassatt and Berthe Morisot, regretted that Redon's drawings were poorly selected, and stated that Gauguin's colors were "very little distant one from another, hence that muffled harmony in his pictures," but his real admiration was centered on Seurat, whose Grande Jatte he minutely explained in technical and scientific terms.²⁵ He made no secret of his conviction that impressionism had been supplanted by Seurat's new style. Fénéon demonstrated clearly that whatever joined Seurat and Signac to their predecessors was too indefinite a link for the young painters to be regarded as impressionists, even though they had participated in the eighth exhibition of the group and could pride themselves on Camille Pissarro's support. He therefore found it necessary to invent a new appellation for them and thus coined the word neo-impressionism. As Signac later explained, this name was adopted by the painters not to curry favor (since the impressionists had still not won their own battle), but to pay homage to the efforts of the older generation and also to emphasize that—while procedures varied—the ends were the same: light and color.26

Photograph of Camille Pissarro, c. 1880.

At the time when Camille Pissarro broke with the old group, Emile Zola did the same, although for different motives and in a different way. In 1886 he published a new novel in his Rougon-Macquart series, L'Oeuvre, the hero of which was a painter. It was common knowledge among his readers that this was a roman à clef, and Zola's own notes are evidence that the portrait of his hero was based partly on Manet and partly on Cézanne, the two painters whom he had known most intimately. L'Oeuvre abounds in biographical details, describing the early struggles of the group, the Salon des Refusés, and the first attempts of plein-air painting, yet the hero, symbolizing an impressionist, is characterized as a painful mixture of genius and madness. The struggle between his great dreams and his insufficient creative power ends in utter failure, in suicide. While the public merely saw in this novel Zola's disguised disapproval of impressionism, and while the painters themselves discovered in it the final evidence of Zola's lack of understanding, Cézanne was deeply hurt. Although the general reader identified Zola's hero with Manet rather than with Cézanne, who was still completely unknown, Cézanne himself, reading between the lines, found there a moving echo of his own youth, which had been inseparable from that of Zola, but also the betrayal of his hopes. What he might have sensed already in his conversations with Zola, whom he had visited almost every year in Médan, he now saw irrevocably expressed in this novel: Zola's pity for those who had not achieved success, a pity more unbearable than contempt. Zola not only had failed to grasp the true meaning of the effort to which Cézanne and his comrades had devoted all their strength, he had lost all feeling of solidarity. From the secure castle he had built himself in Médan, he passed judgment upon his friends, embracing all the bourgeois prejudices against which they had once fought together. The letter which Cézanne wrote Zola to thank him for sending a copy of L'Oeuvre was melancholy; it was in fact a letter of farewell, and the two friends were never to meet again.²⁷

Of Zola's painter friends only Monet was outspoken enough to inform him frankly of his reactions, although Guillemet, too, voiced some objections. "You were kind enough to send me L'Oeuvre," Monet wrote. "I am much obliged to you. I have always had great pleasure in reading your books, and this one interested me doubly because it raises questions of art for which we have been fighting for such a long time. I have read it, and I remain troubled, disturbed, I must admit. You took care, intentionally, that not one of your characters should resemble any of us, but in spite of that, I am afraid that the press and the public, our enemies, may use the name of Manet, or at least our names, to prove us to be failures, something which is not in your mind—I refuse to believe it. Excuse me for telling you this. It is not a criticism; I have read L'Oeuvre with very great pleasure, discovering old memories on each page. You know, besides, my fanatical admiration for your talent. It has nothing to do with that, but I have been struggling fairly long and I am afraid that in the moment of succeeding, our enemies may make use of your book to deal us a knockout blow." Like Cézanne, Monet, Pissarro, and Renoir now avoided Zola.

The break of Cézanne's thirty-year-old friendship with Zola came in the very year in which the painter was at last enjoying some peace. In April 1886 he had married Hortense Fiquet in Aix, with the consent of his parents. Six months later Cézanne's father died at the age of eighty-eight, leaving a sizable fortune to his son, which relieved him of worry. But Cézanne did not change his way of life and

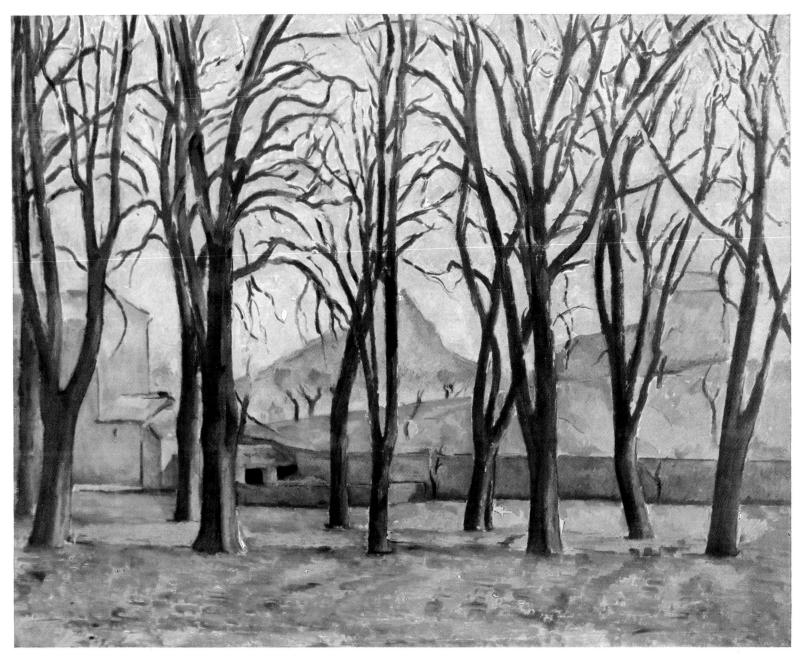

Cézanne: Alley of Chestnut Trees at the Jas de Bouffan, 1885-87. $29\frac{1}{2} \times 37''$. Minneapolis Institute of Arts.

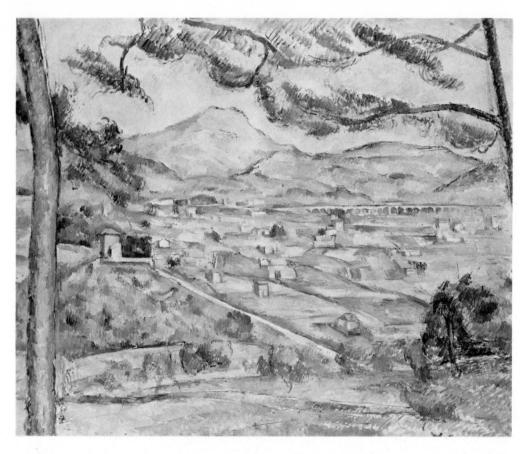

CÉZANNE: View of Mount Sainte-Victoire near Aix, 1885-87. 23½ × 28½". The Phillips Collection, Washington, D.C.

continued in Aix the modest existence he had led before. The world around him seemed to shrink; its center was his father's house, Le Jas de Bouffan, where he lived with his aging mother while his wife and son stayed mainly in Paris. There were few old friends left except Pissarro, Renoir, Chocquet, and père Tanguy, and he did not hear from them often. Besides he did not approve of Pissarro's new conceptions and stated with regret, "if he had continued to paint as he was doing in 1870, he would have been the strongest of us."29 In his self-imposed isolation nothing could divert Cézanne from the sole aim of his life: the work which absorbed all his thoughts and which, as he had once said to Zola, was, "in spite of all alternatives, the only refuge where one finds true contentment in oneself."30

Gauguin, too, finally made up his mind and decided that what he needed was seclusion. Like Cézanne he was going to develop his gifts and progress in loneliness. He spent the year 1886 far from Paris in lower Brittany, but he chose to live at Pont-Aven, a well-known resort of artists. There he took quarters in the Auberge Gloanec, favored by the pupils of Cormon and Julian, two popular studios in Paris. Too self-centered to be truly sociable, he kept away from the gay hordes, not

seeking any company. The young painter Emile Bernard, who, at Schuffenecker's suggestion, paid him a visit, was not too well received but managed to see some of his paintings and noted that "small brushstrokes weave the color and remind me of Pissarro; there is not much style." ³¹

Now almost forty, Gauguin formed a strange contrast with the other boarders at Gloanec's in his appearance as well as in the grimness with which he applied himself to his work, not to speak of this work itself, which seemed revolutionary and brazen to the students from the various academies. A young English painter who saw him there, though he hardly ever spoke to him, later described Gauguin as tall, dark-haired and swarthy of skin, heavy of eyelid and with handsome features, all combined with a powerful figure. He dressed like a Breton fisherman in a blue jersey and wore a beret jauntily on the side of his head. His general appearance, gait and so forth, was rather that of a well-to-do Biscayan skipper of a coastal schooner. In manner he was self-contained and confident, silent and almost dour, though he could unbend and be quite charming when he wished.³²

His strange behavior could not fail to intrigue the others. Eventually he admitted two painters to intimacy: Charles Laval and a young Frenchman who discreetly paid Gauguin's bills. It was through these two that the others, who could not approach him, learned of his ideas, of his frequently expressed admiration for Degas

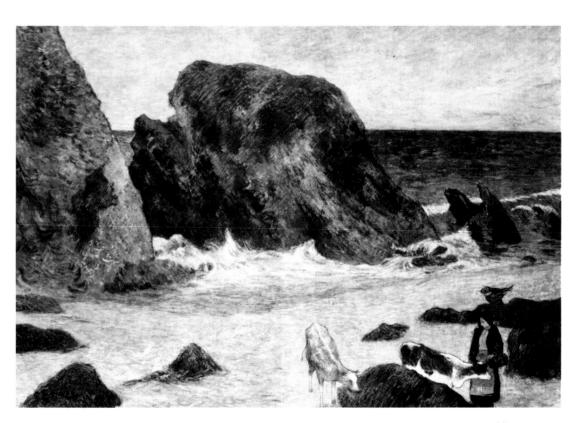

Gauguin: Coast of Brittany, d. 1886. $29\frac{1}{2} \times 39\frac{3}{4}$ ". Private collection, United States.

and Pissarro, of the technical questions which preoccupied him, and of his search for a means to preserve the intensity of colors despite the "muffled" tones he used. "I am making many sketches and you would hardly recognize my painting," he had written at the beginning of his sojourn to his wife.³³ A little later he informed her: "I am working a great deal and with success. I am respected as the strongest painter in Pont-Aven: it is true that this doesn't make me a penny richer. . . . In any case it provides me with a respectable reputation and everybody here (Americans, English, Swedes, French) is anxious to have my advice, which I am stupid enough to give, although in the end one is used without any real gratitude."³⁴

Gauguin no longer worked exclusively out-of-doors as Pissarro had taught him, but endeavored now to match his visual with his visionary experiences. He might say of a painting which he had started in his studio, "I'll finish it outside." A panel of an autumn landscape painted for the dining room of the inn appeared to the others as very extreme in its crude exaggeration. But though they were startled at first, the boldness of his approach left a deep impression on them and created quite a following for Gauguin. With his usual boastfulness he subsequently wrote: "I set the tone here in Pont-Aven—all the artists fear and love me; not one resists my convictions." 35

When they returned to Paris at the end of the summer, the pupils of Cormon communicated their new experiences to their fellow students, who had already grieved their teacher, a member of the Institute, by their lively interest in Seurat's theories. Cormon had even temporarily closed his classes in protest at their revolutionary experiments, in which Emile Bernard had taken a leading part.³⁶ One of his pupils, Vincent van Gogh, eventually decided not to remain at Cormon's but to work on his own.

Vincent—as he called himself and as he signed his canvases—had come to Paris in the spring of 1886 to live with his brother Theo and to acquaint himself with all the new art movements. Then thirty-three, van Gogh had discovered his real vocation only a few years before, after a hectic existence filled with disappointments and failures, in spite or because of the extreme eagerness with which he had approached in turn the professions of art dealer, teacher, preacher, and missionary in a mining district. When he finally decided to become an artist, he set to work with such a burning ardor that he frightened many who approached him. While working at his parents' home in Holland and later at the Academy in Antwerp he felt a growing desire to see the paintings by the impressionists, of whom Theo spoke so often in letters. He also began to be preoccupied with the problems of simultaneous contrast and complementaries, which formed the basis of Seurat's theories and in which he himself had become interested through the study of Delacroix. It soon became obvious that no teacher, but only Paris, could offer the answers to all the theoretical and practical questions which assailed his zealous mind.

At the beginning, Vincent van Gogh did not feel overly attracted by the impressionists. As he later explained to his sister: "One has heard about the impressionists, one expects much and . . . when one sees them for the first time, one is very much disappointed and thinks they are ugly, sloppily and badly painted, badly drawn, of a poor color; everything that is miserable. That was my first impression also, when I came to Paris. . . ."³⁷ This negative impression, obviously conditioned by his

Van Gogh: Windmill on Montmartre, 1887. $21\frac{5}{8} \times 15\frac{1}{8}''$. Collection Mrs. Charles W. Engelhard, Newark.

VAN GOGH: Interior of a Restaurant, Paris, 1887. 18 × 22¼". Rijksmuseum Kröller-Müller, Otterlo.

own background and previous art education, was soon to give place to a sincere admiration.

Theo van Gogh, though shy and retiring, was one of the few who had the intelligence to understand the new tendencies, to distinguish unknown or ill-appreciated talents, and to transmit his knowledge and convictions to those he met. He obviously told his brother all he knew about the impressionists since he already handled the works of Monet, Pissarro, and Sisley whenever he could obtain them and was shortly to take up those of Gauguin, and Toulouse-Lautrec (Vincent had met the latter at the Atelier Cormon). Theo introduced his brother to Pissarro who later said that he had felt very soon that Vincent "would either go mad or leave the impressionists far behind."³⁸

Van Gogh's work had hitherto been very dark, with scarcely any color, and he was at first bewildered by the rich coloring and the light which he discovered in impressionist pictures. But when Pissarro explained to him the theory and technique of his own paintings, van Gogh began to experiment and immediately took to the new ideas with the greatest enthusiasm. He completely changed his palette and his execution, even adopting for a while the neo-impressionist dot, although he used it

without systematically observing the laws of contrast and of complementaries. He went to work in Asnières together with Signac or Emile Bernard (who, for a while, was attracted by pointillism); he paid frequent visits to Guillaumin, living on the Ile St. Louis in the former studio of Daubigny; he studied the masterpieces of the Louvre and particularly the paintings of Delacroix; he saw more or less frequently Toulouse-Lautrec, who had also been for a while under the influence of the impressionists; he had frantic discussions with almost every one of his new acquaintances, trying to absorb as much as he could and to reconcile with his own temperament the continuous flow of new impressions. There can be no doubt that he studied assiduously the paintings at the eighth impressionist exhibition, that he visited the official Salon and later the Salon des Indépendants, held in August-September, where Seurat again showed his Grande Jatte and where there appeared at his side the first converts to neo-impressionism, soon to be followed by many others.

Theo or his painter friends also took Vincent to Durand-Ruel's, to Portier's, to père Martin's, and especially to the little place of père Tanguy, not far from where the two brothers lived. Van Gogh and père Tanguy quickly became fast friends, much to the distress of Mme Tanguy, who saw her husband supply the young man with canvas and paints (he used much of both) in return for unsaleable pictures. Cézanne, who is said to have once met van Gogh at Tanguy's, is supposed to have seen in these pictures only the work of a madman.³⁹ But old Tanguy liked them and from then on divided his admiration equally between Cézanne and van Gogh. The latter painted two portraits of him, sitting against a background decorated with Japanese prints (see p. 557); together with impressionism and neo-impressionism,

Right, Toulouse-Lautrec: Portrait of Emile Bernard, 1885-86. 21½ × 17¾". Tate Gallery, London (Bequest of Arthur Jeffress).

Far right, Bernard: Young Breton Girl, d. 1886. $20\frac{1}{2} \times 18''$. (One of the artist's few "pointillist" works.) Private collection, Paris.

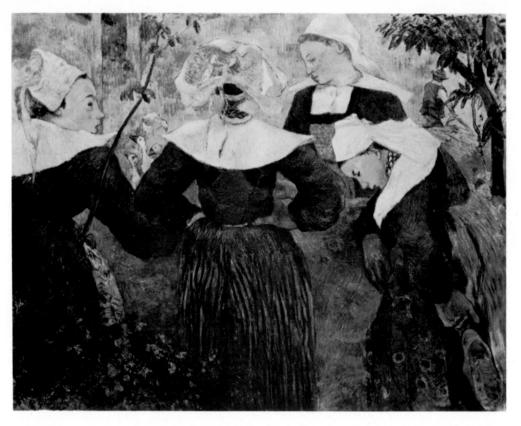

GAUGUIN: Breton Girls, 1886. 28 × 353". Bayerische Staatsgemäldesammlungen, Munich.

Japanese prints had become one of the important factors of his recent evolution, although he had "discovered" them originally back in his parents' home in Nuenen.⁴⁰

When Gauguin returned to Paris in November 1886 he met van Gogh, and a strange friendship soon united the two, in spite of the cold purposefulness of the one and the boiling enthusiasm of the other. All they had in common was the belligerent character of their convictions. Gauguin began to show the superiority and certitude of one who has finally found his way and who has become used to being listened to; van Gogh was animated with all the ardor and humility of the faithful who witnesses wonders and who feels growing in himself the fierce pride of new beliefs. To all the conflicting influences which had been showered on van Gogh, to the kindness and patience of Pissarro, the cold systematization and a certain uncommunicativeness of Seurat, the lively proselytizing of Signac, Gauguin added a new element: a crude outspokenness, an occasional independence from nature, a vague tendency to use exaggeration as a means to go beyond impressionism.

In order to follow this new course Gauguin avoided Pissarro and abruptly turned to Degas. He spoke of leaving France and of seeking in the tropics new subjects as well as more colorful sensations; he began to plan a trip which would carry him and

Seurat: Paul Signac, 1889-90. Conté crayon, 13½×11″. Collection Mme Ginette Signac, Paris.

Laurent: Georges Seurat, d. 1883. Conté crayon, $15\frac{1}{4} \times 11\frac{1}{2}$ ". Musée d'Art Moderne, Paris.

his friend Laval to Panama and thence to Martinique. He railed against Seurat and Signac. Pissarro, who had already witnessed many sterile fights among the old guard impressionists, now saw the younger generation continue in the same spirit of intolerance. He hardly concealed his pain when he wrote his eldest son in November: "The hostility of the romantic impressionists is more and more marked. They meet regularly. Degas himself comes to the café. Gauguin has become intimate with Degas once more, and goes to see him all the time—isn't this seesaw of interests strange? Forgotten are the difficulties of last year at the seashore, forgotten the sarcasms the Master hurled at the sectarian [Gauguin]. . . . I was naive, I defended him to the limit, and I argued with everybody. It is all so human and so sad."41

Monet at the same time had a dispute with Durand-Ruel and returned an advance, saying that henceforth he would only deal on a cash basis. He also refused to sell more than half of his recent pictures to him, explaining that he preferred keeping the others since Durand-Ruel sent all his stock to America.⁴²

Personal antagonisms were no longer concealed; they took the form of bitter quarrels. Thus ended the year of 1886, which had seen the completion and exhibition of Seurat's painting-manifesto, *La Grande Jatte*, the emergence of Fénéon as an art critic and the first manifestations of literary symbolism, van Gogh's arrival in France, publication of Zola's *L'Oeuvre*, Gauguin's first dreams of faraway tropics, Durand-Ruel's initial success in America, and the eighth exhibition of the impressionist group, which was also to be the last. Not even an attempt was made to organize the painters for a new show. The movement constituted by their common efforts had ceased to exist. Thereafter each would go his own way. Pissarro, who had been the only one represented at every exhibition and who had always adopted a conciliatory attitude, now lost all contact with those who had been his comrades for twenty-five years. But while he suffered from his isolation, he found relief in the conviction that he, at least, had kept in step with new ideas. And he also knew that—whatever the future might hold in store—he had contributed to the formation of men like Cézanne, Gauguin, and van Gogh.

It was van Gogh who summed up the situation when he referred bluntly to the "disastrous squabbles" of the impressionist group, "each member getting at the other's throat with a passion worthy of a nobler and better aim." Yet, in spite of this discouraging situation, neither van Gogh nor those of his generation could withhold their admiration from this group of painters who, together and as equals, had advanced a new concept of art and of nature, of color and of light. While Ingres and Delacroix had been more or less isolated exponents of their tendencies, out-distancing their followers, while the naturalist movement had been centered around one man, Courbet, impressionism had come into being through the simultaneous efforts of a number of artists, who in continual give-and-take had elaborated a style of their own to express their vision. It was with their achievement in mind that Vincent wrote in 1888: "More and more it seems to me that the pictures which must be painted to make present-day painting completely itself . . . are beyond the power of one isolated individual. They will therefore probably be created by groups of men combining together to execute an idea held in common." 44

But when van Gogh expressed this belief, the first group of this kind in the history of modern art had lost its unity of purpose and already belonged to the past.

- 1 Pissarro to his son [March 1886]; see Camille Pissarro: Letters to His Son Lucien, New York, 1943, p. 73-74.
- 2 He had written notably that impressionism "is too purely scientific for us" (and this even before Seurat had perfected his theories); see J. F. Raffaëlli: Etude des mouvements de l'art moderne et du beau caractéristic, Paris, 1884, p. 39.
- 3 Degas to Bracquemond [beginning of May 1886]; unpublished document, Musée du Louvre (bequest of A. S. Henraux).
- 4 F. Fénéon: Les impressionnistes en 1886; see Fénéon: Oeuvres, Paris, 1948, p. 74.
- 5 The catalogue lists over 300 works by the following artists (with the approximate number of works in parentheses): Benassit, Besnard, J. L. Brown, Boudin (23), Cassatt (3), Caillebotte (10), Degas (23), Desboutin, Duez, Dumaresq, Fantin, Flameng, Fleury-Chenu, Forain, Guillaumin (7), Huguet, Laugée, J. P. Laurens, Lépine, Lerolle, Manet (17), Mélin, Monet (50), Montenard, Morisot (9), Pissarro (42), Renoir (38), Roll, Serret, Seurat (2 paintings and 12 "studies," probably small panels), Signac (6), Sisley (15). One painting each by Manet and Degas were lent both by Mr. E. Davis and by Mr. A. J. Cassatt; the latter lent also two paintings each by Monet and Mary Cassatt. Mr. H. O. Havemeyer lent one painting by Pissarro and one by Monet. On the catalogue see also the general bibliography.

On this exhibition see especially H. Huth: Impressionism comes to America, *Gazette des Beaux-Arts*, April 1946, particularly p. 239, note 22, where the author tries to identify some of the paintings shown in New York.

- 6 For a condensed catalogue see L. Venturi: Les Archives de l'Impressionnisme, Paris-New York, 1939, v. II, p. 269-271.
- 7 See G. Moore: Impressions and Opinions, New York, 1891, p. 318.
- 8 See Moore: Confessions of a Young Man, London, 1888, p. 28-29.
- 9 P. Signac: Le Néo-impressionnisme, documents, Paris, 1934. (Introduction to the catalogue of an exhibition "Seurat et ses amis," reprinted in Gazette des Beaux-Arts.)
- 10 Gauguin to his wife [end of May 1886]; see Lettres de Gauguin à sa femme et à ses amis, Paris, 1946, p. 88. See also M. Bodelsen: Gauguin's Ceramics, London, 1964.
- 11 See J. K. Huysmans: Certains, Paris, 1889, p. 22-27.
- 12 See Moore: Modern Painting, London-New York, 1898, p. 89.

- 13 T. de Wyzewa: Une critique, art contemporain, Revue Indépendante, Nov.-Dec. 1886; quoted by J. Rewald: Seurat, New York, 1943, p. 31. For other criticisms see ibid., p. 29-32; also H. Dorra and Rewald: Seurat—L'oeuvre peint, Paris, 1960.
- 14 Unsigned article in The New York Daily Tribune, April 11, 1886.
- 15 Durand-Ruel to Fantin-Latour, New York, 1886; see F. Daulte: Le marchand des Impressionnistes, L'Oeil, June 1960.
- 16 Unsigned article in The Sun, April 11, 1886.
- 17 Unsigned article in The Critic, April 17, 1886.
- 18 Unsigned article in Art Age, April 1886.
- 19 See Durand-Ruel: Mémoires, in Venturi, op. cit., v. II, p. 216-217. Durand-Ruel had imported pictures valued altogether at \$82,000. They were admitted temporarily to the United States. When he left with the unsold paintings, he had to pay, for those he had sold, duties in the amount of \$5,500. Since these duties were levied at a rate of 30%, the sales must have amounted to about \$18,000, or about one fifth of the total value of the imported goods. See Huth, op. cit.
- 20 Pissarro to his son [July 1886]; see Pissarro, op. cit., p. 77.
- 21 On the group of *Les Vingt* see M. O. Maus: Trente années de lutte pour l'art, Brussels, 1926; also Rewald: Post-Impressionism—From van Gogh to Gauguin, New York, 1956, ch. II, and catalogue of the exhibition "Le groupe des XX et son temps," Brussels and Otterlo, 1962.
- 22 See Gauguin's letter to his wife, Tahiti [March 1892]; see Lettres de Gauguin, op. cit., p. 221.
- 23 On literary symbolism see Rewald: Post-Impressionism, op. cit., ch. III. Jean Moréas, author of a "Symbolist Manifesto" published in 1886, also wrote that same year an article on impressionism; its language is so precious and esoteric that it resists attempts at translation into English. Excerpts from this article, which appeared in Le Symboliste, Oct. 29, 1886, are quoted in J. Lethève: Impressionnistes et Symbolistes devant la presse, Paris, 1959, p. 125-126.
- 24 Fénéon, op. cit., p. 71-72.
- 25 For Fénéon's explanation of La Grande Jatte see Rewald: Post-Impressionism, op. cit., ch. II.
- 26 See Signac, op. cit.
- 27 On Zola's L'Oeuvre and Cézanne's reaction see Rewald: Paul Cézanne, New York, 1948, ch. XVIII and XIX.

- 28 Monet to Zola, April 5, 1886; see ibid., p. 151-152.
- 29 Cézanne to the painter L. Le Bail, ibid., p. 140.
- 30 Cézanne to Zola, May 20, 1881; see Cézanne, Letters, London, 1941, p. 156.
- 31 E. Bernard, quoted by Rewald: Gauguin, London, 1938, p. 12. It is possible that this note was written later when Bernard was anxious to prove that he had exerted a decisive influence on Gauguin in 1888 (see Rewald: Post-Impressionism, op. cit., p. 476-477). It is only certain that in 1886 Bernard wrote from Pont-Aven to his parents: "There is also an impressionist here, named Gauguin, a rather strong fellow. He is thirty-six years old and draws and paints very well." See Lettres de Gauguin, op. cit., p. 94, footnote.
- 32 See A. S. Hartrick: A Painter's Pilgrimage Through Fifty Years, Cambridge, 1939, p. 31-32; also Rewald: Post-Impressionism, op. cit., ch. I.
- 33 Gauguin to his wife [Pont-Aven, end of June 1886]; see Lettres de Gauguin, *op. cit.*, p. 92.
- 34 Gauguin to his wife [Pont-Aven, July 1886]; ibid., p. 94.
- 35 Gauguin to his wife, Pont-Aven, August 15, 1886; un-

- published document, courtesy Dr. Haavard Rostrup, Copenhagen.
- 36 See Rewald: Post-Impressionism, op. cit., ch. I.
- 37 V. van Gogh to his sister Wil [Arles, June-July 1888]; see Verzamelde Brieven van Vincent van Gogh, Amsterdam, 1952-1954, v. IV. No. W4, p. 150.
- 38 See M. Osborn: Der bunte Spiegel, 1890-1933, New York, 1945, p. 37. Pissarro added that he had no idea at that time that *both* these presentiments would come true.
- 39 See E. Bernard: Julien Tanguy, Mercure de France, Dec. 16, 1908.
- 40 Information courtesy Mme M. de Sablonière, Leiden.
- 41 Pissarro to his son [Nov. 1886]; see Pissarro, op. cit., p. 81-82.
- 42 See Monet's letters to Durand-Ruel, Jan. 12-Dec. 29, 1886; Venturi, op. cit., v. I, p. 305-323.
- 43 V. van Gogh to Bernard [July 1888]; see Verzamelde Brieven, op., cit., v. IV, No. B11, p. 215.
- 44 V. van Gogh to Bernard [June 1888]; *ibid.*, No. B6, p. 198.

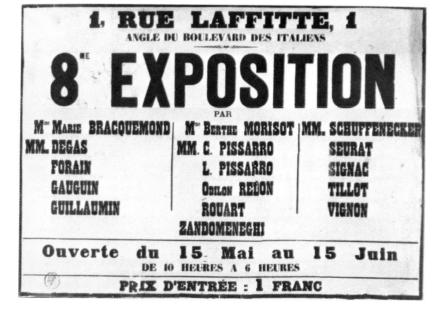

Poster for the eighth exhibition of the impressionists, 1886. Although Mary Cassatt was one of four artists to advance money for the show, in accordance with her own wishes she was the only participant whose name did not appear on the announcement.

Renoir: Bathers, 1884-87, d. 1887. $45\frac{1}{2} \times 67''$. (Suzanne Valadon posed for this painting.) Exhibited at Petit's in 1887. Philadelphia Museum of Art (Mr. and Mrs. Carroll S. Tyson Collection).

The events of the years following 1886 added emphasis to the fact that the impressionist movement had finally broken up, the movement which had taken root back in the studio of Gleyre, in the Salon des Refusés, in Fontainebleau forest and in the inn of Mother Anthony, in the brasseries and on the terrace of the Café Guerbois. The concepts developed at these sources had found their first free expression in works painted in the late 'sixties, had been completely realized in the early 'seventies, and had appeared in all their disconcerting novelty at the exhibition of 1874. When the eighth exhibition closed its doors in 1886, the "impressionist period" had lasted a little less than twenty years. This period had been a decisive phase in the development of the various painters connected with the movement, but scarcely any of them seemed to regret its end.

After 1886, when the impressionists strove to renew their art independently of each other, at the same time beginning to enjoy the hard-earned rewards of modest success, a new generation carried on the fight for new ideas. This generation, like its forerunner, was anxious to escape the tyranny of academicism and turned to the impressionists just as they once had asked the painters of Barbizon for advice. Knowingly or not, the impressionists thus guided the younger artists, who found inspiration in their example and in their art. Yet, just as some of the men of Barbizon had failed to recognize their true successors, they sometimes failed to see in the efforts of the younger painters the continuation of their own conquests.

The history of the years after 1886 is thus the parallel history of two generations: the older one, still in the prime of its vigor and confident in its strength, and the younger, which first had to acquire the independence necessary to unfold its own potentialities. While audacity and initiative often remained with the newcomers, knowledge and experience were the prerogative of the old-timers.

So as to gain experience and independence, after he had absorbed all that impressionism could offer, Gauguin left in the spring of 1887 with Charles Laval for Martinique, attracted by the unknown. At the same time Pissarro and Seurat exhibited with Les Vingt in Brussels, where they were laughed at once more but where their works made a deep impression on many young artists. A little later, in Paris, Berthe Morisot, Sisley, Renoir, Monet, and Pissarro participated in the Exposition Internationale at Petit's, together with Whistler, Raffaëlli, and others. Chocquet, de Bellio, and Murer did not hide their disapproval of Pissarro's new canvases, while Pissarro showed little sympathy for the work of his former comrades, which he considered incoherent. "Seurat, Signac, Fénéon, all our young friends like only my works and Mme Morisot's a little," he wrote his son Lucien, adding: "Naturally they are motivated by our common struggle. But Seurat, who is colder,

more logical, and more moderate, does not hesitate for a moment to declare that we have the right position, and that the impressionists are even more retarded than before."2

Renoir exhibited at Petit's his large composition of bathers, the result of several years of research. Huysmans proclaimed his dislike, Astruc did not approve either, and Pissarro explained to his son: "I do understand what he is trying to do, it is proper not to want to stand still, but he chose to concentrate on the line, his figures are all separate entities, detached from one another without regard for color." Vincent van Gogh, however, admired Renoir's "pure clean line," and so did the general public; Renoir this time achieved noticeable success. "I think," he wrote to Durand-Ruel, "I have advanced a step in public approval, a small step. . . . The public seems to be getting accustomed to my art. Perhaps I am mistaken, but this is being said on all sides. Why at this particular time and not at the others?"

Monet informed Durand-Ruel that the success obtained at Petit's had its repercussions, that Boussod & Valadon had bought works of his as well as of Renoir, Degas, and Sisley and had sold them without difficulty. In Paris there was definitely a demand for impressionists; there were now several dealers competing for the patronage of collectors. Durand-Ruel learned of this while in New York, where his second exhibition did not produce the expected results. Monet insisted that he would have done better to stay in Paris and take advantage of the new situation. But Durand-Ruel was unwilling to abandon the American market and decided in 1888 to open a branch in New York. In Paris meanwhile he ran into further complications when Monet refused to join a group exhibition of Renoir, Sisley, and Pissarro. Monet finally abandoned Durand-Ruel altogether and signed a contract with Theo van Gogh for Boussod & Valadon. Thereafter, if Durand-Ruel wanted any recent paintings by Monet, he had to buy from these dealers. Boussod & Valadon later went so far as to consider sending Theo van Gogh with a collection of picture to New York, but nothing came of it.

Late in 1887 Gauguin suddenly returned to France, illness having driven him and Laval from Martinique, where he thought he had found an ideal background for his work. He arrived in Paris completely penniless. Only after almost a year was Theo van Gogh able to organize an exhibition of his new paintings. "Degas is so enthusiastic about your pictures," he reported to the artist, "that he talks about them to everybody and is going to buy one of your canvases. . . . "5 Yet before this encouraging news reached him, Gauguin was once more in the throes of debt.

Gauguin returned to Pont-Aven in Brittany, barely managing to exist there; he was still suffering from dysentery and sometimes was so poor that he could not paint for lack of canvas and colors. But he had hit upon a new concept and tried relentlessly to formulate it. "Don't copy too much from nature," he advised Schuffenecker. "Art is an abstraction; derive it from nature by indulging in dreams in the presence of nature, and think more of creation than of the result." It was now that he began to speak increasingly of *synthesis*, which became his main preoccupation. He tried to achieve synthesis by insisting on the essential and sacrificing color and execution to style.

Van Gogh meanwhile had left Paris in February 1888 and gone to southern France. Attracted by Provence, where he hoped to find the color schemes of Delacroix, the

Gauguin: By the River, Martinique, d. 1887. 24 × 30". Private collection, Switzerland.

incisive outlines of Japanese prints, and the landscapes he had seen in the canvases of Cézanne at Tanguy's, van Gogh found stimulating views in and around Arles and feverishly set to work. It was not long after his arrival that he informed his brother: "What I learned in Paris is leaving me and I am returning to the ideas I had... before I knew the impressionists. And I should not be surprised if the impressionists soon find fault with my way of working, for it has been fertilized by the ideas of Delacroix rather than by theirs. Because, instead of trying to reproduce exactly what I have before my eyes, I use color more arbitrarily so as to express myself forcibly." Vincent also emphasized that he was "trying now to exaggerate the essential and to leave the obvious vague."

In Brittany, Gauguin's work was guided by similar concepts. When he painted a portrait of himself for Vincent, he explained that it was "so abstract as to be absolutely incomprehensible. At first glance, a gangster's head... from this point of view personifying a discredited impressionist painter.... The drawing is quite special; the eyes, mouth, and nose are like flowers in Persian rugs, hence representing the symbolic side. The color is rather remote from nature..." In this symbolic portrait van Gogh discovered all the unhappiness of his friend. He persuaded Gauguin to join him in the south, where they might set up for themselves and for others a studio in the tradition of medieval workshops, an idea which he had already discussed in Paris with Guillaumin, Pissarro, Seurat, and Theo. At Vincent's request Theo promised to send a monthly remittance to Gauguin in exchange for pictures, thus offering him the same kind of help which Durand-Ruel had given the impressionists.

At the end of October 1888 Gauguin arrived at Arles but cared little for life in the small Provençal town to which van Gogh had become deeply attached. Their divergent temperaments and opinions soon caused van Gogh and Gauguin to quarrel violently. Late in December they traveled together to nearby Montpellier in order to visit the collection of works by Courbet, Delacroix, and others that had been bequeathed to the Musée Fabre by Bruyas, who once had refused to buy paintings by Monet which Bazille submitted to him. When Vincent reported to his brother their discussions in front of these pictures, he wrote: "Our arguments are terribly *electric*, we come out of them sometimes with our heads as exhausted as an electric battery after it is discharged." A few days later van Gogh suffered a nervous breakdown, and in a fit of insanity attempted to attack Gauguin, later mutilating himself. Vincent was taken to the hospital; Gauguin summoned Theo and returned to Paris.

For Pissarro the year 1888 had again been difficult. Durand-Ruel, preoccupied with his affairs in America, had not been of much help, but the painter was able to transact some business with Theo van Gogh; his prices, too, began to pick up. However, Pissarro was losing faith in his new style and became impatient with the slow execution it demanded. Although he vehemently defended Seurat and his method in a discussion with Renoir, he confessed in a letter to Fénéon that the divisionist technique "inhibits me and hinders the development of spontaneity of sensation." Indeed, he soon recognized that he had been deluding himself in following the young innovators. It did not matter any more whether their theory was good in itself, since his paintings no longer fully satisfied him; he now openly admitted his error. In a letter to Henry van de Velde (who was closely connected with the group Les Vingt), he later explained: "I believe that it is my duty to write you frankly and tell you how I now regard the attempt I made to be a systematic divisionist, following our friend Seurat. Having tried this theory for four years and having now abandoned it, not without painful and obstinate struggles to regain what I had lost and not to lose what I had learned, I can no longer consider myself one of the neo-impressionists who abandon movement and life for a diametrically opposed esthetic which, perhaps, is the right thing for the man with the right temperament, but is not right for me, anxious as I am to avoid all narrow, so-called scientific theories. Having found after many attempts (I speak for myself), having found that it was impossible to be true to my sensations and consequently to render

Photograph of Paul Gauguin, probably taken in Brittany, c. 1888.

GAUGUIN: Sketch after a self portrait painted for Vincent van Gogh, 1888. From a letter to Schuffenecker. Collection C. Roger-Marx, Paris.

life and movement, impossible to be faithful to the so random and so admirable effects of nature, impossible to give an individual character to my drawing, I had to give up."¹² Pissarro gradually abandoned the pointillist technique and subsequently reworked some of his divisionist canvases (see p. 571), destroying others.

Monet spent part of the year 1888 in Antibes, painting a series of landscapes which immediately was received with enthusiasm. In 1889 he organized, together with Rodin, a great retrospective exhibition at Petit's, including representative works done since 1864. Commenting on his efforts, Monet told the American painter Lilla Cabot Perry that he "wished he had been born blind and then had suddenly gained his sight so that he could have begun to paint without knowing what the objects were that he saw before him." When Mrs. Perry brought one of Monet's landscapes to Boston, only John La Farge appreciated it. At the same time Monet's friendship with Sargent grew closer when the two men worked side by side in Giverny during the summer of 1888. Nor was Sargent the only American painter to visit Monet; in 1887 Theodore Robinson had come to Giverny where he befriended Monet, whom

Monet: Antibes, 1888. $29\frac{1}{8} \times 36\frac{1}{2}$ ". Toledo Museum of Art, Ohio (Gift of Edward Drummond Libbey).

SARGENT: Mme Hoschedé and Her Son in Monet's Garden, Giverny, 1888. $25\frac{1}{2} \times 27\frac{3}{4}$ ". Collection Mr. and Mrs. Samuel Spector, New York.

Monet: Breakfast under the Tent, Giverny, 1888. $45\frac{3}{4} \times 53\frac{3}{8}$ ". Collection Joseph R. Nash, Paris.

SARGENT: Claude Monet Painting, 1888. 21 × 25½". Tate Gallery, London (Gift of Emily Sargent and Mrs. Ormond).

he greatly admired. Upon his return to America, five years later, Robinson became yet another pioneer of impressionism in the United States.

Having broken with Boussod & Valadon, Monet again dealt with Durand-Ruel. However, he refused to bind himself, kept other dealers bidding for his works, and reserved the right to raise his prices accordingly. His clever salesmanship partly accounts for the fact that he was the first to command high prices, but he remained for his friends a generous comrade, lending them money, buying their pictures, or helping to sell them. Yet he declined to participate in an exhibition of the impressionists which Durand-Ruel wanted to organize. Monet considered the plan to re-establish the old group both unnecessary and bad; his opposition did away with the last chance for a revival of group shows attempted by Durand-Ruel.

Now that he began to be well known, Monet conceived the idea of organizing a subscription in order to offer Manet's *Olympia* to the French nation. Part of the year 1889 was taken up with this endeavor, of which Zola disapproved because he thought that Manet should enter the Louvre on his own. Most of Manet's friends, however, supported the plan, and Monet was able to raise about 20,000 francs with which to purchase the painting from Manet's widow. Among the contributors were G. de Bellio, Bracquemond, Burty, Caillebotte, Carolus-Duran, Degas, Durand-Ruel, Duret, Fantin, Guillemet, Huysmans, Lautrec, Mallarmé, Murer,

Pissarro, Antonin Proust, Puvis de Chavannes, Raffaëlli, Renoir, Rodin, Rouart, and Sargent.¹⁴ Neither Chocquet nor Cézanne seems to have participated.

Renoir had been in the south early in 1888 and had paid a visit to Cézanne at the Jas de Bouffan, occasionally working at his side. Renoir traveled quite a lot, but toward the end of the year he suddenly began to suffer from severe neuralgia: part of his head was paralyzed and he had to undergo electrical treatment. Moreover, like Pissarro, Renoir was dissatisfied with his recent work. When the vanguard-critic Roger Marx prepared the fine arts section of an International Fair to be held in Paris, Renoir informed him: "If you see M. Chocquet, I should appreciate it very much if you would not listen when he talks to you about me. When I have the pleasure of seeing you, I shall explain what is very simple—that I find every-thing I have done bad and that it would be for me the most painful thing possible to see it exhibited." Soon, however, the linear dryness was to disappear from Renoir's work and he was to unfold again the richness of his palette and the vivacity of his brush stroke. In 1890 he exhibited once more at the Salon, after an absence of seven years; he never showed there afterward. A large exhibition of his work put on by Durand-Ruel in 1892 constituted a definite triumph for the artist.

While Chocquet had been hindered by the painter himself from pleading for Renoir in 1889, he succeeded in having one of Cézanne's paintings admitted to the Fair; instead of a recent work the artist selected *La maison du pendu* (p. 322) which Chocquet obtained from Count Doria through an exchange. Monet was represented by three canvases at the same exhibition, and Theo van Gogh managed to sell one of his paintings to an American for the unheard-of price of 9,000 francs.

Gauguin, who had returned to the Auberge Gloanec in Pont-Aven, was not admitted to the International Fair and thereupon arranged an exhibition of his own with the steadily growing group of friends gathered around him in Brittany. It was held at the Café Volpini on the Champ de Mars during the Fair, and was announced as an "Exhibition of Paintings of the Impressionist and Synthetist Group." The inclusion of the word "impressionist" was rather misleading; the exhibition was clearly dominated by the synthetist and symbolic work of Gauguin's recent period. While some traces of impressionism were still discernible in Gauguin's technique of small brush strokes, he began to surround shapes with pronounced outlines (a procedure that can be linked to Japanese prints), to flatten forms, to use color more arbitrarily—although he still favored subtle combinations rather than the violent clashes propounded by van Gogh-and to insist on curvaceous and decorative lines, a tendency which made him one of the forerunners of Art Nouveau. But these endeavors and their inherent negation of impressionism seemed beyond comprehension to a public that had not yet fully accepted impressionism itself. As a result, Gauguin's show at the Café Volpini had little success; on the other hand his works aroused much anger and also much interest in Brussels, where he exhibited that same year with the XX.

The group of XX was becoming increasingly active. In 1888 Toulouse-Lautrec had participated in its exhibition, while Degas declined an invitation—as he did again in 1889. That very year Cézanne accepted, explaining his usual reserve about exhibitions on the basis that he "had resolved to work in silence until the day when I should feel myself able to defend in theory the results of my attempts." Informed

Gauguin: Brittany Coast, d. 1889. $28\frac{3}{4} \times 36\frac{1}{4}$ ". Private collection, United States.

Cézanne: Card Players, 1890-92. $25\frac{5}{8} \times 32\frac{1}{2}$ ". Metropolitan Museum of Art, New York (Bequest of Stephen C. Clark).

that Sisley and van Gogh were also to show, he wrote: "In view of the pleasure of finding myself in such good company I do not hesitate to modify my resolve." Among other paintings Cézanne sent to Brussels his *Maison du pendu* which he asked Chocquet to lend.

Cézanne had not exhibited in Paris since 1877. Only at Tanguy's could his canvases be seen, though few knew this; nevertheless, an increasing number of young painters went there to study his work. Tanguy's small place became a center for artists and critics. Trade in ideas was more active than in paintings, although some, like Signac, purchased canvases by Cézanne for a few hundred francs.

An American critic whom some artists took to Tanguy's shop saw there "violent or thrilling van Goghs, dusky, heavy Cézannes..., daring early Sisleys..., all lovingly preserved, and lovingly brought out by the old man." And the author added: "Le père Tanguy is a short, thick-set, elderly man, with a grizzled beard and large beaming dark blue eyes. He had a curious way of first looking down at his picture with all the fond love of a mother, and then looking up at you over his glasses, as if begging you to admire his beloved children.... I could not help feeling,

apart from all opinions of my own, that a movement in art which can inspire such devotion must have a deeper final import than the mere ravings of a coterie." ¹⁸

When the Danish painter Johan Rohde visited Tanguy's place, he was likewise struck by the strange premises, the even stranger pictures, and by the man himself, "the quaint old color dealer, whose paltry little shop, poorer than the most miserable secondhand dealer's in Adelgade [an old and populous street in Copenhagen] seemed to be the main store for paints used by the impressionists and synthetists. There were stacks of pictures—no doubt payment for materials—and very valuable things among them. After wrangling for a while with his Xanthippe and having appeased her by purchasing some of the presumably quite problematic colors Tanguy is grinding in his kitchen, you are permitted to rummage among the stacks, where you may fetch out many an excellent canvas available here at very modest prices (which makes you imagine how little the artist himself is likely to have received for them). There can be no doubt that it is in such out-of-the-way places in Paris that the painters of the future are to be seen, the finest art being always the cheapest at the moment when it is produced.

"Van Gogh seems to have been quite a particular friend of the house; there were

Van Gogh: *Père Tanguy*, 1887. $36\frac{1}{4} \times 28\frac{3}{4}$ ". Purchased by Rodin from Tanguy's daughter. Musée Rodin, Paris.

scores of pictures by him, excellent Provençal landscapes...and a strongly characterized but coarsely painted portrait of old man Tanguy. There was a landscape by Gauguin with a portrait of himself,19 but I did not consider it particularly significant. There were handsome things by Camille Pissarro, Guillaumin, Cézanne, and Sisley...who is just about to become accepted among the official artists; at any rate pictures by him are being shown at the Champ de Mars Salon."20

Rohde was much less impressed with Signac and "his insufferable pointillist technique." It was his opinion that "much of what was to be found in Tanguy's stacks was such as to make one's hair stand on end, not so much for lack of talent as on account of the most deliberately contrived ugliness in the combination of colors and in the brushwork." The Scandinavian visitor seems to have met some of Seurat's followers at Tanguy's, who had won over the old dealer to their views, for Rohde noted in his diary: "A curious lot of doctrinaires these young people are with their numerous theories and their almost scientific approach to painting. They quote Chevreul and countless other optical scholars and chemists of repute, feeling very sorry for those who do not understand spectral analysis. It was an amusing experience buying colors from Tanguy; if I reached for one of my own tried favorites—notably one that was not on the menu of the *chromo-luminarists*—he winced as if stung by a scorpion and gave me fatherly advice against it, not because it was less durable or seemed objectionable for any other practical reason, but because it was an infraction of the 'catechism' to use it."²¹

While Rohde did not pay any special attention to Cézanne's works at Tanguy's, they were the beacon which attracted most visitors to the small shop on the rue Clauzel in Montmartre. Among them were many former pupils of the Académie Julian and others who had worked with Gauguin in Brittany or were attracted by his theories, such as Emile Bernard, Maurice Denis, Pierre Bonnard, and Edouard Vuillard. To them Cézanne appeared something of a myth; many did not know whether he was living or dead and knew of him only what that simple soul, Julien Tanguy, had to tell. This mystery conferred even more fascination upon his art, in which the younger generation discovered the same preoccupation with structure that had become essential for Seurat, van Gogh, and Gauguin. They recognized in Cézanne the only one of the old impressionists who had abandoned impressionism while retaining its technique, in order to explore spatial relations and reduce forms to their fundamental character.

Maurice Denis later recalled that what they admired most in Cézanne's canvases was the equilibrium, the simplicity, austerity, and grandeur. His paintings seemed just as refined as, yet more robust than the strongest works of the impressionists. Denis and his friends had found that impressionism had "a synthetic tendency, since its aim was to translate a sensation, to objectify a state of mind; but its means were analytical, since color in impressionism was merely the result of an endless number of contrasts..."²² Cézanne, however, by revealing structure beneath richly nuanced surfaces, went consciously beyond the appearances which satisfied a Monet. To the young painters his work offered a solution to the problem of "preserving sensibility's essential role while substituting conscious reflection for empiricism."²² They even discovered a link with their own symbolist efforts in his words to the effect that the sun could not be reproduced but had to be represented

Photograph of Cezanne painting near Aix, 1906.

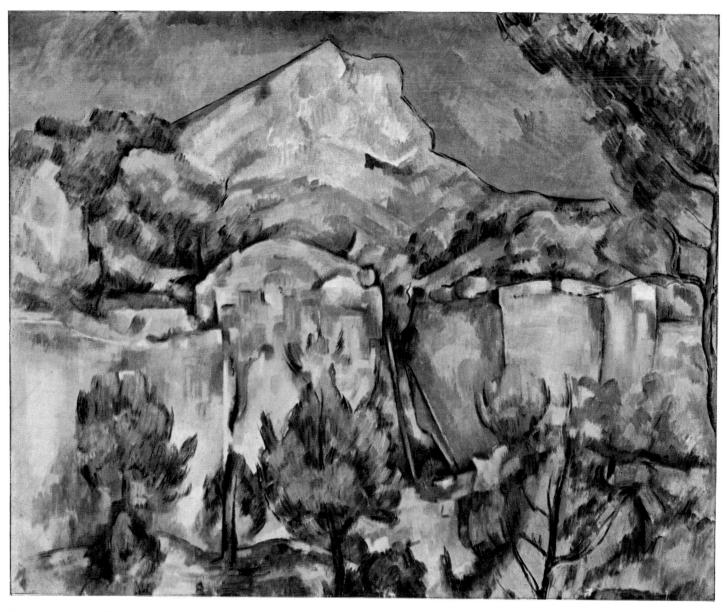

Cézanne: Sainte-Victoire Seen from Bibémus Quarry near Aix, c. 1898. $26\frac{1}{4} \times 32\frac{1}{2}$ ". Baltimore Museum of Art (Cone Collection).

through something else—through color. Cézanne's combination of style and sensibility, the harmony which he achieved between nature and style seemed to them the logical, the sole means of overcoming impressionism—and even symbolism—leading them on a new path. To these young painters, avid for theories and experience, Cézanne thus appeared simultaneously as "the final outcome of the classic tradition and the product of the great crisis of liberty and light which has rejuvenated modern art. He is the Poussin of impressionism." And Cézanne himself said that his aim was to "vivify Poussin in contact with nature."

Gauguin untiringly proclaimed his admiration for Cézanne and kept with him one of Cézanne's still lifes, a relic of his collection with which he refused to part (he placed it in the background of a portrait of a woman painted in Brittany). Cézanne's and Gauguin's followers formed an important nucleus at the Salon des Indépendants, which now every year constituted a decisive event and attracted all those who worked in disregard of official rules. Van Gogh exhibited there; so did Lautrec. In 1886 the works of the douanier Rousseau had appeared there for the first time and excited great hilarity. When a friend dragged Pissarro before Rousseau's paintings to make him laugh, Pissarro caused surprise by admiring—in spite of the naiveté of the drawing—the qualities of the painting, the exactness of the values, and the richness of the colors. Subsequently Pissarro warmly praised the douanier's work to his acquaintances.²³

It was Pissarro's sympathy for all sincere efforts which prompted Theo van Gogh to ask him whether he could help his brother. (Theo had just organized an exhibition of Pissarro's work early in 1890.) After his first seizures Vincent had remained for one year at the Asylum of St. Rémy near Arles, where he had been able to work between repeated spells of madness, hoping against hope that he might overcome his affliction. Tired of his uninspiring surroundings and confident that his attacks would no longer be so frequent, he had asked Theo to find him a place near Paris where he might live and work. At Theo's request Pissarro was ready to take Vincent into his own house at Eragny, but Mme Pissarro was afraid of the effect produced by an unbalanced man on her children. Pissarro thereupon recommended his old friend, Dr. Gachet at Auvers, who declared himself willing to take care of Vincent. The latter came to Auvers in May 1890; he killed himself there in July of the same year, unable to believe any longer in the possibility of cure. After the suicide of his brother, Theo van Gogh fell seriously ill; he was taken to Holland and died there in January 1891. At the gallery he was replaced by Maurice Joyant, a school friend of Lautrec's, to whom M. Boussod, the owner, complained that Theo van Gogh had "accumulated appalling things by modern painters which had brought the firm to discredit." Indeed, Theo had left a stock of works by Degas, Gauguin, Pissarro, Guillaumin, Redon, Lautrec, Monet, and others. According to M. Boussod only Monet's canvases were salable, especially in America.²⁴

In March 1891 Seurat helped arrange once more the Salon des Indépendants, including a small memorial show for van Gogh. He inspected the entries and supervised the hanging, hardly noticing a sore throat. A sudden fever sent him to bed. He died on March 29, at the age of thirty-one. On April 7, Chocquet died at sixty-nine.

A few days after Seurat's death, Gauguin again left France, sailing—this time alone—for Tahiti, hoping to live there "on ecstasy, calmness, and art." Renoir was

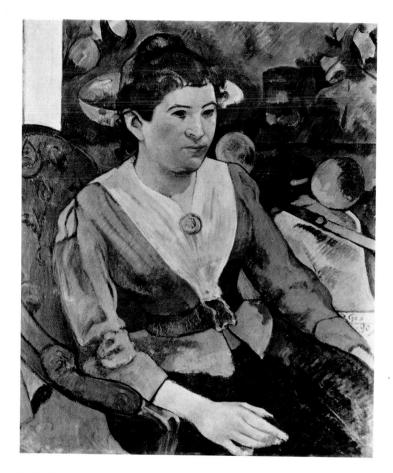

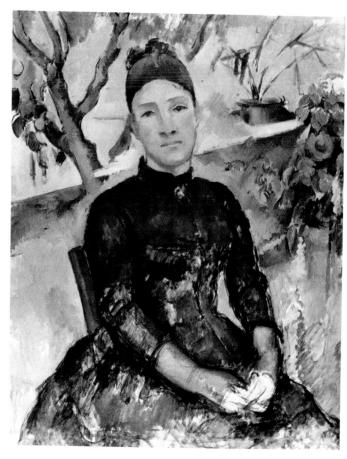

Left, Gauguin: Portrait of Marie Lagadu, d. 1890 (in the background Cézanne's Still Life owned by Gauguin; see p. 474). $25\frac{5}{8} \times 21\frac{1}{2}$ ". Art Institute of Chicago (Joseph Winterbotham Collection). Right, Cézanne: Mme Cézanne in the Greenhouse, c. 1890. $36\frac{3}{8} \times 28\frac{3}{4}$ ". Metropolitan Museum of Art, New York (Bequest of Stephen C. Clark).

greatly puzzled by Gauguin's perpetual longing for exotic subjects; "one can paint so well in Batignolles," was his comment. Pissarro, likewise, was not convinced by Gauguin's theory that "the young would find salvation by replenishing themselves at remote and savage sources." ²⁵ But Degas showed increasing interest in Gauguin's work and bought several canvases at the auction sale organized by Gauguin to raise the money for his trip. At the request of Mallarmé, Mirbeau wrote an enthusiastic article to support the sale, which netted almost 10,000 francs for thirty paintings. Anxious to know what Monet thought of his evolution "toward complication of the idea through simplification of the form," Gauguin had shown great satisfaction when told by Mirbeau that Monet had liked one of his recent paintings, Jacob Wrestling with the Angel. ²⁶ But Monet himself was less charitable and did not hesitate to confess later that he had never taken Gauguin seriously. ²⁷

Monet's own efforts had just diverged in a new direction which became apparent

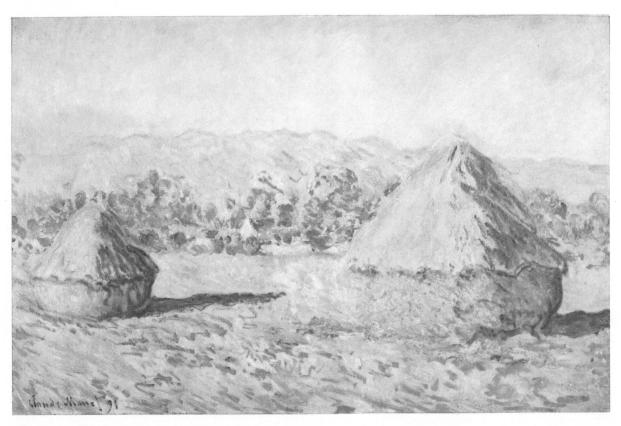

Monet: Two Haystacks, d. 1891. $25\frac{5}{8} \times 39\frac{1}{2}$ ". J. H. Whittemore Company, Naugatuck, Conn.

when he exhibited in 1891 at Durand-Ruel's a series of fifteen paintings representing haystacks at various hours of the day. He explained that in the beginning he had imagined that two canvases, one for grey weather and one for sunshine, would be sufficient to render his subject under different lights. But while painting these *Haystacks*, he discovered that the effect of light changed continually and decided to record a succession of aspects on a series of canvases, working on these in turn, each canvas being devoted to one specific effect. He thus strove to attain what he called *instantaneity* and insisted on the importance of stopping work on a canvas when the effect changed and continuing work on the next one, "so as to get a true impression of a certain aspect of nature and not a composite picture." 28

When one of Monet's *Haystacks* was exhibited in Moscow in 1895 (actually the full impact of the artist's endeavor is felt only when several paintings of the series are viewed together), it made a decisive impression on young Wassily Kandinsky. "Previously," he later wrote, "I knew only realistic art. . . . Suddenly, for the first time, I saw a 'picture.' That it was a haystack, the catalogue informed me. I could not recognize it. This lack of recognition was distressing to me. I also felt that the painter had no right to paint so indistinctly. I had a muffled sense that the object

MONET: Two Haystacks, d. 1891. $25\frac{1}{2} \times 39\frac{1}{4}$ ". Art Institute of Chicago (L. L. Coburn Collection).

was lacking in this picture, and was overcome with astonishment and perplexity that it not only seized, but engraved itself indelibly on the memory and, quite unexpectedly, again and again, hovered before the eyes down to the smallest detail. All of this was unclear to me, and I could not draw the simple consequences from this experience. But what was absolutely clear to me was the unsuspected power, previously hidden from me, of the palette, which surpassed all my dreams. Painting took on a fabulous strength and splendor. And at the same time, unconsciously, the object was discredited as an indispensable element of the picture. . . . ''29

It may be doubted whether Monet really meant to "discredit the object" in his attempt to observe methodically and with almost scientific exactness the uninterrupted changes of light on various motifs. His studies of haystacks were followed by similar series of poplars, of the façade of Rouen Cathedral, of views of London, and of waterlilies in his garden pool at Giverny, as well as of different aspects of Venice. He became disgusted with "easy things that come in a flash," although it had been precisely in those "easy things" that he had manifested his genius for seizing in the first impression the luminous splendors of nature. The stubbornness with which he now pursued his race with light—he himself used the word stubbornness in

this connection—resulted in frequently brilliant solutions of the problem he tried to solve, but this problem itself remained close to being an experiment and imposed severe limitations. His eyes, straining to observe minute transformations, were apt to lose the perception of the whole. Thus Monet abandoned form completely (his pioneering in this field was to lead Kandinsky to totally new concepts) and sought to retain in a vibrant tissue of subtle nuances the single miracle of light.

Monet's "series" met with tremendous success. All his haystack pictures were sold within three days after the opening of his exhibition at prices ranging between 3,000 and 4,000 francs. But public acclaim, led by the artist's old friend Clemenceau, was soon to be opposed by severe criticism. A German historian stated that the painter's efforts to test the fertility of his method on a large scale and in different directions had resulted only in trivialities. He accused Monet of having reduced the impressionist principle to absurdity. As to Monet's former comrades, they witnessed with a certain sadness how his career as an impressionist was ending in technical prowess. Admiring his talent and having tacitly considered him the leader of their group, they now remembered Degas' contention that Monet's art "was that of a skillful but not profound decorator." 31

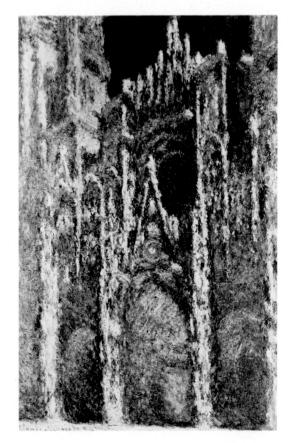

Monet: Rouen Cathedral, Morning, 1894. 42 × 29". Museum of Fine Arts, Boston.

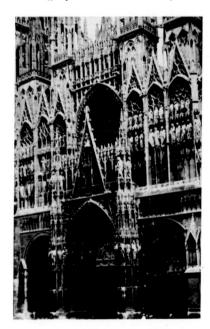

Monet: *Poplars*, d. 1891. $39\frac{1}{2} \times 25\frac{3}{4}$ ". Philadelphia Museum of Art (Bequest of Anne Thomson as a memorial to her father, Frank Thomson, and her mother, Mary Elizabeth Clarke Thomson).

Even Guillaumin objected to Monet's "total lack of construction" while marvelling at his ability to attack the problems posed by the series. Guillaumin in 1891 had won 100,000 francs in a city lottery, and this unexpected fortune had at last enabled him to quit his administrative job in Paris and devote himself entirely to painting. But, having lost contact with his former friends, particularly Pissarro and Monet, he failed to dominate his sensations and scattered his strength in attempts to be forceful in color while he, too, remained weak in construction, lacking the breadth of vision and poetic subtlety which saved Monet from banality.

Degas also lost contact with his colleagues. He seems not to have attended the "impressionist dinners" held monthly between 1890 and 1894 at the Café Riche. The critic Gustave Geffroy—a particular friend of Monet who introduced him at the dinners—tells of having met there Pissarro, Sisley, Renoir, Caillebotte, G. de Bellio, Duret, Mirbeau, and occasionally Mallarmé, but does not mention Degas. Avoiding new acquaintances and contenting himself with a few intimate friends like the Rouarts, the sculptor Bartholomé, and Suzanne Valadon (whom he had met through the latter), Degas led a hermit's life in the center of Paris, steadily complaining about failing eyesight. He did not even feel the urge to show his works any more; after 1886 he appeared only once before the public with a series of landscape pastels, exhibited at Durand-Ruel's in 1892. These very delicate sketches were supposedly executed in his studio and were not really typical of his work at that time. In his incomparably more important pastels of dancers and nudes he was gradually reducing the emphasis on line in order to seek the pictorial. Resorting to ever more vibrant color effects, he found in his pastels a means to unite line and color. While every pastel stroke became a color accent, its function in the whole was often not different from that of the impressionist brush stroke. His pastels became multicolored fireworks where all precision of form disappeared in favor of a texture that glittered with hatchings.

Degas now spent as much time modeling as drawing and making pastels, striving as a sculptor to give form to the instantaneous, seeking mass in movement. When age dimmed his eyesight to the point where he had to give up brush and pencil altogether, he devoted himself exclusively to modeling. In kneading clay or wax he did with his fingers what he could no longer do with his eyes.³² As his self-imposed loneliness became more and more complete, the semi-darkness he lived in made him increasingly irritable. Yet his solitude seems also to have left him conscious of the fact that he had antagonized many of his colleagues, offending them by the sharpness of his tongue and by his uncompromising attitude. After a lifelong effort to hide from others a character combining timidity and violence, modesty and pride, doubt and dogmatism, he made a confession in a letter to his old friend Evariste de Valernes. "I would like to beg your pardon," he wrote, "for something which frequently recurs in your conversation and even more frequently in your thoughts. namely that I was harsh to you or seemed to be so during our long friendship. I was mainly harsh against myself. You will probably remember this, for you yourself were astonished and reproached me for my lack of self-confidence. I was, or seemed to be, harsh against all the world because brutality became a habit of mind, which can be explained by my doubts and my bad temper. I felt so insufficiently equipped, so unprepared, so weak, and at the same time it seemed to me that my calculs on art

Photograph of Edgar Degas, c. 1913.

Degas: Dancers, c. 1903. Pastel, $37\frac{1}{4} \times 31\frac{3}{4}$ ". Museum of Modern Art (Gift of William S. Paley).

were so correct. I quarreled with all the world and with myself. If, under the excuse of this accursed art, I have hurt your high and noble spirit, or perhaps your heart, I beg your pardon."³³

Yet, in spite of this awareness of his faults, Degas remained the same. Paul Valéry, who met him at the Rouarts', later remembered that he was "a great wrangler and formidable arguer, especially excitable on the subject of politics and of drawing. He would never give in, quickly reached the point of shouting, uttered the harshest words, broke off abruptly... But one sometimes wondered if he did not like being intractable and being generally considered as such." Berthe Morisot seems to have been amazed and, moreover, hurt when she heard Degas explain to Mallarmé: "Art is deceit. An artist is only an artist at certain hours through an effort of will; objects possess the same appearance for everyone; the study of nature is a convention. Isn't Manet the proof? For, although he boasted of servilely copying nature, he was the worst painter in the world, never making a brush stroke without the masters in mind..." 35

Degas continued to be less severe toward his followers, but the true inheritor of his spirit as well as of his draftsmanship was not to be found among them. It was Henri de Toulouse-Lautrec, who, after early attempts in an impressionist vein, achieved a style of his own which showed a close yet free relation to Degas', similar to the connection that once existed between Degas and Ingres. Lautrec professed an immense admiration for Degas, for his composition, and his sober execution. This admiration was nourished particularly by a friendship with the musician Desiré Dihau and his sister, whom Degas had painted so frequently. In turn, Lautrec did their portraits, always wondering uneasily whether they could stand the comparison with those by Degas. Once, after a gay night, Lautrec took a group of friends at dawn to Mlle Dihau's, who only hesitatingly admitted them, still in evening attire, to her modest flat. Lautrec led the others before Degas' paintings and ordered them to bend their knees in admiration for the revered master.³⁶

It is doubtful whether Degas showed particular appreciation for Lautrec's works, in spite of the fact that he recognized his craftsmanship. He was highly suspicious of the new generation and—although he himself sometimes chose to be eccentric—could not have had much liking for the kind of eccentricities that rendered Lautrec famous all over Montmartre. Stubborn in his convictions, yet inconsistent in his preferences, Degas, for instance, hated people who advertised themselves but was indulgent toward Gauguin, whom he seems to have helped repeatedly. Of his impressionist friends, Degas appears to have remained cordial only with Pissarro, apparently respecting the modesty with which Pissarro pursued his work.

Pissarro did not change much with the years. He occupied his position as dean of the former group without any ostentation, his just criticism tempered by indulgence, his radical convictions balanced by profound kindness. A chronic infection of one of his eyes began to cause him considerable discomfort and anxiety. It prevented him more and more from working in the open; he therefore concentrated on painting from behind closed windows. When the view from his studio in Eragny failed to reveal anything new, he began to travel, paid frequent visits to his son Lucien, permanently settled in London, painted from hotel rooms in Rouen and later in Paris. After abandoning divisionism, he returned to his impressionist conceptions;

PISSARRO: The Louvre Seen from the Pont-Neuf, Winter, d. 1902. $21\frac{1}{4} \times 25\frac{5}{8}$ ". Formerly collection Mr. and Mrs. Werner E. Josten, New York.

his work regained its original freshness, while a greater lightness and purity of color remained as a result of his divisionist experiments. Now over sixty, he devoted himself to his art with such enthusiasm, optimism, and youthfulness that he inspired veneration in all who met him. Although his paintings did not appeal to such a wide public as those of Monet, he slowly achieved recognition. An important retrospective held at Durand-Ruel's in 1892 contributed definitely to establishing his reputation. But when Mirbeau insisted that the Director of Fine Arts purchase one of Pissarro's canvases for the State, he met with a refusal.

Indeed, when Caillebotte died in 1894, leaving his collection of sixty-five paintings to the nation, the Government received his gift with the greatest embarrassment. The prospect of seeing impressionist pictures in a museum aroused an uproar of protest from politicians, academicians, and critics, equaling and surpassing even the insults heaped upon the painters at the occasion of their first group exhibitions. Several official artists threatened to resign from the *Ecole des Beaux-Arts* and Gérôme summed up the position of the Institute with the words: "I do not know these gentlemen, and of this bequest I know only the title. . . . Does it not contain paintings by M. Monet, by M. Pissarro and others? For the Government to accept such filth, there would have to be great moral slackening. . . ."³⁷

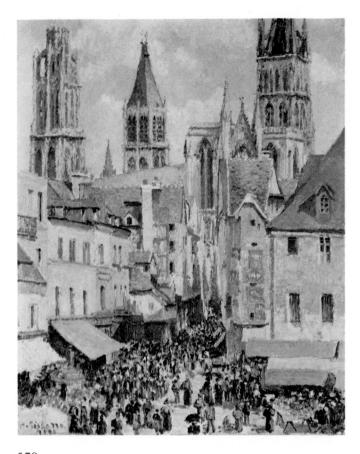

PISSARRO: Rue de l'Epicerie, Rouen, d. 1898. $31\frac{7}{8} \times 25\frac{5}{8}$ ". Metropolitan Museum of Art, New York (Mr. and Mrs. Richard J. Bernhard Fund).

Photograph of the same subject taken before its destruction in World War II.

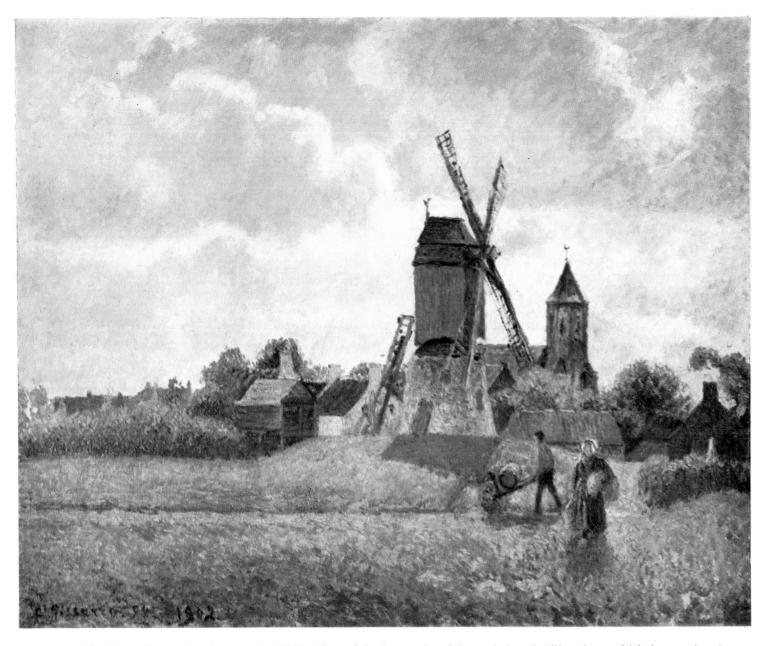

Pissarro: Windmill at Knocke, Belgium, d. 1894-1902. (One of the last works of the artist's pointillist phase which he repainted at a later date.) $25\frac{5}{8} \times 31\frac{7}{8}$ ". Collection Mr. and Mrs. Simon M. Jaglom, New York.

The State actually did not dare to accept the bequest as a whole. Despite Caillebotte's provision that his collection should enter the Luxembourg Museum undivided, Renoir, as executor of the will, was forced to yield unless the bequest were to be rejected. Of sixteen canvases by Monet, only eight were admitted; of eighteen by Pissarro, only seven; of eight by Renoir, six; of nine by Sisley, six; of four by Manet, two; of five by Cézanne, two; only Degas saw all seven of his works accepted.³⁸

Berthe Morisot—not represented in the Caillebotte collection—had held a very successful exhibition in 1892 at Boussod & Valadon's, an exhibition possibly planned by Theo van Gogh before his death. In 1894, when Duret sold his collection, she saw one of her paintings acquired by the State as a result of Mallarmé's intervention. Her work more than that of any of her colleagues remained faithful to the initial concepts of impressionism. Even the severe Seurat had not escaped the charm and freshness of her paintings and watercolors, the directness with which she expressed her delicate vision. But it was Renoir who was most fond of her. Since the late 'eighties he had been seeing her frequently and had painted portraits of her as well as of her young daughter. He considered her the last truly feminine artist since Fragonard and admired the "virginity" of her talent. She died in 1895 in the midst of the debates aroused by Caillebotte's bequest.

In the discussions and protests which raged around the Caillebotte donation, Cézanne's name was hardly ever pronounced, apparently because his case was judged so insignificant as not even to warrant mention. When, after the death of père Tanguy, an auction sale was held of his belongings in 1894, six paintings by Cézanne brought bids varying between 45 and 215 francs. At about the same time Pissarro spoke of Cézanne to a young dealer, Ambroise Vollard, who had recently established himself in the rue Laffitte, where most of the Paris galleries were then located. Vollard did not have a very sure taste in art and, at the beginning, showed little discrimination. Well aware of his lack of judgment, he gladly accepted the advice of others. He had the great good fortune to receive suggestions from Pissarro and occasionally from Degas, and was intelligent enough to follow them. Vollard thus yielded to Pissarro's insistence and went in search of Paul Cézanne, who sent him no less than one hundred and fifty paintings, more than Vollard could display at one time,³⁹ Vollard's show opened in the fall of 1895. After having been absent from Paris exhibitions for almost twenty years, Cézanne's works came as a great surprise. While the public was outraged and the critics judged his efforts with their customary ignorance and brutality, vanguard artists and Cézanne's former comrades greeted him as a master. Commenting on the show, Pissarro wrote his son: "My enthusiasm was nothing compared to Renoir's. Degas himself is seduced by the charm of this refined savage, Monet, all of us. . . . Are we mistaken? I don't think so. The only ones who are not subject to the charm of Cézanne are precisely those artists or collectors who have shown by their errors that their sensibilities are defective.... As Renoir said so well, these paintings have I-do-not-know-what quality, like the things of Pompeii, so crude and so admirable! . . . Degas and Monet have bought some marvelous Cézannes, I exchanged a poor sketch of Louveciennes for an admirable small canvas of bathers and one of his self portraits."40

Gauguin missed Cézanne's show by a few months. He had returned from Tahiti in 1893, had held an exhibition at Durand-Ruel's, and had again gone to Brittany.

Claude Monet, Giverny, 1890, drawn by Th. Robinson after a photograph. Formerly collection Mr. and Mrs. Carroll S. Tyson, Philadelphia.

 $\textbf{Morisot: Young Girl with Dog (H\'el\`ene Fourmanoire), 1892. } 25^3_4 \times 32''. \ Collection \ Mr. \ and \ Mrs. \ Harry \ Rubin, \ New \ York.$

Far left, Renoir: Paul Durand-Ruel, d. 1910. $25\frac{5}{8} \times 21\frac{1}{4}$ ". Private collection, Paris.

Left, Cézanne: Ambroise Vollard, 1899. 40¼ × 32½". Musée de la Ville de Paris, Petit Palais.

His Tahitian paintings had aroused considerable interest, especially among his young followers and their symbolist poet friends, who were attracted by unexpected and novel qualities in his art, by his extreme originality. His powerful, glowing pictures impressed them particularly by the boldness of conception, the naked brutality of forms, the radical simplification of drawing, the brilliance of the pure bright colors expressing states of mind rather than reality, by the ornamental character of his composition, and the willful flatness of planes. Yet of his former colleagues only Degas liked his work; Monet and Renoir found it simply bad. Gauguin had an argument with Pissarro, who was opposed to his mystical tendencies and also almost openly accused him of pillaging the savages of Oceania and adopting a style that did not belong to him as a civilized man.⁴¹ But Gauguin had no ear for these remonstrances. When reproached by an interviewer for the lack of verisimilitude in his color schemes, he pointed to the fact that Delacroix had once been charged with painting a purple horse, and defended the artist's right to use color arbitrarily if the harmony of his picture required it. Gauguin explained that his work was the fruit of calculation and meditation (avoiding the word "observation") and emphasized: "By arrangements of lines and colors, using as pretext some subject borrowed from human life or nature, I obtain symphonies, harmonies that represent nothing absolutely *real* in the vulgar sense of the word; they express no idea directly but they should make one think, as music does, without the aid of ideas or images, simply by the mysterious relationships existing between our brains and such arrangements of colors and lines."42

Gauguin asserted with disdain that the "impressionists studied color exclusively

in terms of decorative effect but without freedom, for they kept the shackles of representation... They look for what is near the eye, and not at the mysterious heart of thought... They are the official painters of tomorrow."⁴³ In spite of his complete break with the impressionists, however, Gauguin did not forget that it was to them, and particularly to Pissarro, that he owed his initiation. After he had left once more—this time finally—for Tahiti, early in 1895, he jotted in his notebook: "If we observe the totality of Pissarro's work, we find there, despite fluctuations, not only an extreme artistic will, never belied, but also an essentially intuitive, pure-bred art.... He looked at everybody, you say! Why not? Everyone looked at him, too, but denied him. He was one of my masters and I do not deny him."⁴⁴

In 1896 Vollard wrote to Gauguin in Tahiti, possibly on the advice of Degas, and eventually made a contract with him according to which he bought Gauguin's entire output.⁴⁵ Vollard thus became the sole depositor in Paris of the works both of Cézanne and of Gauguin. In the world of art Vollard's gallery took the place of père Tanguy's shop. But Vollard possessed neither the touching naiveté of the good old color grinder, nor the benevolent wisdom of Theo van Gogh. Under the mask of an often exaggerated indifference he concealed a shrewd business sense combined

Gauguin: Bathers, d. 1897. $23\frac{1}{2} \times 36\frac{1}{4}$ ". National Gallery of Art, Washington (Gift of Sam A. Lewisohn).

with a prudence incapable of enthusiasm. Meanwhile, Durand-Ruel's establishment gained steadily in importance. In 1894 the dealer had finally been able to pay all his debts and now became more active than ever before, not only in Paris and New York, but also in many European countries where exhibitions of impressionists were organized. While these met with increasing success in Germany, the English public remained aloof.⁴⁶

Whereas the fame of Monet and Renoir quickly spread abroad, Cézanne only now began his struggle for recognition. When, in 1896, one year after Cézanne's first one-man show at Vollard's, Zola wrote another article on art, he called him with unconscious cruelty an "abortive genius." And he expressed a strange regret at having once fought for the principles of the impressionists, explaining that it was their audacity rather than their ideas which he had defended. Hut when, in 1897, Zola courageously took up the desperate cause of Captain Dreyfus, Monet and Pissarro overcame their resentment and immediately supported him, repeatedly expressing their admiration for his action. Degas, on the contrary, joined the militarists, turned anti-Semitic and thenceforth avoided Pissarro, while Cézanne, prisoner of his bigoted environment in Aix, also failed to rally behind Zola in his fight for justice.

Sisley, during all those years, stayed completely in the background, living and working in retirement at Moret. The long period of incertitude and privation had left its mark on him much more than on his colleagues; he had become suspicious and surly, not even seeing his old companions any more who, however, bore him no ill will. He suffered from a temporary paralysis of the face caused by frequent work out-of-doors during the winter, yet graver still was the fact that—according to one of his intimates—he created further and often imaginary troubles for himself. "He was irritable, dissatisfied, agitated. With poignant and moving avidity he accepted any expression of consideration or interest from strangers, but almost immediately, full of suspicions, began to avoid these new friendships. . . . He grew constantly more unhappy and made life unbearable for himself. . . . Little by little all joy left his days, except for the joy of painting, which never abandoned him."48

Having severed relations with Durand-Ruel, Sisley signed a contract with Petit, making him the sole agent for his work. In 1888 Castagnary, as Director of Fine Arts, bought a landscape by Sisley for the State. The artist regularly exhibited at the Champ de Mars Salon.²⁰ He now tried to infuse his work with passion, although his character was more that of a subtle poet and dreamer; he was at his best when he abandoned himself to the delicacy of his perceptions. Asked who were the contemporary painters he liked best, he named only Delacroix, Corot, Millet, Rousseau, and Courbet, not mentioning any living artists, not even any of his former comrades.⁴⁹ Yet when, suffering from cancer of the throat, he felt that his end was near, he sent for Monet who hurried to his side. Little known, poor, full of resignation, Sisley died on January 29, 1899 (less than four months after his wife). Within one year after his death his paintings began to command fabulous prices.⁵⁰

Cézanne's prices began to pick up slowly at about the same time. This became apparent at the sale of Chocquet's collection in 1899, after the death of his widow. Urged on by Monet, Durand-Ruel bought many of the Cézanne paintings owned by Chocquet,⁵¹ while Vollard acquired for Cézanne a large watercolor of flowers by

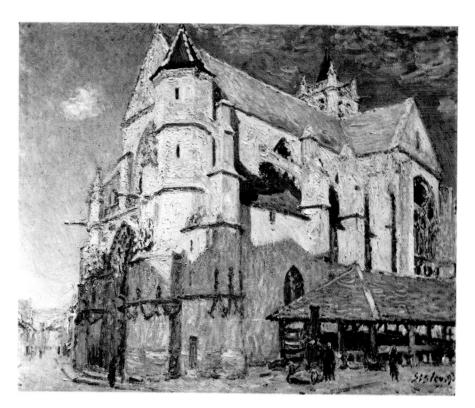

Sisley: The Church of Moret, d. 1893. $25\frac{5}{8} \times 31\frac{7}{8}$ ". Musée des Beaux-Arts, Rouen.

Delacroix which Cézanne had always admired among Chocquet's treasures. Shortly before the Chocquet sale Monet himself bought a canvas by Cézanne at an auction, and the high bid he put in caused a sensation at the Hôtel Drouot.

Cézanne's solitary life in Aix was now frequently interrupted by visits, mostly from young artists of Gauguin's entourage who came to ask him for advice. "I think the young painters much more intelligent than the others," he wrote with unconcealed satisfaction to his son; "the old ones see in me only a dangerous rival."52 From 1899 on he consented to show at the Salon des Indépendants, but his ambition was still to be accepted at the official Salon and even to be nominated to the Légion d'Honneur. It was apparently less a thirst for honors which prompted this desire than the wish to be at last considered "seriously" as a painter, especially since the townfolk of Aix continued to see him as merely a rich man's son who indulged in a harmless fancy. Yet intervention on his behalf by Mirbeau failed to make Cézanne's dream come true, while Renoir was decorated in 1900. Degas, Monet, and Pissarro, however, remained averse to anything connected with officialdom.

The steadily growing number of his followers from the younger generation compensated Cézanne, partly at least, for his failure to win official recognition. It made him sense the coming of a new era in art. He was deeply touched when Maurice Denis, who had never met him, exhibited in 1901 a large canvas, *Hommage à Cézanne*, at the Salon; it showed several artists, among them Redon, Vuillard, Bonnard, and

Denis himself (with Vollard in the background) gathered around a still life by Cézanne—the still life once owned by Gauguin. This composition, bought by André Gide, was conceived in the same spirit that had prompted Fantin to paint his Hommage à Delacroix, and Cézanne himself now frequently spoke of painting an Hommage à Delacroix in which he proposed to unite Pissarro, Monet, Victor Chocquet, and himself. He read again with delight Baudelaire's art criticism, admired his appreciation of Delacroix as well as the sureness of his judgment. He also frequently returned to the writings of Stendhal and the Goncourt brothers, and to Balzac's novel, Le chef-d'œuvre inconnu.

The young artists who came to visit Cézanne in Aix found a tall old man of almost exaggerated politeness, though he sometimes changed abruptly from cordiality to haughtiness.⁵³ Interested in nothing but art, he liked to talk about painting yet could show some irritation if pressed to formulate theories. He would take his visitors with him to the hills around Aix where he worked, insisting that "one says more and perhaps better things about painting when facing the motif than when discussing purely speculative theories—in which, as often as not, one loses oneself."⁵⁴ And he repeated again and again: "All things, particularly in art, are theory developed and applied in contact with nature."⁵⁵ He frequently complained about his difficulty—growing with age—of realizing his sensations, recognizing at the same time that the problems to be solved appeared ever clearer to him.

Gauguin's erstwhile "pupil" Emile Bernard, who had published a eulogy of Cézanne as early as 1892, paid him a first visit in 1904 and, through conversation as well as letters, induced Cézanne to formulate his concepts. Cézanne advised him to "see in nature the cylinder, the sphere, the cone, putting everything in proper perspective so that each side of an object or a plane is directed toward a central point."56 But when Bernard prepared another article on Cézanne, the old artist told him to paint rather than to write, explaining: "Painters must devote themselves entirely to the study of nature and try to produce pictures which are an instruction. Talks on art are almost useless. The work which goes to bring progress in one's own subject is sufficient compensation for the incomprehension of imbeciles. Literature expresses itself by abstractions whereas painting, by means of drawing and color, gives concrete shape to sensations and perceptions. One cannot be too scrupulous or too sincere or too submissive to nature; but one is more or less master of one's model, and above all, of the means of expression." And he insisted: "Get to the heart of what is before you and endeavor to express yourself as logically as possible."57

"I try to render perspective solely by means of color," Cézanne told a German collector who paid him a visit in Aix; "the main thing in a picture is to achieve distance. By that one recognizes a painter's talent." Using one of his landscapes as an example, he followed with his finger the limits of the various planes and showed exactly how far he had succeeded in suggesting depth and where the solution had not yet been found—there color would still be color without having become the expression of distance.⁵⁸

While he warned his friends to avoid the influence of Gauguin, van Gogh, and the neo-impressionists, Cézanne liked to speak of his former comrades, praising Renoir and especially Monet, evoking with particular tenderness the "humble and

Photograph of Cézanne taken in Aix in 1905 by Emile Bernard.

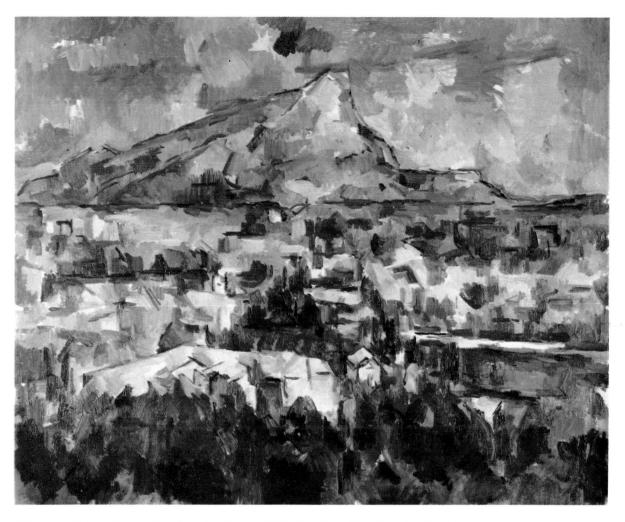

Cézanne: Sainte-Victoire Seen from Les Lauves, 1904-06, 294 x 37". Philadelphia Museum of Art.

colossal" Pissarro. When he was invited by a group of Aix artists to exhibit with them in 1902 and again in 1906, Cézanne—now over sixty and acclaimed by the new generation as their undisputed master—piously affixed to his name: "pupil of Pissarro." Pissarro never learned of this tribute, just as he never learned that Gauguin, in spite of his sarcasm and longing for independence, had remained conscious of his debt of gratitude.

Gauguin died lonely and embittered on one of the Marquesas Islands in May 1903; the news of his death had hardly reached Paris when Pissarro passed away peacefully, after a short illness, in November of the same year. He bequeathed six drawings by Seurat to the Luxembourg Museum. Whistler, too, died in 1903. One year before, Fantin had departed and Zola had succumbed to an accidental poisoning by coal gas; in 1901 Lautrec had gone, his health ruined by drinking.

In that same year, 1901, Vollard held his first exhibition of the works of a young Spaniard, Pablo Picasso, whose paintings were strongly influenced by Lautrec. Only four years earlier Picasso, then sixteen, had written from Madrid to a friend in Barcelona: "If I had a son who wanted to be a painter I would not let him live in Spain for one moment. And don't think I would send him to Paris (where I would gladly be myself), but to Munik (I don't know whether it is spelled like this). It is a town where one studies painting seriously without paying attention to fashions such as pointillism and others, which I am not against, except that others copy the author if he does well. I am not in favor of following any determined school because that only brings about a similarity among adherents."59 But when, at the turn of the century, Picasso eventually made his way to Paris, he no longer dreamt of going to Munich with its colorless and provincial academy. Instead, he became passionately engaged in the bubbling variety of tendencies with which the French capital confronted him. Yet he remained faithful to his decision not to follow "any determined school" and endeavored to absorb all the viable elements he gleaned left and right before launching on a long road of incessant personal discoveries and inventions. During his early years of formation, Picasso derived great benefit not only from the study of Lautrec, but also from Cézanne, whose works he could always contemplate at Vollard's.

Deeply afflicted by the deaths of Zola and Pissarro, Cézanne often spoke of his approaching end and swore that he would "die painting." For once fate granted his wish. On October 15, 1906, a thunderstorm surprised him while he was painting on a hill. He remained outside for several hours and was brought home unconscious in a laundry cart. The next day he went into his garden to work and returned dying. He passed away on October 22, 1906. (In the same year the Metropolitan Museum of New York acquired Renoir's Portrait of Mme Charpentier and her Children.)

Of the old-guard impressionists now only three remained; Monet, vigorous, hardworking, conscious of his world-wide reputation, surrounded by numerous admirers, among whom were many American artists⁶⁰ and collectors; Degas, threatened by total blindness; and Renoir, increasingly crippled by rheumatism, yet joyful, painting in spite of extreme physical difficulties. Suffering continually, plagued by insomnia, his fingers helplessly cramped, he eventually worked with brushes attached to his wrist and considered that he had no right to complain since things might have been worse. Manifesting a particular preference for red, from the pinkish red of flesh to the purplish red of roses, he delighted in retaining the fluidity of living forms in a large array of red nuances, modeling volumes with subtle strokes, an expression of his immense knowledge as well as of his ingenuity and eternal freshness.

Fame and fortune in no way affected him. He continued as best he could "to put colors on canvas in order to amuse myself" and merely stated: "I believe that I deserve my little success since I have worked very hard." When his young friend, the painter Albert André, prepared a short text on Renoir, the old master asked him not to reveal the composition of his palette, explaining: "I don't mean to make a mystery of the colors I use, but I fear that others might think I intend to advise them, and that I abhor." 61

In 1908, when questioned by the American painter, Walter Pach, concerning his method, Renoir replied: "I arrange my subject as I want it, then I go ahead and

Picasso: Self Portrait, Barcelona, 1897. Conté crayon, $12\frac{5}{8} \times 9\frac{3}{4}$ ". Present whereabouts unknown.

Renoir: Bather, d. 1892. $32 \times 25\frac{1}{2}$ ". Formerly owned by Monet. Metropolitan Museum of Art, New York (Robert Lehman Collection).

paint it, like a child. I want a red to be sonorous, to sound like a bell; if it doesn't turn out that way, I put more reds or other colors till I get it. I am no cleverer than that. I have no rules and no methods; anyone can look at my materials or watch how I paint—he will see that I have no secrets. I look at a nude; there are myriads of tiny tints. I must find the ones that will make the flesh on my canvas live and quiver. Nowadays they want to explain everything. But if they could explain a picture it wouldn't be art. Shall I tell you what I think are the two qualities of art? It must be indescribable and it must be inimitable. . . . The work of art must seize upon you, wrap you up in itself, carry you away. It is the means by which the artist conveys his passion; it is the current which he puts forth which sweeps you along in his passion."62

This passion was never to leave Renoir, it even seemed to increase with age. In 1912 he had to submit to a serious operation which failed to benefit him. In December of that year Durand-Ruel, with whom Renoir always maintained the most cordial relations, found him in Cagnes, where he was living permanently, "in the same sad condition, but always amazing in his strength of character. He can neither walk nor even raise himself from his chair. Two people have to carry him everywhere. What torment! And along with this the same good humor and the same happiness when he is able to paint." 63

Renoir: Studies of nudes, the artist's children, and his wife, c. 1888. $17\frac{7}{8} \times 15\frac{3}{8}$ ". Private collection, Montreal.

Renoir: Portrait of Ambroise Vollard as a Toreador, 1917. $10\frac{1}{2} \times 32\frac{3}{4}$ ". Private collection, New York.

Like Cézanne, Renoir achieved in his last years the synthesis of his lifelong experience. Impressionism lay far behind him; he retained merely the glistening texture of it, yet the shimmering surface of pigment he used now not to render atmospheric effects but to build with brilliant and strong colors an image of life in almost supernatural intensity. The study of nature no longer was his unique goal. "How hard it is," he explained to a young painter, "to find exactly the point at which imitation of nature must cease in a picture. The painting must not smell of the model and yet one must be conscious of nature."

In attaining the balance between observation and vision, the aging Renoir created a new style, crowning his work by a series of masterpieces, exalted in color, subtle in rhythm, forceful in volumes, and rich in invention, progressing from canvas to canvas with fertile imagination and happy rendition. His modesty made him wonder frequently during his last years whether his work was worthy of the great French tradition to which he felt himself more and more attached, considering his own efforts as a continuation of the eighteenth century. When a painting of his was placed in the National Gallery in London in 1917, some hundred English artists and collectors seized the opportunity of sending Renoir a testimonial of their admiration. "From the moment your picture was hung among the famous works of the old masters," they wrote, "we had the joy of recognizing that one of our contemporaries had taken at once his place among the great masters of the European tradition."65 Nothing could have pleased Renoir more, for he never tired of proclaiming that "though one should take care not to remain imprisoned in the forms we have inherited, one should neither, from love of progress, imagine that one can detach oneself completely from past centuries."66 And he emphasized: "Nature brings one isolation. I want to stay in the ranks."62

Absorbed in his work, living only during those hours which he could give to his

Photograph of Renoir painting the German actress Tilla Durieux, 1914.

Opposite, Renoir: Portrait of Tilla Durieux, d. 1914. $32 \times 26\frac{5}{8}$ ". Metropolitan Museum of Art, New York (Bequest of Stephen C. Clark).

art, he pitied Degas, who by this time was entirely isolated from the outer world, unable to work, unable to enjoy the rich collection of paintings and drawings gathered through many years (in which Ingres shared honors with Delacroix, Cézanne, and Gauguin), and who wandered aimlessly through the streets of Paris while the battles of the first World War raged not far from the city. When Durand-Ruel informed Renoir of Degas' death in September 1917, his answer was: "It is indeed the best for him.... Every imaginable kind of death would be better than to live as he was living." Renoir was spared a similar fate; for in spite of two decades of physical suffering he was able to work until the very end. He died on December 3, 1919.

Two years later, early in 1922, Paul Durand-Ruel passed away at the age of ninety. He had lived long enough to see glory come to his painters, glory of a magnitude never dreamt of by the artists themselves nor by the dealer who more than half a century before had, with unerring instinct, supported their seemingly hopeless cause.

On June 19, 1926, Mary Cassatt died at her Château Beaufresne near Beauvais. Like Degas she had been afflicted during the latter part of her life with partial blindness which, after 1912, increased until it became almost complete toward the end. A few months later, in December 1926, Claude Monet was buried in the small cemetery of Giverny, at the close of his eighty-seventh year. Guillaumin died at the same age in June 1927.

With the death of Monet the last member of that unique and astonishing pleiad which had constituted the impressionist group disappeared. He died, like Ingres, at a time when the ideas that he personified had long ceased to belong to actuality. The first of the impressionist painters to achieve success, the only one of them to see it turn into a real triumph, he lived to witness his isolation and must have felt some bitterness that the vision which it had taken so many years to impose was most violently attacked by the younger generations. "Techniques vary," he told his friend Geffroy, "art stays the same: it is a transposition of nature at once forceful and sensitive. But the new movements, in the full tide of reaction against what they call 'the inconsistency of the impressionist image,' deny all this in order to construct their doctrines and preach the solidity of unified volumes."68 Yet it was not recent art movements which preoccupied him during his last years, but the past with which history will forever identify his name. In a letter written shortly before his death, Monet tried to sum up his contribution: "I have always had a horror of theories. . . . I have only the merit of having painted directly from nature, trying to convey my impressions in the presence of the most fugitive effects, and I am distressed at having been the cause of the name given to a group of which the majority was not at all impressionist."69

This regret expressed by Monet in the evening of his life seems strange. Might he not have felt some pride in having provided, though involuntarily, a name for a movement that had added one of the most glorious chapters to the history of art? Forty years had passed since the group of Monet's friends had definitely dissolved, but impressionism was not dead because the men who had promoted it had ceased to be impressionists. Even though it was no longer a battle-cry, it remained a living inspiration to those who came afterwards. Its achievements had become the common

Photograph of Claude Monet, 1926.

heritage of mankind on which to base new conquests. It was true, though, that the younger generation had ended by discarding most of the impressionist principles, that fauvists, cubists, expressionists, futurists, dadaists, surrealists had opened entirely new horizons. Yet their efforts had been fertilized by Cézanne, Gauguin, van Gogh, and Seurat, all of whom had gone through impressionist experiences. While the direct influence of impressionism on contemporary art may sometimes seem negligible, while Bonnard was the last of the masters who continued to develop a style of his own in a truly impressionist spirit, it was the art of Monet and his companions which broke down countless prejudices and opened the road for steadily increasing boldness of technique, color, and abstraction.

The impressionists lived to see their concepts partly adopted by officialdom, diluted, polished, adapted to petty standards, and this evolution has not yet stopped. But uninspired followers can merely obscure the luster of an achievement, they cannot tarnish the sources from which they draw. Ingres' pupils once succeeded in vulgarizing their master's principles, yet they were not able to kill classicism, and the present generation has even returned to some of the ideas preached by the man who in his day seemed to personify the obstacle to progress. Impressionism, which contributed its generous share to freeing the world of art from the despotism of misunderstood tradition, may now take its place among the great traditions. And like all traditions it will be rejected at times, only to be rediscovered later; it will remain for periods unexplored or become a vital factor in new efforts. It will be admired as much as it will be opposed, but it will never be ignored.

Impressionism will thus live on as one of the most important phases of the history of modern art, a phase superseded in the eighteen-eighties by another, the representatives of which were partly identical with those of impressionism. It was one of them, Gauguin, who formulated the problems which assailed the artists anxious to advance beyond impressionism: "It was necessary to throw oneself heart and soul into the struggle, to fight against all schools, all without exception, not by disparaging them but by something different, by outraging not only officialdom, but even the impressionists, the neo-impressionists, the old and the new public . . . to take up the strongest abstraction, do all that had been forbidden, and rebuild more or less successfully, without fear of exaggeration, even with exaggeration. To learn afresh, then, though you know, learn again. To overcome all fears, no matter what ridicule might be the result. Before his easel, the painter is not the slave either of the past or the present, either of nature or his neighbor. He is himself, still himself, always himself."70

This struggle was to lead to unexpected results. Begun by Cézanne, Seurat, Gauguin, van Gogh, Toulouse-Lautrec, it was to be continued by new men, Picasso, Matisse, and countless others, who carried on from where their elders had left off. Once again history furnished striking proof that it engraves its dates not on tombs but on milestones; the one which bears the date 1886 is the symbol both of an end and of a beginning. From the dissolution of the movement created by Monet and his friends it points to the equally fertile period of post-impressionism.

- 1 Many events which occurred between 1886 and 1893, treated here in passing, are covered extensively in the sequel of this book: Post-Impressionism—From van Gogh to Gauguin, New York, 1956. This applies particularly to Gauguin's trip to Martinique and his sojourns at Pont-Aven and Le Pouldu; van Gogh's stay at Arles and Gauguin's visit with him there; van Gogh's illness and his suicide at Auvers; the emergence of the neo-impressionist group around Seurat; the exhibitions organized by Les XX in Brussels; Gauguin's show at the Café Volpini in 1889 and his auction sale two years later; the death of Seurat; Gauguin's first trip to Tahiti, as well as the symbolist movement in literature, the roles played by Bernard, Redon, Theo van Gogh, etc., etc. As to the succeeding years, until 1906, from the formation of the Nabi group to the Fauves, from Toulouse-Lautrec, the douanier Rousseau, and Gustave Moreau's pupils to the last years of Gauguin and Cézanne, they will be the subject of a forthcoming second volume on post-impressionism: From Gauguin to Matisse.
- 2 Pissarro to his son, May 15, 1887; see Camille Pissarro: Letters to His Son Lucien, New York, 1943, p. 110.
- 3 Pissarro to his son, May 14, 1887; ibid., p. 107-108.
- 4 Renoir to Durand-Ruel, May 12, 1887; see L. Venturi: Les Archives de l'Impressionnisme, Paris-New York, 1939, v. I, p. 138.
- 5 Theo van Gogh to Gauguin (then with Vincent in Arles), Paris, Nov. 13, 1888; see J. Rewald: Theo van Gogh, Goupil, and the Impressionists, Gazette des Beaux-Arts, Jan., Feb. 1973.
- 6 Gauguin to Schuffenecker, August 1888; see C. Roger-Marx: Lettres inédites de Vincent van Gogh et de Paul Gauguin, Europe, Feb. 15, 1939.
- 7 Vincent to Theo van Gogh, Aug. 1888; see: Verzamelde Brieven van Vincent van Gogh, Amsterdam, 1953, v. III, No. 520, p. 276.
- 8 Vincent to Theo van Gogh, May 1888; *ibid.*, No. 490, p. 220.
- 9 Gauguin to Schuffenecker, Oct. 8, 1888; see Roger-Marx, op. cit. This letter is accompanied by the sketch reproduced p. 550.
- 10 Vincent to Theo van Gogh, Dec. 1888, op. cit., No. 564, p. 363.
- 11 Pissarro to Fénéon, Feb. 1, 1889; see J. Rewald: Georges Seurat, New York, 1943, p. 79, note 134.
- 12 Pissarro to H. van de Velde, March 27, 1896; ibid., p.68.
- 13 See L. Cabot Perry: Reminiscences of Claude Monet from 1889 to 1909, *The American Magazine of Art*, March 1927.

- Monet's words bring to mind a Courbet anecdote: painting near Marly, the artist once included a grey object in his landscape although he could not clearly distinguish it. He asked a friend to go and see what this object was; his companion was amazed to recognize on Courbet's canvas the distant wood-pile he had gone to investigate. "I did not know what it was," Courbet told him. "I painted what I saw without knowing." See G. Riat: Gustave Courbet, Paris, 1906, p. 72.
- 14 See G. Geffroy: Claude Monet, sa vie, son oeuvre, Paris, 1922, v. I., ch. XXXIII.
- 15 Renoir to Roger Marx, July 10, 1888; see C. Roger-Marx: Renoir, Paris, 1937, p. 68.
- 16 On this subject see J. Rewald: Chocquet and Cézanne, Gazette des Beaux-Arts, July-Aug. 1969.
- 17 Cézanne to Maus, Nov. 27, 1889; see Cézanne, Letters, London, 1941, p. 190.
- 18 C. Waern: Some Notes on French Impressionism, Atlantic Monthly, April 1892.
- 19 Probably Gauguin's Christ in Gethsemane or Bonjour M. Gauguin reprod. in Post-Impressionism, op. cit., p. 307 and 295.
- 20 In 1890 a group of artists had seceded from the official Société des Artistes Français, organizer of the yearly Salons, and formed the slightly more liberal Société Nationale des Beaux-Arts, which held its exhibitions on the Champ de Mars. Sisley was invited to become an "associate member" of the dissident society and showed at its Salons; see F. Daulte: Alfred Sisley, Lausanne, 1959, p. 34.
- 21 J. Rohde: Journal fra en Rejse i 1892, Copenhagen, 1955, p. 88-92.
- 22 M. Denis: Cézanne, L'Occident, Sept. 1907, reprinted in Denis: Théories, Paris, 1912.
- 23 Information courtesy the late L. R. Pissarro; see also A. Basler: La Peinture . . . Religion nouvelle, Paris, 1926, p. 62.
- 24 See M. Joyant: Henri de Toulouse-Lautrec, Paris, 1926, v. I, p. 118-119.
- 25 See Pissarro's letters to his son, Nov. 23, 1893, and April 20, 1891, *op. cit.*, p. 221 and 163-164.
- 26 See Mirbeau's letter to Monet, Feb. 1891, Cahiers d'Aujourd'hui, No. 9, 1922; also Pissarro's letter to his son, May 13, 1891, op. cit., p. 170. The painting is reproduced in Post-Impressionism, op. cit., p. 203.
- 27 See L. Vauxcelles: Un après-midi chez Claude Monet, L'Art et les Artistes, Dec. 1905.
- 28 See L. Cabot Perry, op. cit.; also Duc de Trévise: Le

- pèlerinage de Giverny, Revue de l'art ancien et moderne, Jan.-Feb. 1927, and Monet's letter to Geffroy, Oct. 7, 1890, Geffroy, op. cit., v. II, ch. X.
- 29 W. Kandinsky: Rückblick—1901-1913, Berlin, 1913, quoted in W. C. Seitz: Claude Monet—Seasons and Moments, New York, 1960. When told about Kandinsky's reaction Monet laughed heartily and thought it very funny (information courtesy Dr. Ernest L. Tross, Denver, Col.).
- 30 See W. Weisbach: Impressionismus—Ein Problem der Malerei in der Antike und Neuzeit, Berlin, 1910-11, v. II, p. 141.
- 31 See Pissarro's letters to his son, July 8 and 10, 1888, op. cit., p. 127.
- 32 See J. Rewald: Degas, Works in Sculpture, A Complete Catalogue, New York, 1944, 1957.
- 33 Degas to de Valernes, Oct. 26 [1890]; see: Lettres de Degas, Paris, 1931, p. 181.
- 34 See P. Valéry: Degas, Dance, Dessin, Paris, 1938, p. 12.
- 35 From Berthe Morisot's notebook; see M. Angoulvent: Berthe Morisot, Paris, 1933, p. 76. On this subject see also p. 92, note 34.
- 36 Information courtesy the late Professor Paul J. Sachs, to whom this incident was told by Mlle Dihau; see also G. Mack: Toulouse-Lautrec, New York, 1938, p. 59-62.
- 37 Gérôme quoted by A. Leroy: Histoire de la peinture française, 1800-1933, Paris, 1934, p. 165-168. On the Caillebotte bequest see also H. Bataille: Enquête, Journal des Artistes, 1894; O. Mirbeau: Le Legs Caillebotte et l'Etat, Le Journal. Dec. 24, 1894; Geffroy, op. cit., v. II, ch. VI; Vollard: Renoir, ch. XIV; G. Mack: Paul Cézanne, New York, 1935, p. 331-337; A. Tabarant: Le peintre Caillebotte et sa collection, Bulletin de la vie artistique, Aug. 1, 1921; and G. Bazin: French Impressionists in the Louvre, New York, 1958.
- 38 For a discussion of the number of accepted works see Mack: Paul Cézanne, and Renoir's statement, quoted by Leroy, op. cit., p. 167, also Bazin, op. cit., p. 44-48, who provides many details on the bequest.
- 39 See A. Vollard: Cézanne, ch. V and Rewald: Paul Cézanne, New York, 1948, p. 180-182.
- 40 Pissarro to his son, Nov. 21, 1895; op. cit., p. 275-276.
- 41 See Pissarro's letter to his son, Nov. 23, 1893; op. cit., p. 221.
- 42 Gauguin quoted by E. Tardieu: La peinture et les peintres, M. Paul Gauguin, *Echo de Paris*, May 13, 1895.
- 43 Gauguin: Diverses Choses [1902-1903], quoted by J. de Rotonchamp: Paul Gauguin, Paris, 1925, p. 243.
- 44 Gauguin: Racontars d'un rapin, Sept. 1902, ibid., p. 237.

- 45 See: Paul Gauguin, Letters to A. Vollard and A. Fontainas, San Francisco, 1943.
- 46 See Rewald: Depressionist Days of the Impressionists, Art News, Feb. 15-28, 1945.
- 47 On Zola's article see Rewald: Cézanne, op. cit., p. 158-161.
- 48 A. Alexandre: Introduction to the Catalogue: Vente Alfred Sisley, Paris, Galerie Georges Petit, May 1, 1899.
- 49 See Tavernier, article on Sisley in L'Art Français, March 18, 1893.
- 50 In 1900 Camondo, at the sale of Sisley's friend Tavernier, paid 43,000 francs for Sisley's Flood at Port-Marly, reproduced p. 378, for which the artist had received 180 frs.
- 51 At the Chocquet sale, Cézanne's paintings reached a total of over 50,000 francs, the average price being 1,600 francs; the highest bid was made by Camondo who paid 6,200 francs for *La maison du pendu*. On this sale see J. Rewald: Chocquet and Cézanne, *op. cit*.
- 52 Cézanne to his son, Oct. 15, 1906; see Cézanne, Letters, op. cit., p. 273.
- 53 On Cézanne's last friendships see Rewald: Cézanne, Geffroy et Gasquet, Paris, 1960.
- 54 Cézanne to Camoin, Jan. 28, 1902; see Cézanne, Letters, op. cit., p. 218.
- 55 Cézanne to Camoin, Feb. 22, 1903; ibid., p. 228.
- 56 Cézanne to Bernard, April 15, 1904; ibid., p. 234.
- 57 Cézanne to Bernard, May 26, 1904; ibid., p. 236-237.
- 58 See Rewald: Cézanne, op. cit., p. 195-196.
- 59 Picasso to Bas, Madrid, Nov. 1897; see catalogue of the exhibition: Picasso—His Blue Period (1900-1905), Sidney Janis Gallery, New York, April-May 1960.
- 60 On Monet's friendship with Robinson see J. Baur: Theodore Robinson, Brooklyn, 1946, and Robinson: Claude Monet, Century Magazine, Sept. 1892; also the exhibition catalogue: Claude Monet and the Giverny Artists, Slatkin Galleries, New York, March-April 1960.
- 61 Unpublished notes by Albert André. According to Renoir's paint dealer, Moisse, the artist's orders did not vary during his last twenty-five years. His palette was composed of: white lead, antimony yellow, yellow ochre, raw umber, superfine carmine, Venetian red, French vermilion, madder lake, emerald green, cobalt blue and ivory black. Renoir never used cadmium yellow but quantities of Naples yellow. Monet's palette consisted of white lead, cadmium yellow (light, dark and lemon), ultramarine, lemon yellow, vermilion, cobalt violet (light), superfine ultramarine, emerald green. (See Tabarant: Couleurs, Bulletin de la vie artistique, July 15, 1923.) On Monet's palette see also R. Gimpel: At

Giverny with Claude Monet, Art in America, June 1927. Pissarro's palette was composed, according to the private notes of Louis Le Bail, of the six rainbow colors: white lead, light chrome yellow, Veronese green, ultramarine or cobalt blue, dark madder lake, and vermilion.

- 62 See W. Pach: Renoir, Scribner's Magazine, 1912, reprinted in Pach: Queer Thing, Painting, New York, 1938.
- 63 Letter by Paul Durand-Ruel, Dec. 1912; see Venturi: Archives, op. cit., v. I, p. 107.
- 64 See A. André: Renoir, Paris, 1928, p. 42.

SOURCES OF ILLUSTRATION

Amsterdam, Stedelijk Museum: 363 1. Adr. Bijl: 390

Bremen, Stickelmann: 149, 186 r.

Buffalo, Sherwin Greenberg Studio, Inc.: 14 1.

Charlottesville, William C. Seitz, 128 r.

Cologne, Galerie Abels: 359 b.

Copenhagen, Ny Carlsberg Glyptotek: 27 1., 452

Essen, Liselotte Witzel: 181

Hamburg, Kleinhempel: 329

Lausanne, François Daulte: 98. Mme Renée A. Daulte: 110 t., 111, 120, 182 l. and r., 184 l., 253, 471

London, A. C. Cooper & Sons: 528. Courtauld Institute of Art: 347 b., 477.

Marlborough Fine Art Ltd.: 46. Sotheby & Co.: 270, 353

New York, Oliver Baker Associates, Inc.: 573. Brenwasser: 65. Rudolph Burckhardt: 44, 418 t., 444. Carroll Carstairs: 331. Colten: 371. Gutmann (Wolf): 349. Helga Photo Studio: 491. Hirschl & Adler Galleries Inc.: 408 1. Peter A. Juley & Son: 55 r., 94 r. M. Knoedler & Co., Inc.: 34, 70, 151, 164, 208, 212, 263, 280, 290, 343, 383, 438, 512. Paulus Leeser: 517. Marlborough-Gerson Gallery Inc.: 231. James Mathews: 17. Metropolitan Museum of Art: 204. Museum of Modern Art: 433 r., 484. O. E. Nelson: 155 t., 159. Parke-Bernet Galleries, Inc.: 493, 552 t. John Rewald: 118 1., 227, 318, 343, 517, 570 r. Paul Rosenberg & Co.: 219, 251 1., 299 1., 344 b., 362 r., 393, 529, 571. Sam Salz: 41, 132, 297, 389. John D. Schiff: 51, 129. Jacques Seligmann & Co., 552. E. & A. Silberman Galleries: 397. Soichi Sunami: 466, 501 1. and r., 567. E. V. Thaw & Co.: 583. Taylor & Dull at Parke-Bernet: 569. Wildenstein & Co.: 18, 113 r., 145, 156, 201, 238, 248, 287, 291, 365, 367, 379, 462, 469 t., 494 1., 505, 507 t., 537, 539, 555, 561 r.

Oslo, Ragnar Moltzau: 355 1.

Paris, Adelys: 557. Agraci: 118 r. Archives Photographiques:

- 65 See C. Bell: Since Cézanne, London, 1922, p. 73.
- 66 See Renoir: Letter to Mottez, published as introduction to: Le livre d'art de Cennino Cennini, Paris, n.d. [1911].
- 67 Renoir to Durand-Ruel, Sept. 30, 1917; see Venturi: Archives, op. cit., v. I, p. 212-213.
- 68 Monet quoted by Geffroy, op. cit., v. II, ch. XXXIII.
- 69 Monet to Charteris, June 21, 1926; see E. Charteris: John Sargent, London, 1927, p. 131.
- 70 Gauguin: Racontars d'un rapin, Sept. 1902, quoted by de Rotonchamp, op. cit., p. 241.

59 b., 121 1., 124, 169, 183, 222 1., 240 r., 274, 315, 322, 332 t., 356, 363, 384, 387. Bernheim-Jeune: 147, 465. Braun & Co.: 96 r., 280 r. Alfred Daber: 240 1. I.-E. Bulloz: 30, 99 b., 108 b., 192 1., 203 r., 308, 433 1., 437, 574 r. Durand-Ruel: 43, 55 1., 57, 61 r., 95, 99 b., 105, 108 t., 115 t. and b., 122, 140 c. and r., 155 b., 158 r., 198, 257, 262 b., 284, 286 t. and b., 299, 350 1., 352 b., 368 r., 369, 381, 382, 410, 414, 442 r., 459, 468, 475, 489 1., 532 b., 541 r., 574 1. Giraudon: 84, 104, 148, 177, 189 1., 221, 235, 330 a. and b., 317, 337, 361, 378, 398. Mme Julie Manet-Rouart: 125, 366 t., 469 b. Edward Molyneux: 251 r., 348 t. L.-R. Pissarro: 213. Maurice Poplin: 49, 62 c. and r., 114 r. Service Photographiques des Musées Nationaux: 163, 247, 296 r., 304, 411 t. Marc Vaux: 288 t. Vizzavona: 15 r., 146, 173, 346, 409, 419, 507 b. Daniel Wildenstein: 68 b.1., 316. Galerie Zak: 489 r.

Philadelphia, Pennsylvania Academy and/or Philadelphia Museum of Art: 130 t., 165 1., 216, 241 1., 276 t. Alfred J. Wyatt: 422

Rome, Professor Lionello Venturi: 105 t.

Rouen, Monique Porée: 577

Washington, D. C., National Gallery of Art: 443. Schwartz: 78, 536

The following illustrations were made after reproductions in books, periodicals, catalogues, and various documents: 13, 23, 24, 27 c., 29, 36 1. and r., 47 1. and r., 52, 64, 74 1. and r., 75, 80, 81, 88, 91, 101 t., c. and b., 102, 140 1., 162, 172, 180 r., 188 t. and b., 192 r., 196 b., 198 b., 220, 246, 261 1. and r., 276 b., 341, 342, 350 r., 354 t. and b., 358 1., 376, 377, 394 t. and b., 399, 402 t., 403 1., 405 1., 409 1., 434, 441 1., 447, 448, 450, 451 b., 457 b. 1., 461 b., 482, 488, 503 1., 508, 519, 522 1. and r., 526, 532 t., 533, 543, 550 t., 558, 566, 578, 580, 584, 586.

All other illustrations were made after photographs kindly provided by the owners of the various works.

Abbreviations: b., bottom; c., center; l., left; r., right; t., top.

LIST OF PARTICIPANTS IN THE VARIOUS GROUP SHOWS

	1874	1876	1877	1879	1880	1881	1882	1886		1874	1876	1877	1879	1880	1881	1882	1886
Astruc									Maureau								
Attendu									Meyer								
Béliard									Millet, J. B.								
Boudin									de Molins								
Bracquemond, F.									Monet								
Bracquemond, Mme									Morisot								
Brandon	* 1								Mulot-Durivage								
Bureau									de Nittis								
Caillebotte									Ottin, A.								
Cals									Ottin L.								
Cassatt									Piette								
Cézanne									Pissarro, C.								
Colin									Pissarro, L.								
Cordey									Raffaëlli								
Debras									Redon								
Degas									Renoir								
Desboutin									Robert								
Forain									Rouart								
François									Schuffenecker								
Gauguin									Seurat								
Guillaumin									Signac								
Lamy									Sisley								
Latouche									Somm								
Lebourg									Tillot								
Legros									Vidal								
Lepic									Vignon								
Lépine									Zandomeneghi								
Levert																	

	CONTEMPORARY EVENTS	MANET born Paris, Jan. 25, 1832	DEGAS born Paris, July 19, 1834	PISSARRO born St. Thomas, July 10, 1830	CÉZANNE born Aix, Jan. 19, 1839
1855	Crimean War (Guys reporter)	pupil of Couture at Ecole des Beaux-Arts	law student; visits Ingres copies in Louvre since 1853	arrives in Paris from Virgin Islands	at college in Aix; friendship with Zola
	PARIS WORLD'S	FAIR WITH LARGE RE	EPRESENTATION OF I	NGRES, DELACROIX, F	ROUSSEAU
	Baudelaire writes eulogy of Delacroix Guys returns to Paris; Whistler arrives there Duranty prepares periodical, <i>Le</i> <i>Réalisme</i> (published 1856-57)		abandons study of law April: enters <i>Ecole des</i> <i>Beaux-Arts</i> ; works under Lamothe summer trip to south of France and Italy	pays visit to Corot works briefly at <i>Ecole</i> des Beaux-Arts; later at Académie Suisse	
1856- 1857	death of Chassériau, 1856 Bracquemond discovers Hokusai's Mangwa Delacroix elected to Institut de France, 1857 Flaubert prosecuted for alleged immorality of Madame Bovary Baudelaire fined for breach of public morals (Fleurs du Mal) crinoline comes into fashion Wilde, Moréas born	leaves Couture's studio in 1856 travels in Germany, Holland, Italy, etc. (?) makes copies of old masters at the Louvre where he worked al- ready in 1850 and 1852	JanApr. in Paris travels in Italy; Flo- rence, Rome, Naples	works in Montmorency and countryside around Paris	
1858- 1859	Baudelaire writes Salon review, 1859 Bergson, Wilhelm II, Seurat born Darwin publishes <i>Origin of Species</i> Bonvin shows rejected works by Fantin and Whistler Hugo refuses Emperor's amnesty, publishes <i>La Légende des Siècles</i>	rejected at the Salon, 1859, in spite of inter- vention of Delacroix copies at the Louvre	death of his grand- father in Naples (1858) paints in Florence Portrait of the Bellelli Family; visits Pisa makes copies in Rome, Siena (1859) works in own studio in Paris, rue Madame	works in Montmorency and La Roche-Guyon exhibits landscape at the Salon, 1859 meets Monet at Acadé- mie Suisse at about this time his parents settle in Paris	student of law father acquires Jas de Bouffan (1859) wants to become painter
1860	large exhibition of paintings by Delacroix, Millet, etc. Courbet works in Honfleur Baudelaire rejected by Académie Française Schopenhauer dies; Ensor born	rents a studio in the Batignolles quarter, Paris	paints Young Spartans Exercising spends April in Florence his Italian friend Martelli comes to Paris	works in countryside around Paris; meets Chintreuil, Piette falls in love with Julie Vellay, born 1838, his mother's maid	father opposes artistic career
1861	start of American Civil War Delacroix finishes StSulpice fres- coes; Corot works in Fontaine- bleau Victor Emmanuel becomes King of Italy (Garibaldi) Mary Cassatt studies at Penn- sylvania Academy of Fine Arts (1861-65)	great success at the Salon, obtains honorable mention; meets Baudelaire, Duranty, etc. exhibits at Martinet's	paints Semiramis Founding a Town and other historical subjects autumn in Normandy (Menil-Hubert) with the Valpinçons interested in horses and racing subjects copies at the Louvre	rejected at the Salon meets Cézanne and Guillaumin at Académie Suisse paints in Montmartre applies for permit to copy at the Louvre	quits law and goes to Paris; meets Pissarro at Académie Suisse returns discouraged to Aix; enters father's bank
1862	Courbet opens a studio: JanApril Nobel uses nitro-glycerin as explosive Hugo publishes Les Misérables; Dostoevski: House of Death Maeterlinck, Briand, Debussy born	paints Concert in the Tuileries Gardens meets Degas praised by Baudelaire death of his father, substantial inheritance	paints at the races in Longchamps meets Manet friendship with Duranty	Julie Vellay expecting	quits father's bank takes up painting again returns to Paris apparently fails entrance examinations for Ecole des Beaux-Arts

MONET born Paris Nov. 14, 1840	RENOIR born Limoges, Feb. 25, 1841	SISLEY born Paris, Oct. 30, 1839	BAZILLE born Montpellier, Dec. 6, 1841	MORISOT born Bourges, Jan. 14, 1841	GAUGUIN born Paris, June 7, 1848
lives with parents in Le Havre	lives in Paris since age of four	lives in Paris; his parents are British	lives in Montpellier	lives in Paris	lives in Lima, Peru
	COURBET	EXHIBITS IN HIS OW	N <i>PAVILLON DU RÉAL</i>	ISME	
			goes to school in Mont- pellier		returns from Pe- ru'with widowed mother lives in Orléans
draws caricatures in Le Havre	apprentice porcelain painter takes evening courses in drawing	when eighteen sent to England by parents to learn the language and prepare for commercial career (cotton, coffee)		studies painting with Chocarne, later Gui- chard (pupil of Ingres and Delacroix) admires a drawing by Ingres at her music teacher's (Stamaty)	goes to school in Orléans
meets Boudin in 1858 goes to Paris, May 1859 with introduction for Troyon and Monginot from Boudin; Troyon advises him to study with Couture; frequents Brasserie des Martyrs	gives up painting on porcelain; paints stores, fans, etc.—decides to become artist but has to earn his tuition	remains in London for four years (1857-1861) visits museums, more interested in Turner and Constable than in commerce		copies at the Louvre with her sister Edma; there meets Fantin and Bracquemond admires Rousseau, Daubigny, Millet, but above all Corot	enters the Petit Seminaire in Or- léans
works at <i>Académie Suisse</i> paints at Champignysur-Marne	applies for permit to copy at the Louvre lives 23 rue d'Argen- teuil		studies medicine in Montpellier	copies Veronese at the Louvre wishes to paint out-of- doors, against advice of Guichard	
military service in Algiers, excited by southern light and color	applies again for permit to copy at the Louvre; same address		continues medical studies in Montpellier	is introduced to Corot; works with Corot in Ville d'Avray, becomes his pupil; Corot is weekly guest at her parents' home	
discharged from the Army; works with Jongkind and Boudin in and near Le Havre; returns to Paris in Nov.; enters studio of Gleyre	enters Ecole des Beaux- Arts (studio of Gleyre)	returns to Paris; obtains parental permission to become artist; enters <i>Ecole des Beaux-Arts</i> (studio of Gleyre)	goes to Paris for study of medicine and paint- ing; enters studio of Gleyre	travels with sister Edma in Pyrenees	
	MEET AT THE ST	UDIO OF GLEYRE			

	CONTEMPORARY EVENTS	MANET	DEGAS	PISSARRO	CÉZANNE
363	SALON	DES REFUSÉS—INCLU	JDING WORKS BY MA	NET, PISSARRO, JONG	KIND, GUILLAUMIN
	reorganization of <i>Ecole des Beaux-Arts</i> Baudelaire writes study on Guys Renan publishes <i>Life of Christ</i> Nadar balloon ascensions in Paris death of Delacroix, Thackeray Signac, Munch born	March: shows 14 paintings at Martinet's public laughs at works marries Suzanne Leenhoff, musician, mother of a young boy Whistler, Fantin take Swinburne to his studio	probably in Italy with the Musson family from New Orleans	his son Lucien is born works in La Varenne- StHilaire	visits Salon with Zola works at Académie Suisse Nov. applies for permis- sion to copy at the Louvre
864	Gleyre's studio is closed Rodin's L'homme au nez cassé refused by Salon jury First success of Gustave Moreau at the Salon Geneva Convention (Red Cross) Toulouse-Lautrec born	two paintings at Salon meet with no success paints <i>Races at Long-champs</i> Oct.: rents apartment 34 blvd. des Batignolles, gives receptions	does several portraits of Manet death of his brother-in- law Baron Bellelli in Florence	receives advice from Corot; exhibits two landscapes at Salon as "pupil of Corot" works in Montfoucault (where Piette lives) and La Varenne-StHilaire	rejected at the Salon Apr. begins to copy Poussin's <i>Bergers d'Arca-</i> <i>die</i> at the Louvre
1865	Zola visits Courbet publication of Mendel's Memoir on plant hybridity Wagner writes Tristan und Isolde Villier de l'Isle-Adam meets Wagner in Paris Tolstoy writes War and Peace assassination of Abraham Lincoln death of Proudhon; posthumous publication of his Principe de l'art Yeats born	Feb.: exhibits 9 paintings at Martinet's, favorably received Olympia at Salon is violently attacked Baudelaire encourages him during August spends two weeks in Spain; meets Duret in Madrid	exhibits medieval war scene at Salon; is com- plimented by Puvis de Chavannes copies at the Louvre	shows landscape at Salon as "pupil of Corot" visits Renoir and Sisley at Marlotte(?) daughter Jeanne born death of his father; mother continues subsidies until 1870 ill, his mother is cared for by Dr. Gachet lives at La Varenne-StHilaire	spends most of the year in Paris works at the <i>Académie</i> <i>Suisse</i> in fall returns to Aix
1866	Corot and Daubigny members of Salon jury Zola writes Mon Salon, dedicated to Cézanne Goncourt brothers publish Manette Salomon; Dostoevski publishes Crime and Punishment crinoline fashion subsides Kandinsky, Romain Rolland, Vollard born Mary Cassatt in Paris	rejected at the Salon meets Zola, Cézanne, Monet Zola predicts that his place is in the Louvre	exhibits race scene at the Salon	has disagreement with Corot exhibits at Salon (no longer as "pupil of Corot"); is praised by Zola establishes himself at Pontoise	returns to Paris in spring; is complimented by Manet on his still lifes rejected at the Salon in spite of intervention of Daubigny writes letter of protest to Director of Fine Arts
1867		PARIS WOR	LD'S FAIR WITH SPEC	IAL PAVILIONS BY CO	
	Zola writes article mocking jury Mexican Revolution Siemens brothers introduce dynamo Lister introduces antiseptic surgery opening of Suez Canal Marx publishes Das Kapital Constitutional and parliamentary reforms in Hungary, Austria, Northern Germany, England (Disraeli) death of Baudelaire, Ingres, Th. Rousseau, Faraday Bonnard, Toscanini born	decides not to send anything to the Salon one-man show at Fair meets with little success paints Execution of Emperor Maximilien (barred from exhibition) his portrait by Fantin exhibited at Salon Zola publishes articles on Manet in pamphlet, plans to have him illustrate Contes à Ninon moves with wife and mother to 49 rue St. Pétersbourg	exhibits two portraits at the Salon, commended by Castagnary at about this time be- gins friendship with Dihau; the artist shows interest in musicians, opera scenes, and later dancers as subjects	rejected at the Salon; with Renoir, Sisley, and Bazille signs petition for new Salon des Refusés lives at Hermitage, Pontoise	rejected at the Salon a painting exhibited ir Marseilles has to be withdrawn so as not to be torn to pieces by the crowd spends summer in Aix returns to Paris in fall probably first meets Monticelli at the Cafe Guerbois around 1867- 68

MONET	RENOIR	SISLEY	BAZILLE	MORISOT	GAUGUIN
WHISTLER, FANTIN,	CÉZANNE				
works in Fontainebleau forest watches Delacroix at work in his studio	meets Fantin; visits the Louvre frequently with him; applies for permit to copy there	protests change of <i>Ecole</i> des Beaux-Arts statutes ASTER WORK TOGET	together with Monet watches Delacroix at work in his studio	works in Pontoise; meets Daubigny, Daumier, and Guillemet paints under guidance of Corot's pupil Oudinot; copies work by Corot; studies sculpture with Aimé Millet (1863-64)	
			fails in medical exami-	exhibits two landscapes	
meets Courbet in Paris; works in Honfleur in summer with Bazille, Boudin, Jongkind quarrels with family sends works to Bruyas who does not buy them	at about this time begins friendship with Jules Le Coeur meets Diaz in Fontaine- bleau forest; exhibits painting at Salon, des- troys it later	rents small apartment avenue de Neuilly near Porte Maillot	nation; quits medicine for art accompanies Monet to Honfleur	at the Salon spends summer in Beuzeval, Normandy, in the house of Dela- croix's cousin Léon Riesener	
stays at Bazille's in Paris success with two pictures at the Salon paints <i>Déjeuner sur l'herbe</i> in Fontainebleau forest has accident works with Courbet at Trouville; meets Whistler	exhibits two paintings at the Salon with Sisley works in Marlotte (Fontainebleau forest) where Jules Le Coeur acquires a house meets Courbet boat trip with Sisley to Rouen	works with Renoir in Marlotte (Fontaine- bleau forest) in May works at La Celle-St. Cloud boat trip with Renoir to Rouen	poses for Monet's Dé- jeuner sur l'herbe paints Monet after his accident shares his studio with Monet Pissarro, Cézanne, and Courbet come to his studio	exhibits two paintings at the Salon between 1864 and 1874 frequently spends sum- mers in Normandy friendship with Carolus- Duran, Stevens, Jules Ferry copies Rubens at the Louvre	leaves school becomes apprentice pilot at sea, making first voyage in this capacity on board the <i>Luzitano</i> , plying between Le Havre and Rio de Janeiro
great success at Salon with <i>Camille</i> (Camille Doncieux, born Jan. 15, 1847) introduced to Manet lives in Ville d'Avray where he paints <i>Women in the Garden</i> ; later works at SteAdresse and Le Havre	works in Marlotte begins liaison with Lise rejected at the Salon in spite of intervention of Corot and Daubigny paints Paris views; lives with Bazille, rue Vis- conti Aug. with Sisley guest of Le Coeur family at Berck (Channel coast)	Feb. with Renoir and Jules Le Coeur at Milly near Fontainebleau exhibits two paintings at the Salon marries Marie Lescouezec, born 1840; moves to 15 rue Moncey Aug. with Renoir guest of Le Coeur family at Berck (Channel coast)	one painting accepted at the Salon and one rejected paints <i>The Artist's Family</i> shares studio with Renoir, rue Visconti, which he occupies from July 1866 until end of 1867	exhibits two paintings at the Salon works in Pont-Aven, Brittany	seaman
	1				
paints snow scenes near StSiméon and views of Paris shown by Latouche; Women in the Garden rejected at Salon (bought by Bazille); stays with family in SteAdresse while Camille gives birth to Jean in Paris; frequently sees Sisley who stays in Honfleur temporary loss of sight; with Renoir shares Bazille's studio, rue Visconti, in the fall	rejected at Salon; with Pissarro, Sisley, Bazille signs petition for new Salon des Refusés works at Chantilly paints Lise in Fontainebleau forest (first large painting done outdoors) fall, with Monet shares Bazille's studio, rue Visconti	his son born rejected at the Salon; with Renoir, Pissarro, Bazille signs petition for new Salon des Refusés in July works in Hon- fleur (with wife and son); sees Monet fre- quently	The Artist's Family rejected at the Salon, later destroyed with Renoir, Sisley, and Pissarro signs petition for new Salon des Refusés discusses plans for organizing an exhibition of works by his friends; buys Monet's Women in the Garden fall, shares his studio, rue Visconti, with Renoir and Monet	spends summer in Brittany exhibits paintings at Cadart's her sister Yves marries M. Gobillard	seaman

	CONTEMPORARY EVENTS	MANET	DEGAS	PISSARRO	CÉZANNE
1868	Redon reviews Salon, appraises Courbet, Daubigny, Pissarro Zola writes another Salon review, praises Manet and Pissarro death of Rossini Vuillard, Gorki born	exhibits Portrait of Zola at the Salon works at Boulogne; trip to England paints portrait of Duret, contributor with Zola to anti-imperial Tribune; meets Berthe Morisot, who poses for The Balcony flirts with Berthe and her sister receives his friends on Thursday evenings	exhibits Mlle Fiocre at the Salon copies at the Louvre second visit in Paris of his Florentine friend Diego Martelli	two views of Pontoise accepted at Salon with the help of Daubigny; praised by Redon and Zola at about this time obliged to accept commercial jobs with Guillaumin	Feb. applies once more for permission to copy at the Louvre rejected at the Salon from May to December in Aix
1869	Manet and his friends gather at Café Guerbois, Batignolles Clemenceau returns to France from United States death of Berlioz, Lamartine, Sainte-Beuve, Thoré-Burger Matisse, Gide born	exhibits Balcony and Déjeuner at Salon spends summer at Boulogne; makes short trip to England Eva Gonzalès becomes his pupil and poses for her portrait	Portrait of Mme G. accepted, one painting rejected at the Salon Feb. in Brussels, sells works; Belgian dealer offers him contract travels in Italy paints portrait of Berthe Morisot's sister Yves works in pastel on the seashore near Etretat	one painting accepted at the Salon; settles in Louveciennes with his family	returns to Paris rejected at the Salon meets Hortense Fiquet (born 1850) in Paris spends most of the year in Paris
1870	FRANCO-PRUSSIAN WAR DE	CLARED JULY 18—PRO	OCLAMATION OF THE	THIRD REPUBLIC SE	PT. 4
	Courbet and Daumier refuse Legion of Honor Manet, Millet, Courbet, Daumier are unsuccessful candidates for Salon jury Daubigny and Corot resign from jury Duret writes Salon review Prussian king becomes German Emperor death of Dickens, Alex. Dumas Lenin, Maurice Denis born	exhibits two paintings at the Salon unsuccessful candidate for jury is central figure of Fantin's Studio in the Batignolles Quarter National Guard staff officer under Meissonier	exhibits Portrait of Mme Camus at the Salon works on the coast enlists in infantry (his right eye is discovered to be almost blind); friendship with Rouart	exhibits two landscapes at the Salon; flees from Louveciennes to Brittany; later goes with family to England, there marries Julie Vellay, mother of his children	works in Aix, later in nearby L'Estaque avoids draft lives with Hortense Fiquet is joined for a while by Zola
1871	ARMISTICE JAN. 28 — THE	PARIS COMMUNE, MA	RCH 18—MAY 28		
	Courbet president of Commune Art Commission; Millet refuses to join his Federation of Artists; Courbet involved in destruction of Vendôme Column, subsequently imprisoned and condemned Duret travels to U.S., Japan, etc. Nietzsche publishes his first book: The Birth of Tragedy death of Guigou Valéry, Proust, Rouault born	joins family near Bor- deaux during Commune	stays with Valpinçons during Commune Oct. short visit to London paints dancers	sells two paintings to Durand-Ruel in London where he meets Monet; rejected by Royal Academy loses all his work left at Louveciennes returns to France in June son Georges born	returns to Paris after end of <i>Commune</i>

MONET	RENOIR	SISLEY	BAZILLE	MORISOT	GAUGUIN
one painting rejected and one accepted (with Daubigny's help) at the Salon spends several weeks with Renoir and Bazille; works in Etretat, Bennecourt; exhibits in Le Havre, lives in Fécamp June, dispossessed, attempts suicide (?) finds patron in Le Havre (Gaudibert)	Lise accepted at the Salon, praised by Bürger paints portraits of Sisley and Bazille; his Bazille portrait greatly pleases Manet to whom he offers it Lise's sister gives birth to Jules Le Coeur's daughter	moves to 9 rue de la Paix (where Bazille also lives) one painting accepted at the Salon in April at Chailly poses with his wife for Renoir	second version of <i>The Artist's Family</i> and still life accepted at the Salon shares his studio with Renoir and Monet (Sisley lives in same building) meets Manet frequently at the studio of Stevens	one painting accepted at the Salon; introduced by Fantin to Manet while she copies Rubens at the Louvre at about this time has falling out with Oudinot; begins friendships with Puvis de Chavannes, Degas poses for Manet's Balcony	Feb., enlists in the Navy, engaged as scaman at Le Havre and embarks on the cruiser Jérome Napoléon
rejected at the Salon settles at StMichel works in Bougival with Renoir, in Etretat and Le Havre paintings seized by creditors; cannot work for want of paints invited by Manet to join his friends at the Café Guerbois	one painting accepted at the Salon lives at Ville d'Avray with his parents and Lise helps Monet; works with him at Bougival (La Grenouillère); too poor to buy paints	rejected at the Salon paints still lifes	one painting accepted at the Salon and one rejected receives compliments from Puvis de Cha- vannes pays visit to Corot	sends nothing to Salon her sister and steady companion, Edma, marries and gives up painting offers Manet a painting done in Lorient	seaman
rejected at the Salon marries Camille Doncieux June 28 in Paris (Camille receives a dowry) works in Trouville and Le Havre until autumn; leaves for England (September); wife and child remain in France	exhibits two paintings at the Salon lives with Bazille drafted (July-March 1871), sent to Bordeaux, later to Tarbes (Pyre- nees) with regiment of cuirassiers; gravely ill with dysentery	exhibits two Paris land- scapes at the Salon; moves to 27 rue de la Cité des Fleurs (Bati- gnolles)	one painting accepted, one rejected at Salon paints group of friends in his studio which he shares with Renoir enlists in Zouave regiment, Aug. 10 killed at Beaune-la-Rolande Nov. 28	two paintings accepted at the Salon remains in Paris during siege	serves on the cruiser Jérôme Napoléon during the war
	,				
introduced in London by Daubigny to Durand-Ruel who ex- hibits his works meets Pissarro; rejected by Royal Academy goes to Holland (possi- bly with Daubigny) returns to France at end of year; rents house at Argenteuil	during Commune in Paris, later in Louve-ciennes and Bougival where he works with Sisley after Commune takes studio, rue Notre Dame des Champs	his father, ruined by war, dies—leaving him without any support works with Renoir at Louveciennes Durand-Ruel exhibits one of his paintings in London		on advice of Puvis de Chavannes leaves Paris during Commune; goes to StGermain with parents correspondence with Puvis who seems to court her goes with her sister to Cherbourg before returning to Paris	in April leaves naval service; recommended by his godfather Arosa (a patron of Pissarro), en- ters employ of Bertin, stock- broker Arosa's daughter teaches him to paint

	CONTEMPORARY EVENTS	MANET	DEGAS	PISSARRO	CÉZANNE
872	France makes great effort to pay reparations; government loans over-subscribed; heavy taxes, business boom artists protest publicly against nomination of Salon jury by new Fine Arts Administration Dr. Gachet buys house in Auvers Mallarmé professor at Paris Lycée Desboutin settles in Paris Guillaumin meets again former classmate Murer and introduces him to his impressionist friends Courbet completes prison term Durand-Ruel exhibits impressionist works in London Mary Cassatt travels in Italy, Spain, Belgium, Holland; exhibits for first time at Paris Salon	Jan.: sells twenty-nine paintings to Durand-Ruel who pays him 51,000 francs for them, prices varying between 400 and 3000 francs exhibits Combat of Kearsarge and Alabama at the Salon travels in Holland: admires Jongkind and especially Hals moves from rue Guyot, takes studio 4 rue Saint-Pétersbourg signs request for new Salon des Refusés with Jongkind, Pissarro, Cézanne, Renoir, etc.	is introduced to Durand-Ruel apparently sends nothing to the Salon works at Paris Opera (subjects: orchestra, ballet classes) in autumn accompanies brother to New Orleans	apparently sends nothing to the Salon signs request for new Salon des Refusés settles in Pontoise, 26 rue de l'Hermitage, where Cézanne, Guillaumin, etc., join him meets Murer through Guillaumin	Hortense Fiquet gives birth to a son christened Paul Cézanne signs request for new Salon des Refusés joins Pissarro in Pontoise and works at his side
873	crash, followed by a six-year depression new Salon des Refusés Durand-Ruel exhibits impressionist works in London Duret returns from trip to U.S., Japan, China, Mongolia, Java, India H. Spencer publishes The Study of Sociology Courbet flees to Switzerland Mary Cassatt exhibits again at Salon; friendship with Louisine W. Elder (later Mrs. H. O. Havemeyer) death of Napoleon III Péguy, Caruso, Chaliapin born	Bon Bock obtains great success at the Salon spends summer in Berck-sur-Mer sells 5 paintings to Faure (among them Le Bon Bock) at prices varying between 2500 and 6000 francs beginning of friendship with Mallarmé, then professor of English at Lycée Condorcet	paints uncle's cotton exchange office in New Orleans returns to France in spring Opera house destroyed by fire; ballet moves to temporary quarters where Degas continues work future Mrs. Havemeyer buys pastel by Degas upon advice of Mary Cassatt who has not yet met the artist in Dec. in Italy	decides not to send anything to the Salon Duret prefers his work to that of Monet and Sisley his canvases obtain comparatively high prices at Hoschedé auction works in Pontoise, especially Hermitage quarter, also in nearby Osny and Auvers-sur- Oise	moves to Auvers-sur-Oise near Pontoise; works in Dr. Gachet's house paints Modern Olympia and numerous land-scapes through Pissarro meets père Tanguy (1873-74)
1874	first group exhibition at Nadar's, 35 boulevard des Capucines, April 15—May 15; thirty partici- pants Durand-Ruel exhibits impres- sionist works in London Vincent van Gogh for short while in Paris	larmé protests rejections (in 1876 writes more im- portant article on Manet for English periodical) refuses to participate in	death of his father in Naples visited by E. de Gon- court who admires his work insists on inviting as many artists as possible to group show	opposes Duret's advice to exhibit at the Salon; insists that Cézanne and Guillaumin show with the group death of daughter Jeanne, son Félix born	at Pissarro's insistence is admitted to group show Pissarro does his por- trait
	Mary Cassatt exhibits at Salon where her work is noticed by	group show despite insistence of Degas and		FIRST GRO	OUP EXHIBITION OF
	Degas death of Gleyre Lautréamont, Marconi, Churchill, Schönberg, Gertrude Stein born	Monet August, stays at Gennevilliers, joins Monet in Argenteuil across the Seine illustrates Mallarmé's translation of Poe's Raven	exhibits 10 works notices Mary Cassatt's painting at the Salon sells Examen de Danse to Faure for 5000 francs	exhibits 5 paintings joins his friend Piette in Montfoucault, Brittany, during the winter	exhibits 2 landscapes and <i>Modern Olympia</i> which are greeted by laughter; 1 landscape sold returns to Aix, later comes back to Paris confidence unshaken by fiasco of show spends Nov. in Auvers

MONET	RENOIR	SISLEY	MORISOT	GAUGUIN	SEURAT born Paris,
with Boudin visits Courbet, imprisoned for participation in Commune apparently sends noth- ing to the Salon; works in Le Havre and Rouen; in summer re- turns to Holland Daubigny buys one of his Dutch landscapes; paints with Renoir at Argenteuil where he settles in July	rejected at the Salon signs request for new Salon des Refusés introduced by Degas to Duret lives in Paris; paints Pont Neuf and other urban subjects pays frequent visits to Monet in Argenteuil his former mistress Lise marries young architect, friend of Jules Le Coeur; never sees him again	introduced to Durand-Ruel by Monet and Pissarro apparently sends nothing to the Salon works in Argenteuil, Bougival, Villeneuve-La-Garenne, Port-Marly Durand-Ruel shows four of his paintings in London	exhibits at the Salon after sojourn in St. Jean de Luz makes short trip to Spain: Toledo, Madrid, Escurial; impressed by works of Goya and Velázquez later in Maurecourt with her sister Edma	successful bank agent paints occasion- ally	Dec. 2, 1859 lives with mother, younger brother, and sister in Paris, 110 boulevard Magenta; father, an eccentric, stays mostly on his property of Le Raincy on the outskirts of the city
decides not to send anything to the Salon works in Argenteuil; at about this time constructs studio on a boat and frequently paints on the Seine meets Caillebotte takes up Bazille's plan for a group exhibition; Sept. 22, death of Camille's father; she comes into inheritance	introduced to Durand-Ruel whose first acquisitions enable him to take large studio, 35 rue St. Georges, Paris two paintings rejected at the Salon shown at new Salon des Refusés friendship with Murer whom he meets through Guillaumin	decides not to send anything to the Salon works in Louveciennes, Marly, Bougival, Pontoise meets Murer through Guillaumin	works in Fécamp one pastel accepted at the Salon during summer with her sister Edma in Maurecourt	successful bank agent in Nov. marries Danish Mette- Sophie Gad continues to draw and paint	
apparently invites Bou- din to participate in group show; Manet declines his invitation	takes active part in organization of group; votes against too strict rules; member of hang- ing committee	works in Marly, Bougival, Louveciennes	death of her father against Manet's protest agrees to join the group and never to send any- thing again to the Salon	continues to draw and paint increasingly af- ter the birth of his first child, Emil (followed by Aline and Clovis) lives rue	makes first drawings
PAINTERS DUBBED	"IMPRESSIONISTS"			Fourneaux the Norwegian	
exhibits 12 works in- cluding Impression— Sunrise Manet and Renoir join him in Argenteuil also works in Le Havre	exhibits 7 works stays with Monet in Argenteuil friendship with Caille- botte (1874-75) death of his father break with Le Coeur family	exhibits 5 landscapes July-Oct. goes to Eng- land with Faure; works in and around Hampton Court, later returns to France	exhibits 9 works spends part of summer in Fécamp with Manet family; also in Maure- court with her sister Edma in December marries Manet's brother Eugène	painter Frits Thaulow marries sister of Mme Gauguin	

	CONTEMPORARY EVENTS	MANET	DEGAS	PISSARRO	CÉZANNE	
1875	auction sale at Hôtel Drouot, March 24; average price 144 frs. Zola writes Salon review for Russian periodical Durand-Ruel exhibits impressionist works in London; closes his gallery there Vincent van Gogh in Paris as employee of art gallery death of Corot, Millet, Carpeaux, Bizet; Rilke, Ravel, Marquet born	canvas painted in Argenteuil causes scan- dal at the Salon recommends his friends' auction sale to critic A. Wolff	lives 77 rue Blanche in Paris (Montmartre) tries to help his brother in New Orleans who is in financial difficulties in Apr. in Florence	works in Pontoise continues to encourage Cézanne in August participates in founding new artists' association, L'Union, joined by Cézanne, Guillaumin fall in Montfoucault with Piette	canvas of his bought by Chocquet at Tanguy's; through Renoir meets Chocquet whose portrait he paints lives in Paris, quaid'Anjou; neighbor of Guillaumin with whom he sometimes works joins Pissarro's association, L'Union	
1876	second group exhibition, 11 rue Le Peletier, April; nineteen par- ticipants (dividend is 3 frs.)	2 paintings rejected at the Salon; invites pub- lic to see them in his			rejected at the Salon; does not join the group; introduces Chocquet to	
	Henry James comments on show; Duranty publishes <i>La Nouvelle</i>	studio; Méry Laurent attends and becomes	SECOND	GROUP	Monet	
	Peinture; Rivière writes first article on impressionists Zola again reviews Salon in Russian periodical Bell invents telephone Mallarmé publishes L'Après-midi d'un faune illustrated by Manet writes important article on latter Strindberg in Paris admires impressionists death of Diaz, Sand, Bakunin; Vlaminck born	his friend visits Hoschedé at Montgeron; paints por- trait of Carolus-Duran; does portrait of Mallar- mé who meets Méry Laurent in his studio Eva Gonzalès exhibits at the Salon as "pupil of Manet" affected by general "depression"	exhibits 24 works at about this time gives up greater part of his fortune to help brother; from then on occasion- ally obliged to sell some works	exhibits 12 paintings works in Pontoise, also in Melleraye (Mayenne) and Mont- foucault with Piette (who dies following year)	works in L'Estaque favors exhibiting with impressionists rather than with L'Union returns to Paris in fall	
1877	third group exhibition, 6 rue Le Peletier, April; 18 participants Rivière edits L'Impressionniste second auction sale, May 28; average price 169 francs the painters begin to gather at the Café de la Nouvelle-Athènes	one painting accepted, one rejected at the Salon begins portrait of A. Wolff (unfinished)	lives 4 rue Frochot (Montmartre, near Pigalle) does mostly pastels active in preparation of new group show	works with Cézanne in Pontoise with Cézanne and Guillaumin resigns from L'Union	works with Pissarro in Pontoise; also in Auvers and Issy near Paris; resigns from L'Union	
	Edison invents phonograph			THIRD GROUP		
	Murer organizes lottery to help his painter friends Mary Cassatt invited by Degas to join impressionist group; stops exhibiting at Salon Durand-Ruel in financial diffi- culties death of Courbet; Dufy born		exhibits 22 paintings, drawings, as well as monotypes; friendship with the author and librettist Ludovic Halévy invites Mary Cassatt to join impressionist group	exhibits 22 landscapes participates in second sale; bids vary between 50 and 260 francs in Nov. Guillaumin's friend Murer organizes lottery in effort to help Pissarro and Sisley	exhibits 16 works, mostly still lifes and landscapes	
1878	Paris World's Fair; Durand-Ruel shows 300 Barbizon paintings; Zola writes on art section of Fair for Russian periodical Duret publishes Les Impressionnistes Zola buys house in Médan after immense success of L'Assommoir; low prices at Faure and second Hoschedé sales affect painters harvest poor this year and next Whistler intends process against Ruskin death of Daubigny	Jan.: helps Monet sends nothing to the Salon; plans own show but decides against it; obtains low prices at Faure sale, even lower at Hoschedé sale visits Hoschedé at Montgeron has trouble with leg moves studio to 77 rue d'Amsterdam	works at circus scenes Pau Museum acquires his Cotton Exchange Office painted in New Orleans; his friend Diego Martel- li comes to Paris for World's Fair; in 1879 poses for portrait by Degas	works in Pontoise; deeply discouraged paints portrait of Murer who helps him financially rents room in Montmartre to show his pictures to collectors Sept. son Rodo born Degas' friend Martelli persuades Pissarro to exhibit two paintings in Florence	works in Aix, and in L'Estaque with Monticelli has difficulties with his father Zola helps him financially rejected at the Salon; is ready to show with the group but no exhibition is organized	

MONET	RENOIR	SISLEY	MORISOT	GAUGUIN	SEURAT	
	ORGANIZE AUCTIO	N SALE IN MARCH		continues to draw and paint	works in Municipal Art School; does mostly	
auction prices vary between 165 and 325 francs works in Argenteuil (snow scenes) in great financial diffi- culties; appeals to Manet for help; color merchant refuses credit; July, Camille taken ill	10 works obtain less than 100 francs apiece; again rejected at Salon; commissioned by Chocquet to paint portrait of Mme Chocquet; takes Chocquet to Tanguy's; Rouart buys Renoir's painting shown at Salon des Refusés in 1873	auction prices vary between 50 and 300 francs; settles in Marlyle-Roi works in Bougival, Marly, StGermain, Louveciennes, Versailes	obtains better prices at auction than Monet, Renoir, or Sisley summer in Gennevil- liers works in England and on Isle of Wight	in his free time	sketches after plaster casts reads Charles Blanc's Grammar of Painting	
Feb.: meets Choquet through Cézanne	Feb., invites Caillebotte to show with group	paints flood in Port- Marly		exhibits land- scape at the Salon; at about	works in Municipal Art School encouraged by uncle to	
	EXHIBITIO	ON		this time begins	become artist; no oppo-	
exhibits 18 paintings financial difficulties continue; Camille's money is used up visits Hoschedé begins Gare StLazare series in Paris during winter; lives 26 rue d'Edimbourg, studio 17 rue Moncey friendship with J. S. Sargent	exhibits 15 paintings rents house, 12 rue Cortot, Montmartre paints Balançoire, Moulin de la Galette meets Charpentier (publisher of Zola, Maupassant, Daudet) in Champrosay at Alphonse Daudet's	exhibits 8 landscapes works in Louveciennes	participates in group show continues to spend sum- mers in Maurecourt near Paris death of her mother	to buy impressionist pictures, investing 15,000 francs in a collection of Manet, Cézanne, Pissarro, Renoir, Monet, Sisley, Guillaumin, Jongkind, Daumier, etc.	sition from parents makes his first paint ings, later destroyed	
continues Gare St Lazare series	new show is prepared mostly in his studio, 35 rue St. Georges	works in Sèvres, St. Cloud, Marly Durand-Ruel can no longer buy his works	rents apartment near l'Etoile	at about this time meets Pis- sarro, probably through Arosa	draws copies after Holbein, Poussin, Ingres, Raphael, etc.; reads and admires de Goncourts' novels	
	EXHIB	BITION			novels	
exhibits 30 paintings summer, second visit with Hoschedé fall and winter, in des- perate financial straits; appeals to de Bellio for help	exhibits 22 works participates in second sale; bids vary between 47 and 285 francs	exhibits 17 landscapes participates in second sale; bids vary between 105 and 165 francs fall, moves from Marly- le-Roi to Sèvres friendship with Char- pentier, Murer	exhibits 19 works			
settles in Vétheuil; helped by Manet but finishes year again without money in March, a second son, Michel, is born Monet's works average 184 francs at Hoschedé sale summer, Mme Hosche- dé and children join the Monets at Vétheuil; Camille ill	exhibits again at the Salon paints portrait of Mme Charpentier, also portraits of Murer, his son, his sister	works in Sèvres through Duret sells several pictures decides to follow Renoir's example and to exhibit again at the Salon			enters Ecole des Beaux-Arts, class of Ingres' pupil Lehmann studies at about this time Chevreul's Principles of Harmony and Contrast of Colors as well as other theoretical treatises	

	CONTEMPORARY EVENTS	MANET	DEGAS	PISSARRO	CÉZANNE	
1879	fourth group show, 28 avenue de l'Opéra; April 10—May 11; 439 francs benefit for each of 15 participants Zola writes Salon review for Russia, reproaches impressionists for "insufficient technique" Charpentier founds La Vie Moderne which organizes one-man shows Redon publishes first album of lithographs Huysmans writes aggressive Salon review Edison's electric bulb death of Daumier, Couture; Stalin, Trotsky, Einstein, Friesz born	two paintings accepted at the Salon summer at Bellevue for hydrotherapy paints portrait of G. Moore at the Nouvelle-Athènes begins portrait of Clemenceau the singer Mme Ambre exhibits Execution of Maximilien in New York with little success	invites Mary Cassatt to exhibit with the group; announces 25 works in catalogue, exhibits less than a dozen plans publication of print portfolios, to be called <i>Le jour et la nuit</i> , with Pissarro, Cassatt, Bracquemond, etc.	invites Gauguin to show with the group exhibits 38 works; works in Pontoise is interested in Degas' print publication	rejected at the Salon in spite of intervention of Guillemet works in L'Estaque, later in Melun; pays visit to Zola in Médan; in Paris from summer until end of year	
1880	fifth group show, 10 rue des Pyramides, April 1-30; 18 par-	Execution of Maximilien exhibited in Boston	travels in Spain	travels in Spain		
	ticipants Huysmans attacks impressionists Zola publishes new art criticisms in Le Voltaire (Paris) Dostoevski publishes Brothers Karamazov Murer sells Paris shop, moves with collection to Auvers business begins to recover from 1873 crash; stock market feverish with speculation Durand-Ruel recovers from crisis death of Duranty, Flaubert, Offenbach; Derain born	(Jan.); show in Chicago canceled April: one-man show at La Vie Moderne (pastels); exhibits portrait of A. Proust at the Salon; jury considers medal; his pupil Eva Gonzalès has success at Salon spends summer at Bellevue for cure; onset of fatal illness	exhibits 8 paintings and pastels, several drawings and etchings, also portrait of Duranty (who died during show); does etchings with Pissarro and Mary Cassatt his friend Martelli lectures in Italy on impressionism	exhibits 11 paintings and series of etchings in various states, done for Degas' publication does etchings with Mary Cassatt and Degas works in Pontoise	probably again rejected at the Salon lives from April to end of year in Paris; visits Zola in Médan	
1881	sixth group show, 35 boulevard des Capucines; April 2—May 1; 13 participants State abandons control of Salon; Société des Artistes Français created; Durand-Ruel again buys impressionist works Fénéon arrives in Paris Redon holds first one-man show of drawings at La Vie Moderne Huysmans writes new article Clemenceau founds La Justice American painters Chase and Weir meet in Paris, interested in Manet Czar Alexander II assassinated; death of Carlyle, Disraeli, Dostoevski; Picasso born	two paintings accepted at the Salon; awarded second class medal spends summer in Versailles Nov.: Proust becomes Fine Arts Minister in Gambetta government; proposes Manet for Legion of Honor; nominated Dec. 30 Dec.: seriously ill	exhibits dressed wax statuette of dancer and 7 works, apparently mostly pastels	exhibits 11 landscapes works in Pontoise with	probably again rejected at the Salon in Paris Jan. to April; from May to October with Pissarro (and Gauguin) in Pontoise visits Zola in Médan; returns to Aix in Nov.	

MONET	RENOIR	SISLEY	MORISOT	GAUGUIN	SEURAT
exhibits 29 paintings works in Vétheuil-Lavacourt on the Seine, frequently painting on his boat de Bellio buys Gare StLazare painting inspired by Renoir's example decides to exhibit again at the Salon Camille dies in Sept. great financial difficulties continue paints series of winter landscapes at Vétheuil	obtains great success at the Salon with Mme Charpentier and Her Children death of his favorite model Margot June: one-man show at La Vie Moderne; his brother Edmond publishes important article on the painter in La Vie Moderne stays in Wargemont with Bérard family meets his future wife Aline Charigot	rejected at the Salon ejected from 7 avenue de Bellevue, Sèvres; with Charpentier's help moves to 164 Grande rue, Sèvres works in Sèvres, Suresnes, Meudon, St. Cloud	expecting a child, she does not exhibit with the group spends summer in Beuzeval-Houlgate	exhibits sculp- ture with group (invited by Pis- sarro and Degas), not listed in cat- alogue prevents young Signac from sketching at the exhibition works with Pis- sarro in Pontoise and Osny during holidays	greatly impressed by impressionist exhibition; studies works of Renoir (whom he admires) and Barbizon painters at Durand-Ruel's; decides to leave Ecole des Beaux-Arts shares studio with his friend Aman-Jean, rue de l'Arbalète leaves Paris in Nov. for military service in Brest
Georges Petit buys 3 of his paintings 1 painting accepted, 1 rejected at the Salon; protests bad hanging one-man show at La Vie Moderne impresses young Signac accuses impressionists of "opening doors to first-come daubers" works in Vétheuil-Lavacourt returns to the Normandy coast (1880-86) takes studio, 20 rue de Vintimille in Paris	2 canvases accepted at the Salon; protests with Monet against bad placement during summer works in Berneval, also in Croissy at La mère Fournaise (?) with Murer elaborates more liberal bylaws for Salon which Murer publishes	settles in Veneux-Nadon near Moret (until 1882) works in Suresnes, Louveciennes, Moret because of financial support from Feder, Durand-Ruel again buys his works	EXHIBIT exhibits 15 paintings and watercolors summer in Bougival, also in Beuzeval-Houl- gate	exhibits 7 paintings (several done in Pontoise) and a marble bust leaves rue des Tourneaux,rents studio 8 rue Carcel in Vaugirard quarter	military service in Brest in Nov., returns to Paris, takes apartment near his mother's, 19 rue de Chabrol frequent visits to Louvre; studies old masters, also frescoes by Delacroix in Saint-Sulpice church interested in Puvis de Chavannes
never again sends anything to the Salon works in Vétheuil, Fécamp, Petites Dalles and vicinity of Dieppe; Dec. moves to Poissy near StGermain with Mme Hoschedé and children	exhibits 2 portraits of Mlle S. (Samary) and double portrait Cahend'Anvers at the Salon; MarApr., short trip to Algiers with Cordey works in Croissy, and in Wargemont at Paul Bérard's fall, travels to Venice, Rome, Naples, Florence, Calabria; impressed by Raphael and Pompeiian frescoes	on the Isle of Wight in June, can't work for lack of canvas which fails to arrive exhibits 14 paintings in one-man show at La Vie Moderne advises Monet to settle in Moret	exhibits 7 paintings and pastels spends summer in her house in Bougival spends winter 1881-82 in Nice	exhibits 8 paintings and 2 sculptures; a nude study is highly praised by J. K. Huysmans his fourth child born, rue Carcel; spends summer holidays with Pissarro and Cézanne in Pontoise	devotes his time mostly to drawing and study of color theories takes detailed notes on a series of paintings by Delacroix impressed with Puvis de Chavannes' Poor Fisherman exhibited at Salon; sketches copy of it

	CONTEMPORARY EVENTS	MANET	DEGAS	PISSARRO	CÉZANNE
1882	Durand-Ruel organizes seventh group show, 251 rue StHonoré; 8 participants; renews attempt to show impressionists in London Redon's second exhibition at Le Gaulois enthusiastically reviewed by Huysmans, Hennequin Puvis de Chavannes exhibits Doux Pays large Courbet retrospective at Ecole des Beaux-Arts new bank crash causes great losses; bankruptcy of associate imperils Durand-Ruel; his rival, G. Petit, founds Exposition Internationale death of Garibaldi, Gambetta, Darwin; F. D. Roosevelt, Joyce, Braque born	exhibits Bar aux Folies-Bergère at the Salon increasingly ill; spends summer in Rueil	July: in Etretat at Ludovic Halévy's in autumn short sojourn in Veyrier near Geneva; trip to Spain with Pagans	SEVENTH exhibits 36 paintings and gouaches moves to Osny near Pontoise	works in L'Estaque with Renoir for whom he cares during his illness; admitted at the Salon as "pupil of Guillemet"; is caricatured in a novel by Duranty, published posthumously March-Sept. in Paris; visits Zola in Médan visits Chocquet in Hattenville whose wife has inherited a fortune works at the Jas de Bouffan near Aix makes his last will
1883	Durand-Ruel organizes series of one-man shows in new gallery; exhibits impressionists in London, Berlin, Rotterdam; Sept. "Foreign Exhibition" in Boston includes impressionists (no success); Dec. Chase instrumental in Loan Exhibit, National Academy, New York Whistler shows Portrait of His Mother at Paris Salon exhib. of Japanese prints at Petit's; Huysmans publishes L'Art Moderne Pasteur vaccinates against anthrax; business recovers; France enters long period of economic calm Caillebotte draws up will, leaving his collection to the State death of Wagner, Marx, Turgenev; Mussolini, Gropius, Kafka, Utrillo born	bedridden amputation of left leg fails to save him dies April 30 Dec.: his work included in "Pedestal Exhi- bition" in New York	refuses to hold one-man show at Durand-Ruel's (unlike Pissarro, Monet, Renoir, and Sisley) 7 paintings shown in London; his work included in "Pedestal Exhibition" in New York (Dec.)	one-man show in May at Durand-Ruel's works with Gauguin at Osny; later at Petites Dalles on Channel coast and in Rouen where Gauguin joins him again October: also visited by Monet in Rouen	works mostly around Aix probably again rejected at the Salon; in L'Estaque from May to Nov.; sees Monticelli often in Dec. meets Renoir and Monet in the South
1884	Jan.: Société des Vingt founded in Brussels Groupe des Artistes Indépendants founded in Paris; proposes to organize exhibitions without jury and awards Durand-Ruel has mounting debts; Fénéon becomes editor of Revue Indépendante Huysmans publishes Against the Grain first presentation of Bruckner's Seventh Symphony Raffaëlli has large one-man show	Jan.: large memorial show organized at <i>Ecole des Beaux-Arts</i> ; catalogue introduction by Zola Feb.: sale of studio contents (93 paintings, 30 pastels, 14 watercolors, 23 drawings, etc.); prices are "honorable"—total 115,000 francs	spends summer at Ménil-Hubert near Gace (Orne) with the Valpinçons; there works on bust of Hortense Valpinçon short sojourn in Dieppe	moves from Osny to Eragny near Gisors (Eure) works in Eragny and nearby Bazincourt Aug. last son, Paul-Emile, born	rejected at the Salon in spite of intervention of Guillemet works mostly around Aix Signac buys one of his landscapes from père Tanguy upon the advice of Pissarro

MONET	RENOIR	SISLEY	MORISOT	GAUGUIN	SEURAT
	Jan.: does portrait of Wagner in Palermo		works in Nice sojourn in Florence	takes active part in organization of group show	devotes his time mostly to drawing and study of color theories
	paints usually on small wooden panels; works				
exhibits 35 paintings works in Varengeville, Pourville,PetitesDalles, Dieppe, Poissy approves of Durand- Ruel's plan of a series of one-man shows by impressionists	exhibits 25 works with group exhibits portrait at the Salon meets Cézanne in L'Estaque, there stricken with pneumonia; returns to Algiers	exhibits 27 landscapes, almost all owned by Durand-Ruel works in Veneux- Nadon; settles in Sept. in Moret opposes Durand-Ruel's plan of one-man shows favored by Monet	exhibits 9 paintings and pastels spends summer and winter in Bougival	exhibits12 paintings and pastels as well as bust of his son Clovis Huysmans sees "no progress" in his work	in Paris suburbs, Bar- bizon, Le Raincy, Pont- aubert, Ville d'Avray, etc. does mostly landscapes or represents peasants and laborers at work
March: one-man show at Durand-Ruel's in May settles with Mme Hoschedé in Giverny works in nearby Vernon, in Le Havre and Etretat, visits Pissarro in Rouen; in Dec. short trip with Renoir to Genoa and Côte d'Azur where they meet Cézanne	exhibits portrait at Salon one-man show in April at Durand-Ruel's works in Paris; Suzanne Valadon poses for "Dance" paintings during fall in Guernsey; in Dec. short trip with Monet to Genoa and Côte d'Azur where they meet Cézanne	despite his opposition to project, has one-man show in June at Durand-Ruel's composed of 70 paintings; meets no success works in Moret and nearby Les Sablons and StMammès in autumn settles in StMammès	moves to a house she built with her husband, rue de Villejuste, Paris (now rue Paul Valéry); spends summer in Bougival during fall and winter prepares with husband the Manet retrospective and sale of estate	lives rue Carcel; son Pola born works with Pissarro in Osny; Mme Gauguin plans vacation near Dr. Gachet at Auvers buys 2 Cézanne paintings from Tanguy at very low prices in connection with economic crisis loses bank job; joins Pissarro in Rouen with his wife and their 5 children	exhibits large portrait drawing of Aman-Jean at Salon; rest of his entries rejected by jury; continues to paint in Paris suburbs and on Seine banks begins to work on first large composition, <i>Une Baignade</i>
JanMar., works in Bordighera; April in Menton, August in Etretat, later in Giverny; shows at Petit's 3rd Exposition Internationale quarrels with G. de Bellio because the latter sells a few minor of the more than 30 works by Monet he owns	works in Paris and La Rochelle searches for a new style; feels dislike for im- pressionism	works in StMammès, Les Sablons, and La Celle; his favorite sub- jects are views of the Canal du Loing and the Seine	spends summer in Bougival in Paris works frequently in the Bois de Boulogne	sends 8 paintings to exhibition in Oslo lives in Rouen, later goes with family to Copenhagen; there tries without success to represent commercial firms	Baignade rejected at the Salon with Signac and Redon participates in founding Société des Indépendants; shows Baignade in its first Salon; picture is noticed by Fénéon summer, begins to work on La Grande Jatte through Signac meets Guillaumin moves to 128 bis, boulevard de Clichy Dec., shows again with Independents; admired by R. Marx

1	CONTEMPORARY DEGAS PISSARRO CÉZANNE MONET						
=	CONTEMPORARY EVENTS	DEGAS	PISSARRO	GEZANNE	MONET		
1885	Delacroix retrospective at Ecole des Beaux-Arts Durand-Ruel organizes exhibition in Brussels which greatly impresses avant-garde members of Les Vingt; J. F. Sutton of American Art Associates approaches him for show in New York Dujardinfounds Revue Wagnérienne; Mallarmé named Professor at Collège Rollin, Paris Munch, age 19, spends 3 weeks in Paris Rouault apprenticed to a stained-glass maker Zola publishes Germinal Guys has accident, dies in 1892 death of Victor Hugo D.H. Lawrence, Ezra Pound born	Aug.: short trip to Le Havre, Mont Saint- Michel, and Dieppe (where he meets Gauguin and the English painter Sickert)	at about this time meets Theo van Gogh of Boussod & Valadon Gallery at Guillaumin's meets Signac; in Oct. Guil- laumin introduces him to Seurat at Durand- Ruel's; influenced by their theories which he explains to Durand- Ruel	probably again rejected at the Salon works in L'Estaque and Aix has mysterious love affair visits Renoir during June and July in La Roche-Guyon; visits Zola in Médan works in Gardanne near Aix	works in Giverny participates in 4th Exposition Internationale at Petit's (10 works) paints floral decorations for Durand-Ruel's Paris apartment OctDec. in Etretat, stays in home of singer Faure		
1886	eighth and last group show, I rue Laffitte; May 15—June 15; 17 participants van Gogh arrives in Paris; meets Bernard and Lautrec at Cormon Studio; influenced by Seurat, van Gogh and Bernard try pointillist execution Durand-Ruel obtains first success in America (new American exhibition prepared for 1887); his rival, G. Petit, holds 5th Exposition Internationale in Paris; invites Monet and Renoir Zola publishes L'Oeuvre; Fénéon publishes Les Impressionnistes en 1886; becomes correspondent for L'Art Moderne published by Brussels group Les XX Douanier Rousseau exhibits at second Salon des Indépendants Redon exhibits with Les XX in Brussels, is violently derided in press; in Paris Mirbeau attacks his work Verlaine publishes Illuminations by Rimbaud; Moréas publishes "Symbolist Manifesto" large Whistler exhibition during winter 1886-87 at G. Petit's death of Monticelli, Liszt	EIGHTH exhibits 5 works and series of 10 pastels of nudes has difficulties with Faure concerning paintings promised since 1874 shown by Durand-Ruel in New York	exhibits at Clauzet's his first divisionist canvas insists that Signac and Seurat show with the group GROUP exhibits 20 paintings, pastels, gouaches, and etchings meets Vincent van Gogh through his brother Theo works in Eragny shown by Durand-Ruel in New York	probably again rejected at the Salon works in Gardanne in April marries Hortense Fiquet in Aix deeply hurt by Zola's L'Oewre; breaks with him inherits fortune after death of his father, Oct.	trip to Haarlem refuses to join group probably on account of Seurat but attends monthly dinners of impressionists with Renoir, Pissarro, Duret, Mallarmé, Huysmans at Café Riche participates in 5th Exposition Internationale at Petit's and Les Vingtexhibition in Brussels shown by Durand-Ruel in New York (50 works); sells to Petit at relatively high prices SeptNov. in Belle-Isle; there meets Geffroy complains to Zola about L'Oeuvre visits Octave Mirbeau; disagreement with Durand-Ruel		

RENOIR	SISLEY	MORISOT	GAUGUIN	SEURAT	
works in Wargemont; in La Roche-Guyon with Cézanne, later in Essoyes, home of Aline Charigot whom he marries in 1890 overcomes doubts, shows satisfaction with new work Mar. his son Pierre born	works in StMammès, Les Sablons, Moret, and in Fontainebleau forest For the first time con- signs a picture to Theo van Gogh of the Bous- sod & Valadon Gallery; in great diffi- culties in spite of pur- chases by de Bellio and Murer; in Nov. des- perately asks Durand Ruel for help	spends early summer in Bougival, later works in Holland	May, exhibition of his works in Copenhagen is complete failure June, returns from Denmark where he leaves his family except for Clovis who falls ill in Paris; goes to Dieppe where he meets and quarrels with Degas	Grande Jatte ready to be exhibited in March, but no Salon des Indépendants is held that year works during summer in Grandcamp correspondence with Signac through Signac meets Guillaumin who introduces him to Pissarro at Durand-Ruel's in Oct.; since his return from Grandcamp resumes work on Grande Jatte (although considered finished in spring); first application of optical mixture	SIGNAC born Paris, Nov. 11, 1863
refuses to join group probably on account of Seurat participates in 5th Exposition Internationale at Petit's and Les Vingt exhibition in Brussels shown by Durand-Ruel in New York works in Saint-Briac and La Roche-Guyon unlike Monet maintains cordial relations with Durand-Ruel	refuses to join group tries to earn money painting fans but gives up works in Moret and Les Sablons shown by Durand-Ruel in New York	with her husband takes active part in organi- zation of group show	spring, job as billposter June at Gloanec pension in Pont- Aven; there meets E.Bernard	on insistence of Pissarro is admitted to group show with Signac	impressed with Pissarro's divisionist canvas seen at Clauzet's definitely adopts divisionism; works in Clichy
		EXHIBITION			
		exhibits 14 works in June on the Isle of Jersey shown by Durand-Ruel in New York Renoir, Degas, Monet, Mallarmé begin to gather frequently at her house	exhibits 19 paintings done in Rouen, Denmark and Brittany and one wood relief (not catalogued) meets van Gogh in Paris during fall NovDec. in Paris hospital	exhibits 6 paintings, 3 drawings (one owned by Huysmans); Grande Jatte causes scandal, his efforts are supported by Fénéon Durand-Ruel shows Baignade in New York; after its return works on it again summer, in Honfleur; letters to Signac through Pissarro invited to exhibit in Nantes shows Grande Jatte again at Independents quarrel with Gauguin; friendship with Verhaeren, Charles Henry, G. Kahn, de Régnier, P. Adam, Ajalbert	on insistence of Pissarro is admitted to group show with Seurat spends summer with Lucien Pissarro at Les Andelys; correspondence with Seurat

BIBLIOGRAPHY

This bibliography is meant as a guide. While most scholarly and more or less complete bibliographies devote equal space to the important and the unimportant, the good and the bad, an attempt has been made here to limit the list to the principal publications and at the same time to indicate to the reader what to expect from them.

The section devoted to studies on impressionism in general is arranged chronologically so that the reader may follow in the accompanying comments the development of the appreciation of impressionism as well as the progress of research.

The sections concerning individual artists (Bazille, Caillebotte, Cassatt, Cézanne, Degas, Guillaumin, Manet, Monet, Morisot, Pissarro, Renoir, and Sisley) are, for greater convenience, subdivided as follows: Oeuvre Catalogues; The Artist's Own Writings; Witness Accounts; Biographies; Studies of Style; Reproductions; and in some instances Exhibition Catalogues. Within each of these subdivisions the material is arranged chronologically. Since some publications must be listed under more than one heading, all items are numbered and the numbers repeated wherever this seems called for.

The comments deal mostly with the reliability of the various publications, special emphasis being put on firsthand material. Bibliographies, indexes, choice of illustrations, and the quality of reproductions, etc., are noted.

Of articles published in periodicals, only those are mentioned which contain important contributions, new documents, etc. Among books, however, even those which seem comparatively unimportant are listed if they have reached a large public or enjoy an undeserved reputation.

Since no attempt at completeness has been made, not all the publications consulted or quoted by the author are given in the bibliography. The reader will find ample references to further publications in the notes following each chapter.

GENERAL

1 Zola, E.: Mon Salon (1866), reprinted in Mes Haines, Paris, 1866, 1879, 1928; Une nouvelle manière en peinture—Edouard Manet (1867); Nos peintres au Champ de Mars (1867); Mon Salon (1868). All these articles are reprinted in Emile Zola—Salons, recueillis, annotés et présentés par F. W. J. Hemmings et Robert J. Niess, Geneva-Paris, 1959. This volume contains an excellent study on Zola's art criticism by Hemmings as well as reprints of Zola's subsequent writings, notably his studies for the Russian periodical Le Messager de l'Europe, which are not available elsewhere: Une exposition de tableaux à Paris (1875); Deux expositions d'art au mois de mai (1876); L'école française de peinture à l'Exposition de 1878 (1878); Nouvelles artistiques et littéraires (1879). But it is Zola's earlier writings which made a significant

- contribution to the emergence of the impressionist group. See also 13, 42, 238. On Zola's taste and on his collection see J. Adhémar: Le cabinet de travail de Zola, *Gazette des Beaux-Arts*, Nov. 1960; see also A. Brookner: The Genius of the Future—Studies in French Art Criticism, London, 1971 (Chapter on Zola).
- 2 Leroy, L.: L'exposition des Impressionnistes, Charivari, April 25, 1874. Quoted extensively p. 318–324. This article, in which the painters were called "impressionists" for the first time, is indicative of the innumerable attacks published in French papers on the occasion of the various group exhibitions; for other reviews see 232.
- 3 Duranty, E.: La nouvelle peinture. A propos du groupe d'artistes qui expose dans les Galeries Durand-Ruel, Paris, 1876. Quoted extensively and discussed p. 376–377. The first publication devoted to the impressionist group, although the word "impressionist" is carefully avoided. A new edition has been published with notes by M. Guérin, Paris, 1946. See also O. Reuterswärd: An Unintentional Exegete of Impressionism—Some Observations on Edmond Duranty and his "La nouvelle peinture," Konsthistorisk Tidskrift, IV, 1949, Stockholm. On Duranty see also: L. E. Tabary: Duranty, étude biographique et critique, Paris, 1954 (this study is mostly concerned with Duranty as novelist), and M. Crouzet: Un méconnu du Réalisme—Duranty—l'homme, le critique, le romancier, Paris, 1964.
- 4 James, H.: Parisian Festivity, New York Tribune, May 13, 1876; reprinted in James: The Painter's Eye, edited by J. L. Sweeney, New York, 1956 (p. 114–115).
- 5 MALLARMÉ, S.: The Impressionists and Edouard Manet, Art Monthly Review (London), 1876, v. I, no. 9; see J. C. Harris: A Little-known Essay on Manet by Stéphane Mallarmé, Art Bulletin, Dec. 1964, p. 559–563. Important article.
- 6 RIVIÈRE, G. (editor): L'impressionniste, journal d'art. Five issues published in 1877 (April 6–28) on the occasion of the third group exhibition with the special support and occasional collaboration of Renoir. For excerpts see 141, v. II, p. 305–329.
- 7 RIVIÈRE, G.: Les intransigeants et les impressionnistes— Souvenir du Salon libre de 1877, L'Artiste, Nov. 1, 1877. At the request of the editor, this article does not mention Cézanne and Pissarro.
- 8 Duret, T.: Les Peintres impressionnistes, Paris, 1878. Combines a short general study with biographical notes on Monet, Sisley, Pissarro, Renoir, and Berthe Morisot. The first authoritative attempt to explain impressionism and to single out its leaders. Reprinted *in* Duret: Peintres impressionnistes, Paris, 1923, and in 19.
- 9 CLEMENT, C. E. and HUTTON, L.: Artists of the Nineteenth Century and Their Works. A handbook. Boston-

- New York, 1879. Lists no modern painter except Manet; useful, however, for the study of those artists famous when the impressionists first appeared.
- 10 HÉBERT, H.: Physionomie d'un Atelier libre à Paris, Revue illustrée du Cercle des Beaux-Arts, Geneva, I, No. 1–4 [1879]. On the Atelier Suisse.
- 11 Martelli, D.: Gli Impressionisti. Lettura data al circolo filologico di Livorno. Florence, 1880. Lecture given by a friend of Degas and Pissarro; an intelligent analysis of the new movement which Martelli had studied in Paris (where Degas did his portrait) in 1878–79. A. Boschetto has published Martelli's writings, some of which had not appeared in print before. See: Diego Martelli: Piccola Antologia, *Paragone*, No. 3, March 1950, and A. Boschetto (editor): Scritti d'Arte di Diego Martelli, Florence, 1952.
- 12 Burty, Ph.: Grave Imprudence, Paris, 1880. A novel; the love story of a painter who shares certain traits with Renoir, Monet, and Manet. The author relates the early phases of impressionism, describes the gatherings at the cafés, and introduces a critic in whom he portrays himself. For excerpts see 141, v. II, p. 293.
- 13 Zola, E.: Le naturalisme au Salon, Voltaire, June 18, 19, 22, 1880. Reprinted in 1.
- 14 DURANTY, E.: Le pays des arts, published posthumously, Paris, 1881. Four novels of which "Le peintre Louis Martin" offers the author's opinions on art, recollections of the Salon des Refusés, Manet, Degas, Fantin-Latour, as well as a scurrilous description of Cézanne, designated as Maillobert. (On the latter see J. Rewald: Paul Cézanne, New York, 1948, p. 127–129.)
- 15 Brandes, G.: Japanesik og impressionist Kunst, Oct. 30, 1882; reprinted in Brandes: Berlin som tysk Rigshovestad, Copenhagen, 1885 (p. 535–539).
- 16 Wedmore, F.: The Impressionists, Fortnightly Review, Jan. 1883. Exhibition review.
- 17 LAFORGUE, J.: Review of an impressionist exhibition in Berlin, 1883. Reprinted in 56.
- 18 Huysmans, J. K.: L'art moderne, Paris, 1883. Reprints of the author's Salon reviews of 1879, '80 '81 and of articles on the impressionist exhibitions of 1880, '81 and '82. At first rather hostile to the group, sharing the prejudices of his friend Zola, Huysmans eventually became a convinced supporter because, as he thought, the painters had overcome their "errors," whereas actually it was he himself who gradually achieved a fuller understanding of their aims. On Huysmans as art critic, see H. Trudgian: L'esthétique de J. K. Huysmans, Paris, 1934 (with extensive list of his writings and bibliography) as well as J. Rewald: Post-Impressionism—From van Gogh to Gauguin, New York, 1956. See also p. 479, note 7.

- 19 DURET, T.: Critique d'avant-garde, Paris, 1885. Reprints of a Salon review of 1870, of the 1878 pamphlet on the impressionists, and of studies on Monet, Renoir, Manet, Japanese prints, etc., written mostly as forewords to exhibition catalogues.
- 20 Fénéon, F.: Les impressionnistes en 1886, Paris, 1886. Review of the last group exhibition with special emphasis on Seurat, and a discussion of the various tendencies of the impressionists and their followers. Reprinted in Fénéon: Oeuvres, with introduction by J. Paulhan, Paris, 1948. (This edition is not complete and omits some of Fénéon's most important writings on Neo-impressionism.) See also Fénéon: Oeuvres plus que complètes, edited by J. V. Halperin, Geneva-Paris, 1970, 2 v. On Fénéon see J. Rewald: Post-Impressionism—From van Gogh to Gauguin, New York, 1956.
- 21 National Academy of Design. Special Exhibition "Works in Oil and Pastel by the Impressionists of Paris," New York, 1886. Catalogue of the historic exhibition organized by Durand-Ruel with excerpts from writings by Duret, Pellet, Georget, Burty, Mirbeau, Geffroy, and from articles published in *Le Temps* and *The Evening Standard*. On this exhibition consult 168. See also p. 544, note 5.
- 22 Sabbrin, C.: Science and Philosophy in Art, Philadelphia, 1886. Review of the impressionist exhibition in New York, spring 1886; chiefly concerned with Monet, whose paintings are analyzed in detail and defined as "the latest art expression of scientific and philosophic thought."
- 23 Zola, E.: L'Oeuvre, Paris, 1886; Oeuvres complètes, Paris, 1928, with extensive notes by M. Le Blond. English translation: His Masterpiece. A novel filled with autobiographical details, the hero of which is a painter for whose character Zola borrowed many traits from his friends Manet and Cézanne. On this book and Zola's notes for it, see J. Rewald: Paul Cézanne, New York, 1948, ch. XVIII, XIX. See also: C. V. Petersen: Omkring Zola's "Mestervaerket," Afhandlinger og Artikler om Kunst, Copenhagen, 1939; R. J. Niess: Another View of Zola's L'Oeuvre, Romanic Review, New York, 1948; G. Robert: Emile Zola, principes et caractères généraux de son oeuvre, Paris, 1952; H. Mitterand: notes and comments in Zola, L'Oeuvre, édition intégrale, Paris (Bibl. de la Pléiade), 1966, v. IV; and R. J. Niess: Zola, Cézanne, and Manet, Ann Arbor, 1968 (with additional bibliography).
- 24 Moore, G.: Confessions of a Young Man, London, 1888. This and the other writings by the same author offer occasional glimpses of the impressionists, among whom he knew especially Manet and Degas. Moore's Confessions contain a caricatured report of the last group exhibition of 1886. On his reliability see D. Cooper: George Moore and Modern Art, Horizon, Feb.

- 1945. See also Moore's writings in 27, 36, and 67.
- 25 Stranahan, C. H.: A History of French Painting from its earliest to its latest practice, including an account of the French Academy of Painting, its Salons, Schools of Instruction and Regulations, New York, 1888. Chapter VII, section XI is devoted to "The Impressionists"; it deals with Manet, Bastien-Lepage, Duez, etc., and shows no appreciation for the real impressionists. This is, however, one of the earliest general surveys that deals with them at all.
- 26 Lemonnier, C.: Les peintres de la vie, Paris, 1888. Short considerations on the impressionists (p. 208–211).
- 27 MOORE, G.: Impressions and Opinions, London-New York, 1891. Contains an important chapter on Degas.
- 28 L'Art dans les Deux Mondes, periodical published by Durand-Ruel, Nov. 1890 to May 1891. The various issues contain important articles by Wyzewa on Renoir, Berthe Morisot, Seurat; by Geffroy on Degas; by Lecomte on Sisley; by Mirbeau on Pissarro and Monet, etc. Wyzewa's articles on Morisot and Renoir (revised) are reprinted in 55.
- 29 Wyzewa et Perreau: Les grands peintres de la France, Paris, 1891.
- 30 Hamerton, P. G.: The Present State of the Fine Arts in France. IV. Impressionism. *The Portfolio*, 1891. Though the author approached some of the painters and asked them for explanations as well as illustrations, his study reflects the common prejudices of the period, reproaching the artists for "neglect of details, their lack of drawing, their indifference to the charm of composition."
- 31 WAERN, C.: Notes on French Impressionists, Atlantic Monthly, April 1892. A sympathetic essay concluding with a lively description of a visit to Tanguy's shop.
- 32 SILVESTRE, A.: Au pays des souvenirs, Paris, 1892. The chapter on the Café Guerbois contains portrait-sketches of Manet, Zola, Desboutin, Duranty, Degas, Fantin-Latour, etc.
- 33 Lecomte, G.: L'art impressionniste d'après la collection privée de M. Durand-Ruel, Paris, 1892. Written at the time when the impressionists began very slowly to achieve recognition, this book combines short sketches on the artists with more or less lyrical descriptions of some of their most important works; it contains almost no biographical data and constitutes mainly a glowing appraisal of impressionism. Illustrated with etchings after works by Degas, Monet, Manet, Renoir, Pissarro, etc.
- 34 Aurier, C. A.: Oeuvres posthumes, Paris, 1893. Collected writings by a symbolist author passionately devoted to the post-impressionists. On Aurier see J. Rewald: Post-Impressionism—From van Gogh to Gauguin, New York, 1956.

- Geffroy, G.: L'impressionnisme, Revue Encyclopédique, Dec. 15, 1893.
- 36 MOORE, G.: Modern Painting, London-New York, 1893. Contains a study on "Monet, Sisley, Pissarro, and the Decadence," as well as some curious and erroneous remarks on Renoir and an amusing discussion of Degas.
- 37 Geffroy, G.: Histoire de l'Impressionnisme—La vie artistique, IIIe série, Paris, 1894. A study on the evolution of impressionism followed by chapters devoted to the individual artists. This first "History of Impressionism," like 33, was written mainly in defense of the painters, at a time when it was still important to convince readers of their honest intentions and scrupulous efforts. Although the author knew most of the impressionists intimately, he avoids personalities, concentrating instead on the common element of their research and the logic with which they developed the heritage of the past. This book is interesting as a historic document, but the reader is unlikely to find much information not available in more recent publications.
- 38 GARLAND, H.: Crumbling Idols, Chicago-Cambridge, 1894. A short chapter on impressionism presents what is probably the first all-out defense of the movement to be written in English. The author compares the painters to "skilled musicians; the actual working out of the melody is rapid, but it has taken vast study and practice."
- 39 Nittis, J. de: Notes et Souvenirs, Paris, 1895. Not very interesting; contains some notes concerning Manet, Degas (simply designated as D.)—both of whom the author knew well—Caillebotte, and Duranty, and on the author's participation in the first group exhibition.
- 40 MICHEL, A.: Notes sur l'art moderne, Paris, 1896.
- 41 MUTHER, R.: The History of Modern Painting, London, 1896, 3 v. The chapter on impressionism in v. 2, based on a very incomplete knowledge of facts, now seems totally antiquated.
- 42 Zola, E.: Peinture, Figaro, May 2, 1896. Zola's last article of art criticism, which expresses his disappointment with the impressionist movement. Reprinted in 1.
- 43 Séailles, G.: L'Impressionnisme; Almanach du Bibliophile pour l'année 1898, Paris, 1898.
- 44 BRICON, E.: L'art impressionniste au Musée du Luxembourg, La Nouvelle Revue, Sept. 15, 1898. A sympathetic study on the Caillebotte bequest, particularly concerned with Manet, Monet, Degas, and Renoir. See also p. 589, note 37 and General Bibliography 227.
- 45 Signac, P.: D'Eugène Delacroix au Néo-impressionnisme, Paris, 1899. An attempt to sum up the development of art since Delacroix as a logical and inescapable evolution toward neo-impressionism, written by the chief promoter of this movement.

- 46 THIÉBAULT-SISSON: Une Histoire de l'Impressionnisme, Le Temps, April 17, 1899.
- 47 Succession de Mme Veuve Chocquet, Tableaux Modernes, Galeries Petit, Paris, July 1, 3 and 4, 1899. Illustrated catalogue of the Chocquet collection, with introductions by T. Duret and L. Roger-Milès. On this sale see also 261.
- 48 Bridgmann, F. A.: Enquête sur l'Impressionnisme, *La Revue Impressionniste*, Marseille-Paris, 1900 [could not be located].
- 49 GEFFROY, G.: La Peinture en France de 1850 à 1900, Paris, n. d. [1900].
- 50 Mellerio, A.: L'exposition de 1900 et l'Impressionnisme, Paris, 1900. A small, scholarly pamphlet, written in defence of the impressionist movement, based on a thorough documentation and accompanied by a bibliography which lists the publications on (mostly early articles) and exhibitions of Monet, Pissarro, Renoir, Degas, Cézanne, Sisley, Morisot, Guillaumin, Boudin, Caillebotte, Cassatt, and Zandomeneghi. This is apparently the first bibliography of its kind.
- 51 LECOMTE, G.: Catalogue de la Collection E. Blot, Paris, May 1900.
- 52 MacColl, D. S.: Nineteenth Century Art, Glasgow, 1902.
- 53 Mauclair, C.: Les précurseurs de l'impressionnisme, La Nouvelle Revue, 1902. An article devoted mostly to Monticelli whose friendship with Cézanne, however, is ignored.
- 54 MEIER-GRAEFE, J.: Manet und sein Kreis, Berlin, 1902. The first book on the subject by an author whose numerous and enthusiastic writings on impressionism did much to spread its fame in Germany and abroad. This small illustrated book contains chapters on Manet, Monet, Pissarro, Cézanne, and Renoir.
- 55 Wyzewa, T. de: Peintres de jadis et d'aujourd'hui, Paris, 1903. Chapters on Morisot and Renoir.
- 56 Laforgue, J.: Mélanges posthumes, Paris, 1903 (Oeuvres Complètes, v. III). Contains a chapter with an excellent "physiologic esthetic explanation of the impressionist formula," written in connection with an impressionist exhibition at Gurlitt's in Berlin, 1883. For a translation see: Selected Writings by Jules Laforgue, New York, 1956. See also M. Dufour: Une philosophie de l'impressionnisme, étude sur l'esthétique de Jules Laforgue, Paris, 1904, and F. Fosca: Jules Laforgue et la Gazette des Beaux-Arts, Gazette des Beaux-Arts, Feb. 1961.
- 57 MAUCLAIR, C.: The French Impressionists, London, 1903. The first study on the subject translated into English; it has unquestionably contributed much to the

appreciation of impressionism, yet its author was not precisely ordained to be the champion of the movement. As art critic of the Mercure de France he had published many articles of a pretentious character, launching insolent attacks on all the great contemporary painters. He saw in neo-impressionism a trifling technique, referred to Gauguin's art as colonial, spoke of the gangsterism of Lautrec, poured out his scorn for Cézanne, and treated Pissarro with contempt. At the same time he admired Böcklin, Hodler, Carrière, etc. But when the painters were finally rewarded with recognition, and when most of those he slandered had died, Mauclair did not scruple to add his voice to the general expressions of admiration. It must be admitted, however, that he remained at least faithful to his opinions concerning Cézanne and never ceased to consider him a poor provincial artist stricken with incompetence and ambition. See also 53, 88, 100.

Under the Vichy government, Mauclair, once more a turncoat, wrote a book on the Jews in art, denouncing Pissarro among others. After the liberation of France, he was condemned to "national unworthiness."

Mauclair's book offers short chapters on the historic background and the theories of the movement, followed by studies on Manet, Monet, Degas, Renoir, and a chapter entitled: "The minor impressionists, Pissarro, Sisley, Cézanne, Morisot, Cassatt, Caillebotte, Lebourg, Boudin." There follow studies on modern illustrators (where Raffaëlli is preferred to Lautrec), on neo-impressionism (comprising not only Seurat and Signac but also Denis, Vuillard, Bonnard, Gauguin, etc.) and a final chapter on the merits and "faults" of impressionism.

The original French text was published as: L'impressionnisme, son histoire, son esthétique, ses maîtres, Paris, 1904, ill.

- 58 Meier-Graefe, J.: Der moderne Impressionismus, Berlin, n.d. [1903–04]. Devoted to Lautrec, Gauguin, Japanese prints, and neo-impressionism.
- 59 Dewhurst, W.: Impressionist Painting, Its Genesis and Development, London, 1904. A well-intentioned book by a painter who knew and admired Monet and corresponded with Pissarro. Neither historian nor writer, the author is extremely unreliable as far as facts and dates are concerned and shows no understanding of the succession of events. Although himself an artist, he has almost no technical information to offer. Following Mauclair closely in his judgments, he puts Cézanne on the same level as Boudin and Jongkind. Apparently unable to distinguish between initiators and followers, Dewhurst includes in his book many artists who have little or nothing to do with impressionism. Excellent halftone illustrations in black and white and in colors.
- 60 Meier-Graefe, J.: Entwicklungsgeschichte der modernen Kunst, 3 v., Stuttgart, 1904. Second enlarged

- edition: Munich, 1927. English translation: The Development of Modern Art, Being a Contribution to a New System of Aesthetics, 2 v., New York, 1908. The first broadly conceived general history that assigns a dominant place to the individual impressionists. Richly ill., index.
- 61 SIZERANNE, R. DE LA: Les questions esthétiques contemporaines, Paris, 1904. Chapter II: "Le bilan de l'Impressionnisme."
- 62 Burne-Jones, Ph.: The Experiment of "Impressionism,"

 Nineteenth Century & After, March 1905. A diatribe
 against impressionism by an exponent of the PreRaphaelite movement.
- 63 NICHOLSON, A.: The Luminists, Nineteenth Century & After, April 1905. A moderate defense of impressionism against Burne-Jones' attack.
- 64 Lanoé, G.: Histoire de l'école française du paysage, depuis Chintreuil jusqu'à 1900. Nantes, 1905.
- 65 Duret, T.: Histoire des peintres impressionnistes, Paris, 1906. The author's pamphlet of 1878, considerably expanded. This is not a history of the movement but a collection of chapters devoted to Pissarro, Monet, Sisley, Renoir, Morisot, Cézanne, Guillaumin. Though this book-long the standard work on the subject-contains biographical information and personal recollections, it seems today somewhat disappointing in view of the fact that the author, an intimate friend of the painters since before 1870, was the one person from whom a complete eve-witness account might have been expected. Duret fails to give vivid portraits of the painters and makes little or no use of the numerous letters he received from them. According to Tabarant (Autour de Manet, L'Art Vivant, Aug. 15, 1928) who first published many of the documents in Duret's possession, Duret did not know how to evaluate properly either irrefutable facts or original documents (see also 121). Insufficient bibliography, no index, illustrated.

An English edition, augmented with a chapter on Manet, has been published under the title: Manet and the French Impressionists, Philadelphia-London, 1910. 40 halftone ill. and original etchings. No bibl., no index.

- 66 FONTAINAS, A.: Histoire de la peinture française au XIXe siècle, Paris, 1906. An excellent study of the impressionists and their predecessors is followed by an informative chapter on the official art of the same period. New expanded edition (1801–1920), Paris, 1922.
- 67 Moore, G.: Reminiscences of the Impressionist Painters, Dublin, 1906. Reprint of a lecture using much of the material published in the author's "Confessions" (see 24) with additional recollections on Renoir, Pissarro, Cézanne, and Cassatt. Later incorporated in: Vale, London, 1914.
- 68 Hevesi, L.: Acht Jahre Secession, Vienna, 1906. Chapter

- on the impressionists who exhibited in 1903 at the Vienna "Secession."
- 69 Meier-Graefe, J.: Impressionisten, Munich-Leipzig, 1907. Chapters on Guys, Manet, van Gogh, Pissarro, and Cézanne; ill., no index.
- 70 Pica, V.: Gl'impressionisti Francesi, Bergamo, 1908. An important study, though somewhat confused and not too well informed; many well-chosen illustrations.
- 71 Hamann, R.: Der Impressionismus in Leben und Kunst, Marburg, 1908. A philosophical rather than historical treatise of impressionism in painting, sculpture, music, poetry, and abstract thought, with emphasis on the literary expressions. The author sees in neo-impressionism the most characteristic achievement of the impressionist movement. No ill., no index.
- 72 Meier-Graefe, J.: Ueber Impressionismus, *Die Kunst für Alle*, Jan. 1, 1910.
- 73 Holl, J.-C.: Après l'impressionnisme, Paris, 1910. In spite of its title, this pamphlet is more concerned with the impressionists than with their successors.
- 74 Huneker, J.: Promenades of an Impressionist, New York, 1910. Chapters on Cézanne, Degas, Monet, Renoir, Manet, Gauguin, and others. No ill., no index.
- 75 Weisbach, W.: Impressionismus—Ein Problem der Malerei in der Antike und Neuzeit, 2 v. Berlin, 1910–11. The second volume contains a selective study of East Asian art and of French impressionism with a few small color plates of little known works and numerous black and white reproductions.
- 76 KOEHLER, E.: Edmond und Jules de Goncourt, die Begründer des Impressionismus, Leipzig, 1911. A study on the Goncourt brothers as authors, art critics, and artists, with a long bibliography on impressionism in literature and painting.
- 77 Dewhurst, W.: What is Impressionism? *Contemporary Review*, 1911. Traces briefly "the extraordinary analogies which exist between Ruskin's theories and impressionism." See also 59.
- 78 PHILLIPS, D. C.: What is Impressionism? Art and Progress, Sept. 1912.
- 79 Denis, M.: Théories, 1890–1910, Du Symbolisme et de Gauguin vers un nouvel ordre classique, Paris, 1912. Reprints of a number of articles, among them some on Gauguin and Cézanne, both of whom the author had known. An important document on the conceptions of the post-impressionist generation among the leaders of which Denis, for some time, occupied a prominent place. See also 97 and M. Denis: Journal (1884–1943), 3 v., Paris, 1957–1959.
- 80 Coellen, L.: Die neue Malerei, Munich, 1912. Chapter on Impressionism.

- 81 Raphael, M.: Von Monet zu Picasso, Munich-Leipzig, 1913. Contains a long essay on the creative mind in general and a very readable chapter on impressionism concerned mostly with Monet and Rodin. Impressionism is defined as "reaction rather than action" in its submission to immediate perceptions. 30 ill., no bibl. or index. See also the same author's The Demands of Art, Princeton, N. J., 1968. Contains illuminating essays on Cézanne and Degas.
- 82 Borgmeyer, G. L.: The Master Impressionists, Chicago, 1913. This, the first important book published in America on the impressionists, with no less than 234 often well chosen illustrations, is today completely antiquated. The author's critical appreciations lack interest and his factual information is full of errors; the illustrations are arranged with no system whatsoever. They comprise not only works by the real impressionists but also by Carolus-Duran, Bastien-Lepage, de Nittis, Raffaëlli, numerous followers, and even Matisse.
- 83 Hausenstein, W.: Die bildende Kunst der Gegenwart, Stuttgart-Berlin, 1914. Chapters on the French impressionists, on neo-impressionism, Cézanne, van Gogh, and Gauguin.
- 84 Wright, W. H.: Modern Painting, Its Tendency and Meaning, London-New York, 1915. One of the first attempts in English to approach impressionism in a scholarly manner, and to show both that it was not a break with the past and that it was not based on science, as has been so often contended. No bibl.; index, ill.
- 85 Grautoff, O.: Die Auflösung der Einzelform durch den Impressionismus, *Der Cicerone*, 1919.
- 86 Blanche, J. E.: Propos de peintre, de David à Degas. Paris, 1919. Contains three important chapters of recollections on Manet, Renoir, Degas. No ill., no index.
- 87 Fénéon, F. (editor): L'Art Moderne, Paris, 1919. 2 v. with 173 good but undated ill. of works by Cézanne, Manet, Renoir, etc., from the Bernheim-Jeune collection. Interesting quotations from various authors.
- 88 MAUCLAIR, C.: L'Art indépendant français sous la IIIe République, Paris, 1919. Studies on painting, literature, and music between 1890 and World War I. See also 57.
- 89 Landsberger, F.: Impressionismus und Expressionismus, Leipzig, 1919. A brief juxtaposition of the two styles with emphasis on the latter.
- 90 DERI, M.: Die Malerei im XIX. Jahrhundert, Berlin, 1919. 2 vol. (text and ill.) A treatise of development based, in the author's words, on psychology. The chapters on impressionism and neo-impressionism suffer from a lack of discrimination between initiators and followers. No bibl., short index. For a condensed study of impressionism see the same author's: Die neue Malerei, Leipzig, 1921.

- 91 Leteller, A.: Des Classiques aux Impressionnistes, Paris, 1920. Written in defense of official art, this book makes a poor attempt to crush impressionism with a hodgepodge of quotations and a garrulous pseudo-erudition.
- 92 PICARD, M.: Das Ende des Impressionismus, Zurich, 1920.
- 93 Colin, P.: Notes pour servir à l'étude de l'impressionnisme, Paris, 1920.
- 94 MARZYNSKI, G.: Die Methode des Expressionismus, Leipzig, 1920. In a chapter on impressionism, "pointillism" is considered its purest expression.
- 95 KLINGSOR, T. L.: La peinture (L'art français depuis vingt ans), Paris, 1921. Chapter on: "L'Académisme et l'Impressionnisme."
- 96 FAURE, E.: Histoire de l'art—L'art moderne, Paris, 1921. Excellent English translation by Walter Pach, New York, 1924. Deals only briefly with impressionism but devotes penetrating studies to Cézanne and to Renoir. Ill., index, and a summary historical chart.
- 97 Denis, M.: Nouvelles Théories sur l'art moderne, sur l'art sacré, 1914–1921, Paris, 1922. Contains chapters on impressionism, Cézanne, and Renoir. See also 79.
- 98 Fontainas, Vauxcelles and George: Histoire générale de l'art français de la révolution à nos jours, Paris, 1922, v. I. Good chapters on impressionism in general and on the individual painters. Richly ill. No index, no bibl.
- 99 Les Maîtres de l'impressionnisme et leur temps—Exposition d'art français, Brussels, summer 1922. A catalogue with biographical notes and excerpts from various writings.
- 100 Mauclair, C.: Les maîtres de l'impressionnisme, leur histoire, leur esthétique, leur oeuvre, Paris 1923. Reprint of 57
- 101 HILDEBRANDT, H.: Die Kunst des 19. und 20. Jahrhunderts, Potsdam, 1924. This book, dealing on an equal basis with the best and the worst, devotes only little space to impressionism, and this in a wholly unsatisfactory way.
- 102 PACH, W.: The Masters of Modern Art, New York, 1924. The chapter: "From the Revolution to Renoir" sums up the evolution of French art since David. A few ill., list of principal books.
- 103 Anonymous: La grande misère des impressionnistes, Le Populaire, March 1, 1924. Quotations from letters by Monet to G. de Bellio. On this subject see also 249 and Monet bibliography.
- 104 Lamandé, A.: L'impressionnisme dans l'art et la littérature (lecture), Monaco, 1925.
- 105 Maus, M. O.: Trente années de lutte pour l'art,

- Brussels, 1926. The detailed history of the group Les Vingt and of the Libre Esthétique movement in Belgium.
- 106 RIVIÈRE, G.: Les impressionnistes chez eux, L'Art Vivant, No. 48, 1926.
- 107 Goodrich, L.: The impressionists fifty years ago, *The Arts*, Jan. 1927. A very well documented study.
- 108 RIVIÈRE, G.: Les "Nymphéas" de Claude Monet et les recherches collectives des impressionnistes, L'Art Vivant, June 1, 1927.
- 109 Waldmann, E.: Die Kunst des Realismus und des Impressionismus im 19. Jahrhundert, Berlin, 1927. The text does not contain anything new; the good illustrations show mostly well known works. Short index.
- 110 Scheffler, K.: Die europäische Kunst im neunzehnten Jahrhundert, 2 v., Berlin, 1927. Vol. II: Geschichte der europäischen Malerei vom Impressionismus bis zur Gegenwart.
- 111 Mather, F. J.: Modern Painting, New York, 1927. An excellent chapter on "Landscape Painting before Impressionism" is followed by a study on impressionism which, unfortunately, is marred by some errors, and in which Monet is credited with divisionism. This is the first book in English which devotes a whole chapter to a detailed analysis of the important problem of the "Official Art in the Nineteenth Century." Mediocre ill., short index.
- 112 Bell, C.: Landmarks in Nineteenth Century Painting, New York, 1927. A chapter on impressionism opposes the approach of the plein-airists to that of Degas. Ill., no index.
- 113 FOCILLON, H.: La peinture aux XIXe et XXe siècles, Paris, 1928. Contains a short chapter on impressionism with paragraphs devoted to the individual painters.
- 114 Guiffrey, J. (editor): La peinture au Musée du Louvre, Paris, 1929.—v. I, section III, P. Jamot: XIXe siècle. Catalogue of the most important works from the Camondo, May, Dihau, Moreau-Nélaton and other collections, combining biographical notes with analyses of the various paintings. This catalogue does not list the important collections which later entered the Louvre, such as those of Caillebotte, Koechlin, Personnaz, and Gachet; for these see 226 and 227.
- 115 BLANCHE, J. E.: Les arts plastiques—La IIIe République, de 1870 à nos jours. Paris, 1931. In a chapter on impressionism the author gives some personal recollections on the period in general as well as on some of the painters. See also 86.
- 116 Rey, R.: La peinture française à la fin du XIXe siècle— La renaissance du sentiment classique, Paris, 1931. Important studies on Renoir, Cézanne, Gauguin, and Seurat, of which the last mentioned is particularly rich in new material.

- 117 WILENSKI, R. H.: French Painting, Boston, 1931. A general history from the XIVth to the XXth century. The chapter on Impressionism offers a condensation of the material presented in the author's later work: Modern French Painting, 1940; see 144.
- 118 Poulain, G.: Pre-Impressionism, Formes, Nov. 1931.
- 119 Jamot, P.: French Painting II, Burlington Magazine, special issue, Jan. 1932, published on the occasion of a large exhibition of French art in London.
- 120 ROTHENSTEIN, J.: Nineteenth Century Painting—A study in Conflict, London, 1932.
- 121 Besson, G. (editor): L'impressionnisme et quelques précurseurs, Bulletin des expositions, III, Gal. d'art Braun & Cie, Paris, Jan. 22—Feb. 13, 1932. Letters by Courbet, Manet, Pissarro, Renoir, Monet, Cézanne, and Murer, mainly written to Duret.
- 122 COGNIAT, R.: Le Salon entre 1880 et 1900. Catalogue of an exhibition organized by *Beaux-Arts* and *Gazette des Beaux-Arts* (Paris, April-May 1934), containing biographical notices and reproductions of works by the most prominent official painters of the period, that is, of some of the most outspoken foes of impressionism.
- 123 ROTHSCHILD, E. F.: The Meaning of Unintelligibility in Modern Art, Chicago, 1934. Defines impressionism as "the subjectification of the objective."
- 124 Besson, G.: Peinture Française, vol. III, "XIXe Siècle," Paris, 1934. Small book with good ill. from Puvis de Chavannes to Vuillard.
- 125 Les origines de l'impressionnisme, special issue, *Les Beaux-Arts* (Brussels), June-Sept. 1935.
- 126 VENTURI, L.: L'impressionismo, L'Arte, March 1935. An important study of the development and particular character of the impressionist approach to nature. For an English condensation see 127.
- 127 VENTURI, L.: Impressionism, Art in America, July, 1936.
- 128 KATZ, L.: Understanding Modern Art, Chicago, 1936. Ch. XXV-XXVIII, v. I, feature a rather confused explanation of impressionism; dates not dependable.
- 129 Vollard, A.: Recollections of a Picture Dealer, Boston, 1936. Slightly expanded French edition: Souvenirs d'un marchand de tableaux, Paris, 1937. Though he was in a position to add considerably to our knowledge of most of the impressionists whom he had known more or less intimately since around 1895, the author has contented himself mainly with gossip which makes good reading but offers practically no important information. Ill., index.
- 130 GUILLAUME, G.: Influence de l'atelier de Gleyre sur les impressionnistes français, XIVe Congrès International d'Histoire de l'Art, 1936, Actes du Congrès, v. I.

- 131 Schapiro, M.: Nature of Abstract Art, Marxist Quarterly, Jan.-March 1937. An interesting discussion of the relationship between art and historical conditions. The author sees in the unconventionalized, unregulated vision of early impressionism an implicit criticism of symbolic, social, and domestic formalities.
- 132 COGNIAT, R.: La naissance de l'impressionnisme. Catalogue of an exhibition organized in Paris (May 1937) by Beaux-Arts and Gazette des Beaux-Arts.
- 133 Francastel, P.: L'impressionnisme—Les origines de la peinture moderne, de Monet à Gauguin, Paris, 1937. The author fancies that there may be observed a sudden change in style in the works of Monet, Pissarro, Sisley, and Renoir about 1875. Consequently he places the beginning of impressionism at this period, connecting it with the scientific discoveries of Helmholz and Chevreul. Overemphasizing the role of science, the author also greatly exaggerates the importance of Duranty's writings; moreover he confounds impressionism and divisionism. 12 insufficient ill.

See also the same author's Peinture et Société, Paris, 1951, 1965; Etudes et sociologie de l'art, Paris, 1952; La réalité figurative, Paris, 1965 (important chapter on impressionism). See also 171.

- 134 LAVER, J.: French Painting and the Nineteenth Century, London, 1937. Short text, not free of errors, followed by notes on individual painters. Excellent choice of good black and white illustrations, some fair color plates.
- 135 Scheffler, K.: Meisterwerke französischer Impressionisten, Berlin, 1937. Eight color plates with short text.
- 136 Uhde, W.: The Impressionists, New York, 1937. A Phaidon picture book with excellent black and white illustrations and some color plates. Two fifths of the reproductions represent works of Manet and the rest are unequally divided among the impressionists. Even more confusing is the fact that the illustrations are not arranged chronologically.
- 137 Klein, J.: Modern Masters, New York, 1938. A short and popular presentation of modern art from Manet to Gauguin with adequate black and white illustrations but poor color plates.
- 138 Bowie, T. R.: Relationships between French Literature and Painting in the XIXth Century. Catalogue of an exhibition, Columbus Gallery of Fine Arts, April-May, 1938.
- 139 Huyghe, R.: L'impressionnisme et la pensée de son temps, *Prométhée*, Feb. 1939.
- 140 Lноте, А.: Traité du paysage, Paris, 1939. Ill.
- 141 VENTURI, L.: Les Archives de l'Impressionnisme, Paris-New York, 1939. Two volumes indispensable for the study of impressionism. They feature 213 letters by Renoir, 411 by Monet, 86 by Pissarro, 16 by Sisley, 31

by Mary Cassatt, 27 by Degas, and a number of letters by other artists, all written to Durand-Ruel, chiefly after 1881, as well as some letters to Octave Maus; also a few letters by Paul Durand-Ruel, and his memoirs. (Most letters written to Durand-Ruel before 1881 are lost and even for the later period these archives are not absolutely complete since some documents have found their way into private collections.) On Durand-Ruel see also 155 and 241.

Vol. II contains condensed catalogues of the eight impressionist exhibitions. An appendix offers excerpts, complete reprints, or short reports of writings on impressionism published between 1863 and 1880; these are limited to serious studies only and do not include any of the violent attacks directed against the artists (for these see 232). Authors quoted extensively are Zola, Astruc, Silvestre, Burty, Pothey, Rivière, E. Renoir.

Venturi's long introduction traces the story of the Durand-Ruel Galleries and follows the development of Monet, Pissarro, Sisley, and Renoir. It lists the first collectors of impressionist paintings, analyzes the comments of contemporary critics and rounds out the information provided by the documents. Few ill., no bibl.; index.

- 142 RICHARDSON, E. P.: The Way of Western Art, 1776—1914, Cambridge, 1939. A short chapter on "Objective Realism and Impressionism" treats these movements on an international basis. Few ill., index.
- 143 SLOCOMB, G.: Rebels of Art—Manet to Matisse, New York, 1939. More biographical than critical, this book deals with the "wild men" of impressionism in an oversimplified fashion. It is by no means exact in data given and relies sometimes too heavily on anecdotes dear to Vollard and others. Ill., index, no bibl.
- 144 WILENSKI, R. H.: Modern French Painters, London-New York, 1940. An interesting but completely unreliable book. The author, who lists "my knowledge" as his principal source of information, depended on others for research and fitted their findings with the utmost freedom into the general pattern of his work. The results are frequent inaccuracies, oversimplifications, and unwarranted conclusions that suit the author's purpose and make for smooth reading but which make the book unusable as a reference work. No references for quotations are given and, for reasons unknown, numerous quotations are left in French. Summary and insufficient bibliography. Excellent and well-chosen illustrations; exhaustive index. Second edition with some color plates appeared in 1945. For a critical review see J. Rewald: Letter re: Modern French Painters, Burlington Magazine, Jan. 1948.
- 145 Cheney, S.: The Story of Modern Art, New York, 1941.

 A popular book repeating popular errors, confounding impressionist and neo-impressionist doctrines. For a

- correction of these errors see 160. Ill., uncritical bibl., index.
- 146 Neumeyer, A.: One Step before Impressionism, *The Pacific Art Review*, Spring 1941.
- 147 VENTURI, L.: The Aesthetic Idea of Impressionism, The Journal of Aesthetics, Spring 1941.
- 148 VENTURI, L.: Art Criticism Now, Baltimore, 1941. Contains a chapter on "The Problems of Impressionism and Post-Impressionism."
- 149 ROCHEBLAVE, S.: French Painting, XIXth Century, New York, 1941. A Hyperion picture book with badly selected illustrations and particularly poor color plates. Inadequate text and insufficient bibl.
- 150 DORIVAL, B.: Les étapes de la peinture française contemporaine, 3 v., Paris, 1943. Vol. I.: De l'impressionnisme au fauvisme, 1883–1905. Beginning with a general survey of art and ideas in France around 1889, this book is devoted to the period which followed immediately that of the impressionist movement. Condensed bibl., no index, no ill.
- 151 VINDING, O.: Foraaret i Fransk Kunst [Spring of French Art], Copenhagen, 1943. Popularized book, with a chapter on the impressionists and Vollard; 16 ill., insufficient bibl.
- 152 Scheyer, E.: Far Eastern Art and French Impressionism, *The Art Quarterly*, VI, No. 2, Spring 1943.
- 153 SCHMALENBACH, F.: Eine frühe schweizerische Aeusserung über die französischen Impressionisten, Pro Arte, 1943; reprinted in the same author's: Neue Studien über Malerei des 19. und 20. Jahrhunderts, Bern, 1955.
- 154 PISSARRO, C.: Letters to his son Lucien, edited with the assistance of Lucien Pissarro by John Rewald, New York, 1943. Several hundred letters written between 1883 and 1903 with detailed accounts of the last impressionist exhibition and useful information on Pissarro and his friends, 100 ill., index. The French edition, C. Pissarro: Lettres à son fils Lucien, Paris, 1950, contains a few additional letters, more complete footnotes, and a series of letters from Lucien Pissarro to his father; these are added to a new English edition, New York, 1972.
- 155 REWALD, J.: Durand-Ruel, Art News, Dec. 1-14, 1943.
- 156 Scheffler, K.: Die grossen französischen Maler des 19. Jahrhunderts, 1943. Studies on individual painters, ill.
- 157 VENTURI, L.: Qu'est-ce que l'impressionnisme, Labyrinthe, August 15, 1944.
- 158 CAIRNS, H. and WALKER, J. (editors): Masterpieces of Painting from the National Gallery of Art, Washington, New York, 1944. Some good color plates with comments. 2nd v.: Great Paintings from the National Gallery of Art, Washington, 1952.
- 159 JEWELL, E. A.: French Impressionists and their Con-

- temporaries, represented in American collections, New York, 1944. A Hyperion picture book assembled without any plan or order. Poor color plates. The short biographical notes and the bibliography by Aimée Crane are often inaccurate. See the detailed review by Rewald, *Magazine of Art*, March 1945.
- 160 Webster, J. C.: The Technique of Impressionism—a reappraisal, College Art Journal, Nov. 1944. This article offers a welcome refutation of some often repeated errors concerning optical mixture, etc.
- 161 RAGGHIANTI, C. L.: Impressionismo, Turin, 1944. 41 poor color plates, 36 in black and white. In a short introduction the author professes to see in impressionism individuals rather than a movement. No bibl.
- 162 VENTURI, L.: Painting and Painters: How to Look at a Picture, from Giotto to Chagall, New York, 1945. In the chapter "Vitalizing Nature" the author points out that "what impressionists painted and interpreted was not reality but the appearance of reality."
- 163 GOLDWATER, R. and TREVES, M. (editors): Artists on Art, from the XIVth to the XXth Century, New York, 1945. Contains some excerpts from writings and utterances by Manet, Degas, Sisley, Monet, Pissarro, Cézanne, etc.
- 164 Rewald, J.: Depressionist Days of the Impressionists, Art News, Feb. 15–28, 1945. On the large impressionist exhibition organized by Durand-Ruel in London in 1905. On this exhibition see also 211.
- 165 ALAZARD, J.: Les origines de l'impressionnisme, Etudes d'Art, Musée d'Alger, No. I, 1945.
- 166 VAGUETTI, G.: Impressionisti, Florence, 1945. Short introduction and short notes. Mediocre plates, some in color; arranged by artist, but not chronologically.
- 167 ORTWIN-RAVE, P.: Die Malerei des 19. Jahrhunderts, Berlin, 1945.
- 168 HUTH, H.: Impressionism comes to America, Gazette des Beaux-Arts, April 1946. Very interesting study, well documented, on the early exhibitions, the dealers, collectors, and critics through whom impressionism was introduced to America between 1879 and 1892.
- 169 Rewald, J.: The History of Impressionism, New York, 1946. First edition of the present volume.
- 170 Chase, E. T.: The Etchings of the French Impressionists and Their Contemporaries, Paris-New York, 1946. 72 plates, some in color, rather badly selected and showing more lithographs than etchings (Hyperion).
- 171 Francastel, P.: Nouveau dessin, nouvelle peinture. Paris, 1946. Chapters I and II are on impressionism.
- 172 Baschet, J.: Pour une Renaissance de la peinture française, Paris, 1946. Uninteresting text accompanied

- by a collection of color plates (previously published in *L'Illustration*) including many impressionist works.
- 173 Bazin, G.: L'époque impressionniste, Paris, 1947. The condensed text is based on a concept similar to that in this publication and is accompanied by well-selected plates in black and white and in color (Tisné).
- 174 BAZIN, G., FLORISOONE, M. and LEYMARIE, J.: L'impressionnisme, special issue of L'Amour de l'Art, 1947, Nos. III and IV. Excellent ill., photos of details, etc.
- 175 VENTURI and PALLUCHINI: Gli Impressionisti, Venice, 1948. Catalogue of the impressionist exhibition at the Venice Biennale, 1948, ill.
- 176 NATANSON, T.: Peints à leur tour, Paris, 1948. Recollections of Renoir, Monet, Degas, Pissarro, and others whom the author knew at the turn of the century.
- 177 VAUDOYER, J.-L.: Les impressionnistes, de Manet à Cézanne, Paris, 1948. 53 fairly good color plates of different sizes (apparently mainly from L'Illustration), assembled without system and accompanied by a text which contains nothing new.
- 178 Robiquet, J.: L'impressionnisme vécu, Paris, 1948. A purely anecdotal and journalistic account.
- 179 LEYMAIRE, J.: Manet et les impressionnistes au Musée du Louvre, Paris, 1948. 54 good plates; short introduction.
- 180 RAMUZ, C. F.: Les grands moments du XIXe siècle français, Lausanne, 1948. Lectures given in 1915–16.
- 181 Longhi, R.: Introduction to the Italian version of the first edition of this book, Rewald: Storia dell' Impressionismo, Florence, 1949. A thorough and interesting study on "Impressionism and the taste in Italy," on the attitude of Italian painters and critics—such as Martelli and Pica—from the start of impressionism to 1948.
- 182 Monet and the Beginnings of Impressionism. Catalogue of an exhibition, Currier Gallery of Art, Manchester, N. H., Oct.-Nov., 1949. Ill.
- 183 [Prins]: Pierre Prins et l'époque impressionniste, Paris, 1949. A feeble attempt to link this mediocre painter, who had known Manet, with the impressionist movement. Ill.
- 184 RAYNAL, M., LEYMARIE, J., READ, H.: History of Modern Painting, from Baudelaire to Bonnard, Geneva, 1949. Chapters on the years 1858–1870, 1871–1880, 1881–1884, treating the problems of impressionism in a rather journalistic manner but accompanied by numerous chronological charts, biographical notices, a bibl., etc., all very well arranged. Many ill., sometimes too vivid in color, but well selected (Skira).
- 185 NORDENFALK, C.: Luminarismen, Konstrevy (Stockholm), 1949.
- 186 Gauss, C. E.: The Aesthetic Theories of the French Artists, 1855 to the present, Baltimore, 1949.

- 187 Gebser, J.: Ursprung und Gegenwart, 2v., Stuttgart, 1949–53.
- 188 CLARK, K.: Landscape Painting, London-New York, 1950. Contains passages on the impressionists. Index, ill.
- 189 VENTURI, L.: Impressionists and Symbolists. New York, 1950. Chapters on Manet, Degas, Monet, Pissarro, Renoir, Cézanne, etc. Ill.
- 190 REUTERSWÄRD, O.: The "Violettomania" of the Impressionists, Journal of Aesthetics and Art Criticism, Dec. 1950.
- 191 GOMBRICH, E. H.: The Story of Art, London-New York, 1950. An excellent general history, ill., with a passage on impressionism.
- 192 Jedlicka, G.: Französische Malerei, von Fouquet zu Cézanne, 1950. Short introduction, section on impressionism, plates.
- 193 Soffici, A.: Trenta Artisti Moderni Italiani e Stranieri, Florence, 1950. Reprints of articles, some fairly early, on: Manet, Monet, Renoir, Pissarro, Degas, Cézanne, Redon, Gauguin, Seurat, etc.
- 194 Cogniat, R.: French Painting at the Time of the Impressionists, New York, 1951. 101 mediocre plates in color, assembled without system and accompanied by a text which offers nothing new (Hyperion).
- 195 RAYNAL, M.: Goya to Gauguin—The XIXth Century, Geneva-Paris-New York, 1951. General text accompanied by fairly good color plates (Skira).
- 196 FRY, R.: French, Flemish and British Art, London, 1951. Posthumous edition of a series of articles among which is a study of impressionism.
- 197 SLOANE, J. C.: French Painting Between the Past and the Present; Artists, Critics and Traditions from 1848 to 1870, Princeton, 1951. Erudite study of the artistic situation in the period during which impressionism was born. Useful appendix, bibl., index, ill.
- 198 Impressionnistes et romantiques français dans les musées allemands. Catalogue of an exhibition, Musée de l'Orangerie, Paris, 1951, with 71 good ill.
- 199 Fosca, F.: Les historiens d'art et la technique impressionniste, *Etudes d'Art*, Musée d'Alger, No. 6, 1951. Useful refutation of many often repeated errors.
- 200 Novotny, F.: Die grossen französischen Impressionisten, Vienna, 1952. Excellent introduction with 44 good and well-selected color plates, often of little-known works, from Delacroix to Matisse. Analytical notes on plates, no bibl.
- 201 Bell, C.: The French Impressionists, London-New York, 1952. 50 fairly poor color plates (Phaidon).
- 202 REUTERSWÄRD, O.: The Accentuated Brush Stroke of the Impressionists, *Journal of Aesthetics and Art Criticism*, March 1952.

- 203 Roger-Marx, C.: Le paysage français de Corot à nos jours, Paris, 1952. Chapter on "le miracle impressionniste." Ill., index.
- 204 Reuterswärd, O.: Impressionisterna inför publik och kritik, Stockholm, 1952. A year by year account, from 1873 to 1886 (with a long concluding chapter) on the impressionists and the critical appraisals with which they met. Very useful for the study of art criticism of the period and the roles played by Silvestre, Chesneau, d'Hervilly, Burty, Hoschedé, Castagnary, Leroy, A. Houssaye, Wolff, Rivière, Claretie, Zola (though written without knowledge of his Russian articles first reprinted in 1), Duranty, Duret, Huysmans, Alexis, Geffroy, Laforgue, Fénéon, etc. Among the reproductions are numerous contemporary caricatures of impressionist pictures as well as portraits of critics. An extensive alphabetical list, p. 245-262, provides short information on the major critics and bibliographies of their writings, followed by a chronological list of articles published anonymously. Unfortunately no translation of this basic book is as yet available.
- 205 Moser, R.: L'impressionnisme français—Peinture, Littérature, Musique, Geneva-Lille, 1952. A study of the aesthetic features of impressionism as expressed in the various arts.
- 206 Wechsler, H. J.: French Impressionists and their Circle, New York, 1952. Small volume with short introduction and commentaries, color plates (Abrams).
- 207 RUHLEMANN, H.: Methods of the Masters, II, Impressionists and Post-Impressionists, *The Studio*, Feb. 1953. A popularized article that is full of common misconceptions.
- 208 TAYLOR, B.: The Impressionists and Their World, London, n.d. [1953]. 96 fair to poor plates in black and white and color (Manet, Monet, Pissarro, Sisley, Renoir, Cézanne, Gauguin, van Gogh, Lautrec, Seurat, Redon, Rousseau) with short biographies and bibl.
- 209 Cassou, J.: Les impressionnistes et leur époque, Paris, n.d. [1953–54]. 48 plates in color with short introduction.
- 210 GAFFÉ, R.: Introduction à la peinture française, de Manet à Picasso, Brussels, 1954. A chapter on Manet and impressionism which contains nothing new.
- 211 COOPER, D.: The Courtauld Collection, London, 1954.
 A catalogue raisonné of this important collection which comprises famous works by Cézanne, Degas, Manet, Monet, Renoir, Seurat, Gauguin, etc., with 116 good ill. in black and white and an extensive index. The text treats at length not only the collection itself, but also Whistler and his friends, the French impressionists and their relationship with England and the British critics.
- 212 Dictionnaire de la Peinture Moderne, Paris, 1954. Very well-conceived reference book, richly ill., covering the

- period from impressionism to the present day, with very readable studies on the painters as well as on the various movements and people connected with the art world.
- 213 GILARDONI, V.: Impressionismo, Milan, 1954.
- 214 Chan, G.: Les peintres Impressionnistes et le chemin de fer, Paris, 1955. Pamphlet with mediocre ill.
- 215 Leymarie, J.: Impressionnisme, 2 v., Geneva, 1955. V. I, before 1873; v. II, after 1873; each with a chronological survey and index. Numerous small color plates (occasionally with comments) including some little known works. Neo-impressionism is included, but not Redon. Very condensed bibl. and short list of exhibitions.
- 216 Francastel, P.: Histoire de la peinture française, v. II: Du classicisme au cubisme, Amsterdam-New York, 1955.
- 217 Vaudoyer, J.-L.: Les impressionnistes de Manet à Cézanne, Paris, 1955.
- 218 FRIEDENWALD, J. S.: Knowledge of Space Perception and the Portrayal of Depth in Painting, *College Art Journal*, Winter 1955.
- 219 LAPRADE, J. de: L'impressionnisme, Paris, 1956.
- 220 Cogniat, R.: L'impressionnisme, Paris, 1956. From Jongkind to Slevogt. Small volume with mediocre color plates accompanied by short comments.
- 221 Roger-Marx, C.: Les impressionnistes, Paris, 1956. Popularized account; numerous plates in black and white or color of generally well-known works.
- 222 Gachet, P.: Deux amis des impressionnistes—Le Docteur Gachet et Murer, Paris, 1956. A rambling and very detailed biography of two peripheral figures with only occasional information on the impressionists; ill.
- 223 Gachet, P. (editor): Lettres impressionnistes au Dr. Gachet et à Murer, Paris, 1957. Letters by Pissarro, Guillaumin, Renoir, Monet, Sisley, Vignon, Theo van Gogh, Cézanne, etc. Unfortunately most of these documents are of minor importance (the most revealing letters by Pissarro to Murer were quoted by Tabarant in a Pissarro biography, Paris, 1924; the letters by Vincent van Gogh included were not addressed to either Gachet or Murer and have been published elsewhere).
- 224 Stoll, R. Th.: La peinture impressionniste, Lausanne, 1957. Extensive introduction with numerous good plates in black and white or color.
- 225 ROBIDA, M.: Le Salon Charpentier et les impressionnistes, Paris, 1958. The author, though related to the Charpentier family, has little new information to offer, except for minor anecdotes. This small volume does not contain, nor refer to, the letters which Renoir, Monet, etc., wrote to M. and Mme Charpentier.
- 226 Catalogue des peintures, pastels, sculptures impres-

- sionnistes, Musée National du Louvre, Paris, 1958. Introduction by G. Bazin. An excellent catalogue with detailed information on many works by H. Adhémar, but no ill.
- 227 Bazin, G.: French Impressionists in the Louvre, New York, 1958 (French edition: Trésors de l'Impressionnisme au Louvre, Paris, 1958). The author discusses among others the story of the Caillebotte bequest and traces in general the growth of the amazingly rich impressionist collection of the Louvre, based almost exclusively on donations and bequests rather than on purchases. Numerous color plates with comments, supplemented by small black and white reproductions in an appendix. A useful companion volume to 226.
- 228 STERLING, C.: Great French Painting in the Hermitage, New York, 1958. A major section of this large volume is devoted to the important impressionist and postimpressionist collection of the Leningrad museum. (Equally important modern works are in the Pushkin Museum in Moscow, not recorded here.) Numerous excellent black and white and fair color plates of generally little-known paintings.
- 229 Balzer, W.: Derfranzösische Impressionismus, Dresden, 1958. Short introduction, 112 large and good black and white, 18 mediocre color plates, mostly after well-known works in the Louvre.
- 230 Meier-Graefe, J.: Grundstoff der Bilder, Munich, 1959. A selection of writings, edited by C. Linfert, with short chapters on Monet, Degas, van Gogh, Cézanne, and Renoir.
- 231 Alley, R.: Tate Gallery—The Foreign Paintings, Drawings and Sculpture, London, 1959. A useful and detailed catalogue which, together with 211, records the majority of the publicly exhibited impressionist works in England.
- 232 Lethève, J.: Impressionnistes et Symbolistes devant la presse, Paris, 1959. With a running text limited to the bare minimum, this small volume presents a great wealth of quotations from contemporary newspapers; many of these are of anecdotal interest only, yet their accumulation constitutes a practical compendium of early criticism. Few ill., summary bibl.
- 233 Mathey, F.: Les impressionnistes et leur temps, Paris, 1959. A general survey, containing nothing new, with numerous ill.
- 234 Cogniat, R.: Le siècle des impressionnistes, Paris, 1959. Yet another of the popular large volumes with general text and numerous good plates in black and white or color; this one extends from Turner to Macke. Short biographical notes.
- 235 Anonymous: The Geography of Impressionism, *The Times* (London), Sept. 22, 1959.
- 236 CANADAY, J.: Mainstreams of Modern Art, New York,

- 1959. Chapters on the "Salon at Mid-Century," on Manet, and on impressionism. Profusely ill. in black and white, with some poor color plates. No bibl., index.
- 237 SERULLAZ, M.: Les peintres impressionnistes, Paris, 1959. General survey from the pre-impressionists to van Gogh, Gauguin, Seurat, and Redon, interspersed with numerous good color plates. Short biographical notes, index.
- 238 Zola, E.: Salons, Geneva, 1959, Edited by F. W. J. Hemmings and R. J. Niess. See also 1.
- 239 Novotny, F.: Painting and Sculpture in Europe—1780 to 1880, London, 1960. This excellent volume of the Pelican History of Art devotes a short chapter to impressionism in general and to its chief protagonists. Few ill., condensed bibl., index.
- 240 Jones, P.: Daumier et l'impressionnisme, Gazette des Beaux-Arts, April 1960.
- 241 DAULTE, F.: Le marchand des impressionnistes [Durand-Ruel], L'Oeil, June 1960.
- 242 Hamann, R. and Hermand, J.: Impressionismus, Berlin, 1960. Concerned exclusively with German impressionists whose first significant works date from the '90s.
- 243 Badt, K.: Die Farbenlehre van Goghs, Cologne, 1961.
 An important chapter on the theories of impressionism.
- 244 PLATTE, H.: Zauber der Farbe—Der französische Impressionismus, Stuttgart, 1962. Exists also in English; ill.
- 245 Stein, M.: Fransk Impressionisme, Copenhagen, 1962. Pamphlet with 4 poor color plates.
- 246 Reidemeister, L.: Auf den Spuren der Maler der Ile de France, Berlin, 1963. The author has traced many "motifs" from Corot to Matisse, with special emphasis on the impressionists. Unfortunately, he undertook this task somewhat too late. Although a number of his photographs are amazingly close to the subjects, others are almost meaningless because nature, men, and war have wrought such radical changes that the juxtaposition of paintings and photographs only stirs up regret for a past gone forever.
- 247 Catalogue of exhibition "Birth of Impressionism," Wildenstein Galleries, New York, 1963. An important exhibition: from Turner to Corot. Introduction by John Rewald; all works ill.
- 248 Catalogue of exhibition "The French Impressionists and Some of Their Contemporaries," Wildenstein Galleries, London, 1963. Excellent catalogue with detailed notices and many ills.
- 249 NICULESCU, R.: Georges de Bellio, l'ami des impressionnistes, Revue Roumaine d'Histoire de l'Art, v. I, no. 2, 1964. Very important article on one of the first collectors of impressionists, of whom little is known; also reprinted in Paragone, 247–49, 1970.

- 250 Reff, T.: Copyists in the Louvre 1850–1870, Art Bulletin, Dec. 1964. Useful record of when the various impressionists copied what.
- 251 Catalogue of exhibition "Olympia's Progeny—French Impressionist and Post-Impressionist Paintings," Wildenstein Galleries, New York, 1965. Important exhibition; all 87 works ill. Introduction by K. S. Champa.
- 252 GOULD, C.: An Early Buyer of French Impressionists in England, Burlington Magazine, March 1966.
- 253 Hamilton, G. H.: Painting and Sculpture in Europe 1880–1940, Baltimore, 1967. Begins with an important section on "Later Impressionism."
- 254 Dauberville, H.: La Bataille de l'impressionnisme, Paris, 1967. Disappointing.
- 255 Pool, P.: Impressionism, London, 1967. Good survey with mediocre illustrations. Selected bibl., index.
- 256 Bodelsen: M.: Early Impressionist Sales 1874–94 in the Light of Some Unpublished 'procès-verbaux,' Burlington Magazine, June 1968. Extremely valuable article with new data on the sales of Hoschedé (1874, 1878), the impressionists (1875, 1877), the Atelier Manet (1884), Duret, and Tanguy's widow (1894).
- 257 Bodelsen, M.: Gauguin og Impressionisterne, Copenhagen, 1968. For an English condensation see the same author's: Gauguin, the Collector, *Burlington Magazine*, Sept. 1970.
- 258 Lethève, J.: La vie quotidienne des artistes français au XIXe Siècle, Paris, 1968.
- 259 Boime, A.: The Salon des Refusés and the Evolution of Modern Art, Art Quarterly, Winter 1969.
- 260 DORIVAL, B., ed.: Histoire de l'art, 4—Du Réalisme à nos jours, Paris, 1969. Important chapter on impressionism by Dorival.
- 261 Rewald, J.: Chocquet and Cézanne, Gazette des Beaux-Arts, July-Aug. 1969.
- 262 Catalogue of exhibition "Pre-Impressionism, 1860–1869," University of California at Davis, 1969. Excellent, with numerous contributions by faculty members and students; a model of its kind.
- 263 Rey, J. C.: Pour l'impressionnisme. Bersier, J. E.: Contre l'impressionnisme, Paris, 1969.
- 264 GAUNT, W.: Impressionism—A Visual History, New York, 1970. Introduction, uneven color plates with comments, notes.
- 265 Catalogue of exhibition "One Hundred Years of Impressionism: A Tribute to Durand-Ruel." Excellent exhibition, Wildenstein Galleries, New York, April-May 1970; ill. See also 269.
- 266 Roskill, M.: Van Gogh, Gauguin and the Impres-

- sionist Circle, London-New York, 1970. Chapter on Impressionism.
- 267 Blunden, M. and G., and Daval, J.-L.: Impressionists and Impressionism, Geneva, 1970. The final word (or is it?) in "coffee-table" books; the plates leave a good deal to be desired. Hilton Kramer reviewed it thusly: "If you have been living on the moon and have therefore not yet caught up with Impressionism, the new Skira production... will provide a moderately diverting run-through of the general terrain."
- 268 Hamilton, G. H.: 19th and 20th Century Art, New York, 1970. Short chapter: "From Romantic Realism to Naturalism and Impressionism."
- 269 Catalogue of exhibition "Französische Impressionisten —Hommage à Durand-Ruel," Kunstverein, Hamburg, Nov. 28, 1970-Jan. 24, 1971. An important exhibition. Text on Paul Durand-Ruel by H. Platte; chronologies and ills. See also 265.
- 270 Kelder, D.: The French Impressionists and Their Century, New York, 1970. This is announced as "a new text based on *Die Maler des grossen Lichtes* by Hans Platte." Why? Superficial.
- 271 Anonymous: L'Impressionnisme, Paris, 1971. Introduction by René Huyghe (2 pages). Profusely illustrated. The prose, built around the often capriciously assembled reproductions, is somewhat purplish. No concern for chronology.
- 272 Leymarie, J. and Melot, M.: Les gravures des Impressionnistes—Oeuvre complet, Paris, 1971. Excellent presentation of the etchings and lithographs of Cézanne, Manet, Pissarro, Renoir, and Sisley (for Pissarro also some woodcuts). However, only one state of each work is shown. Good plates, numerous details.
- 273 Rewald, J.: Theo van Gogh, Goupil, and the Impressionists, *Gazette des Beaux-Arts*, Jan., Feb. 1973.

BAZILLE

Oeuvre Catalogues

A detailed catalogue of Bazille's works, most of which are reproduced, is appended to 6; it supersedes the list in 5.

Another oeuvre catalogue and an edition of Bazille's correspondence are being prepared by G. Sarraute.

- 1 Catalogue of exhibition "Frédéric Bazille" organized by the Ass. des Etudiants Protestants, Paris, n.d. [1935]. Short introduction by G. Poulain, ill.
- 2 Centenaire de Frédéric Bazille, Musée Fabre, Montpellier, May-June 1941. Summary catalogue.
- 3 CLAPARÈDE, J. and SARRAUTE, G.: Catalogue of exhibition "Bazille," Wildenstein Galleries, Paris, summer

- 1950; detailed notes and quotations from letters concerning 67 exhibited works, 14 good ill.
- 4 Catalogue of exhibition "Frédéric Bazille," Musée Fabre, Montpellier, Oct. 1959.

The Artist's Own Writings

A great number of letters by Bazille to his family are quoted in 3, 5, and 6. A few excerpts in English are to be found in 15.

Biographies

- 5 Poulain, G.: Bazille et ses amis, Paris, 1932. This book is of prime importance not only for the study of Bazille but for the beginnings of impressionism. It is based on letters written by Bazille to his family as well as received by him from Monet and Renoir. The importance of these documents cannot be overestimated. Unfortunately, they have not been edited with sufficient care. Several letters seem inaccurately dated, many have not been copied completely—but even more disturbing is the fact that they have been either badly deciphered or else rewritten, for some of these same documents, quoted in an article by the same author (19), present noticeable variations in syntax and expression. A list of works in appendix. No index, bibl., or ill.
- 6 Daulte, F.: Frédéric Bazille et son temps, Geneva, 1952. Richly documented text, more thoroughly done than bibl. 5, although somewhat pedantic. Some new documents, but on the whole bibl. 5 is still essential for Bazille's letters. Numerous ill. in black and white, 3 poor color plates; detailed oeuvre catalogue of 59 paintings, 37 drawings, and 2 sketchbooks, most of which are reproduced; iconography, list of exhibitions; first extensive bibl., index.

Studies of Style

- 7 CHARENSOL, J.: Frédéric Bazille et les débuts de l'impressionnisme, L'Amour de l'Art, Jan. 1927.
- 8 Focillon, H.: La Peinture aux XIXe et XXe siècles, Paris, 1928, p. 211–212.
- 9 Poulain, G.: Le pré-impressionnisme, Formes, No. 19, 1931.
- 10 Santenac, P.: Sur le peintre méridional Frédéric Bazille, Sud, Dec. 1, 1932.
- 11 COLOMBIER, P. du: La place de Frédéric Bazille, Candide, April 4, 1935.
- 12 Dabit, E.: Quelques impressions à propos d'une Exposition Bazille à l'Association des étudiants protestants, Revue Europe, May 15, 1935.
- 13 GAUTHIER, M. and LAPRADE, J. de: Frédéric Bazille, Beaux-Arts, No. 117, 1935.

- 14 Anonymous: A Painting by Bazille, Fogg Art Museum, vol. VII, 1937.
- 15 Scheyer, E.: Jean Frédéric Bazille—The Beginning of Impressionism, *The Art Quarterly*, Spring 1942. Study based on Poulain's documents (5) and several unpublished works, some of which have since been contested, in American and European collections. Ill.
- 16 POULAIN, G.: Une oeuvre inconnue de Frédéric Bazille, Arts de France, Nos. 17–18, 1947.
- 17 DORIVAL, B.: La Scène d'Eté de Bazille et Cézanne, Musées de France, May 1949.
- 18 SARRAUTE, G.: Deux dessins de Frédéric Bazille au Musée du Louvre, Musées de France, May 1949.

Reproductions

19 POULAIN, G.: Un languedocien, Frédéric Bazille. La Renaissance, April 1927. French and English text, reproductions of Bazille's major paintings.

See also 1, 3, and especially 6.

CAILLEBOTTE

- 1 Bérhaut, M.: Catalogue of exhibition "Caillebotte," Wildenstein Galleries, Paris, summer 1951, with list of 332 paintings (not all in the show) and 14 good ill. Introduction by D. Wildenstein.
- 2 Bérhaut, M.: Trois tableaux de Caillebotte, Musées de France, July 1948; also by the same author: Gustave Caillebotte, Arts (Paris), August 30, 1948.
- 3 BOURET, J.: Un peintre de notre temps, Arts (Paris), May 25, 1951.
- 4 Catalogue of exhibition "Caillebotte et ses amis impressionnistes," Chartres, June-Sept. 1965. Introduction by G. Besson.

See also p. 589, note 37.

CASSATT

Oeuvre Catalogues

- 1 Breeskin, A. D.: Mary Cassatt: A Catalogue Raisonné of the Oils, Pastels, Watercolors, and Drawings, Washington, D.C., 1970. Ill.
- 2 Breeskin, A. D.: The Graphic Work of Mary Cassatt, New York, 1948. Catalogue raisonné with introduction, chronology, etc., 232 superb ill.
- 3 Mary Cassatt, catalogue of a comprehensive exhibition, Baltimore Museum of Art, 1941. Unsigned introduction (by A. D. Breeskin); ill., chronological chart, bibl. See also the same author's article in *L'Oeil*, Jan. 1959.

- 4 Catalogue of exhibition "Mary Cassatt," Wildenstein Galleries, New York, Oct.-Dec. 1947. Text by A. D. Breeskin, ill.
- 5 Catalogue of exhibition "Mary Cassatt, peintre et graveur," Centre culturel américain, Paris, Nov. 1959-Jan. 1960. Introduction by F. A. Sweet, chronology, ill.
- 6 Catalogue of exhibition "Hommage à Mary Cassatt," Château de Beaufresne, Musée départemental de l'Oise, Beauvais, June-July 1965. On this subject see also F. A. Sweet: A Château in the Country, Art Quarterly, summer 1958.
- 7 Catalogue of exhibition "Mary Cassatt," International Galleries, Chicago, Nov.-Dec. 1965. Introduction by F. A. Sweet.
- 8 Catalogue of exhibition "Mary Cassatt," Knoedler Galleries, New York, Feb. 1966.
- 9 Catalogue of exhibition "Mary Cassatt," National Gallery of Art, Washington, D.C., Sept.-Nov. 1970. Introduction by A. D. Breeskin; ill.

The Artist's Own Writings

31 letters to Durand-Ruel are reproduced by L. Venturi: Les Archives de l'Impressionnisme, Paris-New York, 1939, v. 2. Letters to Mrs. Havemeyer are quoted in 11, a letter to Avery is quoted in 3, letters to Weitenkampf are quoted in 32, a letter to a friend is quoted in 2, another in 5, p. 20. Mrs. Breeskin is now assembling the letters of Cassatt.

Witness Accounts

- 10 Biddle, G.: Some Memories of Mary Cassatt, The Arts, Aug. 1926.
- 11 HAVEMEYER, L. W.: Mary Cassatt, *The Pennsylvania Museum Bulletin*, May 1927. See also 14 and 31.
- 12 Watson, F.: Philadelphia Pays Tribute to Mary Cassatt, The Arts, June 1927.
- 13 Watson, F.: Mary Cassatt, New York, 1932. Important recollections, with 20 halftone reproductions of paintings, pastels, and prints, chronologically arranged. Bibl.
- 14 HAVEMEYER, L. W.: Sixteen to Sixty: Memoirs of a Collector, New York, 1961. See also 11 and 31.

Biographies

15 Segard, A.: Mary Cassatt, un peintre des enfants et des mères, Paris, 1913. Although the author interviewed the artist, he offers little precise information (and this often relegated to footnotes); his book consists mostly of lyrical commentaries. 38 good ill., chronologically arranged. Appendix: list of exhibitions and private collections, bibl., no index.

- 16 Anonymous: Mary Cassatt, Painter and Engraver, Index of Twentieth Century Artists, Oct. 1934. Features a short biography, list of exhibitions, reproductions, and bibl.
- 17 Carson, J. M. H.: Mary Cassatt, New York, 1966.
- 18 Sweet, F. A.: Miss Mary Cassatt: Impressionist from Pennsylvania, Norman, Okla., 1966. Reliable fulllength biography; bibl.

Studies of Style

- 19 BEURDELEY, Y. R.: Miss Cassatt, L'Art dans les Deux Mondes, Nov. 22, 1890.
- 20 WHITE, F. L.: Young American Women in Art, Frank Leslie's Popular Monthly, Nov. 1893.
- 21 Walton, W.: Miss Mary Cassatt, Scribner's Magazine, March 1896.
- 22 Geffroy, G.: Femmes Artistes—Un Peintre de l'Enfance —Mary Cassatt, Les Modes, v. IV, Feb. 1904.
- 23 CAREY, E. L.: The Art of Mary Cassatt, The Scrip, Oct. 1905.
- 23a MAUCLAIR, C.: Trois crises de l'art actuel, Paris, 1906. Chapter on Cassatt.
- 24 Pica, V.: Artisti Contemporanei—Berthe Morisot, Mary Cassatt, Emporium, v. XXVI, July 1907.
- 25 PACH, W.: Quelques notes sur les peintres américains, Gazette des Beaux-Arts, Oct. 1909.
- 26 Anonymous: Mother and Child—The Theme as Developed in the Art of Mary Cassatt, Good Housekeeping Magazine, Feb. 1910.
- 27 Mellerio, A.: Mary Cassatt, L'Art et les Artistes, Nov. 1910. Contains list of exhibitions and bibl.
- 28 Anonymous: Mary Cassatt's Achievement, The Craftsman, March 1911.
- 29 McChesney, C.: Mary Cassatt and Her Work, Arts and Decoration, v. III, 1913.
- 30 Grafly, D.: In retrospect—Mary Cassatt, American Magazine of Art, June 1927.
- 31 ALEXANDRE, A.: La Collection Havemeyer et Miss Cassatt, La Renaissance, Feb. 1930. See also 11 and 14.
- 32 Johnson, U. E.: The Graphic Art of Mary Cassatt, American Artist, Nov. 1945.
- 33 Fuller, S.: Mary Cassatt's Use of Soft-Ground Etching, Magazine of Art, Feb. 1950.
- 34 Sweet, F. A.: Sargent, Whistler and Mary Cassatt. Descriptive catalogue of an exhibition, Art Institute of Chicago and Metropolitan Museum, New York, 1954.

See also 2 and 4.

Reproductions

- 35 Valerio, E.: Mary Cassatt, Paris, 1930. 32 photogravures after paintings, pastels, drawings, and prints with no dates, measurements, or owners given.
- 36 Breuning, M.: Mary Cassatt, New York, 1944. 46 ill. not in chronological order, poor color plates, short bibl. (Hyperion).
- 37 Catalogue of the exhibition "Mary Cassatt Among the Impressionists," Joslyn Art Museum, Omaha, Nebr., 1969. Good catalogue, richly ill. Essays by W. A. McGonagle and A. D. Breeskin.

See also 1, 2, 4, 11, 13, 15, and 34.

CÉZANNE

Oeuvre Catalogues

1 Venturi, L.: Cézanne, son art, son oeuvre, Paris, 1936.
2 v. (text and plates) with 1,619 ill. after paintings, watercolors, drawings, and prints, plus 15 photographs. The descriptive catalogue raisonné is preceded by an excellent and authoritative study of Cézanne's evolution, but the dating of many works has since been questioned (on this subject see 51, 62, and various exhibition catalogues assembled at the end of this section). The index unfortunately is limited to last owners.

For reproductions of drawings and watercolors neither catalogued nor reproduced by Venturi, see 3 (French edition), 55, 70, 71, 101, and 112.

A new catalogue raisonné of Cézanne's paintings and watercolors is being prepared by J. Rewald; a similar catalogue of his drawings is being readied for publication by A. Chappuis. See also 84.

la Gatto, A. and Orienti, S.: Opera completa di Cézanne, Milan, 1970. Presentation by Gatto, critical research by Orienti. A series of mediocre to atrocious color plates followed by minute black and white reproductions (sometimes 25 and more to a page). The "critical research" consisted in a rather shameless plagiarizing of Venturi (see 1), even copying his errors in dates and attributions; two paintings that are now known not to be by Cézanne-one published in the Burlington Magazine with a newly revealed signature by one of the artist's friends, the other withdrawn from a London auction sale as spurious—are included. The same uncritical reliance on Venturi manifests itself throughout in many mistakes (for example, in dating, V. 438 and 702; in wrong titles, V. 294 and 716; for wrong owners, V. 645 and 647). Most of these mistakes have been corrected in monographs, exhibition catalogues, etc., which were blithely ignored. For instance, the catalogue of the Pearlman collection appeared in

1959, listing and reproducing five paintings by Cézanne; this collector is not named once as owner of a work, nor are three of his pictures, which had escaped Venturi, to be found in the Gatto-Orienti product.

The title is misleading since this "complete" catalogue omits not only a certain number of paintings but does not contain any watercolors or drawings at all.

- 2 Gachet, P.: Cézanne à Auvers—Cézanne graveur, Paris, 1952. Catalogue of Cézanne's five etchings, more complete than Venturi's. See also 2a, 2b.
- See also J. Goriani: Cézanne's lithograph, "The Small Bathers," Gazette des Beaux-Arts, Feb. 1943.
- 2a LEYMARIE, J. and MELOT, M.: Les gravures des Impressionnistes, Paris, 1971. Includes a complete catalogue of Cézanne's graphic work with excellent reproductions. See also 2b.
- 2b Cherpin, J.: L'oeuvre gravé de Cézanne, Marseilles, n.d. [1972]. Catalogue with discussions of various states.

The Artist's Own Writings

- 3 Paul Cézanne: Letters, edited by J. Rewald, London, 1941. More than 200 letters: ill., index. Original French edition: Paul Cézanne, Correspondance, Paris, 1937, illustrated exclusively with works not reproduced in 1.
- 4 REWALD, J.: Cézanne, Geffroy et Gasquet, suivi de Souvenirs sur Cézanne de Louis Aurenche et de lettres inédites, Paris, 1959. Contains hitherto unpublished letters to Count Doria, Geffroy, and Vollard, but above all a group of letters to J. Gasquet and his father, of which only excerpts had appeared (see 14) as well as all letters to L. Aurenche. Ill.

An unpublished letter to A. Emperaire has appeared in V. Nicollas: Achille Emperaire, Aix-en-Provence, 1953, p. 5.

- 5 A new, complete edition and translation of Cézanne's letters has appeared in Cézanne—Briefe, Zurich, 1962. This includes documents not published in 3, such as those in 4 (with the exception of 6).
- 6 Rewald, J.: Une lettre inédite de Paul Cézanne, in Pour D.-H. Kahnweiler, Stuttgart, 1966.

See also 17.

Witness Accounts

- 7 Zola, E.: Correspondance (1858–1871); Oeuvres complètes, Paris, 1928. Numerous letters to Cézanne and their mutual friends. See also Zola: Mes Haines; Oeuvres Complètes, Paris, 1928, which contains "Mon Salon" with a dedication to Cézanne.
- 8 Scolari, M. and Barr, A.: Cézanne in the Letters of

- Marion to Morstatt, 1865–68, Magazine of Art, Feb., April, May 1938, and: Cézanne d'après les lettres de Marion à Morstatt, Gazette des Beaux-Arts, Jan. 1938. These are among the most important documents on Cézanne's youth.
- 9 Vollard, A.: Paul Cézanne, Paris, 1914, 1919, 1924, 1938 (English translation: Paul Cézanne, His Life and Art, New York, 1926). The first biography of Cézanne, written by his dealer, it is mostly anecdotal and now antiquated except for the part that relates the author's personal experiences with the artist, whom he knew during the last ten years of the painter's life. Some details on the years 1860–70 were communicated by Guillemet, who knew Cézanne intimately during that period, but the author neither quotes him directly nor acknowledges his collaboration. Appendix I features excerpts from contemporary criticisms. Ill., index.

For an early review see: R. Fry, *Burlington Magazine*, 1917; reprinted *in* Vision and Design, London.

- 10 Jaloux, E.: Fumées dans la campagne, Paris, 1918; also: Souvenirs sur Paul Cézanne, *L'Amour de l'Art*, 1920.
- 11 OSTHAUS, K. Article in *Das Feuer*, 1920; condensed translation in *Marianne*, Feb. 22, 1939. Account of a visit paid to Cézanne in 1906 (English version in 24, p. 195–196, and 133).
- 12 CAMOIN, C.: Souvenirs sur Paul Cézanne, L'Amour de l'Art, Jan. 1921; later incorporated in 17. The author, a painter who did his military service in Aix at the same time as Larguier, enjoyed the particular friendship of Cézanne, whom he approached—unlike Bernard—with a wholly unselfish admiration. See also Brassaï: Picasso and Company, Garden City, New York, 1966. French ed. Conversations avec Picasso, Paris, 1964.
- 13 LAFARGUE, M.: Souvenirs sur Cézanne, L'Amour de l'Art, Jan. 1921.
- 14 Gasquet, J.: Cézanne, Paris, 1921. The author, a poet of distinction, was the son of a school friend of Cézanne's and knew the painter during his last years. He succumbs frequently to the tendency to report Cézanne's utterances in a style of his own which—beautiful though it may be—does not always appear truthful. In three chapters of more or less imaginary conversations with Cézanne on the "motif," in the Louvre, and at the artist's studio, he quotes him freely, mostly from memory, occasionally from letters written to him by Cézanne, published in 4. In spite of its short-comings this book provides the most lively account of Cézanne offered by a contemporary. Richly ill., no index. See also 19.
- 15 Bernard, E.: Souvenirs sur Paul Cézanne, Paris, 1921, 1925, 1926. The author, a painter who had already published a short study on Cézanne in 1892, met the artist in 1904 and subsequently corresponded with him (see 3). His recollections are somewhat colored by his

- efforts to justify his own work through utterances by Cézanne. On Cézanne's opinion concerning Bernard, see his letters to his son in 3. Bernard later criticized Cézanne (see 43). Ill., no index.
- 16 GEFFROY, G.: Claude Monet, sa vie, son temps, son oeuvre, Paris, 1922, v. II, ch. XIII and XIV. Cézanne did the author's portrait. For a description of Cézanne at Monet's see also Mary Cassatt's letter quoted by A. D. Breeskin: The Graphic Work of Mary Cassatt, New York, 1948, and in 24, p. 166. See also 4.
- 17 LARGUIER, L.: Le dimanche avec Paul Cézanne, Paris, 1925. A charming account of the author's frequent visits to Cézanne while he did his military service in Aix, 1901–1902. Augmented by some of Cézanne's statements as transcribed by his son and by Camoin's recollections (see 12). The author has added nothing to this initial account in two subsequent publications: Paul Cézanne ou le drame de la peinture, Paris, 1936, and: Cézanne ou la lutte avec l'ange de la peinture, Paris, 1947.
- 18 JOURDAIN, F.: A propos d'un peintre difficile, Cézanne, Arts de France, No. 5, 1946. Jourdain visited Cézanne in his studio in 1904 with Camoin (see 12).
- 19 Le Tombeau de Cézanne, Paris, 1956. Small anthology with, among others, the recollections of Marie Gasquet.
- 20 FLORY-BLONDEL: Quelques souvenirs sur Paul Cézanne par une de ses nièces, *Gazette des Beaux-Arts*, Nov. 1960. Unimportant.

For L. Aurenche's recollections of Cézanne, see 4.

For M. Denis' recollections see 34; also 126.

Emile Zola used some of Cézanne's traits for his characterization of the painter Claude Lantier in: L'Oeuvre; see 24 and General Bibliography 23.

Biographies

- 21 Coquiot, G.: Paul Cézanne, Paris, 1919. Containing no firsthand material, this rambling book has become completely obsolete through more recent publications.
- 22 RIVIÈRE, G.: Le Maître Paul Cézanne, Paris, 1923. The author, a life-long friend of Renoir and father-in-law of Cézanne's only son, has little new information to offer. Ill., no index. (See also the same author's: Cézanne, Paris, 1936; poor ill., no index.)
- 23 Mack, G.: Paul Cézanne, New York, 1935. The best biography in English, excellently written, with a chronological outline, condensed bibl., 48 ill. and an exhaustive index.
- 24 REWALD, J.: Cézanne et Zola, Paris, 1936. New revised edition: Cézanne, sa vie, son oeuvre, son amitié pour Zola, Paris, 1939. English version: Paul Cézanne, New York, 1948. The most complete biography of Cézanne

- with special emphasis on his thirty-year friendship with Zola, based on numerous new documents, letters, interviews, etc. Ill., extensive bibl., index. This volume has since been supplemented by 4.
- 25 Graber, H.: Paul Cézanne nach eigenen und fremden Zeugnissen, Basel, 1942. This book presents a more or less clumsy translation of material first published in 1 and 9, but especially in 3 and 24, without indicating any source or even acknowledging the fact that the documents were not actually gathered by the author. There is not a single new document in the entire book nor in the similar publications by the same author. R. Goldwater in his review (*The Art Bulletin*, June 1945) has justly censured Graber's methods as piracy.
- 26 Schildt, G.: Cézanne, Stockholm, 1946.
- 27 Beucken, J. de: Un portrait de Cézanne, Paris, 1955 (previously published in *France Illustration*—Supplément théâtral et littéraire, August 11 and 25, 1951). Draws on all available sources, especially 1, 3, 23, and 24.
- 28 Perruchot, H.: La vie de Cézanne, Paris, 1956. Of all the biographies based on previous publications without adding new material, this is the most readable and intelligent. Chronology, bibl., no ill. American edition: New York, 1963.
- 29 Hanson, L.: Mortal Victory—A Biography of Paul Cézanne, New York, 1959. Like 27 and 28, draws on all available material without offering anything new, unless one wants to consider as new the author's analysis of the painter's relationship with his father and, especially, a highly questionable interpretation of Cézanne's decision to marry Hortense Fiquet, here linked to his disappointment with Zola's L'Oeuvre.
- 30 Langle de Cary, M. de: Cézanne, Paris, 1957. Small, popular biography; nothing new.
- 31 Cézanne, Paris, 1966. A collective volume with contributions by Cabanne, Cogniat, Perruchot, Rheims, etc.; ill.
- 32 Lindsay, J.: Cézanne—His Life and Art, London-New York, 1969. A lengthy study with psychoanalytical tendencies; the author consistently refers to the painter as "Paul," doubtless in order to show how intimately he knows him.
- 33 REWALD, J.: Chocquet and Cézanne, Gazette des Beaux-Arts, July-Aug. 1969.
- 33a Rewald, J.: Cézanne and His Father, Studies in the History of Art (Washington, D.C.), 1971-72.

Studies of Style

34 Denis, M.: Théories, 1890–1910, Paris, 1912. Chapter on Cézanne, written in 1907, whom the artist-author

- had met in Aix shortly before his death. See also Denis': Journal, v. I, 1884–1904, Paris, 1957; v. II, 1905–1920, Paris, 1957; v. III, 1921–1943, Paris, 1959.
- 35 RILKE, R. M.: Lettres sur Cézanne, Paris, 1944. With an introduction and translated by M. Betz from Rilke: Briefe aus den Jahren 1906–1907. Rilke's letters were written in 1907 upon visiting the Cézanne retrospective at the Paris Salon d'Automne; the poet even considered writing a book on Cézanne. On this subject see also R. Pitrou: Rilke et Cézanne, Cahiers du Sud, Feb. 1940.
- 36 BURGER, F.: Cézanne und Hodler, Munich, 1913. Ill.
- 37 RAPHAEL, M.: Von Monet zu Picasso, Munich-Leipzig, 1913.
- 38 Morice, C.: Quelques Maîtres modernes, Paris, 1914. Chapter on Cézanne.
- 39 MEIER-GRAEFE, J.: Cézanne und sein Kreis, Munich, 1919, 1922; richly illustrated. See also by the same author: Cézanne, London-New York, 1927, 40 ill., no index, as well as 95.
- 40 POPP, A. E.: Cézanne—Elemente seines Stiles anlässlich einer Kritik erörtert, *Bildende Künste*, Vienna, 2nd year, 1919, p. 177–189. Extensive and important review of 39.
- 41 Wedderkop, H. von: Paul Cézanne, Leipzig, 1922, with mediocre ill.
- 42 FAURE, E.: Cézanne, Paris, 1926. 59 ill., no index. (See also the same author's: Cézanne, New York, 1913. No ill., no index.)
- 43 Bernard, E.: L'erreur de Cézanne, Mercure de France, May 1, 1926.
- 44 FRY, R.: Le développement de Cézanne, L'Amour de l'Art (special issue), Dec. 1926. The first good study of Cezanne's artistic evolution, subsequently published in English: Cézanne, A Study of His Development, New York, 1927. 54 ill., no index. New edition, n.d. [1952–53].
- 45 PFISTER, K.: Cézanne, Gestalt, Werk, Mythos, Potsdam, 1927. Richly ill.
- 46 Ors, E. D': Paul Cézanne, Paris, 1930, London, 1936. Richly ill.
- 47 REY, R.: La renaissance du sentiment classique, Paris, 1931. Important chapter on Cézanne.
- 48 TOLNAI, K. VON: Zu Cézannes geschichtlicher Stellung, Deutsche Vierteljahrsschrift für Literaturwissenschaft und Geistesgeschichte, Heft 1, 1933.
- 49 HUYGHE, R.: Cézanne, Paris, 1936. Ill. See also Huyghe, R. and Rewald, J.: Cézanne, special issue of L'Amour de l'Art, May 1936. Offers a chronological chart and a study of Cézanne's evolution by Huyghe, as well as an iconography of Cézanne; richly ill.

- 50 La Renaissance, special issue: Cézanne, May-June 1936. Ill. Articles by P. Jamot, Ch. de Tolnay, Ch. Sterling, J. Vergnet-Ruiz, and J. Combes.
- 51 Rewald, J.: A propos du catalogue raisonné de l'oeuvre de Paul Cézanne et de la chronologie de cette oeuvre, La Renaissance, March-April 1937; see also by the same author: Cézanne au Louvre, L'Amour de l'Art, Oct. 1935; Une copie par Cézanne d'après Le Greco, Gazette des Beaux-Arts, Feb. 1936; As Cézanne Recreated Nature, Art News, Feb. 15–29, 1944; Proof of Cézanne's Pygmalion Pencil, Art News, Oct. 1–15, 1944; The Camera Verifies Cézanne's Watercolors, Art News, Sept. 1944; Rewald, J., and Marschutz, L.: Cézanne au Château Noir, L'Amour de l'Art, Jan. 1935; Cézanne et la Provence, special issue, Le Point, Aug. 1936.
- 52 NOVOTNY, F.: Cézanne und das Ende der wissenschaftlichen Perspektive, Vienna, 1938. 56 ill., index. A thorough investigation of Cézanne's space organization, with a list of the artist's "motifs." New edition, Vienna, 1970.
- 53 BARNES, A. C. and MAZIA, V. de: The Art of Cézanne, New York, 1939. With 71 ill. and an analysis of them. Index.
- 54 LORAN, E.: Cézanne's Composition, Analysis of His Form with Diagrams and Photographs of His Motifs, Berkeley and Los Angeles, 1943. Richly ill., index. This book aims at establishing a few general principles of drawing and composition that can be applied to creative work, by presenting concrete examples that reveal the "organization of space" in Cézanne's work. See also the same author's: Cézanne's Country, *The Arts*, April 1930 (published under the name of Erle Loran Johnson). New, revised edition 1970.
- 55 VENTURI, L.: Paul Cézanne—Water Colours, London, 1943. 32 good ill.
- 56 BAZIN, G.: Cézanne devant l'impressionnisme, Labyrinthe, Feb. 15, 1945.
- 57 NOVOTNY, F.: Cézanne als Zeichner, Wiener Jahrbuch für Kunstwissenschaft, v. XIV (XVIII), 1950, ill.
- 58 Guerry, L.: Cézanne et l'expression de l'espace, Paris, 1950. Ill., extensive notes, bibl. New edition 1966 under the name of Brion-Guerry.
- 59 RAMUZ, C. F.: L'exemple de Cézanne, suivi de Pages sur Cézanne, Lausanne, 1951. Passages from a series of lectures delivered in Lausanne in 1915–16 (see also 112) and short review of an exhibition held by Vollard in 1906. Unfortunately there are, among the few ill., works of highly doubtful authenticity.
- 60 SHERMAN, H. L.: Cézanne and Visual Form, Columbus, Ohio, 1952. Original study, richly documented; numerous ill., diagrams, etc.

- 61 Sterne, M.: Cézanne Today, The American Scholar, v. 22, No. 1, winter 1952-53.
- 62 COOPER, D.: Two Cézanne Exhibitions, Burlington Magazine, Nov. and Dec. 1954. For an answer by L. Gowing see Burlington Magazine, June 1956, and Cooper's reply: Cézanne's Chronology, ibid., Dec. 1956; see also in this connection 33, pp. 90–91.
- 63 COOPER, D.: Au Jas de Bouffan, L'Oeil, Feb. 15, 1955.
- 64 BADT, K.: Die Kunst Cézannes, Munich, 1956. An important study of the artist's watercolor technique, his compositions of cardplayers, his historical position, etc., with extensive notes, no index, ill. English trans.: The Art of Cézanne, Berkeley-Los Angeles, 1965. For review see: A. Neumeyer in Art Bulletin, Sept. 1967, p. 271–274.
- 65 FUSSINER, H.: Organic Integration in Cézanne's Painting, College Art Journal, Summer 1956.
- 66 Hamilton, G. H.: Cézanne, Bergson and the Image of Time, College Art Journal, Fall 1956.
- 67 ROSTRUP, H.: Den braendende Tornebusk, Meddelelser fra Ny Carlsberg Glyptotek, Copenhagen, 1957. On Cézanne's compositions of bathers.
- 68 KEMP, M. L.: Cézanne's Critics, News, The Baltimore Museum of Art, Dec. 1957.
- 69 Biederman, C.: The New Cézanne—From Monet to Mondriaan, Red Wing, Minn., 1958. The author sees in Mondriaan the logical heir of Cézanne; his approach to the latter is based on totally uncritical acceptance of the writings of Bernard and Gasquet (on Gasquet's reliability see 4).
- 70 Neumeyer, A.: Cézanne Drawings, New York-London, 1958. A lengthy introduction with 93 well selected ill. and detailed comments on them.
- 71 Berthold, G.: Cézanne und die alten Meister, Stuttgart, 1958. A thorough investigation of the significance of Cézanne's drawings after works by other artists with a detailed catalogue of his copies (many of which are here identified for the first time), profusely illustrated. For a review see 76. See also 84 and 89.
- 72 Novotny, F.: Der Reiz des Unvollendeten bei Cézanne, Du, April 1959.
- 73 Reff, T.: Cézanne's Drawings, 1875-85, Burlington Magazine, May 1959. Ill.
- 74 Reff, T.: Cézanne—The Enigma of the Nude, Art News, Nov. 1959.
- 75 Neumeyer, A.: Paul Cézanne—Die Badenden, Stuttgart, 1959. Booklet with ill.; study of Cézanne's composition of bathers.
- 76 Reff, T.: Gertrude Berthold: Cézanne und die alten Meister, *The Art Bulletin*, June 1960. An extensive review of 71 with corrections and additional material.

- 77 BENESCH, O.: Rembrandt's Artistic Heritage—From Goya to Cézanne, Gazette des Beaux-Arts, July-Aug. 1960.
- 78 Reff, T.: Reproductions and Books in Cézanne's Studio, Gazette des Beaux-Arts, Nov. 1960.
- 79 Reff, T.: Cézanne and Poussin, Journal of the Warburg and Courtauld Institutes, v. XXIII, Jan.-June 1960.
- 80 DITTMANN, L.: Zur Kunst Cézannes, in Festschrift Kurt Badt, Berlin, 1961.
- 81 Andersen, W. V.: Cézanne's Sketchbook in the Art Institute of Chicago, Burlington Magazine, May 1962. See also 108.
- 82 Bodelsen, M.: Gauguin's Cézannes, Burlington Magazine, May 1962. See also the same author's: Gauguin, the Collector, Burlington Magazine, Sept. 1970.
- 83 WALDFOGEL, M.: A Problem in Cézanne's "Grandes Baigneuses," *Burlington Magazine*, May 1962.
- 84 Chappuis, A.: Les dessins de Paul Cézanne à Bâle, 2 vol., Olten and Lausanne, 1962. Superb catalogue raisonné with excellent ill.
- 85 Feist, P. H.: Paul Cézanne, Leipzig, 1963. A serious study, tinged with Marxism, accompanied by plates with commentaries.
- 86 Reff, T.: Cézanne's Constructive Stroke, Art Quarterly, Autumn 1963. Very important article.
- 87 Andersen, W. V.: Watercolor in Cézanne's Artistic Process, Art International, VII, no. 5, 1963.
- 88 Reff, T.: Cézanne's Dream of Hannibal, Art Bulletin, June 1963.
- 89 Chappuis, A.: Cézanne dessinateur—copies et illustrations, Gazette des Beaux-Arts, Nov. 1965.
- 90 Reff, T.: Cézanne and Hercules, Art Bulletin, March 1966.
- 91 SCHAPIRO, M.: The Apples of Cézanne—An Essay on the Meaning of Still Life, *The Avant-Garde*, *Art News Annual*, XXXIV, 1968, pp. 34–53.
- 92 Lem, F.-H.: Sur le chemin de la peinture: Paul Cézanne [Paris?], 1969. The author takes himself very seriously, but who else can?
- 93 ROSTRUP, H.: Studier i Fransk Portraetmaleri— Cézanne, Meddelelser fra Ny Carlsberg Glyptotek, Copenhagen, 1969.
- 94 Andersen, W.: Cézanne's Portrait Drawings, Cambridge and London, 1970. Handsome volume with a general essay and a catalogue raisonné of over 250 drawings, mostly well reproduced, grouped by models. Some of the author's identifications and dates may be open to question.
- 94a IKEGAMI, C.: Le dessin de Paul Cézanne, Bijutsushi

- (Journal of the Japan Art History Society), No. 76, 1970 (with French résumé).
- 94b Elderfield, J.: Drawing in Cézanne, Artforum, June 1971
- 94c Hoog, M.: L'Univers de Cézanne, Paris, 1971. Accompanied by good reproductions of drawings and watercolors (in color), but without dates or chronological sequence.
- See also 1, 106, 107, 109, 112, and General Bibliography 81.

Reproductions

- 95 Meier-Graefe, J.: Cézanne und seine Ahnen, Munich, 1910—Cézannes Aquarelle, Munich, 1920. Two excellent albums of the Marées Gesellschaft.
- 96 MIRBEAU, DURET, WERTH, ETC.: Cézanne, Paris, 1914. 49 good ill. in black and white and color.
- 97 KLINGSOR, T. L.: Cézanne, Paris, 1923. 40 plates.
- 98 Gasquet, J.: Cézanne, Paris, 1926. An Album d'Art Druet with rather poor black and white ill.
- 99 RAYNAL, M.: Cézanne, Paris, 1936. 119 good though small ill., 4 color plates.
- 100 NOVOTNY, F.: Cézanne, New York, 1937. This Phaidon book presents an excellent choice of 126 good black and white and color plates, chronologically arranged.
- 101 Chappuis, A.: Dessins de Paul Cézanne, Paris, 1938. 48 well-reproduced drawings, among which are several not illustrated in 1, and 4 color plates.
- 102 RAYNAL, M.: Cézanne, Paris, 1939. Album of 8 good color plates.
- 103 NICODEMI, G.: Cézanne, Disegni, Milan, 1944. 75 rather poor ill. of drawings, taken mainly from 24, 95, 100, and 101.
- 104 Jewell, E. A.: Paul Cézanne, New York, 1944. Carelessly edited with poor color plates. 48 ill., not in chronological order.
- 105 Jedlicka, G.: Cézanne, Bern, 1948. 52 good though small plates, some in color, chronologically arranged.
- 106 DORIVAL, B.: Cézanne, Paris-New York, 1948. Profusely ill. with good plates in black and white and in color, chronologically arranged. Important text, useful appendices, chronological table, notes on plates, list of exhibitions, bibl., index.
- 107 Rewald, J.: Cézanne, Carnets de dessins, Paris, 1951.
 2 v. (text and plates). Drawings selected from five sketchbooks (four of them unpublished), not mentioned in 1, with introduction and catalogue raisonné, page by page, of the sketchbooks (see also 108).
- 108 Schniewind, C. O.: Cézanne Sketchbook, New York,

- 1951. 2 v. (text and plates). Facsimile reproduction of one of five sketchbooks; excellent plates (see also 107).
- 109 SCHAPIRO, M.: Cézanne, New York, 1952. 50 large and fairly good color plates, with commentaries and introduction (Abrams).
- 110 RAYNAL, M.: Cézanne, Geneva-Paris-New York, 1954. Much too vividly done color plates, of "postal card" size and quality (Skira).
- 111 Zahn, L.: Paul Cézanne—Aquarelles de Paysages, Paris, 1957. 12 fair to mediocre color plates.
- 112 CHAPPUIS, A.: Dessins de Cézanne (preceded by Pages de C. F. Ramuz; see also 59), Lausanne, 1957. 56 excellent ill. with short comments.
- 113 Rewald, J.: Cézanne—Paysages, Paris, 1958. Booklet with mediocre color plates.
- 114 Musée National du Louvre—Peintures, Ecole Française, XIXe siècle, v. I, A-C, Paris, 1958. Lists and reproduces 24 paintings by Cézanne.
- 115 Stokes, A.: Cézanne, London [n.d.]. Introduction and notes, mediocre color plates (Faber Gallery).
- 116 Recueil important des oeuvres de Paul Cézanne, Japan [n.d.]. v. I, Landscapes; v. II, Portraits and Nudes; v. III, Still lifes. Each vol. contains 20 poor color plates with comments in Japanese.
- 117 DORIVAL, B.: Cézanne, Paris. Small vol. with 20 mediocre color plates (Hazan).
- 118 Taillander, Y.: P. Cézanne, Paris, 1961. Very poor color plates assembled without regard for chronology.
- 118a TAYLOR, B.: Cézanne, Middlesex, 1961, 1968. 48 miserable color plates, with comments by N. Wadley.
- 119 GONTHIER, P. H.: P. Cézanne, Paris, 1962.
- 120 CHAPPUIS, A.: Album de Paul Cézanne, Paris, 1966. Preface by R. Bacou. Excellent facsimile reproduction of an important sketchbook (see also 107 and 108).
- 120a Ikegami, C.: Cézanne, Tokyo, 1969. Numerous color plates, mostly mediocre.
- See also 1, 3 (French edition), 14, 39, 44, 45, 46, 49, 52, 53, 54, 55, 60, 70, 71, 84, 85, and 94c.

Exhibition Catalogues

- This section lists catalogues of major exhibitions held since the appearance of 1.
- 121 Cézanne. Musée de l'Orangerie, Paris, spring 1936. Important exhibition. Prefaces by J.-E. Blanche and P. Jamot, extensive notices by C. Sterling, long bibl. Ill.
- 122 Paul Cézanne. Kunsthalle, Basel, Aug.-Oct. 1936.
- 123 Cézanne. Bignou Gallery, New York, Nov.-Dec. 1936. 30 paintings, some ill.

- 124 Paul Cézanne. San Francisco Museum of Art, Sept.-Oct. 1937. Texts by G. L. McCann Morley and G. Mack; bibl., excellent ill.
- 125 Cézanne. Paul Rosenberg, Paris, Feb.-April 1939. Preface by Tabarant. All 35 oils shown are ill.
- 126 Paul Cézanne. Société des Artistes Indépendants, Grand Palais, Paris, March-April 1939. Preface by M. Denis, list of 85 works, no ill.
- 127 Cézanne. Rosenberg & Helft, London, April-May 1939. All 23 oils shown are ill.
- 128 Cézanne. Musée de Lyon, 1939. Few ill.
- 129 Homage to Paul Cézanne, Wildenstein & Co., London. July 1939. Preface by J. Rewald; extensive notes; ill.
- 130 Cézanne. Wildenstein, New York, March-April 1947. Important exhibition; commentary, numerous ill.
- 131 Six Masters of Post-Impressionism. Wildenstein, New York, April-May 1948. (Cézanne, Gauguin, Lautrec, Rousseau, Seurat, van Gogh.) Ill.
- 132 Cézanne. Art Institute of Chicago and Metropolitan Museum of Art, New York, 1952. Important exhibition. Preface by T. Rousseau, Jr., running commentary, numerous good ill.
- 133 Cézanne—Rarely Shown Works, Fine Arts Associates, New York, Nov. 1952. Text by K. E. Osthaus (see 11). Also at the same gallery: Cézanne—Watercolors. Feb. 1956. Ill.
- 134 Cézanne. Musée Granet, Aix-en-Provence, and Nice Museum, summer 1953. Few ill.
- 135 Monticelli et le Baroque Provençal. Orangerie des Tuileries, Paris, June-Sept. 1953 (important Cézanne section).
- 136 Hommage à Cézanne. Orangerie des Tuileries, Paris, July-Oct. 1954. 50 paintings from the former Pellerin collection together with all works owned by the Louvre. Extensive catalogue notes by A. Châtelet, lengthy biographical outline, some ill.
- 137 Cézanne. Edinburgh and Tate Gallery, London, summer-fall 1954. Preface by L. Gowing, biographical outline, extensive catalogue notes, ill. See also 62.
- 138 Paul Cézanne. Gemeentemuseum, The Hague, June-July 1956 (see also bibl. 140 and 141). Preface by F. Novotny, excellent biographical and stylistic outline, good ill.
- 139 Cézanne. Pavillon de Vendôme, Aix-en-Provence, July-Aug. 1956. Preface by F. Novotny, numerous ill.
- 140 Paul Cézanne. Kunsthaus, Zurich, Aug.-Oct. 1956 (see also 138 and 141).
- 141 Paul Cézanne. Haus der Kunst, Munich, Oct.-Nov. 1956 (see also 138 and 140).

- 142 Cézanne. Kunsthaus Lempertz, Cologne (Wallraf-Richartz-Museum), Dec. 1956–Jan. 1957. Catalogue and comments by L. Reidemeister, numerous ill.
- 143 Cézanne. Wildenstein, New York, Nov.-Dec. 1959. Important exhibition. Short preface by M. Schapiro, commentary reprinted from 130. All 87 works shown are ill.
- 144 Cézanne. Oesterreichische Galerie, Vienna, April-June 1961. Preface by F. Novotny, extensive catalogue notes, biographical outline, excellent ill., some in color.
- 145 Cézanne. Pavillon de Vendôme, Aix-en-Provence, summer 1961. Small exhibition.
- 146 Cézanne. Watercolors. Knoedler Galleries, New York, April 1963. Important exhibition, all works shown are reproduced and analyzed in the catalogue.
- 147 Cézanne. The Phillips Collection, Washington, D.C.; Art Institute, Chicago; Museum of Fine Arts, Boston, Feb.-July 1971. Introduction by J. Rewald, excerpts from the writings of Duncan Phillips. 83 paintings, watercolors, and drawings, all reproduced, some in color.

DEGAS

Oeuvre Catalogues

- 1 Catalogues des tableaux, pastels et dessins par Edgar Degas et provenant de son atelier dont la vente...aura lieu à Paris, Galeries Georges Petit, May 6–8, 1918 (336 ill.); Dec. 11–13, 1918 (421 ill.); April 7–9, 1919 (637 ill.); July 2–4, 1919 (755 ill.). Four sales of paintings, water-colors, pastels, drawings, and monotypes, which—with the exception of oils and pastels—are not in 4.
- See also Catalogues of: Succession de M. René de Gas [Degas' brother], Paris, Nov. 10, 1927 and Collection de Mlle J. Fèvre [Degas' niece], Paris, June 12, 1934.
 - 2 Delteil, L.: Edgar Degas. Le peintre-graveur illustré, v. IX, Paris, 1919. A catalogue of Degas' 66 prints. See also 5 and 127.
 - 3 Rewald, J.: Degas, Works in Sculpture, A Complete Catalogue, New York, 1944, 1956. 141 ill. of bronzes, wax models, plaster casts and drawings; bibl. See also 41a, 64a, 81, 83a, 83b, 110, 111, 118, and 121.
 - 4 Lemoisne, P.A.: Degas et son oeuvre, 4 v., Paris, 1946–49. Vol. I, text, with an abundance of notes, summary bibl.; v. II, paintings and pastels, 1853–82; v. III, paintings and pastels, 1883–1908; v. IV, lists, alphabetical, geographical index, etc. (Further volumes, notably on the artist's drawings, were announced.) This publication is beautifully done, with excellent plates (over 1,500 ill.)

- and text on opposite pages. Unfortunately, works of similar character or subject are not always grouped together and there are no mentions of preparatory drawings. The text distinguishes itself by strong prejudices which prevent the author from mentioning any publications with which he happens to disagree. This attitude renders his work incomplete. Nevertheless, this catalogue is the basic book on Degas and the first serious effort to establish a chronology of his output, although the author usually refrains from giving his reasons for the dates he proposes. See also 69.
- 5 Janis, E. P.: Degas Monotypes—Essay, catalogue, checklist, Cambridge, Mass., 1968. Catalogue raisonné with detailed study of this neglected subject, including also the artist's pastels over monotypes; excellent plates. See also 61, 75, and 122.
- 5a Russoli, F. and Minervino, F.: Opera completa di Degas, Milan, 1970. Presentation by Russoli, critical research by Minervino. A series of mediocre to atrocious color plates followed by minute black and white reproductions (often 25 and more to a page). What has been said for the similar volume on Cézanne (see Cézanne, la) also applies here where the "critical research" consisted in extensive use of 4. But here, too, mistakes made by Lemoisne have been slavishly copied. The false dimensions for L. 430 have been faithfully transcribed, and Lemoisne's erroneous date for the pastel L. 1089 (1890-95) has been repeated, although the work was exhibited by Theo van Gogh in January 1888 and described in a review by Fénéon; it must have been finished by 1887 at the latest. To such errors the editors have added a good measure of their own and in many cases have simply avoided further mistakes by not indicating any owners at all, even where works have been reproduced or exhibited as belonging to such famous collections as those of Paul Mellon (Nos. 122, 446, 631, 684, 720, 721, 786, and others); Norton Simon (No. 596); Mrs. Mellon Bruce (No. 859); and Mrs. Charles Payson (No. 793). For Degas' sculpture, all the indications provided by 3, edition of 1956, have been religiously transcribed.

Despite the title, this volume is not "complete," if only because not all pastels, only a few drawings, and no prints are included (it is true that there is no catalogue of drawings that could have been conveniently copied).

The Artist's Own Writings

- 6 Duranty, E.: La nouvelle peinture, Paris, 1876, 1946. The letter by an unnamed artist, quoted by Duranty, was supposedly written by Degas; it is not included in 8.
- 7 Lemoisne, P. A.: Les Carnets de Degas au cabinet des Estampes, Gazette des Beaux-Arts, April 1921. Interesting

- excerpts from Degas' notebooks, presented without chronology or system. See also 65, but especially 77.
- 8 Lettres de Degas, recueillies et annotées par M. Guérin, Paris, 1931. 193 letters (1872–1910), 17 ill. More complete edition, Paris, 1945. Further, hitherto unpublished letters are included in the English edition, Oxford, 1947. Neither book is complete.
- 9 Degas, E.: Huit Sonnets, Paris, 1946. With an introduction by J. Nepveu-Degas; excellent ill.
- 10 Fevre, J.: Mon oncle Degas. Unpublished recollections and documents assembled by P. Borel. Geneva, 1949. Contains approximately 25 unpublished letters, ill.
- 11 NEWHALL, B.: Degas, photographe amateur, Gazette des Beaux-Arts, Jan. 1963. With 8 unpublished letters (of 1895). Concerning Degas' photographs see also L. Hoctin: Degas photographe, L'Oeil, May 1960.
- 12 Reff, T.: Some Unpublished Letters of Degas, Art Bulletin, March 1968.
- 13 Reff, T.: More Unpublished Letters of Degas, Art Bulletin, Sept. 1969. 10 letters, mostly early ones to Gustave Moreau, and a list of 62 other unpublished letters.

For further letters see 4 and 29.

Witness Accounts

- 14 GONCOURT, E. and J. DE: Journal, v. V, 1872–77. Paris, 1891.
- 15 MOORE, G.: Impressions and Opinions, New York, 1891 (chapter on Degas); Modern Painting, London, 1893; also: Memories of Degas, *Burlington Magazine*, Jan., Feb. 1918.
- 15a Тschudi, H. von: Gesammelte Schriften zur neueren Kunst, Munich, 1912. Short interview with Degas, 1899.
- 16 SICKERT, W.: Degas, Burlington Magazine, Nov. 1917. Reprinted in Emmons, R.: The Life and Opinions of Walter Richard Sickert, London, 1941.
- 16a LAPAUZE, H.: Ingres chez Degas, La Renaissance, March 1918.
- 17 CHARLES, F.: Les mots de Degas, La Renaissance, April 1918.
- 18 THIÉBAULT-SISSON: Article on Degas, Le Temps, May 18, 1918.
- 19 MICHEL, A.: Degas et son modèle, *Mercure de France*, Feb. 1 and 16, 1919. Two excellent articles by one of Degas' models, which give a vivid description of the aging artist at work, his studio, etc.
- 20 Blanche, J.-E.: Propos de peintre, de David à Degas, Paris, 1919.

- 21 Vollard, A.: Degas, Paris, 1924, 1938. English translation: Degas, An Intimate Portrait, New York, 1927. A series of unrelated and often poor anecdotes which at times offer a better insight into Vollard than Degas. The most disappointing among the author's books of recollections, it is of little help to the student. Bad ill., no index.
- 21a ROUAULT, G.: Souvenirs intimes, Paris, 1927. The artist met Degas through his teacher, Moreau.
- 22 Moreau-Nélaton, E.: Deux heures avec Degas. L'Amour de l'Art, July 1931. Interesting notes on an interview in 1907, concerned chiefly with Degas' meeting with Ingres.
- 23 CHIALIVA, J.: Comment Degas a changé sa technique du dessin, Bulletin de la Société de l'Histoire de l'art français, 1932.
- 24 HALÉVY, D.: Pays parisiens, Paris, 1932. Recollections. See also 30 and 99.
- 25 Jeanniot, G.: Souvenirs sur Degas, *La Revue Universelle*, Oct. 15, Nov. 1, 1933. Important study.
- 26 ROUART, E.: Degas, Le Point, Feb. 1937.
- 27 ROMANELLI, P.: Comment j'ai connu Degas, Le Figaro Littéraire, March 13, 1937.
- 28 NATANSON, T.: Peints à leur tour, Paris, 1948. Chapter on Degas.
- 29 ROUART, D.: Correspondance de Berthe Morisot, Paris, 1950. With letters of Berthe Morisot and Degas. Recollections of E. Rouart and "Souvenirs de Berthe Morisot, notés par elle sur un carnet" have been published in 56, p. 160–173 and p. 146–148.
- 30 Halévy, D.: Degas parle... Paris-Geneva, 1960. Excerpts from a diary started in 1888 when the author, whose parents were close friends of the artist, was sixteen years old. Translated as: My Friend Degas, Middletown, Conn., 1964. See also 24 and 99, and Ludovic Halévy: Carnets, published by his son Daniel, Revue des Deux Mondes, 1937, 1938, 1941 for information on Degas, 1872–85.
- 31 HAVEMEYER, L. W.: Sixteen to Sixty. Memoirs of a Collector, New York, 1961. The author knew Degas through her lifelong friend, Mary Cassatt.
- 31a Soffici, A.: Opere VI, Florence, 1965. Chapter "Ricordi su Degas"; very slight.

See also 10, 32, 36, 47, and 56.

- For Caillebotte's letter on Degas see p. 447–449 of the present book.
- Octave Mirbeau has used some of Degas' traits for the artist in his novel: Le Calvaire. English edition: The Calvary, New York, 1922.

Biographies

- 32 Lafond, P.: Degas, 2 v., Paris, 1918–1919. A study of Degas' life and art written by a friend of the artist. Richly ill. The black and white and color plates in the second volume are superior to those in the first, but all are assembled without order. No bibl., no index.
- 33 MEIER-GRAEFE, J.: Degas, Munich, 1920; English translation, London, 1923, 1927. 103 excellent plates, chronologically arranged. No bibl., no index.
- 34 Coquiot, G.: Degas, Paris, 1924. More verbiage than information, accompanied by an insufficient list of Degas' "principal" works, assembled without any dates. Mediocre ill., no index, no bibl.
- 35 Manson, J. B.: The Life and Work of Edgar Degas, London, 1927. This conscientious biography is the best work in English on the artist. 81 good black and white plates, chronologically arranged, some color plates. No bibl., no index.
- 36 Rivière, G.: M. Degas, Bourgeois de Paris, Paris, 1935. Although the author knew Degas, he has nothing new to offer and sees the artist mostly through the eyes of Renoir, who was Rivière's lifelong friend. 71 mediocre ill., no bibl., no index.
- 37 Graber, H.: Edgar Degas, Eigene Zeugnisse—Fremde Schilderungen—Anekdoten, Basel, 1940. On this author's methods see Cézanne 25.
- 38 Rewald, J.: Degas and His Family in New Orleans, Gazette des Beaux-Arts, Aug. 1946. Article based on research done in New Orleans and on information provided by a nephew of the artist. With a genealogy, ill. See also 129.
- 39 RAIMONDI, R.: Degas e la sua famiglia in Napoli (1793–1917), Naples, 1958. A detailed record of the Degas family in Italy with numerous, rather carelessly transcribed documents; ill. See also 40.
- 40 Boggs, J. S.: Edgar Degas and Naples, Burlington Magazine, June 1963. Important article with family tree.
- 40a VITALI, L.: Three Italian Friends of Degas, Burlington Magazine, June 1963.
- 41 POOLE, P.: Some Early Friends of Edgar Degas, *Apollo*, May 1964.
- 41a Burollet, T.: Bartholomé et Degas, L'Information de l'Histoire de l'Art, May-June 1967.

See also 4 and 51.

Studies of Style

42 Huysmans, J. K.: L'Art moderne, Paris, 1883, 1902. See also the same author's: Certains, Paris, 1889.

- 43 Geffroy, G.: Degas, L'Art dans les deux Mondes, Dec. 20, 1890.
- 44 LIEBERMANN, M.: Degas, Berlin, 1899, 1912. Short essay.
- 45 Mauclair, C.: Edgar Degas, La revue de l'art ancien et moderne, Nov. 10, 1903.
- 46 GRAPPE, G.: Degas, L'Art et le Beau, n.d. [3rd year].
- 47 Lemoisne, P. A.: Degas, Paris, n.d. [1912]. 48 plates, chronologically arranged, accompanied by a running commentary which occasionally contains information supplied by Degas, whom the author knew. Short bibl., no index
- 48 ALEXANDRE, A.: Monsieur Degas, special issue, Les Arts, No. 166, 1918.
- 49 HERTZ, H.: Degas, Paris, 1920. Mediocre ill.
- 50 Fosca, F.: Degas, Paris, 1921. No ill.
- 51 Jamot, P.: Degas, Paris, 1924. An excellent study of Degas' evolution. 88 good halftone plates, chronologically arranged and accompanied by detailed commentaries. Also a list of exhibitions in which Degas participated, with titles of the works shown. Short bibl., no index.
- 52 GUÉRIN, M.: Remarques sur des portraits de famille peints par Degas, Gazette des Beaux-Arts, June 1928.
- 53 Moncan, A.: Portrait Studies by Degas in American Collections, *Bulletin of the Fogg Museum*, Harvard University, May 1932.
- 54 Walker, J.: Degas et les maîtres anciens, Gazette des Beaux-Arts, 1933. Includes a list of works copied by Degas. See also 55, 73a, and 76.
- 55 George, W.: Oeuvres de vieillesse de Degas—Sur quelques copies de Degas, *La Renaissance*, Jan.-Feb. 1936.
- 56 VALÉRY, P.: Degas, Danse, Dessin, Paris, 1936, 1938. Subtle considerations on art in general and on Degas in particular, whom the author knew and about whom he reminisces. To these are added recollections of E. Rouart and notes by Berthe Morisot, see 29. English editions New York, 1948, 1960.
- 57 MITCHELL, E.: 'La fille de Jephté' par Degas, génèse et évolution, Gazette des Beaux-Arts, Oct. 1937. See also 78
- 58 Mongan, A.: Degas as seen in American Collections, Burlington Magazine, June 1938.
- 59 ROUART, D.: Degas à la recherche de sa technique, Paris, 1945. Very competent study on the various techniques used by Degas, with detailed notes, bibl., ill. A basic book. See also 61.
- 60 Rewald, J.: The Realism of Degas, *Magazine of Art*, Jan. 1946.
- 61 ROUART, D.: Degas, Monotypes, Paris, n.d. [1948].

- Short introduction for an album of superb plates. On Degas' monotypes see also 5, 75, and 122.
- 62 Browse, L.: Degas, Dancers, London, 1949. Study on the place which the ballet occupies in Degas' work; profusely ill.
- 63 GILBERT, C.: Degas and the Problem of Verifiable Excellence, *Journal of Aesthetics and Art Criticism*, March 1952.
- 64 Boggs, J. S.: Edgar Degas and the Bellellis, Art Bulletin, June 1955. Well-documented study.
- 64a PAYNE, E. H.: A Little-known Bronze by Degas, Bulletin, Detroit Institute of Arts, vol. XXXVII, 1956–57.
- 65 Boggs, J. S.: Degas Notebooks at the Bibliothèque Nationale, I — Group A (1853–1858), Burlington Magazine, May, June, July 1958. See also 77.
- 66 ROSENBERG, J.: Great Draughtsmen from Pisanello to Picasso, Cambridge, 1959. Important chapter on Degas.
- 67 Cabanne, P.: Edgar Degas, Paris, 1960. Richly ill. with excellent black and white and good color plates, photographs, etc. The reproductions are chronologically arranged. Excerpts from early writings on Degas, chronology, detailed notes on the plates, bibl., list of exhibitions, index. A very useful book (Tisné).
- 68 SCHARF, A.: Painting, Photography, and the Image of Movement, Burlington Magazine, May 1962.
- 69 Boggs, J. S.: Portraits by Degas, Berkeley-Los Angeles, 1962. The author's painstaking research will necessitate changes in the chronology established in 4. Excellent ill.; appendix with Biographical Dictionary of Degas' sitters, selected bibl., index.
- 70 Keller, H.: Edgar Degas—Die Familie Bellelli, Stuttgart, 1962 (Reclam).
- 71 Burroughs, L.: Degas Paints a Portrait [of Yves Gobillard], Bulletin, Metropolitan Museum of Art, New York, Jan. 1963.
- 72 Nicolson, B.: Degas as a Human Being, *Burlington Magazine*, June 1963.
- 73 POOLE, P.: Degas and Moreau, Burlington Magazine, June 1963.
- 73a Reff, T.: Degas's Copies of Older Art, Burlington Magazine, June 1963. Includes a list of "New Sources for Degas's Copies." See also 54 and 76.
- 73b PICKVANCE, R.: Degas's Dancers, 1872–76, Burlington Magazine, June 1963.
- 74 Fries, G.: Degas et les Maîtres, Art de France, 1964.
- 75 ROUART, D.: Degas. Paysages en Monotype, L'Oeil, Sept. 1964. For an English translation see 128.
- 76 Reff, T.: New Light on Degas's Copies, Burlington Magazine, June 1965. See also 54 and 73a.

- 77 Reff, T.: The Chronology of Degas's Notebooks, Burlington Magazine, Dec. 1965. Important article on notebooks in the Bibliothèque Nationale. See also 65.
- 78 POOLE, P.: The History Pictures of Edgar Degas and Their Background, *Apollo*, Oct. 1964. See also 57 and 82.
- 78a TANNENBAUM, L.: Degas: Illustrious and Unknown, Art News, Jan. 1967.
- 79 Browse, L.: Degas's Grand Passion, Apollo, Feb. 1967.
- 80 Reff, T.: The Pictures within Degas's Pictures, Metropolitan Museum Journal, v. 1, 1968.
- 81 Beaulieu, M.: Les sculptures de Degas—Essai de chronologie, *Revue du Louvre*, no. 6, 1969.
- 82 Burnell, D.: Degas and His "Young Spartans Exercising," Museum Studies 4, The Art Institute of Chicago, 1969.
- 83 Reff, T.: Degas and the Literature of His Time—I, Burlington Magazine, Sept. 1970. Important article.
- 83a Burollet, T.: Degas, Oeuvres du Musée du Louvre, peintures, pastels, dessins, sculptures, *Revue de l'Art*, no. 7, 1970.
- 83b Reff, T.: Degas's Sculpture, 1880–1884, Art Quarterly, no. 3, 1970. Important article.
- 83c Reff, T.: The Technical Aspects of Degas's Art, Metropolitan Museum Journal, v. 4, 1971.
- 83d Wells, W.: Who Was Degas's Lyda? Apollo, Feb. 1972.
- 84e Reff, T.: Degas's "Tableau de Genre," Art Bulletin, Sept. 1972. On Le viol.
- See also 3, 4, 35, 100, and General Bibliography 81.

Reproductions

- 84 Degas, vingt dessins, 1861–1896, Paris [n.d.]. 20 superb color reproductions executed according to a new process invented by Manzi, friend of Degas. The artist himself supervised the printing and autographed each album.
- 85 Degas, Paris, 1914, 1918. 98 black and white reproductions of paintings, pastels, drawings, and prints. Vollard first submitted all photographs to Degas who signed them. The plates are mediocre.
- 86 Rivière, H.: Les dessins de Degas, Paris, 1922–23. A large album of excellent reproductions in black and white and in color printed by Demotte.
- 87 Fosca, F.: Degas, Paris, 1927. 24 mediocre plates (Album d'art Druet).
- 88 Huyghe, Bazin, Lemoisne, etc.: Degas, special issue of L'Amour de l'Art, July 1931, with essays on Degas' paintings and sculpture. Richly ill., several interesting photographs of and by Degas.

- 89 Guérin, M., and Lemoisne, P. A.: Dix-neuf portraits de Degas par lui-même, Paris, 1931.
- 90 André, A.: Degas, Paris, 1935. 30 excellent black and white plates of drawings and pastels.
- 91 Grappe, G.: Degas, Paris, n.d. [1936].
- 92 Mauclair, C.: Degas, Paris, 1937, New York, 1941, 1945. Fair black and white ill., poor color plates.
- 93 NICODEMI, G.: Degas, 28 Disegni, Milan, 1944. Mediocre reproductions of paintings, pastels, and drawings.
- 94 WILENSKI, R. H.: Degas, London, 1946. Introduction and notes, poor color plates; 2nd album with text by M. Ayrton (Faber Gallery).
- 95 HAUSENSTEIN, W.: Degas, Bern, 1948. Good ill., although small.
- 96 LEYMARIE, J.: Dessins de Degas, Paris, 1948. 24 small plates, mostly in color (Hazan).
- 97 Schwabe, R.: Degas the Draughtsman, London, 1948. 44 plates assembled without system.
- 98 ROUART, D.: Degas, dessins, Paris, 1948. 16 excellent color plates of drawings.
- 99 HALÉVY, D.: Album de dessins de Degas, Paris, 1949. Short, separate introduction and perfect facsimile reproduction of a sketchbook which once belonged to the artist's friend Halévy, and which contains drawings from 1877 and the following years. See also 30.
- 100 Rich, D. C.: Degas, New York, 1951. 50 rather good large color plates with introduction and commentaries.
- 101 Champigneulle, B.: Degas, dessins, Paris, 1952. 80 small mediocre plates, chronologically arranged.
- 102 Fosca, F.: Degas, Geneva-Paris-New York, 1953. Too vivid color plates of post card size (Skira).
- 103 CHARENSOL, G.: Degas, New York, 1959. Small volume with mediocre color plates.
- 103a Musée National du Louvre—Peintures, Ecole Française, XIXe siècle, v. II, D-G, Paris, 1959. Lists and reproduces 51 paintings and pastels by Degas. See also 131.
- 104 COOPER, D.: Pastels by Edgar Degas, Basel-New York [n.d.]. 32 fair color plates with short introduction and comments.
- 105 HUTTINGER, E.: Degas, Paris [n.d.]. Poor plates, mostly in color, frequently without dates, haphazardly arranged.
- 106 Pecirka, J.: Degas Dessins, Prague-Paris, 1963 (ill. reprinted from 86?).
- 107 ROUART, D.: The Unknown Degas and Renoir in the National Museum in Belgrade, New York, 1964. Good plates of drawings and pastels.

- 108 Bouret, J.: Degas, Paris, 1965 (Somogy).
- 108a Takashina, S.: Degas, Tokyo, 1971. Numerous color plates, mostly mediocre.
- See also 1–5, 8, 10, 26, 32, 33, 35, 36, 46, 47, 51, 59, 61, 62, 67, 112, 115, 117, 120–124, 126, and 132.

Exhibition Catalogues

- 109 Exposition Degas, Paris, Galeries Georges Petit. April-May 1924, catalogue compiled by M. Guérin; ill.
- 110 Edgar Degas, das plastische Werk, Berlin, May 1926; Munich, July-Aug. 1926; Dresden, Sept. 1926. Introductions by C. Glaser and W. Hausenstein.
- 111 Degas, Portraitiste, Sculpteur, Paris, Musée de l'Orangerie, n.d. [1931]. Introductions by P. Jamot and P. Vitry; ill.
- 112 Degas, Philadelphia Museum of Art, 1936, catalogue compiled by H. P. McIlhenny, introductions by P. J. Sachs and A. Mongan; ill.
- 113 Degas, Paris, Musée de l'Orangerie, March-April 1937, compiled by J. Bouchot-Saupique and M. Delaroche-Vernet, introduction by P. Jamot; ill., extensive bibl.
- 114 Degas, peintre du mouvement, Paris. Galerie A. Weill, 1939. Introduction by C. Roger-Marx.
- 115 Works by Edgar Degas, Cleveland Museum of Art, 1947. Ill.
- 116 Edgar Degas Sculpturer og Monotypier, Tegninger og Malerier, Ny Carlsberg Glyptotek, Copenhagen, 1948.
- 117 Degas, Wildenstein Galleries, New York, 1949. Text by D. Wildenstein, ill.
- 118 The Complete Collection of Sculptures by Edgar Degas, Marlborough Galleries, London, 1951.
- 119 Degas, Edinburgh Festival and Tate Gallery, London, 1952. Introduction by D. Hill, ill.
- 120 Degas dans les collections françaises, Gazette des Beaux-Arts, Paris, 1955. Text by D. Wildenstein, ill.
- 121 Edgar Degas—Original Wax Sculptures, Knoedler Galleries, New York, 1955. Forewords by J. Rewald and J. Nepveu-Degas, ill.
- 122 Degas—Monotypes, Drawings, Pastels, Bronzes, Lefevre Gallery, London, 1958. Foreword by D. Cooper, ill.
- 123 Degas—Paintings, Drawings, Prints, Sculpture, Los Angeles County Museum, 1958. Text by J. S. Boggs, ill. Exceptionally fine publication.
- 124 Renoir—Degas, Drawings, Pastels, Sculptures, Charles E. Slatkin Galleries, New York, 1958. Foreword by V. Price. Many ill.

- 125 Twenty-six Original Copperplates engraved by Degas, Frank Perls Gallery, Beverly Hills, 1959. Texts by J. Rewald and J. S. Boggs, ill.
- 126 Degas, Wildenstein Galleries, New York, 1960. Texts by K. Lansner and D. Wildenstein, ill.
- 127 Etchings by Edgar Degas, University of Chicago, 1964.Preface and notes by P. Moses, ill. Excellent cat.
- 128 9 Monotypes by Degas, E. V. Thaw Gallery, New York, 1964. Preface is English translation of 75.
- 129 Degas, His Family and Friends in New Orleans, Isaac Delgado Museum, New Orleans, 1965. Important catalogue; numerous ill., essays by J. B. Byrnes and J. S. Boggs, and reprint of 38.
- 130 Lithographs by Edgar Degas, St. Louis and Lawrence (Kansas), 1967. Preface by W. M. Ittmann, Jr.
- 131 Degas—Oeuvres du Musée du Louvre, Orangerie, Paris, 1969. All the Louvre-owned paintings, pastels, drawings, sculptures (and some prints) grouped by affinities. An overwhelming exhibition of which the catalogue provides only a pale impression; few and poor ill. See also 103a.
- 132 Degas, Lefevre Gallery, London, June-July 1970. Text by D. Sutton, ill.

GAUGUIN

Gauguin's impressionist period has not yet received proper attention. His works have neither been assembled in any special publication nor have they been studied critically. The same holds true for his paintings done in Martinique. Most of Gauguin's biographers have devoted serious attention to his evolution only beginning with the year 1888, when the artist first expressed his theories of *Synthesism*.

For a catalogue raisonné of Gauguin's paintings see G. Wildenstein: Gauguin, Paris, 1964. For an extensive Gauguin bibliography see J. Rewald: Post-Impressionism—From van Gogh to Gauguin, New York, 1956.

GUILLAUMIN

- 1 Serret, G. and Fabiani, D.: Armand Guillaumin, Paris, 1971, with text by R. Schmit. This so-called catalogue raisonné provides little of the information that one would expect; there are no chronology, no bibliographical or other references, and few indications of present owners.
- 2 Gray, C.: Armand Guillaumin, Chester, Conn., 1972. Contains more information and references than 1, as well as larger plates, but those in color are poor.
- 3 BORGMEYER, C. L.: Armand Guillaumin, The Fine Arts, Feb. 1914.
- 4 COQUIOT, G.: Armand Guillaumin, Le carnet des artistes,

- Feb. 15, 1917.
- 5 Tabarant, A.: Quatre-vingts ans de Guillaumin, Bulletin de la vie artistique, Feb. 15, 1921.
- 6 Courrières, E. des: Armand Guillaumin, Paris, 1924.
- 7 LECOMTE, G.: Guillaumin, Paris, 1926.
- 8 Rivière, G.: Armand Guillaumin, L'Art Vivant, July 15, 1927.

MANET

Oeuvre Catalogues

- 1 Tabarant, A.: Manet, Histoire catalographique, Paris, 1931. A valuable attempt to unite oeuvre catalogue and biography. Unfortunately, this book is not illustrated. Extensive bibl. See also 4.
- 2 JAMOT, WILDENSTEIN, BATAILLE: Manet, 2 v., Paris, 1932. The catalogue lists 546 paintings and pastels (no watercolors or drawings) including a number of doubtful works and fakes, designated as such. Detailed notes give all desirable information on every work. A long introduction by P. Jamot examines the evolution of Manet's style. It is followed by a genealogy of the artist's family, by an iconography of Manet, by descriptions of Manet quoted from the writings of A. Proust, Bazire, Zola, Mallarmé, Moore, de Nittis, etc. An extremely detailed chronological chart with numerous direct quotations from documents is particularly valuable. Excellent index. The 487 illustrations unfortunately are not chronologically arranged and make it extremely difficult to follow Manet's development. Extensive bibl. Revised edition is in preparation by D. Rouart; see also 6.
- 3 Guérin, M.: L'oeuvre gravé de Manet, Paris, 1944. A new and more complete edition of Moreau-Nélaton's: Manet Graveur et Lithographe, Paris, 1906, the introduction to which is here reprinted. A chronologically arranged record of Manet's important output of etchings, lithographs, etc. 182 good ill., including paintings or sketches related to prints. Short bibl. See also 8, 8a, 44, and 66.
- 4 Tabarant, A.: Manet et ses oeuvres, Paris, 1947. A gigantic undertaking, combining a day by day account of Manet's life with a description of his works, canvas by canvas, drowning the whole story in an overpowering wealth of often insignificant details, of documents, gossip, conjectures, etc. Moreover, the text is poorly written and the book is difficult to use as a reference, in spite of indexes. Among the 678 postage stamp size reproductions at the end of the volume are several illustrations of which the authenticity appears doubtful. Lists, indexes, no bibl. See the review by J. Rewald, *The Art Bulletin*, Sept. 1948, with a list of concordance between 1, 2, and 4.

- 5 Mathey, J.: Graphisme de Manet—Essay de catalogue raisonné des dessins, Paris, 1961. This disconcerting book dealt with the then still unexplored field of Manet's drawings, yet it is difficult to follow the author in many of his attributions, based on stylistic interpretations unsupported by pedigrees or similar data. Profusely ill. See also the same author's: Graphisme de Manet II—Peintures réapparues, Paris, 1963, and: Graphisme de Manet III, Paris, 1966. These bewildering publications seem to reflect a real mania for attributing to Manet almost anything the author has come across. Some refutations of this dangerous tendency can be found in T. Reff: Copyists in the Louvre, Art Bulletin, Dec. 1964; also in 7.
- 6 Venturi, M. and Orienti, S.: Opera pittorica di Edouard Manet, Milan, 1967. Presentation by M. Venturi, critical research by Orienti. Like the other volumes of this series (Cézanne, la, Degas, 5a), this one combines a group of mediocre to atrocious color plates with small black and white reproductions; but here, unlike the other later publications, the short notes on the pictures are accompanied by a number of ugly little signs that purport to indicate the "degree of authenticity" of the work. The "critical research" has been greatly facilitated by the existence of 2 and also 4 (though for illustrations 2 was much more useful).

French edition: Tout l'oeuvre peint de Manet, Paris, 1970, with an introduction by D. Rouart, shows somewhat greater care in the printing of the color plates (more restraint in the reds) and a slightly improved layout: certain important works have been reproduced a little larger. Miss Orienti's critical research has also been corrected under Rouart's supervision, at least as far as the "degree of authenticity" of Nos. 29, 94, and 433 is concerned, and the dating of No. 196.

English edition: The Complete Paintings of Manet, New York, 1971, by S. Orienti and text by P. Pool.

- 7 Leiris, A. de: The Drawings of Edouard Manet, Berkeley and Los Angeles, 1969. The first thorough study of Manet's style as a draftsman and of his artistic evolution as revealed by his drawings and watercolors, followed by a catalogue raisonné of his works in these media (which also touches authoritatively on the problems raised by Mathey's recent "attributions," see 5). The reproductions are very good, and the author has succeeded in identifying the originals after which many of Manet's sketches were made, illustrating these next to Manet's works. But, unfortunately, not all of Manet's drawings are reproduced; and, since the index uses French titles exclusively, it may prove to be difficult for many American readers to locate a specific drawing for which there is no illustration.
- 8 Harris, E. J.: Edouard Manet—Graphic Works: A Definitive Catalogue Raisonné, New York, 1970. Good reproductions, frequently of several states, some of

- which had escaped Guérin (3). Extensive notes on the prints, with discussion of preparatory drawings. See also 8a.
- 8a Leymarie, J. and Melot, M.: Les gravures des Impressionnistes, Paris, 1971. Includes the complete catalogue of Manet's graphic output. Each work is reproduced in one state only; excellent plates, but those of 8 appear crisper.

The Artist's Own Writings

- 9 Duret, T.: Quelques lettres de Manet et de Sisley, *Revue Blanche*, March 15, 1899.
- 10 Manet, E.: Lettres de jeunesse, Paris, 1929. A number of letters written by Manet at the age of 17 while sailing as apprentice between Rio de Janeiro and Le Havre.
- 11 Guiffrey, J.: Lettres illustrées de Edouard Manet, Paris, 1929. Excellent facsimiles of 22 letters written around 1880 and more interesting for their charming watercolor illustrations than for their text. English edition: Manet, Letters with Aquarelles, New York, 1944.
- 12 TABARANT, A.: Une correspondance inédite d'Edouard Manet—Lettres du siège de Paris, Paris, 1935.
- 13 Lettres d'Edouard Manet sur son voyage en Espagne, Arts, Paris, March 16, 1945.
- Some letters to Eva Gonzalès are quoted in C. Roger-Marx: Eva Gonzalès, Paris, 1950.
- Most of Manet's important letters to his family and friends (he did not express himself much in letters) are quoted at length in 25; others are to be found in 1, 2, 3, 4, and 31.

Witness Accounts

- 14 Zola, E.: Edouard Manet, étude biographique et critique, Paris, 1867. Reprinted in Mes Haines, Oeuvres complètes, Paris, 1928, together with other writings by Zola on Manet and with notes and commentaries by M. Le Blond. See also: Emile Zola—Salons, recueillis, annotés et présentés par F. W. J. Hemmings et R. J. Niess, Geneva-Paris, 1959.
- 15 ALEXIS, P.: Manet, Revue Moderne et Naturaliste, 1880, p. 289–295. This article and the two following are accounts of visits to the artist's studio, published during his lifetime.
- 16 JEANNIOT: article on Manet in La Grande Revue, Jan. 1882.
- 17 GOETSCHY, G.: Edouard Manet, La Vie Moderne, May 12, 1883.
- 17a GILBERT, F.: J.-B. Faure interrogé sur Manet, Le Gaulois, Jan. 6, 1884.
- 18 MOORE, G.: Confessions of a Young Man, London, 1888.
 See also the same author's: Modern Painting, London-

- New York, 1898, and Memoirs of my Dead Life, London, 1906. On Moore's friendship with Manet see D. Cooper: George Moore and Modern Art, *Horizon*, Feb. 1945.
- 19 NITTIS, J. DE: Notes et souvenirs, Paris, 1895. The few passages of interest have been quoted in 25; some also appear in the present book.
- 20 BLANCHE, J.-E.: Essays et portraits, Paris, 1912. Notes on Manet later reprinted in: Propos de peintre, de David à Degas, Paris, 1919.
- 21 PROUST, A.: Edouard Manet, Souvenirs, publiés par A. Barthélemy, Paris, 1913. The author, who met Manet at college and again at Couture's and who later turned to politics, presents his recollections in a more or less coherent way. He is not always reliable, errs in dates, follows the artist's career only intermittently and, above all, does not fully understand Manet's art. Yet his book, expanded from his: Souvenirs de Manet, Revue Blanche, 1897, offers occasionally useful information.
- 21a Fels, F.: Propos d'Artistes, Paris, 1925. Short interview with Duret concerning Manet; see also 23.
- A chapter on Manet based on Mallarmé's recollections is to be found in T. Natanson: Peints à leur tour, Paris, 1948. See also 22, 23, and 31.

Biographies

- 22 BAZIRE, E.: Manet, Paris, 1884. The first book on Manet, published the year after his death. It is of value as a testimony of admiration but suffers from considerable incompleteness.
- 23 Duret, T.: Histoire de Edouard Manet et de son oeuvre, Paris, 1902, 1906, 1919, 1926; English edition: Manet and the French Impressionists, Philadelphia-London, 1910. A biography based on the author's long friendship with Manet. See also 21a.
- 24 WALDMANN, E.: Edouard Manet—Sein Leben und seine Kunst, Berlin, 1910, 1923. Ill.
- 25 Moreau-Nélaton, E.: Manet raconté par lui-même. 2 v., Paris, 1926. Extremely conscientious and excellent presentation of all data concerning Manet with abundant quotations from letters and other documents. The author's careful exploration of source material practically renders all previously published biographies obsolete. Profusely ill., with excellent photogravures. In appendix a catalogue and photographs of the Manet exhibition. Paris, 1884. Extensive index, no bibl.
- 26 Flament, A.: La vie de Manet, Paris, 1928.
- 27 VAN ANROY, A.: Impromptu, The Hague, 1931. On Manet and his Dutch wife (in Dutch). In French, Geneva-Annemasse, 1949.
- 28 COLIN, P.: Edouard Manet, Paris, 1932. A list of Manet's works in public collections, 96 fair plates, bibl., no index.

- 29 Jedlicka, G.: Manet, Erlenbach-Zurich, 1941. An attempt to unite a biographical account with a critical study, this book offers a painstaking investigation of Manet's life and development which presupposes a thorough acquaintance with the artist's world. Those who look for precise data and documents may be disappointed. Occasionally the author seems not to be critical enough in his use of source material, such as 21, etc. But this does not detract from the merits of his book as an extremely detailed portrait of Manet. Profusely ill. with excellent halftones, no bibl., index.
- 30 GRABER, H.: Edouard Manet, nach eigenen und fremden Zeugnissen, Basel, 1941. On this author's methods see Cézanne 25. Ill.
- 31 COURTHION, P. and CAILLER, P. (editors): Manet raconté par lui-même et par ses amis, Vésenaz-Geneva, 1945, 1954. Excerpts from Manet's letters and from writings by Zola, Baudelaire, Mallarmé, A. Proust, M. Proust, etc. No new material. Ill., short bibl., no index. Considerably expanded English edition: Portrait of Manet by himself and his contemporaries, London, 1960.
- 32 PIÉRARD, L.: Manet l'incompris, Paris, 1946.
- 33 Schwarz, H.: Two Unknown Portraits of Manet, Gazette des Beaux-Arts, April 1959.
- 34 Perruchot, H.: La vie de Manet, Paris, 1959. This competent biography contains few new elements and suffers from the author's endeavors to infuse the artist's life with adventures of a sentimental character. Few ill., chronology, condensed bibl., no index.
- 34a Gurley, E. R.: Edouard Manet et un Salon des Refusés en 1872, Gazette des Beaux-Arts, Dec. 1972.

See also 2, 4, and 100.

Studies of Style

- 35 MALLARMÉ, S.: The Impressionists and Edouard Manet, Art Monthly Review, London, 1876, v. I, no. 9, p. 117–121. See J. C. Harris: A Little-known Essay on Manet by Stéphane Mallarmé, Art Bulletin, Dec. 1964.
- 36 Bietz, J. de: Edouard Manet (lecture), Paris, 1884.
- 37 TSCHUDI, H. VON: Edouard Manet, Berlin, 1902. Slim volume with numerous ill.; neither bibl. nor index.
- 38 Meier-Graefe, J.: Manet und sein Kreis, Berlin, 1903. See also by the same author: Edouard Manet, Munich, 1912. Ill.
- 39 PAULI, G.: Raffael und Manet, Monatshefte für Kunstwissenschaft, 1908.
- 40 HOURTICQ: Manet, Paris, n.d., [1912]. 48 ill. chronologically arranged, accompanied by a running commentary by J. Laran and G. Le Bas. No bibl., no index. English edition, Philadelphia-London, 1912.

- 41 Bernard, E.: Tintoret, Greco, Magnasco, Manet, Paris, 1920.
- 42 GLASER, C.: Edouard Manet, Munich, 1922.
- 43 Blanche, J.-E.: Manet, Paris, 1924. Introduction with 40 mediocre plates.
- 44 ROSENTHAL, L.: Manet aquafortiste et lithographe, Paris, 1925. An exhaustive study, some ill. On Manet's graphic work see also 3, 8, and 8a.
- 45 LÉGER, C.: Manet, Paris, 1931.
- 46 George, W.: Manet et la carence du spirituel, Paris, 1932.
- 47 Bazın, G.: Manet et la tradition, L'Amour de l'Art, May 1932.
- 48 Zervos, C.: A propos de Manet, *Cahiers d'Art*, No. 8–10, 1932.
- 49 STERLING, C.: Manet et Rubens, L'Amour de l'Art, Sept.-Oct. 1932.
- 50 LAMBERT, E.: Manet et l'Espagne, Gazette des Beaux-Arts, 1933. See also 116.
- 51 Mesnil, J.: Le Déjeuner sur l'herbe, L'Art, 1934.
- 52 FLORISOONE, M.: Manet inspiré par Venise, L'Amour de l'Art, Jan. 1945.
- 53 Thyis, J.: Manet et Baudelaire, Etudes d'Art, Algiers, 1945.
- 54 Ebin, I. N.: Manet and Zola, Gazette des Beaux-Arts, June 1945.
- 55 FAISON, S. L., Jr.: Manet's Portrait of Zola, Magazine of Art, May 1949.
- 56 Venturi, L.: Impressionists and Symbolists, New York, 1950. Chapter on Manet.
- 57 Sloane, J. C.: Manet and History, Art Quarterly, v. 14, 1951.
- 58 Hamilton, G. H.: Manet and His Critics, New Haven-London, 1954. Extremely conscientious compilation of everything that was written on Manet during his lifetime, with an appreciation of his evolution. Ill., short bibl., detailed index.
- 59 SANDBLAD, N. G.: Manet—Three Studies in Artistic Conception, Lund, 1954 (in English). Highly interesting analysis of Manet's Concert in the Tuileries Gardens, Olympia, and The Execution of Emperor Maximilian. Ill., short bibl., notes, no index. See also M. Davies: Recent Manet Literature, Burlington Magazine, May 1956.
- 60 Busch, G.: Manet—Un Bar aux Folies-Bergère, Stutt-gart, 1956 (in German). See also 87.
- 61 RICHARDSON, J.: Edouard Manet—Paintings and Drawings, London, 1958. Very readable introduction to 84

- well-selected plates in black and white and color, with informative comments.
- 62 CORRADINI, G.: La Nymphe Surprise de Manet et les rayons X, Gazette des Beaux-Arts, Sept. 1959.
- 63 DAVIDSON, B. F.: Le Repos—A Portrait of Berthe Morisot by Manet, Bulletin of the Rhode Island School of Design, Dec. 1959.
- 64 Leiris, A. de: Manet—"Sur la plage de Boulogne," Gazette des Beaux-Arts, Jan. 1961.
- 65 BOWNESS, A.: A Note on "Manet's Compositional Difficulties," Burlington Magazine, June 1961.
- 66 Reff, T.: The Symbolism of Manet's Frontispiece Etchings, *Burlington Magazine*, May 1962.
- 67 DORIVAL. B.: Meissonier et Manet, Art de France, II, 1962.
- 68 Leiris, A. de: Manet, Guéroult and Chrysippos, Art Bulletin, Sept. 1964.
- 69 HARRIS, J. C.: Manet's Race-Track Paintings, Art Bulletin, March 1966.
- 70 Siegl, T.: The Treatment of Edouard Manet's 'Le Bon Bock,' Philadelphia Museum of Art Bulletin, Autumn 1966.
- 70a Bowness, A.: Manet and Mallarmé, *Philadelphia Museum of Art Bulletin*, April-June 1967.
- 70b Harris, J. C.: Edouard Manet as an Illustrator, Philadelphia Museum of Art Bulletin, April-June 1967.
- 71 Hanson, A. C.: Manet's Subject Matter and a Source of Popular Imagery, *Museum Studies*, Art Institute of Chicago, no. 3, 1968.
- 72 HOPP, G.: Edouard Manet, Farbe und Bildgestalt, Berlin, 1968. A valuable and original investigation; ill.
- 72a Waldvogel, M.: Manet's "Smoker," Minneapolis Institute of Arts Bulletin, v. LVII, 1968.
- 73 FRIED, M.: Manet's Sources, Aspects of His Art, 1859– 1865, Artforum, March 1969 (special issue). Ill., many notes.
- 74 OSTEN, G. VON DER: Manets Spargelbündel "bei Liebermann" jetzt in Köln, Wallraf-Richartz-Jahrbuch, v. XXXI, 1969.
- 75 CHIARENZA, C.: Manet's Use of Photography in the Creation of a Drawing, Master Drawings, Spring 1969.
- 76 COURTHION, P.: La genèse et les personnages du "Balcon" de Manet, L'Oeil, Aug.-Sept. 1969.
- 77 HANSON, A. C.: Edouard Manet, 'Les Gitanos,' and the Cut Canvas, *Burlington Magazine*, March 1970.
- P. Jamot has published a series of articles on Manet listed in 2. See also his introduction to 2.

See also p. 92, note 34 in the present book and 115.

Reproductions

- 78 SEVERINI, G.: Manet, Rome, 1924. 33 small and mediocre reproductions.
- 79 BLANCHE, J.-E.: Manet, Paris-New York, 1925. 40 good but small ill.
- 80 Fels, F.: Edouard Manet, Paris, n.d. [1928?]. An Album d'art Druet with 24 mediocre plates.
- 81 Manet, Album of the Marées Gesellschaft, Munich, 1928, with 15 superb color plates.
- 82 Manet, special issue of L'Art Vivant, June, 1932.
- 83 Manet, special issue of *L'Amour de l'Art*, 1932. Very interesting ill. See also special issue, 1947, Nos. 3–4.
- 84 REY, R.: Choix de soixante-quatre dessins de Edouard Manet, Paris-New York, 1932. 64 good ill. of drawings.
- 85 Rey, R.: Manet, Paris-London, 1938. The plates are arranged without order; the captions were written without consulting 2, which is not even listed in the bibl. Fair ill., some color plates (Hyperion).
- 86 TABARANT, A.: Manet, Paris-London, 1939. Portfolio with 8 excellent color plates.
- 87 MORTIMER, R.: Manet's "Un bar aux Folies-Bergère," London, n.d. [1944]. Excellent photographs of details. See also 60.
- 88 FLORISOONE, M.: Manet, Monaco, 1947. Preface with 96 mostly good plates in black and white and 8 in color. A series of statements by the artist, quotes from contemporary critics, list of exhibitions, chronologically arranged bibl.
- 89 REWALD, J.: Manet Pastels, Oxford, 1947. Good ill.
- 90 Reifenberg, B.: Manet, Bern, 1947. 52 small but good plates.
- 91 ALAZARD, J.: Manet, Lausanne, 1948.
- 92 LEYMARIE, J.: Manet et les impressionnistes au Musée du Louvre, Paris, 1948.
- 93 ROTHENSTEIN, J. and WILENSKI, R. H.: Manet, London-New York, 1949. Introd. and notes, fair color plates.
- 94 Leymarie, J.: Manet, Paris, 1952. 20 well selected color plates of paintings, pastels, and watercolors (Hazan).
- 95 Cogniat, R.: Manet, Paris, 1953.
- 96 Cassou, J.: Manet, Paris, 1954.
- 97 Faison, S. L., Jr.: Edouard Manet, New York, 1954. Short preface, mediocre plates in black and white and color with comments (Pocket Library of Great Art).
- 98 VAUDOYER, J.-L.: E. Manet, Paris, 1955. Large volume with short preface, also biography by A. Rouart-Valéry,

- and 113 splendid plates (7 in color) among which many details; comments on the plates and bibl. This book presents by far the finest reproductions of Manet's paintings.
- 99 MARTIN, K.: Edouard Manet—Aquarelle—Pastelle, Basel, 1955. 24 color plates with introduction and comments. English edition: Ed. Manet, Watercolors and Pastels, New York, 1959. Fair reproductions.
- 100 BATAILLE, G.: Manet, Geneva, 1955. Excellent biographical and critical study, chronological survey, selected bibl., index, profusely ill. with small color plates (Skira).
- 101 Trost, H.: Edouard Manet, Berlin, 1959. Short preface, chronology, 16 mediocre plates, mostly in color.
- 102 ROUART, D.: Manet, Paris, 1960 (Somogy).
- 103 Jedding, H.: Manet, Milan, n.d. Portfolio of 10 poor color plates with comments.
- 104 Musée National du Louvre—Peintures, Ecole Française, XIXe Siècle, v. III, H-O, Paris, 1960. Lists and reproduces 32 paintings and pastels by Manet.
- 105 COURTHION, P.: Manet, Paris, 1961. Good color plates with comments; also English edition, New York, 1961 (Abrams).
- 106 Rey, R.: Manet, Paris, n.d. [1962]. Mediocre plates assembled without any order; some of the drawings appear to be of doubtful authenticity.
- 106a Schneider, P.: The World of Manet, New York, 1968. The plates, mostly in color, are poor.
- 106b Sasaki, H.: Manet, Tokyo, 1971. Numerous color plates, mostly mediocre.
- See also 2, 3, 11, 24, 25, 28, 29, 30, 37, 38, 40, 58–61, 109, 111, 113, and 114.

Exhibition Catalogues

- 107 Exposition Manet, Ecole des Beaux-Arts, Paris, 1884. Preface by E. Zola. List of 179 works without dimensions; no ill.
- 108 Manet, trente-cinq tableaux de la Collection Pellerin, Bernheim-Jeune Gallery, Paris, 1910. Preface by T. Duret, 9 good plates.
- 109 Ausstellung Edouard Manet, Galerie Mathiesen, Berlin, 1928. Preface by E. Waldmann, 89 plates.
- 110 Manet, Musée de l'Orangerie, Paris, 1932. Introductions by Paul Valéry and P. Jamot, catalogue notices by C. Sterling. Ill.
- 111 Edouard Manet, Wildenstein Galleries, New York, 1937. Preface by P. Jamot, chronology, extensive notices on 37 works, all ill.
- 112 Masterpieces by Manet, Paul Rosenberg Gallery, New York, 1947. 11 paintings, all reproduced.

- 113 Manet, Wildenstein Galleries, New York, 1948. Chronology, documents, many ill.
- 114 Manet, Dessins et aquarelles réunis en cinq albums par Auguste Pellerin. Catalogue of a sale, Gal. Charpentier, Paris, June 10, 1954, with excellent reproductions of unpublished drawings and watercolors (which were acquired by the Louvre Museum).
- 115 Manet, Philadelphia Museum of Art and Art Institute of Chicago, 1966. Carefully researched catalogue by A. C. Hanson; unfortunately, a very ugly presentation. On this exhibition and catalogue see M. Schmierer and R. Verdi: Thoughts Arising from the Philadelphia-Chicago Manet Exhibition, Art Quarterly, no. 3–4, 1967.
- 116 Manet and Spain—Prints and Drawings, Museum of Art, University of Michigan, Ann Arbor, 1969. Texts by J. C. Harris and J. Isaacson. See also 50.
- 117 SASAKI, H.: Edouard Manet dans les collections Japonaises, Bulletin annuel du Musée National d'Art Occidental, No. 4, Tokyo, 1970.

MONET

Oeuvre Catalogues

WILDENSTEIN, D.: Claude Monet: Catalogue raisonné, v. 1, 1840–1881–Peintures, Lausanne-Paris, 1974.

Among exhibition catalogues see the following:

- 1 Claude Monet—Les meules, Galeries Durand-Ruel, Paris, 1891. Preface by G. Geffroy, reprinted *in* Geffroy: La vie artistique, première série, Paris, 1892. For other articles on Monet exhibitions see the same author's: La vie artistique, sixième série, Paris, 1900.
- 2 Claude Monet, Galeries Durand-Ruel, Paris, 1928. 84 works.
- 3 Claude Monet, Galerien Thannhauser, Berlin, 1928. Ill.
- 4 Claude Monet, Musée de l'Orangerie, Paris, 1931. Preface by P. Jamot. 128 works.
- 5 Claude Monet, Galerie Rosenberg, Paris, 1936. Preface by A. Charpentier.
- 6 Claude Monet, Wildenstein Galleries, New York, 1945. Text by D. Wildenstein, chronology, 49 ill.
- 7 Claude Monet, Kunsthaus, Zurich, 1952. Introductions by G. Besson and R. Wehrli, chronology, 49 good ill.
- 8 Claude Monet, Marlborough Galleries, London, 1954. Excerpts from various texts, chronology, bibl., good ill.
- 9 Claude Monet, Edinburgh Festival and Tate Gallery, London, 1957. Text by D. Cooper, detailed chronology by J. Richardson, selected bibl., extensive notes on the works included, ill. An excellent catalogue.

- 10 Claude Monet, City Art Museum, St. Louis, and Minneapolis Institute of Arts, 1957. Long study on Claude Monet's View of Nature by W. C. Seitz, chronology, ill. See also 13 and 76.
- 11 Claude Monet, Galeries Durand-Ruel, Paris, 1959. Preface by C. Roger-Marx, chronology, ill.
- 12 Claude Monet and the Giverny Artists, Charles E. Slatkin Galleries, New York, 1960. Ill.
- 13 Claude Monet—Seasons and Moments, Museum of Modern Art, New York, and Los Angeles County Museum, 1960. Excellent text by W. C. Seitz, excerpts from various writings, documentary photographs, biographical outline and list of major exhibitions, selected bibl. Profusely ill. in black and white and color. See also 76.
- 14 Musée National du Louvre—Peintures, Ecole Française, XIXe siècle, v. III, H-O, Paris, 1960. Lists and reproduces 78 paintings by Monet as well as views of the Nymphéas series at the Musée de l'Orangerie.
- 15 Claude Monet, Letzte Werke, Galerie Beyeler, Basel, 1962. Profusely ill.
- 15a Kuroe, M.: Claude Monet dans les collections japonaises, Bulletin annuel du Musée National d'Art Occidental, No. 2, Tokyo, 1968. 38 works with pedigrees, all ill.
- 16 Claude Monet, The Early Years (From British Collections), Lefevre Gallery, London, 1969. An excellent catalogue; long preface by D. Sutton, ill., and notes on many little-known works.
- 16a Monet, catalogue of an exhibition held in Tokyo, Osaka, and Fukuoka, 1970. Ill. See also 15a.
- 16b Monet et ses amis, Musée Marmottan, Paris, 1971.

 Catalogue of the Michel Monet and Donop de Monchy bequests (the latter represents part of the G. de Bellio collection). The Monet bequest includes some of the paintings in the artist's collection, but it is incomplete; Monet's son sold all the Cézanne paintings his father owned and probably others, too. Catalogue notes and comments by F. Daulte and C. Richebé; many ill., good color plates.

The Artist's Own Writings

- For letters to Boudin see G. Cahen: Eugène Boudin, sa vie et son oeuvre, Paris, 1900.
- 17 For letters to G. de Bellio see: La grande misère des impressionnistes, Le Populaire, March 1, 1924. Also: Des lettres inédites de Claude Monet, Arts-Documents, Feb., March 1953; C. Richebé: Claude Monet au Musée Marmottan, Académie des Beaux-Arts, 1959-60, and R. Niculescu: Georges de Bellio, l'ami des Impressionnistes, Revue Roumaine d'Histoire de l'Art, v. I, no. 2, 1964; reprinted in Paragone, 247-49, 1970.

- 18 A letter to Houssaye was published by R. Chavance: Claude Monet, *Le Figaro Illustré*, Dec. 16, 1926.
- A letter to Charteris appears in Charteris: John Sargent, London, 1927.
- For letters to Manet see A. Tabarant: Autour de Manet, L'Art Vivant, May 4, 1928.
- 19 For letters to Bazille see G. Poulain: Bazille et ses amis, Paris, 1932, and F. Daulte: Frédéric Bazille et son temps, Geneva, 1952.
- For letters to Chocquet see J. Joëts: Les impressionnistes et Chocquet, L'Amour de l'Art, April 1935.
- 20 VENTURI, L.: Les Archives de l'Impressionnisme, Paris-New York, 1939, 2 v. Contains 411 letters to Durand-Ruel (1876–1926) and 6 to O. Maus. The most important group of Monet's letters.
- For a letter to R. Laurent see Beaux-Arts, Paris, Jan. 31, 1941.
- Some letters to Zola are quoted in J. Rewald: Cézanne, New York, 1948, as well as in the present volume.
- 21 Some letters to Jeanne Baudot are published in J. Baudot: Renoir, ses amis, ses modèles, Paris, 1949.
- For letters to Berthe Morisot see D. Rouart: Correspondance de Berthe Morisot, Paris, 1950.
- For letters to Dr. Gachet and E. Murer see: Lettres impressionnistes au Dr. Gachet et à Murer, edited by P. Gachet, Paris, 1957.
- For letters to his step-daughter and daughter-in-law, Blanche, to Clemenceau and others see J.-P. Hoschedé: Blanche Hoschedé Monet, Rouen, 1961.
- For some letters to Whistler and Mallarmé see C. P. Barbier (ed.): Mallarmé-Whistler, Correspondance, Paris, 1964.
- Letters to Geffroy are quoted in 46, letters to Charpentier in 48, letters to Duret in 45.
- For letters by Mirbeau to Monet see Cahiers d'Aujourd'hui, Nov. 29, 1922.
- For some letters by Pissarro to Monet see J. Joëts: Lettres inédites de Pissarro à Claude Monet, L'Amour de l'Art, III, 1946.

For some letters by Renoir to Monet, see 21.

Many letters written to Monet are quoted in 46.

See also 32, 81a, 83, and 85.

Monet also expressed his opinions in a number of interviews:

- 22 TABOUREUX, E.: Claude Monet, La Vie Moderne, June 12, 1880.
- 23 Guillemot, M.: Claude Monet, Revue Illustrée, March 15, 1898.
- 24 THIÉBAULT-SISSON: Claude Monet, An Interview, Le

- Temps, Nov. 27, 1900 (translated and reprinted in English by Durand-Ruel, New York). Important text, particularly on Monet's youth, quoted extensively in the present book. See also: C. Monet as a Young Man, Art News Annual, 1957.
- 25 VAUXCELLES, L.: Un après-midi chez Claude Monet, L'Art et les Artistes, Dec. 1905.
- 26 PACH, W.: Interview of Monet, published in Scribner's Magazine, 1908; reprinted in the same author's: Queer Thing, Painting, New York, 1938.
- 27 Marx, R.: Les 'Nymphéas' de M. Claude Monet, reprinted in the same author's: Maîtres d'hier et d'aujourd'hui, Paris, 1914.
- 27a Fels, F.: Propos d'Artistes, Paris, 1925. Short interview with Monet.
- 28 Trévise, Duc de : Le pèlerinage de Giverny, Revue de l'art ancien et moderne, Jan., Feb. 1927.
- 29 GIMPEL, R.: At Giverny with Claude Monet, Art in America, June 1927. See also R. Gimpel: Journal d'un collectionneur, marchand de tableaux, Paris, 1963. English trans.: Diary of an Art Dealer, New York, 1966.

Witness Accounts

- 30 BRYVANCK, W. G. C.: Un Hollandais à Paris en 1891, Paris, 1892. Short chapter on Monet.
- 31 ROBINSON, T.: Claude Monet, Century Magazine, Sept. 1892.
- 32 Elder, M.: Chez Claude Monet à Giverny, Paris, 1924. A series of interviews pertaining mostly to the painter's youth and to his last years, the period of his waterlilies. Ill.
- 33 Rivière, G.: Claude Monet aux expositions des impressionnistes, L'Art Vivant, Jan. 1, 1927.
- 34 Koechlin, R.: Claude Monet, Art et Décoration, Feb. 1927.
- 35 Perry, L. C.: Reminiscences of Claude Monet from 1889 to 1909, *The American Magazine of Art*, March 1927.
- 36 CLEMENCEAU, G.: Claude Monet, Les Nymphéas, Paris, 1928. Though written by one of Monet's closest friends, this book contains little firsthand information, offering instead a panegyric of his last works. Excellent English translation by George Boas, New York, 1930. See also 43.
- 37 Prince Eugene (of Sweden): Monet och hans maleri. Minnen och intryck, Ord och Bild, Dec. 1947. [Monet and his art, recollections and impressions.] With notes and commentaries by O. Reuterswärd (in Swedish).
- 38 Natanson, T.: Peints à leur tour, Paris, 1948. Two chapters on Monet.
- 39 Salomon, J.: Giverny, 14 juin 1926—Aujourd'hui

- déjeuner chez les Monet, Arts, Paris, Dec. 14, 1951. Excerpts quoted in 41. See also 44a.
- 40 Barbier, A.: Monet, c'est le Peintre, *Arts*, Paris, July 31-Aug. 6, 1952. Excerpts quoted in 41.
- 41 Hoschedé, J.-P.: Claude Monet ce mal connu (intimité d'un demi siècle à Giverny de 1883 à 1926), 2 v., Geneva, 1960. Written by Monet's step-son with more fervor than perspicacity, this account offers disappointingly few new facts or documents. Vol. I contains some notes by Blanche Hoschedé-Monet and a list of exhibitions; vol. II furnishes details on the waterlily series, excerpts from two Scandinavian articles of 1895 (p. 109–115), and includes unwarranted refutations of other writers on Monet. Profusely ill. with many little-known photographs.
- 42 GOODMAN, P.: The Passion of Monet, Art News, Oct. 1960.
- 43 CLEMENCEAU, G.: Claude Monet, cinquante ans d'amitié, Paris-Geneva, 1965. See also 36.
- 44 Howard-Johnston, P.: Une visite à Giverny en 1924, L'Oeil, March 1969. (The author is the daughter of Helleu.)
- 44a Salomon, J.: Chez Monet, avec Vuillard et Roussel, L'Oeil, May 1971. See also 39.

See also 22-29, 45, 46, and 65.

Marcel Proust has used some of Monet's traits for his characterization of the painter Elstir in: A la recherche du temps perdu; see M. E. Chernowitz: Proust and Painting, New York, 1945. See also 59.

Biographies

- 45 Duret, T.: Manet and the French Impressionists, Philadelphia-London, 1910. A chapter on Monet based chiefly on the author's long association with the painter.
- 46 Geffroy, G.: Claude Monet, sa vie, son temps, son oeuvre, Paris, 1922 (a one-volume and an inexpensive two-volume edition). The author, one of the painter's most intimate friends, had access to Monet's private papers. His rambling book contains a great wealth of documents, letters addressed to Monet by his painter friends, generous quotations from early press clippings and narrations of various episodes which Monet confided to his biographer whose publication appeared while he was still alive. Unfortunately the book is edited without great care; the author apparently neglected to do any research of his own or even to classify the material obtained from Monet, nor does he seem to have consulted the latter in order to clarify many obscure points. His book therefore is not as authoritative as it ought to be and some flagrant errors indicate that Monet may not himself have read the text before it went to press.

- Extensive bibl., index. The de luxe edition has excellent illustrations.
- 47 MAUCLAIR, C.: Claude Monet, Paris, 1924, London, 1927. Chiefly lyrical comments, contains no firsthand information. 40 undated ill. not chronologically arranged, short bibl.
- 48 Fels, M. de: La vie de Claude Monet, Paris, 1929. To date the best and most discriminating biography of Monet, intelligently conceived, and presenting the documents most effectively. Contains a list of Monet's principal works in France and abroad, but does not give the dates for these works. Short bibl., no index.
- 49 Lathom, X.: Claude Monet, London, 1931, New York, 1932. A rather poor and uncritical account of Monet's life, not free of errors. 24 good plates, assembled without any order.
- 50 GWYNN, S.: Claude Monet and His Garden, London, 1934. Contains nothing new, relies heavily on 36. Index, 23 ill., among which are many photographs of Monet's garden in Giverny.
- 51 Grappe, G.: Monet, Paris, 1941.
- 52 Graber, H.: Pissarro—Sisley—Monet, nach eigenen und fremden Zeugnissen, Basel, 1943. Material from various French publications translated into German without any indication of sources. On this author's methods see Cézanne 25.
- 53 REUTERSWÄRD, O.: Monet, Stockholm, 1948. Compilation based mainly on 19, 20, 46, and 48, but without mentioning these sources. 130 black and white ill. and some color plates, chronologically arranged and including little-known works. Detailed index. (In Swedish.)
- 54 WEEKES, C. P.: The Invincible Monet, New York, 1960. A "popular," poorly organized biography, leaning heavily on 46. Short bibl., no ill., no index.
- 55 Mount, C. M.: New Materials on Claude Monet—The Discovery of a Heroine, *Art Quarterly*, winter 1962. New documents on Camille Doncieux and her family, presented unfortunately with a tendency to see her as the victim of an unscrupulous husband. See also 56.
- 56 Mount, C. M.: Claude Monet—A Biography, New York, 1967. The author has done a good deal of research (the most interesting part of which he published in 55), but his presentation is so insufferably biased and smug that the book reads like a wholly unwarranted "debunking" of Monet. He also tends to draw conclusions with the greatest of ease; his identification of Bruyas as one of the subjects of Monet's early caricatures has been refuted by P. Georgel: Monet, Bruyas, Vacquerie et le Panthéon Nadar, Gazette des Beaux-Arts, Dec. 1968. See also review by J. Rewald, Art News, Jan. 1968.

See also 64 and 76; General Bibliography 273.

- 57 Sabbrin, C.: Science and Philosophy in Art, Philadelphia, 1886.
- 58 MIRBEAU, O.: Claude Monet, L'Art dans les deux Mondes, March 7, 1891. See also chapters on Monet in the same author's: Des artistes, Paris, v. I, 1922; v. II, 1924.
- 59 PROUST, M.: Contre Sainte-Beuve, Paris, 1954. Short chapter on Monet, probably written between 1896 and 1904.
- 60 ALEXANDRE, A.: Claude Monet, Paris, 1921. With 48 good ill., chiefly of little-known works.
- 61 TOULET, P.-J.: Notes d'Art, Paris, 1924. Short chapter on Monet.
- 62 RÉGAMEY, R.: La formation de Claude Monet, Gazette des Beaux-Arts, Feb. 1927.
- 63 GILLET, L.: Trois variations sur Claude Monet, Paris, 1927. No ill.
- 64 FOSCA, F.: Claude Monet, Paris, 1927. Study of the life and work of Monet, with bibl. and summary list of his major works, some ill.
- 65 BLANCHE, J.-E.: Propos de peintre, de Gauguin à la Revue nègre, Paris, 1928. The chapter on Monet also contains some reminiscences of him.
- 66 ROSTRUP, H.: Claude Monet et ses tableaux dans les collections danoises, Copenhagen, 1941. With some good ill.
- 67 Roger-Marx, C.: Monet, Lausanne, 1949. Rather small
- 68 Bachelard, G.: Les Nymphéas ou les surprises d'une aube d'été, Verve, Nos. 27–28, 1952.
- 69 Masson, A.: Monet le fondateur, Verve, Nos. 27-28, 1952.
- 70 Usener, K. H.: Claude Monets Seerosen—Wandbilder in der Orangerie. Wallraf-Richartz Jahrbuch, 14, 1952.
- 71 Francis, H. S.: "Spring Flowers" by Claude Monet, Bulletin of the Cleveland Museum of Art, Feb. 1954.
- 72 GREENBERG, C.: The Later Monet, Art News Annual, 1957.
- 73 Rostrup, H.: Det Levende Oejeblik, Meddelelser fra Ny Carlsberg Glyptotek, Copenhagen, 1958.
- 74 HAMILTON, G. H.: Claude Monet's Paintings of Rouen Cathedral, London, 1960 (Charlton Lecture, University of Durham).
- 75 LINDON, R.: "Falaise à Etretat" par Claude Monet, Gazette des Beaux-Arts, March 1960. See also the same author's: Etretat et les peintres, Gazette des Beaux-Arts, May-June 1958.
- 76 Settz, W. C.: Claude Monet, New York, 1960. An excellent book, profusely ill. with good color plates

- and black and white reproductions, chronologically arranged and accompanied by well-documented comments. Extensive biographical outline, selected bibl., documentary photographs. The best modern publication on Monet (Abrams). See also the same author's: Monet and Abstract painting, *College Art Journal*, fall 1956, as well as 10, 13, and 97.
- 77 Lewison, F.: Theodore Robinson and Claude Monet, Apollo, Sept. 1963.
- 78 Butor, M.: Claude Monet ou le monde renversé, Art de France, III, 1963.
- 79 ISAACSON, J.: Monet's Views of Paris, Allen Memorial Art Museum Bulletin, fall 1966. Excellent article on Monet's early Paris views and his erroneous dating of his own pictures. See also 81.
- 80 WALTER, R.: Les maisons de Claude Monet à Argenteuil, Gazette des Beaux-Arts, Dec. 1966. Topographic study.
- 81 Rewald, J.: Notes sur deux tableaux de Claude Monet, Gazette des Beaux-Arts, Oct. 1967. See also 79.
- 81a Isaacson, J.: Monet—Le Déjeuner sur l'herbe, New York, 1972. Excellent and detailed study of a crucial early work; good ill., extensive notes, bibl., index.
- See Venturi's Introduction to 20, as well as 45 and 46.

Reproductions

- 82 Mirbeau, O.: Claude Monet, "Venise," Paris, 1912. Some ill.
- 83 Fels, F.: Claude Monet, Paris, 1925. 28 small and poor ill. The introduction quotes some of Monet's statements.
- 84 Fels, F.: Claude Monet, Paris, 1927. 24 plates (Album d'art Druet).
- 85 Werth, L.: Claude Monet, Paris, 1928. 67 good halftone plates after paintings and drawings, dated and chronologically arranged; also some photographs of Monet.
- 86 Francastel, P.: Monet, Sisley, Pissarro, Paris, 1939. Portfolio with some excellent color plates (Skira).
- 87 Malingue, M.: Claude Monet, Monaco, 1941. Album with 12 poor color plates.
- 88 Cetto, A. M.: Claude Monet, Basel, 1943, 1947. Album with 8 good color plates.
- 89 Malingue, M.: Claude Monet, Monaco, 1943. 144 plates in black and white, not always chronologically arranged, and 10 mediocre color plates. Insignificant text; bibl. and list of exhibitions.
- 90 Besson, G.: Claude Monet, Paris, n.d. 60 excellent though small ill. (Coll. des Maîtres).
- 91 Schweicher, C.: Monet, Bern, 1949. Small but good reproductions.

- 92 Adhémar, H.: Monet—peintures, Paris, 1950.
- 93 LÉGER, C.: Claude Monet, Paris, 1950. 32 good though small ill.
- 94 Westheim, P.: Claude Monet, Zurich, 1953. Album with 6 excellent color plates.
- 95 SALINGER, M.: Claude Monet, New York, 1957. Short introduction and comments accompanying 33 plates in black and white or color (Pocket Library of Great Art).
- 96 ROUART, D.: Claude Monet, Geneva, 1958. Introduction and conclusion by L. Degand (Skira).
- 97 Settz, W. C.: Monet, New York, 1960. Portfolio with short introduction and 16 good color plates with comments; 90 black and white ill. (Abrams). See 76.
- 98 Taillander, Y.: Claude Monet, Paris, n.d. [1963–64]. Mediocre plates assembled without order.
- 99 Catalogue of the exhibition "Claude Monet," Richard L. Feigen Gallery, New York, 1969. All 48 paintings reproduced.
- 100 Sapego, I.: Claude Monet, Vienna, 1969. English text. Reproduces all the Monets in the U.S.S.R. in color, including details, with commentaries.
- 101 Kuroe, M.: Monet, Tokyo, 1970. Numerous color plates, mostly mediocre.

See also Art News Annual, 1957 (24 and 72).

See also 6-11, 13-16b, 32, 47, 49, 53, 60, 66, 68, 76, 81a.

MORISOT

Oeuvre Catalogues

 BATAILLE, M. L. and WILDENSTEIN, G.: Berthe Morisot— Catalogue des peintures, pastels et aquarelles, Paris, 1961.
 Preface by D. Rouart. Catalogue compiled in close collaboration with the artist's daughter, Mme Ernest Rouart, née Julie Manet. 820 reproductions with biographical and critical studies, bibl. A basic though not very handsome publication.

The Artist's Own Writings

- 2 Some letters concerning Manet are quoted in E. Moreau-Nélaton: Manet raconté par lui-même, Paris, 1926.
- 3 Notes on Degas are reproduced in P. Valéry: Degas, Danse, Dessin, Paris, 1938. For an English translation see P. Valéry: Degas—Manet—Morisot, New York, 1960, which also contains translations of 7 and 25.
- 4 Some letters by Berthe Morisot are to be found in J. Baudot: Renoir, ses amis, ses modèles, Paris, 1949.
- 5 ROUART, D.: Correspondance de Berthe Morisot, Paris, 1950. Exchange of letters by the artist with her family (interesting letters by her mother) and her friends: Puvis

de Chavannes, Degas, Monet, Renoir, and Mallarmé. Many hitherto unpublished documents, extremely well edited by the artist's grandson. This is not only the best book on Berthe Morisot, but a volume indispensable for the knowledge of her friends. Numerous and excellent ill. in black and white and in color, mainly after drawings and watercolors. No bibl., no index. English translation: The Correspondence of Berthe Morisot, New York, 1957.

Letters by Renoir to B. Morisot, her husband, and her daughter are published in *Bulletin des Expositions*, I, Galerie d'art Braun & Cie, Paris, Nov. 14–Dec. 3, 1932.

See also 35.

Witness Accounts

- 6 MALLARMÉ, S.: Preface to the catalogue of the memorial exhibition at the Galeries Durand-Ruel, Paris, March 1896. See also H. de Régnier: Nos rencontres, Paris, 1931. Chapter on: Mallarmé et les peintres.
- 7 Valéry, P.: Tante Berthe, *La Renaissance*, June 1926. The author married one of Morisot's nieces, Jenny Gobillard, daughter of the painter's sister Yves. Ill. See also 3 and 25.
- 8 Bernier, R.: Dans la lumière impressionniste, L'Oeil, May 1959. A visit with the artist's daughter; ill.

Biographies

Most books on Manet refer to Berthe Morisot; Angoulvent, however, neglects studying her relationship with Manet (11); on the other hand, H. Perruchot: La vie de Manet, Paris, 1959, seems to insist too strongly on the Manet-Morisot relationship.

- 9 Marx, R.: Maîtres d'hier et d'aujourd'hui, Paris, 1914. Chapter on Morisot.
- 10 FOURREAU, A.: Berthe Morisot, Paris-New York, 1925. A serious, well-documented study based on material provided by the artist's family (her brother Tiburce and her daughter, Mme Ernest Rouart). 40 ill.
- 11 Angoulvent, M.: Berthe Morisot, Paris, 1933. Preface by R. Rey. Although somewhat amateurishly written, this book is valuable for its documents, its bibl. and its good ill., chronologically arranged. No index. Most of the material has since reappeared in 5; the list of paintings, pastels, etc., has been rendered obsolete by 1.
- 12 ROUART, L.: Berthe Morisot, Paris, 1941. Short text, good ill., chronologically arranged.
- 13 ROUART-VALÉRY, A.: De "Mme Manet" à "Tante Berthe," Arts, Paris, March 29—April 4, 1961.

See also 1, 5, and 17.

Studies of Style

- 14 WYZEWA, T. DE: Mme Berthe Morisot, L'Art dans les deux Mondes, March 28, 1891. Reprinted in T. de Wyzewa: Peintres de jadis et d'aujourd'hui, Paris, 1903.
- 15 Pica, V.: Artisti Contemporanei—Berthe Morisot, Mary Cassatt, Emporium, v. XXVI, July 1907.
- 16 ROUART, L.: Berthe Morisot, Art et Décoration, May 1908.
- 17 Duret, T.: Manet and the French Impressionists, Philadelphia, 1910. Chapter on Morisot.
- 18 Reuterswärd, O.: Berthe Morisot, *Konstrevy*, Stockholm, 1949, V (in Swedish).
- 19 Mongan, E.: Berthe Morisot—Drawings, Pastels, Water-colors, New York, 1960. Introduction by E. Mongan, preface by D. Rouart, research and chronology by E. Johnson, catalogue commentary by R. Shoolman. Good, large plates, 25 in color, 32 in duotone, 34 pages of black and white ill.
- 20 CHARMET, R.: Berthe Morisot, Arts, Paris, March 1-7, 1961.

Reproductions

- 21 Morisot, B.: Seize aquarelles, Paris, 1946. Album with 16 excellent color plates of watercolors, chronologically arranged (1871–1893).
- 22 ROUART, D.: Berthe Morisot, Paris, n.d. [1948]. Small but good ill., chronologically arranged (Coll. des Maîtres).
- 23 Huisman, P.: Morisot, Charmes, Lausanne, 1962. Good ill.
- See also bibl. 1, 5, 8, 10, 11, 12, 19, 29, 31, 33, 34, and 35.

Exhibition Catalogues

- 24 Berthe Morisot, Galerie Boussod & Valadon, Paris, 1892. Preface by G. Geffroy. See also the chapter on B. Morisot in Geffroy: La vie artistique, troisième série, Paris, 1894.
- Berthe Morisot (Mme Eugène Manet), Galeries Durand-Ruel, Paris, 1896. Preface by Stéphane Mallarmé (see 6). On this exhibition see G. Geffroy's article reprinted in Geffroy: La vie artistique, sixième série, Paris, 1900.
- 25 Berthe Morisot, Musée de l'Orangerie, Paris, summer 1941. List of 287 works, some ill. Preface by P. Valéry (see 3).
- 26 Berthe Morisot, Ny Carlsberg Glyptotek, Copenhagen, 1949. Foreword by H. Rostrup. This exhibition was also shown at the Nationalmuseum, Stockholm.
- 27 Berthe Morisot—Paintings and Drawings, Arts Council of Great Britain, London, 1950. Introduction by D. Rouart, 9 ill., chronology.
- 28 Hommage à Berthe Morisot et à Pierre-Auguste Renoir,

- Limoges, Musée Municipal, 1952. Introductions by M. Gauthier and D. Rouart, ill.
- 29 Berthe Morisot and Her Circle, Canada and United States, 1952–53. Introduction by D. Rouart. 30 works by B. Morisot and her friends, all from the Rouart collection, Paris, and all ill.
- 30 Berthe Morisot, Musée de Dieppe, 1957. Preface by P. Valéry (reprint of 25), 85 works, some ill.
- 31 Berthe Morisot, Musée Toulouse-Lautrec, Albi, 1958. Preface by R. Escholier, 103 works, chronology, bibl., ill.
- 32 Musée National du Louvre—Peintures, Ecole Française, XIXe siècle, v. III, H-O, Paris, 1960. Lists and reproduces 7 paintings by B. Morisot.
- 33 Berthe Morisot, Wildenstein Galleries, New York, 1960. 69 paintings, all reproduced.
- 34 Berthe Morisot—Drawings, Pastels, Watercolors, Museum of Fine Arts, Boston, Charles E. Slatkin Galleries, New York, 1960; California Palace of the Legion of Honor, Minneapolis Institute of Fine Arts, 1961. See 19.
- 35 Berthe Morisot, Musée Jacquemart-André, Paris, n.d. [1961]. Catalogue inserted into an exquisite facsimile reproduction of one of the artist's sketchbooks with notes; chronology and short excerpts from texts by Geffroy, Mallarmé, and Valéry.
- 36 Berthe Morisot, Galerie Lucien Blanc, Aix-en-Provence, 1962.

PISSARRO

Oeuvre Catalogues

- 1 Delteil, L.: Pissarro, Sisley, Renoir (Le peintre-graveur illustré, v. XVII), Paris, 1923. Pissarro's very important graphic work comprises 194 etchings, aquatints, and lithographs, some of which are reproduced here in various states. Richly ill. See also 3a 8, 26, and 27.
- 2 PISSARRO, L. R. and VENTURI, L.: Camille Pissarro, son art, son oeuvre, 2 v., Paris, 1939. One volume of text, listing 1,664 paintings, gouaches, détrempes, and paintings on porcelain as well as pastels (no watercolors or drawings), is accompanied by a volume of plates with 1,632 excellent illustrations. This book is absolutely indispensable for the study of Pissarro's work. The catalogue has been most carefully prepared by the artist's son, Ludovic Rodo, and is preceded by an important critical study of Pissarro's art by Venturi. Many of the catalogue notices include quotations from letters and other documents concerning the specific work. An extensive bibliography, chronologically arranged, lists over 500 publications. The index of collectors, unfortunately, is limited to owners at the time of publication. A supplement is planned.

- 3 See also the catalogues of three Pissarro sales, Paris: (1) Dec. 3, 1928; works by Pissarro and pastels, watercolors, and drawings by Cassatt, Cézanne, Guillaumin, Jongkind, Manet, Seurat; paintings by Cézanne, Guillaumin, Luce, Monet, Seurat, Signac, etc. (2) Dec. 7–8, 1928; etchings and lithographs by Pissarro, paintings, pastels, etc., by various artists. (3) April 12–13, 1929; etchings and lithographs by Pissarro, Gauguin, Manet, Millet, Toulouse-Lautrec, etc. Good ill.
- 3a Leymarie, J. and Melot, M.: Les gravures des Impressionnistes, Paris, 1971. Includes a complete catalogue of Pissarro's etchings and lithographs with excellent reproductions, some in color. It also includes some woodcuts

The Artist's Own Writings

- 4 For letters to Dewhurst see Dewhurst, W.: Impressionist Painting, London-New York, 1904.
- 5 Lecomte, G. and Kunstler, C.: Un fondateur de l'impressionnisme, Revue de l'art ancien et moderne, 1930. Two articles with quotations from letters to Mirbeau and Lucien Pissarro. For letters to Mirbeau see also 18.
- 6 For letters to Duret see *Bulletin des Expositions*, III, Galerie d'art Braun & Cie, Paris, Jan. 22–Feb. 13, 1932. For letters to Duret as well as to Murer see also 21.
- 7 VENTURI, L.: Les Archives de l'Impressionnisme, 2 v., Paris-New York, 1939. The second volume includes 86 letters written to Durand-Ruel between 1881 and 1903, as well as 16 letters to O. Maus.
- 8 Camille Pissarro, Letters to His Son Lucien, edited with the assistance of Lucien Pissarro by John Rewald, New York, 1943. Complete transcription of, or excerpts from, 477 letters written to the artist's oldest son between 1883 and 1903. A great wealth of firsthand material with comments on Pissarro's impressionist friends and on art in general. Profusely ill., index. An edition of the original French text, containing also some 30 letters by Lucien Pissarro to his father, appeared in Paris, 1950.

New American edition, revised and enlarged (with translations of Lucien's letters), Mamaroneck, 1972.

- 9 For letters to Fénéon and Verhaeren see J. Rewald: Georges Seurat, New York, 1943. The French edition: Georges Seurat, Paris, 1948, contains an additional chapter with quotations from letters to Signac. These and others also appear in the same author's: Post-Impressionism—From van Gogh to Gauguin, New York, 1956. See also G. Cachin-Signac: Autour de la correspondance de Signac, Arts, Paris, Sept. 1, 1951.
- 10 Joëts, J.: Lettres inédites de Pissarro à Claude Monet, L'Amour de l'Art, III, 1946. For further letters to Monet see G. Geffroy: Claude Monet, sa vie, son oeuvre, Paris, 1922.

- 11 For letters to Zola and Huysmans see J. Rewald: Cézanne, New York, 1946.
- 12 For letters to Petitjean see: Souvenirs du peintre Jules Joëts, recueillis par M.-A. Bernard, Art-Documents, Nov. 1954.
- 13 For letters to Dr. Gachet, E. Murer, and G. de Bellio, see: Lettres impressionnistes au Dr. Gachet et à Murer, Paris, 1957. More important letters to Murer are quoted in 21. Other letters to de Bellio appear in R. Niculescu: Georges de Bellio, l'ami des impressionnistes, Revue Roumaine d'Histoire de l'Art, v. I, no. 2, 1964; reprinted in Paragone, 247–49, 1970.

See also 2.

Witness Accounts

- 14 Mirbeau, O.: Famille d'artistes, Le Journal, Dec. 6. 1897. Reprinted in Mirbeau: Des artistes, Paris, 1924, v. II; see also 48.
- 15 VILLEHERVÉ, R. DE LA: Choses du Havre, les dernières semaines du peintre Camille Pissarro, *Havre-Eclair*, Sept. 25, 1904.
- 16 MOORE, G.: Reminiscences of the Impressionist Painters, Dublin, 1906. See also the same author's: Modern Painting, London-New York, 1893, chapter: "Monet, Sisley, Pissarro, and the Decadence."
- 17 Duret, T.: Manet and the French Impressionists, Philadelphia-London, 1910. Chapter on Pissarro.
- 18 Lecomte, G.: Camille Pissarro, Paris, 1922. The first chapter gives an excellent description of Pissarro's physical appearance and of his character. The last chapter excerpts long passages from letters to Mirbeau. Although the author knew Pissarro intimately over a period of 20 years, he offers very little biographical data or information about the painter's artistic conceptions. Good ill., no bibl., no index.
- 19 NATANSON, T.: Peints à leur tour, Paris, 1948. Chapter on Pissarro.
- 20 Meadmore, W. S.: Lucien Pissarro, London-New York, 1962. Contains a good deal of information on the Pissarro household.
- For the recollections of the painter Louis Le Bail see p. 456–458 of the present book.
- Some recollections are contained in C. Kunstler's book on the artist's son Paulémile, Paris, 1928.

See also 25.

Biographies

21 Tabarant, A.: Pissarro, Paris, 1924; New York, 1925. An excellent, well-documented study based mainly on

- private papers of Eugène Murer and on information apparently supplied by the artist's family. Quotations from letters to Murer and Duret. 40 good plates, no index. Concerning Murer see also 13.
- 22 GRABER, H.: Camille Pissarro, Alfred Sisley, Claude Monet, nach eigenen und fremden Zeugnissen, Basel, 1943. On this author's methods see Cézanne 25.
- 23 Rewald, J.: Pissarro in Venezuela, New York, 1964. A pamphlet, ill. See also 41.

See also 2.

Studies of Style

- 24 MIRBEAU, O.: Camille Pissarro, L'Art dans les deux Mondes, Jan. 10, 1891.
- 25 Stephens, H. G.: Camille Pissarro, impressionist, Brush and Pencil, March 1904. Also contains some recollections of the artist.
- 26 Hind, A. M.: Camille Pissarros graphische Arbeiten und Lucien Pissarros Holzschnitte nach seines Vaters Zeichnungen, Die Graphischen Künste, 1908.
- 27 Rodo, L. [L. R. Pissarro]: The Etched and Lithographed Works of Camille Pissarro, The Print Collector's Quarterly, Oct. 1922.
- 28 Rewald, J.: Camille Pissarro, His Work and Influence, Burlington Magazine, June 1938.
- 29 Nicolson, B.: The Anarchism of Pissarro, *The Arts*, [London], no. 11 [1946]. See also 36.
- 30 Brown, R. F.: Impressionist Technique—Pissarro's Optical Mixture, *Magazine of Art*, Jan. 1950.
- 31 Coe, R. T.: Camille Pissarro in Paris, A Study of His Later Development, Gazette des Beaux-Arts, Feb. 1954.
- 32 Perruchot, H.: Pissarro et le Néo-impressionnisme, Jardin des Arts, Nov. 1965. Contains nothing new.

See also 2, 7, 33, and 40.

Reproductions

- 33 Kunstler, C.: Camille Pissarro, Paris, 1930. 32 good though small illustrations, chronologically arranged, preceded by a short biographical and critical text.
- 34 Rewald, J.: Camille Pissarro au Musée du Louvre, Paris-Brussels, 1939. 10 good color plates accompanied by brief comments.
- 35 Francastel, P.: Monet, Sisley, Pissarro, Paris, 1939. A few excellent color plates.
- 36 Dessins inconnus de Camille Pissarro: "Turpitudes sociales," *Labyrinthe*, Nov. 15, 1944. Anarchistic drawings.
- 37 Jedlicka, G.: Pissarro, Bern, 1950. 53 small but excellent ill., well selected and chronologically arranged.

- 38 Rewald, J.: Pissarro, New York, 1954. Short introduction, commentaries, small and mediocre color plates (Abrams).
- 39 Rewald, J.: Pissarro, Paris, n.d. 60 good though small ill., chronologically arranged (Coll. des Maîtres).
- 40 Rewald, J.: C. Pissarro, New York, 1963. Profusely illustrated with color plates and black and white reproductions, documentary photographs, etc. Biographical outline, selected bibl. (Abrams).
- 41 BOULTON, A.: Camille Pissarro en Venezuela, Caracas, 1966. Superb reproductions of early drawings and water-colors. See also 23 and 53.

See also 1-3, 8, 18, 21, 23, 45, 48, and 56.

Exhibition Catalogues

- 42 Exposition des eaux-fortes de Camille Pissarro, Galerie Max Bine, Paris, 1927. Introduction by C. Roger-Marx.
- 43 Centenaire de la naissance de Camille Pissarro, Musée de l'Orangerie, Paris, 1930. Introductions by A. Tabarant and R. Rey. List of 139 paintings, 57 drawings, pastels, and watercolors, 80 etchings; few ill.
- 44 Paris by Pissarro, Carstairs Gallery, New York, n.d. [April 194?]. Preface by G. Wescott.
- 45 Camille Pissarro, Wildenstein Galleries, New York, Oct. 24–Nov. 24, 1945. 50 works plus paintings by various friends, etc. Chronology, short bibl., numerous ill.
- 46 Pissarro, Galerie André Weil, Paris, 1950. Preface by G. Huisman. 44 paintings, few ill.
- 47 Camille Pissarro, Matthiesen Gallery, London, 1950. 55 paintings, drawings, pastels, and watercolors; some ill.
- 48 Three Generations of Pissarros [Camille, Lucien, Manzana, Félix, Ludovic Rodo, Paulémile, Orovida], Ohana Gallery, London, 1954. Preface by J. Rewald with long quotes in English from 14.
- 49 Pissarro—Sisley, Marlborough Galleries, London, 1955. Preface by A. Clutton-Brock. Chronology, 30 works by Pissarro, 10 ill.
- 50 Camille Pissarro—A Collection of Pastels and Studies, Leicester Galleries, London, 1955. Preface by L. Abul-Huda. 37 works, some ill.
- 51 Camille Pissarro, Galeries Durand-Ruel, Paris, 1956. Preface by R. Domergue, family tree, 111 works, ill.
- 52 Camille Pissarro, Berner Kunstmuseum (Bern), 1957. Introduction by F. Daulte. Chronology, 138 paintings, pastels, drawings, etchings, etc., ill.
- 53 Pissarro en Venezula—Dibujos de Camille Pissarro, Museo de Bellas Artes, Caracas, 1959. Preface by A. Boulton. See also 23 and 41.
- 54 Camille Pissarro, Galeries Durand-Ruel, Paris, 1962.

- 55 Camille Pissarro, Wildenstein Galleries, New York, 1965. Preface by J. Rewald.
- 56 Pissarro in England, Marlborough Gallery, London, 1968. An important exhibition with richly ill. catalogue; introduction by J. Russell.

RENOIR

Oeuvre Catalogues

The project of assembling a catalogue raisonné of Renoir's paintings, abandoned by L. Venturi, is being carried on by F. Daulte in collaboration with the Galeries Durand-Ruel, Paris.

Daulte, F.: Auguste Renoir—Catalogue raisonné de l'oeuvre paint. Tome I, Les Figures (1860–90), Lausanne, 1971; to be followed by Tome II, Figures (1891–1905), Tome III, Figures (1906–1919), Tome IV, Paysages, and Tome V, Natures mortes. The first volume features, among other items, a preface by Charles Durand-Ruel, 646 paintings (all reproduced), a chronological table (until 1890), a list of exhibitions, and an extremely useful biographical index of all identified models painted by the artist between 1860 and 1890.

Nos. 1–6a of this bibliography list major catalogue publications, followed by a series of exhibition catalogues.

- VOLLARD, A.: Tableaux, Pastels et Dessins de Pierre-Auguste Renoir, Paris, v. I, 1918, 667 ill.; v. II, n.d., 192 plates. This essential publication is very scarce; a second edition—photographically reproducing the first—has recently been issued in limited numbers.
- 2 Catalogue of the sale of the Maurice Gangnat collection, Paris, 1925. With 160 illustrations, mostly of later works. Introductions by R. de Flers and E. Faure.
- 3 André, A. and Elder, M.: L'atelier de Renoir, Paris, 1931. Two volumes, profusely illustrated, reproducing in chronological order all the works found in the painter's studio after his death.
- 4 Delteil, L.: Pissarro, Sisley, Renoir (Le peintregraveur illustré, v. XVII), Paris, 1932. Listing of Renoir's 55 etchings, lithographs, etc., profusely ill. See also 6 and 6a.
- 5 HAESAERTS, P.: Renoir Sculpteur, printed in Belgium, n.d. Catalogue of Renoir's sculpture with an essay on these works and the artist's collaboration with Guino. Excellent ill., with numerous large photos of details but little information on individual works. See also 53 and 83.
- 6 ROGER-MARX, C.: Les lithographies de Renoir, Monte Carlo, 1951. Catalogue raisonné of 31 lithographs, excellent ill. See also 4 and 6a.

- 6a LEYMARIE, J. and MELOT, M.: Les gravures des Impressionnistes—Oeuvre complet, Paris, 1971. Includes a complete catalogue of Renoir's etching and lithographs with excellent reproductions. See also 4 and 6.
- 7 A. Renoir, Galeries Durand-Ruel, Paris, 1892. Preface by A. Alexandre.
- 8 Renoir, Galerie Bernheim-Jeune, Paris, 1913. Preface by O. Mirbeau. Small catalogue, no ill.
- 9 Renoir, Galerie Alfred Flechtheim, Berlin, 1927. Small catalogue, list of 70 works, all belonging to the artist's sons; also includes bronzes. Various texts, some ill.
- 10 The Classical Period of Renoir (1875–1886), Knoedler Galleries, New York, 1929. Forewords by E. Bignou and C. Carstairs. 11 paintings, all ill.
- 11 Renoir, Galerie d'art Braun & Cie, Paris, Dec. 1932. 27 oils, 23 drawings, various documents.
- 12 Renoir, Paris, Musée de l'Orangerie, 1933. Preface by P. Jamot, catalogue compiled by C. Sterling; extensive notes on 149 works, bibl. Published as a separate volume: Album de soixante-quatre reproductions.
- 13 Masterpieces by Renoir, Durand-Ruel Galleries, New York, 1935. 26 works, some ill.
- 14 Renoir, His Paintings, Metropolitan Museum of Art, New York, 1937. Introduction by H. B. Wehle, 62 oils, all ill., also 5 bronzes.
- 15 Renoir, Rosenberg & Helft, London, 1937. 23 paintings, some ill.
- 16 Renoir portraitiste, Galerie Bernheim-Jeune, 1938. Small catalogue, 47 paintings, some ill.
- 17 Renoir Centennial, Duveen Galleries, New York, 1941. Forewords by A. M. Frankfurter and H. B. Wehle. 86 paintings, all ill.
- 18 Pierre-Auguste Renoir, California Palace of the Legion of Honor, San Francisco, 1944. Introduction by J. MacAgy, 33 works, all ill.
- 19 9 Selected Paintings by Renoir, Durand-Ruel Galleries, New York, Dec. 1946—Jan. 1947. All works ill.
- 20 Masterpieces by Delacroix and Renoir, Paul Rosenberg Gallery, New York, 1948. Unsigned foreword, 15 paintings by Renoir, all ill.
- 21 Renoir, Wildenstein Galleries, New York, 1950. Text by D. Wildenstein, chronology, 78 paintings, numerous ill.
- 22 Auguste Renoir—Paintings, Marlborough Galleries, London, 1951. 45 paintings, many ill.
- 23 Renoir, Palais Saint-Pierre, Lyons, 1952. Introduction by R. Jullian.
- 24 Renoir, Galerie des Ponchettes, Nice, 1952. Preface by

- G. Bazin, short chronology, 42 oils, 10 drawings and watercolors, ill.
- 25 Renoir, Edinburgh Festival, 1953. Introduction by J. Rothenstein, 50 works, some ill., chronology, bibl.
- 26 The Last Twenty Years of Renoir's Life, Rosenberg Gallery, New York, 1954. 17 paintings, all ill.
- 27 Chefs-d'oeuvre de Renoir dans les collections particulières françaises, Galerie des Beaux-Arts, Paris, 1954. Preface by Jean Renoir, extensive chronology, 100 works, some little-known, numerous ill.
- 28 Renoir—Collection Maurice Gangnat, Galeries Durand-Ruel, Paris, 1955. Preface by G. Besson, short text by Jean Renoir. 53 works, no ill.
- 29 Pierre-Auguste Renoir, Paintings, Drawings, Prints and Sculpture, Los Angeles County Museum and San Francisco Museum of Art, 1955. Texts by G. L. McCann Morley and Jean Renoir (reprint of 64), long study by R. F. Brown; chronology, 193 works, numerous ill., some in color.
- 30 Renoir, Musée Jenisch, Vevey, 1956. 94 works, some ill.
- 31 Renoir, Marlborough Galleries, London, 1956. Preface by A. Clutton-Brock. 55 works, most of them ill.
- 32 Auguste Renoir, Städtische Galerie, Munich, 1958. Preface by H. Brüne. 26 paintings, good ill., some in color. An unpublished letter by Renoir. The preface relates recollections of Renoir during his stay in Munich; for other recollections of that visit, by E. Tross, see the present book, p. 210.
- 33 Renoir, Wildenstein Galleries, New York, 1958. Reprints of text by Jean Renoir (see 64) and Edmond Renoir (see 47); chronology by J. Rewald, 69 oils, all ill., 12 sculptures.
- 34 Hommage à Renoir, Galeries Durand-Ruel, Paris. 1958, Preface by G. Besson, 56 works, chronology, ill.
- 35 Renoir—Degas, Drawings, Pastels, Sculptures, Charles E. Slatkin Galleries, New York, 1958. Foreword by V. Price. 39 works by Renoir, many ill.
- 36 Renoir, peintre et sculpteur, Musée Cantini, Marseilles, 1963. 103 works, some ill.
- 37 Renoir et ses amis, Musée de Troyes, 1969. Elaborate notes, ill., poor color plates.
- 37a Renoir, catalogue of an exhibition held in Tokyo, Fukuoka, and Kobe, 1971–1972. Ill.

The Artist's Own Writings

38 An important letter to Mottez has been published as introduction to a translation of Le Livre d'Art de Cennino Cennini, Paris, 1911.

- 39 Geffroy, G.: Claude Monet, sa vie, son oeuvre, Paris, 1924. Some letters to Monet appear in v. II.
- 40 Poulain, G.: Bazille et ses amis, Paris, 1932, contains excerpts from Renoir's important letters to Bazille, written in the '60s. See also F. Daulte: Frédéric Bazille et son temps, Geneva, 1952.
- 41 Joërs, J.: Les Impressionnistes et Chocquet, L'Amour de l'Art, April 1935, reproduces letters to Chocquet.
- 42 FLORISOONE, M.: Renoir et la famille Charpentier, L'Amour de l'Art, Feb. 1938. Letters to Charpentier and Duret.
- 43 VENTURI, L.: Les Archives de l'Impressionnisme, 2 v., Paris-New York, 1939. 212 letters to Durand-Ruel, written between 1881 and 1919, are included in v. I. Among these letters is Renoir's "Manifesto on the importance of irregularity in the arts" (partly translated in R. Goldwater and M. Treves: Artists on Art, New York, 1945). Vol. II of the Archives contains 9 letters to O. Maus.
- 44 SCHNEIDER, F.: Lettres de Renoir sur l'Italie, L'Age d'Or, No. 1, 1945. 4 letters to Deudon.
- 45 Renoir's "Projet d'Exposition Artistique" published by E. Murer is reproduced in P. Gachet: Deux amis des Impressionnistes—le Docteur Gachet et Murer, Paris, 1956, p. 166–167.
- 46 P. Gachet: Lettres impressionnistes au Dr. Gachet et à Murer, Paris, 1957. Contains a group of letters by Renoir to the physician and to Murer.
- A letter to Manet is quoted in E. Moreau-Nélaton: Manet raconté par lui-même, Paris, 1926.
- 5 letters to A. André are published in 11.
- For letters to Berthe Morisot see D. Rouart: Correspondance de Berthe Morisot, Paris, 1950.
- A letter concerning Renoir's portrait of Wagner is included in *L'Amateur d'Autographes*, Paris, 1913, p. 231–233; see also 89 and 93.
- A letter to Durand-Ruel has appeared in Catalogue d'Autographes No. 61 of Marc Loliée, Paris, 1936.
- Some letters to Jeanne Baudot, B. Morisot, Monet, and Paule Gobillard are quoted in 63.
- Letters to Roger Marx, Eugène and Julie Manet, and A. André are quoted in 71.
- For letters to G. de Bellio see R. Niculescu: Georges de Bellio, l'ami des impressionnistes, Revue Roumaine d'Histoire de l'Art, v. I, no. 2, 1964; reprinted in Paragone 247–249, 1970.

For excerpts from letters to Le Coeur, see 92.

See also 32, 49, 51, 58, and 60.

Witness Accounts

- 47 RENOIR, E.: Article on his brother in La Vie Moderne, June 19, 1879; reprinted in 43. On Edmond Renoir's recollections see also J. Rewald: Auguste Renoir and his Brother, Gazette des Beaux-Arts, March 1945.
- 48 Mongade, C. L. de: Le peintre Renoir et le Salon d'Automne, *La Liberté*, Oct. 15, 1904. An interview.
- 49 PACH, W.: Interview with Renoir, Scribner's Magazine, 1912, reprinted in the same author's: Queer Thing, Painting, New York, 1938. Condensation of a series of interviews, 1908–1912. An important text, approved by Renoir.
- 50 Mirbeau, O.: Renoir, Paris, 1913. Mirbeau's introduction is followed by 58 interesting excerpts from writings by A. Wolff, Burty, Castagnary, Huysmans, Geffroy, Mellerio, Signac, Fontainas, Denis, Pach, Maus, Bonnard, etc. 40 good ill., chronologically arranged.
- 51 Vollard, A.: Renoir, Paris, 1918 (profusely ill.), 1920, 1938. English edition: Renoir, An Intimate Record, New York, 1925. The best of Vollard's books, based on an acquaintance with Renoir of over 20 years. The painter's friends, however, claim that Renoir, a dry joker, enjoyed surprising his biographer with misleading or paradoxical statements and that many of the conversations recorded by Vollard do not give the painter's real views. See G. B. (Besson): Renoir, par Ambroise Vollard, Les Cahiers d'Aujourd'hui, July 1921.
- 52 Blanche, J.-E.: Propos de peintre, de David à Degas, Paris, 1919. Chapter "De Cézanne à Renoir."
- 53 OSTHAUS, K. E.: Erinnerungen an Renoir, *Das Feuer*, Feb. 1920. Information on Renoir as a sculptor.
- 54 GIMPEL, R.: A Portrait of Renoir at Cagnes, *The Dial*, 1920 (p. 599-604). See also R. Gimpel, Journal d'un collectionneur, marchand de tableaux, Paris, 1963; English translation: Diary of an Art Dealer, New York, 1966.
- 55 ALEXANDRE, A.: Renoir sans phrases, *Les Arts*, No. 183, 1920. Recollections with some new photographs.
- 56 Anonymous: L'éternel Jury, Les Cahiers d'Aujourd'hui, 1921. 2 letters on the painter by Mme F., sister of Renoir's friend Jules Le Coeur. See 92.
- 57 Rivière, G.: Renoir et ses amis, Paris, 1921. Written by a lifelong friend of the painter, this book offers the best, most detailed and most vivid record of Renoir and his entourage. By far the most rewarding book on the subject. Richly ill., no bibl., no index.
- 58 André, A.: Renoir, Paris, 1923, 1928. A valuable record of numerous conversations with the artist, whom the author knew intimately during his last years. The 116 good halftone plates of the second edition are chronologically arranged, but not all dates are correct.

- 59 BESSON, G.: Auguste Renoir, Paris, 1929. Some recollections of Renoir, 32 fair ill. chronologically arranged. See also the same author's: Arrivée de Matisse à Nice—Matisse et quelques contemporains, Le Point, July 1939, and: Renoir à Cagnes, Les Cahiers d'Aujourd'hui, Nov. 1920.
- 60 BÉRARD, M.: Renoir à Wargemont, Souvenirs, Paris, 1939. A very brief introduction, accompanied by 35 good illustrations of works done by Renoir in Wargemont; also contains facsimile of a letter by Renoir. See also 65.
- 61 NATANSON, T.: Peints à leur tour, Paris, 1948. Two chapters on Renoir.
- 62 RENOIR, CLAUDE: Renoir—Souvenirs sur mon père, Paris, 1948. Short introduction for an album of 16 superb color plates of watercolors and sanguine drawings.
- 63 BAUDOT, J.: Renoir, ses amis, ses modèles, Paris, 1949.
 Rather unimportant text by a woman painter who frequently posed for Renoir. With some interesting documents and letters to the author, B. Morisot, Monet, and Paule Gobillard. Among the ill. are several hitherto unpublished works.
- 64 Renoir, Jean: My Memories of Renoir, *Life*, May 19, 1952. See also 27–29, 66, and especially 69.
- 65 BÉRARD, M.: Un Diplomate ami de Renoir, Revue d'Histoire Diplomatique, July-Sept. 1956. See also 60.
- 66 RENOIR, JEAN: Recollections of my father, Art News, April 1958 (excerpt from a book in preparation); see 69.
- 67 Meier-Graefe, J.: Grundstoff der Bilder, Munich, 1959. Chapter of recollections on Renoir. See also 78.
- 68 LIVERMAN DUVAL, E.: Téodor de Wyzewa—Critic Without a Country, Geneva-Paris, 1961. Contains some notes on Renoir from Wyzewa's diary (in French). See also 77.
- 69 Renoir, J.: Renoir, Paris, 1962; also in English: Renoir, My Father, Boston, 1962. This book of recollections provides an excellent and touching portrait of the painter and his entourage. The author, who really became close to his father only during the last years of the artist's life, nevertheless has been able to give a lively picture even of Renoir's youth. Unfortunately, there are numerous errors of chronology which competent editing could have easily avoided. Ill.
- Sert, M.: Misia, Paris, 1952. This autobiography of the former wife of Thadée Natanson (see 61) who was painted by Renoir as well as by Lautrec, Bonnard, Vuillard, etc., contains disappointingly few references to these artists, and the few are devoid of interest.

See also 32, 70, 78, and 98.

Biographies

- 70 DURET, T.: Auguste Renoir, Paris, 1924; English edition: Renoir, New York, 1937. A biography based on the author's long friendship with Renoir. 60 fair to poor halftone ill., 8 mediocre color plates.
- 71 Coquiot, G.: Renoir, Paris, 1925. Another disappointing book by this author who likes to speak about himself as much as about his subject. 32 ill. and an inadequate attempt to catalogue Renoir's work. No bibl., no index.
- 72 ROGER-MARX, C.: Renoir, Paris, 1933. Mediocre ill., short bibl., no index.
- 73 GRABER, H.: Auguste Renoir nach eigenen und fremden Zeugnissen, Basel, 1943. On this author's methods see Cézanne 25.
- 74 SCHUH, W.: Renoir und Gabrielle, Neue Zürcher Zeitung, March 22, 1959; reprinted as pamphlet [Zurich?], 1960.
- 75 DAULTE, F.: Renoir—son oeuvre regardé sous l'angle d'un album de famille, Connaissance des Arts, Nov. 1964.
- 76 Renoir, texts by P. Cabanne, R. Cogniat, F. Daulte, F. Duret-Robert, C. Renoir, M. Robida, C. Roger-Marx, D. Rouart, Y. Taillandier. Paris, 1970; ill.

See also 47, 51, 57, and 92.

Studies of Style

- 77 WYZEWA, T. DE: Pierre-Auguste Renoir, L'Art dans les deux Mondes, Dec. 6, 1890. On Renoir's classical period; reprinted with important additions in Wyzewa: Peintres de jadis et d'aujourd'hui, Paris, 1903. See also 68.
- 78 MEIER-GRAEFE, J.: Renoir, Munich, 1911, Leipzig, 1929, (richly ill.); French edition, Paris, 1912. A study based on the author's acquaintance with Renoir. The illustrations are not always correctly dated. See also 67.
- 79 FAURE, E.: Renoir, Revue Hebdomadaire, 1920.
- 80 Fosca, F.: Les dessins de Renoir, Art et Décoration, Oct. 1921.
- 81 Jamot, P.: Renoir, Gazette des Beaux-Arts, Nov.-Dec. 1923.
- 82 Fosca, F.: Renoir, Paris, 1923; London, 1924. Accompanied by 40 mediocre plates, undated and arranged without order.
- 83 George, W.: L'oeuvre sculpté de Renoir, L'Amour de l'Art, Nov. 1924, ill. See also 5.
- 84 BAZIN, G.: Renoir's Sanguine Drawings, Formes, May 1930.
- 85 LABASQUE, F.: La pureté de Renoir, Esprit, Dec. 1, 1933.
- 86 FONTAINAS, A.: The Encounter of Ingres and Renoir, Formes, March 1931.

- 87 REY, R.: La Renaissance du sentiment classique, Paris, 1931. Important chapter on Renoir, ill.
- 88 Barnes, A. C. and Mazia, V. de: The Art of Renoir, New York, 1935. An approach to art based on a method which supposedly "promises results of the same verifiable objectivity as those of science." 158 good ill., chronologically arranged and accompanied by detailed analyses. Extensive index, no bibl.
- 89 LOCKSPEISER, E.: The Renoir Portrait of Wagner, *Music & Letters*, Jan. 1937. For a more complete treatment see 93.
- 90 Thyis, J.: Renoir den franska Kvinnans Mälare, Stockholm, 1944. Profusely ill.
- 91 ROSTRUP, H.: Blomsten og Frugten, Meddelelser fra Ny Carlsberg Glyptotek, Copenhagen, 1949.
- 92 COOPER, D.: Renoir, Lise and the Le Coeur Family— A Study of Renoir's Early Development, *Burlington Magazine*, May and Sept.-Oct. 1959. New documents, ill.
- 93 Schuh, W.: Renoir und Wagner, Zurich-Stuttgart, 1959. Exhaustive study on the Renoir-Wagner meeting and the painter's portrait of the composer. Extensive notes with bibliographical references, ill. See also the same author's: Renoirs Wagner-Portraits, Schweizerische Musikzeitung, July 1947.
- 93a White, B. E.: Renoir's Trip to Italy, Art Bulletin, Dec. 1969.
- See also Venturi's introduction to 43; as well as 72, 105, 113, and 118.

Reproductions

- 94 L'Art et les Artistes, special issue, Renoir, Jan. 1920. Contributions by A. André, G. Lecomte, G. Geffroy.
- 95 Meier-Graefe, J. and Hausenstein, W.: Renoir, Munich, 1920, 1929. 2 Marées Gesellschaft Portfolios, each with 20 superb plates of drawings, pastels, and watercolors.
- 96 L'Amour de l'Art, special issue, Renoir, Feb. 1921.
- 97 René-Jean: Portfolio with 10 mediocre plates of watercolors, sanguines, and pastels, Geneva-Paris, 1921.
- 98 RÉGNIER, H. DE: Renoir, peintre du nu, Paris, 1923. 40 fair plates; some in color. The brief foreword contains some recollections of the painter.
- 99 DUTHUIT, G.: Renoir, Paris, 1923. 15 small, extremely poor ill.
- 100 DUMAS, P.: Quinze tableaux inédits de Renoir, La Renaissance de l'Art français, July 1924. See also 92.
- 101 Basler, A.: Pierre-Auguste Renoir, Paris, 1928. 29 small, poor ill., short excerpts from various texts.

- 102 Stein, L.: A. Renoir, Paris, n.d. [1928?]. An Album d'art Druet with 24 poor plates.
- 103 L'Art Vivant, special issue, Renoir, July 1933.
- 104 Besson, G.: Renoir, Paris, 1938. 60 small but good ill. (Coll. des Maîtres).
- 105 FLORISOONE, M.: Renoir, Paris-London, 1938. 120 fair black and white ill., 8 poor color plates, not chronologically arranged, bibl. (Hyperion).
- 106 BAZIN, G.: Renoir, Paris-London, 1939. Portfolio with 8 excellent color plates.
- 107 Terrasse, C.: Cinquante portraits de Renoir, Paris, 1941. 50 fair reproductions.
- 108 Kunstler, C.: Renoir, peintre fou de couleur, Paris, 1941. Short text, 15 poor color plates, all reproduced from 57.
- 109 Lhote, A.: Peintures de Renoir, Paris, 1944. Portfolio with 12 good but not too well chosen color plates.
- 110 Frost, R.: Pierre-Auguste Renoir, New York, 1944. A Hyperion book with fair black and white but poor color illustrations, not chronologically arranged.
- 111 PICENI, E.: Auguste Renoir, Milan, 1945. Small, poor plates. Extensive bibl. by G. Scheiwiller.
- 112 Bell, C.: Renoir, Les parapluies, London, n.d. [1945]. Interesting photographs of details.
- 113 Rewald, J.: Renoir Drawings, New York, 1946, 1958. 89 good reproductions, chronologically arranged.
- 114 Jedlicka, G.: Renoir, Bern, 1947. 53 small but good ill., chronologically arranged, some in color.
- 115 JOURDAIN, F.: Le Moulin de la Galette, Paris, n.d. [1947]. 13 plates in color of details in their original size.
- 116 WILENSKI, R. H.: Renoir, London, 1948. 11 fair color plates with commentaries (Faber Gallery).
- 117 Zahar, M.: Renoir, Paris, 1948. Short text, 102 fair ill., chronologically arranged, some poor color plates (Somogy).
- 118 Drucker, M.: Renoir, Paris, 1949. Important text on Renoir's work, amply documented, accompanied by 162 well-selected plates chronologically arranged (those in black and white are superior to the color plates). Analytical notes on the ill., quotations from writings and statements by the artist, etc., chronology, list of exhibitions, bibl., index. A well-conceived and well-presented book (Tisné).
- 119 LEYMARIE, J.: Renoir, Paris, 1949. Small vol. with fair color plates after drawings, pastels, and watercolors (Hazan).
- 120 André, A.: Renoir, Dessins, Paris, 1950. 16 very good plates, some in color.

- 121 PACH, W.: Renoir, New York, 1950. 50 large and fairly good color plates, accompanied by commentaries (Abrams). Only the preface is by Pach.
- 122 GAUNT, W.: Renoir, London, 1952. 104 large plates in black and white and in color (the latter rather poor). Insufficient bibl. (Phaidon). French edition with text by M. Berr de Turique, Paris, n.d. [1957].
- 123 ROUART, D.: Renoir, Geneva, 1954. Numerous, too colorful plates of post card size; chronology, selected bibl., list of exhibitions, index (Skira).
- 124 HANOTEAU, G. and DE PIREY, P.: Auguste Renoir, le peintre de la joie, *Paris-Match*, July 10–17, 1954.
- 125 Renoir en Italie et en Algérie, introductions by A. André and G. Besson, Paris, 1955. Good facsimile edition of a sketchbook with mostly minor drawings.
- 126 Renoir—Aquarelles et Dessins, Paris, 1956. Preface by G. Besson. 12 fair plates, some in color.
- 127 Schneider, B. F.: Renoir, Berlin, n.d. [1957]. Very poor color plates and black and white ill., arranged without order (Hyperion).
- 128 DAULTE, F.: P.-A. Renoir—Aquarelles, pastels et dessins en couleurs, Basel, 1958. Sumptuously presented English edition, New York, 1959 (Abrams).
- 129 ROBIDA, M.: Renoir—Enfants, Lausanne, 1959. 30 fair color plates, chronology, short bibl.
- 130 ROUART, D.: The Unknown Degas and Renoir in the National Museum in Belgrade, New York-London, 1964. Good plates of drawings, pastels, and a few paintings.
- 131 Tominaga, S.: Renoir, Tokyo, 1970. Numerous color plates, mostly mediocre.
- 132 Renoir, P. and Pirra, S.: 125 Dessins inédits de Pierre-Auguste Renoir, Turin, 1971. Mostly sketches of scant importance, without any dates and often without proper identification of the subject; also 62 pages from a sketchbook of 1857 that is of some historic interest.
- See also 1–6a, 10–12, 14, 17, 18, 21, 22, 26, 27, 29–33, 50, 51, 57–60, 62, 63, 70, 71, 78, 87, 88, 90, 92, and 93.

SISLEY

Oeuvre Catalogues

- Delteil, L.: Pissarro, Sisley, Renoir (Le peintre-graveur illustré, v. XVII), Paris, 1923. Catalogue of Sisley's few prints. See also 2a.
- 2 DAULTE, F.: Alfred Sisley—catalogue raisonné de l'oeuvre peint, Lausanne, 1959. Preface by C. Durand-Ruel, essay on L'art de Sisley by Daulte; extensive chronology,

bibl., with special section on publications concerning public or private collections which contain works by Sisley; index of subjects, of names, and owners, list of exhibitions. The catalogue lists and reproduces (in small though sufficiently clear ill.) 884 paintings executed between 1865 and 1897; 4 good color plates, some portraits of the artist, and photographs of his subjects. An essential and handsome publication to be followed by a second volume devoted to Sisley's pastels and drawings. The author, however, provides no clues for his dating of undated works.

2a Leymarie, J. and Melot, M.: Les gravures des Impressionnistes—Oeuvre complet, Paris, 1971. Includes a complete catalogue of Sisley's graphic work with excellent reproductions. See also 1.

The Artist's Own Writings

- 3 A letter to the artist's friend, Tavernier, containing an explanation of Sisley's approach to nature, was published in an article, A. Tavernier: Sisley, L'Art français, March 18, 1893. It is partly translated in R. Goldwater and M. Treves: Artists on Art, New York, 1945. For a complete German translation see Kunst und Künstler, March 1908.
- 4 Duret, T.: Quelques lettres de Manet et Sisley [to Duret], Revue Blanche, March 15, 1899.
- 5 Huyghe, R.: Some unpublished letters of Sisley, Formes, Nov. 1931. 12 letters to Charpentier, Mirbeau, and Tayernier.
- 6 Eight letters to Duret, Monet, and Dr. Viau were published in *Bulletin des Expositions*, II, Galerie d'art Braun & Cie, Paris, Jan. 30-Feb. 18, 1933.
- 7 VENTURI, L.: Les Archives de l'Impressionnisme, Paris-New York, 1939. Vol. II includes 16 letters to Durand-Ruel (1887–1891) and 5 letters to O. Maus (1887–1897). The archives of the Galeries Durand-Ruel in Paris contain further letters by the artist.
- 8 Gachet, P.: Lettres impressionnistes au Dr. Gachet et à Murer, Paris, 1957. 6 letters to E. Murer.
- For letters to de Bellio see R. Niculescu: Georges de Bellio, l'ami des impressionnistes, *Revue Roumaine d'Histoire de l'Art*, v. I, no. 2, 1964; reprinted in *Paragone*, 247–249, 1970.
- For two unpublished letters see P. Angrand in La Chronique des Arts, supplement of Gazette des Beaux-Arts, July-Sept. 1971, p. 33.

Witness Accounts

ALEXANDRE, A.: Introduction to the catalogue of the sale of the artist's estate (see 28).

See also 21.

Biographies

- 9 Duret, T.: Manet and the French Impressionists, Philadelphia, 1910. The chapter on Sisley offers a condensed biography. There exists no complete biography of the artist. For other biographical details see 2 and Venturi's introduction to 7.
- 10 Watson, F.: Sisley's Struggle for Recognition, The Arts, Feb.-March 1921.
- 11 GRABER, H.: Camille Pissarro, Alfred Sisley, Claude Monet, nach eigenen und fremden Zeugnissen, Basel, 1943. On this author's methods see Cézanne 25.
- 12 SISLEY, CLAUDE: The Ancestry of Alfred Sisley, Burlington Magazine, Sept. 1949.

Studies of Style

- 13 Leclerq, J.: Alfred Sisley, Gazette des Beaux-Arts, March 1899.
- 14 Bibb, B.: The Work of Alfred Sisley, The Studio, Dec. 1899.
- 15 WILENSKI, R. H.: The Sisley Compromise, Apollo, Jan. 1928.
- 16 REUTERSWÄRD, O.: Sisley's "Cathedrals"—A Study of the "Church at Moret" Series, Gazette des Beaux Arts, March 1952.
- 17 Reidemeister, L.: Alfred Sisley—Die Brücke von Hampton Court, Die Kunst und Das schöne Heim, 1956.
- 18 DAULTE, F.: Découverte de Sisley, Connaissance des Arts, Feb. 1957. Important article with 21 excellent ill., 3 of which are in color.
- 19 CARTIER, J.-A.: Sisley, le plus timide et le plus harmonieux des impressionnistes, *Jardin des Arts*, July 1957. 8 ill.
- 20 WILDENSTEIN, G.: Un carnet de dessins de Sisley au Musée du Louvre, Gazette des Beaux-Arts, Jan. 1959.

See also 25 and Venturi's introduction to 7.

Reproductions

- 21 Geffroy, G.: Sisley, Paris, 1923, 23 plates. New edition, Paris, 1927, 60 good halftone plates, assembled without order. The author knew Sisley but his text consists chiefly of lyrical comments.
- 22 Heilmaier, H.: Alfred Sisley, Die Kunst für Alle, 1930-31.
- 23 Besson, G.: Sisley, Paris, n.d. 60 good though small ill. (Coll. des Maîtres).
- 24 Francastel, P.: Monet, Sisley, Pissarro, Paris, 1939. A few excellent color plates (Skira).
- 25 COLOMBIER, P. Du: Sisley au Louvre, Paris-Brussels, 1939. 10 good color plates with commentaries.

- 26 Jedlicka, G.: Sisley, Bern, 1949. Good though small ill., chronologically arranged.
- 27 Daulte, F.: Les paysages de Sisley, Lausanne, 1961. Good color plates.

See also 2, 2a, 9, 10, 16, 18, 20, 30, 31, 32, 34, and 35.

Exhibition Catalogues

- 28 Tableaux, Etudes, Pastels par Alfred Sisley, Galeries Georges Petit, Paris, May 1, 1899. Forewords by G. Geffroy and A. Alexandre, some ill. Catalogue of the sale of the artist's estate; his family retained some works. See 29.
- 29 L'Atelier de Sisley, Galerie Bernheim-Jeune, Paris, 1907. Introduction by A. Tavernier (see also 3), 24 paintings, no ill.

- 30 Pissarro—Sisley, Marlborough Galleries, London, 1955. Preface by A. Clutton-Brock, chronology, 21 paintings by Sisley, 10 ill.
- 31 Sisley, Galeries Durand-Ruel, Paris, 1957. Preface by C. Roger-Marx, chronology, 59 paintings, 14 ill.
- 32 Alfred Sisley, Berne Kunstmuseum, Bern, 1958. Chronology by F. Daulte; 98 oils, pastels, and drawings, 24 ill. The most important Sisley exhibition to date.
- 33 Sisley, P. Rosenberg Gallery, New York, 1961.
- 34 Sisley, Wildenstein Galleries, New York, 1966. Introduction by F. Daulte; ill.
- 35 Alfred Sisley, Galeries Durand-Ruel, Paris, 1971. 50 paintings, all reproduced.

For a more complete listing of exhibitions see 2.

INDEX

Numbers in italics indicate illustrations

Académie Julian, 536, 558

Académie Suisse, 48, 49, 61, 62, 63, 102, 116, 139

Academy of Fine Arts, 18, 21, 28, 30, 31, 47, 73, 77, 88

Aix-en-Provence, 61–62, 65, 172, 174, 200, 204, 246, 248, 249, 250, 334, 336, 412, 416, 489, 534, 536, 558, 576, 577, 578; ill. Cézanne 535 (color), 559 (color)

Alexis, Paul, 198, 213, 272, 304, 306, 309, 311, 313, 314, 401, 439, 502, 508; appears in Cézanne 201; portrait by Seurat 508

Algiers, 50, 69, 209, 454, 469; ill. Renoir 462

Aman-Jean, 424, 508

Ambre, Emilie, 430

American Art Association, 517, 532 Andler Keller, 28, 296; ill. Courbet 36

André, Albert, 580, 589 n. 61 Andrée, Ellen, 399; appears in Degas 398

Angèle (Renoir's model), 456; appears in Renoir 442, 454

Antibes, 551; ill. Monet 551

Argenteuil, 280, 281, 284, 285, 289, 290, 341ff, 360, 363, 387, 392, 412, 426; ill. Caillebotte 350, 485, Manet 346, 347, 360, Monet 284, 286, 288, 347, 349 (color), 352, 353, 357, 378, Renoir 285, 286, 348, 352, Sisley 288, 290, 291 (color), 308, 329 (color), 357

Arles, 549, 550, 560

Arosa, Gustave, 213, 260, 409-410

Arosa, Marguerite, 409

Art Age, 532

Art Nouveau, 554, 588 n. 16

L'Artiste, 148, 245, 394

Asnières, 526, 541

Association des Artistes Peintres d'histoire et de genre..., 312

Astruc, Zacharie, 31, 33, 36 n. 45, 52, 55, 70, 83, 85, 118, 123, 125, 137 n. 40, n. 51, 148, 171, 188, 197,

205, 316, 366, 458, 548; appears in Fantin 196; portraits by Bazille 116, Manet 109

Atelier Cormon, see Cormon Atelier Gleyre, see Gleyre Attendu, Antoine Ferdinand, 316 Auberge Ganne, 94

Auberge Gloanec, 536, 537, 554 Auction sales, (Monet, 1868) 185; (Pissarro, 1873) 301; (Hoschedé, 1874) 309-310; (Monet, Morisot, Renoir, Sisley, 1875) 351, 354, 384, 395 n. 13; (Caillebotte, Monet, Pissarro, Sisley, 1877) 394, 397 n. 76; (Faure, 1878) 413; (second Hoschedé sale, 1878) 413, 436 n. 30; (Barbizon masters) 417; (Manet estate, 1884) 478; (Gauguin, 1891) 561; (Tanguy estate, 1894) 572; (Chocquet estate, 1899) 396 n. 28, 576, 589 n. 51; (Sisley estate, 1900) 576, 589 n. 50

Auvers-sur-Oise, 101, 103, 294, 296, 298, 299, 314, 375, 392, 490, 560; ill. Cézanne 299, 322, Corot 103 L'Avenir Nationale, 304, 309

Balzac, Honoré de, 578

Barbizon, 17, 18, 28, 48, 93, 94, 96, 101, 106, 254, 271, 284, 310, 416, 417, 506, 507, 531, 547

Bartholomé, Paul Albert, 566

Barye, Antoine, 102

Bastien-Lepage, Jules, 242, 476

—, Albert Wolff, 370

Batignolles group, 192, 197–235, 236 n. 1, 240, 246, 272, 301, 302, 311, 326; ill. Fantin 196

Baudelaire, Charles (1821–1867) on Ingres, 16, 19–20 on Delacroix, 16, 52, 60–61 reviews Salon of 1859, 33, 42 on Manet, 54, 106, 125 on Millet, 96 on Guys and role of the artist, 126–128

appears in Manet 77; portraits by Courbet 54, Manet 52

—, mentioned, 16, 29, 42, 46, 52,

54–55, 69, 73, 76, 89, 91 n. 18, 106, 116, 121, 143, 172, 195 n. 63, 207, 578

Bazille, Frédéric (1841–1870) at Gleyre's studio, 70–75 and Monet, 70, 72, 93, 109ff, 119, 120, 123, 166, 167–169, 182, 184, 189–190, 226ff and Renoir, 72, 93, 120–121, 165, 182, 226ff, 232ff group exhibition plans, 172 at Café Guerbois, 197 described, 199–200 during Franco-Prussian War, 248 killed in action, 253

—, exhibitions: Salons (1866) 139, 144, 193 n. 2, (1867) 168, (1868) 186, 188, 189, 195 n. 59, (1869) 216, 217, 218, 223, (1870) 234, 237 n. 40, 240, 242, 268 n. 3

—, appears in Bazille 177, Fantin 196, Monet 118, 119; photograph of 200; portrait by Renoir 183

—, Artist's Family on a Terrace..., 177, 179, 186; Artist's Studio, rue de la Condamine, 234, 235, 237 n. 62; Artist's Studio, rue Visconti, 184; Zacharie Astruc, 116; Beach at Sainte-Adresse, 110; Farmyard, 111; Flower Pots, 113; Girl at the Piano, 134, 139; Landscape at Chailly, 98; Edmond Maître, 116; Monet after His Accident..., 120; Pink Dress, 222; Auguste Renoir, 203; Self Portrait, 116; Alfred Sisley, 158, 185; Still Life of Fish, 139; Still Life with Heron, 182; Summer Scene. Bathers, 232, 234; La Toilette, 253; View of the Village, 218, 223 (color)

—, mentioned, 76, 77, 86, 89, 90, 107, 134, 137 n. 61, 140, 142, 144, 158, 162, 172, 173, 179, 205, 237 n. 61, 244, 250, 273, 309, 341, 349, 461, 550; chronology, 592

Béliard, Edouard, 258, 292, 294, 309, 313, 316, 334, 336, 363, 366, 372, 391

Bellelli family, 55, 56; portrait by Degas, 57

Bellio, Georges de, 317, 364, 388,

392, 413, 420-421, 431, 433, 547. 553, 566; photograph, 421 Bellot, or Belot (engraver), 302: portrait by Manet, 303 Bérard, Paul, 433, 490 Béraud, Jean, 476 Berlin, 496, 497, 498 -, Gurlitt Galleries, 498, 500 Berlioz, Hector, 116 Bernard, Emile, 537, 538, 541, 545 n. 31, 558, 578; portrait by Toulouse-Lautrec, 541; Young Breton Girl, 541 Bertall (Charles-Albert d'Arnoux) (caricaturist), 188, 196, 220 Bertin (banking firm), 260 Bertin (painter), 318, 319, 323 Bibesco, Prince, 185, 248-249, 260 Blanc, Charles, 505 Bonheur, Rosa, 48, 261 Bonnard, Pierre, 558, 577, 587 Bonnat, Léon, 242, 405 Bonvin, Louis, 29, 32, 33, 34, 69, 239, 251 Bordeaux, 249, 252, 258 Boston, 261, 430, 485, 519 n. 11, 551 Boucher, François, 76 BOUDIN, EUGÈNE (1825-1898) and Monet, 37–41, 48, 69–70, 71. 75, 76, 93, 96, 110ff, 128, 166, 184. 185, 189, 214, 314 and Courbet, 41, 42, 43-44, 184 and Baudelaire, 42 subject matter, 44 impressionist exhibition (1874), 315, 316 —, Beach at Trouville, 44; Beach Scene, 67; Cloud Study, 43; Fishing Boats at

- Trouville, 45 (color); Hollyhocks, 113
- —, mentioned, 34, 61, 84, 101, 109, 114, 123, 128, 184, 185, 251, 263, 271, 322, 334, 338, 351, 366, 377, 481, 516, 524, 531, 544 n. 5

Bougival, 224, 226-227, 232, 454, 483; ill. Renoir 454

Bouguereau, William, 16, 405, 529, 531

Boulogne, 191, 222, 224 Boussod & Valadon, 518, 548, 553,

560, 572 Bracquemond, Félix, 52, 55, 69, 76, 82, 89, 118, 137 n. 51, 173, 197, 207, 209, 250, 314, 316, 324, 366, 423, 439, 448, 486, 523, 526, 553; portraits of Degas 199, Manet 198 Bracquemond, Marie, 423, 439, 448 Brandes, Georg, 496–498 Brandon, Edouard, 316 Brasserie des Martyrs, 28, 29, 30, 31, 41, 42, 44, 51, 52, 66 n. 20, 75, 84, 197 Bresdin, Rodolphe, 414

Brittany, 109, 180, 251, 336, 350, 404, 537, 550, 555, 558, 560, 572; see also Pont-Aven

Brussels, 125, 251, 532, 547, 554, 556 Bruyas, Alfred, 16, 29, 54, 70, 113,

Bureau, Pierre, 316, 336

Bürger, Wilhelm (Théophile Thoré). 106, 146, 148 n. 13, 180, 187, 210 Burty, Philippe, 205, 220, 304, 314, 328, 351, 366, 401, 413, 477, 553

Cabanel, Alexandre, 16, 88, 90, 102, 154, 171, 188, 216, 360, 361, 401, 476, 529, 531; Birth of Venus, 88 Cabaner (Jean de Cabannes), 388,

399, 414; appears in Renoir 382, portrait by Manet 399

Cadart (gallery), 69, 107 Café de Bade, 81, 197 Café Fleurus, 28

Café Guerbois, 192, 197-202, 204-207, 209, 211, 212, 222, 232, 235, 236 n. 1, 239, 253, 265, 271, 296, 301, 302, 303, 304, 309, 341, 399, 405, 547; ill. Manet 202

Café de la Nouvelle-Athènes, 398, 399, 401, 405, 448, 458; ill. Degas 398, 402, Manet 400

Café Riche, 566 Café Taranne, 28 Café Tortoni, 28, 52, 526; ill. 522 Café Volpini, 554 Cagnes, 582

Caillebotte, Gustave (1848–1894), 221, 346, 349, 350, 354, 364, 434, 456, 476, 486, 518, 533, 553, 566

- —, beguest, 383, 384, 387, 388, 390, 411, 570, 572
- -, exhibitions: Durand-Ruel (New York) 523, 524, 531, 544 n. 5; impressionist (1876) 366, 372, (1877) 390-394, 397 n. 76, (1879) 423, 424, (1880) 439, (1881) 447-449, 450, (1882) 464, 467, 468, 471, 472
- —, appears in Renoir 432, 454; photograph of 350
- -, Man at a Window, 373; Pont de l'Europe, 392; Seine at Argenteuil, 350; Self Portrait, 449; Street in Argenteuil, 485
- Cals, Félix, 69, 110, 314, 316, 336, 391, 423

Camille (Doncieux) (Mme Monet), 134, 152, 167, 168, 184, 190, 232, 248, 251, 280, 285, 341, 342, 363, 378, 412, 431, 437 n. 71; appears in Manet 343, 346, Monet 118, 119, 169, 184, 251, 252, 282, 283. (color), Renoir 343: portraits by Monet 148, 149, 345 (color), Renoir 344

Campineano, Lise, 421

Capri, 458, 460

Caricatures, 403; see also Bertall, Cham, Daumier, Gill, Monet, Stock

Carlyle, Thomas, 509

Carolus-Duran, 52, 125, 250, 374, 401, 419, 469, 553; portraits of Monet 150, Manet 374

Cassatt, Mary (1845–1926) and Degas, 406, 408, 409, 467, 469, 472, 515, 524, 525 described, 408-409 aids Durand-Ruel, 514-515 death, 586

- -, exhibitions: Durand-Ruel (London) 482, (New York) 523, 524, 531, 544 n. 5; impressionist (1879) 423, 424, 428, (1880) 439, (1881) 449, 450, (1882) 467, 469, 472, (1886) 521, 523; Salons, 408–409
- —, appears in Degas 438 (color), 446 (color), 524; portrait by Degas 516
- -, Loge, 473; Morning Toilet, 525;

Torero, 408; Woman Reading, 408; Woman in Black at the Opera, 423, 425 (color); Woman with Fan, 423

—, mentioned, 279, 310, 386, 421, 448, 478, 518, 533

Castagnary, Jules Antoine, 29, 31, 52, 64, 80, 114, 123, 148–150, 170, 185–186, 208, 224, 241, 304, 306, 339 n. 9, 315, 329–330, 360, 362, 373, 399, 413, 424, 482, 576

Cazin, J.-C., 137 n. 51, 436 n. 51Cézanne, Louis-Auguste, 61, 174, 249, 250, 336, 414, 416, 534;portrait by Cézanne 147

Cézanne, Mme, see Fiquet, Hortense Cézanne, Paul (1839–1906)

early years, 61–62 at *Académie Suisse*, 62 and Pissarro, 61, 62, 206, 249, 280, 292, 294, 336, 362 n. 22, 410, 411, 421, 456, 474, 536, 543, 572, 578–579

and Monet, 62, 376, 572, 577, 578 and Zola, 62, 142–143, 146, 156, 157, 168, 170, 248, 249, 410, 416, 474, 534, 576 and Delacroix, 76, 576

and Chocquet, 89, 356, 358, 364, 366, 374, 394, 416, 554 and Manet, 139, 200, 314 and Courbet, 154, 156 at the Café Guerbois, 197ff description, 200, 406, 435 n. 16,

n. 17, 578 exhibits in Marseilles, 214 and Hortense Fiquet, 248, 249, 271, 416, 534, 536

during Franco-Prussian War, 250 and Dr. Gachet, 296, 298–299, 301 and *père* Tanguy, 301, 541, 549, 556, 558

Castagnary on, 330 and Renoir, 342, 356, 463–464, 490, 554, 578 and *L'Union*, 390, 396 n. 46

at the Café Nouvelle-Athènes, 399, 406

and Rivière, 394 and Gauguin, 410, 456, 458, 560, Huysmans on 473–474 and World's Fair, 554 influence on young painters, 558– 560, 577, 580 and Denis, 558–560, 577–578 and Vollard, 572, 575, 576

561

death, 580

—, exhibitions: impressionist (1874) 314, 316, 322, 324, 328ff, (1877) 390–394, (1879) 421, (1881) 448, 449, (1882) 467, 468; Salons (1861) 67 n. 31, (1864) 107, (1865) 134, (1866) 134, 138, 139, 142, 143, (1867) 168, 170, (1868) 186, 189, 214, (1869) 214, 216, (1870) 246–248, (1872) 272, (1876) 366, (1879) 421, 424, (1882) 475; Salon des Indépendants, 577; Salon des Refusés, 82, 86, 143, 168, 237 n. 35, 326; Les Vingts, 554, 556; Vollard's, 572

—, sales, 334, 556, 572, 576–577, 589 n. 51

—, technique and theories, 156, 157, 249, 292, 298, 299, 374–375, 412, 558–560, 578

—, caricature of 246; photographs of 74, 296, 362, 558, 578; portraits by Pissarro 298, 313; Renoir 475

-, Abduction, 157, 158; Afternoon in Naples, 170; Paul Alexis Reading..., 201; Alley of Chestnut Trees..., 535 (color); Artist's Father Reading..., 147; Bathers, 388; Bathers (small version), 389 (color); Black Clock, 248; Card Players, 556; Mme Cézanne in the Greenhouse, 561; Victor Chocquet, 368, 391; Victor Chocquet in an Armchair, 393 (color); Copy after Prud'hon, 61; Copy after fashion print, 208; Achille Emperaire, 246, 247; L'Estaque (1871), 249; L'Estaque (1876-78), 374, 375: Forest Scene, 105; Forest Scene (Bernhard), 195; House on a Hill ..., 487 (color); House of Dr. Gachet, Auvers, 299; House of Père Lacroix, Auvers, 299; Impression d'après nature, 392; Maison du pendu, Auvers, 314, 322, 324, 334, 382, 556, 589 n. 51; Man in a Blue Cap, 117 (color); Mill on the Couleuvre near Pontoise, 457; A Modern Olympia, 298, 315, 316, 322, 324, 330; The Negro Scipion, 158; Nude Studies, 63; Orchard in Pontoise..., 411; Camille Pissarro, 312; Pissarro on His Way to Work, 296; Ravine near L'Estaque, 465; Reclining Nude, 246; Sainte Victoire seen from Bibémus Quarry, 559 (color); Sainte Victoire seen from Les Lauves, 579; Self Portrait (1865-66), 146; Self Portrait (c. 1875), 351; Self Portrait (1875-76), 362: Self Portrait with Black Hat, 475: Self Portrait with Straw Hat, 407 (color); Standing Nude, 62; Still Life (c. 1870), 157; Still Life (c. 1880), 474; Street in Pontoise, Winter, 294; Study of a Negro Model, 62; Study of a Nude, 62; Study for The Autopsy, 63; Turning Road, 359; Anthony Valabrègue (c. 1866), 138, 139: Anthony Valabrègue (c. 1870), 215(color), 249; View of Mount Sainte Victoire..., 536; Ambroise Vollard, 574; Wine Grog, 168, 170

—, mentioned, 62, 65, 70, 90, 102, 116, 144, 148, 158, 162, 172, 173, 174, 204, 258, 264, 274, 306, 334, 350, 351, 362, 363, 372, 373–374, 375, 376, 377, 416, 439, 444, 477, 488, 489, 490, 533, 584, 586, 587; chronology, 592

Chabrier, Emmanuel, appears in Degas 274

Chailly, 93, 94, 96, 119, 120, 123, 134, 180, 506

Cham (Amédée de Noé) (caricaturist), 394

Champfleury, Jules, 16, 20, 29, 42, 47, 50, 51, 52, 55, 61, 73, 89, 414

Champigny-sur-Marne, 49

Champs de Mars, Salon, 558, 576, 588 n. 20

Champsaur, Félicien, 405 Chaplet, Ernest, 35 n. 4, 526 Chaplin, Charles, 220, 241, 409

Chardin, Jean Baptiste, 76, 220 Charigot, Aline, see Renoir, Mme Le Charivari, 124, 318, 394, 403; caricatures, 29, 81, 91 Charpentier, Georges, 382, 384, 385, 387, 392, 413, 419, 424, 426, 430, 431, 433, 440 Charpentier, Mme, 424, 430, 463, 479 n. 14; portrait by Renoir 420 Chase, William M., 531 Chassériau, Théodore, 17, 19, 22, 66 n. 30 Chatou, 226-227, 433, 454, 456; ill. Renoir 432 (color) Chesneau, Ernest, 80, 84, 92 n. 34, 413, 476 Chevreul, Eugéne, 505, 506, 512, 558 Chintreuil, Antoine, 50, 90, 377 CHOCQUET, VICTOR (1821-1891) auction (1875), 354 and Cézanne, 89, 356, 358, 364, 366, 374, 394, 475, 536, 554 and Renoir, 355-356, 383, 384, 388, 554 and impressionist exhibitions, 366, 368, 392–394 sale of collection, 364, 366, 396 n. 28, 576–578, 589 n. 51 -, portraits by Cézanne 368, 393 (color), Renoir 355, 368 —, mentioned, 322, 346, 354, 366. 375, 378, 395 n. 16, 412, 413, 464. 465, 536, 547, 556, 578 Chocquet, Mme, 89, 413, 475. 576; portrait by Renoir 355 Claretie, Jules, 123, 450, 472 Claus, Jenny, appears in Manet 221 Clemenceau, Georges, 250, 564 Colin, Gustave, 316, 336 Commune, 259, 260, 263, 265, 271, 273, 419 Constable, John, 72, 114, 258 Copenhagen, 14, 493, 496, 500, 511, 514, 522, 557; ill. Gauguin 494 Cordey, Frédéric, 384, 385, 386, 391. 414, 448, 454; appears in Renoir 382, 383 Cormon (Fernand), Atelier, 536. 538, 540

COROT, CAMILLE (1796–1875)

at Paris World's Fair, 16 and Pissarro, 17, 48, 49, 86, 101, at the Salons, 40, 48, 144, 189, 217 and Berthe Morisot, 76, 101 and Renoir, 96, 100-101, 113, 203 as Salon jury member, 102, 139, 140, 168, 240, 268 n. 1 death, 361, 417 -, photograph of 101 -, Daubigny Working on His "Botin" ..., 103; Le Martinet near Montpellier, 48; Road in the Woods, 132 —, mentioned, 18, 20, 27, 28, 33, 50, 61, 69, 75, 94, 95, 96, 102, 110, 120, 121, 133, 150, 154, 165, 172, 174, 188, 189, 204, 205, 212, 214, 216, 245, 252, 254, 261, 267, 289, 290, 301, 311, 316, 320, 324, 335, 338, 361, 377, 419, 472, 486, 576 Courbet, Gustave (1819–1877) Pavillon du Réalisme, 16, 17, 25, 170 and Couture, 25 and Baudelaire, 29, 42 at the Brasserie, 29, 52 and Salons, 31, 79, 125, 144, 188, 189, 217, 239, 272, 245-246 and Whistler, 32, 49-50, 132, 160 and Boudin, 41-42, 43-44, 61, 109 subject matter, 42, 43, 224 Champfleury on, 42, 50-51 and Pissarro, 49, 157-158 and Manet, 52, 123, 125, 172, 241 studio, 64-65; ill. 64 and Salon des Refusés, 85 and Monet, 116, 120, 128, 131-132, 134, 150, 154 his influence, 154, 156, 157, 158, 160, 161, 162, 164–165, 168, 180, 240 show at 1867 World's Fair, 171, 172 and the Commune, 251, 259, 260, 261, 263, 271 death, 417 —, appears in Whistler 130; photograph of 172; portrait by Manet 93 -, Andler Keller, 36; Artist Saluting the

Baudelaire, 54; Beer Drinkers at the

Andler Keller, 36; Cliff at Etretat

Mediterranean, 130; Bathers, 144;

after the Storm, 163 (color); Curée, 261; Demoiselles au bord de la Seine, 30, 31, 144; Forest Scene, 105; Fringe of the Forest, 94; Jo. the Beautiful Irish Girl, 131, 132; Portrait of a Man, 241; Normandy Coast, 129; Painter's Studio, 16-17, 43; P.- J. Prud'hon and His Family, 165; Still Life Painted in Sainte-Pélagie Prison, 273 , mentioned, 18, 20, 26, 28, 33, 41, 51, 70, 75, 76, 80, 81, 85, 96, 102, 112, 113, 114, 118, 121, 128, 143, 144, 148, 170, 174, 184, 187, 197, 205, 214, 232, 244, 254, 268 n. 15, 301, 311, 324, 338, 358, 361. 376, 377, 385, 399, 408, 417, 452, 458, 460, 516, 543, 550, 576 Courrier Artistique, 79-80, 84

Couture, Thomas, 16, 17, 24, 25, 28, 31, 38, 40, 41, 47, 48, 49, 50, 52, 64, 72, 78, 90, 239; The Realist, 24 Crimean War, 13, 46, 265 The Critic, 532 Croissy, 226 Cuvelier (sculptor), 252

Danish Academy, 496 Danish West Indies, 493 Daubigny, Charles (1817–1878) at Paris World's Fair, 16 and Monet, 39, 40, 101, 132, 185, 240, 254, 263, 346 Gautier on, 101 as Salon jury member, 139, 140, 168, 185, 186, 216, 239, 240 Redon on, 188 in England, 251, 254, 258 in Holland, 263 death, 417

- —, appears in Corot 103; photograph of 101
- -, Artist in His Floating Studio, 102; Barge on a River, 103; Evening, 104; Ferry, 103; Hermitage near Pontoise, 186; Mills of Dordrecht, 262; Spring Landscape, 100
- —, mentioned, 90, 94, 102, 110, 121. 144, 172, 174, 212, 224, 296, 299, 301, 311, 541

Daudet, Alphonse, 382, 385, 399, 413 Daumier, Honoré, 14, 52, 101, 102, 152, 239, 417; caricatures 29, 81, 91, 354; The Inheritance, 261 David, Louis, 19 Debras, Louis, 316 De Gas, Achille, 275; appears in Degas 276; portrait by Degas 56 Degas, Auguste, 15, 25ff, 55, 122 DEGAS, EDGAR (1834-1917) and Ingres, 15, 16, 25, 26, 27, 55, 140, 162 early years, 25-28 Italian notebooks, 27-28, 174-175 and Delacroix, 25-27, 58, 66 n. 30, 140 family portraits, 55-57 and Manet, 55, 60, 107, 125, 198, 404–405, 476, 533, 553 and Duranty, 66 n. 18, 376-378 and the Goncourt Brothers, 174, 278 - 279Zola on, 189, 372, 444, 445 at Café Guerbois, 197ff, 202 described, 198-199, 279, 405, 490, 566-568 and Japanese prints, 207, 208, 403 during Franco-Prussian War, 248, 250, 252, 253 and Durand-Ruel, 271-272, 274, 301, 453 in New Orleans, 274-277 at Paris Opera, 273–274, 277–279 and ballet, 274, 277, 278-279 and Mary Cassatt, 310, 406, 408, 409, 469, 515, 525 and Caillebotte, 390, 447, 448, 449 at Café Nouvelle-Athènes, 399,401 Huysmans on, 428, 441, 450, 526 and Monet, 434, 493, 564 Fénéon on, 478, 533 and Gauguin, 493, 514, 561, 568, 574 and Toulouse-Lautrec, 568 last years and death, 586 -, exhibitions: Durand-Ruel (London) 269 n. 34, 482, 484, (New York) 524, 531-532, 544 n. 5,

(1892) 566; impressionist (1874)

311 ff, 323, 328, (1876) 366, 369,

(1877) 390–392, (1879) 421, 423f, (1880) 59, 439ff, (1881) 449, 450–452, (1882) 464f, 467ff, (1886) 518, 521, 523ff, 529; Salons (1865) 122, (1866) 140, (1867)170, (1868) 175, (1869) 217, 218, 237 n. 41, (1870) 240, 244, 268 n. 3, (1872) 272

—, sales, 310, 453, 548

—, technique and theories, 27–28, 140, 174–177, 278–279, 380–382, 525, 566, 568

—, appears in Fantin 206; photographs of 27, 566; portraits by Bracquemond 199, Desboutin 376, 526, Manzi 468

-, Absinthe, 398, 399, 401; After the Bath, 524, 525; Artist's Brother Achille 56; Artist's Brother René, 56; At the Milliner's (Metropolitan Museum), 524; At the Milliner's (Museum of Modern Art), 446 (color); At the Races, 429 (color); At the Races: "They're Off," 60; Ballet at the Opera, 423 (color); Ballet of "Robert le Diable," 273, 274, 275; Mathilde Musson Bell, 277; Bellelli Family, 56, Blue Dance, 499; Café-Concert, Les Ambassadeurs, 381; Café de la Nouvelle-Athènes, 402; Mme Camus, 240, 244; Carriage at the Races, 311; Mary Cassatt, 516; Mary Cassatt at the Louvre, 438 (color); Copy after drawing in Uffizi, 55; Dancers, 567 (color); The Daughter of Jephthah, 58, 66 n. 30, study for, 58; Mme René De Gas, 277; Edmond Duranty, 441; Edmond Duranty in His Study, 439, 440; L'Etoile, 422 (color); False Start, 216; Mlle Fiocre in the Ballet "La Source," 158, 175, 186; Le Foyer, 279 (color); Foyer de Danse, 278; Mme Gaujelin, 217, 218; Yves Gobillard, 222, 226; Ingres, 20; Miss La La at the Cirque Fernando, 381; Laundresses, 323, 466 (color); Madonna and Child, Manet Listening to 55:

Wife..., 107, 108, 198; Manet at the Races, 109; Orchestra of the Opera, 274; Pedicure, 337; Place de la Concorde, 369; Portraits in an Office, New Orleans, 276, 366, 372; Henri Rouart, 391, 449; Self Portrait (c. 1852), 14; Self Portrait (c. 1854), 14; Self Portraits (c. 1857), 27: Semiramis Founding a Town, 58, 59; Sketch after Ingres' Angelique, 16; Sketch after Ingres' Bather, 15; Steeplechase—Fallen *Iockey*, 140, 141 (color), studies for, 140; James Tissot, 176, 207; Hortense Valpinçon, 265; Woman Bathing, 527 (color); Young Dancer (bronze), 439, 449, 450, 451, studies for, 450, 451; Young Spartans Exercising, 59

—, mentioned, 76, 128, 131, 162, 172, 173, 179, 188, 200, 203, 204, 206, 211, 214, 242, 244, 254, 258, 260, 267, 280, 304, 336, 363, 369, 379, 380–382, 408, 434, 436 n. 51, 452, 476, 486, 498, 500, 523, 524, 536, 540, 542, 543, 554, 572, 575, 576, 577, 580; chronology, 592

De Gas, René, 274, 275, 277; appears in Degas 276; portrait by Degas 56 Delacroix, Eugène (1799–1863) at the Paris World's Fair (1855), 15, 16 and Baudelaire, 16, 34, 52 and Ingres, 19, 20, 21–22, 24, 43

at the Academy, 21, 22, 31 and Manet, 25, 50, 76, 79 and Degas, 26–27, 58, 140 and the Salon, 40, 48, 50, 79 murals, 60–61 death, 88–89 influence on Renoir, 208–209, 240,

246, 272, 454, 469 collected by Chocquet, 355, 366 influence on Seurat, 504, 505 influence on van Gogh, 538, 541, 548, 549

influence on Cézanne, 576, 578

—, caricature of 23

—, Dante and Virgil, copy by Manet, 25, 76 —, mentioned, 17, 28, 43, 46, 75, 116, 139, 204, 245, 301, 358, 361, 416, 428, 452, 543, 550, 574, 586

Denis, Maurice, 558; Hommage à Cézanne, 577-578

Denmark, 493, 494, 514; see also Copenhagen

Desboutin, Marcellin, 235, 366, 399, 544 n. 5; appears in Degas 398; portraits by Manet 367, 405; portraits of Degas 376, 526, Duranty 377, Manet 366, Renoir 405

Desnoyers, Fernand, 28, 51, 52, 84–85

Desoye, M. and Mme, 207–208 Deudon, 462

Diaz de la Peña, Narcisse, 69, 93, 94, 95, 96, 100, 110, 152, 172, 174, 204, 251, 301, 417; Forest Scene, 94; View of the Forest, 164

Dieppe, 253, 258, 433, 467, 469, 510, 514; ill. Gauguin *515*

Dihau, Désiré, 273, 568; appears in Degas 274

Dobigny, Emma, appears in Puvis 267

Doncieux, Camille, see Camille Dordrecht, ill. Daubigny 262 Doré, Gustave, 79 Doria, Count Armand, 322, 334, 382 Dreyfus, Capt. Alfred, 576 Drouot, see Hôtel Drouot Duez, Ernest, 476, 544 n. 5 Dunkirk, 72

Duran, Carolus, portrait of Monet 150

Durand-Ruel, Paul (1831–1922) and Barbizon group, 28, 94, 254, 271, 416, 417 financial dealings with impressionists, 254–255, 257, 271–272, 280, 301, 310–311, 326, 413, 452–453, 481, 485–486, 514–515, 543, 548, 553, 589 n. 51

London gallery, 254, 255, 258, 261, 311

exhibitions in London, 255, 269 n. 34, 274, 301, 482, 484–486 publishes catalogue, 301–302 and impressionist exhibitions

(1875) 354, (1876) 366, 367, 368, (1878) 416, 417, 419, (1882) 465, 467–469, 471, 472 holds one-man shows, 481–482, 554, 562, 566, 570, 572 exhibitions in New York, 518, 523–524, 529, 531–532, 543, 544 n. 5, n. 19, 548, 576 death, 586

—, etching of 532; portrait by Renoir 574

—, mentioned, 251, 265, 271, 285, 318, 350, 372, 380, 390, 434, 452, 462, 474, 478, 488, 490, 498, 500, 504, 511, 512, 533, 541, 550, 582 Duranty, Edmond, 30, 47, 52, 73, 75, 89, 102, 118, 137 n. 51, 142, 143, 174, 197, 198, 199, 205, 245, 258, 380, 399, 401, 405, 406, 413, 424, 435 n. 6, n. 16, 439, 440, 447, 449; photograph of 441; portraits by Degas 440, 441, Desboutin 377; La Nouvelle Peinture..., 376, 377—

Duret, Théodore, 191–192, 197, 205, 242, 244–245, 250, 252, 260, 261, 271, 273, 274, 279, 280, 294, 301, 310, 314, 325, 331, 334–336, 354, 364, 368, 384, 392, 394, 401, 412, 413, 414, 419, 421, 434, 447, 453, 454, 472, 477, 482, 489, 553, 566, 572; portraits by Manet 192, Whistler 241

378, 388; Réalisme, 28-29, 376

Durieux, Tilla, photograph of 584; portrait by Renoir 585 (color)

Eakins, Thomas, 268 n. 9

Ecole des Beaux-Arts, 16, 18, 19, 21, 22–23, 25, 26, 28, 31, 38, 41, 42, 58, 60, 62, 64, 65, 72, 73, 74, 75, 79, 81, 82, 89, 90, 161, 162, 259, 370, 377, 384, 385, 401, 406, 424, 452, 465, 478, 496, 505, 570

Elder, Louisine Waldron, see Havemeyer, Mrs. H. O.

Emperaire, Achille, 246; portrait by Cézanne 247

England, 65, 81, 126, 191, 251, 254ff, 261, 263, 315, 334, 354, 361, 366, 382, 454, 456, 575

Ephrussi, Charles, 454, 456; appears in Renoir 454

Eragny, 489, 560, 568; ill. Pissarro 512

L'Esprit Moderne, 370

L'Estaque, 249, 250, 374–375, 463, 464, 468, 469; ill. Cézanne 249, 375, 465, Renoir 464

Etretat, 184, 232, 516; ill. Courbet 163 (color), Monet 233, 516

L'Evénement, 134, 143, 144, 146, 170; appears in Cézanne 147, Renoir 135 Exposition Internationale, see Petit, Georges

Exposition Maritime Internationale, 184, 185

Exposition Universelle, see Paris World's Fair

Fabre, Musée (Montpellier), 550 Fantin-Latour, Henri (1836–1904) student, 23–25 technique, 162, 164, 236 n. 27 death, 579

—, exhibitions: Bonvin's, 32, 33; Salons (1859) 32, 33, (1863) 79, 92 n. 30, (1864) 106, 116, (1865) 121, 125, 137 n. 40, (1866) 193 n. 2, (1867) 170, 189, (1869) 217, 218, (1870) 196, 240, 242, 244, 268 n. 3, (1884) 509; Salon des Refusés, 81, 82

—, caricatures of paintings, 188, 196

—, Artist's Sisters Embroidering, 32, 33; Hommage à Delacroix, 89, 106, 118, 136 n. 22, 578; Hommage à la vérité, (Le Toast), 118, 121, 125, 137 n. 40, n. 51, 207; Edouard Manet, 170, 188, 189; Reading, 240; Scène du Tannhäuser, 116, 136 n. 22; Self Portrait (1858), 26; Self Portrait (1859), 65; Still Life, 160; Studio in the Batignolles Quarter, 196, 205, 240, 342, 578, study for, 206

--, mentioned, 28, 52, 60, 65, 73, 76, 86, 116, 160, 172, 174, 190, 191, 197, 207, 211, 222, 234, 235, 258, 315, 358, 362, 377, 458, 461, 477, 531, 544 n. 3, 553

Faure, Jean-Baptiste, 212, 213, 219, 303, 309, 311, 318, 334, 364, 366,

380, 412, 436 n. 30, 458, 466, 485 Fécamp, 189–190, 516 Feder, 452, 467 .

Fénéon, Félix, 472, 478, 503, 508, 523, 533, 543, 547, 550

Le Figaro, 143, 168, 170, 240, 344, 351, 368, 426, 450, 500

Fiquet, Hortense (Mme Cézanne), 248, 249, 271, 416, 534, 536; portrait by Cézanne *561*

Flaubert, Gustave, 28, 46, 428, 492 Fontainebleau, 17–18, 93, 94, 119, 121, 123, 132, 164, 165, 180, 203, 301, 489, 506, 547; ill. Monet *118*, *119*, Sisley *99*; see also Chailly

Forain, Jean-Louis, 399, 405, 423, 439, 441, 449, 452, 472, 478, 509, 523, 533, 544 n. 5; *Dancer*, 472

Fould, Achille, 31

Fourmanoire, Hélène, appears in Morisot 573

Fournaise, 226, 456

Fragonard, Jean-Honoré, 572

Franc-Lamy, 384, 385, 386, 391, 414; appears in Renoir 383 Franco-Prussian War, 248ff, 258–260

Franco-Prussian War, 248ff, 238–260 Fromentin, Eugène, 376, 396 n. 47

Gachet, Dr. Paul, 29, 204, 296, 298–299, 301, 307 n. 19, 315, 323, 324, 364, 391, 412, 414, 433, 476, 490, 560

Gainsborough, Thomas, 258

Galerie Martinet, 60, 76, 77, 78, 79–80, 81, 84, 214; see also *Courrier Artistique*

Gambetta, Léon, 116, 250, 252, 382, 399, 458

Garibaldi, Giuseppe, 125

Garnier, Charles, 304-305

Gaudibert, 184, 185, 190, 213, 225

Gauguin, Clovis, 514

Gauguin, Mette, 410, 492–493, 496, 500

GAUGUIN, PAUL (1848–1903) at banking firm, 260, 409 as collector, 409–410 and Pissarro, 409–410, 449, 456, 458, 486, 490, 492, 493–494, 496, 500, 538, 542, 543, 561, 574, 575, 579 and Cézanne, 410, 458, 560, 561, 578 in Rouen, 490, 492, 493

in Copenhagen, 493, 496, 500, 511 and Degas, 493, 514, 542–543, 561, 568, 574 and Bernard, 537, 545 n. 31

and Independents, 532 at Pont-Aven, 536–538, 548, 550, 554

described, 537 and van Gogh, 542, 550 to Martinique, 547, 548, 588 n. 1 and Monet, 561

to Tahiti, 560–561, 574, 575 and Durand-Ruel, 572

contract with Vollard, 575, 576 death, 579

—, exhibitions: Café Volpini, 554;
Copenhagen, 496; impressionist (1879)423, (1880) 439, 440, 441, (1881) 448, 449, 450, 452, (1882) 465, 467, 468, 471, 472, (1884) 490, (1886) 522, 525, 526, 529; Les Vingts, 554

-, sales, 561, 575

—, technique and theories, 494–496, 548–550, 554, 561, 574–575, 587

—, photographs of 409, 550; portrait by Pissarro 488

—, Bathers, 575; Beach at Dieppe, 515; Breton Girls, 542; Brittany Coast, 555 (color); By the River, Martinique, 549; Coast of Brittany, 537; Country Lane, 491 (color); Farmhouse in Osny near Pontoise, 410; Houses in Vaugirard, 457; Jacob Wrestling with the Angel, 561; Marie Lagadu, 561; Nude, 452, 453; Portrait of the Artist's Son Clovis, 493; Camille Pissarro, 452, 488; Queen's Mill, Copenhagen, 494; Road to Pontoise in Osny, 489; Seine in Paris, Winter, 409; Self Portrait, 550; Still Life, 495 (color); View of Rouen, 494

—, mentioned, 35 n. 4, 447, 510, 515, 516, 533, 540, 547, 558, 560, 577, 586, 587; chronology, 592

Le Gaulois, 501

Gautier, Amand, 29, 40, 52, 70, 82, 125, 239, 259, 271, 309

Gautier, Théophile, 21, 48, 50, 52, 55, 101, 123–124, 187

Gazette des Beaux-Arts, 123

Geffroy, Gustave, 566, 586

Germany, reaction to French impressionism, 496–498, 500, 576

Gérôme, Léon, 16, 73, 90, 101, 102, 171, 188, 216, 217, 261, 268 n. 9, 335, 529, 570

Gervex, Henri, 476; appears in Renoir 383

Gide, André, 578

Gill, André (caricaturist), 188

Giorgione, 76, 85

Girardon, François, 488

Giverny, 476, 489, 490, 518, 551, 552, 563, 572, 586; ill. Monet *517*

Gleyre, Charles, 25, 28, 70–75, 67, 77, 90, 93, 100, 102, 106, 122, 136 n. 2, 139, 164, 167, 172, 246, 273, 416, 531, 547; The Charmer, 72

Gobillard, Mme (Yves Morisot), 222, 240, 252; portrait by Degas 226

Goeneutte, Norbert, 476; appears in Renoir 383

van Gogh, Theo, 518, 538, 540, 541, 548, 550, 554, 560, 572, 575

van Gogh, Vincent, 538–542, 543, 548–550, 554, 556, 557–558, 560, 578, 587, 588 n. 1; Interior of a Restaurant, 540; Père Tanguy, 541, 557, 558; Windmill on Montmartre, 539 (color)

Goncourt, Edmond and Jules de, 22, 94, 174, 177, 207, 278–279, 304, 376, 382, 428, 445, 475, 505, 578

Gonzalès, Eva, 218, 220, 237 n. 48, 240, 241, 253, 302, 315, 326, 366, 399, 409, 414, 428, 477; portrait by Manet 225; Little Soldier, 240, 241; Loge at the Théâtre des Italiens, 361, 424

Goya, Francisco de, 50, 51, 106, 154, 171, 192, 220

Grandcamp, 511, 526

La Grenouillère, 226-232, 281; ill. Monet 229; Renoir 229, 230, 231 (color) Grévy, Jules, 500 Groupe des Artistes Indépendants, see Independents

Guérard, Henri, 399, 414

Guichard, Joseph, 76, 101, 324-325 Guigou, Paul, 204, 205, 244, 296; Village d'Allauche, 205

Guillaumin, Armand (1841–1927), 62, 158, 173, 190, 258, 292, 296, 356, 373, 399, 410, 413, 414, 493, 503, 510, 511, 514, 532, 541, 550, 558, 560, 566, 586

—, exhibitions: Durand-Ruel (New York) 531, 544 n. 5; impressionist (1874) 309, 313ff, (1876) 363, 366, (1877) 390, 391, (1880) 434, 439, 441, 448, (1881) 449, 452, (1882) 467, 468, 469, 471, 473, (1886) 518, 521ff, 525, 526, 529, 533; Salon des Refusés, 82

-, Pissarro's Friend Martinez..., 427 (color); Pissarro Painting Blinds, 192; Pont Louis-Philippe, 391; Seine at Charenton, 356 (color); Self Portrait, 363; Street in Vanves, 282; Turning Road, 359

Guillemet, Antoine, 102, 139, 142, 143, 168, 172, 174, 180, 192, 197, 250, 258, 292, 316, 341, 362, 452, 475, 534, 553; appears in Manet 221

Guys, Constantin, 13, 52, 89, 126-127, 172, 197; portrait by Manet 198; Emperor Napoléon III Riding, 46; On the Balcony, 126

Haarlem, 273, 302 Hachette, 142, 143 Halévy, Ludovic, 408 Hals, Frans, 76, 273, 302 Hamerton, P. G., 82-83, 84, 85, 102 Havemeyer, Mrs. H. O., 25, 83, 275, 279, 310, 327, 360, 402, 451, 515, 524, 525, 544 n. 5

Le Havre, 34, 37-41, 44, 47, 65, 69, 109, 120, 123, 148, 166, 180, 184, 185, 190, 209, 213, 224, 232, 248, 251, 285, 316, 364, 516; ill. Jongkind 129, Monet 155, 316, 317 (color)

Hecht, Albert, 213, 273; appears in Degas 275 Heffernan, Joanna, see Jo Hennequin, Emile, 501 Henner, Jean-Jacques, 316 d'Hervilly, Ernest, 148, 413 Hokusai, 207 Holbein, Hans, 76, 177 Holland, see Netherlands Homer, Winslow, 76; wood engraving, 75 Honfleur, 109ff, 114, 122, 166, 180; ill. Monet 122, 128, 155, 179 de Hooch, Pieter, 76 Hoschedé, Ernest, 310, 364, 374, 378, 392, 412-413, 414 Hoschedé, Mme, 420, 433, 489, 517; appears in Sargent 552 Hoschedé sale, 310, 413, 420, 436 n. 30 Hôtel Drouot, 310, 351-354, 384, 413, 514, 577 Houdon, Jean-Antoine, 174 Houssaye, Arsène, 168, 184, 185, 195 n. 55, 224–226, 245–246, 258, 268 n. 15, 394 Houssaye, Henri, 476 Hugo, Victor, 46, 54, 123, 250, 374 Hunt, Holman, 372, 484 Hunt, William Morris, 24 Huysmans, Joris-Karl, 404, 426, 428, 441ff, 447, 450, 452, 472-475, 484,

489, 500, 501, 526, 548, 553

Illustrated London News, 13

316, 326, 330, 336, 338, 339 n. 23, 376, 390, 426, 524 Impressionist exhibition (1st 1874), preparations, 309-313, 339 n. 9; entries, 314-315, 339 n. 19; opening, 316; reactions, 318-338, 339 n. 27; caricatures, 394; see also Cézanne: Maison du pendu; A Modern Olympia; Degas: Carriage at the Races; Monet: Boulevard des Capucines; Déjeuner sur l'herbe; Im-

pression, Sunrise; Steamer and Fishing

Boats in the Harbor of Honfleur;

Morisot: The Cradle; Hide-and-

Impressionism, origin of word, 212,

Seek; Pissarro: Public Garden, Pontoise; Renoir: Dancer; Harvesters; Loge; Rouart: View of Melun; Sisley: Orchard

- (2nd, 1876), opening, 366; entries, 366-368, 396 n. 34; reactions, 368-370, 372-373; see also Caillebotte: Man at a Window; Degas: Absinthe; Portraits in an Office, New Orleans; Monet: Japponerie; Woman in a Garden, Springtime; Renoir: Nude in the Sun; Bazille at His Easel; Sisley: Flood at Port-Marly
- (3rd, 1877), preparations, 390-392; entries, 391-392; reactions, 392, 394, 397 n. 70, n. 76; see also Caillebotte: Pont de l'Europe, study for; Cézanne: Bathers; Chocquet; Degas: Café-Concert, Les Ambassadeurs; Henri Rouart; Renoir: Balançoire; Dancing at the Moulin de la Galette (Louvre); Mme Daudet; Mlle Samary; Alfred Sisley; Sisley: Bridge at Argenteuil
- —, (4th, 1879), preparations, 421, 423; entries, 423-424, 436 n. 51, n. 56; reactions, 424; see also Cassatt: Woman in Black at the Opera; Woman with a Fan; Degas: Miss La La at the Cirque Fernando; Monet: Impression, Fog; National Holiday ...; Pissarro: Marie Murer; Orchard in Pontoise...
- (5th, 1880), preparations, 434, 439; entries, 439; reactions, 440-443, 445, 447; see also Degas: Young Spartans Exercising; Edmond Duranty
- (6th, 1881), preparations, 449; entries, 449, 479 n. 19; reactions, 449-450, 452; see also Degas: Young Dancer; Gauguin: Nude
- (7th, 1882), preparations, 464-465, 467-468; entries, 468-469, 471-472; reactions, 471-473; see also Pissarro: Peasant Girl Drinking Her Coffee; Sisley: Fields at Veneux-Nadon
- (8th, 1886), preparations, 521-

522; entries, 522-526, 544 n. 5; reactions, 526-529, 533; see also Cassatt: Morning Toilet; Degas: After the Bath; At the Milliner's; Seurat: La Grande Jatte; Signac: Gas Tanks at Clichy

L'Impressioniste, journal d'art, 394 Independents, 500, 502, 503, 508, 514, 523

- -, Salon (May, 1884), 500-505, 508, 509, 522, 560, 577; see also Seurat, Une Baignade
- —, Salon (Dec., 1884), 510
- —, Salon (1886), 532, 541

Ingres, Jean Dominique (1780–1867) at Paris World's Fair (1855), 15, 16 influences Degas, 15-16, 25, 26, 27 as teacher, 16, 19-20 Baudelaire on, 16, 19-20, 52 theories, 19-21 and Delacroix, 19, 20, 21-22, 24, 43 memorial show, 170-171

- -, caricature of 23; portraits by Degas 20, Lehmann 21
- -, Angélique, 76, Bather (Baigneuse Valpinçon), 15, 16; Count Nieuwerkerke, 142; Mme Rivière, 203; La Source, 203
- -, mentioned, 17, 28, 48, 76, 78, 89, 102, 161, 162, 203, 220, 384, 461, 462, 486, 505, 543, 586, 587 Inn of mère Toutain, 41

Inn of Mother Anthony, 121, 134, 547; ill. Renoir 135

Institute de France, 19, 134, 239, 259, 538, 570; see also Academy of Fine Arts

Italian Primitives, 76

Italy, 55, 208, 222, 235, 409, 458, 460-462, 485

Jacque, Charles, 93 Jacques-François, 391 James, Henry, 370-371, 372, 376 Japanese prints, 197, 207-209, 403, 441, 541-542, 549, 554 Jas de Bouffan, 489, 536, 554; ill. Cézanne 487 (color), 535 (color) Jo (Joanna Heffernan), 132, 207, 271; appears in Whistler 51; por-

traits by Courbet 131, Whistler 87 BARTHOLD Jongkind, JOHANN (1819 - 1891)at Paris World's Fair (1855), 16 and Monet, 48, 69, 71, 75, 76, 111, 112, 113, 114, 309, 314, 516 at Salons, 79, 189, 302, 475 at Salon des Refusés, 82, 84 technique, 114 photograph of 101

- -, Coast near Le Havre, 129; Chapel near Honfleur, 68; Delivery of Paintings at the Salon, 7; Self Portrait, 69; View of Notre Dame, 114; View of Notre Dame at Sunset, 114
- —, mentioned, 123, 189, 212, 214, 304, 338, 410

Joyant, Maurice, 560

Kandinsky, Wassily, 562-563, 564, 589 n. 29

La Farge, John, 22, 24, 551 Lamothe, Louis, 26 Lamy, Franc, see Franc-Lamy Lascou, 116, 461 Latouche, Louis, 150, 193 n. 20, 214, 316, 324, 334, 336, 363 Laurent, Ernest, 424; Georges Seurat, 543 Laval, Charles, 537, 543, 547, 548 Lawrence, Sir Thomas, 258 Lebourg, Albert, 423, 439 Lecadre, M. and Mme, 37, 39, 40, 70, 168, 179, 184 Le Coeur, Charles, 185, 254

Le Coeur, Joseph, 302; appears in

Renoir 305

Le Coeur, Jules, 132–133, 134, 140, 164–165, 185, 260, 272, 304; appears in Renoir 135, 164

Lecoq de Boisbaudran, 23, 25, 52, 377

Lefebvre, Jules, 406

Legros, Alphonse, 51-52, 82, 89, 125, 313, 315, 366, 448; appears in Whistler 51

Lehmann, Henri, 16, 18, 22, 384, 385, 424; portrait of Ingres 21

Lejosne, Commandant, 55, 76, 113,

116, 168, 197

Lemonnier, Camille, 509

Lepic, Viscount Ludovic Napoléon, 70, 273, 313, 316, 366, 391, 448; appears in Degas 369

Lépine, Stanislas, 316, 320, 531, 544 n. 5

Leroy, Louis, 124, 318-324, 390 Lescouezec, Marie (Mme Sisley), 165, 178

Lestringuez, 385, 386, 454, 456; appears in Renoir 382, 383, 454 Levert, Léopold, 313, 316, 366, 391,

Lhote, Paul, 386, 454, 456; appears in Renoir 383, 454

Lise (Lise Tréhot), 99, 132, 164, 165, 217, 224, 230, 240, 260, 272, 307 n. 7; appears in Renoir 165, 217, 238, 239; portrait by Renoir 273

London, 72, 89, 118, 125, 191, 216, 251, 254, 255, 258, 260, 261, 272, 274, 275, 301, 311, 313, 324, 473, 482, 484, 488, 514, 563, 568, 584; ill. Monet 256, 257, 259; Pissarro 257; see also Durand-Ruel, London exhibitions

-, Royal Academy, 81, 258 Longchamps, 107 Longfellow, Ernest W., 24 Lorient, 222; ill. Morisot 227 (color) Louis-Philippe, 14, 106

Louveciennes, 206, 250, 258ff, 280, 291, 572; ill. Monet 212, Pissarro 213, 251, 295 (color), 297 (color), Sisley 211 (color), 289, 300, 365 (color), *371* (color)

Madrid, 126, 191, 580

Maison Dorée, 523, 526, 529; ill 522 Maître, Edmond, 116, 182, 197, 205, 234, 358, 384, 461; appears in Bazille 235, Fantin 196; portrait by Bazille 116

Mallarmé, Stéphane, 86, 326-327, 372-373, 374, 489, 502, 553, 561, 566, 568, 572

Manet, Edouard (1832-1883) and Delacroix, 25, 76 and Baudelaire, 52, 54, 55, 69, 91 n. 18, 106, 124, 125, 126, 128, 143 at cafés, 52, 81, 197ff, 399, 401, 405 influence, 52, 88, 134, 156, 377, 385 and Degas, 54, 56, 58, 60, 107, 174, 198, 404–405, 448, 476, 568 Spanish influence, 50-52, 76, 106, 125-126, 148, 171 and old masters, 76, 85-86, 208, 273, 302 and Monet, 77, 122ff, 148, 152, 169, 363, 364, 374, 392, 412, 435 n. 26, 341ff, 395 n. 1 and Astruc, 85, 118, 171 Rossetti on, 118 and Cézanne, 139, 200, 315 and Zola, 86, 143, 171, 182, 198, 239, 401, 403, 447, 534, 553 Zola on, 143-144, 168, 188, 361-362, 426 and Renoir, 182, 183, 205, 341ff, 458, 460 Gautier on, 187 Redon on, 188 and Morisot, 190-191, 192, 204, 218, 222, 227, 241-242, 252-253, 315, 318, 325, 331, 485 and Duret, 191-192, 244-245, 261, 414 at Boulogne, 191, 222-224 and Duranty, 197, 198 and Wolff, 218, 242, 302, 351, 374, 440 and Eva Gonzalès, 218, 220, 240, 241, 253–254, 315, 477 Castagnary on, 224, 424 during Franco-Prussian War, 250, 252-253 in Netherlands, 253 and Durand-Ruel, 272, 301; see also Manet, exhibitions, Durand-Ruel and Sisley, 290 Silvestre on, 302 and impressionist exhibitions, 313, 314, 315, 351, 366, 467, 469 at Argenteuil, 341ff, 395 n. 1 Mallarmé on, 372–373 described, 401

Legion of Honor, 404, 458

death, 439, 476–477 Fénéon on, 478, 533

- —, exhibitions: Le Havre, Exposition Maritime, 184; Durand-Ruel (London) 269 n. 34, 482, (New York) 524, 531, 544 n. 5; Martinet Gallery, 76, 77, 79, 214; memorial exhibition and auction (1884) 478; New York, 524, 531, 544 n.5; Salons(1859)31,32, (1861) 50, 52, (1863) 77, 79, (1864) 106, 136 n. 22, (1865) 121–125, (1866) 139, 142, 240, (1868) 186, 195 n. 59, (1869) 217, 218, 224, 237 n. 41, (1870) 239, 240, 244, 246, 254, 268 n. 3, (1872) 272ff, (1873) 302, 303, 304, (1874) 326-327, (1875) 360, (1876) 366, 396 n. 30, (1878) 416, (1879) 424, 428, (1880) 443, (1881) 452, (1882) 476; Salon des Refusés, 81, 82, 83, 85-86; Paris World's Fair (1867), 171f
- —, sales, 214, 272, 309, 410, 413, 478, 485
- —, technique and theories, 86, 131, 209–210, 346, 458
- —, appears in Bazille 235; Degas 108, Fantin 196; caricatures of 188, 403; photographs of 125, 404; portraits by Bracquemond 198, Carolus-Duran 374, Degas 109, Desboutin 366, Fantin 189, Monet 342
- —, The Artist (Marcellin Desboutin), 366, 367; Artist's Garden in Versailles, 458, 459 (color); Artist's Wife at the Piano..., 108; Zacharie Astruc, 109; Balcony, 192, 217-218, 221, caricature of, 220; Bar at the Folies-Bergère, 476, 477; Barricade, 260, 261; Baudelaire, 52; Boating at Argenteuil, 360; Bon Bock, 302, 303, 304, 305, 306, 309, 314, 533; Brioche, 219 (color); Mme Brunet, 32, 34; Bullfight in Spain, 127, 272; Iean de Cabannes (Cabaner), 399; Lise Campineano, 421; Christ with Angels, 106, 136 n. 22; Christ Insulted by the Soldiers, 121, 123, 137 n. 40; Combat of the Kearsarge and the Alabama, 107, 272;

Concert in the Tuileries Gardens, 55, 76, 77, 79, 272; Copy after Delacroix's Dante and Virgil, 25; Courbet, 93; Déjeuner sur l'herbe, 84, 85-86, 92 n. 34, 119, 123, 309; Marcellin Desboutin, 405; Théodore Duret, 191, 192; Execution of the Emperor Maximilian, 171-172, 430; Fifer, 240; Folkestone Boat, 224, 498; Eva Gonzalès, 220, 225, 240, 242; Constantin Guys, 198; illustration for Poe's The Raven, 374; Le Linge, 366; Lola de Valence, 79, 91 n. 18, 309; Mlle V. in the Costume of an Espada, 83, 85, 272; Mallarmé, 374; Claude Monet, 341; Monet Family in Their Garden at Argenteuil, 341, 342, 343; Monet Working in His Boat at Argenteuil, 346; George Moore, 402; George Moore at the Nouvelle-Athènes, 402; Berthe Morisot, 314; Nana, 403, 403-404; Olympia, 121, 123, 124, 125, 137 n. 40, 154, 224, 298, 324, 553; Paris Café, 202; La Pêche, 128; The Plum, 400 (color), 401; Antonin Proust, 443, 445; Railroad, 326, 327, 482; Repose (Berthe Morisot), 225, 302, 304, 305; Rue Mosnier..., 418 (color), 419; Self Portrait, 404; Seine at Argenteuil, 347; Spanish Dancers, 78, 79, 272; Spanish Guitar Player, 50-51, 52, *53* (color), 187, 272; View of the Paris World's Fair, 172, 173; Albert Wolff, 478; Young Man in the Costume of a Majo, 85; Emile Zola, 186, 188, 189, 207, caricature of, 188

—, mentioned, 27, 40, 49, 73, 89, 90, 137 n. 51, 150, 157, 161, 162, 200, 202, 206, 211, 212, 213, 258, 260, 261, 271, 274, 279, 292, 322, 340 n. 29, 356, 374, 377, 378, 380, 387, 406, 408, 426, 428, 440, 444, 445, 476, 496, 519 n. 11, 526, 531, 572; chronology, 592

Manet, Eugène, 250, 252, 351, 370, 387, 469, 471, 472, 478, 521–522 Manet, Mme, 107; appears in Degas 108; portrait by Manet 108

Mantz, Paul, 123 Manzi, portrait of Degas 468 Marcantonio, engraving after Raphael, 85 Margot, 416, 433; portraits by Renoir 417, 433 Marlotte, 121, 132, 133, 140, 260; ill. Renoir 132, Sisley 99, 133 Marly, 260, 363, 378; ill. Sisley 378 Marquesas Islands, 579 Marseilles, 204, 214, 249, 416, 463, 488 Martin, père, 214, 255, 334, 335, 406, 414, 541 Martinet, Louis, Galerie Martinet Martinique, 543, 547; ill. Gauguin 549 Marx, Roger, 511, 554 Massé, Victor, 116 Matisse, Henri, 67 n. 32, 587 Maupassant, Guy de, 382, 516 Maureau, Alphonse, 391, 448 Maxwell, James Clerk, 512 Médan, 416, 426, 490, 534 Meissonier, Ernest, 16, 48, 171, 250, 272, 324, 419, 420, 529 Melbye, Antoine, 17, 18, 33, 101, 121, 139 Melbye, Fritz, 14, 17 Menzel, Adolph, 498, 500, 519 n. 29 Mérimée, Prosper, 89 Meryon, Charles, 69 Meurent, Victorine, 85, 401, 435 n. 3; appears in Manet 83, 84, 124, Meyer, Alfred, 316, 362, 375, 390 Millais, John Everett, 372 Millet, Jean-François, 16, 18, 24, 25, 32, 38, 43, 48, 93, 95, 96, 100, 106, 144, 217, 239, 245, 301, 361, 377, 416, 417, 428, 472, 506, 576; Women Carrying Fagots, 96; Wood Gatherer, 96 Mirbeau, Octave, 528, 561, 566, 570, 577 Molins, Auguste de, 316, 336 Monet, A. (father of the artist), 37, 39-40, 50, 69, 70, 168; appears in Monet 153

Monet, Claude (1840–1926) youth in Le Havre, 34, 37ff, 66 n. 1, n. 3 caricaturist, 37, 39, 66 n. 20 and Boudin, 37-40, 42, 44, 61, 69, 70, 71, 75, 76, 96, 112, 113, 114, 116, 119–120, 128, 189, 271 and Daubigny, 39, 40, 101, 132, 185, 240, 254, 263, 346 at Académie Suisse, 48, 49 and Jongkind, 48, 69-70, 71, 76, 112, 113, 114 and Pissarro, 49, 50, 116, 239, 254, 258, 294, 296, 310 military service, 50, 69 and Cézanne, 62, 314, 376, 572, 576, 577, 578 at Gleyre's studio, 70-71, 72, 73, 75, 136 n. 2 and Bazille, 70, 93, 109, 110, 111, 112, 116, 168, 182, 190, 226, 309 and Manet, 77, 172, 192, 412, 435 n. 26, 477, 553, 554 at Chailly, 93, 96, 100, 101, 119-121, 134 and Millet, 96, 100 at Honfleur, 109, 110, 111, 112 and Courbet, 112, 128, 131, 134, 150, 154, 158, 172, 271 and Camille, 134, 152, 167, 168, 184, 190, 232, 248, 251, 280, 363, 378, 412, 431, 437 n. 71 and Zola, 144, 189, 362, 386, 387, 394, 412, 445, 534 Castagnary on, 148 financial difficulties, 166, 167, 168, 173, 184, 189-190, 341, 363-364, 374, 387, 412, 420, 431 at Sainte-Adresse, 179-180 and Sisley, 180, 232, 289, 576 and Houssaye, 184-185, 224-226, 245-246 at Café Guerbois, 197, 199, 200-201, 202 described, 201-202 Japanese prints, 207, 209 at Grenouillère, 226ff and Renoir, 226ff, 281, 284, 285, 307 n. 13, 341–342, 349, 532–533, 580

during Franco-Prussian War, 251 in London, 254ff, 263, 268 n. 15 and Durand-Ruel, 254, 255, 271, 272, 301, 467, 481-482, 485, 515, 532, 533, 543, 553 in Netherlands, 263, 268 n. 22, 271, 273 at Argenteuil, 280, 341-350, 363, 378 Silvestre on, 302 and Chocquet, 358, 366, 392 and the Hoschedés, 378, 433 and Sargent, 378, 531, 551 and Dr. Gachet, 412 at Vétheuil, 420, 431, 433 and Degas, 434, 449, 493, 564 difficulty with painting, 488 at Giverny, 489, 518 and Signac, 502, 503 haystack series, 517-518, 561-564 de Maupassant on, 517 at Antibes, 551 on Gauguin, 561 series paintings, 561–564 influences young painters, 562-563, 564, 580, 587 death, 586 —, exhibitions: Durand-Ruel (London) 269 n. 34, 484, 485, (New York) 524, 531, 532, 544 n. 5, (Paris, one-man show) 481–482; impressionist (1874) 309ff, 320, 323, 324, 326, 328, 329, 334, (1875) 351, 354, (1876) 366, 367, 372, 373, (1877) 390–394, (1879) 423, 424, 426, (1880) 439, (1882) 467, 468, 469, 471, 472, 474, (1884) 490, (1886) 518, 521, 528; International World's Fair, 554; Petit's, 493, 515, 522, 532-533, 547, 548, 551; Salons (1864) 107,

(1865) 107, 116, 122, 123, 137

n. 40, n. 41, (1866) 134, 139, 146.

193 n. 2, (1867) 168, (1868) 155,

180, 185, 186, 188, 189, 190, 195

n. 59, (1869) 217, (1870) 240, 268

n. 3, (1872) 272, (1873) 302, (1880) 434, 443, 444, 445, 447;

La Vie Moderne, 447; Les Vingt, 532

-, sales, 185, 214, 255, 309, 310,

Monet, Camille, see Camille

334, 354, 367, 410, 413, 414, 424, 434, 453, 479, 532, 560, 564

—, subject matter, 44, 46, 47, 48, 150, 152, 379–380, 517–518, 561–564

—, technique and theories, 112, 113, 131, 132, 150, 152, 193 n. 2, 210, 211, 228, 230, 280, 281–285, 516, 562–564, 589 n. 61

—, appears in Bazille 120, 235, Fantin 196, Manet, 343, 346, Renoir 285, Sargent, 553; photographs of 47, 363, 586; portraits by Duran 150, Manet 341, Renoir 298, 362, 363, Robinson 572, de Severac 47

-, Antibes, 551; Argenteuil Bridge, 353; Artist's Garden in Argenteuil, 284; Artist's Garden at Vétheuil, 470; Basin at Argenteuil, 357; Bazille and Camille, study for Déjeuner..., 118; Beach at Sainte-Adresse, 110, 154; Blue House at Zaandam, 270 (color); Boats at Argenteuil, 347; Boats at Etretat, 517; Boulevard des Capucines, 320, 321 (color), 322, 324, 326, 340 n. 30; Boulevard Héloïse in Argenteuil, 288, 289; Breakfast under the Tent, Giverny, 552; Breakup of the Ice near Vétheuil, 443; Camille, 345 (color); Camille (The Green Dress), 134, 139, 148, 149, 166, 180, 184-185, 189, 246; Camille with a Small Dog, 148; Canal in Zaandam, 263 (color); Cap Martin, near Menton, 492; Caricatures, 39; Chapel near Honfleur, 68; Church at Vernon, 484; Cliffs at Dieppe, 510; Cradle—Camille with the Artist's Son Jean, 184; Déjeuner sur l'herbe, 118 (fragment), 133, 193 n. 20, studies for, 118, 119; Les dindons blancs, 292; Duck Pond, 284, 286; Family at Dinner, Etretat, 233; Farm in Normandy, 104; Fishing Nets at Pourville near Dieppe, 469; Floating Ice on the Seine, 443, 479 n. 14; Garden of the Princess, 150, 151, 152, 193 n. 20; Gare St.-Lazare, 379

(color), 380; Green Park, London (Philadelphia), 257; La Grenouillère, 229; Hyde Park, London (Providence), 256; Impression, Setting Sun (Fog), 289, 317 (color), 339 n. 23, 413; Impression, Sunrise, 289, 316, 323, 339 n. 23; Japonnerie, 366, 374; Jetty at Le Havre (c. 1868), 155; Jetty at Le Havre (c. 1870), 255; Manet Painting in Monet's Garden, 341, 342; Mill in Zaandam, 262; Mme Monet on a Garden Bench, 283 (color); Mme Monet and Her Son in the Garden, 282; Mme Monet in a Red Cape, 251; National Holiday..., 419; On the Beach (Mme Monet), 252; Le Pavé de Chailly, 95; Pont Neuf, 281, 285; Poplars, 565 (color); La Porte d'Amont, Etretat, 233; Railroad Bridge at Argenteuil, 353; The River, 228; Road in Fontainebleau Forest, 139, 146; Road in the Forest with Woodgatherers, 97 (color); Road near Honfleur, 115; Road near Honfleur in the Snow, 179 (color); Road near Honfleur in Winter, 115: Road to Versailles at Louveciennes-Snoweffect, 212; Les Roches Noires near Trouville, 129; Rouen Cathedral, Morning, 563, 564; Rue de la Bavolle, Honfleur, 128; Sailboats at Argenteuil (1873-74), 352; Sailboats at Argenteuil (1874), 349 (color); Saint-Germain l'Auxerrois, 152, 413; Seine Estuary at Honfleur, 122, 123, 137 n. 40; Self Portrait, 532; Spring Flowers, 112; Steamer and Fishing Boats in the Harbor of Honfleur, 155, 320; Still Life (c. 1859), 41; Still Life (c. 1869), 232; Still Life with Kidney, 71; Terrace at the Seaside, 152, 153 (color); The Thames and the Houses of Parliament, 259, 413; Two Haystacks, 562 (color); Two Haystacks (Chicago), 563 (color); Vétheuil in Summer, 431; Wild Poppies, 332; Winter in Vétheuil, 430; Woman in a Garden, Springtime, 386, 387; Women in the Garden, 150,

165, 166, 167, 168, 169, 193 n. 20 Young Woman in a Garden, 180 —, mentioned, 65, 67 n. 32, 89, 90, 101, 157, 162, 182, 187, 188, 193 n. 20, 194 n. 28, 213, 234, 242, 269 n. 36, 274, 296, 306, 336, 399, 406, 488, 452, 473, 478, 498, 519 n. 11, 540, 550, 558, 566, 570, 572, 580; chronology, 592

Monet, Jean, 168, 190, 232, 341, 433; appears in Manet 343, Monet 184, 282, Repoir, 343

184, 282, Renoir 343 Monet, Michel, 362, 433, 532 Monginot, 40, 41 Montfoucault, 109, 251, 336, 392 Montgeron, 374, 378, 392

Monticelli, Adolphe, 204, 205 Montmartre, 49, 58, 182, 198, 250, 384, 385, 399, 462, 539, 558, 568; ill. Renoir 383 (color), Sisley 204 Montpellier, 16, 29, 70, 110, 112, 172, 177, 204, 217, 222, 550

Moore, George, 401, 405f, 435 n. 17, 526, 528; portraits by Manet 402 Moreau, Gustave, 406, 419, 444, 452, 501; Galatea, 444

Moret, 489, 576; ill. Sisley 577

Morisot, Berthe (1841–1895) pupil of Corot, 76, 101 and Manet, 190, 191, 192, 204, 218, 220, 222, 241, 242, 252–253, 304, 305, 314, 325, 342, 477, 478 and Degas, 204, 218, 222, 253, 568 marries Eugène Manet, 351 death, 572

—, exhibitions: Durand-Ruel (London) 482, 485, (New York) 524, 531, 544 n. 19; impressionist (1874) 311–312, 313, 322, 324, 325, 326, 329, 334, (1875) 351, 354, (1876) 366, 367, 372, (1877) 391, 392, 394, (1880) 434, 439–442, (1881) 448, 449, (1882) 467, 468, 469, 470, 472, (1886) 518, 521, 522, 526, 533; Petit's, 547; Salons (1864) 106, 136 n. 22, (1865) 121, 137 n. 40, (1866) 140, 193 n. 2, (1867) 170, (1868) 186, 188, 189, 195 n. 59, (1869) 217, (1870) 240, 241, 242, 244, 268

n. 3, (1872) 272, (1873) 302

-, sales, 334, 354, 485

—, technique, 290, 292

—, appears in Manet 221; photograph of 366; portraits by Manet 225, 314

-, Artist's Sister Edma and Their Mother, 241-242, 243; Artist's Sister, Mme Pontillon, Seated on the Grass, 325 (color); Cradle, 315; Girl with Fan, 433; Harbor of Lorient, 222, 227 (color); Hide-and-Seek, 318, 331; In the Dining Room, 497; On the Balcony, 293 (color); Paris Seen from the Trocadéro, 290, 292; Self Portrait, 521; Young Girl with Dog, 573 (color); Young Woman at the Window, 241, 242

—, mentioned, 172–173, 180, 198, 244, 259, 260, 264, 273, 274, 341, 387, 390, 413, 421, 434, 478, 498; chronology, 592

Morisot, Edma (Mme Pontillon), 76, 101, 189, 190, 218, 220, 222, 241-242, 252; appears in Morisot, 227, 243, 325

Morisot, Mme, 218, 241, 242, 252, 260, 324, 325

Morisot, Yves, see Gobillard, Mme Mortier, Arnold, 168, 170

Moscow, 562

Moulins, 173

Mulot-Durivage, Emilien, 316

Munich, 580

Murer, Eugéne, 382, 413, 414, 416, 430, 443, 444, 490, 492, 493, 547, 553; portraits by Pissarro 414, Renoir 415 (color)

Murer, Marie; portraits by Pissarro 412, Renoir 413

Murger, Henri, 19, 134, 135

Musée Fabre, see Fabre, Musée

Musson family, 276-277; appear in Degas 276, 277; photo of Michel Musson 276

Nadar (Félix Tournachon), 116, 172, 197, 253, 313, 314, 325, 326, 334, 354, 358, 399, 449

Naples, 461-462, 463; ill. Renoir 461

Napoléon III, 31, 44, 46, 80, 85, 88, 89, 90, 91 n. 24, 250, 272, 399; appears in Guys 46

Naturalism, 148, 150, 188–189, 428, 444, 543

Neo-impressionism, 533, 541, 550 Netherlands, 263, 268 n. 22, 271, 280, 285, 409, 486, 538, 560; see also Haarlem, Zaandam

New Orleans, 274-277, 366; ill. Degas 276, 277

New York 271, 275, 336, 377, 392, 394, 396, 405, 406, 419, 424, 428, 517, 523, 548, 576

—, American Art Galleries, 531, 572 -, National Academy of Design, 532 New York Daily Tribune, 370, 529, 531, 532

Nietzsche, Friedrich, 266–267, 340 n. 41

Nieuwerkerke, Count, 18, 32, 80, 142, 170, 185–186, 272, 476; portrait by Ingres 142

Nini, 334; appears in Renoir 335 Nittis, J. de, 304, 313, 316, 318, 324, 339 n. 27, 364, 366, 390, 395 n. 27, 404, 431, 478, 481, 497, 509; Horsewomen in the Bois de Boulogne, 338

Normandy, 60, 114, 433, 526; ill. Courbet 129

Nouvelle-Athènes, see Café de la Nouvelle-Athènes

Nouvelle Peinture, see Duranty, Nouvelle Peinture

Ochard, Jacques François, 39; caricature by Monet 39

Oise River, 101, 102, 158, 296, 301 Old Chrome, 258

Osny, 486; ill. Gauguin 489, Pissarro 489

Ottin, Auguste, 313, 314, 316, 334,

Ottin, Léon, 316, 320, 336 Oudinot, 101, 173, 258, 259

Pach, Walter, 580 Palermo, 460, 461 Paris, Louvre, 25, 30, 32, 38, 39, 55, 75, 76, 104, 106, 118, 124, 144, 150, 162, 163, 169, 177, 183, 196, 202, 221, 222, 235, 240, 274, 296, 300, 308, 315, 322, 323, 332, 337, 356, 361, 362, 363, 378, 384, 387, 390, 398, 399, 409, 411, 437, 438, 477, 488, 541, 553; ill. Homer 75, Pissarro 569

Paris, Luxembourg Museum, 25 Paris World's Fair (1855), 13-16, 26, 28, 80; ill. 13

— (1867), 168, 171, 172, 207, 290 -(1878), 416, 419

Perry, Lilla Cabot, 551

Petit, Georges, 419, 434, 481, 532, 546, 551, 576; Exposition Internationale, 481, 493, 515, 522, 523, 529, 532, 547–548

Picasso, Pablo, 580, 587; Self Portrait, 580

Picot, 22, 64

207

Piette, Ludovic, 50, 109, 251, 336, 363, 391, 392, 423; Camille Pissarro at Work, 207

Pissarro, Camille (1830–1903) early years, 13ff and Corot, 16, 17, 33, 48, 49, 75, 76, 101 and Courbet, 49-50, 154, 158 and Monet, 49, 50, 116, 254, 258, 294, 296, 310, 485 at Académie Suisse, 49, 61, 62 and Cézanne, 61, 62, 249, 292, 294, 336, 350, 375–376, 410, 411, 421, 456, 474, 543, 572, 579, 580 and Zola, 142, 144, 372

Redon on, 188 at Café Guerbois, 197, 199, 205-

described, 206, 405-406, 568, 570 in Louveciennes, 206, 263-264 on impressionism, 211–212

and Duret, 244, 260-261, 294, 301, 310, 330, 334–336, 413, 414, 453– 454

during Franco-Prussian War, 250f and Durand-Ruel, 254-255, 271, 272, 301, 453, 485–486, 512, 518, 524, 533; see also Pissarro, exhibitions, Durand-Ruel

in London, 254–255, 258, 260–261, 263, 268 n. 15, 269 n. 36 in Pontoise, 158, 280, 292, 294, 312, 331, 334, 362, 378, 410, 456 views on group exhibition, 312ff and L'Union, 362, 375-376, 390 and Caillebotte, 390, 423, 447, 448, 449, 572 at Café de la Nouvelle-Athènes, 399, 401, 405, 406 and Gauguin, 410, 456, 458, 490, 492, 493-494, 500, 537, 538, 542, 543, 561, 574, 575, 579 and Murer, 414, 416-417, 430 Huysmans on, 452 advice to young painters, 456, 458 in Eragny, 489 in Rouen, 490, 492 and Seurat, 511-512, 514, 518, 547-548, 550-551, 579 and van Gogh, 540, 542, 543, 560 and Henri Rousseau, 560 death, 579

-, exhibitions: Durand-Ruel (London) 255, 269 n. 34, 272, 482, (New York) 523–524, 531–532, 544 n. 5, (Paris, one-man shows) 482, 485, 570; impressionist (1874) 309ff, 320, 328, 329, 331, (1876) 366–367, 369, 372, 373, (1877) 390–394, (1879) 416, 423, 424, (1880) 439, 441, (1881) 447, 449, 450, 452, (1882) 464–465, 467, 468, 469, 471, 473, (1886) 518, 521, 522, 525, 526, 528, 529; Petit's, 547; Salons (1859) 32–33, 34, (1861) 50, (1864) 101, 106, 136 n. 22, (1865) 121, 137 n. 40, (1866) 134, 139–140, 144, 193 n. 2, (1867) 168, (1868) 185, 186, 188, 189, 195 n. 59, (1869) 217, 237 n. 41, (1870) 240, 244, 254, 268 n. 3, (1872) 272, (1873) 302; Salon des Refusés, 82, 86

—, sales, 255, 301, 308 n. 24, 309, 310, 332, 394, 397 n. 76, 410, 413, 414, 453–454, 485, 486, 517

—, technique and theories, 157, 158, 210, 249, 292, 294, 296, 456–458, 511–512, 514, 550–551, 568, 570,

571, 589 n. 61

—, appears in Piette 207, Guillaumin 192; photograph of 533; portraits by Cézanne 296, 312, Gauguin 452, 488, Renoir 382

-, Apple Pickers, 529; Paul Cézanne (Basel), 298; Paul Cézanne (Louvre), 313; Chestnut Trees at Louveciennes, 295 (color); Côte du Jallais near Pontoise, 186; Crystal Palace, London, 257; Entrance to the Village of Voisins, 300; Paul Gauguin, 488; Hermitage at Pontoise, 159 (color); Landscape near Pontoise, 145 (color); Louveciennes, the Road to Versailles, 251; Louvre Seen from the Pont-Neuf, Winter, 569 (color); Marne at Chennevières, 106; Eugène Murer, 413, 414; Mlle Marie Murer, 412, 413; Orchard in Bloom, Louveciennes, 297 (color); Orchard in Pontoise, Quai de Pothuis, 411; Path above Pontoise, 266 (color); Peasant Girl Drinking Her Coffee, 473; Penge Station, Upper Norwood, 255, 256; Road to Pontoise in Osny, 489; Road to Rocquencourt, 264; Road to Versailles at Louveciennes—Rain-effect, 213; Rue de l'Epicerie, Rouen, 570; Rue St. Vincent, Montmartre, 49; Sketch after Ingres' La Belle Zélie, 17; Springtime in Eragny, 512; Still Life, 156; Street in Pontoise, Winter, 294; Tropical Landscape, 18; Windmill at Knocke, 571 (color)

—, mentioned, 19, 22, 23, 27, 28, 30, 50, 65, 96, 102, 109, 144, 172, 173, 189, 190, 209, 213, 248, 301, 302, 336, 363, 374, 427, 434, 441, 473, 475, 477, 478, 481, 486, 490, 519 n. 11, 533, 534, 548, 554, 558, 566, 572, 576, 577, 580; chronology, 592

Pissarro, Lucien, 456, 482, 511, 521, 522, 543, 547, 548, 568, 572
Poe, Edgar Allan, 374
Pointillism, 512, 541, 542, 550, 551, 568, 570
Poissy, 476

Pont-Aven, 536, 538, 548, 554

Pont Neuf, 281, 285; ill. Monet 281, Renoir 280

Pontoise, 101, 158, 186, 280, 292, 294, 296, 298, 301, 312, 331, 334, 336, 362, 378, 392, 410, 439, 456, 457, 475, 486, 489; ill. Cézanne 294, 411, Daubigny 186, Gauguin 410, Pissarro 145, 159, 186, 266 (color), 294, 318, 411

Port-en-Bessin; ill. Signac 503
Porte Chinoise, 207
Portier, A., 518, 541
Pothey, 428
Poussin, Nicolas, 18, 76, 560
Pre-Raphaelites, 15, 372
Prévost, A., Courbet's Studio, 64
Prix de Rome, 19, 73, 90, 106
Proudhon, Pierre-Joseph, 28, 42, 43, 125, 143, 148; family portrait by Courbet, 165

Proust, Antonin, 25, 212, 224, 443, 458, 460, 477, 554; portrait by Manet 445

Proust, Marcel, 419

Prud'hon, Pierre Paul; Children with Rabbit, 61

Puvis de Chavannes, Pierre, 122, 173, 217, 222, 241, 242, 250, 260, 264, 361, 424, 428, 488, 508, 509, 554; Hope, 267; Sacred Wood..., 509

Raffaëlli, Jean François, 73, 399, 423, 428, 439, 441, 447ff, 452, 464, 465, 467, 472, 478, 522–523, 533, 544 n. 2, 547, 553; Man Having Just Painted His Fence, 434; Sculptor in His Studio, 448

Rambure, Countess de, 523
Raphael, 20, 85, 92 n. 34, 462, 464, 486; engraving after, 85
Réalisme, see Duranty, Réalisme
Redon, Odilon, 73, 89, 101, 188,

Redon, Odilon, 73, 89, 101, 188, 414, 442, 443, 500–502, 506, 508, 510, 523, 533, 560, 577; Cyclops, 501; The Monster looked..., 501; Upon waking I perceived..., 501

Regnault, Henri, 242; *Salomé*, 242 Rembrandt, 76 Renan, Arv. 401

Renoir, Auguste (1841–1919)

early years, 71-75 at Glevre's studio, 71-76, 77, 90, 100, 136 n. 2 and Bazille, 72, 93, 165, 182, 226ff, 232ff and Sisley, 72, 93, 120-121, 132, 133, 180, 182, 203-204, 289 and Fantin-Latour, 76 in Chailly, 93, 95, 100, 121, 180 and Corot, 96, 101 and Courbet, 96, 154, 158, 162, 164-165 and Diaz, 96, 100 at Fontainebleau, 121, 132, 180 and Lise, see Lise and Jules Le Coeur, see Le Coeur, **Jules** and Houssaye, 184, 245-246, 476 at Café Guerbois, 197ff described, 202-203 and Manet, 205, 341-342, 533 in Algiers, 209, 454, 469 and Monet, 226ff, 281, 284-285, 307 n. 13, 341-342, 349, 532-533, 580 at Grenouillère, 226-232 during Franco-Prussian War, 248ff, 259, 260 and Durand-Ruel, 280, 301, 453, 467-468, 485; see also Renoir, exhibitions, Durand-Ruel in Argenteuil, 281, 341-350 and Cézanne, 342, 356, 463-464, 490, 554, 578 and Caillebotte, 346, 349, 388, 390, 572 and Chocquet, 355-356, 358, 364, 366 and Duranty, 378 and Charpentier family, 382-386, 419, 463 at Café de la Nouvelle-Athènes, 399, 406 and Gauguin, 410, 560-561, 574 and Murer, 413, 414 and Bérard family, 433, 490 in Italy, 458, 460-462 at L'Estaque, 463-464, 468, 469 and Legion of Honor, 577 death, 586

—, exhibitions: impressionist (1874) 312ff, 318, 322, 328, 334, (1875) 351, 354, (1876) 367–368, 370, 372, (1877) 390–394, (1882) 464, 467, 468, 469, 471, 472, 473, (1886) 521, 522, 523; Durand-Ruel (London) 269 n. 34, 272, 484, (New York) 514, 524, 531, 544 n. 5, (one-man) 482, 554; Petit's, 515, 522, 532-533, 546, 547, 548; Salons, 214, (1864) 106, (1865) 121, (1866) 139, 140, 142, (1867) 168, (1868) 181, 186, 188, 189, 195 n. 59, (1869) 217, 230, 237 n. 41, (1870) 238, 239, 240, 244, 245, 268 n. 3, (1872) 272, (1873) 302, (1875) 358, 395 n. 19, (1878) 416, (1879) 421, 424, 428, 430, 434, (1880) 443-444, 447, (1881) 449, 450, 452, 454, (1890) 554; Salon des Refusés, 237 n. 36, 304, 306, 308 n. 31; La Vie Moderne, 431; Les Vingts, 532

, sales, 184, 272, 334, 351, 354, 397 n. 76, 410, 419, 420, 453, 485
, technique and theories, 154, 162, 164–165, 210, 228, 230, 281–285, 338, 386, 419–420, 486, 488, 490, 580–584, 589 n. 61

—, appears in Fantin-Latour 196; photographs of 74, 364, 469, 584; portraits by Bazille 203, 235, Desboutin 405

-, Arab Boy, 455 (color); Artist's Studio, rue St. Georges, 382; At the Inn of Mother Anthony, 134, 135; Le Bal au Moulin de la Galette, see Dancing at the Moulin de la Galette; La Balançoire, 384, 385, 388, 392, 433; Barges on the Seine, 121; Bather (Lise) (1870), 238, 240, 246; Bather (1879-80), 442; Bather (1881), 463; Bather (1892), 580, 581 (color); Bathers (1884–87), 488, 546, 548; Bay of Naples, 461; Bazille at His Easel, 182, 183, 368; Boating Party at Chatou, 432, 433, 456; Bouquet of Spring Flowers, 161; Bridge near Paris, 348; Paul Cézanne, 475; Mme Charpentier and Her Children, 419, 420, 424, 428, 580; Mme Chocquet, 355; Victor Chocquet (Fogg), 355; Victor Chocquet (Reinhart), 368; Clearing in the Woods, 98; Country Road, Springtime, 287, 289; Crags at L'Estaque, 464; Cup of Chocolate, 416, 417; Dance at Bougival, 482, 483, 488; Dancer, 316, 318, 319; Dancing at the Moulin de la Galette (Louvre), 383, 388, 392, 433, 450, study for, 390; Dancing at the Moulin de la Galette (Whitney), 383 (color), 385; Mme Daudet, 392; Déjeuner des Canotiers, 454, 456, 471, 472, 473; Diana (Lise), 166, 168; Duck Pond, 284, 286; Paul Durand-Ruel, 574; Tilla Durieux, 585 (color); La Esméralda, 106, 136 n. 22; Fantasia, Algiers, 454, 462; First Outing, 385; Girl with Cat (Angèle), 442, 443; Gondola in Venice, 460, 472; La Grenouillère (Milwaukee), (color); La Grenouillère, 230; La Grenouillère (Stockholm), 229; Harvesters, 322, 332; Horsewoman, 304; Jules Le Coeur in Fontainebleau, 164; Lise, 180, 181, 187, 189; Lise Sewing, 164, 165; Lise in a White Shawl, 272, 272; La Loge, 316, 334, 335 (small version), 354; Margot, 433; Meadow, 333 (color); Claude Monet, 298; Claude Monet (detail), 363; Claude Monet Reading, 362; Monet Working in His Garden at Argenteuil, 284, 285; Mme Monet, 344; Mme Monet and Her Son in Their Garden, 341, 342, 343; Mme Monet Reading Le Figaro, 344; Morning Ride, Bois de Boulogne, 302, 305; Eugène Murer, 413, 415 (color); Mlle Marie Murer, 413; Nude in the Sun, 370, 387; Parisian Women Dressed as Algerians, 272; Pont des Arts, 167 (color), 272, 354; Pont Neuf, 280, 285, 354; Potted Plants, 112; Road near Marlotte, 132; Sailboats at Argenteuil (1873-74), 352; Sailboats at Argenteuil (1874), 348; Mlle Samary, 392; Self Portrait,

- 364; Alfred Sisley, 364, 392; Alfred Sisley and His Wife, 178, 180; William Sisley, 121, 137 n. 40; Skating in the Bois de Boulogne, 190, 191; La Source, 354; Still Life, 232; Studies of nudes..., 582; Summer (Lise), 217, 230; Summer Evening, 121, 137 n. 40; Ambroise Vollard, 583, Richard Wagner, 461; Winter Landscape, 209; Woman of Algiers (Lise), 239, 240
- —, mentioned, 79, 112, 116, 150, 172, 173, 185, 189, 206, 207, 208, 209, 234, 258, 280, 294, 362, 363, 372, 376, 410, 426, 439, 448, 449, 478, 519 n. 11, 534, 536, 550, 566, 576; chronology, 592
- Renoir, Mme (Aline Charigot), 456; appears in Renoir 454
- Renoir, Edmond, 121, 260, 281, 318, 430, 431; appears in Renoir 483 Renoir, Jean, 237 n. 36
- Revue internationale de l'art et de la curiosité, 254
- Reynolds, Sir Joshua, 258
- Ribera, José, 156
- Richepin, Jean, 401
- Rivière, Georges, 370, 385f, 392, 413; appears in Renoir *382*, *383* Robert, Léopold, 316, 336
- Robinson, Theodore, 551, 553; portrait of Monet, 572
- La Roche-Guyon, 109, 490
- Rochenoire, Jules de la, 239
- Rodin, Auguste, 551, 554, 557
- Rohde, Johan, 557-558
- Rome 125, 462
- —, French academy, 19, 65, 73, 259 Rood, Ogden N., 506, 512
- Rossetti, Dante Gabriel, 89, 118, 207, 258, 268 n. 15
- Rouart, Henri, 250, 301, 302, 304, 313, 318, 336, 391, 392, 423, 434, 439, 449, 464, 469, 523, 554, 566, 568; portrait by Degas 449
- Rueil, 226, 476
- Rouen, 112, 121, 285, 346, 489, 490, 492, 494, 500, 526, 563, 568; ill. Gauguin 494, Monet 564, Pissarro 570

- Rousseau, Henri, 560
- Rousseau, Théodore, 17, 24, 40, 93, 94–95, 144, 199, 204, 212, 301, 361, 416, 576
- Royal Academy, see London, Royal Academy
- Rubens, Peter Paul, 19, 76, 128, 210 Russia, 13, 360, 419 Ruysdael, Jacob, 18
- Sainte-Adresse, 109, 111, 112, 168, 179, 180, 214; ill. Bazille *110*, Monet *110*, *154*
- Sainte-Beuve, Charles-Augustin, 55 St. Cloud, 150, 187
- Saint-Mammès, 489
- Saint-Siméon Farm, 42, 109, 110, 111: ill. Bazille *111*
- St. Thomas, V.I., 14, 17, 350; ill, Pissarro 18
- Saint-Victor, Paul de, 18, 21, 123 Salon des Indépendants, see Independents, Salons
- Salons, 19, 20, 21, 31, 35 n. 1, 42, 60, 65, 67 n. 31, 77, 78, 79, 80, 89, 90, 93, 101, 152, 205, 213, 214, 237 n. 36, 259, 272, 304, 306, 309, 310, 311, 312, 313, 314, 326, 328, 329, 360, 374, 390, 409, 410, 416, 423, 434, 443, 444, 445, 469, 482, 509, 577, 588 n. 20
- of 1857, 30, 31, 35 n. 1; see also Courbet: *Demoiselles au bord de la* Seine
- of 1859, 31ff, 40, 47, 48
- of 1861, 50, 51, 53, 67 n. 31; see also Manet: Spanish Guitar Player
- of 1863, 77, 78, 79, 80, 88, 102,123, 148, 150, 205; see also Cabanel: Birth of Venus
- of 1864, 89, 92 n. 30, 101, 102,
 106, 107, 136 n. 22; see also
 Renoir: La Esméralda
- of 1865, 121, 122, 123-125, 137
 n. 40, 207; see also Fantin:
 Hommage à la vérité; Manet:
 Olympia; Monet: Seine Estuary at
 Honfleur; Pissarro: Marne at Chennevières; Renoir: Summer Evening;
 William Sisley; Whistler: Princesse

- du pays de porcelaine
- of 1866, 133, 134, 138, 139, 140, 142, 143, 144, 146, 148, 193 n. 2; see also Degas: Steeplechase—Fallen Jockey; Fantin: Still Life; Monet: Camille (Green Dress); Road in Fontainebleau Forest; Sisley: Village Street in Marlotte
- —, of 1867, 166, 168, 169, 170; see also Fantin: *Edouard Manet*; Whistler: *Wapping on the Thames*
- of 1868, 155, 179, 180, 185, 186, 187, 188, 189, 195 n. 59; see also Bazille: Artist's Family on a Terrace...; Degas: Mlle Fiocre...; Manet: Emile Zola; Monet: Steamer and Fishing Boats...; Pissarro: Côte du Jallais...; Renoir: Lise; Sisley: Alley of Chestnut Trees...
- of 1869, 216, 217, 230, 237 n. 41; see also Bazille: View of the Village; Degas: Mme Gaujelin; Manet: Balcony; Renoir: Summer
- of 1870, 196, 227, 239ff, 253, 254, 268 n. 3; see also Bazille: Summer Scene, Bathers; Degas: Mme Camus; Fantin: Studio in the Batignolles Quarter; Gonzalès: Little Soldier; Manet: Eva Gonzalès; Morisot: Artist's Sister Edma and Their Mother; Harbor of Lorient; Renoir: Bather (Lise); Woman of Algiers; Regnault: Salomé; Sisley: Canal Saint-Martin
- of 1872, 272–273
- of 1873, 302, 358; see also Manet:
 Bon Bock; Repose
- of 1874, 326, 327, 328, 329, 340
 n. 30, 361, 400, 408; see also
 Manet: Railroad
- of 1875, 358, 360, 361, 362, 408
- of 1876, 366, 367, 373, 408, 410; see also Manet: Le Linge; The Artist
- of 1877, 404, 408
- of 1878, 416; see also Renoir: Cup of Chocolate
- of 1879, 421, 424, 426, 428, 430; see also Gonzalès: Loge at the Théâtre des Italiens; Manet: Boating

- at Argenteuil; Renoir: Mme Charpentier and Her Children
- of 1880, 434, 437 n. 76, 443, 444, 445; see also Manet: Antonin Proust; Renoir: Girl with Cat
- of 1881, 449, 452, 454, 500
- of 1882, 475, 476; see also Manet: Bar at the Folies-Bergère
- of 1883, 508
- —, of 1884, 500, 504, 509; see also Puvis: Sacred Wood...
- of 1886, 521
- of 1890, 554
- of 1891, 577
- Salon des Refusés, 170, 306, 312, 326, 331, 358, 508, 547, ill. 80; (1863) 80–86, 87, 89, 90, 92 n. 29, 132, 142, 143, 168, 216; see also Manet: Déjeuner sur l'herbe; Mlle V. in the Costume of an Espada; Whistler: White Girl; (1873) 271–272, 303–306, 309, 534
- Samary, Jeanne, 385, 392, 424
 Sargent, John Singer, 378, 531, 551, 554; Claude Monet Painting, 553; Mme Hoschedé and Her Son..., 552
 Schanne, Alexandre Louis, 41, 109
 Scholderer, Otto, 137 n. 51, 205; appears in Fantin 196
- Schuffenecker, Emile, 409, 496, 510 514, 522, 537, 550; Winter Landscape, 523
- Seine, 42, 109, 110, 122, 165, 226, 235, 281, 290, 341, 346, 349, 412, 416, 431, 433, 489; ill. Caillebotte 350, Gauguin 409, Guillaumin 356, 391, Manet 347, Monet 122, 228, 229, 347, 349, 352, 353, 357, 430, 431, 443, 484, Renoir 121, 167 (color), 229, 230, 231 (color), 348, 352, 432, Seurat 504, 505, Signac 502, Sisley 290, 291(color), 308, 357
- Seurat, Georges (1859–1891) and Renoir, 436 n. 58 early works, 503–508 and Chevreul, 505, 506, 558 and Signac, 508, 509–510 Fénéon on, 508, 533 paints La Grande Jatte, 510–511 Roger Marx on, 511

- and Pissarro, 511–512, 514, 518, 547–548, 550, 579 and *Les Vingt*, 547 technique and theory, 512, 514 death, 560
- —, exhibitions: Durand-Ruel (New York) 523, 531, 544 n. 5; impressionist (1886) 521, 522, 526, 528, 529; Salon des Indépendants, 532, 560
- —, portrait by Laurent, 543
- —, Paul Alexis, 508; Aman-Jean, 508; Une Baignade, 503–505, 504, 508, 509, 510, 523, 531, 533, final study for, 505 (color), two studies for, 506; Fishing Fleet at Port-en-Bessin, 511; The Gardener, 507; Haystack, 507; Man with a Hoe, 509; Paul Signac, 542; Sunday Afternoon on the Island of La Grande Jatte, 510, 511, 512, 521, 522, 526, 528, 530 (color), 533, 541, 543, 544 n. 25, complete study for, 510, 511, 512, 513, two studies for, 513
- —, mentioned, 424, 472, 538, 540, 542, 550, 572, 587, 588 n. 1; chronology, 599
- de Séverac, G., portrait of Monet 47 Signac, Paul, 440, 447, 472, 502–504, 508ff, 518, 521ff, 526, 528, 531ff, 540ff, 547, 556; chronology, 607; portrait by Seurat 542; Coast at Porten-Bessin, 503; Gas Tanks at Clichy, 528; Pont Louis-Philippe, 502(color); Still Life, 503
- Signol, Emile, 75, 79
- Silvestre, Armand, 198, 199, 200, 265, 301–302, 328–329, 421, 441 Silvestre, Théophile, 101
- SISLEY, ALFRED (1840-1899)
- at Gleyre's studio, 72, 73, 75, 136 n. 2
- and Renoir, 72, 120–121, 132, 133, 134, 165, 180, 431
- and Monet, 93, 180, 232, 289, 489, 576
- at Chailly, 93, 96, 100
- at Marlotte, 121, 132, 133
- described, 203-204
- during Franco-Prussian War, 260,

- 269 n. 42 to England, 269 n. 42, 334, 456 and Durand-Ruel, 271–272, 301, 481, 548, 576 Silvestre on, 302, 328 at Marly, 363, 378 Brandes on, 498 death, 576
- , exhibitions: Champs de Mars Salon, 558, 576, 588 n. 20; Durand-Ruel (London) 272, (New York) 524, 531, 532, 544 n. 5; (Paris, one-man) 482; impressionist(1874) 312ff, 320, 323, 324, 328, 329, 334, (1875) 351, 354, (1876) 368, 372, 373, (1877) 391, 392, (1881) 449, 450, (1882) 467, 468, 471, 472, 473, (1886) 523, 533; Petit's, 515, 547, 576; Salons (1864) 107, (1866) 139, 193 n. 2, (1867) 168, (1868) 180, 186, 187, 188, 195 n. 59, (1869) 217, (1870) 240, 244, 245, 268 n. 3, (1872) 272, (1873) 302, (1879) 421, 424, 431, (1880) 443, (1881) 449; La Vie Moderne, 431
- —, sales, 214, 310, 334, 351, 354, 397 n. 76, 410, 413, 414, 453, 485, 576, 589 n. 50
- -, technique, 210, 289-290
- —, appears in Renoir 135; photograph of 203; portraits by Bazille 185, Renoir 178, 364
- —, L'allée des Châtaigniers à la celle St. Cloud, 99; Alley of Chestnut Trees..., 187; Boats at Anchor, Argenteuil, 357; Boulevard Héloïse in Argenteuil, 288, 289; Bridge of Argenteuil, 290, 392; Bridge of Villeneuve-la-Garenne, frontispiece (color), 290; Canal Saint-Martin, 240, 245; Church of Moret, 577; Country Lane near Marlotte, 99; Country Road, Springtime, 287, 289; Early Snow at Louveciennes, 211 (color); Fields at Veneux-Nadon, 471; Flood at Port-Marly, 378, 413, 589 n. 50; Landscape, Louveciennes, Autumn, 371 (color); Louveciennes, Fall, 289; Louveciennes, Winter, 289;

Orchard, 320; Port-Marly, 358; Road at Louveciennes, 365; Road to Sèvres, Louveciennes, 300; Seine at Argenteuil, 291 (color); Snow at Veneux-Nadon, 437; Still Life with Heron, 182; View of Montmartre, 182-183, 204; Village Street in Marlotte, 133 (color); Wheatfields near Argenteuil, 329 (color); Wooden Bridge at Argenteuil, 308 -, mentioned, 77, 90, 107, 154, 165, 173, 189, 197, 205, 258, 280, 285, 294, 296, 309, 312, 334, 336, 363, 390, 399, 413, 416, 434, 439, 448, 449, 478, 490, 498, 519 n. 11, 556, 558, 566, 572; chronology, 592 Sisley, William, 121; portrait by Renoir 121 Société anonyme des artistes..., 313, 315, 326, 336, 339 n. 20 Société des artistes français, 588 n. 20; see also Salons Society of American Artists, 425 Society of French Artists, 255 Solari, Philippe, Bust of Emile Zola, 143 South Kensington, International Exhibition, 258 Soutzo, Prince Grégoire, 27 Spain, 50, 76, 125, 126, 127, 128, 208, 248, 409, 580 Stendhal (Henri Beyle), 578 Stevens, Alfred, 190, 197, 214, 216, 217, 252, 272, 273, 302, 477, 526 Stevens (brother of Alfred), 214 Stock (caricaturist), 246

Tahiti, 560, 572, 574, 575

Tanguy, père Julien, 301, 356, 358, 414, 536, 541, 549, 556–558, 572, 575; portrait by van Gogh, 557

Le Temps, 450

Thaulow, Frits, 496

Thiers, Adolphe, 265

Third Republic, 250, 264ff, 272, 304, 399, 419

Strindberg, August, 372, 496

Synthetism, 548, 554

Swinburne, Algernon Charles, 88

Symbolism, 533, 543, 554, 558, 574

Thoré, Théophile, see Bürger, Wilhelm Tiepolo, Giovanni Battista, 462 Tillot, Charles, 366, 391, 423, 439, 449, 523 Tintoretto, 76 Tissot, James, 76, 207, 208, 250, 313, 315; portrait by Degas 176 Titian, 76, 210 Toulmouche, 70, 71, 93, 242; Girl and Rose, 70 Toulouse-Lautrec, Henri de, 509. 540, 541, 553, 554, 560, 568, 579, 580, 587; portrait of Bernard 541 Tréhot, Clémence, 133, 164 Tréhot, Lise, see Lise La Tribune, 191, 252 Trouville, 132, 160, 255; ill. Monet 129, Whistler 130 Troyon, Constant, 17, 38, 40, 41, 48. 61, 65, 90, 110, 261, 301, 419 Turner, J. M. W., 72, 258, 269 n. 36 Turgenev, Ivan, 360

L'Union, 362f, 366, 375f, 390f
United States of America, 261, 273, 361, 419, 430, 517, 518, 553; see also Boston, New Orleans, New York

Valabrègue, Anthony, 139, 168, 214. 249, 250; portraits by Cézanne 138, 215 (color) Valadon, Suzanne, 488, 566; appears in Renoir 483, 546 Valernes, Evariste de, 26, 566 Valéry, Paul, 568 Valpinçon, Edouard, 15, 60, 260, 490 Valpinçon, Hortense; portrait by Degas, 265 Valpinçon, Paul; appears in Degas 311 Velázquez, Diego, 50, 51, 52, 76, 106, 125, 154 van de Velde, Henry, 550 Venice, 364, 461, 462, 563; ill. Renoir 460 Verhaeren, Emile, 526 Verlaine, Paul, 254

Vermeer, Jan, 76

Vernon, ill. Monet 484 Veronese, 76, 462 Versailles, 259, 260, 271, 458; ill. Manet 459 (color) Vétheuil, 412, 420, 423, 424, 431. 433; ill. Monet 430, 431, 443 Vidal, Eugène, 439, 449 La Vie Moderne, 430-431, 440, 447, 456, 479, 481, 500, 502 Vignon, Victor, 439, 449, 468, 471. 472, 522, 523; Landscape, 523 Ville d'Avray, 76, 150, 165, 166, 224. 252 Villemessant, Henri de, 143 Villiers de l'Isle-Adam, August, count de, 401 Vincent, Joseph, 318, 320, 322ff Les Vingt, 532, 547, 550, 554-555 Viollet-Le-Duc, Eugène Emmanuel, 22 Vollard, Ambroise, 572, 575ff, 580, 589 n. 51; portrait by Cézanne; 574 portrait by Renoir 583 Le Voltaire, 426, 428 Vuillard, Edouard, 558, 577

Wagner, Richard, 116, 254, 460-461; portrait by Renoir 461 Walewski, Count Alexandre, 79 Wargemont, 433, 490 Watteau, Antoine, 76 Watts, George Frederic, 258 Wheelwright, 95 WHISTLER, JAMES McNeill (1834-1903) in Paris, 19 and Courbet, 25, 32, 49, 50, 128, 160-161, 241 and the Salons, 32, 79, 137 n. 40, 170, 509 at Salon des Refusés, 81, 82, 86, 195 n. 55 Oriental influence, 118, 207-208 London exhibition of etchings, 482 death, 579 photograph of 162 -, At the Piano, 32, 160; Butterfly

signature, 482; Courbet at Trou-

ville..., 130; Carlyle, 509; Théodore

Duret, 241; Princesse du pays de

porcelaine, 137 n. 40, 207; Self Portrait, 26; Wapping on Thames, 49, 50, 51, 160; White Girl, 81, 86, 87, 132, 160, 195 n. 55

—, mentioned, 69, 72, 73, 76, 89, 125, 132, 137 n. 51, 161, 162, 377, 439, 454, 547

Weir, J. Alden, 531

Wolff, Albert, 218, 237 n. 46, 242, 302, 351, 368–370, 374, 386, 394, 440, 444, 450, 476, 477–478, 500; portraits by Bastien-Lepage 370, Manet 478

World's Fair (Paris), see Paris World's Fair

Zaandam, 263; ill. Monet 262, 263, 270

Zandomeneghi, Federico, 399, 423, 439, 441, 448, 449, 523, portrait of Paul Alexis, 439

ZOLA, EMILE (1840-1902) and Cézanne, 62, 142, 143, 146, 157, 158, 168, 170, 248, 249, 416, 473, 474, 534, 576 and Manet, 86, 143-144, 168, 171, 173, 182, 188, 198, 239, 361-362, 401, 403, 426, 447, 477, 553 on Salon des Refusés, 86, 143, 170 L'Evénement, 134, 143, 144, 170 theories, 142-143, 265-266 on the Salons, 143, 144, 188-189, 360-362, 424, 426, 444, 445, 447 and Monet, 144, 362, 364, 387, 412, 445, 534 on Pissarro, 144 Mon Salon, 146, 168 on Paris World's Fair (1867), 171 at Café Guerbois, 197ff describes Bazille, 200 described, 200-201 during Franco-Prussian War, 249-

250
on impressionist exhibitions, 327–
328, 372, 394, 397 n. 60, 419, 426
L'Assommoir, 401, 403, 416
Nana, 403, 404
L'Oeuvre, 534, 543
defends Dreyfus, 576
death, 579

—, appears in Bazille 235, Cézanne 201, Fantin 196; bust by Solari 143; photograph of 447; portrait by Manet 189 and caricature of 188

—, mentioned, 65, 102, 150, 156, 186, 189, 191, 203, 205, 207, 214, 234, 252, 258, 260, 264, 271, 294, 304, 336, 341, 376, 380, 382, 401, 404, 406, 410, 413, 420, 428, 449, 450, 452, 490, 500, 501, 536, 580 Zurbaran, Francisco, 156

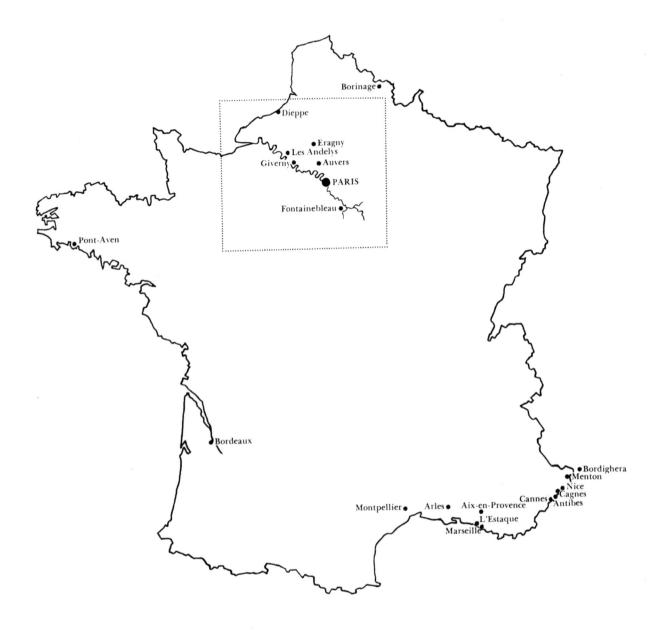

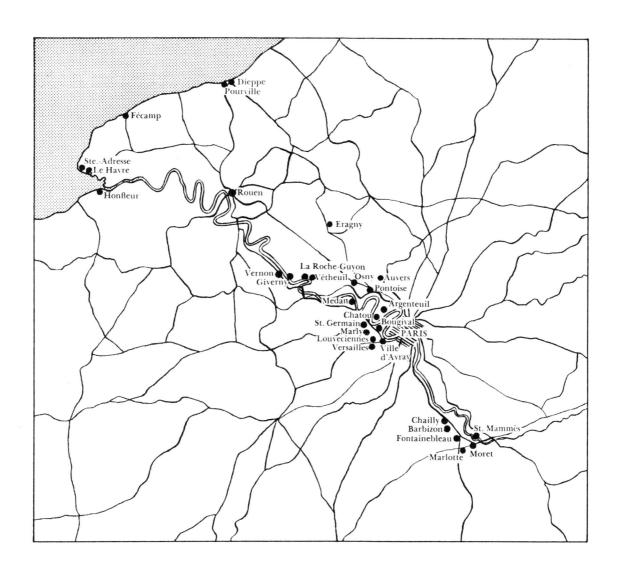